A HISTORY
OF VIRILITY

EUROPEAN PERSPECTIVES

EUROPEAN PERSPECTIVES

A SERIES IN SOCIAL THOUGHT AND CULTURAL CRITICISM

LAWRENCE D. KRITZMAN, EDITOR

European Perspectives presents outstanding books by leading European thinkers. With both classic and contemporary works, the series aims to shape the major intellectual controversies of our day and to facilitate the tasks of historical understanding.

For a complete list of books in the series, see pages 745–46.

A HISTORY OF VIRILITY

EDITED BY

ALAIN CORBIN,

JEAN-JACQUES COURTINE,

AND GEORGES VIGARELLO

TRANSLATED BY

KEITH COHEN

COLUMBIA UNIVERSITY PRESS

NEW YORK

Columbia University Press
Publishers Since 1893
New York Chichester, West Sussex
cup.columbia.edu
Copyright © Éditions du Seuil, 2011
English translation copyright © 2016 Columbia University Press
All rights reserved

Cet ouvrage a bénéficié du soutien des Programmes d'aide
à la publication de l'Institut Français.
This work, published as part of a program of aid for publication,
received support from the Institut Français.

Library of Congress Cataloging-in-Publication Data
Histoire de la virilité. English
A history of virility / edited by Alain Corbin, Jean-Jacques Courtine, and Georges Vigarello ;
translated by Keith Cohen.
pages cm. — (European perspectives : a series in social thought and cultural criticism)
Includes bibliographical references and index.
ISBN 978-0-231-16878-6 (cloth : alk. paper)
1. Masculinity—History. 2. Men—History. 3. Men—Social conditions. 4. Men—Identity.
5. Men—Psychology. 6. Sex role—History. 7. Gender identity—History. I. Corbin, Alain,
editor. II. Courtine, Jean-Jacques, editor. III. Vigarello, Georges, editor. IV. Title.
HQ1090.H5713 2016
305.3109—dc23
2015030845

Columbia University Press books are printed on permanent and durable acid-free paper.
This book is printed on paper with recycled content.
Printed in Canada
c 10 9 8 7 6 5 4 3 2 1

Cover and book design: Lisa Hamm
Cover image: © Photofest

References to websites (URLs) were accurate at the time of writing.
Neither the author nor Columbia University Press is responsible for URLs
that may have expired or changed since the manuscript was prepared.

CONTENTS

CONTENTS

CONTENTS

CONTENTS

COLOR PLATES FOLLOW PAGE 464

TRANSLATOR'S NOTE

A HISTORY *of Virility* has been constructed from a longer work, *Histoire de la virilité*, published in three volumes by Éditions du Seuil in 2011. These twenty-two chapters represent a selection of the original forty-six chapters. In abridging the original I aimed at preserving what I perceived to be its greatest strengths: a comprehensive account of the idea of virility in the Western world from ancient times to today, based on documents and testimony; the contributors' ability to mesh a general argument about cultural history with very specific revelatory examples and anecdotes; and a frankness about changes in behavioral and sexual mores, regardless of the people involved.

In its historical sweep this volume discloses the major trends of our cultural development using the unique portal of how men have modeled, exploited, and worried about their manhood. While the focus is at first on ancient Greece and Rome, it shifts to Western Europe, mainly France, from the early modern period to the Enlightenment. The United States and the Anglophone world more generally become one of the main focal points as the authors treat the nineteenth, twentieth, and twenty-first centuries. In the ebb and flow of male domination, a major theme of the modern period, these scholars also give voice to the objects of domination, servants and lower classes in general, subjugated indigenous peoples, and women in particular. It is thus a history at once of men's exuberance and preoccupation about their manly prerogative, their access to power, and the challenges to their domination.

The second attribute, the writers' ability to combine the general with the specific, makes this a highly readable volume. Far from a dry chronicle, it lets us peer into men's private lives to reveal the inner workings of their minds—their ambitions as well as their anxieties. We are with the Spartans as they inspect newborn males to determine whether they are fit to live. We learn the subtle codes of signifying virility among the rich and powerful men of the Renaissance. We peer into the journals and correspondence of well-known writers and painters of the nineteenth century as they vaunt their sexual exploits and share with each other intimate data. We are with the crestfallen survivors who watch the parade of maimed and mutilated return from the Great War.

The writers' candor regarding behavioral and sexual matters makes creates in *A History of Virility* an overlay of gender and genre; a preeminent study of the male gender, it also combines scholarly with confessional modes and historical analytics with vivid archival reportage. Readers will learn how Athenian citizens opined about each other's amorous inclinations by describing their fellows' body parts. They will understand better how Greco-Roman society, tolerant of homosexual as well as heterosexual relations, maintained nonetheless a strict hierarchy of which practices were more or less ignoble. They will read how such revered writers as Stendhal and Flaubert, Vigny and Musset, kept track of their orgasms and tallied them over against those of their confreres. Readers may be surprised as well by how many new slants are offered on radically different relationships and sexual practices since the 1970s, even those who lived through that era.

In saying all this, I want to take responsibility for the cuts I had to make, in the interest of brevity and economy. If the reader senses that significant swaths of cultural history have been abruptly elided, I am the one to blame. The reader who knows French is well advised to consult the original French volumes to appreciate better the magnificent scope that editors Alain Corbin, Georges Vigarello, and Jean-Jacques Courtine have achieved in their selection of authors and topics. I wish to express my gratitude, moreover, to the editors for having conferred with me on various knotty issues.

I want to thank as well those colleagues and friends who have come to my aid at various points: Jennifer Crewe, Kathryn Schell, Lisa Hamm, and Roy Thomas at Columbia University Press, Jordan Benderly, Tim Walton, Marcia Bronstein, Barry Friedman, and Aurélien Ros.

To those interested in the process of translation I wish to confide a few of the conundrums I faced. French scholarly writing, like that of the Anglophone world, has certain recurrent terms that are polyvalent or idiosyncratic. "*Discours*" in

French may mean discourse in some contexts, but more often I translated it as "set of ideas" or "set of attitudes." "*Imaginaire*" may mean imaginary when used as an adjective, but as a noun it refers, variously, to the realm of the imagination, to a part of the sensorium different from reason, or to a part of the psyche distinct from the real or the symbolic. "*Valoriser*" is not "valorize," though occasionally it does mean that; "*privilégié*" may mean privileged, but more often needs to be translated as "favored" or "given priority to;" and "*s'inscrire*" rarely turns out as being inscribed, but rather as coming within the scope of something. I point to these *faux amis* as the most obvious cases of linguistic traps, deceptive road signs inviting the English translator to settle for a cognate. I did my best to avoid these traps.

In dealing with the writing styles of a broad range of different authors, I have endeavored to maintain a consistent voice and register. This has the possible advantage of allowing the English reader to pick up resonances and cross-references among authors. The disadvantage, however, is that the reader may be deprived of some of the stylistic flourishes that characterize each contributor's work.

This is a book, then, that aims very high: to inform us in detail about the concept of virility, which has received scant scholarly attention until recently, and to make that information as close to people's lived reality as possible—human, deeply felt, determined yet tentative, and even comic. As with other aspects of the human condition, we discover upon contemplating virility how very little we understood it before now.

PREFACE

VIRILITY CAN be characterized by an age-old tradition: not simply by masculinity, but by its very nature and by its most "noble" part, if not in fullest measure. Virility has been seen as virtue, accomplishment. Roman *virilitas*, from which the word derives, remains one model, with its characteristics clearly outlined: sexual traits—those of the "assertive" husband, powerfully built, procreative but also levelheaded, vigorous yet deliberate, courageous yet restrained. The *vir* is not simply *homo*; the virile is not simply what is manly; it is more: an ideal of power and virtue, self-assurance and maturity, certitude and domination. All of this traditionally places the man in a challenging situation: aiming for "perfection" and excellence as much as for "self-control." There are numerous qualities interlaced: sexual dominance mixed with psychological dominance, physical force with strength of character, courage and "greatness" accompanied by strength and vigor. These qualities are embodied and popularized in a gallery of heroes—from Alexander to Caesar, for example, and from Theseus to Pompey. It is an especially harsh tradition, by which perfection tends always to be threatened by some insufficiency: a doubt insidiously slipped into certitudes, or a devious flaw that runs the risk of sanctioning hoped-for successes. The cord knotted by our rustic sorcerers, nullifying the potency of future husbands, is not unrelated to the sense of failure that the eldest son traditionally tries to inflict on his younger brother. Virile perfection inevitably discloses requirements: extreme power cannot be unaware of delusion; strength cannot be unaware of frailty. Anxiety hovers over this supposed excellence.

While it has become more complex, however, this tradition has by no means fixed virility in an immovable history. The traits are reconstructed over time. Mercantile society could not have the same virile ideal as military

society. The courtier could not have the same virile ideal as the knight. The courtier, for example, is required to add elements of gracious elegance to the old coarse values of combat. Yet there is no loss of domination; nor is there any loss of courage in this courtier whom certain contemporaries may accuse at times of effeminacy. His virile ideal, however, has been transformed, even though his interests still seem quite remote to us: his haughty attachment to a sense of honor and his manner of stonily defying death, without vacillation, by drawing his sword. Showing no hesitation whatsoever, of course, Brântome's sixteenth-century courtiers idealize an implacable virility: sexual potency is supposedly combined with an absolute ascendancy over women, refined manners are meant in no way to diminish one's expected valor in combat. Virility dominates and shows off, all the while being itself revamped and displaced.

It is this transformation of the virile ideal in Western societies that this book charts: this striving for perfection, this model of ascendancy and domination, itself changing direction in relation to cultures and time periods. Our enterprise is based on the wish to introduce history into something that seems to have none: a history lodged at the heart of everyday practices and social relations, a history that reveals the characteristics of a society, an economy and even a political system. Our wish is also to show, beginning with Antiquity, across the archeology of our societies, how much virility can change in relation to social orders, sub-cultures, urban or rural ideals, and ideals of combat or scholarship. Virility is historical; and so it is, inevitably, anthropological.

There is still one line of questioning to follow. It bears on the very stuff of virility and explains, in part, the origin of this book. Virility today could not impose any kind of dominance without some sharing. Male domination persists, but it tends to lose its meaning as equality gains ground. Man's "authority" over woman, for example, could have no basis whatsoever; nor could the so-called superiority of the "masculine" over figures of virile weakness or of effeminacy. The old-time legitimacies end up verging on the ridiculous. The model slips away and fades, doomed to such derisive nostalgia as to invalidate the very word "virility." Hence this immense journey at the core of our history, in which the tradition of virility, after considerable tipping and tossing, may today be kept in some anachronistic conservatory, immobilized by dismantled ideals, or the tradition may create new identities and keep on metamorphosing.

ALAIN CORBIN

JEAN-JACQUES COURTINE

GEORGES VIGARELLO

A HISTORY OF VIRILITY

1

GREEK VIRILITIES

MAURICE SARTRE

GREEK IDEAS about virility—that is, the set of traits and behaviors peculiar to a man—derive more from ideological constructions than from anthropological observations. The documents and images provide information more on how society expects the male to behave than on actual practices, notably in the area of intimate relations, where deviance from the stated norm is never likely to be on view. But, although failing to describe slices of Greek men's life, the voluminous documents available to us help to depict an ideal portrait of the Greek man as an element of a sexualized group. From the Homeric epic to such novels of the imperial period as *Daphnis and Chloë*, from the Pindaric odes on champion athletes to the moralizing narratives of Plutarch, from Aristophanes's comedies to the Platonic dialogue, a great consistency predominates despite generic differences and temporal disparities. It is a consistency that might appear suspicious were it to betray only the permanence of a model solidly established in discourse. It is a consistency that must also be questioned with regard to reality. A close reading of the relevant texts and images leads one to perceive quite well some deviations from this model that reveal moralizing stories, plaintiffs' arguments, or treatises on the interpretation of daydreams. Moreover, between Homer and the end of paganism, more than a thousand years go by that witness the evolution of a number of behaviors, even if the dominant tradition weighs heavily in Greece and not only in Sparta. Nevertheless, removing an improbable ideological constant, the Greeks left a relatively consistent image of what they conceived of as virility, an image often constructed on the opposition of genders and that bears witness to a profound reflection on social, political, and even religious behaviors in relation to the groups that make up the city-state.

ANDREIA: THE FACT OF MALENESS

When Homer wishes to qualify the actions of a man, he has no choice but to declare that he "is man," that he "presents as man," which generally means that he has manifested his brute force (*alkè*), sometimes excessively (*agènôr*). For man is possessed of a *thumos*, a will, a desire that it is his responsibility to control but that might lead him to excessive violence.

Andreia appears for the first time in Aeschylus's *Seven Against Thebes* in 467 B.C.E.: "For their iron-hearted spirit (*thumos*) heaved, blazing with *andreia*, as of lions with war in their eyes."[1] Coming from *anèr*, which refers to man not as a human species (*anthropos*) but as a male, *andreia* possesses a less cursory meaning than the Homeric expression "to be a man." To be sure, at the heart of the notion one finds physical courage, which is first shown on the battlefield but which is not the complete demonstration of the Homeric hero's bravery and brute force, since hoplite combat requires order and discipline. However, muscular strength remains present, and it is no accident that Aristophanes makes Hercules the very symbol of *andreia* (*The Frogs*, 491–99). The idea that *andreia* is manifested on the battlefield is also the first thing that comes into the minds of his interlocutors when Socrates tries to get them to define the notion in Plato's *Laches*. But this *andreia* is accompanied by audacity in adversity as well as obstinacy in the face of bad luck. It is therefore not unreasonable that women should manifest *andreia*: Electra entreats her sister Chrysothemis to demonstrate *andreia* in helping her to avenge their father (Sophocles, *Electra*, 983). Herodotus is not afraid of judging Artemis of Halicarnassus as "virile" (III, 99, 1); her conduct at war and the wisdom of her opinions place her on a par with the best generals of the Great King at the time of the second Persian War. Gender is no longer a question of sex but of behavior and virtues, with courage placed as the top priority. Physical courage is very important of course, but so is moral courage, which means opposing the laws of the city-state that run counter to divine laws. Even Aristophanes, so quick to emphasize women's foibles, acknowledges in them a real *andreia* in the management of the city (*Lysistrata*, 549, 1108; *Assemblywomen*, 519). It is all the more remarkable in that these are the only passages in which the comic dramatist uses the term without sarcasm.

The development is made smoothly, then, from warfare *andreia* to an *andreia politikè*, a basic quality of the citizen, which Thucydides defined implicitly on the occasion of the upheavals in civic and individual morale caused by the war (III, 82, 4): "the senseless audacity was described as *andreia* for the benefit of

one's own group [*hetairia*]." In what remains the most complete picture of civic virtues, the famous funeral oration that Thucydides attributes to Pericles at the end of the first year of the Peloponnesian War (II, 35–46), *andreia*, which everyone took to be the province of the male, gathers together all the qualities that the male citizen manifests in that exemplary democracy constituted by Athens: the sole objective of an education in courage, praised by the orator, is the formation of a perfect citizen, a master of speech who gives good advice. These are non-negligible traits, for among those that definitely distinguish man from woman is access to political speech, to that eloquence which persuades.

War and politics provide the occasion to manifest one's *andreia*, but it is also expressed in other domains. The capacity to impose one's sexual desire and the fact of having dominion over one's *oikos* are no less important, but speech obviously gives priority to that which comes from the public sector, that which takes place before the eyes of everyone.

The link established by Pericles (in Thucydides) between the perfection of civic *andreia* and the political realm naturally implies that the Greeks ascribe to education a major role in the formation of virility, including in the demonstration of physical qualities that one might think could partially elude the realm of acquired traits: beauty and physical strength. It can be understood, on the one hand, that the cities accorded an essential place for the education of young males, and on the other hand, that Greek thinkers indulged in impassioned comparisons between varying systems of education that they saw before them. Otherwise, long passages of the funeral oration pronounced by Pericles can only be understood by an implicit comparison between the Spartan and Athenian systems of education.

THE EDUCATION OF THE MALE: FAMILY, CITY

From the moment the father recognizes his son by walking around the home with the newborn in his arms (which eliminates the risk of exposure to the elements) until his inscription in the civil registries, the young Greek man lives almost continuously in view not only of his family, his friends, and his teachers but of the entire city. Such is the force of the social constraint in an educational system that is directed, with all the nuances that will become apparent, more toward the reproduction of a model of the *polites* [citizen] confirmed by the community than toward the intellectual or physical development of the individual.

Nevertheless, the family ensures the beginnings of that formation. Even in Sparta, which was so quick to consider children as community goods, they were raised in their families up to the age of seven, at least if the city had decided on the survival of the infant:

> Offspring was not reared at the will of the father, but was taken and carried by him to a place called Lesche, where the elders of the tribes officially examined the infant, and if it was well-built and sturdy, they ordered the father to rear it, and assigned it one of the nine thousand lots of land; but if it was ill-born and deformed, they sent it to the so-called Apothetae, a chasm-like place at the foot of Mount Taÿgetus; they believed that the life of that which nature had not well equipped at the very beginning for health and strength, was of no advantage either to itself or the state. On the same principle, the women used to bathe their new-born babes not with water, but with wine, thus making a sort of test of their constitutions. For it is said that epileptic and sickly infants are thrown into convulsions by the strong wine and lose their senses, while the healthy ones are rather tempered by it, like steel, and given a firm habit of body. Their nurses, too, exercised great care and skill; they reared infants without swaddling-bands, and thus left their limbs and figures free to develop; besides, they taught them to be contented and happy, not dainty about their food, nor fearful of the dark, nor afraid to be left alone, nor given to contemptible peevishness and whimpering."[2]

It is thus the women who were in charge, as if the fathers had no responsibility in the formation of their little child. The fathers' slight interest in their male children has been attributed to the high incidence of infant mortality before the age of five, which prompted them not to show too much attachment prior to that age. But the collective responsibility of men in the Spartan "breaking in" no doubt better explains the individual withdrawal of fathers.

THE SPARTAN *AGÔGÈ*: MODEL OR EXCEPTION?

The Spartan education system is undoubtedly the best known in all of Greece because of the contradictory passions that it has aroused since antiquity. Plutarch gave a fairly complete description of it in his *Life of Lycurgus*.

Lycurgus would not put the sons of Spartans in charge of purchased or hired tutors, nor was it lawful for every father to rear or train his son as he pleased, but as soon as they were seven years old, Lycurgus ordered them all to be taken by the state and enrolled in companies [*agelai*], where they were put under the same discipline and nurture, and so became accustomed to share one another's sports and studies. The boy who excelled in judgment and *was most courageous in fighting*, was made captain of his company; on him the rest all kept their eyes, obeying his orders, and submitting to his punishments, so that their boyish training was a practice of obedience.[3]

The division of individuals into classes by age—which was not peculiar to Sparta, since all the Greek cities functioned according to a more or less elaborate hierarchy distinguishing at least among children (*paides*), youth (*neoi*), and adult men (*andres*)—is not limited to validating the gradualness of the training, which was nonetheless real:

As they grew in age, their bodily exercise was increased; their heads were close-clipped, and they were accustomed to going bare-foot, and to playing for the most part without clothes. When they were twelve years old, they no longer had tunics to wear, received one cloak a year, had hard, dry flesh, and knew little of baths and ointments; only on certain days of the year, and few at that, did they indulge in such amenities. They slept together, in troops and companies, on pallet-beds which they collected for themselves, breaking off with their hands—no knives allowed—the tops of rushes which grew along the river Eurotas. (Ibid., 16:6-7)

The collective training by division of age is first of all a means of awakening and consolidating both the spirit of competition (*agôn*) among members of the same division and the sense of group solidarity (*philia*) when up against others. This is the way one must interpret some of Plutarch's anecdotes which, given the lag in time, are not always likely to bear the meaning that he gives them. Thus, before being a spectacle of enduring pain, which could go on to the point of death, the flagellation of naked young men before the altar of Artemis Orthia is first an *agôn* within the framework of a sacred ritual. The sense of *agôn*, of competition, found in all aspects of the citizen's public life, increases from childhood on and is keenly encouraged by the civic authorities. There is no *andreia* without a profound sense of *agôn*: doing better than the other all the time and everywhere. This spirit of

competition is located at the core of the city and, consequently, central to the behavior of those who are its members—men.

But the "program" followed by young Spartans—at least what Plutarch has recorded of it—throws light on the objectives of an education aimed at making perfect men of them in accordance with the vision held in Sparta: "Of reading and writing, they learned only the bare essentials; all the rest of their training was calculated to make them obey commands well, endure hardships, and prevail in combat"[4] For the system aimed at forming a warrior, a disciplined hoplite. The fiercest in combat—a combat that was provoked as often as possible—was named to head the group: "The older men used to watch their sports, and often picked quarrels and fights to learn accurately how each one of them was naturally disposed when it was a question of boldness and aggressiveness in battle."[5]

It is nonetheless necessary to add a moral and political dimension to this picture. Regarding the acquisition of the virtues that make up a good citizen, Plutarch furnishes numerous anecdotes that have often been overlooked, although they seem to be at the center of the Spartan education system.

> The *eiren*,[6] as he reclined after supper, would order one of the boys to sing a song, and to another would put a question requiring a careful and deliberate answer, for instance, "Who is the best man in the city?" or, "What do you think of this man's conduct?" In this way the boys were accustomed to pass right judgments and interest themselves at the very outset in public life. For if one of them was asked who was a good citizen, or who an infamous one, and had no answer to make, he was judged to have an apathetic attitude, one that would not aspire to excellence. And the answer must not only have reasons and proof given for it, but also be couched in very brief and concise language, and the one who gave a faulty answer was punished with a bite on the thumb from the *eiren*. Often-times, too, the *eiren* punished the boys in the presence of the elders and magistrates for them to see whether his punishments were reasonable and proper or not. While he was punishing them, the elders did not stop him, but after the boys were gone, there were accounts to settle if the *eiren*'s punishments were harsher than was necessary, or, on the contrary, too mild and gentle.[7]

We note in passing the importance of song—not the refrains in fashion (the "roulades" that Aristophanes made fun of in *The Clouds*, 969)—but the martial airs that chant about training or marches into battle, those strictly forbidden by the city for the slaves to use:

In later times, they say, when the Thebans made their expedition into Laconia [369 B.C.E.], they ordered the Helots whom they captured to sing the songs of Terpander, Alcman, and Spendon the Spartan; but they refused, saying that their masters did not allow it, thus proving the correctness of the saying: 'In Sparta the free man is freer than anywhere else in the world, and the slave more enslaved.'[8]

Moreover, smooth talkers were looked upon with suspicion—from which arises the concern to express oneself in few words, or "laconically." This does not stop them from requiring each young man to know how to pass judgment on past and present events, i.e., to know how to tell right from wrong and be able to express it. Plutarch observes that the youths in Sparta attended the meals of citizens within the *syssitia* (or *pheiditia*) [common meals]—whose masculine character the Cretins emphasized by giving them the name *andreiai*—where they served the older men and, above all, listened to the accounts of noble actions from the past:

> Boys also used to come to these public mess halls, as if they were attending schools of sobriety; there they would listen to political discussions and took part in amusements worthy of free men. There they themselves also became accustomed to sport and jest in good taste, and to endure kidding without getting angry. Indeed, it seems to have been especially characteristic of a Spartan to endure kidding.[9]

In other words, Spartan education primarily valorized the indefinite repetition of the same models, according to which courage in war remains the paragon of virility. To be sure, one might consider that Spartan *andreia* also extends to political life, but in this city they expected hardly anything of the citizens other than that they obey the law and fight courageously when the city goes to war. They did not expect the *homoios* to give good advice to his compatriots or to propose new laws useful to the nation, but just that he obey: the term comes up incessantly in Plutarch's writings.

Education has, just as society, a pyramidal aspect, keenly hierarchical. At the top of the group formed by an *agele* (troop) (there were to be several of them for each age division), was a chief who came from the group (the fiercest in battle). Above him, there was a young adult, the *irene*, who carried out the coercive functions and had charge of education. But he himself was subject to the surveillance of the *pedonome* (headmaster), the elders, and the magistrates. As a general rule, as Plutarch emphasizes, "there was not a single moment or a single place where the young man who made a mistake would not find an older man to reprimand and

punish him." In Sparta it is the entire community of men who bear the responsibility for an education integrally aimed at the reproduction of the model.

The importance of the model of citizen-soldier appears as well in the arrangements made by Lycurgus for funerals:

> To begin with, he did away with all superstitious terror by allowing them to bury their dead within the city, and to have memorials of them near the sacred places, thus making the youth familiar with such sights and accustomed to them, so that they were not confounded by them, and neither had a horror of death nor held to the idea that by touching a corpse or walking among graves one is sullied. In the second place, he permitted nothing to be buried with the dead; they simply covered the body with a scarlet robe and olive leaves when they laid it away. To inscribe the name of the dead upon the tomb was not allowed, *unless it were that of a man who had fallen in war*, or that of a woman who had died in childbirth.[10]

Sparta was not the only city to accord specific status to citizens who died for their country or to their descendants. In Thasos, a city decree at the end of the fifth century specifies:

> Their fathers and mothers and their children shall also be given places of honor in the games; a placement shall be reserved for them, and the contest organizer shall have a bench placed in their honor; in the case of all those who have left children, when these children have attained their majority, the chieftains should give each, if they are boys, greaves, a breast-plate, a dagger, a helmet, a shield and a lance, whose value shall be no less than three minas; "they shall be given to them" at the Heraclea [festivals] during the games.[11]

Even outside the city-barrack that was Sparta, death in combat remained the most complete expression of civic *andreia*: wounds and scars were never exalted, only a beautiful death.

The exaltation of physical courage in the citizen results in the chastisement of those who did not conform to the model or who diverged from it. There existed in Sparta a category of inferior citizens, including *homoioi*, relegated to a lower class for having been "tremblers" (*tresantes*), for not having held their place in the phalanx, or for having fled before the enemy. The first law of the city that had to be obeyed was precisely to stand one's ground at whatever cost: "Passerby, go declare in Sparta that we lie here for having obeyed its laws," is what one reads on the

monument erected in Thermopiles in honor of the three hundred Spartans (whose king was Leonidas) who fell in 480 in combat against the Persians. A sick soldier who could have thrown himself into the melee with the others but who preferred to flee to Sparta was the object of shaming measures when he got there:

> no Spartan would give him fire or speak with him, and they taunted him by calling him Aristodemus the Trembler. In the battle at Plataea, however, he made up for all the blame brought against him. It is said that another of the three hundred survived because he was sent as a messenger to Thessaly. His name was Pantites. When he returned to Sparta, he was dishonored and hanged himself.[12]

Andreia consists of the combination of true courage and obedience, for it is not good to ignore orders or to give proof of one's individual courage with disregard for orders received, even for the best of reasons.

This type of virile education had a correlative for Spartan girls, who underwent a training that, although lighter, was no less rigorous: the objective of motherhood was substituted for that of war. Virile education, however, elicited criticism from the ancients, including political thinkers rather favorably disposed toward Sparta, such as Plato, Xenophon, and Aristotle. The tiny portion of intellectual discipline did not bother them as much as the restrictive character of the educational system as a whole. As Plato observes in connection with the Cretin *ageles*, the young men are treated like packs of horses.

The most serious charge, however, comes from Thucydides in the funeral oration he gives to Pericles (II, 37–40). He implicitly reproaches Spartan education for any number of things: for stifling individual liberty; for destroying the spirit of initiative; for stirring up citizens' mistrust of foreigners; for creating an artificial equality among citizens thus disallowing the most virtuous among them from distinguishing themselves while pushing aside the poorest among them; for stifling all political debate in the interest of a few professional politicians; for disdaining "matters of the mind"; and, in the final analysis: "as for the educational system, contrary to these people who establish from youth an onerous training to achieve courage, we, with our unfettered lives, face dangers at least on a par with theirs."

Even Plutarch, who continually praises this education, indirectly describes its defects:

> The training of the Spartans lasted into the years of full maturity. No man was allowed to live as he pleased; in the city, as in a military encampment, they always

had a prescribed regimen and employment in public service. They believed that they belonged entirely to their country and not to themselves. When they had not been ordered to do anything else, they kept an eye on their children, either teaching them some useful thing or learning it themselves from their elders.[13]

This constant mutual surveillance resembled a beehive:

> It was shameful for the elderly men to be continually seen loitering there, instead of spending the greater part of the day in the places of exercise that are called *leschai*. For if they gathered in these, they spent their time suitably with one another, making no allusions to the problems of money-making or of exchange. They were instead chiefly occupied there in praising some noble action or censuring some base one, with jesting and laughter that let any warnings or protestations pass amidst light banter. For not even Lycurgus himself was immoderately severe; indeed, Sosibius tells us that he actually dedicated a little statue of Laughter, and introduced seasonable jesting into their drinking parties and like diversions, to sweeten, as it were, their hardships and meagre fare.
>
> As for the oldest people, they would have been ashamed to appear constantly busy at such tasks and not to spend the better part of the day at the gymnasium or in what they called the *leschai*. They would gather there to make use honestly of their leisure time with one another, not speaking of anything that touched on ways of making money or business affairs. The majority of these chats were devoted to the praise of fine actions or the critique of bad ones, the whole thing enlivened by jokes and laughter that let any warnings or protestations pass amidst light banter. [...] In a word, he trained his fellow-citizens to have neither the wish nor the ability to live private lives; but, like bees, they were to make themselves always integral parts of the whole community, clustering together about their leader, almost beside themselves with enthusiasm and noble ambition, and to belong wholly to their country.[14]

While Sparta pushed virility to the extreme and at times to the point of absurdity, espousing a model of education that had proven to be a failure as early as the fourth century, it was not alone in this choice. What Ephorus says as early as the fourth century about Cretin education is in line with this criticism:

> In order that courage, and not cowardice, might prevail, [Ephorus] commanded that from boyhood they should grow up accustomed to arms and toils, so as to scorn heat, cold, marches over rugged and steep roads, and blows received in gymnasiums

or regular battles; and that they should practice, not only archery, but also the war-dance, [. . .] so that not even their sports were without a share in activities that were useful for warfare; and likewise that they should use in their songs the Cretic rhythms, which were very high pitched, and were invented by Thales, to whom they ascribe, not only their Paeans and other local songs, but also many of their institutions; and that they should use military dress and shoes; and that arms should be to them the most valuable of gifts [. . .]. The children must learn, not only their letters, but also the songs prescribed in the laws and certain forms of music. Now those who are still younger are taken to the public mess halls, the "*andreia*" [a house where men from the same civic group eat together]; and the boys sit together on the ground as they eat their food, clad in shabby garments, the same both winter and summer, and they also wait on the men as well as on themselves. And those who eat together at the same mess hall join battle both with one another and with those from different mess halls. A *pedonome* presides over each *andreion*.[15]

When they got older the youth entered the *ageles*, and "on certain days one *agele* is put up against another as the flute and lyre set the rhythm for the march into combat, just as is done going into war. They come back with wounds inflicted on one another not only with their bare hands but also with weapons free of iron:"[16] this is reminiscent of the combats organized in Sparta. In Crete, as in Sparta, emphasis was placed on military training and obedience to the laws and the magistrates, while literature was neglected, and the only music they heard was that used to set the rhythm for the hoplites.

THE ATHENIAN SCHOOL: FROM *PEDONOME* TO SOPHIST

Pericles and Thucydides's sharp criticisms presuppose a diametrically opposite view of the Athenians. Even if it is unclear whether some of the objectives are not identical, a first essential point separates the Athenian system from Spartan training (*agôgè*): the family seems to be more present, and their youth continue to live with them except for the times reserved for school or gymnasium. Moreover, while a common ground existed for what we would call primary school, the youths from well-off milieus went to expensive teachers chosen by their fathers, and most followed the path of farming or family business. It is only later, and perhaps not for all young men, that the system of *ephebeia* was established. But it derives more from virile initiation rites, to which we shall return, than from the education system in the strict sense.

In truth, little is known in detail about the Athenian education system, and the sketch given by Aristophanes of the new education in the last quarter of the fifth century should be taken with a grain of salt. For the comic author's main objective is to make people laugh, even if it is by means of obvious excesses, and, without saying so, his characters' speech clashes bluntly with a Spartan-style education, which was never in place in Athens, and with a "new" education that affected only young men from very well-off backgrounds. Thus, in a famous passage in which he sets up a debate between the personifications of Just Reasoning and Unjust Reasoning, he accords to the first statements that the *ephors* of Sparta would not deny, even though these are presented in the mode of burlesque:

Let me explain what it was like during the time when I was at my peak. The old education system was all about virtue and common decency. These were the acceptable norms in our society then.

The first, most important rule was that young boys should be seen but never heard; not a sound, not even a whisper out of them! Then, it was a strict rule that all the boys from the same neighbourhood would march together to their music school, in an orderly fashion and, even if it was snowing snow as thick as flour outside, these kids would be wearing nothing. At the music school, their teacher would first sit them down—thighs spread open to avoid self stimulation—and then get them all to memorise great songs, like "O, Pallas Athena, awesome goddess who destroys cities" or "I hear the distant sound of a cry." Songs which the boys had to sing in the same way that their own fathers used to sing them. No boy dared buggerise around with that style by adding his own, new little fancy, flowery improvisations like that aggravating Phrynis does with his guitar. He'd be severely whipped with a lash for adulterating the good work of the Muses.

At the gym, when the boys had to sit down on the sand, they did so with their thighs crossed so as not to exhibit anything that could shock the onlooker and when they got up, they'd immediately smooth the sand upon which they were sitting so that they would erase all imprints of their pubescent bodies lest their lover leer over them.

When a boy oiled himself, he'd never rub his body below his navel and so his balls would glisten with a soft, cool dew, much like the skin of a quince. And when he went for walks with his lovers he wouldn't make his voice all soft and sleazy or drop his glances coyly at other boys like a pimp.

When our young man sat at the table, they wouldn't snatch their radishes like ill-mannered fools, or eat dainty little morsels, or steal the dill or the parsley out of the plates of the older men, nor was he allowed to guffaw or sit cross-legged.[17]

Modesty, respect for the elders, refusal of the slightest comfort, discipline: here were elements of the Spartan *agôgè*! They are satisfied with military music, for the objective is not to do the heart good but rather to be trained for war: this is the education, Aristophanes adds, that formed the conquerors at Marathon!

In contrast, the new education, dispensed by Socrates, like that of the sophists, "teach[es] the children of to-day to spend their whole lives wrapped up in thick cloaks,"[18] takes away from them the respect their parents and elders in general deserve, encourages them to frequent strip clubs rather than the gymnasium, and most of all, promotes endless discussions and the most twisted arguments that lead to "taking as nasty everything that is beautiful, and as beautiful everything that is nasty." Moreover, Unjust Reasoning provides a demonstration of the point on the spot: in response to Just Reasoning, who regrets the days when young men did not frequent the baths, and, using a procedure characteristic of the sophists, the syllogism Unjust Reasoning proves instead their beneficial effect: was Hercules not the most valiant of Greek heroes, the one who accomplished the most brilliant feats? Well, the "baths of Hercules" are set up on hot springs!

This organized attack against the sophists undoubtedly had a large following among the common people, who did not grasp the innovative aspect of an education system of which they saw only the defects: the exorbitant price of the lessons (denounced by Plato's Socrates in the *Protagoras*, 310a–312c) and the arrogance of the young aristocrats whose scandalous conduct (i.e., mutilating the Herms and mocking the mysteries in 415, belonging to the tyranny of the Four Hundred in 411 and to that of the Thirty in 404) seemed to them to derive from the education they received. The trial of Socrates (399) brought to a tragic end the teaching of a certain form of new education.

But the profoundly innovative dimension of the Sophists' teaching, besides their excesses, cannot be concealed. By claiming that anything can be learned, that each person can exercise judgment and reason about everything, they encourage a questioning of the knowledge acquired. It is the polar opposite of Spartan education, which is aimed at the infinite reproduction of a model. But let us not conclude from this that the Athenians wished to be innovators: in Athens, as throughout the Greek world, innovation was never considered a virtue in itself. Anyone who innovates sets out to show that he is remaining faithful to the tradition of the ancients, that he is satisfied to give a new form to old ideas. In reality, the education of the Sophists favors the formation of individual thinking that includes intellectual innovation as reflected in the whole literary and artistic tradition. It takes *andreia* out of its military context and promotes other aspects of

masculine behavior, such as mastery of political speech, another form of virile domination.

That said, the basic Athenian education remains largely directed toward civic usefulness. As Thucydides reminds us in Pericles's funeral oration, it is really about forming individuals who are at once obedient to the laws and useful to the city:

> We are free and tolerant in our private lives; but in public affairs we keep to the law. This is because it commands our deep respect.
>
> We give our obedience to those whom we put in positions of authority, and we obey the laws themselves, especially those which are for the protection of the oppressed, and those unwritten laws which it is an acknowledged shame to break. [...]
>
> Even those who are mostly occupied with their own business are extremely well-informed on general politics—this is a peculiarity of ours: we do not say that a man who takes no interest in politics is a man who minds his own business; we say that he has no business here at all. We Athenians, in our own persons, take our decisions on policy or submit them to proper discussions [...]."[19]

During the first year of ephebe training strong emphasis is placed upon military training.

> These [officers] take the cadets in a body, and after first making a circuit of the temples then go to Peiraeus, and some of them garrison in Munichia, others in the Acte Peninsula. And the people also elect two athletic trainers (*paedotribae*) and instructors for them, to teach them their drill as heavy-armed soldiers, and the use of the bow, the javelin and the sling.[20]

This is not very different from the Spartan model, with the notable exception that the training lasts only two years.

MASCULINE INITIATION: THE INVERTED CITIZEN

Greek societies partake of all the initiation rites that mark the integration of youths into the group of men: the passage from childhood to adolescence and to adulthood is a matter not only of sexual maturity but also of collective rites, that is, of social construction. As Father François Lafitau,[21] a Jesuit from Bordeaux who knew

his classics and who had had contact with the Indians of Canada, observed at the beginning of the eighteenth century, not without a certain malice, the Greeks after all were just as much savages as any others! He saw clearly that, between the rites of passage of the Indians, the "savages of his time," and what he had read about Spartan and Cretan practices, there were a number of similarities. Historians have proved him right.

These rites are best known in Sparta, in Crete, and later in Athens, but there is no doubt that they existed in one form or another elsewhere. Without going into the details often mapped out (notably by Henri Jeanmaire, Pierre Vidal-Naquet, and Bernard Sergent), it is fair to figure that there existed, between the Lacedaemonian (or Spartan) *krypteia*, the Cretan initiations, and the Attic *ephebeia*, practices derived from the same mental and social processes.

These rites were all intended to ensure the passage from childhood to adulthood, from a virtual virility to an assumed virility. The emphasis placed on warrior training, on the engagement of the individual at the side of other adult males in the defense of the city, comes out with particular clarity in the oath taken by the Athenian ephebes at the end of their two years of testing:

> I shall not dishonor the sacred weapons. I shall not abandon my comrades at arms lined up at my side. I shall fight for all that is holy and sacred. I shall not leave the nation diminished but rather greater and stronger than it was before, whether alone or with everyone. I shall obey all those who command in turn. I shall be subject to the laws wisely established, and to all those that will be wisely established. If someone tries to undermine or to break them, I shall not allow it but shall defend them, alone or with everyone. I shall revere the beliefs of my fathers. May the gods be my witness: Aglauros, Hetia, Enyo, Enyalos, Ares and Athena Areia, Zeus, Thallo, Auxo, Hegemoné, Hercules, and the borders of the nation, its fields, grains, vines, olives, and figs.[22]

As can be seen, the objective is no different from what Spartan education aims at from the members of its *ageles*: courage in combat, obedience to the laws, respect for the gods.

The rites in Sparta, Crete, and Athens are composed of a number of common traits that can perhaps be synthesized and articulated around three phases: marginalization, inversion, and reintegration. First marginalization: At the time of initiation, the young men, individually (Sparta, Crete) or collectively (Athens), are taken from the heart of the city out to its margins. In Sparta the *kryptes* hide out

in the countryside and must not be seen in the city. In Crete, the young man, after a simulated abduction, is led by a lover and a band of companions to the edges of the territory:

> After giving the boy presents, the abductor takes him away to any place in the country he wishes; and those who were present at the abduction follow after them, and after feasting and hunting with them for two months (for it is not permitted to detain the boy for a longer time), they return to the city. [23]

In Athens this marginalization can be recognized in the obligation imposed on the ephebes during the second year of their training, when they have received their military paraphernalia, to conduct "military marches into the country and [set up] garrisons inside the forts," that is, on the margins, along the borders; moreover, they are forbidden to return to Athens during this period. "They are not allowed to be sued nor to sue at law, in order that they may have no pretext for absenting themselves, except in cases concerning estate, marriage of an heiress, and any priesthood that one of them may have inherited,"[24] that is, when the survival of the *oikos* depends on it.

Once placed outside the city, the young man lives in a world where inversion of the citizen norm seems to be the rule. The *krypteia* no doubt provides the clearest examples of this. Thus, living on the margins of the territory, in the countryside, far from the agora and city temples, is not the citizen's lot. In addition, the *krypte* hides away during the day and comes out at night, and, instead of living in sight of everyone, he tries to get by unnoticed. To nourish himself he neither grows food nor buys it at the market: he steals or hunts; and he does not practice honest hunting, confronting the animal face-to-face as the hoplite confronts the enemy, but he engages in trick hunting using nets and lime. Similarly, the young Cretan, his lover and companions, spend their time hunting. But it is undoubtedly the sexual inversion that our sensibilities have been most struck by. We shall return later on to homoerotic practices as a constituent element of Greek virility, but two things should be emphasized here: on the one hand, masculine and/or transvestite sexual relations are an integral part of the practices of inversion as a whole, and, on the other hand, they are carefully framed by legal acts. Ephorus declares explicitly, with regard to Cretan initiation rites, that the duration of the stay in the countryside is limited by law, that the young man must report on the relations he has had with his lover, and that the gifts at the end of the initiation are regulated by law. Neither physical attraction nor feelings seem to play a part in the choice of a lover. Cretans

insist instead on the necessity of finding a lover of the same social class and with distinguished moral qualities. At the very moment when the young man submits, as a woman, to the power of a male who dominates him, he is nonetheless expected later to engender legitimate children and thus to use his virility to perpetuate the citizenry. Safeguards are increased to ensure that this obligatory acting-out as the opposite sex constitutes only a provisional, strictly delimited stage.

During this phase, when he is situated out of the way, the young man behaves in a manner opposite of what is expected of him as a citizen, as if integration into the group of men were preceded by a journey into another world in which craft, trickery, and femininity were the rule. No need to recall that the rare traces of feminine initiations consist of rites that are exactly parallel. In Sparta, the young fiancée, on the eve of her wedding, is adorned with a false beard. Going round about through the opposite sex is not restricted to men.

The third phase consists of reintegrating the young men into the city: "When the two years are up, they now are members of the general body of citizens."[25] Though the author of the *Athenian Constitution* makes do with a single sentence to summarize the operation, the ceremonies are known to be marked by a certain luster and include different phases. First, the ephebes make their solemn entrance into the city, led by two who are dressed as girls, at the time of the Oschophorian Festival, mimicking the return of Theseus, conqueror of the Minotaur, an enterprise for which he slipped two boys made to look like frail virgins among the seven young maidens offered to the monster. In Crete, at the end of the two months of life together in the countryside the *erastes* offers to his *eromenos* three gifts whose nature is fixed by law:

> The boy is released after receiving as presents a military habit, an ox, and a drinking-cup [*poterion*] (these are the gifts required by law), and other things so numerous and costly that the friends, on account of the number of the expenses, make contributions thereto. Now the boy sacrifices the ox to Zeus and offers a feast to those who returned with him; and then he makes known the facts about his intimacy with his lover, whether, perchance, it has pleased him or not, the law allowing him this privilege in order that, if any force was applied to him at the time of the abduction, he might be able at this feast to avenge himself and be rid of the lover.[26]

Bernard Sergent has shown convincingly that in the three gifts the reflection of the three functions in Indo-European societies can be seen, and it is simple to understand how they are connected to the activities of the future citizen: the military

paraphernalia confirms his primal status as warrior in the service of the city and the bull his relation to the gods, to whom he must sacrifice it; as for the *poterion*, it is hard not to take it as a symbol of masculine sociability, such as it is expressed in the *Symposium*.[27]

The initiations consecrate the end of a long process of education, for the making of men out of boys requires a long apprenticeship. As Sophie Lalanne notes pertinently, "masculinity is an acquired [. . .] intrinsic quality," or, in other words, "a being endowed with the physiological attributes of virility [. . .] must nevertheless go through the development of a social construction," consisting "of constructing masculine identity on a dominant position put forward as natural with regard to women in general and to one's wife in particular."[28] Dominating one's *eros*, orienting it and satisfying it according to the social codes in force, demand no less of an apprenticeship. While men are offered a panoply of possibilities many times greater than the part reserved for women, they do not enjoy complete liberty, and the rigor of normalizing rhetoric no doubt betrays the fear of having the admitted norms violated. It is probably in this area that the ideal and actual practices are the farthest apart, even if we lack specific information about them.

THE NAKED MALE AND HIS SEX ORGAN

THE IMAGE OF MASCULINE BEAUTY

Ancient Greece imposes an aesthetic model according to which male nudity occupies a major place, with a concern for a straightforward realism that showcases the entire body. The habit of representing the gods naked does not strictly belong to the Greeks, but in those civilizations that practice it, it is a matter most often of bringing out a divine attribute, notably physical or sexual prowess, for propitiatory purposes. Statues of Greek gods and heroes stand out in sharp contrast to this model, and if Zeus appears older, Hercules more muscular, or Dionysius more languid, it is more to correspond to the image created by the myths than to attract the faithful by imitating one virtue or another. The actual sexual characteristics are scarcely highlighted outside of specific gods (Pan ithyphallic) or apotropaic monuments based on destination (hermaic pillars). In other words, the nakedness of the gods aims more at exalting the beauty of the male body than at highlighting any divine virtue.

The representation of present-day men (athletes and politicians) or heroes of the past (fighters from the Trojan War) in the same system as the gods confirms the fact that it is clearly an artistic choice and therefore a social convention. Moreover, this choice of nudity cannot be confined to certain circumstances of collective life such as sports, the baths, and, less frequently, one or another religious procession (such as the *lampadephores* or the Panathenean Festivals in Athens [fig. 1.1]). Engaging in sports in the nude was even established as a veritable marker of civilization. The Greeks gave various explanations for it, but the main authors interested in its origins agree on one point at least, i.e., the relatively recent date of the phenomenon toward the end of the eighth century B.C.E. The reasons advanced vary, and the most rational in appearance are likely the most false. In any case, it is difficult to maintain that it was for convenience or comfort that a runner—Orhippos of Megaris in 720, according to Plutarch—started the trend, for it is obvious that the opposite is true: the absence of

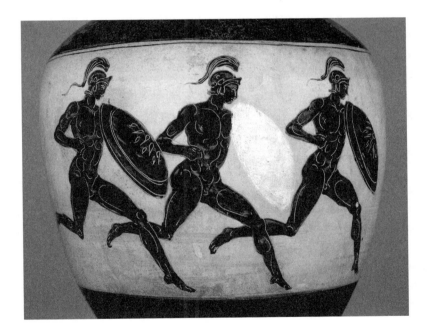

FIGURE 1.1 *HOPLITODROMOS*. BLACK-FIGURE PANATHENAIC AMPHORA, 323–322 B.C.E., PARIS, LOUVRE.

The *hoplitodromos*, or footrace while armed, organized during numerous Greek contests, is the occasion to highlight what is the very essence of virile activity, i.e., war, and to emphasize one behavioral trait that the man and the citizen must never do without, the spirit of competition, the *agôn*.

Source: © RMN-Grand Palais/Art Resource, NY

any support for the genitals makes running painful. We must therefore take this Greek innovation, regardless of its origin, for what it is: a concern for differentiating the Greek man from all others. Its immediate success throughout the Greek world proves that it ran counter to no taboos but that it also legitimated practices that were infrequent or not completely lawful. It should be remembered that, between the multitude of artistic representations—sculptures, paintings on vases, and large murals most notably— and many occasions in everyday life, male nudity was exhibited uncompromisingly.

The omnipresence of the male nude contributes to the establishment of aesthetic canons in art as well as in real life. It is well known that the setting of ideal proportions owes a good deal to Polycletus of Argos and then to Praxiteles; the latter favored lankier forms. Of course, in ancient Greece as elsewhere, nature endows individuals with forms at times quite clearly wide of the mark set by the elite's taste and their canons of beauty. But norms of masculine beauty keep on being established, norms celebrated by inscriptions on vases at the end of the classical period that proclaim, "Such and such a man is beautiful."

This aspect of virility is all the more important in that the Greeks are apt to see a connection between physical beauty and moral qualities, between education and beauty. Aristophanes provides a good example in his (comic) way when he has Just Reason describe the effects of the earlier good education on the physical traits of young men and the ravages of the new education:

> You'll be spending your time at the gym, making your body taut, trim and terrific. Not like the other young fools of today who just waste their days chattering idly in the market place, telling each other vulgar jokes!
>
> And you won't be the one who'd get dragged into court for some ugly, slippery and trivial dispute. No, my boy! Instead, you'll be attending the Academy where you'll be able to have a sensible friend of your own age, all fragrant with the scent of yew trees, with whom you can sit under the sacred olive trees, crown yourselves with white reed, have a race and be free of any concerns. [. . .] If you keep everything I said in your head and do as I say, you'll:
> Always have a splendid chest,
> A resplendent skin,
> Huge shoulders,
> A tiny tongue,
> A terrific bum
> And,
> A cute, slender dick.[29]

While it is not surprising that physical exercise should have an effect on one's complexion, shoulders, torso, and butt, one may, on the other hand, remain skeptical about its effect on the penis, which, as Alain Fleischer once made note,[30] is the only part of the body that does not take part in any athletic sport.

But it would be wrong to see in Aristophanes's speech just a joke to make people laugh, even if that is also the desired effect. He is giving us, no doubt indirectly, one of the keys for understanding the representation of Greek nudes: it has been noted for a long time that the heroes are endowed with very modest if not ridiculously small sex organs, especially in vase painting. In fact, a small penis implies a good education on the part of its owner. Obscenity resides, according to Greek criteria, not in the exhibition of the sexual organs—at least not when one is among men and in a situation in which being naked is legitimate—but in the act of proffering an uncovered glans or an excessively voluminous cock, as do the satyrs of comedy.

Although the criteria of beauty change over time, as proved by the evolution in the canon of sculptors, the celebration of beauty remains a constant in the praise of masculinity, and certain traits even form a constant of virility: a tanned complexion (women, on the other hand, are white), or, more exactly bronze ("the color of a well-mixed bronze,"[31] in which copper and tin are in the right proportions), bulging musculature (Hercules is super-virile by definition), and untrimmed body hair. The beauty contests during the feasts, such as the Pantheneans or the Theseia in Athens, contests involving ephebes only, combine an evaluation of plastic beauty and an appreciation of the qualities of endurance, courage, and correct behavior; it is in fact a contest of *euandreia*, of "good masculinity." For beauty remains in the eyes of the Greeks the translation of less ephemeral virtues, or at least should be accompanied by such virtues, even if exceptional beauty can suffice in ensuring a man's reputation.[32] Authors' positions on this are often ambiguous. Thus Pindar, in his poems glorifying athletes, often links victory, glory, and beauty without always making it clear if he is evoking physical or moral beauty.[33] An inscription glorifying a deceased *kouros* from the years 550–530 B.C.E. appears less uncertain: the base, which is all that remains, bears a text indicating that contemplating the funerary statue is all it takes to gauge the *andreia* of the young man, Xenocles;[34] never has the equivalency been so clearly established between beauty and *andreia*, that virile virtue par excellence. But it was the same for all the statues of champion athletes erected in Greek cities: while the victory fell to the city as a whole, it remained nonetheless the athlete's combination of *andreia* and physical beauty that was highlighted for eternity.

VIRILITY AND ELEGANCE

If nudity allows for an appreciation of its splendors, the body is nevertheless more often clothed than unclothed. And there is a masculine elegance that virility adjusts to, while certain attire is not suitable for the male. We will pass over the transvestites, voluntary or otherwise, whose bearing is ridiculed by Aristophanes: when the female protagonists in *Assemblywomen* take up their position on the Acropolis and decide to manage the city on their own, they take away their husbands' outfits; the only thing that Blepyros, the leader Praxagora's husband, can get on his back is his wife's little saffron-colored mantle and on his feet her Persian slippers (311–26). It is as if he were considered dead: all he needs is for his wife to place by him a lecythus or funeral vase (535–38). Absent a real death, it is the death of his virility that he fears he will be mourning.

Any attire that is too refined or any "feminine" practice arouses mistrust. The waxing of body hair signals the adult male's desire to maintain his adolescent look and thus to pursue a career of *eromenos* beyond the age it is customarily authorized; it is the very sign of the invert, as Aristophanes repeatedly emphasizes, opposing those "shaved asses" to the "black asses" of yesteryear, on virile men who knew how to lead the people. Hair itself becomes the center of attention. If in the ancient period long hair characterized the aristocrats, during the classical period it was seen clearly as a sign of feminization, appropriate for the Ionians and the Barbarians, especially if one's hair was allowed to flutter in the wind. It is the fineness of the clothing that bespeaks the real man. We have seen how, in Sparta and in Athens, they attempted to get the ephebe accustomed to wearing coarse material, a synonym for virility. Aeschines tries to denigrate Demosthenes by drawing the judges' attention to his clothing:

> Demosthenes, if anyone should strip off that exquisite, pretty mantle of yours, and the soft, pretty shirts that you wear while you are writing your speeches against your friends, and should pass them around among the jurors, I think, unless they were informed beforehand, they would be quite at a loss to say whether they had in their hands the clothing of a man or of a woman![35]

The effeminate comportment of his ally Timarchus rubs off on Demosthenes, who is dressed as a dandy. He is included in the opprobrium for the soft Alcibiades, who, at the head of a military expedition, dressed himself in robes of purple and was not afraid of hanging his bed from straps to avoid swaying. Clothing and bodily traits

(hair, whiskers) reveal the greater or lesser degree of an individual's femininity and, by contrast, the limits of his virility.

The texts that propose masculine superiority are devoted much more to denigrating the feminine than to exalting masculinity. To be sure, the genders are constructed in relation to each other, but the denigrating attitude toward women turns out to be easier to hold and to develop than the construction of a model of virility based on positive masculine values.

THE MALE AND COMPETITION

Sports in general and participation in the games (*agones*) in particular provide the occasion for forcefully expressing a less militaristic form of *andreia* but highlighting corporeal beauty and the moral qualities possessed by the winner. War remains the preferred arena in which to express virility, and Pindar is so conscious of this that he actually describes the athlete as a combatant ("Diagoras [. . .], the gigantic athlete, the swift fighter who, by the Alpheus River and also by the Castalia Fountain, won the crown, the prize for fighting [*pygmè*]"[36]). But war provides the occasion to compete to win the prize for valor, awarded to the citizen who distinguished himself, as if in an *agôn*: Alcibiades wins it at the time of combat in Thrace (Isocrates, *On the Team of Horses*, 29–30; Plato, *Symposium*, 220d–e). But the gymnasium, especially during the competitions, constitutes the frame, or one might say the setting, in which the quintessence of masculinity unfolds. First of all because the body is nude at the gymnasium, where oil and a variety of poses accentuate its form. Naturally, oil prevents the skin from drying out and gives it suppleness, but it also highlights the nuances of musculature. A well-oiled body catches the light, and the nuances of the tan are brought out better—another way of accentuating masculine beauty.

The gymnasium and the games lead, however, to the question of masculine hierarchies—social hierarchies expressed by requirements and differentiated masculine behaviors. Far from being a means of social climbing, the athletic competition remains, until the time of the Roman Empire, the privilege of a certain social elite, despite a few exceptions (Isocrates, *On the Team of Horses*, 33). While all men, regardless of their social standing, must satisfy certain moral exigencies (honor one's parents, respect the body of the free man) or civil requirements (serve the city), the same standards do not apply to certain highly valued behaviors such as going to the gymnasium, love relations among men, or participation at the

symposion. Paradoxically, in the democratic city aristocratic behaviors of distinction are maintained, whereas in Sparta, at least officially, a certain egalitarianism reigns, notably during meals taken together.

Beauty contests, athletic competitions, and contests of eloquence are therefore the purview only of a masculine elite fortunate enough to lead a life of leisure in which working out takes up a part of one's free time, between civic and social obligations. The consequences of winning, even when celebrated by the whole city, are mainly the exaltation of the winner and his family, thus helping to anchor it in a civil elite whose substantiation is not only wealth but also the excellence of behaviors that are specifically masculine: beauty, courage, competitive spirit, extent of one's network of friends (*hetairoi*), and generosity toward the city. Now, in Crete it is these young men alone who garner the glory of having undergone the initiation rites:

> It is disgraceful for those who are handsome in appearance or descendants of illustrious ancestors to fail to obtain lovers, the presumption being that their character is responsible for such a fate. But the *parastathentes* (for thus they call those who have been abducted) receive honors; for in both the dances and the races they have the positions of highest honor, and are allowed to dress in better clothes than the rest, that is, in the habit given them by their lovers; and not then only, but even after they have grown to manhood, they wear a distinctive dress, which is intended to make known the fact that each wearer has become "kleinos," for they call the *eromenos* "kleinos" and the lover "philetor."[37]

The accumulation of glorious feats increases for life the differences among men of the same city. The existence of specific sexual relations—that is, among men—further adds to these practices of merit.

AN ASYMMETRICAL IMAGE OF SEXUAL RELATIONS

It is difficult to write about amorous relations among men as practiced by the Greeks, for they have nourished too many contradictory fantasies, and the vocabulary employed appears most often to be inappropriate. The term homosexuality, totally absent from the Greek language, must be put aside as much as possible, for it presupposes permanent behavioral categories foreign to the Greeks. For the Greeks, the object of desire is less important than the strength of that desire and the

individual's capacity to satisfy it; one could say that virility consists first in satisfying one's desire. This does not mean that every desire is legitimate. In effect, a radically unequal conception of sexual relations combines with this priority given to desire: sexual relations do not unite two individuals trying to attain pleasure while looking to satisfy their partner but rather a dominant one and a dominated one, or, one might say more brutally, a penetrator and a penetrated; this conveys less trivially but with just as strong a sense of inequality the expression still largely in use: active partner and passive partner. As J. J. Winkler says pithily, "*eros* [. . .] more often traveled along one-way streets."[38] Virility is located clearly on the side of the penetrator:[39] not a single ancient text, so far as I know, depicts a sexual relation between men in which the roles could be changed at the whim of the actors; it is always explicitly a relation between a dominant male, acting in his role as male, and a man dominated as a woman, whether it is a young man at the age when the city recognizes (indeed, recommends) this conduct without incurring the least mark of infamy; or a prostitute, on whom society will pass a different judgment depending on his juridical status; or a slave. What eludes us and will no doubt always elude us is how to figure out the margin that exists between the set of ideas and the actual practices, between the stated codes and the ways of being intimate. In this domain, the historian can only analyze the idea-set and try to compare it to snippets of real life.

We have seen that the initiation rites carry with them a strong sexual connotation, with rites of inversion that consist in having the future citizen play the opposite sex. The texts relating to Sparta and Crete leave no doubt about this point, emphasizing clearly that the young man from a good family who has not found a lover by the time he reaches the age for taking one will be dishonored, undoubtedly the bearer of a grave defect in education and of some kind of moral shortcoming. In those societies in which young men grow up under the constant scrutiny of all men, it is scarcely thinkable that a young man lacking in courage, for example, could escape the attention of the others. For a long time historians have wanted to consider these "special friendships" as an educational camaraderie, a platonic relation devoid of any sexual dimension. The vocabulary belies such an interpretation, and the choice of the active *erastes* and the passive *eromenos* to designate the adult on the one hand and the adolescent on the other has a clear sexual connotation. Moreover, in societies that pay tribute to those men who, when having sexual relations with other men, comply with the rules, notably those regarding the age of the partners, it is hard to see why this kind of relation would be excluded at the time of the initiation rites, that is, precisely when those conditions are satisfied. Vase painting is sufficiently explicit on this point to confirm that

there are certainly sexual relations between men and adolescents, regardless of the exact form they take. When Ephorus tells us that the Cretan adolescent abducted by an adult gives his account, at the end of the legal two-month term in the country, of the relations he has had with his lover, it is probable that the sexual aspect was to be included, for the young man is neither slave nor prostitute but really a free adolescent whose body would not have undergone any type of sexual relation whatsoever. However, the texts remain mute on details as to what is allowed and what is not. Anyone who would doubt the carnal aspect of these relations should read the meticulous description given by Alcibiades of the seductive stratagems that he carries out on Socrates; the latter, to be sure, refrains from the temptation of proceeding with the philosophical education of his disciples but he does not condemn in any way the unabashedly erotic aim of the young man (Plato, *Symposium*, 217–219e) with whom he freely admits elsewhere he is in love (*Gorgias*, 481d). Actually, one should perhaps go back to the interpretation of dreams in Artemidorus, second century C.E., to understand what elicits horror in sexual matters: incest and oral-genital contact.

Outside of the initiation rites, amorous relations between a grown man and an adolescent (an elastic term) clearly exalt those who engage in them. In a famous text in which Aeschines admits to a charge of violence against a citizen, Timarchus, a friend of Demosthenes, accused at once of having squandered his patrimony and of having gotten himself, a free man, into prostitution, he takes care to distinguish between those who use their bodies for money and those who engage in legitimate masculine relations:

> To be in love with young men who are beautiful and wise is the experience of a kind-hearted and generous soul; but to hire for money and to indulge in licentiousness is the act of a man who is excessive [*hubristes*] and ill-bred.[40]

Besides, there is no law that finds any fault in it:

> The free man was not forbidden to love a boy, and associate with him, and follow after him, nor did the lawgiver think that harm came to the boy thereby, but rather that such a thing was a testimony to his wisdom.[41]

Of course, this allows Aeschines to open a long passage on famous friends, among whom certain ones appear obviously to be lovers (Harmodius and Aristogiton, the assassins of the tyrant Hipparchus in 514, and Achilles and Patroclus),

before he enumerates a long list of well-known lovers at the time—including several athletes (§155–57) whose recognized beauty explains the number of male conquests. Throwing out into the public in this way the names of those lovers carries no opprobrium but, on the contrary, lends value to those who are thus named. Greek societies consider masculine *eros* to be licit and, for prominent men, it is even a clear sign of distinction. The most important Athenian politicians of the fifth century nearly all (except Nicias) associate with their name anecdotes relating to amorous rivalry: either they are up against a political adversary in the conquest of a handsome adolescent, such as Themistocles and Aristides fighting over the favors of Stesilius of Ceos, or the future leader is obliged to choose between multiple beaus, as with Alcibiades choosing Socrates. It would be only fair to acknowledge the literary *topos* in these stories of which Plutarch is the ultimate reporter, but it is clear that no ignominy is attached to these masculine love affairs. Nevertheless, it should be noted that this is about a very specific milieu, that of the great Athenian families for whom male sexual relations may be one distinguishing practice among others: when Hippothales describes to Socrates his deep love for Lysis, the values brought out are the adolescent's beauty as well as his family's wealth and his moral qualities (Plato, *Lysis*).

In a society in which the forms of sociability favor the separation of the sexes and, as a result, men have multiple occasions to find themselves alone, there clearly developed an atmosphere of homoeroticism, accentuated by the practice of partial or full nudity. Men generally lived among themselves, and not only in Sparta, where young men, even when married, slept in collectivities reserved for them up to the age of 30. Without the gaze of women—and for married men, their wives—they give free expression to all forms of desire, whether for women or for men. The presence of flute players (real musicians or prostitutes in disguise), male and female slaves, and ephebes at the banquets allowed the satisfaction of the most varied tastes and passing desires, *eros* in all its forms. For it follows that each man may change his desires: Aeschines himself declares that Timarchus the prostitute did not disdain the flute players offered at the banquets by his wealthy lovers. And he qualifies as practically abnormal (without disapproving of it) the case of the quasi-exclusive male desire of one of Timarchus's first lovers, a certain Misgolas,

> a man otherwise honorable, and beyond reproach save in this, that he is bent on that sort of thing like one possessed, and is accustomed always to have about him singers or cithara-players. [. . .] Misgolas, perceiving Timarchus' motive in staying at the house of the physician, paid him a sum of money in advance and caused him

to change his lodgings, and got him into his own home; for Timarchus was well developed, young, and lewd, just the person for the thing that Misgolas wanted to do, and Timarchus wanted to have done.[42]

The portrait of Misgolas, as unfavorable as it is, does not win him the measured disapproval of Aeschines, regardless of how much time is given to Timarchus's debauchery. Generally speaking, the search for lovers dignifies *erastes* and *eromenos*, since it is not a question of either constraint or money. Let us recall a few considerations explicitly favorable to masculine love affairs that Aristophanes reports in passing, even though he regrets the time when education led to modestly giving in: sitting "with their thighs crossed" but not exhibiting "anything that could shock the onlooker," erasing "all imprints of their pubescent bodies and never rubbing themselves with oil below the navel."[43] Decency consists of not offering oneself, not leading another on, but awaiting with modesty (*sophrosyne*) the attentions of the lover. Such attentions, moreover, were normal and expected: in another passage from Aristophanes (*The Birds*, 137–42), the father of a young man bitterly reproaches a family friend for having snubbed his son on the way out of the gym and for not having courted him properly!

It might seem surprising the way sexual relations between young men and adults are thus encouraged during a phase of the young men's lives when their adult sexuality is being constructed. The ultimate goal remains, nevertheless, to make adults out of them, capable and desirous of procreating. All this takes place, actually, as if to distract the young adults from the world of female sexuality, that of married women as well as of girls, both reserved for matters other than young men's erotic pleasure. This turning away of the sexual desire of young men who are still sexually immature—and therefore neuter in terms of gender—toward a type of relation that is socially of superior value allowed for the easy acquisition of an adult sexuality without endangering the fundamental structures of society. This is what explains the fact that some people consider male sexual relations in Greece as a form of pseudo-homosexuality (e.g., Georges Devereux, the ethno-psychiatrist). One cannot emphasize enough, moreover, that this male erotic quest derived from the public sphere and not the private sphere: we are dealing not with an intimate love relationship but rather with a conquest that makes no sense unless it is brought into the clear light of day (Plato, *Lysis*). To be sure, this does not rule out sentiments, but what counts for much more is the public *agôn* between lovers, the *erastes'* seduction efforts (including the writing of poems, for instance, by Hippothales in *Lysis* or by Aeschines in *Contra Timarcus*, and the revealing of their authors) or the *eromenoi's* concern for displaying their beauty.

Does this mean that there are no limits to men's desires? Certainly not, as there exist written and unwritten codes that must be followed by all. As to the written laws, we can first consider those that Aeschines has cited during Timarchus's trial: no one may injure an individual, free man or slave, on pain of being punished under the law against violence (§ 15); any man who prostitutes a child or a free woman receives the most severe sanctions (§ 14); and, above all, any free man who prostitutes himself loses the right to speak in the assembly, for "anyone who has used his body for money in the face of infamy (*hybris*) will likely sell the collective interests (*koina*) of the city without hesitation" (§ 29). Infamy is thus at once selling one's body and adopting in the exchange the feminine role, which Aeschines says in guarded language but which Aristophnes, with his usual raunchiness, lays out unabashedly: he has nothing but contempt for the *kataphygonai* ("butt-fucked"), the *euryprôktoi* ("big asses"), and the *gynnides* ("the effeminate") who have their whole bodies epilated, including the anus, the way women do, while a real male remains "black-assed!" The characters Agathon and Clisthene embody the perversion of the effeminate male: epilated, shaved, dressed like women, speaking like them, they are the reverse image of virility. This should not be confused with the adolescent image of Dionysius or Achilles disguised as girls, manifesting unambiguously the virility they are temporarily masking: once the trumpets of war are sounded, Achilles unveils himself to Ulysses (Apollodorus, III, 174).

The discussion hardly dwells upon the roles in sexual exchanges as long as it is agreed that each man will stick only with the role of active or passive. In contrast, the line limiting the age for being seduced remains blurry, that is, the age limit for being the *eromenos*, or the limit for being the seducer, the *erastes*; the age marks the passage from the status of nonmale to that of virile adult. These are uncertain limits, on which it is quite difficult to agree. The vocabulary helps little: *pais* refers clearly to a child but is applied up to the age of 14 or 15, the point at which Aristotle places the sexual maturity of boys (*Generation of Animals*, I, 20). The *meirakion*, or adolescent, is normally 14 to 18 but can scarcely be distinguished from the *neos*, the qualifier that can be used up to the age of 21 and beyond. An epigram by Strato points indirectly to the age limits of *eromenoi*:

> I delight in the prime of a boy of twelve, but one of thirteen is much more desirable. He who is fourteen is a still sweeter flower of the Loves, and one who is just beginning his fifteenth year is yet more delightful. The sixteenth year is that of the gods, and as for the seventeenth it is not for me, but for Zeus to seek it. But if one has a desire for those still older, it's no longer child's play—he's asking for it![44]

Thus, the *eromenos* is supposed to be between 12 and 17; younger, it becomes rape; older, perversion.

But age seems to be a less certain indicator of maturity than beard and body hair. Socrates's courting of Alcibiades is shocking not so much because of the ugliness of the former and the beauty of the latter but because Alcibiades has facial hair (Plato, *Protagoras*, 309a). Hair is supposed to put an end to *eromenos* status or, as Bion had Borysthenes pithily say in response to those who considered the loving of boys as a kind of tyranny: "Oh yes, a tyranny that can be brought down by a hair."[45] Greek vases abound with erotic representations that bring together a bearded man and a younger man, beardless and often smaller, the better to evoke the latter's youth. But the hairiness given to adolescents hardly corresponds to physiological development, which grows more solid over time. Moreover, when young Spartans and Cretans began an amorous relation with their lovers, they were at least 16 years old and more often 18 or 20—that is, they had quite sufficiently attained sexual maturity and were approaching the age at which Aristotle, wrongly, considers they are capable of procreating (i.e., 21). We touch once again on the contradictions between the ideal and the real: the idea of a progressive revelation of *andreia* in the young man refers to distinguishing secondary sexual traits (beard, pubic hair, musculature, size), ideally brought together in the figure of the *kouros* [fig. 1.2], already a man but still the object of male desire—*eromenos* but not yet *erastes*—whose full sexual capacity one feigns not to know—thus enabling the young man to play one role or the other in the relationship. The whole idea is to prolong as much as possible the appreciated pleasures, although it is true that, as was said by Euripides, who was in love with the poet Agathon until he was advanced in years, "with beautiful boys, even the autumn is beautiful" (Plutarch, *Eroticus*, 770 C).

The situation of the *erastes* appears to be even more complex. It is said that *erastes* must still be young, and an old man who pursues an ephebe runs the risk of ridicule or indeed, of disapprobation. It must be recognized that many did not fear taking this risk: according to a famous anecdote, Sophocles, very keen on loving boys, liked frequenting the remote places where young prostitutes cruised, along the Athenian ramparts, and during one of his outings, he had a prize mantle stolen. His love affairs did not cost him any moral condemnation, but his imprudence made people laugh. Pericles, who did not turn away any more than another from the beautiful ephebes, remarked one day to Sophocles, who was leading an expedition with him and was praising a handsome young man, that a "strategist must have not only clean hands, but clean eyes as well" (Plutarch, *The Life of Pericles*, 8, 8). Outside of specific circumstances, adolescent *eros* may also lead to moral

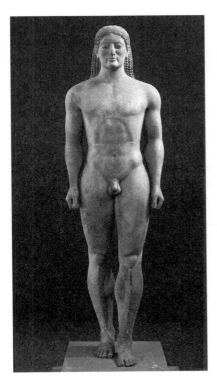

FIGURE 1.2 ARCHAIC KOUROS. SIXTH CENTURY B.C.E., ANAVYSSOS (ATTICA), ATHENS, NATIONAL ARCHEOLOGICAL MUSEUM.

Designed to preserve the memory of the deceased, funereal statues of young men convey an ideal of aesthetic beauty—harmony of forms, strength, balance, and fullness of facial traits. These traits not only correspond to the canons of beauty in themselves but are also supposed to reflect the moral qualities of the deceased.

Source: © Leemage

condemnation, especially if the attraction is not based reciprocally on the moral and physical qualities of the young man lusted after. Thus concluded Plutarch on the subject of Socrates and Alcibiades: "Socrates' love was a great testimony to the fortunate natural disposition of the child [*pais*] for virtue" (*The Life of Alcibiades*, 4, 1). The *erastes* has the responsibilities of an adult, or even of a father [cf. fig. 1.3]. In Sparta the *erastes* was punished for the bad behavior of his *eromenos*, which highlights, if such were needed, a displacement from biological paternity to chosen paternity. But many were not content with this quasi-paternal role: Alcibiades' numerous *erastes* are far from enjoying the moral authority of Socrates; they expect from Alcibiades more carnal pleasures. As pointed out by the Stoic philosopher Cleanth of Assos (third century B.C.E.) and cited by Plutarch, "the one I love I grab around the neck, whereas my rivals have a hold on him that is forbidden me," a hold that Plutarch elucidates thus: "he meant by that his belly, his penis and his throat" (*The Life of Alcibiades*, 6, 2).

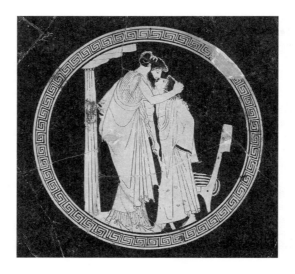

FIGURE 1.3 MAN COURTING AN EPHEBE. RED-FIGURE CUP BY THE PAINTER OF BRISEIS, CA. 480 B.C.E., PARIS, LOUVRE.

Modestly but unequivocally, the painter places strong emphasis on the unequal nature of the amorous relationship, uniting a fully grown citizen (large stature, beard) and the ephebe. Both belong to the upper classes of the city-state, as evidenced by their abundant curly hair and the fine pleated tunic of the *erastes*; the *eromenes* simply wears a robe thrown over his nakedness after leaving the gymnasium.

Source: RMN-Grand Palais/Art Resource, NY

So rules do exist, or, if one prefers, there is a system of autoregulation of masculine behaviors, although one might wonder, along with Winkler, if it is not "a kind of façade, concealing a laissez-faire attitude to actual practice"[46]—practices that are far from receiving unanimous approval from ancient authors. Plato, in the *Laws* (835d–842a), like Xenophon, shows himself to be very hostile to male sexual relations, and Dion of Prusa sees in them the signs of urban corruption as opposed to the simple life of peasants: not only do the rich spend a lot of time charming one another, men as well as women—preferably free and virgin—but also the men, tiring of the conquest of women deemed too unfriendly, go after the young men who will be the magistrates, judges, and strategists of tomorrow, proof that one is in the ruling-class milieus of the city (Dion, *Of Euboea*, Discourse VII, 149–52). Even Socrates, who shies away from disapproving of the love of boys, knows about its risks: "Poor wretch," says Socrates, "what do you think will happen to you through kissing a pretty face? Won't you lose your liberty in a trice and become a slave . . . ?"[47]

Thus, the official set of ideas on virtue cannot entirely mask the reality of amorous sentiments and the blurring of the senses brought on by excessive physical proximity. Man, one of whose signs of virility is remaining master of his pleasures and his passions, may therefore lose this position and find himself, despite being the *erastes*, in a situation of being dominated. From male-masculine—the ideal of the hoplite-citizen—he may be tipped toward male-feminine, which is tantamount to *kinaidos*. Could he be knocked down to the point of conducting himself like the vulgar Gnathon who offers himself to the handsome shepherd Daphnis "as nanny-goats offer themselves to billy-goats?"[48] This is just another way of speaking of barbarity: a curious red figure vase, dating from 465–460 B.C.E., shows a young Greek, his penis brandished in his right hand, advancing toward a soldier, who turns his back to him and, raising his arms, exclaims, his fearful mien aimed at the spectator: "I am Eurymedon, I'm holding my position, bent forward"—an allusion at once to the Athenian victory over the Persians at the Eurymedon Pass (468) and to his imminent sodomization [fig. 1.4].[49] Political caricature meets up unexpectedly with the civic notion of *andreia*.

a b

FIGURE 1.4 CARICATURED PENETRATION. ATTIC OENOCHOE, CA. 460 B.C.E.

The vanquished Persian is referred to in the inscription as "Eurymedon"—location of a famous victory by the Athenian navy over the Persians in 466. Identifiable by his cap with earflaps and his quiver (*b*), he innocently waits for the Greek, running with his erect penis in his hand (*a*), to come take him from behind. It is a fairly rare political caricature, symbolizing the rights that the warrior acquires over the vanquished.

Source: © Museum für Kunst und Gewerbe Hamburg

Within masculine social life, drinking and seducing constitute highly prized activities, of which Socrates, in spite of his legendary ugliness, appears paradoxically to be one of the most brilliant practitioners. As we just pointed out, Alcibiades finally prefers him as a lover to the crowd of others who are richer, from more prestigious families, and correspond better to the criteria of Greek beauty. Socrates, moreover, was just as renowned for holding his drink better than anyone else in the *symposium*. At the beginning of Plato's dialogue named *The Symposium*, as the drinkers gather for a new round, several admit to being wasted by the previous night's debauches, even the supposedly most hardened drinkers; as one of the guests, Eryximachus, notes:

> the weak heads like myself, Aristodemus, Phaedrus, and others who never learned how to drink, are fortunate in finding that the stronger ones are not in a drinking mood. (I do not include Socrates, who is able either to drink or to abstain, and will not mind, whichever we do.)[50]

While the Platonic dialogue gives an intellectual image of this gathering of men, the *symposium* aims first of all at providing intoxication in addition to the pleasures that the guests like to come up with: singing contests (flute players are there to set the tone) in which each person improvises in turn on a given theme and games like charades and kottabos. But the *symposium* also provides the occasion for seducing. The scenes depicted on the vases or on a few rare murals (e.g., the tombs of Poseidonia) leave scarcely any doubt: the intertwined lovers proclaim the success of the adult's seduction enterprise. For within the *symposium* the dividing line is clear: on one side the adult citizens, on the other the young men, reduced to the same role as women, who will eventually be summoned for diverse pleasures (cf. fig. 1.5).

The aristocratic *symposium*—which differs in every way from the civil *symposium*—appears clearly from two perspectives. It might be a gathering of friends undoubtedly bound together by familial ties as well as by warrior solidarity; the endless drinking and the pleasures that accompany it reinforce the group's cohesion at the same time that they affirm the superior character of its members. Whatever the occasion may be (e.g., a marriage), the aristocratic *symposium*, by no means open to all, is intended for the chosen guests, even if parasites occasionally slip in. Within the group of friends there reigns a certain spirit of rivalry among the drinkers, that sense of *agón* that is at the base of the Greek value system. But it might also be a space for discussion and intellectual rivalry: here we find the same spirit of *agón*,

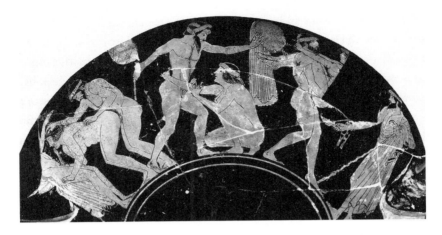

FIGURE 1.5 ATTIC DRINKING CUP (*KYLIX*) BY THE PAINTER BRYGOS, CA. 490–480 B.C.E., FLORENCE, NATIONAL ARCHEOLOGICAL MUSEUM.

A favorite place for male aristocratic sociality, the symposium brings together partially undressed men and provides the occasion for attempted seductions, such as the one that Alcibiades started up with Socrates. With the help of wine, when the simple banquet turns into the *symposion*, amorous talk may change into explicit acts, such as those shown on rare vases, at times called "pornographic:" male and/or female slaves submitting indiscriminately to the attacks of the banqueters.

Source: © Leemage

applied to other objects. The Platonic *symposium*—and those in turn described by Xenophon, Plutarch, Epicurus, Lucian of Samosate, and Atheneus of Naucratis, to mention only the most famous—seem to be a misappropriation of the aristocratic *symposium*: all that has changed is the quality of the guests: philosophers and scholars instead of warriors and politicians. The *symposium* of Sages, so often represented in mosaics through the end of antiquity, thus preserves the memory of this aristocratic symposium, diverted in a sense from its primary function and stripped of the excesses that gave it value for the young Greeks invited to participate. But it is nonetheless an expression of masculine sociability and a means of manifesting one's *andreia*!

THE MALE AND WOMEN

While seduction among men exalts the two partners in spite of the highly differentiated roles that they are led to play, Greek men generally attain no glory

from their success with women—which does not mean that women cannot play a decisive role in masculine strategies. They are even capable of taking the initiative in matters of seduction: Alcibiades is said to be tracked down by women because of his beauty (Xenophon, *Memorabilia*, I, 2, 24), as confirmed by the comedian Eupolis, who chides the man pursued by both women and men (Eupolis, *The Flatterers*, cited by Atheneus, *The Deipnosophites*, XII, 48, 535). Giving in to their seduction is inadmissible unless virility is triumphant, that is, the male is affirmed as the master. In the world of the Greek novel, which Sophie Lalanne (see note 28) has recently shown to have been a novel of masculine and feminine initiation, the transformation of the hero into a man is accomplished when he finally asserts himself in bed the same way he has proved himself in combat. This is one of the things at stake in *andreia*.

The man is situated in the middle of a matrimonial apparatus in which the woman has no say, and sentiment is usually excluded. The ancients point out as a curiosity the fact that Cimon is "passionately in love with Isodikè, daughter of Euryptolemos and grand-daughter of Megacles, who was her legitimate husband"—to the point that he was grief-stricken by her death (Plutarch, *The Life of Cimon*, 4, 10). The surprise comes not from the fact that Cimon loves Isodikè but rather from the fact that love finds its place within a legitimate couple, that is, within a family arrangement whose ends are political and economic. To be sure, love is by no means seen as a marginal sentiment, but it appears by and large dissociated from marriage.

For the Greek male is situated at the center of a complex and diversified feminine universe. Once past the age of adolescence and the time for being an *eromenes*, the Greek man, even if he continues to go after beautiful boys, is concerned with engendering a male heir who will replace him one day at the head of the family *oikos* and who will prolong his presence within the phratry and the city. Celibacy is not well thought of and may have been the object of condemnation: in Sparta,

> Lycurgus . . . put a kind of public stigma upon confirmed bachelors. They were excluded from the sight of the young men and maidens at their exercises, and in winter the magistrates ordered them to march round the market-place in their tunics only, and as they marched, they sang a certain song about themselves, which proclaimed that they were justly punished for disobeying the laws. Besides this, they were deprived of the honour and gracious attentions which the young men habitually paid to their elders.[51]

In Crete an entire age division appears to proceed to a collective marriage:

> Among the Cretans, the young men who have come out of the boys' *agele* are required to get married at the same time, but they do not carry home right away the girl they marry and must wait until she is capable of managing the household.

Marriage probably takes place in one's city, which limits the possibility of weddings and obligates men to marry very young girls, at times still incapable of managing an *oikos*, indeed scarcely nubile. Thus the origin of the rules that prohibit taking the new bride home right away. It is perhaps in the same manner that one should interpret a Spartan rule that obligates young married men to share their comrades' barracks up to the age of 30! According to Plutarch, that did not stop them from slipping away secretly to the conjugal home, making love and engendering children without ever having seen their wife in broad daylight (Plutarch, *The Life of Lycurgus*, 15, 9).

The procreation of legitimate children, as essential as it is, does not justify the choice of a spouse. Political ambition and underlying economic necessities play just as powerful a role. As numerous studies have shown, in Athenian ruling-class milieus most notably, marriage takes place within one's group, and often to the closest relative, namely, to first cousins. It is symptomatic that ancient authors who inform us about marriages of Athenian politicians blithely forget the name of the women married but never the name of their father or of their previous husband. Thus it was not known until recently—and it is still not absolutely certain—that the name of the wife of the most famous man in Athens, Pericles, was Deinomache. She was, however, an Alcmaeonid, granddaughter of Clisthenes and, later, after her repudiation by Pericles, mother of Alcibiades. An illustration, then, of the imbalance in the social construction of gender in Greece.

Legitimate spouses are exchanged if necessary, and examples of multiple marriages abound. Naturally, a deceased spouse is replaced most quickly, but one who seems unable to bear children is repudiated. It is much rarer that a separation comes about for reasons of sentiment, as happened with Pericles and his wife, Deinomache: "Since their married life was not agreeable, he legally bestowed her upon another man, with her own consent, and himself took Aspasia, and loved her exceedingly."[52] The man, as a *kyrios*, that is, one who has power over women, gives orders to them, whether they are his daughters, his sisters, his wife, or some other women in the family of whom he happens to be in charge. For marriage is part of an overall strategy in which political interests and economic necessities blend

together. Cimon gives his sister Elpinike to the very wealthy Callias in order to be able to pay a fine of 50 talents imposed by the city on his father Miltiade, and he weds himself to Alcmaeonid Isodikè for reasons of prestige and political ambition (Plutarch, *The Life of Cimon* 4, 8–9). Similarly, Alcibiades, on his own son's admission, marries the daughter of the richest man of Athens, which is another means of winning the high stakes prize (Isocrates, *On the Team of Horses*, 31), a proof of *andreia*. Alcibiades certainly did not need this marriage to maintain his rank at the top of the social ladder; such was not the case with Lysicles, "sheep merchant of obscure birth and of contemptible character [who] became the premier citizen of Athens because he was the lover of Aspasia after the death of Pericles."[53] But this strategy can be found even in more modest milieus. Thus, a man who is in a position of marrying a shopkeeper[54] might see the advantage in accepting the marriage in order to take advantage of the inheritance that it conveys, even if he is already married. Attic pleadings reveal several examples of citizens who repudiate their legitimate wives in this way, then marry them off to a relative or friend in order to wed a rich shopkeeper.

This absence of sentiment seems pushed to the maximum in Sparta, if both Xenophon and Plutarch are to be believed. These two authors—the first lived there during the fourth century—claim that the husband may have his legitimate wife impregnated by any man who he believes could engender children who are more beautiful or more robust than his own, or simply because he admires the moral qualities of that man and hopes they will appear in his future children. Plutarch, as is often the case, provides a moral justification for this:

An elderly man with a young wife, if he looked with favour and esteem on some fair and noble young man, might introduce him to her and consider her offspring by such a noble father as his own. And again, a worthy man who admired some woman for the fine children that she bore her husband and the modesty of her behaviour as a wife, might enjoy her favours, if her husband would consent, thus sowing, as it were, in fertile terrain and begetting for himself noble children, who would have the blood of noble men in their veins. At first, Lycurgus did not regard sons as the peculiar property of their fathers, but rather as the common property of the state, and therefore would not have his citizens spring from random parentage, but from the best there was. Later, he saw much folly and vanity in other people's regulations in these matters; in the breeding of bitches and mares they insist on having the best sires which money or favour can secure, but they keep their wives under lock and key, demanding that they have children by none but themselves,

even though they be foolish, or infirm, or diseased—as if those who have children and raise them were not the first to suffer from the defects of these children, if they are born of defective parents, or, instead, to enjoy the qualities that they might get from the children of good stock.[55]

This form of eugenics had perhaps only a limited impact, but the very fact that it seems to have been acceptable underlines the purely functional nature of Greek marriage. The male expects procreation, not pleasure, and least of all love: to be noted is the parallel established between the wife, the mare, and the bitch.

It is therefore outside of marriage that the Greek man usually expresses his feelings for women. The impassioned relation between Pericles and Aspasia is liable to overshadow other liaisons no less marked by love. Cimon was believed to be very much inclined toward the love of women, and epigrams celebrated his liaisons with Asteria of Salamine and Mnestra, undoubtedly courtesans, since the names of free women would never have been released to the public. Pericles was also suspected of having affairs with free women whom he would have met through an intermediary, his friend Phidias (*The Life of Pericles*, 14–16), and these included married women, something the city punished severely, since legitimacy of birth, so important in Athens, notably beginning with the law that Pericles himself decreed in 451 B.C.E., could be jeopardized. Even in Sparta, the liaison between Alcibiades and Timaia, wife of King Agis, created all the more scandal in that it resulted in the birth of a bastard, an event that forced Alcibiades to flee the city (*The Life of Alcibiades*, 23, 6–9; 24, 2–4). The punishment meted out to adulterous men—epilation and the insertion of a horseradish into the anus (Aristophanes, *The Acharnians*, 949; *The Clouds*, 1083–84; *Plutus*, 168), in addition to the loss of civil rights—shows that they are grouped together with *kinaidoi*, indeed with women, not for their sexual comportment but because they prove their inability to control desire: by the same token, adultery testifies to their incapacity to conduct themselves as men (*andres*), which leads to their civic downfall.

Masculine power held limitless sway over the women in the family, while the amorous adventures of the husband, with women or with men, could not be the basis of a complaint by the legitimate wife. When Alcibiades's wife, Hipparete, appeared in person before the archon to petition for divorce, her husband pounced on her and took her back to the house by force without anyone's opposition: she died there soon afterward (*The Life of Alcibiades*, 8, 4–6). Masculine power does not preclude feelings, as the two different exemplary figures of Cimon and Pericles show, one for his legitimate wife, the other for a concubine (*pallake*). In Xenophon's

Economics, Ischomachus provides another example of the conduct of a man with his legitimate wife: the wife, whose name is not known, newly married, certainly has a role to play in the management of the *oikos*, but always under the supervision of her husband, who trained her for this. The age difference, which one senses as important, no doubt helps to increase the subordinate role of the wife even more. But, in any case, the married woman remains a minor, while the husband acquires sexual and juridical power.

It is all the more surprising to read in Aristotle (*Politics*, I, 2, 1) that the husband-wife relation resembles a democracy: every citizen is eligible to become a magistrate, and when they are elected, they bear the signs of their function. But the difference in the case of the husband-wife couple, Aristotle adds, is that the distinction is permanent. In other words, Aristotle conceives of the couple as a democracy in which the same people are always in power—which is precisely the opposite of a democracy, at least as it was practiced in Athens. Should one see here a convoluted way of justifying a situation that certain Greek men considered unjustifiable?

Master of women and children in the household just as he is master of slaves, the Greek man, by contrast, appears infrequently in his role as father. To be sure, he plays a decisive role at the time of the birth, since he confers on the child legitimacy, at least on the son, by taking him in his arms, walking him around the house and declaring him his son in front of the members of his phratry: in Athens, no one may obtain citizenship without these familial rites. Similarly, the father decides whether to keep the child or to leave the child exposed, notably in the case of daughters. However, we know that in Sparta it is a civil commission that makes this decision, thus stripping the father of one of his powers. So here *andreia* is reduced to the qualities of the citizen, setting aside the values properly belonging to husband and father.

The father, moreover, is not very much involved in the education of the children, including the sons. He is in greater demand as a citizen to keep an eye on the youth than as the person responsible for his own children's education. It is all the more remarkable that the Greeks, especially on the basis of Aristotle's teachings, attribute to the father alone the responsibility of paternity. Aristotle had in fact shown the falseness of the idea, predominant till then, that the child was born from the mixing of two sperms, masculine and feminine. Correctly rejecting the existence of a feminine sperm—though not knowing about ovulation—Aristotle sees the child as born from the masculine sperm alone, thus denying the role of the woman in conception and reducing her role to that of carrier and nurturer. Paradoxically, the virtually unique responsibility of the male in the act of conception

does not translate in the slightest way to increased responsibilities of the father after birth, outside of recognizing the child's legitimacy and choosing its name. It is as if, lacking a way of conceiving children in which women would be totally absent, the father were following the wish of Euripides's Hippolytus or imitating Zeus, who was both the father and mother of certain of his children (Athena, Dionysus)—i.e., as if the over-valorization of the role of the father in the process of engendering freed him of any other obligation after the birth of the child.

Of course, the father must nourish his children and pay for their education in accordance with his income, but that comes more from the high-profile politics of the *oikos* than from a moral obligation toward the individual. When Strepsiades decides to provide for his offspring lessons from a prestigious instructor, it is with the hope of getting some benefit from it and not for the child to get better life-skills for success. The world of the novel furnishes a confirmation of this through inverse example: the attainment of virility by the hero is based on the help and advice of a father, but it is almost always the father of the heroine (the hero's future father-in-law), practically never the hero's own father. The father-in-law is the one who allows the young hero to accede to adult maturity by giving him wife and power (the hero inherits repeatedly from the father-in-law's realm).

Despite the relative distance between father and son, it is nevertheless biological paternity that ensures family continuity. For a father, seeing his son or sons die before him constitutes a major drama: Pericles had the tragic experience of it at the end of his life and was obliged to ask the city to legitimate the son he had had from the Milesian Aspasia—going against the law that he himself had gotten passed in 451—in order to preserve his line. For, whether he comes from a prestigious family or not, the Greek man's concern is to perpetuate himself by another male who will carry on the line, at once as master of the *oikos* and as member of the civil community. This concern is expressed even by the often modest epitaphs of the imperial period, in which the tombstone constructors pray to Destiny or the gods to act in such a way that the tomb receive the dead only in the normal order of generations. It was a legitimate concern of parents who wished not to see their children die before them but also a legitimate preoccupation of fathers who knew that only men perpetuate the line, since the woman, upon marrying, leaves the *oikos* to blend into a foreign *oikos*. Perhaps it is in this conception that can be found the explanation of the all-powerfulness of the Greek male, whose position is reinforced more than limited by the laws of the city. The ideal of virility is imposed on everyone, in reality as well as in discourse. Consequently, the worst attack that can be carried out against a city is to kill its men (this is the normal fate of prisoners of war)

or, even worse, its young boys. The tyrant of Corinth, Periander, set the example of immoderation by making off, following the revolt in Corfu, with the Corfuan youths of the noblest families and sending them to Lydia to be castrated (Herodotus, III, 48). It was tantamount to endangering civic norms as regards sexuality by the way it reduced future city leaders to slaves and robbed the city of any future.

But death is also a touchstone of virility. The citizen desires "noble death," a death at war in the defense of the nation. Otherwise, he must control his sadness. The sensitive emotion of epitaphs should not create an illusion: one of the integral elements of Greek virility is self-control. In the funeral procession that he leads, the father of the family is supposed to dispense with any excessive manifestation of sadness, which is considered to be feminine. Plutarch, in his *Consolation of Apollonius* (113a), reports the existence of a Lycian law on which he makes a comment: the law recommends to men who conduct mourning to wrap themselves up in women's clothes, for "marks of sadness are the affair of women and are not appropriate for upstanding men (*ouke harmotton andrasi kosmiois*) who claim to have had a free man's education. It is really the sign of a feminine character (*thelus*), weak and ignoble, to let go of oneself in mourning." As early as Homer's *Odyssey*, tears are forbidden men (*Odyssey*, XI, 506–37).

Greek societies give priority to the male. They strive to construct a dominant masculine identity that goes beyond innate physiological characteristics, an identity based on the citizen who alone has access to politics. The emphasis continually placed on the primacy of politics above any other activity in Sparta as well as in Athens led naturally to conferring upon men a status without equivalency throughout society: women, youth, children, and of course foreigners and slaves could only be in the service of the one dominant group, adult men. Naturally, the latter are led to compromise, for they cannot make children without women (and there are no citizens without the daughters of citizens in Athens), they cannot earn their living and find the means of attaining their political ambitions without slaves, and they sometimes need enriching products brought by foreign merchants or they take lessons from itinerant Sophists (all foreigners in Athens). Nevertheless it remains the case that the entire society is organized around the adult male, while also paying continual attention to the young men who will in turn come to join the community of men. The over-valorization of relations among men and the concern for distancing youths from feminine dangers while also lending a particular ceremoniousness to the gradual progression from adolescent ambivalence to adult sexual maturity are at the heart of a complex apparatus. Exaltation of masculine beauty and of *eros* among men should not lead one to underestimate the importance of education,

beginning with early infancy: the construction of a masculine ideal that associates the warrior and the politician, the slow apprenticeship in the management of the *oikois* and everything that it contains (from women to cattle and harvest), and the concern for the continuity of lineage—in a word, to undervalue the perpetuation of the city. The elimination of men—comical in Aristophanes when the women seize power and tragic under the tyranny of Aristodemus of Cumes, who kills men, parses out the wives to the slaves, sends the sons into the fields in their place, and devirilizes the slaves promoted to the rank of master by treating them as women, with long hair, frequent baths, fine garments, and perfumes[56]—marks the end of the well-organized city, which is to say the turning of the world upside down.

This construction of virility is encapsulated in the Greek novel's depiction of the passage from adolescence to adulthood—at times with the help of real antiheroes, e.g., black hunters resistant to initiation. The contrast between women and men is clearly displayed in the novel. While the heroines manifest from the start of the novel traits appropriate to their gender, the heroes accumulate proofs of their *andreia*, even though their physique leaves no doubt as to their masculinity. Thus, Theagenes, "with broad chest and shoulders, [. . .] holds his head up proudly, way above the others, and dominates everyone with his great size," but "his hair falls in long curls and his cheeks are covered with blond fuzz" (*Theagenes and Chariclea*, VII, 10, 4)—i.e., he possesses signs that reveal his sexual immaturity. All the twists and turns of the novel are designed to have these adolescent heroes pass into adulthood, as shown by the dénouement when they finally acquire, sometimes unwittingly, the three signs of virility: glory in battle, a legitimate wife, and power. For it is obvious that each one strives to pay tribute to the greatest gift that Nature may grant to a human being: being made a man. As the orator Hyperides says regarding a *kinaidos*: "Nature would certainly take offense and be surprised were a man not to consider that being born a man was the most precious of gifts, and were he to ruin this bounty that she had for him by rushing to transform himself into a woman."[57] It would be hard to state any better how fortunate it is in Greece to be born a man, even if becoming one requires a great deal of effort.

2

ROMAN VIRILITIES:
VIR, VIRILITAS, VIRTUS

JEAN-PAUL THUILLIER

QUESTIONS OF LEXICON

THE LATIN lexicon of virility seems hardly out of the ordinary, since French has taken from it most of the terms that we use, and the same sense has generally been preserved. There is one exception, though, which is significant: the word *vir*, from which all the rest of the vocabulary derives, disappeared from French, and its replacement, the word "*homme*," which comes from the Latin *homo*, refers to the male as well as to a member of the human species.[1] This does not mean, of course, that our conception of virility has remained the same as that of the Romans: As in many other domains, the numerous parallels that may be picked out should not hide the considerable developments and differences that have occurred. But the Latin vocabulary will scarcely need to be translated. To begin with: the word *virilitas* itself refers to manhood as well as to the male organs; in Tacitus, a eunuch is someone whose *virilitas* has been removed (*adempta*) (*Annals*, 6:31). And it is used by the satirical poet Martial to evoke, at the end of the first century B.C.E., those adolescents (*pueri*) who were castrated by greedy slave merchants (*virilitatis ereptae*, 9:5, 5), no doubt because they were more appreciated that way by certain clients.

A MAN, A REAL MAN (VS. *VIR*)

From the very outset, then, there is obviously the word *vir*, "man," in the sense of "male:" *vir* is not *homo*, if we may be allowed to express it that way.

The word *vir* by itself may refer also to the male organs, as seen in poets such as Catullus, contemporary of Caesar and Cicero. When Attis the Phrygian emasculated himself, when he cast off his virility, as Voltaire put it, Catullus states that his body is *sine viro* (63:6),[2] without the organs of virility—and at times the poet then employs the feminine gender to describe him (her?). Nevertheless, half-man, half-woman, as a hermaphrodite, Attis becomes at that point either a *notha mulier* (27), a woman of indeterminate sex, or a *vir sterilis* (69), a sterile man: in reality, he is henceforth a *semivir*, half a man, as will be, in imitation of him, all the *galli*, the castrated priests of Cybele, who, again in Catullus's words, have de-*vir*-ed, or un-manned, their bodies (*corpus evirastis*, 17). As for Catullus, far from all these excesses, which are regrettable according to Attis himself, the poet presents himself in another poem (32:8–11) as a real male, ready to fuck nine times in a row the sweet Ipsithillia (*novem continuas fututiones*). While waiting, lying on his back after lunch, his member pierces through mantle and tunic In these hypothetical exploits of our poet, we could find an example (a phantasm?) of virility, which would not seem very foreign to our own time. However, in Rome things are not so simple, and the quarry of virility is multiple, as Catullus himself reveals a little later.

Adulthood is attained progressively at the first sign of a beard on the cheeks: this is when the young man is led to cut off his long curly hair, which is the mark of children and young adolescents. In Martial (9:36), the speech that Ganymede, cupbearer of the gods, makes to Jupiter is revelatory: "Already the first down lies hidden by my long locks already your Juno laughs at me and calls me a man [*vocatque virum*, 6]."[3] And Jupiter, to rebut this request, not without finesse, says: "[. . .] but if the elimination of your curls gives you the face of a man [*vultus viriles*], who, then, will pour me nectar in your place?" (11–12). Actually, out of this story about curly hair emerges an essential question for our subject because it bears on the proper usage of virility in the Greco-Roman world.

THAT'S MY MAN

It is therefore not surprising that *vir* often means "husband," since it is precisely the man whose sex organ allows him to "unknot the virginal girdle" of his wife. For the Roman woman, it was a mark of honor, proclaimed in particular on epitaphs, to call oneself *univira*, the "wife of a single man." Before dragging his interlocutor through the mud, Catullus also reminds Aufilena that it is for a wife an unparalleled glory to be satisfied for one's whole life with a single man (*viro contentam*

vivere solo 111:1). We shall see that certain men, such as Drusus Germanicus, had sexual relations only with their wives, which was certainly looked upon with curiosity and even with a certain admiration. Such men manifested a perfectly respectable restraint, but at the same time this was not an attitude shared by the Romans, since they felt the need to take note of it. It is also an attitude of the philosophers: while the average Roman judged it normal to have several partners, Marcus Aurelius takes pride in "having protected the flower of his youth, not having had sex too early and having refrained for longer than usual."[4] This long abstinence, whether from relations with men or with women, remains exceptional in any case.

YOU SHALL BE A MAN, MY SON

The *vir* is thus a male and an active husband . . . unless, unlike the fantastical Catullus, it is a case of an impotent (*iners*, 67:26) man: the latter has "a penis that hangs more languidly than the soft stem of a beet" (62:21), and consequently "it never rises to halfway up his tunic" (22). "He's my man" is still said in the French vernacular, linking the active sexual role to the marker of manhood. Besides, Latin uses the same turn of phrase as French to indicate that one becomes a man, a *vir*, only after one's first sexual experience with a woman. It is Martial, another Latin author of salty epigrams, who will serve this time as our guide (11:78). Victor, who is going to be married, has known only the love of boys (*pueri*) until now, and the poet advises him to get initiated into this new terrain by a professional from Suburus, the red-light district of Rome: she will know how to make him a man (*illa virum faciet*). The same expression is used with regard to a handsome adolescent, the *puer* Cestus: "Happy [. . .] the girl who shall first make you a man!" (*Felix [. . .] quae se faciet prima puella virum*, 8:46, 7–8.) This rhetoric sounds like the end of the nineteenth century, when, before the sexual revolution, it was mandatory for young men to pass through the brothel before wedding.[5]

The *vir* stands opposite, of course, from the female gender and feminine comportment, but he is also opposite from the *puer*, and this is not simply a question of age or juridical condition; the *puer* often refers to a young slave. There is also in this opposition a directly sexual connotation. Describing the portrait of the ideal young slave he would like to possess, Martial depicts him as coming from Egypt, with a complexion white as snow and straight hair. And, "let him have no fear of the boys and often shut out the girls; let him be a man to all besides, a boy to me only" (4:42, 13–14, *vir reliquis, uni sit puer ille mihi*). One must obviously

understand that this *puer* may very well play the man, that is, enact the active role, with girls and boys, but, with the poet, he must stick to the passive role. This is the same meaning that should no doubt obtain in another poem from the same book: the *puer* Hyllus rejects Martial on the grounds of his age, his beard, and his body hair. "Yesterday you were a boy [*puer*], Hyllus. Tell me, how do you come to be a man [*vir*] today?" (4:7, 5–6). No doubt Hyllus has reached an age (and the hair is important in this regard) when he wants to play the active role and assume all the responsibilities of virile conduct.

A study of these points should not be limited to substantives alone but may also impact the whole family of words, adjectives, and adverbs included. The young man will be not only virile but correct when putting on the virile toga, that is, when marking his entry into adulthood, into manhood. He is all the more correct in that the toga, etymologically, is designed to protect or cover (*tegere*) nudity, if not Noah's, at least that of the young man. At this time, around the age of 17, the *toga praetexta* with the purple border is abandoned, along with the spherical pendant, both symbols of childhood, to be given back to the *Lares* [household gods] of the family.[6] The adult male toga was, in contrast, totally white (*pura vestis*, says Catullus for himself, 68:15). When dealing with the plural neuter of the adjectival noun, *virilia*, it is of a completely different register, but this is all completely natural, as we are obviously dealing once again with the virile members.

But the Latin *virilis* can be taken in a clearly more risqué sense when referring to the impressive dimensions of the male sex organ: in that case, it is tempting to translate it as "well-hung, well-endowed."[7] Thus, the Emperor Elagabalus, according to the *Augustan History*,[8] had the compulsion, for his personal satisfaction, to have the whole city combed for men well-endowed by nature, *onobeli*: that is how they named those who seemed *viriliores*, "more virile." The Latin term, moreover, is the subject of a scholarly discussion: it is a question either of *onobeli*, a term evidently related to the Greek *onos*, "ass," or of *monobiles*, which would imply the use of a single weapon—easily guessed at. It should be noted also that, interestingly, it is mainly among sailors (*ex nauticis*) that this hunt took place. Regarding the comparison with the ass, it appears as early as in Commodus, who held in great esteem and paid generously a man with an impressive penis: he called him just that, his ass (*quem onon appellabat*).[9] It is not only the emperors who had such tastes: Gallus also, whose penis was flaccid, sleeps with *pueri mutuniati*, i.e., "well-hung" (Martial, 3:73). Thousands of allusions can be found in the satirical poets to outsized sex organs, and Roman arts and crafts offer a fine crop of enormous phalluses as well: the tourists of Pompeii can testify to it as they leave certain houses with amused

FIGURE 2.1 PHALLUS AND LATIN INSCRIPTION. PAINTED TRAVERTINE IN POMPEII, FIRST CENTURY, NAPLES, NATIONAL ARCHEOLOGICAL MUSEUM.

The Latin text emphasizes the magical quality of the image: *Hic habitat felicitas*, "Here lives happiness, prosperity." At the time of ceremonies held in honor of Priapus, the erect penis at the entrance to a house or a shop (here a bakery) had the role of keeping away undesirable visitors and ensuring the success, fecundity, . . . and virility of the owners.

Source: © Leemage

looks on their faces (cf. fig. 2.1). But should we see in this a specific trait of Roman civilization?

ACTING LIKE A MAN

The adverb *viriliter* refers back first to the idea of acting sexually as a man. Here we find in another poem (*Appendix Vergiliana, Quid hoc novi est?*, 4–5) our impotent man whose inert penis [*iners penis*] was unable to lift up [*viriliter*] its old man's head [*senile caput*] at the moment when he should have been satisfying a handsome young man with milk-white skin [*candidus puer*]. This adverb and the behaviors that it assumes apply as well to women wishing to act like men, and from a moral perspective this is obviously the *summum* to be attained in that type of society. The *virgo* ["virgin"] then becomes a *vir-ago*, a nonpejorative term in Latin, since it is used to describe goddesses such as Diana and Minerva as well as nymphs like Juturna.

Such behavior would be admirably virile unless this imitation led to the reproduction of the excesses, particularly the sexual ones, of certain men. In an epigram that does not bother with niceties (7:67), Martial shows us the picture of a lesbian out of control: a certain Philaenis keeps sodomizing young boys [*pueri*], and she

also wears out eleven girls [*puellae*] in one day. All joking aside, it sounds like a page from Catullus with his erotic *tours de force*. Philaenis is sexually turned on but she does not want to perform fellatio on any men, for she deems it not a very virile position [*parum virile*]. And of course, beyond the caricature-like quality of the epigram, we have some interesting observations on the codes of Roman virility that we will come back to. Ultimately, Philaenis prefers "to lick the girls' vaginas" [*cunnum lingere*] because she thinks that it is a virile position. All of this, whether it is about virility or the affectation of virility, has to do with penetration, as we shall see, but it is not absolutely certain that the practice of cunnilingus was highly recommended as a sign of virility. We have to see here, no doubt, as C. A. Williams rightly believes, a final jab [sic] by Martial and therefore the opinion only of Philaenis, who perhaps wrongly categorized Roman males' behaviors.[10] The beginning of Juvenal's Satire 9 leaves no room for ambiguity about the unfavorable image associated with man's practicing cunnilingus (3–5). And even if Martial jokingly implies that a eunuch who practices cunnilingus is a "male by mouth" (*ore vir es*, 3:81, 6), all of his epigrams go in the same direction as Juvenal's satire.

Actually, we come back to the noun *vir* itself with the behavior of a certain Bassa, who is one of Martial's favorite targets: in another poem he reproaches her for smelling like an old billy goat [*piger hircus*, 4:4]. But here (1:90) it is her sexual conduct that is aimed at, along with a certain pious posturing, which the poet sees as his task to point out and takes pleasure in bringing to light; once again, he does all this without pulling any punches:

> I never saw you close to men, Bassa, and no rumor gave you a lover. Your were always surrounded by a crowd of your own sex, performing every office, with no man coming near you. So I confess I thought you a Lucretia; but Bassa, for shame, your were a fornicator [*fututor eras*] (of women). You dare to join two cunts [*geminos cunnos*] and your monstrous organ [*i.e.* her clitoris] feigns masculinity. (1:90)

This last verse (*mentiturque virum prodgiosa Venus*) has been questioned in an effort to find out if, to play the man (*vir*), Bassa did not more likely use a dildo: but the use of the noun Venus and the allusions to the two female sex organs (*cunnus*) in the preceding verse prompt us to think that the interpretation made by J. Izaac, the translator of the Collection des Universités de France, is justified.[11]

Having followed (however reluctantly) the satirical poets along their slippery paths, we must return to more noble topics. For *vir* has not only yielded all these terms involving *virilitas* and sexuality by itself, it also leads to *virtus*, virtue and

virile valor, which is at first courage (*fortitude*: cf. Cicero, *Tusculan Disputations*, 2:18, 43), but which is not only that, contrary to the translation too often given for this word by budding Latinists. Thanks solely to etymology, it can thus be easily surmised that virile conduct required in Rome a certain number of psychological and moral qualities that could not be reduced simply to courage. This is the moral portrait that we should conjure up after having analyzed the various codes and traditions of virile sexuality, which may concern, of course, only citizens, and after having studied the physical appearance of the Roman male. Such an examination relies particularly on literary sources and also epigraphs as well as on a few iconographic documents. From a chronological point of view, it corresponds, in the main, to the end of the Republic and the first centuries of the Empire. In spite of particular movements, such as the austerity policy regarding family morals established by Augustus, it is not certain that there were any fundamental changes on this subject in the Roman mind prior to the definitive victory of Christianity, which introduced or attempted to impose a new sexual tradition, one that actually was not totally absent from Stoic morality. For certain philosophers of this persuasion, chastity was already a good thing, and it was in fact advised to have sexual relations only with one's wife—and even then only for the appropriate reason, that is, to procreate, which excluded automatically any fantasy and any variation, even with one's own wife.

ON THE PROPER USE OF VIRILITY

Here we are in the presence of a Roman, a man who has attained full maturity, no longer a tender adolescent and not yet an old man afflicted with infirmity. In short, a real man, perfectly developed physiologically and not a *semivir*, a half-portion: he is endowed by nature with male organs, which are in normal functioning order. But what does Roman society expect of this man in terms of sexuality? What are the characteristics of virile conduct in Rome during the first century B.C.E. or in the era of the Antoninuses? Which attitude is deemed correct for a Roman male, which is satisfactory to others, and which substantially tarnishes a man's reputation? It is of course only the Roman citizen who is concerned with these questions, and perhaps we should even say only the elite of the body politic, those who discharge political tasks:[12] this "public norm" is of scarcely any concern to the freed slave, who is often in between social ranks. His only purpose is to satisfy the desires of his master or

mistress; the problem of his reputation, as regards sexuality, is of no importance—even though his "virility," in the most concrete sense of the term, may be of great interest to this or that citizen or his wife, as seen abundantly in the satires.

Regarding a domain such as sexual behavior, whose authenticity is often difficult to establish, it should be understood that, for antiquity, the answers to these questions raise many problems. We are obliged to use literary texts and juridical sources, remaining aware that the first group are mainly satirical works (e.g., Catullus, Martial, Juvenal) and contain caricatures or travesties of reality, although it is mainly these authors who talk about sexuality, and the second group that establishes norms that are not necessarily those of public opinion and do not take account of all practices. This is clearly seen when the premise is about putting back into currency a law of morality that has existed for centuries and yet that has not been followed. Besides, we sometimes have only the name of the law and not its contents, which we must try to decode, incurring the risk of error. And when a practice seems to have been morally and socially condemned, what was the exact import of this social constraint? We do not have for Roman civilization those surveys that might allow us to approximate such realities. In spite of these difficulties and obstacles, it remains the case that, through the study of the available diverse sources, a certain number of constants take shape that are recognized today by historians as a group and that allow us to trace the contours of the proper exercise of virility for a *civis Romanus* during the second century C.E.; however, as we said earlier, Rome did not experience any fundamental change on this point afterward.

"TO SCREW BUT NOT GET SCREWED"

This pithy, direct formula by Paul Veyne summarizes perfectly the situation and will unquestionably win general adherence.[13] In Rome, virility is characterized first by an active and not a passive sexuality, all the more so because some people contest this idea of a passive attitude—the "passive" partner in a couple never being totally passive—the man is the one who sexually penetrates his partner, regardless of the method of penetration and regardless of the penetrated partner. By contrast, to be sexually penetrated can be the act only of an effeminate man who has renounced his virility, at least provisionally. There are so many behaviors in this domain and so many transgressions that we will have to look into particular cases. But this initial rule is what draws a line in the sand when it comes to virile sexuality.[14]

On this basis a very precise terminology, at once very raw and very refined, of sexual practices was established in the Latin language; we encounter it, in particular, in the authors of epigrams and satires mentioned previously (but whom the editors of the Collection des Universités de France have often and very consciously refrained from translating directly). As Georges Lafaye wrote in 1932 regarding Catullus's poetry, which is teeming with "violent or familiar expressions," often "obscene," "I rendered others, in order for the sequence of ideas not to be broken, with more or less decent equivalents that I placed in brackets. Let the more daring push fidelity further."[15] And that is exactly what certain more recent translators have done.

Let us take a look at a first example that summarizes it all, poem 16 by Catullus, in which the author sharply attacks two characters who have spoken ill of his verses and of his person and who have (would have?) questioned his own virility:

> *Male me marem putatis?*
> ("You accuse me of not being a real male?" 13)

The alliteration is admirable. Catullus's scathing response:

> *Pedicabo ego vos et irrumabo*
> *Aureli pathice et cinaede Furi* (1–2)

G. Lafaye's translation has the virtue of having us penetrate to the heart of the matter: "I will give you proof of my virility, Aurelius the gypsy and you, Furius, despicable self-satisfied one. . . ." In fact, the verb *pedicure* means "to penetrate anally" (it could therefore be translated as "bugger"), and the verb *irrumare* refers to an act of fellatio, "to penetrate orally." A possible translation, respecting the off-color quality of the sentiment is "to get sucked off by." And Catullus's two adversaries are treated with a beautiful chiasmus—obscenity not standing in the way of rhetoric—as *pathicus*, passive, "buggered," and as *cinaedus*, which would then be "cocksucker"—but this term, difficult to translate, has the more general sense of "effeminate man" and of "sexually penetrated."[16]

Martial would not be outdone in this avalanche of insults and allusions to sexual attitudes.

Sextillus, go ahead and laugh out loud at whoever calls you a *cinaedus* [a passive] and flip him your middle finger [we see here that certain obscene gestures were not invented yesterday]. But you are not a boy-fucker [*pedico*], Sextillus, or a

woman-fucker [*fututor*], nor do you like the hot mouth of Vetustina. I declare that you are none of these things: so what are you? I do not know; but you know what two things are left.[17]

We have here a summary of what a *vir Romanus* can do in sexual terms, a picture of virility in action, and the Sextillus in question, even though he refuses to be labeled "*cinaedus*," does not fit into this category. Virility is thus anally penetrating young boys (or women), vaginally penetrating women (*futuere*, "to fuck"), and having fellatio performed. As for Sextillus, he is perhaps not effeminate to the point of letting himself be sodomized, but he must practice a few fellatios and lick a few vaginas, to use the terms so often employed by Martial himself. None of this has anything virile about it, and Sextillus should therefore stop trying to be clever, as the poet reminds him.

This range of virile sex acts exists as well with a single partner: "I had to myself for an entire night a lascivious mistress [*puellam*] [. . .]. After she exhausted me in a thousand ways, I asked her to let me treat her like a young boy [*illud puerile*: the *puella* is taken like a *puer*] [. . .]; I made an even more licentious request: she said yes . . ." (Martial, 9:67). And that *puella* remains pure in the eyes of Martial, which would obviously not be the case with a man such as Aeschylus, were he given to such indulgences. It might even be possible to establish a hierarchy of these virile activities: in fact, even the impotent Lupercus can indulge himself with acts of fellatio, thanks to his money (Martial, 3:75), and "nobody is an old man [. . .] when it comes to giving suck (*ad irrumandum*)" (ibid., 4:50, 2).

Another category of documents is revelatory here: the graffiti, which, on the walls of Pompeii in particular, exalt the sexual exploits of their author, who brags about having fucked (*futuere*) a certain *puella*, usually several times, or sodomized (*pedicare*) a certain *puer*.[18] In this we see a good illustration of the idea of virility in the milieu of common folks. In any case, the separation is clear between these active and passive roles, and Latin literature—not just that of the satirists—teems with accusations against partners who accept or who play the passive role in a sexual relation. The *cinaedus*, the *pathicus*—and there are other terms in Latin that are more or less synonymous—is regarded socially with contempt, his reputation is tarnished, or in any case, people try to tarnish it by publicly accusing him of such practices. And each one is said to be trying to dissimulate this passive conduct with an ostentatious virility that fools no one:

Word is out, Hamillus, that you sodomize yourths who are already adults [a circumstance that is undoubtedly as worrisome for him as the advanced age of his partners],

and you want to be caught doing so [. . .]. Anyone who calls to witness that he is not sodomized, Hamillus, usually does what he does without witnesses (7:62).[19]

This accusation of passivity, of shamelessness, returns repeatedly in political vocabulary. It would take too long to list all the "wimps" [*molles*] of Roman history, at least those who were regarded as such in the eyes of their adversaries. It will be sufficient therefore to recall the exemplary case of Caesar, whom Catullus out and out called "Romulus the buggerer" (29); Catullus also publically condemned Caesar's lieutenant, Mamurra, whom he kindly named *Mentula*, in other words "The Penis, the Cock." Such were the political and literary mores to which our more correct epoch is not accustomed: we do not make fun anymore, at least not in writing, of someone's sexual practices or even of someone's name. And we cannot refrain from citing here the vicious formula used by the old Curion, who called Caesar "the man for all the women and the woman for all the men" (Suetonius, *Caesar*, 52, 3). This is an allusion, on the one hand, to the numerous affairs with women that the bald seducer was to have had, in particular with married women—hence the reproach of adultery—and, on the other hand, to his (passive) relation with the King of Bithynia, Nicodemus. Caesar's own soldiers, at the time of a victory, were quick to take up these themes in their ritual jibes at the time. It can be seen, in any case, that such accusations did not lead to a trial and that, in spite of the infamy that normally ensued, they did not prevent Caesar from pursuing a brilliant military and political career. Until more data are obtained, and even if he complained himself about the stigmatization that Catullus's epigrams inflicted upon him, this is not where we shall find the reasons for his assassination on the Ides of March.

SCREW, YES, BUT SCREW WHOM?

[You were] an adulterer more notorious than Aufidius, quiet too
About how you also found favour with their husbands.[20]

It should already have been made clear, based on a certain number of citations, that the virility of the Roman male is expressed with regard to male as well as female partners;[21] more precisely put, if the *puella* may be a girl or a woman, the sexually penetrated *puer* is, for his part, a young boy, an adolescent [cf. fig. 2.2]. In any case, it is clear from the outset that the category of "homosexuality" does not pertain in Rome so long as the male partner remains the stripling just alluded to. If the

FIGURE 2.2 SCENE OF HOMOSEXUAL COUPLING. SILVER CUP, 25–50 C.E., LONDON, BRITISH MUSEUM.

For various reasons, perhaps deriving from the means of preservation, images of the sexual relations between two men are less numerous in the Roman world than heterosexual scenes. This silver *skyphos* (the "Warren cup") shows us a somewhat acrobatic coupling between a beardless young man who is holding onto a strap and, underneath him, his bearded, crowned lover. The scene, moreover, is being watched by a voyeur.

Source: © The Trustees of the British Museum

relationship is carried on with mature men who have developed a full beard, it can be the object of disapprobation, even for the one who penetrates his partner (cf. the citation from Juvenal above); the other man, in any case, is a despicable *cinaedus* (one who indulges in unnatural lust), pursued by the flames of rumor. But no such attitude is found earlier. It is striking that in the writings of Catullus, Martial, and Juvenal *pueri* and *puellae* are placed on the same plane and that Roman society casts no aspersions upon a sexual relationship with *boys*. Dozens of examples could be provided on that score (Martial, 11:15; 12:86: a man possesses thirty *pueri* and thirty *puellae*, but he has only one penis). Catullus describes in the same way the desires and feelings he has for Lesbie (7:51) and for Juventius (24:48): both deserve a ton of kisses. In Juvenal's case, the wife (inevitably), outraged in order to hide her own depravities, reproaches her husband (inevitably) as naïve, both for his *pueri* and for his alleged mistresses (*Satires*, 6, 272–73).

Martial's epigrams are filled with these beautiful *pueri*, these *molles pueri* who make up life's pleasures just as much as young women do: "may you have a boy queen (or young Ganymede) [*puer cinaedus*] all to yourself and the purest of girls [*puella castissima*] lust only for you" (9:90, 7–8). The translation evokes that superb cupbearer of the gods who was Zeus's catamite and therefore the emblem of beauty, a term ("your Getulian Ganymede") often used by Martial and Juvenal (5:61) to refer to a beautiful young slave. Let us cite, out of thousands of others,

a last poetic example of this apparently equal treatment of boys and girls, both objects of male desires: the kisses of the *puer Diadumenus* are as fragrant as "the scent of an apple as a young girl bites it" (Martial, 3:65, 1:9). The *pueri's* fragrant, lusty kisses are a recurrent motif in Martial (11:8; 11:23; et al.). When Marcus Aurelius takes credit for never having touched either his slave Theodotus or his servant Benedicta, it is an indication that such was habitually and naturally the practice in the *domus*, and that the question of the gender (of slaves) was basically of no consequence. A character in Martial seems to think that the ideal situation in sexual matters is to have at one's disposal a mistress (*amica*), a female servant (*ancilla*), and a male attendant (*minister*), the last two being, of course, of servile status (11:23).

If one had to establish a hierarchy, the impression is that, for our poets, or for their narrators at least, it is the beautiful *puer* who would be at the top of the pyramid of erotic desires—especially if he is of exotic origin (Martial, 4:42, 3: "I should like to ask [that] this boy be born in the land of Nile"). In sum, a Ganymede or an Antinous. It is a question of a "luxury item" that, in a very striking enumeration, comes before the expensive furniture, the Corinthian bronzes, the crystal goblets, the emeralds and jewelry: "Mamurra inspected tender boys, devouring them with his eyes" (9:59, 3). And here he is in action at the banquet, in all his elegance:

> When a page more willowy than Ida's catamite [*cinaedo*] [i.e., Ganymede] pours me Caecuban wine, groomed as smart as your daughter or your wife or your mother or your sister reclining at the table, why gaze at your lamps . . . ? (10:98, 1–4).[22]

And when, owing to financial constraints, one has no beautiful *puer* on hand, one is left, unfortunately, to masturbate:

> Your waiters could vie with the Ilian catamite [Ganymede]: but my hand comes to *my* assistance [. . .] (2:43, 13–14).

It is a practice that, while always available, seems "biblically" condemned (*scelus*, a "crime") in 9:41, for it does not allow procreation, but we must always bear in mind Martial's imagination. The last proof of this hierarchy of erotic values: if Linus takes his pleasure with his steward or with a country bumpkin's wife, it is because he has no tender servant from Greece (4:66).

It is again Martial who can provide for us the conclusion on this debate with his epigram 11:43, delightful in its bawdiness. From Olympus to the home of the

poet, the women are complaining of their companion's preferences, even though they hold all the trumps in the game:[23]

> Catching me with a boy [*puer*], wife, you upbraid me harshly and point out that you too have an ass [*culum habere*]. How often did Juno say the same to her wanton Thunderer! Nonetheless, he lies with strapping Ganymede. The Tirynthian used to lay aside his bow and bend Hylas over: do you think Megara had no buttocks? Fugitive Daphne tormented Phoebus: but the Oebalian boy bade those flames vanish. Though Briseis often lay with her back to Achilles, his smooth friend [Patroclus] was closer to him.[24] So kindly don't give masculine names to your belongings, wife, and think of yourself as having two cunts [*duos cunnos*]. (11:43)

In another epigram (12:96), bearing on the same theme, Martial elegantly compares the anus of *pueri* to the form of a fig from Chios, whereas that of women is but a sawtooth sedge. For the wives of gods, heroes, or poets, the competition is tough!

Playing the active role at times, these young slaves delight their masters and at times also delight their mistresses (the Latin word *deliciae* precisely translates this situation). Glaucias, who was extremely beautiful, died at the age of 13 and therefore was able to furnish only ephemeral delights (*deliciae breves*) to his dear master (*carus patronus*) Melior. This is not necessarily an enviable situation for the slave, as Juvenal noted, with certain scatological details: "The slave who plows the field / Is less unhappy than the one who plows his master!" (*Satires*, 9, 42–43). There is, moreover, some recompense: Trimalchio, the parvenu of the *Satyricon*, started to build his fortune after sleeping with his master and his master's wife (75, 11). In any case, a pretty boy is one of the jewels of patrimony, and when his master dies, the heir does not shrink from sleeping with this catamite on the very first night of mourning (Martial, 8:44, 17). It is perhaps not very elegant from a moral perspective to "screw" so quickly the widow, the mistress, or the favorite slaves of the deceased, but given the attitude of Roman society toward these behaviors, the question of gender is absolutely secondary, and the heir's virility is seen the same way, whether he sleeps with the surviving females or the males.

THE STATUS OF THE SCREWED

It can thus be seen that no social disapprobation develops toward these Roman citizens who sleep with boys, so long as they play the active role in the relationship.

But the ambiguity of the word *puer* in Latin, at once denoting young boy and young slave, masks an important censure around this question. We have seen that, in most of the citations given we were dealing quite clearly with slaves, or servants, often of exotic origins or bought from merchants selected on the basis of the quality of their "products," and whose beauty or whose physical qualities, easy to imagine, allowed them to accede to the rank of catamite for the *dominus* or eventually the *domina*, the Ganymedes and Antinouses. But regarding the relations with the *dominus*, the normal role of these *pueri* is exclusively passive: the humorous point of certain epigrams consists precisely in giving the impression that the master can easily reverse the roles and that, as a result, he becomes an odious personage whose conduct is morally shameful and despised by public opinion. But if the relations are socially "correct," the Roman who possesses these *pueri*, as seductive as Ganymede, not only incurs no hatred but is admired and envied: it is up to him to watch out that his guests do not take advantage of the situation by seducing them themselves or even abducting them. And if the master prefers girls, *puellae*, it is simply a matter of taste, and he is certainly not thought of any the better for it.

On the other hand, sleeping under the same circumstances with a young man born free is a scandalous matter in Rome, the object of disapprobation, and it may even lead to punishments of varying degrees. Here we touch on one of the essential differences with the Greek way of life. We know that in Greece the education of young men from good families passes—or may pass—through a phase of affective and sexual relations with an older man: this is pederasty in its etymological sense, in which we find the word *pais*, or "child, young boy." On that score, again, the preface by the Latin historian Cornelius Nepos (4) places in perfect relief the particular mores of each people; and this author reminds the Romans that, "in Greece it is considered a claim to fame for adolescents [*adulescentulis*] to have had as many lovers as possible." To explain this difference in attitude—this Roman refusal of pederasty—stress has been laid on the importance in Rome of paternal authority, the *patria potestas*. The *pater familias* would not admit that a man other than himself could play a role in the education of his son.[25]

Whatever the exact nature of the sexual relations between these young boys and their older lovers—whether it was between the thighs or the actual act of sodomy—it was a habit that really shocked Rome.[26] And since these encounters took place mainly at the gymnasium, where athletic nudity was the rule—just read Aristophanes or Plato to confirm this—it is here that we find the origin of the violent rejection by the Romans of the culture of the gymnasium and of nudity among citizens. As a result, this rejection of the gymnasium even led people to

believe that the Romans had no interest in athletic activities, which is absurd, as we will see.[27] But it is true that they found this habit of getting totally undressed in places frequented by free men and citizens shameful; and the formula by Tacitus is illuminating when he cites the followers of the tradition, of the *mos maiorum*, which pops up again in the middle of the first century C.E.: the *otia, gymnasia, turpes amores* (*Annals*, 14:20). At this time to adopt the Greek competitions of the Olympic type was in effect to accept idleness, the civilization of the gymnasium (and therefore athletic nudity), and "shameful loves:" not homosexual relations in general, for there is no harm in screwing a slave, but rather those relations among citizens, notably the pederastic relations that were spreading in the Greek palestras.

Such, in any case, was the rule, and these were the codes of good sexual behavior for a Roman citizen. But how was it in reality? There is quite a distance separating the rules of respect in the face of public opinion, by which you are being observed and judged, and the practices in the field—or rather off the field. Reading the satirists, the biographers like Suetonius, and the polemical writings such as those of Cicero, one sees that some young men born free, certain very well-known ones (e.g., Octavio, Marc Antony), had the same sexual experiences as the *pueri* of servant status: that, in any case, is the impression that these authors give, not without a certain taste for caricature and insult. Yet it is reasonable to think that this is based, at least in certain cases, on reality. Some laws, such as the *lex Scantinia* or *Scatinia*, may perhaps have been voted on in order to prohibit these practices, but even though Claude-André Tabart translates it as the *"loi des pédés"* (law for faggots),[28] the contents of this law are not well known, and judging from Juvenal (9:5–7), one would think that its main objective was to contend with the forced prostitution of children and, in particular, the practice of castrating them to render them *softer* in the eyes of their customers.

The same questions could be found in the relationships between men and women. Although Martial (3:33) places the free woman (*ingénua*) at the top of the hierarchy of conquests, ahead of the freed and the indentured slave—unless the latter is really very attractive, we know that consorting with free-born married women was condemned. A law passed by the moralizing Augustus sets a certain number of punishments (*lex Julia de adulteriis coercendis*); but even earlier the adulterous woman ran huge risks, and her husband could exact his private "justice" on the lover by raping him or mutilating him in various ways (Martial—e.g., 2:83—and Juvenal—e.g., 15:18–19—make a number of allusions to this subject). The father might exact the same vengeance in the case of his young son's seduction. In fact, without going so far as to accept the views of Juvenal, who in Satire 6 would

convince us that Rome was immersed in adultery, the ancient sources are teeming with stories of adulterers, especially in ruling-class milieus. And, in general, it scarcely caused any reaction or at times merely led to amused indignation when the affair was too visible. A good divorce took care of all that.[29]

Outside of these conventions, this very strict codification that we have reviewed in the last pages (to screw and above all not to get screwed like a *cinaedus*, not to touch young men born free or—theoretically—married women), the rest, one might say, was a question of taste and personal preference, of general attitudes toward life, and of philosophical choices. There are men (and the same can be said about women, although the ancient sources pay less attention to them) who love only men, and there are those who, like the Emperor Claudius, love only women. There are even those who are satisfied with their wives, as Drusus is: attitudes so rare that it seems necessary to point them out. But let us remember once again that our sources give priority to the upper classes—even though the satirists do make reference to other milieus—and that many of the notations are somewhat biased by literary or political views.

PHYSICAL PORTRAIT OF THE VIRILE MAN

TANNED BODY AND COMPLEXION

In Roman society the body is scrutinized by others and is supposed to conform to certain standards.[30] The Roman man is presented with a tanned face and body, and when, in his role as citizen, he is almost entirely covered by a very loose-fitting toga, his face still remains visible. For Seneca, *virtus* itself is *colorata* ("bronze-colored," the complexion sun-tanned; *On Happy Life*, 7, 3). White skin is a sign of outright femininity: in the Etruscan frescoes the differences in color are clearly marked between the men painted with a red-brick color and the women with very fair skin—if not completely white. It is a matter not simply of aesthetic convention but corresponds also to a different way of life, whereby the man is exposed much more often to the sun, even though the Etruscan woman is not confined to the *gynoecium* as some of her Greek correlatives had been. The gentle *pueri* who delight the poets are often described as *candidi*, with soft skin white as snow or milk: *sit nive candidior*, "let him be whiter than snow," says Martial (4:42, 5) of his ideal catamite. This is normal, since they play the "feminine" role in the sexual relationship and are often even considered as not yet having acquired the attributes of virility.

It is well known that for a long time women considered this an essential criterion of feminine beauty, and that all sorts of artifice were used in various countries to attain this sought-after result: at the beginning of the twentieth century such creams as Simon Cream, which were supposed to whiten the skin, had an international renown, even as far as China. And in fact, in Rome it was a mark of beauty for young women also. The poet, tongue in cheek, plays on all possible comparisons relating to this point: "A certain girl [*puella*] has a crush on me (envy me, Procillus!): one whiter than a washed swan, than silver, than snow, than lilies, than privet . . ." (Martial, 1:115, 1–3, modified).

Running counter to this idea about the connection in Rome between tanned skin and virility would be the case of Q. Fabius, councilor and censor at the end of the second century B.C.E, who was actually nicknamed Eburnus, "of ivory," a *cognomen* (family name) that he got from the whiteness of his complexion (*candor*). But this example is hardly emblematic once one reads what happened (or was supposed to have happened) to him (Festus, 284L): struck on the rear end by lightning, he was thought to have been sodomized by the god of lightning and was thereafter nicknamed Jupiter's "chicken" (*pullus*)—we might say instead Jupiter's pet or chickadee. As we can see, this Roman of good breeding from a high-ranking family is nonetheless not to be remembered as a paradigm of Roman virility. An epigram by Martial in which every verse ends with the verb *pallet* ("he is pale") summarizes perfectly the relation between paleness and the absence of virility: Charinus is in good health, and despite the sun and his make-up, he is nonetheless still pale. It is because he is a "vagina-licker" (*cunnum lingit*), which should make him blush in shame, says the commentator—but maybe he is exhausted by this duty. In any case, this behavior is evidently judged in Rome to be hardly virile (cf. Martial's very telling epigram 4:43), and its connection with a pale complexion is revelatory.

It is, in particular, by doing athletic exercises that this tanned complexion is achieved by the Romans, and Ovid even specifies: "That bodies darken on the Field of Mars [*fuscentur corpora campo*]" (*Art of Love*, 1, 511). But what is a virile quality will soon become a mania during the Empire, an obsession denounced by Stoic writers like Seneca: "It would take too long to review those whose life is consumed by playing checkers, playing tennis, or cooking under the sun" (*On the Shortness of Life*, 13, 1). This vogue of tanning, then, not unknown to our contemporaries, eventually loses all its significance in relation to a virile appearance, for in Rome there is nothing more feminine than constantly paying attention to one's body and primping it in every way. A real man has other concerns: besides, all excess is reprehensible, revealing a deplorable lack of control.

AN ATHLETE'S BODY

A virile body is a warrior body and athletic body—in Rome as well as in other places and at other times. This is so true that, as is apparent in the Riace bronzes, one can scarcely distinguish a number of the ancient statues of warriors from those of athletes. This was noted in the citation from Ovid: it is on the Field of Mars (*campus*) that the Romans can acquire, completely naturally, this necessary tan, and it is above all not a question of make-up or foundation! In other words, it comes from practicing physical exercise, by engaging in sports in the open air and in different places, which we shall return to. But we should first emphasize this point: one cannot imagine a virile man in Rome unless he practices athletic exercises regularly, and a *homo umbraticus* (fond of the shade), *doctor* (instructor) or not, is not a model from this perspective. In a play by Plautus, *The Rustic Man*, we come across a character judged, justly or unjustly, as effeminate, a *mollis*, who has these three adjectives applied to him (610–11): *malacus* ("soft"), *cincinnatus* ("frizzy"), and *umbraticulus* ("spending one's life in the shade"). We have seen and will see again what these criticisms conceal in connection with virility or its image, but it is clear that the last one evokes the life of a man who spends more time in the dressing room looking at himself in the mirror or in a salon in the midst of society ladies than in sweating from a run or fighting under the glaring sun. And it is surprising to find Cincinnatus (the Curly-Headed) in the gallery of *viri*, Roman heroes, with such a *cognomen*! It is therefore necessary to forcefully emphasize the importance of athletic training for men in Rome, for too often sports are associated solely with the Greeks, and the long-time refusal by the Romans of athletic nudity and certain other aspects of gymnasium culture has led erroneously to the idea that they also refused to practice any sports.

There is certainly one point on which the Romans can be totally differentiated from the Greeks, as Cornelius Nepos underlined in the quite remarkable preface to his work *On the Great Generals of Foreign Nations* (5): for the Greeks, winning the crown in a pan-Hellenic competition, and especially at the Olympics, being an "Olympian," was a claim to extraordinary glory that was scarcely a step behind military victories, whereas for the Romans, allowing oneself to be part of a spectacle in a large official competition before a grand public led to a reputation of infamy and disgrace. We know that, during the Empire, Nero, who had a burning passion to get up on stage or to perform in the circus arena, must have incurred his people's disapproval by doing so, and he went to Greece, in particular to the Olympics, the better to satisfy this passion. But if the "pride of the Roman oligarchs prohibited them from competing openly before the crowd" (Max Weber), refusing all athletic

training would have been a sign of nonvirility on the Roman citizen's part, if only because it might be detrimental to military preparation. It would therefore be seriously wrong to reduce Roman sports to spectator sports alone, and, among others, to the *ludi circenses*, even if these circus games and these chariot races did have a considerable social impact, and even if they have certain points in common with our contemporary spectator sports.

Literary texts do not focus disproportionately on this aspect, but it can be noted that from the time of the founding of Rome, it was not absent. Romulus, his brother, and their companions exercise naked in the sun and test their strength by boxing and hurling javelins and rocks (Ovid, *Fasti*, 2, 359ff.). At this time in history, during the Samnite games, one of the great Roman chieftains is named Papirius Cursor (and this *cognomen* means, of course, "Runner"). Livy provides us with the explanation: "Papirius Cursor had prodigious bodily strength, apt for backing up the vigor of his soul. He was above all extraordinarily fast; and that is precisely how he got his surname. No one of his century could wrest from him the prize for running . . ." (9, 16, 3). It was an allusion not to any official contest, something impossible in Rome as we have just noted, but to those spontaneously organized sporting events among Roman officers (and soldiers?) in the course of military campaigns.

But the most revealing text perhaps concerns Cato the Elder, who can justly be considered the paragon of Roman virility. It was he himself, Plutarch tells us (*The Life of Cato the Elder*, 20), who took over his son's education:

> Cato thought it not right, as he tells us himself, that his son should be scolded by a slave, or have his ears tweaked when he was slow to learn, still less that he should be indebted to his slave for such a priceless thing as education. He was therefore himself not only the boys' reading-teacher, but his tutor in law, and his athletic trainer, and he taught his son not merely to hurl the javelin and fight in armour and ride the horse, but also to box, to endure heat and cold, and to swim lustily through the eddies and billows of the Tiber.[31]

One might wonder if this choice of a strictly familial education were not dictated by another reason: might Cato, who did not like the Greeks, have been fearful about establishing closer relations between his son and his instructor, as occurred in Greece? It is clear, in any case, that this fairly rigorous physical training prepared the young man for hunting and for war, two areas in which Roman masculinity could be expressed both naturally and by necessity. To characterize hunting and horseback riding, Horace employs a significant expression, *militia Romana*, but we

should also take note of the interest in swimming, which is without any doubt a characteristic of the Roman man.

Without overdoing the historical references, let us note that Pompey the Great is also a good example of this athletic virility—he who competed with the best in the pole vault and track. This is, in the end, just the image of the whole Republican Roman elite—at least at the beginning of the Empire:

> This is why the ancient Romans, trained by so many wars and continuous perils in the practice of military arts, chose the Field of Mars next to the Tiber: after their martial exercises, the youths could, in effect, clean off the sweat and dust and forget their fatigue by going swimming (Vegetius, *Epitoma rei militaris*, 1:10).

And in fact, the Field of Mars, the *Campus Martis*, an area very well adapted to athletic practice, horseback riding, and sports because it was a zone not covered by a tight network of buildings (Strabo, 5, 3, 8), becomes the favorite meeting place of all those Romans who are fans of sports, horse races, ball playing, wrestling, and even hoop rolling (*trochus*). As surprising as it might seem to us, the practice of hoop rolling is in fact a virile activity, and on the mosaics decorating the thermal baths, this object figures right alongside clearly athletic objects (e.g., balls, barbells, scrub brushes). Objects, after all, have a history of their own and their greater or lesser virile quality evolves with societies: in the history of culinary arts the fork was not used by men in Europe until the eighteenth century because of its supposed lack of virility.

So the word *campus* suffices to refer to athletic activities and, for example, the pronominal adjective *campestre* is used for the loincloth (*subligar, subligaculum*) that the Romans wore during their exercise. And the Field of Mars becomes one of those places where the best athletes can show off their force, their strength, their virility, and their beauty to their fellow citizens. These large lawns shaded by plantain trees hold a sizeable crowd, and circles of spectators would form around the most brilliant athletes: in Martial (7:72, 10), we find the expression *corona uncta* (the "oiled crown," that is, the chaplet of the athletic spectators who were themselves covered with oil), and Horace advises mediocre athletes to steer clear of certain exercises so as not to be ridiculed. Outside of Rome, most likely in the western provinces, the *campus* becomes the name of the edifice designated for athletic practice, frequented, among others, by the *Iuventus*, the organization of youths from local elites. During the Empire the Field of Mars competes with the palestras of the thermal baths, which become, to use Yvon Thébart's very apt expression, the gymnasiums of the Roman era.[32]

Besides such nearly universal sports training as running, boxing, or wrestling and horseback riding, which retain a Roman aspect, or the more Greek—and therefore less coarse—ones like discus throwing, or those that are frankly surprising to us like hoop rolling, the men of Rome seem to have had a predilection for playing ball (*pila*) as well as swimming. Naturally, playing ball is not the sole province of men: children and women play also, but that is rather with the *follis*, a ball made of skin and filled with air (Martial advises its use; 14:47). For the virile quality of this sport depends also on the hardness of the ball used, and the *pila* was normally a small solid ball, rather hard, that bounced on the floor: it is reminiscent of handball or squash, which require a lot of energy. At any rate, such great personages as Cato of Utica did not hesitate to get into the sport, and we know through Pliny the Younger (3, 1) that a certain Spurinna was still playing ball with intensity at the age of 78. That said, the virility of this sport might be somewhat in question in light of how languidly and nonchalantly it was practiced by the parvenu of Petronius's *Satyricon*, Trimalchio. And Maecenas, who relaxed by playing ball during his voyage to Brindisi, or who even played sometimes on the Field of Mars (Horace, *Satires*, 1:5, 48–49; 1:2, 6), had a rather diabolical reputation when it came to virility.

SKILLED SWIMMERS . . .

Everyone knows about the importance of the thermal baths in Roman civilization; they are today often still the most impressive ancient remains on our landscape. But their role as sports structures has often been neglected or underestimated: we should re-evaluate the place of the palestras among these edifices and the number and dimensions of pools or *natationes* (the one at the Antonin baths in Carthage is nearly 50 meters long), where one could wade and wash or really dive in and swim: Latin, moreover, distinguishes clearly between the two verbs, *lavari* and *nature* (Seneca, *On the Shortness of Life*, 12:6, and *Letters to Lucilius*, 56:2). A text by Manilius (*Astronomica*, 5:422) helps us learn that the Romans were quite familiar with different swimming strokes, such as the crawl and the breaststroke. Martial does not hesitate to compare an unpleasant face to a man swimming underwater (*faciem sub aqua natantis*, 2:87), which gives at least some indication of his familiarity with this element of the exercise.

The young Cato learned how to swim and, as seen earlier, ventured into turbulent waters; Roman youths, after their athletic feats on the Field of Mars, would take a dip

in the Tiber, a river that is not exactly tranquil. Horace advised those who wanted to get a good night's sleep to swim across the Tiber three times before retiring.

Besides this, prior to the construction of the first thermal baths, the Romans could also swim in a public pool located near the Grand Circus (Lucilius, cited in Festus, 232L). Of course, swimming in Rome was not reserved solely for men; from the legendary Clelia to Agrippina the unsinkable, Roman women proved that they knew how to swim. Moreover, in Latin as well as Greek, a man who does not know how to read or swim is incompetent (and, as if by chance, Caligula did not know how to swim). Among the stories of great Romans, the swimming feats of one man are highlighted: Caesar's [cf. fig. 2.3]. "If rivers stood in his way, he swam across them or used inflatable floats, so that many times he arrived before his couriers" (Suetonius, *Caesar*, 57). It is, in particular, during the siege of Alexandria that his athletic qualities were most admired:

> As the Egyptian boats were coming at him from several directions, he dove into the sea and got away with great difficulty by swimming; it is said that he was holding at the time a large number of papers that he would not let go of, even though he was in the water and exposed to the enemy's arrows: he held his papers over the sea with one hand and swam with the other. . . . (Plutarch, *The Life of Caesar*, 49, 7–8).

But it is not only in Rome that dictators demonstrated that they knew how to swim.

FIGURE 2.3 MARBLE BUST OF JULIUS CAESAR OF CHIAROMONTE. FIRST CENTURY B.C.E., ROME, VATICAN MUSEUM, CHIAROMENTE GALLERY. The magnificent conqueror of Gaul, ruler of peoples, was nonetheless, according to Suetonius, "too meticulous in his personal grooming [. . .]. He went so far as to have himself epilated [. . .] and couldn't get over being bald." And some, such as C. Memmius, even reproached him for having been the cupbearer and mignon of King Nicomedes.

Source: © Leemage

. . . NAKED IN THE POOL

It was noted above that the Romans exercised on the Field of Mars wearing a loin-cloth (*campestre*). The refusal of Greek athletic nudity is a constant in the Roman mind, as was often emphasized by Latin authors. Even professional athletes participating in the *ludi* are dressed in a loincloth (this can be clearly seen, for example, on lamp medallions), and it was not until the diffusion of the Greek games in the West, in the style of the Olympic Games, that this nudity would be (perhaps) accepted in Rome, beginning in the third century C.E. But at the thermal baths, by contrast, complete male nudity was *de rigueur*: otherwise it would be difficult to understand the multiple allusions to the delightful obscenity of one man or another's penis encountered by Martial and Juvenal at the baths. Petronius's *Satyricon* certainly confirms this point and does not fail to inform us about how its heroes are endowed by nature. We shall see below the amazing sketch that Martial draws of a *cinaedus*, his eyes bulging before the sight of all those male sex organs (1:96). In two verses the epigram (9:33) summarizes it all: "When you hear applause in a bath, Flaccus, you may be sure that Maro's cock is there." The same theme is found in Juvenal, even if the place is not specified. (However, it would be hard to imagine the scene anywhere but at the baths):

> Yet if the stars abandon you,
> The immeasurable length of your mighty cock won't
> Help, even though Virro with drooling lips sees you
> In the nude, and his host of flattering notes assails you
> Endlessly. . . . (*Satires*, 9:33–36.)[33]

When, unusually, a man appears at the baths with a bathing suit, it is because he has something to hide:

> Your slave stands with a black strap round his loins whenever you submerge your
> whole self in the warm water. But my slave, Lecania, to say nothing of me, is hung,
> uncovered, with a mass of organs worthy of a Jew, and young men and old men
> bathe with you naked. Is your slave's cock [*mentula*] the only genuine article?[34]

No doubt Lecania wishes to reserve for herself the view and use of her slave's sex organs: she has perhaps good reason in view of the crowd that frequents these places. On such a subject as this, Juvenal would not be likely to lag behind:

His voice hasn't broken, he doesn't display his [fist-sized] balls
At the baths, he hasn't yet offered his armpits for plucking.
Nor does he nervously hide his swollen cock with an oil-flask.[35]

If we are to follow Plutarch, this practice of nudity at the baths was of Greek origin, and he even adds this detail, confirmed by the previous citations: "Meanwhile, however, when the Romans learned from the Greeks how to appear naked, they in turn corrupted the Greeks by giving them the example of bathing even with the women" (*The Life of Cato the Elder*, 20:7–8). But such promiscuity had its limits when it was a question of citizens from the same family: "Following our practice, assuredly, adult sons do not bathe with their fathers, nor do sons-in-law with their fathers-in-law. It is thus necessary to maintain this sort of modesty, especially when nature herself teaches it and points us toward it" (Cicero, *On Duties*, 1:129). And this kind of preoccupation will continue to be seen up to Saint Augustine: "One day at the public baths [my father] saw the signs of active virility coming to life in me . . ." (*Confessions*, 2:3, 6).[36]

THE VIRILITY OF HAIR

Wearing a beard was considered a sign of virility in Rome for a long time,[37] before being simply a fashion statement. Men started shaving around 300 B.C.E.; the beard was forsaken at the end of the Republic (Cicero and Caesar are depicted clean-shaven), and it came back into vogue with Hadrian at the beginning of the second century. Even today, it is clear, with the example of the rugby player Sébastien Chabal, how a thick head of hair can be a symbol of virility. But in Rome, it is true, first and foremost, that the shaving of the beard was the sign of the adolescent's having finally arrived at the stage of manhood, reinforced by the forsaking of the pendant and the *toga praetexta*. Shaving this first complete beard, between the ages of 17 and 20, was also considered a religious act, since the shavings were preserved in a box and dedicated to the household gods. Trimalchio is more than a little bit proud to show this first beard to his guests. This beard and the whole system of normally grown hair correspond to the moment when the adolescent definitively plunges into the world of virility, and that is when the *puer* must no longer give in to the desires of a mature man. It is, moreover, the pretext that certain young men seem to come up with, as seen above, when they no longer want to cede to the advances of the older lover.[38] In any case, it is the utmost in ridiculousness for an invert (a *cinaedus*) to wish to sell a hairy ass (*natis pilosas*, Catullus, 33:7–8).

MIRROR, MIRROR ON THE WALL

In the ancient period, all Romans were austere, long-haired, and bearded; at least that is what they wanted to believe in later centuries, which established this rite of origins as a myth: for Juvenal (5:32), the ancient consuls had long hair. If, as time goes by, Roman hair loses length and moral significance, and if the adult male distinguishes himself from the curly-haired *puer* by his short hair, it is nevertheless the case that too much hair removal appears to be a patent sign of nonvirility and implies an excessive concern for one's own body. After all, today there is still the debate in society as to whether men who spend a great deal of time in beauty salons can, in the eyes of the public, keep their virility intact. In any case, having one's legs shaved and smooth (*leves*)—the skin, in short, of a *puer*—is a trait of passive men and a criterion or marker of femininity. *Mollis* and *levis*, "soft" and "smooth": this pair of adjectives describes indubitably effeminate men. Gallus—a name that in passing also evokes the priests of Cybele with their dwindling virility—has a body "smoother than Cytherea's shells" (Martial, 2:47, 2). And in the heaping of insults that a personage receives who has the audacity to criticize the works of our poet (6:64, 4–5), not only are his mores focused upon ("your bride could call you *her* bride") but also his origins, and he would appear born to it, if we are to believe Martial: you are "the son of a father who has his hair cut at a mirror and of a mother who wears a toga." The die is cast: the mother is a courtesan, or at least an adulterous woman, and the father an effeminate man like his son: the allusion to the mirror (*speculum*) is fatal, since it is a reference to an instrument typical of female toilette, as can already be clearly seen in Etruscan art.

Since the years of the Republic, a man in Rome who looks at himself in the mirror lacks all virility, but the most outstanding and beautiful case is that of the Emperor Othon, as depicted by Juvenal (*Satires*, 2:99–107):

> One holds a mirror, the pederast Othon's constant companion,
> 'The spoils of Auruncian Actor' (Virgil), in which he used
> To admire himself armed, as he issued the order for battle.
> It's worth noting in modern annals, and current histories:
> A mirror was essential equipment to raise civil war.
> It's the mark of a supreme general, of course, to kill Galba
> While powdering your nose, the maximum self-possession
> Shown on Bebriacum's field, to aspire to the Palatine throne
> While your fingers plaster your face with a mask of dough. . . .

This latter habit was to have had the effect, according to Suetonius, of preventing the beard from growing: therefore the dream of having smooth skin persisted among certain *cinaedi*. In Juvenal, this criticism applies to the Greeks as a whole, this soft, effeminate population of artists (the cowardice of the men of Rhodes and Corinth—the perfumed): "what could a whole effeminate race/Of youths, from there, with their depilated legs, do to you?"[39] Ah, it is not like "hairy-chested Spain," which had remained primitive and authentic (Juvenal, 8:117)!

THE HAIRY MEN [*POILUS*] OF THE FIRST WARS

As for the shaving of the genitals, it should not fool anyone, even when we pretend to be hypocrites: "You pluck your chest and your shins and your arms, and your shaven cock is ringed with short hairs. This, Labienus, you do for your mistress' sake, as everybody knows. For whose sake, Labienus, do you depilate your ass?" (Martial, 2:62). The punch-line of the epigram demonstrates clearly that this self-proclaimed lover of the fair sex aspires also (or aspires only) to get sodomized. Another epigram from the same poet (9:27), which includes funny, suggestive images, sums things up well:

> You have depilated testicles, Chrestus, and a cock like a vulture's neck and a head smoother than prostituted asses, there is not a hair alive on your shins and cruel tweezers purge your white jowls. But your talk is of Curius, Camillus, Quinctius, Numa, Ancus, and all the other hairy men [*pilosi*] we read about [. . .]. Meanwhile, if some young athlete comes your way, now freed from tutelage, whose swollen penis has been unpinned by the smith, you summon him with a nod and lead him off; and I am ashamed to say, Chrestus, what you do with your Catonian tongue. (Martial, 9:27, modified)

The *pilosi* cited are those heroes, those *viri*, of the royal era and the beginning of the Republic: they are in a way the *poilus* [World War I French infantrymen] of the first wars whose virility led Rome to gradually become the mistress of the world (for example, Camille, called *fatalis dux*, or "leader chosen by fate," is the conqueror of the great Etruscan city of Véies, then conqueror of the Gauls who had taken Rome). The buckle mentioned above ("unpinned by the smith") was a sort of ring placed on the prepuce and which had the function of a chastity belt. There again the conclusion is clear: a "man" thus shaven plays the woman when it comes to sex.

Stern and hairy-chested in the beginning of Rome, such as the Cavemen in a comic strip—this was the way Roman tradition, the *mos maiorum*, wished to see the first inhabitants of the *Urbs*: no doubt a fantastic image that no longer corresponds to the one presented to us of the Roman man in more civilized centuries—yet our literary sources, although dating from the decades around the change to the civic-minded era, keep referring back to more ancient periods. In any case, during the time of Catullus and Martial, Cicero and Caesar, Titus and Domitian, Roman virility becomes quite used to a minimum of cleanliness—and even demands it: one must have, for example, clean fingernails, white teeth, beard and hair properly cared for. Better yet, if we are to believe Ovid, who was never parsimonious giving advice in matters of seduction, it is necessary—he reminds us in the same passage in which he evokes sun-tanning—to shave one's underarms and nostrils. There is nothing worse than a man who stinks and who therefore scares young women off: virility that has no way of being expressed disappears all by itself. Catullus remarks to Rufus (69): "Don't wonder why no woman, Rufus, wants to place her tender thigh beneath you [. . .], you bear housed in the valley of your armpits a grim goat." Regarding a man he does not like, our poet hopes that "an atrocious goat-stench from armpits will hinder him as often as he takes his pleasure" (71). Even the stoic Seneca shares this point of view on shaving the underarms: some go too far in shaving their legs, others don't go far enough by forgetting to shave under their arms.

It is a happy medium that a real man must observe: in a word, be neither woman nor beast: no excessively elaborate care for one's toilette, whether for the body or for one's clothing, but no exaggerated country manners either. He who always smells good, like Postumus, does not smell good, including when his kisses smell like myrrh (Martial, 2:12): he exudes a pestilential odor by nature. Ridiculous are those who dye their hair to make people forget their age, since their white beard betrays them (4:36)—from which we might note that Martial would have a field day today with our politicians and others, were there still satirical poets and were they still free to mock people's mores and physical flaws.

TARTUFFES STRIPPED BARE

Martial is adept also at smoking out the falsely pious, the "tartuffes." We had the case previously of Chrestus, who certainly appears and behaves like a *cinaedus* but who always talks like a vigorous male to keep up appearances. We shall cite again this epigram, in the briefer, more direct translation by Dominique Noguez:

With your shaved balls
Your penis shaped like a vulture's neck
Your skull smoother than a hustler's ass
Your legs without a hair about
Your cheeks perfectly hairless
You affect the diatribes and the look
Of preacher-men, of austere heroes
Among the hairiest soldiers
That show-biz and daily life have only to hold dear!
But if, in the midst of these couplets,
Some hot young guy appears,
Recently freed from his mentor
And his chastity belt,
Just see how you're on the make
And I dare not say what you'll do to him
With your ascetic father's tongue. (9:27)[40]

Others try in vain to trick people by parading an exterior that is hairy and there-fore, in theory, virile:

> Do you think you avoid gossip, Charidemus, because your shins are stiff with bris-tles and your chest with hair? Be advised by me, extirpate the hairs from your whole body and swear you depilate your buttocks. "What for?" you say. You know that many folks say many things. Make them think you are sodomized. (Martial, 6:56, modified)

The implication being that his reputation was even more tarnished.

And here is another portrait, made on the spot and fairly striking, of a Tartuffe who would gladly have worn a hair shirt and shown the right discipline if such had been done in his day (1:96). By his clothing, he affects the behavior of a male, but his nudity at the baths seals his fate:

> That lover of sad-colored cloaks, who goes about in Baetic wool or grey, thinks people who wear scarlet or violet are not real men [*non viros esse*], though he praises native stuff and is always somberly attired [*fiscos colores*], his morals are chartreuse (effeminate). He will ask how I come to suspect the man is effeminate [*virum mollem*]. We bathe together. He never looks up, but watches the athletes

with devouring eyes and his lips work as he gazes at their cocks. (Martial, I:96, modified)

This *mollis* personage (the adjective says it all) is therefore a *fellator*: this passage has the merit of showing us that effeminate Romans were inclined toward pale green (*galbinos*), and real men wore natural colors, basically rather somber. This impression is confirmed by epigram 3, 82, in which we encounter another *fellator galbinatus* (dressed in pale green). Themes and details are rigorously identical in Juvenal's Satire 2:

> Put no trust in appearances; after all isn't every street packed
> With sad-looking perverts? How can you castigate sin, when you
> Yourself are the most notorious of all the Socratic sodomite holes?
> Though hairy members and those stiff bristles all over your arms
> Promise a rough approach, your arse turns out to be smooth enough
> When the smiling doctor lances away at your swollen piles. (8-13)[41]

Very charitably, Martial goes so far as to offer advice to women who are looking for a real husband, and apparently it is not a simple matter (it sounds like an opinion poll in one of today's magazines about the end of the virile man). Galla (the feminine of *gallus*), he tells us, has been able to marry until now only "*cinaedi*" and inverts—therefore sodomites, who have scarcely brought her any satisfaction sexually despite all her efforts to awaken their ardor manually. And the poet lavishes on her the following advice:

> Look for someone who is always talking about Curii and Fabii, some husky boor, hairy and gruff; you will find him. But even the sour-faced has its queens [*cinaedos*]. It's hard, Galla, to marry a real man [*difficile est vero numbere, Galla, viro*]. (Martial, 7:58, modified)

Between, on the one hand, a mythic, fantastic austerity about origins, a virility characterized by a severe air, frowning, with thick, tousled hair and dark clothing—all the things that are quite often affected by anyone wishing to dissimulate their actual effeminate desires—and, on the other hand, the walk and clothing of a Little Lord Fauntleroy, perfumed, with curled hair and frills and a pale green outfit, the virile man can easily adopt a median, more natural attitude (without raising any questions about so-called "unnatural" behaviors). Let us give the floor once again to Martial for an epigram not lacking in seriousness and power:

I would not want you to curl your hair, but neither would I want you to muss it up. I don't want your skin to glisten, nor yet to be dirty. Don't wear the beard of the turbaned crew [in fact, these are the original *galles* from Phrygia who are beardless eunuchs] or let your beard be rough like men on trial. I don't want too much of a man [*virum*], Pannychus, and I don't want too little [*nolo nimium . . . nolo parum*]. As it is, your shins bristle with hairs and your chest with shag, but, Pannychus, you have a depilated mind. (Martial, 2:36, modified)[42]

VIRILE BUT HANDSOME

One might conclude this developing account of virile appearance and behavior in ancient Rome by recalling that, contrary to what some might think, the inhabitants of the *Urbs* had a good sense of masculine beauty. There again we have a tendency to associate everything solely with Greece: we have been no doubt overly impressed by the aesthetically perfect image of Greek athletes, such as the Discobolus of Myron, or that of the red-colored figures of palestra ephebes painted on Attic vases, and conversely overly impressed by the disquieting visage and the monstrous muscles of Roman athletes who appear in the mosaics of the Caracalla Baths. But we need only go back to the epitaph of Scipio Barbatus,[43] who was consul and censor (the two highest offices in the Republic) at the beginning of the third century B.C.E.—and his surname will be appreciated in light of what we just noted about the importance of hair in definitions of virility. In this beautiful archaic inscription, the Latin gives its full weight in fact to beauty (*forma*), which was considered equal to the *virtus* of the personage. This beauty is linked to *dignitas* and gravitas, and Cicero provides us with interesting details on this subject: " . . . the dignity of one's physical appearance should be backed up by the quality of one's complexion [*coloris bonitas*] and this complexion [*color*] by physical exercise." (*On Duties*, 1:36, 130—a passage in which one finds athletic training essential for *viri Romani*.)

This virile beauty of course has nothing to do with feminine beauty, which is of the order of grace—and Cicero, in the same passage, draws attention to the fact that one quickly runs the risk of slipping into "unpleasant" physical exercises and gestures, which were for him, undoubtedly, effeminate. When Catullus, speaking about Aemilius, whose mouth is less graceful than "the split twat of a she-mule pissing in the summer heat," says that he "makes himself out to be charming [*se facit esse venustum*]," one gets the idea that the choice of this adjective, linked to Venus,

is not only ironic but also humiliating for a man (97:8–9). The "beautiful male," the handsome man, is not in Latin a *bellus vir* either, for this adjective, from which the French "*beau/bel*" derives, refers in Rome to *pueri* and to "catamites" (Catullus, 106) and could modify *homo* but not *vir*. And Martial, playing in 2:7 on the adverb *belle*, "in a lovely manner," concludes that anyone who does everything in a lovely manner does nothing good. But it is in his epigram 3:63 that he best settles accounts with the *bellus homo*, who has nothing to do with virile beauty:

> Cotilus, you're a pretty fellow [*bellus homo es*] [. . .]. A pretty fellow curls his hair and arranges it carefully and always smells of balsam or cinnamon [. . .]; he moves his plucked arms in time with tuneful measures and lounges all days among ladies' chairs[. . .]. (Martial, 3:63, modified)

The point is well taken: a *bellus homo*, primped, perfumed, shaven, and chattering with the women is not the model of virility or, despite the adjective and the etymology, of virile beauty.

3

BARBARIAN AND KNIGHT

· · · · · ·

THE BARBARIAN WORLD: HYBRIDITY AND THE TRANSFORMATION OF VIRILITY

BRUNO DUMÉZIL

IN ARRAS, in a small sanctuary frequented in the fourth century C.E. by barbarian mercenaries, an ithyphallic statue of the Germanic god Frô was recently brought to light [fig. 3.1]. Clumsy in its craftsmanship but endowed with a strongly evocative power, this representation reflects a certain image of masculinity. The Romans were certainly well aware of the cults rendered in virile symbols. However, when the northern frontier of the Empire was threatened with ruin and the army was no longer able to seal off all the breaches, the power of the Germans and of their large-limbed gods provided sufficient persuasion. The Christians affirmed in vain that the Messiah, new protector of Rome, was fully a man; he scarcely succeeded in embodying the full range of masculine values. The Barbarians, the neighbors and eternal rivals of the Empire, in many ways projected a more convincing male image.

We must recall that we know practically nothing about the ancient Germanic mentality. The sources provide hardly any information about their view of the Romans, and by the time the Barbarians finally began to describe their own image of virility, Latin literature had already influenced their conceptions. However, the High Middle Ages are not lacking

FIGURE 3.1 ITHYPHALLIC STATUE. FOURTH CENTURY, ARRAS, MUSÉE DES BEAUX ARTS.

This statue, found in Arras, apparently depicts Frô (or Freyr), fertility god of the Nordic pantheon. It was venerated in a small urban sanctuary frequented by Germanic units integrated into the Roman army. In medieval depictions, Frô is no longer holding his penis but rather a long pointed beard.

Source: © Leemage

in originality, and at the border between Roman civilization, Germanic culture, and Christianity, the period gradually elaborated a new image of the ideal man.

ROMAN VIEWS OF THE BARBARIAN MALE

For Roman thinkers, much more so than for their Greek counterparts, Mediterranean culture constitutes less of a blessing than a threat. In fact, if philosophy allows man to conceptualize his virile values, the civilization of leisure diverts him from the activities that should allow him to cultivate his heroic temperament. The Barbarian, unfamiliar with the charms of writing and luxury, appears in a better position to embody the ideal of masculine perfection.

WARRIOR, THEREFORE VIRILE

Knowing nothing about the *pax romana* except how to place it in peril, the Barbarian had no kind of security. Having continually to take up arms to defend his liberty and to protect his family, he developed those warrior values—to their utmost limits—that the Romans of the first centuries c.e. feared they had forgotten.

First of all, the Barbarian is trained at a very young age to handle the spear and the shield. Consequently, he acquires very quickly the military virtues of courage

and discipline. Evoking the Franks of the fifth century, Senator Sidonius Apollinaris writes that "from boyhood's early year, the virile love of warfare is full-grown."[1] The Barbarian transcends linear aging by becoming a man before puberty. However, it is only at adolescence that he attains perfection. In 469, in the streets of Lyon, the wedding cortege of a young Frankish prince, Sigismer, stirs the emotions of the Roman populace. All the finery that the bridegroom wears actually constitutes at once precious objects and formidable weapons: here is a man who has a passion for wealth only because it might make him more effective at combat. Sigismer illustrates the most virile of philosophies of existence.

Even in adulthood the Barbarian continues to fight with determination. According to Tacitus, the German brings his wife and his children close to the battlefield so that their presence and their cries might exhort him to win victory. The same author declares that the dowry brought by Barbarian brides was composed of weapons and shields. This all seems remarkable to him: virile values imbue both sexes. Moreover, even when rich, the Barbarian disdains luxury and never renounces his original values. The Visigoth king Theodoric II (453–466 C.E.) was held in admiration by his Roman subjects because he refused to have a servant prepare his bow before leaving for the hunt: not to string the bow himself seemed to him an "effeminate" gesture.

Observers' fascination applies even to elderly Barbarians. In 451 the old King Theodoric I, probably in his seventies, charged like a young man into the Battle of the Catalaunian Plains. A fine death crowns his fine existence. Why does the Barbarian remain virile longer than others? Undoubtedly because the society in which he lives categorizes individuals solely in terms of their warfare abilities. When he is no longer able to fight, the German finds himself forced to join the women working in the fields, according to Tacitus's account. On that day, practically speaking, he ceases to be a man. Many prefer to turn gray in battle gear rather than to suffer this opprobrium.

HAIRY, THEREFORE VIRILE

While the Romans envy their neighbors' virility, they do not conceive it to be as civilized as their own. The valor of the Germans constitutes a product of nature much more than a product of culture, and the Barbarian remains at the level of a kind of animality. Consequently, he can only be furry. In the bas-reliefs on the Trajan Column, bearded heads accompany thick-haired foreheads. Barbarian virility is hairy.

It is known that Rome had a critical attitude with regard to hair: for a long time its emperors and its legionnaires distinguished themselves from their adversaries by their smooth cheeks. Roman virtue is clean-shaven. Hair that is slightly frizzy or a carefully neglected beard is all it takes to suggest the Greek, or the philosopher, which is almost the same thing and which leads immediately to a suspicion of softness. Happily for him, the Barbarian's hair is completely different: it is a mane that has never seen a comb, any more than the forests of Germania have seen the axe. Bushy, disheveled, untamable, the hair of the savage elicits either fear or respect, but never a hint of immortality.

Tacitus has thus a certain tenderness for the coiffure of the Suebis, who "ruffled and combed their hair backward, and often they fastened it on the crown of the head [. . .]. Concern for a certain type of adornment, yes, but irreproachable, for it is not intended for love or to be loved but is to seem taller and more terrible in war; they adorn themselves like this for the eyes of their enemies."[2] Hair is beautiful when it is male; it is legitimate when it highlights the courage of the man whose head it is on.

Obviously, when a real Barbarian meets a Roman, he is at times surprised by the Roman's lack of any exotic hairiness. It is all a question of point of view. In the fifth century, Sidonius Apollinaris thus notes that the king of the Visigoths has his beard carefully shaven but that if the beard grew, it would be remarkably thick! Besides, this Barbarian still had long locks over his ears. Even more remarkable, his soldiers and his counselors are dressed in animal skins. All this hair, which a veneer of civilization is not sufficient to hide, seems repugnant and admirable to Sidonius, the old Roman.

A century later, the Byzantines still experience an aesthetic pleasure before the Franks, whose sovereigns grow a long mane that earns them the name of "thick-haired kings." For the chronicler Agathias, this abundant growth is the sign of Barbarian vigor still in force, whereas the various shampoos that the Merovingians use prove that the latter are henceforth open to culture.

CHASTE, THEREFORE VIRILE

The Barbarian is also more virile than others because he is more chaste. For the ancient Romans polygamy, adultery, or tempestuous love affairs always have an Oriental scent. Giving in too often to the charms of women is in itself slightly effeminate.

There is no such behavior on the part of the Barbarians, Tacitus affirms. On the contrary, the Germans have "late-blooming desires" and put off the age of marriage. Individuals take only one wife, and if the leaders enter into several unions, they do so for political reasons, not for physical ones. Moreover, the western Barbarians have the reputation of not practicing adultery and not tolerating it in others. Through merciless punishments, they impose on their wives virile values of temperance.

In the fifth century the priest Salvian of Marseilles proclaims a similar admiration for the Barbarians' chastity. Thus, in his view, the Visigoths' great sense of decency would explain their victory over the imperial troops. Conversely, the sexual intemperance of the Romans supposedly incurred the wrath of God and, more simply, it softened them at the moment when the enemy went on the offensive. But Salvian's greatest praise is reserved for the Vandals. The latter, after having conquered Carthage in 439, ordered the closing of the brothels, particularly those in which male prostitution was carried on. "They wanted wives to be wives only for their husbands and for husbands to be husbands only for their wives," said the priest of Marseilles approvingly. Screwing without getting screwed no longer defines the virile ideal; the real man is henceforth the one who knows how to curb his libido.

The sexual continence of the Barbarian, real or supposed, thus resonates with an evolution of profane values, perceptible since the third century and in tandem with the Christianization of society. Beginning at that time, role models are changing. Thus, in the 560s the Frankish king Sigebert I constitutes, in the eyes of the last Roman poets, the finest image of masculinity: besides his extraordinary military talents (and his equally remarkable hairiness), Sigebert maintained perfect chastity until marriage. In him are combined all the admired qualities of the new males.

LAZY, THEREFORE VIRILE

So busy is he in going to war, letting his hair grow, and watching out for his women that the Barbarian has no time to engage in futile activities. Consequently, he is, in the eyes of the Romans, the symbol of a certain glorious idleness, of that "heroic laziness" evoked with irony by Marxist historians.

First, the Barbarian does no manual labor. In Germania it is believed that, crafts and agriculture are the business of women, slaves, or old people. The real man would not lower himself to such trivial and base activities. This does not mean that he is outside the economic arena, but his wealth comes to him from the work of others or, more simply, from the spoils he wins at the expense of his blood.

In the eyes of foreigners, moreover, the Barbarian lives an unaffected life. His house is composed of a rough-hewn construction in wood, and his outfit of skin and linen shows no sign of any effort at stylization. Even his food remains very simple: wild fruit, fresh venison, or curdled milk is ordinarily enough for him. The Germania we imagine somewhat resembles Arcadia, plus virility. A good Roman like Tacitus wonders, however, if we should see in this a sign of healthy frugality or a total ignorance of the benefits of technology. Perhaps, quite simply, the Barbarian gets pleasure only in combat.

The inhabitants beyond the *limes*, moreover, resemble in certain respects large, slightly naïve children. According to the Romans, they are especially fascinated by gambling. Certain Germans would not hesitate to forfeit their personal liberty in order to continue betting in a game of dice. In their court in Toulouse the Visigoth kings also spend long hours gambling; therefore Gallo-Roman courtiers learn to lose at the opportune moment in order to advance their affairs.

Virtuous when in his natural environment, the Barbarian does not really know how to resist the pleasures of civilization when he comes into contact with them. In this way the Mediterranean peoples become familiar with their northern neighbors' taste for drink. The Romans attest to the fact that the German can be corrupted with wine; indeed, inebriating him brings him more easily to his knees. One could guess the critique: the virtue of the Barbarians is the result simply of their milieu, not of a veritable philosophy. It would take only a few generations of peace to soften them. But perhaps this is just the mirror that Roman ethnographers hold up to their own fellow-citizens, whom they judge far more advanced in the decline of ancestral values.

In sum, for Latin literature, the virility of the Barbarians seems as beautiful as it is contemptible: warlike by obligation and virtuous by necessity, it constitutes at best a point of reference. Just as the eighteenth-century philosophers discuss the kindness of the savage the better to criticize those who are civilized, the Empire gauges the enemy warrior with the aim of evaluating the benefits of its own culture. The view remains external and dehumanizing. A force of nature more than a being of flesh, the Barbarian male wavers between beast and angel.

· · · · · ·

THE MEDIEVAL: STRENGTH AND BLOOD

CLAUDE THOMASSET

VIRILITY IN the Middle Ages, this force coming from somewhere else, this way of behaving, this appearance that exceeds masculinity and that adds something to each of the acts of certain men, can only be rooted in mythologies, can only refer to a model consciously or unconsciously imitated and revered. If we take a look at the history of science, the system by which the human being's gender is determined remains very complex until the metaphor of blood comes to justify, in the simplest way, the transmission of the qualities of descent. From a more cultural perspective, being virile in the Middle Ages is possessing what is recognized as a set of qualities by one's companions, one's peers—a set in which the voices of youth, of adolescents, are dominant.

STRENGTH: A GENERIC MODEL

GUILLAUME AND STRENGTH IN COMBAT

Strength is dominant in the set of these qualities, and were one to choose an emblematic figure of strength in medieval literature, it would ineluctably be the hero of several *chansons de geste* bearing his name: Guillaume d'Orange. He is one of the most ancient heroes of French literature, since, as early as the first half of the eleventh century, perhaps even at the end of the tenth century, this personage had become memorable. He becomes the hero of an epic poem entitled the *Chanson de Guillaume*, composed around 1140. The *chansons de geste* that recount his adventures cover the entirety of his life: from *Infancy of Guillaume, Coronation of Louis, Chariots of Nimes, Capture of Orange* up to an edifying retreat in the *Monkhood of Guillaume*. He is called at first Guillaume "of the Short Nose:" the epic justification of this physical peculiarity originates from the blow of a Sarasin's sword, healed in an unattractive manner. It is a slightly bestial face that will soon be known to his friends as well as his adversaries. While throughout the literature—*chansons de geste* or romances—the muscular strength of the hero is

a given accepted by all, Guillaume imposes his corpulence and his muscles with a certain insistence and not without a hint of vulgarity. Nicknamed "Guillaume Fierabrace"—the man whose vigorous embrace can be deadly—he eliminated a number of his adversaries with the sword. Among other victories, he beat a traitor to the crown with a punch in the neck, a primitive, expedient method that seems out of keeping with the chivalric ritual of eliminating the villain. The cycle of *chansons de geste* about Guillaume bears witness to the emergence of a personage stronger and rougher than the hero. This is Rainouart au Tinel. The *tinel* is an enormous club made from the finest fir trees of France. This hero with the pure heart of a child, galley cook, and outstanding fighter will be made a knight. But even after having been dubbed, and even though he knows how to handle the sword, he remains loyal to his *tinel*.[3] Behind the parodic aspect of this personage is no doubt hidden the idea that strength is the foundational quality of chivalry and that any man who possesses it to the highest degree may be part of the elite. It is through strength that a constant regeneration of the caste of warriors is produced.

But let us return to Guillaume and stop at the moment when he will confront Gui D'Alemaigne, who wants to make off with the Pope's possessions. This is the response of the hero to the challenge of the usurper, a physical device first: "Guillaume climbs up on the small step. . . ."[4]

All the eyes of Christendom are turned toward its champion. Courage, strength, and virility need stagecraft. Ostentatiousness is one of the first tasks of virile affirmation. It is the demonstration of a power reassuring to the collective. The man has a horse at his disposal, which guarantees him speed. The incline of the terrain and the momentum and the mass of the horse and knight bring together the greatest energy that it is possible to summon up in one feat in the Middle Ages. This energy is concentrated in the end of the lance, which prolongs the constricted muscles of the arm and probably the knight's whole body onto a minute surface. After the shock, the adversaries, back up on their feet, thrust their swords; thereupon commences a fencing match not of finesse but of force. Every thrust is delivered with maximum power: one must break apart the adversary's shield, damage and undo the mesh of his coat of mail, knock his helmet off his head, then cut into or pierce him. The combat is a profusion of energy.

Though codified and less dangerous, the tournament is just as violent. The techniques are the same. The exhibition of warrior valor and of strength needs the regard of spectators. Everyone stands on their doorsteps watching the cortege that conducts the participants to the tournament, and the knights read the admiration

felt for them in the eyes of the female spectators, who keep on watching them for a long time:

> From the bottom of their hearts and with eyes uplifted, they follow it
> As far as the length of the street allows.[5]

The cortege that arrives on the battle site shows strength, beauty, and valor. Upon returning, the knight who has distinguished himself in the jousting, the one who has carried off the *los* (praise) and the *pris*, receives, of course, glory and fame from the collective but also attracts the envious regard—including, no doubt, a desire for revenge—of his peers. This is the way a knight becomes established. He must be spoken about. He may speak about others.

THE COMMONER

A look into medieval society cannot be limited solely to the cavaliers. The iconography shows us the commoner, the peasant, going through the motions of his work throughout the whole year.[6] He is the man who holds the handlebars of the plow or the cultivator, thus attacking the body of mother earth, as has been repeated over and over. He is the one who takes care of the harrowing, in the process of which Chrétien de Troyes catches sight of Perceval, the hero of *The Story of the Grail*, in the first verses of his romance. It is the hand of this man that handles all the harnesses, that organizes the carts. It is the hand of this man that holds the hoe, the scythe, the sickle, the hatchet, the flail, the sledgehammer, the rod, or the piece of wood thrown to knock down the acorns from the oak to feed the pigs. All these movements bring into play the power of the body. The tools are often simply the prolongation or the extension of the strength of the arm. During the revolts, these same tools become weapons capable of responding to the violence of the knights' power.

These are so many jobs foreign to women—even if we note a few representations in which they are swinging the sickle, always with rake or pitchfork—because their vocation lies elsewhere, as Robert Fossier says:

> Women are first of all in their private space where they exercise an activity and exert energy, even physical effort, that is equal to or greater than that of the men outside: the fire and the hearth, the oven and the mill, the water from the well along with

helping with the harvests: everything reputed to be women's work: spinning and sewing, braiding and weaving, after they have sheared and combed the sheep.[7]

MEN AND WOMEN

In the countryside, when women are led to carrying out a man's job—and this we were able to observe during the last war—the opinion that arose was that the earth was not cultivated to the right depth, the harvests were not done to completion on the land and in the trees, the pruning was not ensured, and everything was deteriorating in running the farm. Not all jobs were allowed for women, to which should be added the interdictions associated with menstrual periods, which directly separated them from certain activities. Male superiority is also manifested in the missions, the travel, and the prestige that men receive on the part of the women who stay at home. Even through the twentieth century, women stood to serve meals to the men and manservants after the fieldwork. We will merely allude to the abuses of virile strength: the files on women physically abused and living constantly under the threat of violence are well known.[8] The *fabliaux* are not silent on the fights among the couples.

The contrast between the gestures of the man and those of the woman is obvious. The man's gesture is ample, mobilizes all his muscular strength, and is carried out to its completion. It liberates energy from the body. By contrast, the action carried out by the woman is short, repetitive, and follows a rhythm of coming-and-going: raking, cleaning by scraping, working at the loom. Working the sickle, which seems an exception, actually is not, for one cuts a handful of the crop that has been previously grabbed and held steady with the left hand. This implement has nothing in common with the scythe that is thrust, or the sledgehammer, or the axe that is used for felling on the fly. Similarly, in the iconography, the august motion—ample and harmonious—is made by the male sower, not the female. Thus established by dint of the ostentatiousness and effectiveness of his strength, man appears to have no rival.

4

ABSOLUTE VIRILITY IN THE EARLY MODERN WORLD

MODERN VIRILITY: CONVICTIONS AND QUESTIONINGS

GEORGES VIGARELLO

IN ONE of the innumerable court treatises of the early modern period, Eustache de Refuge, counselor to the Parliament in Paris, proposed in 1616 to describe "virility and local mores:"[1] a model of the perfectly realized man, that is, the model that would best ensure the major "qualities" expected of the male gender. The result is detailed. The author compares, specifies, and lambasts "fear" and "mistrust," pauses on "determined" attitudes and "complexions," and evokes the humors and the "appetites." He makes comments as well—by no means traditional, however. Nothing here resembles the "ancient" views of a virility blending sudden force and unquestioned domination. Strength itself is not foregrounded any more than energy; what dominates is wisdom, restraint, prudence, and "circumspection." It is certainly "the man worthy of the name,"[2] however, who lies at the center of the text, even if the reference to the age comes first: the man of "virile age," always identical, in early modernity, to the image expected of the "perfect" man.

The break is remarkable. The inflection is clear: diligence becomes *délicatesse,* ardor becomes cautiousness. These are traits systematically taken up again in a number of texts of modernity, with very precise attention paid to gentleness, politeness, and urbanity. The "*honnête homme,*" newly defined by the first court texts, was to be a man of "control" before being a man of

turmoil or profusion. He was to be a man of finesse, of ingeniousness. All these are characteristics opposed to immediate power, even those which traditional virility was supposed to project. Virility was no longer a vigor affirmed from the outset but rather a prudence that was muted, even reflective.

A remarkable break . . . but a complex break also. Inevitably, opposition is manifested, especially doubts addressed to a possible feminization provoked by this *délicatesse* and these moderations. The virile would seem to lose what had always defined it: severity and firmness. An anxiety is felt and is spoken. The word "virile," in any case, remains strongly in demand, anchored in these texts or these behaviors extolling politeness and gentleness. "Unquestioned," even triumphant, virility would simply have to find, in modernity, renewed paths for affirmation.

THE INVENTION OF "*DÉLICATESSE*"

A light-hearted rejoinder, the day of an official ball, says it all. The rejoinder of that "beautiful lady" of the Spanish court in the seventeenth century to a gentleman who does not know the dance. The man claims that "his feet" know how to fight but do not know how to dance. The lady suggests that "it would be good to hang [them] up on the wall with the weapons while waiting till they are needed."[3] The complete man, in other words, cannot be limited to bravery. The captain cannot be satisfied with his courage. His body must bend in other ways, be seen in other ways. It must comply with "*la bonne grâce*,"[4] dexterity, and composure—these all being skills that the courtier must show from now on. An image also says it all. Think of André Alciat, the Milanese jurist, whose emblem at the beginning of the seventeenth century represents "Hercules, club in hand, with chains coming from his mouth and captivating listeners by the charm of his speech."[5] This speech "imprisons" the audience by its pertinence, persuades by its skillfulness. From this behavior there emerges the new vision of the hero: his victories are to be won "by his subtlety more than by strength."[6] A "power" unaware of "finesse" is no longer valid now that fine manners and refined taste are triumphant.

History has no longer to do with that wavering between emergent culture and modernity.[7] Words and gestures are no longer the same: there is a high value placed on precise terms, "smooth civility,"[8] *courtoisie*, decorum, distinction, and urbanity. There is an unprecedented semantic constellation governing manners and an equally unprecedented insistence on the promotion of refinement—which

transforms the totality of behavior, that of the elite first and foremost. The field marshal of Boucicaut, for example, boasts, in the fourteenth century, of his own military training and his regular use of strength:

> He made the jump, armed with all the equipment. He sallied forth on a fully equipped charger without putting his foot in the stirrup [...]. He climbed up to the very top of the reverse side of a large ladder propped up against a wall without touching it with his feet. Then, when he got home, he had a go with the other horsemen at hurling the lance, or other trials of war, without ever ceasing.[9]

By contrast, the field marshal of Bassompierre boasts, at the end of the sixteenth century, of a military training blended with the study of literature, music, and choreography. No surprise when, just having returned from Italy where he carried out his apprenticeship, the future friend of Henry IV is drawn into a ballet conceived in honor of the king, with "music, pages and violins."[10] Bodies and physical "positions" are transformed. The model of svelteness and thinness becomes central in social references of modernity, contrary to the earlier references in which a noticeable heaviness, at least for a man, could be appreciated. The word "light" is repeated like a leitmotif in Baldassare Castiglione's *Book of the Courtier* in 1528—"light and adroit,"[11] "strong, refined and light,"[12] or "strength and lightness acquired through art,"[13]—winning out as best indicator of the qualities expected of patient training cited in the treatises.

The context provoking such changes also hardly needs to be evoked. In the sixteenth century the accent on social hierarchies amplifies distances and distinctions: politeness becomes stricter; propriety becomes more common. François de Callière differentiates ostentatiously in the seventeenth century the respective words belonging to the nobleman, the commoner, or the bourgeois the better to regulate their "positions," as well as the "new ways of speaking."[14] The strengthening of the courts around the king and the diversification and differentiation of roles that they impose suggest for the courtiers sharpened manners and social graces. A model spreads. An obligation is articulated: "bring peace" to relations between people, regulate their exchanges, favor the "reasonable" over the "sensual." Giovanni della Casa's "polite" man, in the middle of the sixteenth century, reminds us of this, clearly underlining the break with the past:

> All the virtue and perfection of a gentleman, Monseigneur, consists not of spurring a horse well, handling a lance, sitting up straight in the saddle, using all kinds of

weapons, behaving modestly among ladies and moderating Love, for each is one of the exercises attributed to the gentleman; there is more: waiting on the Kings and Princes, the way of calibrating his language with respect to people and according to their stature and qualities, the glances, the gestures and even the slightest sign and wink of the eye that he is to make.[15]

The added complexity in social relations brings with it the complexity of gestures and their regulation: a tighter auto-surveillance is in sync with the now more numerous controls. The model comes from the court but is aimed more broadly at society. As much as the political centralization of modern states, the monopolizing of force and violence by royal power has a precise meaning: prohibition of individual vengeance, respect for collective justice, and the necessity imposed on everyone for control and restraint. There is no place for direct attack. Bravado, insult, or "code of honor" may no longer call for violent reaction. Haughty pride may no longer determine the law. The new treatises on civility insist on it: "The populace shed its right to take vengeance at the same time it became subject."[16] This statement could make ardor a crime. It could transform vengeance into "inhumanity."[17] It is the king's job to regulate and adjudicate public and private violence. It is the people's job to observe an obligatory moderation. It is a slow change, without any doubt: "From 1503 to 1603, seven thousand duelists who killed their adversary receive letters of dispensation."[18] Yet there is a noticeable change: accusations of heresy, of "divine and human lese-majesty," of blasphemy, of "sacrilegious theft," and of "child neglect" increase during the second half of the sixteenth century. Criminalization that is extravagant, disparate, profuse, and also always "imperfect" indubitably calls for a gradual change of mores.[19]

VIRILITY THREATENED?

This path toward softening is also, for certain people, a path toward anxiety, a path threatening strength and virility. Montaigne himself evokes it at the end of the sixteenth century. New-order modesty and restraint curb the "virile," creating obstacles and embarrassment: "What has become of men's genital activity—so natural, so necessary and so right—that we dare not talk about it without shame and exclude it from serious, decorous discussion?"[20] More brutally, if trivially, Béroalde de Verville, in his *Means to Making It*, characterizes this resistance at the beginning

of the seventeenth century, transforming the references of a new *courtoisie* into pretensions "full of wind and nothingness,"[21] stigmatizing "the foolishness of the great ones of our time," delighting in the image of the "fat," of the "pissers," of the "bawdy ones," and dwelling upon the immediate pleasures of the senses that the propriety of the treatises rules out. The new "bodily canon"[22] is seen as weakness, and *délicatesse* is seen as the denial of the virile.

It is again this loss of virility that a number of critics of the court take aim at: complaints from old barons about a world slipping away from them as they bitterly stigmatize the "curled" courtiers "serving as men and as women"[23] or the courtiers who soften themselves by becoming "fair-haired blonds."[24] Refinement in mores was simply seen as feminization—a casting of the old indisputable forces into oblivion. The narrative of the nobleman of Embry, Thomas Artus, in 1606, bears the best testimony to these persistent worries: a luxurious setting that identifies the court at the end of the sixteenth century with an island whose inhabitants would be none other than hermaphrodites.[25] A grouping of detailed, diverse physical traits in which the men would systematically invert their connection to the virile with "sweet fragrances" to perfume the surroundings, "quicksilver" to "lighten the complexion," "warmers" to "curl the hair," "rings" to decorate the hands, "decoupage" to refine the slippers, and finally "gilding" to transform swords into decorative objects rather than assault weapons. The quintessentially virile weapon, the sword, would become no more than an innocent object, a simple, flexible fine wire, a "strap" reduced to a "whip." The "softnesses" of *courtoisie* would definitely become a loss of virility.

It is necessary to highlight the modern sword, sole source of precise worries at the time of its diffusion during the sixteenth century. Its appearance arises from the invention of the firearm. The abandonment of armor pierced by bullets allowed for the attack of the sword's tip: "impale" now rather than "sabre," attack with the "point" (the thrust) rather than attack with the "edge" (the ancient knight's cutting edge). One must have recourse to skill. It is for many a loss of virility. The thrust of the sword is rethought, the culture displaced. Descriptions of combat indicate by themselves the decisive change between the fifteenth and sixteenth centuries. Here is one scene at the tournaments of Bayard, for example, where the sword is broken against armor after an oblique blow intended to be the more powerful: "The good knight broke his sword in two."[26] And here is a very different evocation of duels in the sixteenth century in which the sword, with one deft move, makes blood gush by "piercing through" the body: "The marquis of Maguelait killed his man with a direct fatal thrust of the sword that I could show better than I could

describe."[27] Dexterity henceforth trumps strength, calculation trumps furor. Speed and elegance may even claim to go along with the swiftness of the arm. The "old" swordsmen are invalidated. Thus we hear of their pique, their exasperation over this "pernicious, nasty method of fighting with the rapier, which is good only for the thrusting play."[28] There results a certain lost virility: "So a strong man, a really brave man, will find himself skewered like a cat or like an ordinary rabbit."[29] Strength, heretofore sanctified, seems to have been definitively thwarted. Montaigne himself takes up the theme, consciously separating courageous action from the science of weaponry, the bold blow from the skillful blow. No doubt Montaigne is modern in his implacable critique of the duel: "an offense against our police,"[30] dangerous, obstinate vengeance. He is closer to the tradition, on the other hand, when he pits "valor" against "fencing," or when he designates virility in face-to-face combat[31] as the most challenging of daring acts, the act of courage whose skill would most be compromised were deviousness and treachery to enter the picture.

These are so many soon to be outdated remarks, no doubt, with the imposition of the new science of weaponry as well as the new ways of behaving at court. Doubt about virility, as it turns out, is now the expression of the inevitable generational distance between different practices. In the same way, this doubt is the expression of the originality of modernity, as seen in the repeated references to composure and moderation. We must still explain this originality with greater specificity: the insistent affirmation of virility in behaviors that have been completely transformed.

VIRILITY AND AUTHORITY

An apparently anodyne retort from one of Baldassare Castiglione's personages suggests the more profound meaning of this change. Count Ludovico Canossa, the man in charge of the dialogue in *The Book of the Courtier*, responds to Bernardo da Bibbiena, the man evoking those physical attributes to be desired and asking for an opinion of his own face: "[. . .] we unquestionably perceive your aspect to be most agreeable and pleasing to everyone, albeit the lineaments of it are not very delicate. Still it is of a manly cast and at the same time full of grace [. . .]."[32] *Délicatesse*, in other words, should in no way compromise a certain virile harshness. Moderation is not to limit perseverance and will power. The revival of ancient narratives in the sixteenth century expresses even more clearly this attempt to point to a virility blending beauty and hardness. Take the example of Demetrius, among others,

repeated in *Diverse Lessons* by Antoine Du Verdier in 1592 who wrote about the son of Antigone whom no painter or sculptor "dared make a portrait of," so "beautiful" was "his appearance."[33] But Demetrius was to add to this beauty a precise difference that the moderns claim to be promoting as much as ever: "He had within himself an elegant beauty and terror mixed together with an indulgence and gravity such that he seemed born to be loved and venerated at the same time."[34] The "perfect" man was supposed to be domineering, "terrible and handsome," said Romei, "so that, in furious combat, he would be terrifying to his enemies."[35] "Grace," no doubt, like the courtier's, but also austerity—and even hardness.

So many different qualities, almost at odds, were rendered more distinct through the reference to combat: "May the one we are looking for be thus very proud and aggressive when he confronts his enemies and always at the forefront; but in all other cases may he be human, moderate and composed."[36] The semantic constellation of *délicatesse* and urbanity may be compared to another constellation referring, in parallel, to "invincible courage,"[37] "boldness of heart,"[38] and "contempt of danger."[39] The "virile" hero evoked by Castiglione possesses values that are practically "double." He is supposed to confront death in battle. He is supposed to transform literature into a virtue: "The true and main adornment to the mind is literature."[40] Brantôme's admiration for some of the "great captains" confirms the new role given to such a combination. It is the "taste" attributed to François I, for example, a fighting and a cultured king, a man leading the army and a man filling his sumptuous library: "He was called the father and real restorer of literature, since before him ignorance pretty much held sway in France."[41] Boldness was not to be abandoned, even if diversified.

The theme is obviously more complex than the reference to literature alone would suggest. These models of modernity focus on influence, while making that influence more subtle. They extend it to speech, gestures, eloquence, silence, and self-control. They evoke the principles of "self-knowledge," the better to "know how to control oneself,"[42] just as they evoke the principles of knowing others so as to better "find each person's weak spot."[43] So many measures taken with the aim in each case of domination; assuredness and "superiority" are even theorized here in an overall vision. Ascendancy is deliberate, global, criss-crossing behavior, insinuating itself "in conversation, speech, bearing, countenance—and even in love."[44] Timidity and hesitation are questioned as types of defects, whereas "influence over others"[45] and "the spirit of domination"[46] are exalted as kinds of values. Such measures establish for the first time a quest for authority exercised for itself: a power drawing from itself, and itself alone, its own legitimacy. It is no longer

some superior principle or some lofty value but the principle of excellence in and of itself, a perfection all the more remarkable in that it manages to bring together mastery and moderation.

Beyond this, new principles of leadership are also involved. Virile virtue becomes civic virtue. The transposition of royal power becomes the main example of it. Old models of the prince leading the state with lance and armor, such as the image of Charles V painted by Titian,[47] are succeeded by models of the prince leading the state with the pomp of civic attributes, such as the image of Louis XIV painted by Henri Testelin in 1648[48] or by Hyacinthe Rigaud in 1701.[49] Silks, laces, books, and geographical tables make up the décor of a power intended to resort to persuasion and discourse, while the tenseness of the bodily position, the darkness and firmness of the look aimed at the spectator, confirm the existence of some exclusive domination.

Absent is any reference to women in this diverse enumeration of qualities. The advice of James I of England to his son, at the very end of the sixteenth century, confirms this better than other examples. The king knows how to make room for moderation. He evokes a necessary "gentleness and kindliness." He even advises against violent games likely to "maim the body." He preaches modesty and prudence. But he insists on an absolute domination, the first example of which is about taming "the horses that have the greatest energy." He stresses, beyond this, a very precise rapport with the wife, who must be "governed like a pupil;" she is a deliberately fragile creature, a lady who must "be as quick to obey as you are to command."[50]

Domination and strength, moderation and restraint, fear of one's own downfall—all blend together in modernity to transform the major model of virility.

VIRILITY AND ITS "OTHERS": THE REPRESENTATION OF PARADOXICAL MASCULINITY

LAWRENCE D. KRITZMAN

THE RENAISSANCE is a period in which numerous texts of different genres bring masculinity and its "others" to light. These texts bring masculinity face to face with the question of impotence as well with the perception of power and the place of women in society.[51]

Virility belongs to the domain of social constructions and constraints imposed by society. The masculine ideal during the French Renaissance is expressed in the rediscovery of ancient texts, such as those of Aristotle and of Horace, for whom moderation is the golden rule.[52] This moderation, or *aurea mediocritas*, represents the masculine ability to avoid excess. In fact, so-called normative masculinity is characterized by certain rules of balance and of physical and moral values that construct an image of man as a virile being. This is what Judith Butler asserts: we are constituted as virile subjects by the power that requires respect for order and authority.[53] The physical sex organ is not necessarily a sign of virility. By transposing Simone de Beauvoir's phrase, a man is not born man, he becomes man,[54] we see virility not as an effect ordered by the body. It is rather a question of a social construction and a psychological phenomenon, which each give access to virility.

If courage, in particular, is associated with a virile personality, Rabelais's Panurge becomes the counter-example of it: the anti-hero incapable of embodying masculinity. In the Rabelaisian novel Panurge manifests an excessive fear. Lacking sufficient "retentive virtues," he is incapable of controlling himself: "How Panurge, through male fear, shat himself." He is thus subjected to a verbal and symbolic castration because he lacks courage, and he sees himself from that point as destined to being emasculated. Frère Jean says as much to him: "You want to stay away from combat, you don't have the balls."

Without any doubt, the Renaissance codified virile comportment and the relationship between the sexes. According to Brantôme, women "love warriors more than other men, and their violence brings out in them a keener appetite."[55] The

woman is supposed to be respectable and virginal, whereas the man is supposed to preserve every prerogative in amorous relations. In general, while the woman is obliged to remain faithful to the rules of chastity, the man, for his part, may not let himself be seduced by a woman. He who accepts a woman's advances risks being "devirilized." According to Brantôme, however, there is one stratagem to avoid this challenge to virility: men should marry a woman who is "a bit of a whore." She who is moderately sinful guarantees the man's virility, whereas the chaste woman who has never been deflowered but who has sinned later puts the husband in a very challenging situation: his masculinity is radically in danger.

In this context, virility seems to be a given, inscribed on the body; it constitutes a performance, a staging, in which the sex organ is reduced to a material element; it becomes a sort of merchandise representing the paternal penis. Thus, man tries to live his sexuality in relation to his male organ—always with a risk:

> Another Lady, conversing with a gentleman about love, is told by him, among other things, that if he could sleep with her, he would undertake to perform in six positions during the night, her beauty would be so exciting to him: "You boast about a great deal," she said. "So I will grant you such a night." A tryst he did not fail to keep: but his misfortune was to be taken by surprise, once in bed, with such a convulsion, cooling and loss of nerve, that he could not perform in even one position.[56]

The penis is thus just as susceptible to failing. Thus there emerges this drama surrounding virility as a whole and how it may be shaken: this is the drama in which the very existence of the virile subject has lost all grounding owing to his sexual impotence. The penis that fails places in doubt the man's virility: it removes from the phallus all its symbolic significance.

But these masculinity codes are in constant recomposition during the Renaissance. Literary texts function as laboratories in which virility eludes contraction. One should regard this fact not simply as a challenge to the idea of masculinity but as an opening of the field of possibilities. And this field is varied and unexpected. A simple example will show it: the story of Marie Germain, taken from Ambroise Paré and retold by Montaigne, "a girl who became a man for having taken too great a stride." A strange phenomenon whereby the soft parts of one's femininity can suddenly be revealed as masculine.

In another context, however, the woman, in heat, according to Brantôme, acquires the quasi-identity of the male gender when her libidinal desire is as powerful as the man's.

She was a very large lady, very tall and lovely; the fine traits of her face and her coiffure done up nicely in the ancient Roman style, along with her great height, demonstrated well that she was just as they said; for, from what I understand from several philosophers, doctors and judges of physiognomy, large women are willingly inclined, inasmuch as they are mannish, to take part in the ardor of both man and woman; and, as the two are joined together in a single body and person, they are more violent and more forceful than one woman alone....[57]

Possessed of something double, this feminine figure goes past the limits of genital sex and locates itself beyond the canonical modes of differences between masculinity and femininity. Women who manifest such behavior, in which sexual passion is displayed as favoring the phallocentric, allow for a transformation of the other in terms of the same. This symbolic travesty actualizes the paradox of femininity, its inadequacy in furnishing a full identity.

RABELAIS AND VIRILE ANXIETY

In certain episodes of the Rabelaisian novels, the writing captures and brings to light the dangers associated with man's immoderate passions. "The middle road was held by the ancient sages to be golden, that is to say, precious, praised by all men, and pleasing in all places."[58] In Rabelais the male subject emerges from the figurative images in cultural activities. Relations between men and women are an example of this process and play an essential role in it. They reflect the masculine anxieties associated with the famous *"querelle des femmes."* Woman, such as she is depicted in Rabelais, is elusive, incapable of controlling herself, while the virile ideal is self-control: man defines woman essentially as an unstable being.

When I say womankind, I speak of a sex so frail, so variable, so changeable, so fickle, inconstant, and imperfect [. . .]. For nature hath posited in a privy, secret, and intestine place of their bodies, a sort of member, by some not impertinently termed an animal, which is not to be found in men. Therein sometimes are engendered certain humours so saltish, brackish, clammy, sharp, nipping, tearing, prickling, and most eagerly tickling, that by their stinging acrimony, rending nitrosity, figging itch, wriggling mordacity, and smarting salsitude (for the said member is altogether sinewy and of a most quick and lively feeling), their whole body is shaken

and ebrangled, their senses totally ravished and transported, the operations of their judgment and understanding utterly confounded [...].[59]

Hysteria, however, which is considered as a feminine characteristic, will be transposed from woman to the man who fears being cheated on.

A SUPERIORITY CONFIRMED

The misogynist tradition that one observes in Renaissance writers goes back to antiquity, when male superiority over women was implacably affirmed. Plato, for example, saw in woman a being too inferior to "be a partner in Love." However, in the sixteenth century, certain humanists, given impetus by a jurist of the time, André Tiraqueau, opened up the feminine condition for debate, suggesting a new reflection. The objective: to proclaim the importance of reciprocal affection in marriage.

In the sixteenth century masculine superiority is strongly affirmed by the socialization of men—a socialization that takes place in a "homosocial" context. The role of the father is primordial, since it is on his watch that masculine apprenticeship takes place. In Gargantua's letter to Pantagruel,[60] the father aims to fashion the son in his image. The propagation of the species functions as the guarantee of filial duty. Sons are supposed to take after their fathers' example. They are supposed to become fathers and pass on their seed as a means of survival and affirmation of virile behavior.

> Amongst the gifts, graces, and prerogatives, with which [...] God Almighty hath endowed [...] human nature at the beginning, that seems to me most singular and excellent by which we may [...] attain to a kind of immortality, and in the course of this transitory life perpetuate our name and seed [...].[61]

This letter theorizes gender as a sexual performance learned and carried out in the name of the propagation of the species. However, it is through the union of man and woman that the human being can benefit from this gift of God that is sexuality. The disappearance of the father is compensated for by the birth of the son; Gargantua carries out this duty joyfully.

In the father's letter to his son, the *pater familias* explains to him his main virile duty: to take responsibility for the education of his progeny. Although "seminal propagation" ensures the biological survival of the family, it is rather the father's

educational program that allows the child to take stock of this gift of divine kindness and to enrich his soul. The transformation of Pantagruel into a "good child" makes him responsible for earthly well-being. The son is obliged to be the vassal of the patriarchal lord by following this pedagogical program, thus ensuring the passage of the past to the present. "The time was not so anodyne or easygoing in literature as it is at present, and you had no such mentors as you have had."[62]

A symbolic object of the virile being, moreover, seems to have been the codpiece. It represents a phallic cornucopia, associated with the male sex organ and capable of inexhaustible generation. What is more, the form of the codpiece, "like an arch-buttress," transmits an image of virile energy embodied in an erect sex organ, ready to be stimulated. Chapter XI of *Gargantua* confirms this magnificently, telling the story of the governesses in charge of the giant child. They stimulate him "between their hands" and succeed at getting him excited (they "lift his Ears").

APORIAS

Rabelais nevertheless tends to play on aporias: first of all, that of the possible difference between the word and the thing as regards the depiction of the codpiece. This slippage reveals a possible absence, a challenge to masculine character, right inside the codpiece because the description of the codpiece suggests a container that hides an empty content. This paradoxical praise of the codpiece in *Gargantua* functions as a questioning of virility. By playing on the *topos*, according to which clothes do not make the man, Rabelais reveals a possible discrepancy between seeming and being, thus throwing light on the inverse of virility.

> For his codpiece were used sixteen ells and a quarter of the same cloth, and it was fashioned on the top like unto a triumphant arch, most gallantly fastened with two enamelled clasps, in each of which was set a great emerald, as big as an orange [...].[63]

The "large emerald" on the outside of the codpiece alludes to the emptiness inside, for the jewel in question symbolizes sterility in the sixteenth century. This so-called sign of virility that is the codpiece becomes the paradox of the encomium in question.

The Abbaye de Thélème may suggest another aporia. Its motto, "Do as you wish," constitutes first and foremost the embodiment of an anti-monastery in the Rabelaisian novel. Rabelais stresses the harmony that could exist between men and

women. The abbey functions as a counter-example, a sort of *locus amoenus* where earthly perfection reigns. There are no longer walls separating men from women, and the latter are no longer considered to be the abject targets of masculine misogyny. Those who enter the abbey are, moreover, elegant men of noble birth. The paradox, on the other hand, is that personal will here depends on collective will. All at once, ironically, this subverts the so-called ideal society by emptying it of possibilities.

Another utopia is added here: men and women live side-by-side in a place where sexuality has been suppressed, placed under wraps. If virility resonates as a series of injunctions based on the body, ideal behavior practiced in the anti-monastery is not natural. If the golden rule of Thélème—chastity—imposes constraints, it is in the mode of "having to be" rather than on being. Physical desires must be sacrificed to those of the mind. There is no trace of them in this society. This prohibition robs the Thélèmites of the humanity embodied in marriage and procreation, neither one being realizable except outside the abbey. One interesting detail: the absence of the codpiece in the male outfit of the Thélèmites suggests that this piece of clothing, which draws attention to the body, is improper in an aristocratic society. Thus, Thélème brings to light a "crisis of virility" provoked by an asexual society: the sexes believed to be inscribed in the body lead to nondifferentiation. By annulling sexuality in this regime of parity, this nondifference becomes a danger that threatens virility.

MARRIAGE AND PANURGE'S FEAR

Renaissance humanists attempted to restore prestige to marriage as a social institution. The question of marriage is brought out in the *Tiers Livre* when Panurge expresses his fear of being deceived by a woman. This behavior reveals his incapacity to control himself, a determinant element of virility. In the antifeminist cultural context of the sixteenth century, marriage raises a suspicion of the possibility of being cuckolded.

In this climate dominated by doubt, Panurge takes off in search of a response to the only question that counts for him: "Should I get married or not?" Obsessed by the possibility of cuckoldry, Panurge becomes a victim of indecision, thus appearing as a man imprisoned by hesitation. This "crisis of virility" takes the form of a comic caricature, for Panurge's hysteria, a behavior traditionally considered to be a feminine characteristic, tips over into an imaginary order subjected to matriarchal

domination. The markers of the masculine disappear in the course of multiple consultations, during which pieces of oral and written advice abound.

The part of the *Tiers Livre* devoted to a consultation with Doctor Rondibilis clearly brings out Panurge's anxiety. Rondibilis, heir to the platonic tradition in medicine, suggests that man would not ignore reason when it came to sexuality, whereas woman, an irrational being, could never be controlled.[64]

> By the haven of safety, cried out Rondibilis, what is this you ask of me? If you shall be a cuckold? My noble friend, I am married, and you are like to be so very speedily; therefore be pleased, from my experiment in the matter, to write in your brain with a steel pen this subsequent ditton, There is no married man who doth not run the hazard of being made a cuckold. Cuckoldry naturally attendeth marriage.[65]

What makes feminine sexuality so dangerous is its ungraspable character and its power of rendering the man impotent; cuckoldry is conceived of as a consequence of his situation as husband. Anxiety-ridden and ill at ease, man discovers in women's behavior the origin of his own weakness and his inability to control it.

Panurge's existential drama constitutes the greatest challenge to his virility. If he is afraid of being "cuckolded, beaten down and deceived" by his wife and abandons the possibility of getting married, the man will find that the woman has robbed him of the satisfaction of a primordial need: the child, that living monument to the father's virility.

BALANCE AND HEALTH, THE ADVERSITY OF EXCESS

The Prologue to the *Quart Livre* treats the question of excess and its relation to human health: the ideal of mediocrity and its failures prefigure the portrayals of virility in the text that follows. The fable to which the Prologue refers, "The Honest Woodcutter" by Aesop, serves as exemplum, throwing light on the dangers associated with excessive proliferation.

The function of this fable is actually completely allegorical with respect to the male gender. A man named Couillatris loses his wooden axe ("*coignée*"): Jupiter then intervenes and sends him Mercury, god of thieves, his messenger. The latter offers Couillatris the choice of three axes: one of gold, another of silver, and the wooden one that belongs to him. Couillatris chooses his own axe—and receives as a reward the two other ones. Paradoxically, the wooden axe takes on an incommensurable value.

Rabelais appropriates this fable to show the benefits of moderation and the dangers of an excessive appetite. By playing on the semantic ambiguity of the word *coignée,* the text actually associates the image of the axe with that of the phallus.

The text goes on to set forth all the misfortunes that will befall the grotesque characters as they slip into the excess of sexual practices considered unnatural. The reference in the Prologue to Priapus, the phallic god of fecundity, allows Rabelais to play on the semantic valence of the word *coignée* by giving it a licentious meaning. The axe, a figure of sexual union, represents an idealization based on harmony and plenitude, enacted by two different entities. Thus, the Rabelaisian text brings to light the model of the heterosexual couple and a moderated manner of realizing desire.

There remain scenes that, in their very violence, show the necessity of moderation, such as the episode of the Chicanous: virility appears here as the end point of an initiatory pathway, and it is acquired after a rite of passage intended to reinforce the man's masculinity. It is nothing but the staging of a spectacle: "the custom observed in all wedding engagements," in which the young men are involved in a series of baton strokes, "maul him, drub him, lambast him."[66] This homosocial activity of "beating the drum" is supposed to stimulate the new husband's fertility in his virile duties. These "saturnalian institution rites," to quote Pierre Bourdieu, serve to establish "a durable difference between those whom this rite concerns and those whom this rite does not concern." This gathering together of the men functions to lead them back home and to reassure them of their virility.[67]

The depiction of grotesque characters in the *Quart Livre* carries on the Rabelaisian questioning of virility. Quaresmeprenant is, in various ways, the best example of this. The description of his frame opens with a series of *copia verborum*, reproducing mimetically the grotesque and ascetic character of this unnatural male figure. This barbaric being calls into question the beauty of people, since he is a dark monster, "deformed and distorted in spite of Nature." "Here is a strange and monstrous member of the human race, if he must be called human,"[68] says Pantagruel when he sees this mysterious being dwelling on the Island of Tapinois, the *locus* of moral hypocrisy.

This sad figure of obligatory fasting reflects the very opposite of health: his moral ugliness symbolizes his lack of fecundity. Quaresmeprenant does not like to attend weddings and rejects the divine gift of reproduction, the fruit of marriage. He gives the impression of embodying all the sexual practices that transform him into a son of Antiphysis. In sum, he likes to "*lanterner*" (dilly-dally). Samuel Kinser suggests that this pejorative slang expression signifies "penis."[69]

The depiction of Quaresmeprenant itself opens on a paradoxical figure. While the mouth is identified as the *locus* of the wrong, the fast or prodigious abstinences and an excess of religious discipline are practices aimed at attaining a state of holiness. The required alimentary temperance excludes all verbal intemperance. The prohibition of excess produces an excess of another order—a phenomenon whereby food or the enjoyment of living things is replaced by the disgust of words, evoking the stagnation of reified matter.

The explosive energy concentrated in the depiction of Quaresmeprenant ends, moreover, with the creation of a being all the more sterile for having resulted from copulation among men, something judged unnatural in relation to the exigencies of virility. This textual emblem creates the image of a void that seeks the satisfaction of its own end, for this unhealthy monster is but a sterile being. Although the text offers no description of his genital organs, it alludes to the uncanniness of his actual creation, which calls into question the virility of the heterosexual male. Quaresmeprenant is a "syphilitic" character, and the baldness that he suffers from, according to Guy Demerson, functions as a symptom of his illness. What is more, he is surrounded by pregnant male personages. These phantasmatic births result from social practices associated with anal sex as well as with an alimentary regimen responsible for intestinal disorders.

Devoid of sensibility, Quaresmeprenant has engendered a number of "local adverbs" and reduplicated fasts. Nothing productive nourishes his portrayal. The desire that requires a nearly immobile body seeks only to produce more deaths.

> The animal spirits, like swinging fisticuffs.
> The blood-fermenting, like a multiplication of flirts on the nose.
> The urine, like a figpecker.[70]

The episode of the "Andouilles" (translated as "Chitterlings" though the word is slang for "imbeciles") offers another example of what happens to the male figure when the man is not "one hundred percent" man. The eight chapters that make up the epic of the war of the Andouilles bring onto the stage Quaresmeprenant's mortal enemies: symbolic figures of abundance who "get fat" on days of abstinence. By their excessive, superstitious practices, the Andouilles also create a monstrosity: they transform a hog into a cult object. Ironically, the symbols of plenitude are again "prodigies, load-bearing monsters and prescient signs formed against every order of nature" (120). In fact, these are alimentary andouilles "for half the body." As for the rest, as a race with biblical and mythological reference points, they take the form of

the serpent-tempter of Eve (symbol of the traitor) and of the satyr Priapus for the figure of the ithyphallic andouille. This is a strange morphological mixture: human and inhuman, man and woman, living matter to be eaten and inanimate matter to be eliminated. Whatever the case may be, the hybrid form of this "andouille-like" being makes of him a monster, totally subverting the virile order.

The question of the Andouilles' sexual identity is raised in Chapter XXIX: "Are these same Chitterlings, said Friar John, male or female, angels or mortals, women or maids? They are, replied Xenomanes, females in sex, mortal in kind, some of them maids, others not."[71]

The Andouilles, female in gender, are actually feminine in the grammatical and referential sense, but they take a phallic form in the text. These composite bodies have a queen whose name is Niphleseth, which, according to the Brief Declaration, is of Hebrew origin and is translated by the expression "virile member."[72] Sexual ambiguity reigns in this matriarchy in which the monstrous figures represent a woman with a masculine silhouette. A quasi-masculine physiognomy takes on a "mixed" identity: feminine, phallic, and excremental. What Judith Butler characterizes as a difference between sex (biological identity) and "gender" (construction of sexual identity) blurs little by little as the schism between word and thing develops in this episode.[73] The barrier of difference is shaken: male and female, masculine and feminine, phenomena that are essentially antonymous, merge here in an uneven manner. The depiction of this grotesque body does not correspond to the model of the hermaphrodite described by Ambroise Paré in *On Monsters and Marvels*: "A double being who has both sexes, well-formed, and who can use them to conceive." The Rabelaisian text reveals rather a polymorphous monster: distinct and mixed, representing pleasure as much as aggression, incapable in the end of conceiving [cf. fig. 4.1].[74]

This confusion between female identity and priapic but nonvirile anatomy, which makes it paradoxically possible to breed as a woman, projects the monstrous fantasy of a composite being, thus raising the question again of the libidinal connection to the other, that is, the very essence of *eros*. The figure of the phallic mother implies the symbolic threat of castration—Pantagruel actually gives the queen "a beautiful little knife," for the feminine phallus in question represents the danger of the anxiety linked to desire. The Rabelaisian text maintains a certain ambiguity about sexuality in order to become attached to primitive affects, especially fear. It blocks relational orgasm, which supposes genital contact and libidinal euphoria. So, the dangers of the difference between man and woman move dramatically away from the libidinal context. At the other extreme, the nondifferentiation of

Figure d'un enfant ayant deux teftes, deux bras, & quatre jambes.

Figure de deux gemeaux n'ayans qu'une feule tefte.

FIGURE 4.1 AMBROISE PARÉ, *DES MONSTRES ET PRODIGES* (MONSTERS AND WONDERS), 1573.

"Hippocrates, on the generating of monsters, says that if there is too much semen, a large number of litters will be produced in which a monstrously born child will have superfluous and useless parts such as two heads, four arms or legs, six fingers on the hands and feet, or other abnormalities. Inversely, if there is too little semen, some member of the child will be missing, such as a hand, an arm, or feet, or head or other part. [. . .] In 1569, a woman from Tours gave birth to twins having only one head; the two infants were stuck to one another and were given to me dried and anatomized by Maître René Ciret, master barber and surgeon." Genital organs are not necessarily a sign of virility.

Source: © Leemage

this disfigured being creates a scriptural phantasm whose absolute alterity has para-doxically disappeared.

In this episode the Andouilles make a mistake and attack Pantagruel, think-ing that he is actually Quaresmeprenant followed by his allies. But even when the Andouilles go to war against the real Quaresmeprenant, they are unable to control their emotions or to engage in more temperate strategies. In effect, it is a woman who leads the Andouilles. Now, according to Salic law, "women and effeminate men do not have the right to lead an army."[75] In this context, the anatomical entity functions as a trope for the male sex organ. We know, however, that it cannot

represent a virile man: an ambiguous being does not lead armies. Metonymically associated with the male body, this figure lacks the power of the patriarchal phallus: rather, it is threatened with castration. In the final analysis, the Andouilles embody a virility manqué.

The feminization of the male member in this context might recall the platonic idea according to which Eros would be a woman. For Plato, man would have to appropriate the sexuality of the man as well as that of the woman.

BLAZONS OF THE BODY AND ILLUSORY DESIRES

The blazons of the body evoked by the poets conceal even more examples likely to threaten virility. The depiction of virility is expressed in the lyric poetry of the sixteenth century through the descriptions of women who are desired. In the anatomical blazons, the female body merges with the body of writing: the representation of the woman stands for the poet's imagination, projecting the reality of his virile desire onto an object that he subjectivizes narcissistically. If the body is in the spoken word, it is because the male imagination is constituted in language. The poetic blazon is therefore the articulation of the man's discourse on the woman's body.[76]

THE "DIVIDED" SUBJECT

The woman's body represents the fragmentary and the dismembered, whose theme is absence. The sonnet by Ronsard, "*Petit nombril, que mon penser adore*," ("O little navel that my thoughts inflame")[77] shows this: it calls on the lack that affects the desiring subject. The navel takes on a symbolic value: it is the architectural scar as well as the point that represents the rupture of the bodily tie with the mother and the mark of man's fundamental incompleteness. The male subject is prey to maternal nostalgia, and this lack produces the image of a man who is not totally a man. The love quest is therefore motivated by a wound that imprints on the body the separation and the hope of uniting with the maternal figure sensually and ideally. The love object is, then, the metaphor of a divided subject: the navel becomes the figure of an ego uprooted from its anatomical "vertex." The phantasm of the androgen uses names for both sex organs to better evoke the desire of an integrated body, the place of a durable construction in which nothing is missing.

O little navel that my thoughts inflame,
And not my eyes—for never have I had
The privilege of seeing you unclad,
You, who deserve a city in your name;
Symbol of Love and sign of his acclaim,
Remnant of Jove's wild rage, who, near gone mad,
Severed the Androgyne we were, then bade
Us mindful be that we, thus, two became [. . .][78]

Recalling the myth evoked by Aristophanes in Plato's *Symposium*, this poem forces us to question the integrity of the male body and stops virility from liberating itself purely from the male body.

THE THREAT OF TIME

In the sonnet *"Madame se levoit un beau matin d'été"* (Madame arose one fine summer's morning), Ronsard renews the anatomical blazon while transforming the myth of Medusa into an allegory of the poet's action on the female body, which he ends up dominating. Instead of admitting the lessening of his desire and the diminution of the love relation, the virile figure transforms this decline into an aesthetic accession conveying victory over the object of his desire: the ephemeral feminine body.

Whereas the mythic legend spoke of the face of Medusa and her power to petrify, this poem, for its part, sets out to stiffen the body of the threatened figure, that of Helen-Andromeda. But her deliverance by Ronsard-Perseus constitutes an ironic salvation, for her transformation into a statue amounts to a symbolic paralysis of the woman by taking away her sensibility and her life.

Determined by the motifs of hardness and duration, static beauty is imposed by dint of masculine violence in its attempt to dominate the woman. The rewriting of the Medusa intertext allows the poet to devitalize the female body and to substitute an inalterable aesthetic matter for living or perishable matter. The metamorphosis carried out by love evokes a virile artistic "master" whose function is to sweep aside the fatality inscribed in the withered body. The poem, which is intended to be about mastery, ironically glorifies the art of the master. Thus, the artistic creation displaces in the myth the decomposition that follows youth; it leads to an ideal in which time is frozen by the purified body. Such, then, is the

miracle of the creative act and the act of virile control: it delivers the feminine body from its own decadence in order to make of it the object of a utopian vision that paradoxically confers on it the immortality of antimetamorphosis.

If this poem discloses the power that Ronsard exercised over statuary material, it also strongly marks his desire to be a Pygmalion and to establish a symbolic link between the scriptural and the sculptural.

> Give me ink and paper too:
> On a hundred sheets, witnesses of my cares,
> I want to set out the trouble I'm enduring;
> On a hundred sheets harder than diamond,
> So that one day in the future our countrymen
> Can judge the harm I suffer from being in love.[79]

The symbolic metamorphosis of the woman becomes the necessary condition to allow for the birth of the scriptural act, a metaphor for an autonomous work. The statuary symbol conveys the image of a fixed writing as a poetic tomb controlled by the poet. Like the figure of Pygmalion in Greek mythology, Ronsard falls in love with his paper Galatea. Unlike Ovid, who brings life to Galatea, Ronsard demonstrates spectacularly that the virile relation to the feminine is carried out by a woman whose vital, indeed sexual, forces have been annulled.

THE UNSTABLE OBJECT

In certain texts of the sixteenth century, the figure of the poet calls virility into question. Ronsard's blazon *"Soit que son or se crespe lentement"* (Whether her golden hair curls languidly), inspired by Petrarch and Ariosto, is inscribed in a quasi-voluptuous movement in which the woman is reduced to the "indefinable ambiguity of a touching coiffure." The desired object is embodied in the image of a swimmer caught in the slowed rocking of the hair-sea, the undulation of the waves being compared to that of the hair. The soft movement of physical oscillation is expressed by metaphors evoking the mobility associated with sexual desire.

> Whether her golden hair curls languidly,
> Or whether it swims by, in two flowing waves
> That over her breasts wander there, and stray,

And across her neck float playfully:
Whether a knot, ornamented richly,
With many a ruby, many a rounded pearl,
Ties the stream of her rippling curls,
My heart delights itself, contentedly.[80]

The syntax of the grand rhythms of psychic rocking projects an essentially inconstant image over the imaginary "waves" of the text. The aquatic metaphor is displaced at the visceral level; the amorous subject is attracted to a detachable part of the feminine body, a fetishized object, which moves in relation to the contours of scriptural desire.

In the tercets of the poem, the loss of virile identity emerges in the form of a spectacle of alterity, a mimesis of instability that the fiction of the body conveys. The woman who had already left the scene of writing disappears amidst the grand fading of textual becoming. Through a paradoxical reversal, the figure of the woman vanishes in the mist of writing. The Ronsardian text follows a path whereby the virile libido is displaced from the desired feminine object (hair) toward the phantasmal image of a boy-woman. Attracted by the feminine body, the poet sees in it a dubious sexuality, a symbolic representation in the form of an Adonis-like figurehead, born out of the sea of writing:

What delight it is, a wonder rather,
When her hair, caught above her ear,
Imitates the style that Venus employed!
Or with a cap on her head she is Adonis,
And no one knows if she's a girl or boy,
So sweetly her beauty hides in both disguises.

Through her appearance in these verses, this indeterminate Venus, emerging from the imaginary wave of fleeting visibilities, is made a source of ambiguity and confusion, for her femininity mixes with a feminized masculinity. Far from being an encomium of feminine beauty, that desired object is presented in the form of an ungraspable and indecisive image, because it is but the inbetween.

The rewriting of the mythic intertext reveals the contours of equivocal male desire: the very nature of the poetic representation suffices to make of the desired subject a devirilized being. This ambivalence of the depicted object—hair—brings to light the pleasure of acceding to a speech heretofore unknown ("What delight it is, a wonder rather . . .").

The inscription of intertextual relations manages, through this gender vertigo, to make male sexuality uncertain. According to the Athenian version of the myth, Adonis, sprung from the incest between his father and Myrrha, "is for the Greeks neither husband nor even a virile being: he is none other than a lover and an effeminate man whose followers," Plutarch notes, "are recruited from among women and androgynes." The disjunctive synthesis that makes up this text calls into question the sexual bipolarity of the masculine/feminine couple.

Ronsard's poem forms a subject defined by means of the phantasmal image and the taste for disguise that it projects: instability. It is a paroxysm of indecision, since the mythical intertext defines the desired object, Adonis, as an androgynous being. The Ronsardian subject may identify in its way with this reverie (the figure of Venus-Adonis); he passes into her, absorbs her. The desiring subject becomes a double phantasm, a phenomenon by which the image of the body functions as narcissistic mirror of the redundancy of desire. "I am content with my contentment." Thus, the sexuality of the two figures inscribed in the text is destabilized, for the reverie that constitutes sexual desire confounds the identity of one with the other.

The transfiguration of Venus, goddess of love and fecundity, into Adonis, the figure who is the opposite of marriage and procreative sexual intercourse, is very striking. Destined to fall into a garden of stones, Adonis's seed never metamorphoses into a fertile root. The desiring subject gives birth to Adonis from Venus. The sterility figured here evokes the infertility associated with the equivocal love of a man for a woman: this love thereby problematizes virile desire and proposes a redefinition of its own sexuality.

MONTAIGNE AND THE "FICTION" OF THE VIRILE MAN

The relations between men and women found in Montaigne are often paradoxical. On the one hand, the essayist inherited the misogynist traditions of the Middle Ages, whereby male superiority is perpetuated by cultural practices and a set of medical opinions aimed at bringing out woman's supposed physiological defects. Characterized by an active, insatiable sexual appetite, woman is paradoxically defined also as a passive being whose role is to "suffer and give in." In this context, her function is to incite virile pleasure, and subsequently to internalize the virginal shame imposed upon her.

But, on the other hand, ironically, this virile male being who knows how to take advantage of erotic pleasures also admits the necessity of recognizing the injustices visited upon women. He protests against "savage" virility, which he considers a cultural phenomenon and not a natural practice. He does not accept the absolutism of phallocentric superiority imposed by tradition, for he feels that man, relying on myths of masculinity, often falls victim to these virile phantasms. Phallocentrism attributes more libidinal energy to man than to woman, who, in reality, surpasses man in sensuality and in love. "We treat them [women] inconsiderately. We have discovered [. . .] that they are incomparably more capable and ardent than we in the acts of love [. . .]" (*Essais*, III, 5).[81] Montaigne enjoys questioning the fictions of the virile man because he can thereby denounce the hypocrisy enacted in the name of virility.

Although he describes ideal virile behavior in the *Essais*, Montaigne also sets about questioning the obligatory performance associated with masculinity. The essayist questions the imaginary fiction of a natural gender as being the distinction between the external, biological sex organ and the internal gender. Montaigne denounces the fiction according to which an individual would possess a stable gender.

"DERAILING" OLD AGE

In Montaigne, imagination allows the writer, whose body has grown old and weak, to remedy the impotence of his libidinal economy. "I am merry only in fancy and in dreams, to divert by trickery the gloom of old age."[82] The essayist demands of the imagination and memory that they bring back his youth by reviving the lost paradise of orgasm. The mind is used to replace the virile pleasures of youth by the trampoline of the imagination. Writing functions as a fallback solution, "a deliberate debauchery," which creates a simulation of bodily experience. "Let it grow green, let it flourish meanwhile, if it can, like mistletoe on a dead tree."[83]

The essayist transforms the essay into a tomb of writing that allows him to record a simulation of past virile pleasures. Art offers him the possibility of going beyond what nature is able to generate, for nature treats art "unfairly and unkindly."[84] This scriptural reality, made up of intertextual references, has become a mosaic of literary and personal citations that paradoxically prolongs what no longer exists. Montaigne gives new life to that love in which the desiring subject is entirely in the grip of the beauty of Venus.

THE POWER OF THE IMAGINATION

The power of the imagination plays an important role in the essay "On a monstrous child."[85] The essayist uses the metaphor of the monstrous body to go beyond the essentialism of gender and the constraints imposed by the myth of the natural. He analyzes what might be characterized as monstrous by considering its relation to difference. From the beginning of this essay the reader is placed in contact with the spectacle (the "monster") of these two twins.

> This story will go its way simply; for I leave it to the doctors to discuss it. The day before yesterday I saw a child that two men and a nurse, who said they were the father, the uncle, and the aunt, were leading about to get a penny or so from showing him, because of his strangeness. [. . .] Below the breast he was fastened and stuck to another child, without a head [. . .]; if you turned the imperfect child over and up you saw the other's navel below [. . .]. The navel of the imperfect child could not be seen.[86]

The nature of the child's strangeness cannot be known solely by his external traits. Depicted as he was by a composite figure, the monster brought to light here blurs the boundaries between self and other. He springs from our visual perception, which reduces what we do not know to absolute strangeness. Acknowledged as an image that cannot be classified, the monstrous appears as a sign having no consensus value. "Whatever falls out contrary to custom we say is contrary to nature."[87] But from a divine perspective, the universe is immense and subject to differences.

> What we call monsters are not so to God, who sees in the immensity of his work the infinity of forms that he has comprised in it; and it is for us to believe that this figure that astonishes us is related and linked to some other figure of the same kind unknown to man. [. . .] [B]ut we do not discern its arrangement and relationship.[88]

In opposing the so-called universal ethos of reason, the imagination enables us to open up to what is strange or different. To be open to the possibility of multiple images, the human being must accept the alterity of the world order.

> I do not share that common error of judging another by myself. I easily believe that another man may have qualities different from mine [. . .] and, in contrast to the common run of men, I more easily admit difference than resemblance between us.[89]

An interesting anecdote appears in this essay following the story of the twins. It is about another example of the monstrous, someone whose monstrosity is situated within himself. This anecdote tells the story of a man who wears a beard but has no genital organs.

> I have just seen a shepherd in Médoc, thirty years old or thereabouts, who has no sign of any genital parts. He has three holes by which he continually makes water. He is bearded, has desire, and likes to touch women.[90]

Montaigne's text brings out the aporia between internal and external, or the discrepancy between ontology and biology. He presents us with an example of radical otherness that the biological signs of the body cannot totally convey. Despite the beard, the male body becomes the site of an absence that would have marked masculinity.

This split demonstrates that the question of gender is not limited to the sexuality of man. If masculine identity does not proceed from biological givens (i.e., what is considered to be "natural"), we are led to conclude that biology does not determine our destiny. In this context, the idea of monster (a word derived from the Latin *monere*, "to warn") loses its ability to determine things. What we see (what is missing from our visual perception) does not represent the reality of virile desire. This anecdote teaches us that the sole manner of "reading" the signs of gender should be "backward."[91] Montaigne's text suggests that desire is expressed by an invisible signifier bereft of the biological means of depicting it; this absence reveals the paradoxical presence of a monstrosity within desire itself.

The lack inscribed in this man's body does not erase his masculinity. It does not make him any less a man. We learn that he likes "to touch women."[92] Virility is inscribed here as the consequence of the libidinal power associated with desire and not as biological identity. The absent penis does not foreclose the functioning of the phallic. Virility is redefined as an invisible phenomenon in which being counts for more than having. In other words, the penis does not make the man. The ontological plenitude of desire displaces the anatomical void of the shepherd because phallic power is more a psychological phenomenon than a "physical reality."

Writing in the Renaissance functions as a laboratory in which the experiences of virility are weighed. What is often discovered in analyzing the depiction of virility is difference: it is thus the figure of the monster and its characteristic capacity to surprise that is perceived as an unnatural phenomenon. The fantasy

representations must also be linked to a reading of the human being grappling with existence. While the text marks the excesses of the misshapen and inventories them by spectacular type, the intervention paradoxically consists of imprinting them with an identity that blurs the contours of the particular and brings to light the exemplary nature, the alterity of virility.

EXAMPLES FROM PAINTING

NADEIJE LANEYRIE-DAGEN

FROM THE beginning of the Renaissance, European painting and sculpture place the human figure at the center of their preoccupations. The nude, the body either draped or clothed in contemporary dress, or the portrait, all treated in a manner intended to be illusionist—these are the subjects of the works. Enjoyment and edification are defined as the goals of the artists. The latter are supposed to suffuse people's vision with beauty and lift up their souls with the spectacle of virtues. Art becomes the expression of an ideal and an excellent observation post from which to see what the ideal human being is or is supposed to be. Are the personages presented or whose portraits are captured "illustrious," are their lives and mores reputed to be flawless? Their bodies and their faces, then, are very likely to be beautiful, and their attitudes and gestures imbued with harmony. Does a physiognomy fail to conform to the canon through which, at a given time, beauty is recognized, or does the person's bearing go against the exigencies of decorum? The spectator then deduces that the figure is that of a bad person.

THE MALE BODY, SOLE IMAGE OF GOD

Through this filter whereby a person's value is measured by appearances, the superiority accorded to man over woman is manifested prominently. The hierarchy of the sexes derives less from the taint of original sin, for which Eve would bear responsibility, than from the conditions of her creation, as described in Genesis. Concerning Adam, "On the last day of creation, God said: 'Let us make man in our image, in our likeness'" (1:26). Concerning Eve, "The Eternal God formed a woman from the rib that he had taken from the man, and he brought her to the man" (2:21). Theological exegesis can clearly show that Adam's resemblance to God is of a spiritual essence, or tied to youth and health that should have remained eternal. According to common knowledge or the knowledge of the artists and the first writers who treat aesthetic questions, the matter is understood:

man's body is the only one that is truly worthy of admiration because it alone reflects the beauty of God.

This exclusive primacy of the male is verified in the choice of a male and not a female body to illustrate the first anatomy treatises published with engravings, notably the most famous of them, *The Fabrication of the Human Body (De humanis corporis fabrica)* by doctor Andreas Vesalius (1514–1576) in 1543. In this folio edition of 663 pages, the virile anatomy is given as a model. The draftsman of the plates, who was a draftsman and not an engraver (the name of Jan Stefan Van Calcar has been suggested, and it is known that the work was done in Titian's studio), chose the dramatic staging of an *écorché* progressively peeled away. The skin is removed, then the successive layers of muscles, and then the entire network of nerves is drawn away until the skeleton is finally reached. Each time, the emaciated silhouette is presented in poignant positions. The virile character of the body is evident in the myological plates. Even when the silhouette is reduced to bones alone, it would never occur to the spectator for an instant that it could be that of any but a male individual. The only engravings in which a woman appears are those devoted to the womb, although this is a part of the work that is of little importance. So it goes with the other doctors or experimenters at the beginning of the history of anatomy, including the greatest among them, Leonardo da Vinci (1452–1519). At the Monastery of Santa Maria Novella in Florence, and later at the Ospedale de San Spirito in Rome, the artist and Florentine savant dissected thirty cadavers, often in the company of Marc Antonio della Torre of Milan. These were dead bodies from the hospice and often those of older people—even though in one case there is a two-year-old child. In his notes, Leonardo speaks about these cadavers almost always using the masculine pronoun, as if he performed autopsies only on men.[93] He is thus struck by the case of an old man with whom he had had a conversation the very morning on which he opened his body. Again, female physiology does not interest him except when he is studying procreation. When he attempts the drawing of coitus, depicting the virtual cross-section of the entwined bodies, he details the figure of the man and makes do with quick sketches for that of the woman.[94]

The *Anatomy Lessons* that painting frequently depicts thereafter, notably in Northern Europe, show the motif of a man's cadaver and not that of a woman: witness those celebrated ones by Rembrandt, the *Anatomy Lessons* of Doctors Tulp, and then of Deyman.[95] There are reasons of decorum for this (a public anatomy session should not allow the naked body of a woman to be seen, even deceased), and other reasons that related at the time to the conditions of obtaining the cadavers

(they were often those of people sentenced to death). But these reasons are decisive only because the artists' intention was to work on the best of human material, that is the virile body derived from God. It is thus not by chance that, on the second frontispiece of Vesalius's *Fabrication*, the male cadaver was captured frontally and foreshortened, with the feet toward the spectator. The point of view adopted is the revolutionary one of Andrea Mantegna's *Dead Christ*:[96] the classic body examined by Vesalius is, ideally, that of Christ, the image of God and God himself.

When it no longer involves internal physiology and anatomy but rather the external description of a body and notably a body in motion, the same preference is shown for virile anatomy. Here again Leonardo is to be invoked. In his writings, Leonardo set out to describe the changes (e.g., swelling of muscles) produced at the time of a dynamic shock to the body as well as the specter of possible movements and the conditions under which balance is maintained in various poses. These studies are not accompanied by any handwritten sketches, either because they never existed or, more probably, because they have been lost. But two series of illustrations survive, completed after the fact and on different dates. The older one forms what is called the *Codex Huygens*: drawings completed shortly before 1570, no doubt by a continuator of Leonardo named Carlo Urbino.[97] In each one, the successive movements of a male silhouette are described in a "kinetic" manner by means of a process that evokes chronophotography centuries later. In no instance is the man's silhouette replaced by a female nude. The second series is made up of images engraved in the seventeenth century at Poussin's studio for the first publication of Leonardo's notes, collected under the title *Treatise on Painting*.[98] The plates show the human body no longer in a dynamic progression of a movement but in positions of physical exertion artificially arrested. Again, the silhouettes are male: no female body is brought in to illustrate the strain, the thrust, or the lifting of a weight.[99]

In a domain that impassioned the Renaissance—research on proportions—the triumph of the virile body is no less exclusive. Readers and illustrators of the Roman Vitruvius's treatise *On Architecture*,[100] wherein the author proposes a definition of the ideal proportions of the human body, Italian humanists and artists of the fifteenth and sixteenth centuries[101] never think of including a woman's image in this quest for perfection. The body they propose as a model is definitely the virile body, but, more precisely, it is that of a man who has reached the age of Christ's maturity, which is also the time of his Passion. Very shortly after the humanist philosopher Giovanni Pico della Mirandola, in his *On Man's Dignity*,[102] defined the greatness of the human being by his capacity to progress—the fact of having a "potential," a

physical and moral development not comparable to that of animals—the ideal of human accomplishment is set by two conditions: virility and an age of about 30. It is such a man, who no longer has the delicate delineation of adolescence but has not yet been touched by the first marks of old age, that Leonardo da Vinci depicts at the center of two perfect geometrical figures that are the circle and the square to illustrate "The Vitruvian Man." It is again this man who is depicted, in 1521, in the first illustrated edition, in the vernacular, of the Vitruvian treatise, that of Cesare Cesariano, published in Como.

RUBENS AND THE GEOMETRY OF MAN

In the beginning of the modern era, then, when the male body is thought of as an ideal, the painting of the woman's body nevertheless becomes essential as an artistic genre entirely apart: it is the time of the first nudes, from Botticelli to Cranach, and of the Venetian Venuses. Even in this context, however, the artists' observations are the same: the male body is perfect; the female body is imperfect. Around 1400 the Italian painter Cennino Cennini wrote *The Book of Art*, the first treatise on painting that in the West blends practical recipes with considerations that could be, with some indulgence, called "aesthetic." Chapter LXX is devoted to the "measurements that the perfectly proportioned man should have." The "exact measurements," which we will spare the reader an enumeration of, are those of men only. In fact, Cennini informs us, "those of woman I shall not speak of, for she has no perfect measurement."[103]

Two centuries later, a little known yet fundamental text by the Flemish painter Rubens, the *Theory of the Human Figure*, provided the most detailed theoretical definition of virile superiority. Rubens undoubtedly wrote this essay between 1600 and 1609, at the time of the long sojourn he made in Italy, unless he finalized it in the years following his return to Anvers, around 1610.[104] He is steeped in speculations that he actually knows little about but that excite him: Pythagorean thought, otherwise known as a philosophy of numbers and geometry, and the Kabbala. His interpretation of Genesis, and more specifically of the story of the creation of man and woman, is influenced by these doctrines. Man, created by God, is superior: "The virile form is the true perfection of the human figure. The perfected idea of his beauty is the immediate work of divinity, which created it as unique and in accordance with its own principles." Woman is less perfect because she is "the

result of duality"—two being a despised number in the Pythagorean system. In other words, Eve is part of those creatures that having come "after" in relation to Adam, "deviated more and more from that first creature" and "degenerated from his primal excellence."

The description that Rubens gives of the configuration of virile and feminine bodies is completely influenced by this first opinion. It is not anatomical and does not speculate on physiological differences, but it does consider the geometrical figures that structure the man's and the woman's body, which the draftsman should highlight. Now, the virile body is made of those figures that the symbolic geometry of the time considers to be perfect: the "equilateral triangle" (a projection of three, held in high esteem by the Pythagoreans, symbol of the Trinity, and perfect because of the equality of its sides), as well as the square and the cube, made of equal sides like the equilateral triangle.

> [The] cube or the perfect square is the primal element of all strong and vigorous bodies, such as heroes, athletes, and everything that is supposed to express simplicity, weight, steadfastness and strength; for the cube has a base on which it can be held without any other outside help, and it maintains a universal influence over the human species, especially the male gender.

In woman, "the perfection is less"; masculine forms in her are found to have "degenerated from their original excellence." Do the sphere and the circle predominate in her body? It is because of a lack of strength: "The strength of the angles (in the square or perfect cube) is weakened and diminished" in woman. Would this "rounded form" not be "the more beautiful?" Undoubtedly, but in the female body the circle, like the other geometric figures found by chance in it, is only imperfect: "instead of the cube [. . .], it is a long square or parallelogram whose sides are unequal, and instead of the triangle (implied to be equilateral), it is a pyramid [isosceles triangle]; instead of the circle, it is an oval."[105]

MAN, THAT OTHER LION

Illustrated with drawings, an example of which we reproduce here [fig. 4.2], Rubens uses words[106] that speak volumes about the anatomical and moral qualities that the Flemish painter expects to find in men. "Heroes" and "athletes" provide, in his eyes, prototypes of ideal virility. The virile model is made up of "strength," "weight," and

FIGURE 4.2 PETER-PAUL RUBENS, *MALE TORSO*, AFTER THE STATUE OF THE FARNESE HERCULES, CA. 1600–1608, DRAWING, LONDON, COURTAULD INSTITUTE.

Source: © The Courtauld Institute

"steadfastness." These substantive qualities, confirmed in another passage from the *Theory* by the terms "greatness" and "heaviness," are set against the characteristics of the female physique, in which "everything," on the other hand, "is weaker and smaller." Hercules embodies for Rubens the paradigm of masculine strength. He draws the demigod after a famous statue in Rome given at the time to Glycon, and he analyzes at length the relationships[107] of his head with the physiognomy of the lion and with that of the bull. The hero of the twelve labors has a thick head of hair and is hairy like the first of these animals; it is implied that he gets from the lion his sensitivity as much as his power.

This affinity asserted between virility and the "lion's temperament" has been a commonplace, at least in the Italian cultural milieu, since the sixteenth century. Here we must mention again Leonardo da Vinci. He is the creator, shortly after 1500, of a drawing depicting frontally the face of a mature man, with thick hair and a determined if not cantankerous expression. This face is accompanied, at the bottom of the page, by a much less worked out sketch of a lion's head in three-quarter profile. The way in which the leathery folds between the eyebrows (what they call "expression lines") are treated in the face creates a strong link between the two

heads, in spite of the differences in size and presentation as well as the dissimilar degree of completeness. At a time when the conviction has been established that the soul of an individual is reflected in his physique, that it is conveyed in particular in his face and most especially in the eyes and the area around the eyes, the inscription of folds in similar directions between the eyebrows of the man, who one imagines in Leonardo's drawing must be a warrior, and those of the king of beasts, establishes the idea that the two are linked by "sympathetic" ties.[108]

However, it is especially in the Venetian painting of the 1530s that the leonine metaphor becomes fundamental. In Titian's *Allegory of Prudence*, three related faces represent the past (which instructs the present), the present (which prepares the future), and the future [fig. 4.3]. They are placed above three animal heads: a wolf, a lion, and a dog. The portrait that symbolizes the present dominates the lion and is in the center: it is a man in his prime—he is supposed to have been Titian's son. The forehead is large, the hair thick, the cheeks enlarged by a dense beard. Wrinkles are beginning to make lines between the eyebrows, and the lower lip is drawn down a bit, in the same way that the lion was usually depicted at the time. This "leonine type" appears in most of Titian's masculine portraits, provided that the model has reached a certain age but is still in his youth. The Captain-General of Venetian Land, Francesco Maria della Rovere (1490–1538)[109] exhibits, for example, these characteristic traits, although it is

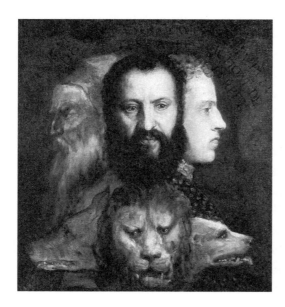

FIGURE 4.3 TITIAN, *ALLEGORY OF PRUDENCE*, CA. 1565, OIL ON CANVAS, LONDON, NATIONAL GALLERY.

Source: © Leemage

unknown whether he actually possessed them or Titian conferred them upon him to flatter him: an abundance of hair, folds at the bridge of the nose, and shadows that, by rounding out the area around the eyes, completed for the sixteenth-century spectator the resemblance with the lion. These are the particular traits that, in a sonnet dedicated to the painting, Pietro Aretino, Titian's communications man, celebrates: "He shows terror between his eyebrows, courage in his eyes, pride across his forehead."[110]

VIRILE COURAGE: A MULTIPLE MEANING

Francesco Maria della Rovere's courage is physical: his aggressiveness results from a haughty character inclined toward combat. Mathias Corvin, King of Hungary in the preceding century, whose contemporaries were already praising his resemblance to a lion, was similarly noted to be *promptus ad iram*: "quick to anger."

The sixteenth century was a time when there arose other ways of being a lion, that is, of affirming one's virility. In ancient Rome the concept of *virtus* evolved from having a bellicose meaning—physical courage—to having a moral meaning—the virtue of the person seeking wisdom.[111] There was similar progress as a result of Christian humanism and especially a better knowledge of Ciceronian thought: the bellicose lions of Leonardo and Titian are no longer the only ones to populate their paintings. They have as rivals those beasts also spoken of by Aristotle and Pliny: magnanimous and peaceful lions. The figures associated with these animals, which are inevitably male, are always those of men. But it is henceforth a distinct type of man: an intellectual. The model is a saint whose figure emerges in spirituality beginning at the end of the Middle Ages: Jerome, monk, doctor, and cardinal, penitent in the desert or humanist in his workroom.[112] The physical demeanor of this saint is never suitable for evoking a lion: he is depicted as aged, hoary, and often beardless. But he is accompanied by this animal that serves as his emblem, the lion: dangerously vigorous, yet, at his side, as docile as a cat. In the fourteenth and fifteenth centuries the beast is shown with the saint while he domesticates it in the desert, caring for a wound to its paw. Around 1500 Vittore Carpaccio shows the lion following Jerome to the monastery, where it elicits terror from the brothers. Albrecht Dürer and also Antonello da Messina depict it sleeping in the dwelling where the saint meditates and studies. The image that the beast projects is that of a virility rethought. Pride and irascibility, qualities regarded—as we have seen—as

intrinsic to a virile nature, are controlled and tamed; while virtually present, they no longer serve as support for one's personality. The victory over oneself determines one's progress toward the knowledge of God. The difficulty of this step is enormous. It makes of the man who undertakes it and carries it out successfully not only a lion but a lion conqueror. Thus, in the portrait of Erasmus by Hans Holbein the Younger, an inscription runs along the edge of the book where the humanist's hands are lying: *Heracles ponoi*—"the labors of Hercules."[113]

THE CODPIECE

The depiction of man, in fact, wavers in the sixteenth century between an image of strength and another in which athletic characteristics give way to grace or to moral qualities that do not appear particularly impressive.

In Holbein's work, specifically, this alternative appears clearly. The author of the portrait of Erasmus as a hero of the mind is also the painter who, with his depiction of King Henry VIII of England, creates a silhouette whose stocky appearance is a sign of virile majesty. The sovereign was naturally of an imposing stature, and the first paintings that depict him do not hide this characteristic. When Holbein becomes the official painter of King Henry in 1536, the king's corpulence changes to obesity. The artist makes a positive quality out of this situation. He exaggerates the build of his model in such a way that the portraits of his bust never manage to contain the king's shoulders entirely—they seem about to exceed the frame. In the only full-sized portrait of the king by Holbein known to us[114] [fig. 4.4], the spread legs increase the solidity of the figure, and the skirt of the doublet is split over the codpiece, decorated with a knot in padded fabric as was the fashion, thus highlighting the place of the virile member.

The portraits of Francis I, Henry VIII's rival for power in Europe and also a man of heavy stature, present the same characteristics, as if the rivalry between the two men were expressed in the exhibition of their manly power as well. Painted in Italy around 1539 without Titian's ever having met the king but based on a medallion, his portrait depicts Francis in profile, bearded, with slightly puffy features, the neck powerful and the chest very broad.[115] About fifteen years earlier, François Clouet's portrait captures the king in his thirties, more slender and more muscular.[116] His chest spreads out over the entire width of the painting, and the wide paneled sleeves emphasize a broad stature that this painter also refrains from keeping within the dimensions of the painting. The portrait is of the head and shoulders,

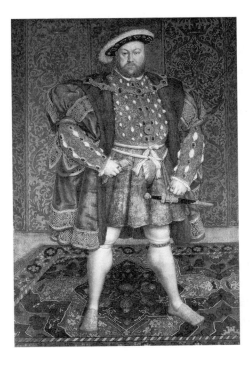

FIGURE 4.4 HANS HOLBEIN, *KING HENRY VIII*, 1537, PEN AND WASH DRAWING ON MAROUFLAGED PAPER ON CANVAS, LONDON, NATIONAL PORTRAIT GALLERY, DETAIL.

Source: © Belvoir Castle, Leicestershire, UK/ Bridgeman Images.

with the rest of the body not visible, but the huge nose, bowed at the top and slightly curved at the bottom, aquiline, forms a powerful appendage that might also appear as a mark—a metonymy—of his virility.

In the portraits from the south of Europe, in Italy, and particularly in Florence at the court of the Medicis, phallic presence is expressed, as with Henry VIII, in an extremely literal manner by highlighting the codpiece; framings were frequently cut off at the thighs. In Bronzino's portrait of Guidobaldo della Rovere[117]—a handsome boy of 18 years old known for his amorous ardor and portrayed with a thick beard despite his youth—this part of his clothing is treated with extraordinary attention. What is called in Italian the *cazzaria* sticks out from the armor in suggestive, stupefying relief. The effect is accentuated by the play of complementary colors: the *cazzaria*, in satin embroidered with gold thread, is of a red that stands out against the gray-green and green of the armor and the background curtain. The model's sexual potency is made manifest—what one historian nicely calls his *vis generative*: "his capacity to perpetuate himself."[118]

. . . AND THE STOMACH

The painter has at his disposal still other means, less explicit than the *cazzaria* or the beard or the stature, to emphasize virility. Masculine beauty depends on a silhouette—or rather, let us say, on contours, since the other word is anachronistic.[119] The clothing, the first piece of artifice, determines how these contours are modeled, but the metamorphosis is achieved by the painter, who redesigns bodies at will. Let us take another look at the well-endowed Guidobaldo. The young nobleman has chosen to pose in the brand new armor that has just arrived from Milan. His chest is straight—inasmuch as the back side of the armor prevents him from bending and the waist is squeezed in, but the breastplate presents a bulge at the level of the abdomen. The volume that results from this arrangement is artificial and quite different from what is customary today. The corset does not emphasize the pectorals, it does not flatten the stomach, but, on the contrary, it makes room for a place where a vast paunch may be lodged or, in the case of the slender Guidobaldo, suggests an artificial void where the stomach is virtually present. An examination of sixteenth-century armor confirms that this is a general characteristic: the convexity of the breastplate contributes to the pomp of the virile body. In another portrait by Bronzino, that of a grown man, the *condottiere* Stefano Colonna,[120] the painter, who was also a connoisseur of weaponry, decked out his model with black armor adorned with gold chasing. He worked on the light and dark values so as to highlight the bulge of the corset around a crest that divides it into two halves. More surprisingly, this crest, which is treated like a line, is found underneath, in the slit of the skirt of the armor through which the *cazzaria* juts out. While the latter is modestly painted in black, it sticks up very high and forward, and its end, split by a vertical piping, might evoke a glans and meatus.

Even semi-civil clothing—that of courtiers likely one day to bear arms—confirms the tendency to "puff out the chest" or rather the stomach area in the depiction of a masculine model. A contemporary of Bronzino, Jacopo Pontormo, paints the figure of an adolescent in the famous *Portrait of a Swiss Guard*:[121] perhaps a young man named Francesco Guardi, then 15 years old.[122] The model, standing up straight and leaning against the halberd that has given the painting its name (French title: *Portrait d'un hallebardier*), is wearing a red pant on which the beginning of an enormous knot designates the *cazzaria*, and above the waist, whose narrowness is emphasized by a fine belt, a jacket whose buttonhole is in alignment with the obvious circularity. The history of fashion teaches us that a semi-rigid lining could lend such a convexity to this part of the clothing.

THE POSE: BEGINNING OF AN EVOLUTION?

When looked at closely, the posture of Bronzino's Swiss Guard is character-ized by a gesture that is quite probably not without significance. The boy is standing, his face turned toward the spectator; he looks out without timid-ity, the lance of his halberd held tightly in his right hand. The other hand is positioned on his hip above the pommel of the sword. This latter gesture gives the model a kind of swagger: it is the means by which the young man displays his self-assurance, whether he actually experiences it or just wishes to appear determined. Evidenced here for one of the first times in the history of portrai-ture, [123] it is found again, throughout the sixteenth and seventeenth centuries, only in the paintings of a male model. The hand on the hip appears at least once in another portrait by Bronzino,[124] and it is present in other Italian art-ists' works of the sixteenth century.[125] By the next century it is found all over Europe. In Rembrandt's bourgeois Holland, the dandy on horseback in *The Polish Rider*,[126] the surgeon's colleague in the *Anatomy Lesson of Dr. Deyman*,[127] or the self-satisfied companion of Captain Cocq in *The Night Watch*[128]—all place a fist on the hip. In van Dyck's monarchistic England, the painter him-self in self-portraits during his youth,[129] the extrovert Sir Endymion Porter beside the painter,[130] John Stuart in a beautiful portrait that depicts him at 21,[131] King Charles I as a hunter [fig. 4.5], and still other models[132]—all exclu-sively men—prop their hands on their hips. In France under Louis XIV the full-length portraits of the king capture the same gesture: this is true as early as Louis's childhood (for instance, in a painting that depicts the little king with his brother Philippe next to Anne of Austria[133]) and up till his later years (as in portraits by Hyacinthe Rigaud around 1700[134]). Still in France, but during the first half of the century, Rubens uses the same pose very obviously as an indica-tor of virility, viz., in *The Marriage by Proxy of Marie de' Medici to Henry IV*,[135] painted for the Parisian cycle at the Luxembourg Palace.[136] In the absence of Henry IV, who was delayed in France and would be receiving Marie in Lyon, the fiancée's uncle, the Grand Duke Ferdinand of Tuscany, plays the role of bridegroom. The man is short, stocky, and not very young anymore. Rubens depicted him with his chin raised toward Marie, his legs apart in such a way that he seems able to stand up against an attack, and his left hand resting on his hip, or, more precisely, in a quite curious manner given the circumstances inside a church, positioned on the pommel of his sword.

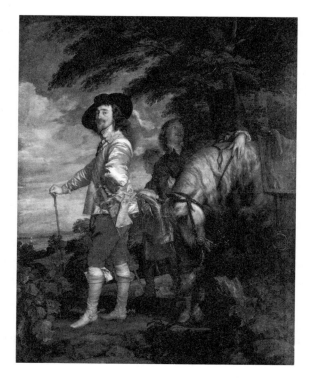

FIGURE 4.5 ANTOON VAN DYCK, *PORTRAIT OF CHARLES I, KING OF ENGLAND,* CALLED *CHARLES I AT THE HUNT*, CA. 1635, OIL ON CANVAS, PARIS, LOUVRE.

Source: © Peter Willi/ARTOTHEK

SWORD AND GLOVE

This gesture is certainly military in origin. Vittore Carpaccio, in one of the most famous works of Venetian painting, the *Young Knight in a Landscape*, done in 1510, depicts a young man—no doubt Francesco Maria della Rovere—in armor, legs apart like needles on a compass, the *cazzaria* evident through the gap of the metal corset—on the point of unsheathing his sword. The gesture can be explained by the circumstances: the boy has just been named by Pope Julius II, his uncle, Captain-General of the Pontifical Troops.[137] In the motion that he makes, his arms move away from his chest and his hands come together above his codpiece. The posture suggests a determination in accord with the inscription on the piece of paper set on the ground ("better to die a man than to be defiled"[138]) and contradicts the youth and the melancholy of the tilted face: the expressive force of the

painting comes from the union of these apparently opposite attitudes. While the *Young Knight* is not the origin, in the genetic sense, of the portraits that depict noblemen or sovereigns with their hands on their hips, it does bring together the elements that, whether declining or reuniting, are emblematic of the conception of what we would call virile leadership in the Renaissance—elements that consequently influence the depiction of its leaders: the legs apart, the arms bent and spread out from the chest, the hands joined (as it happens, on the sword above the sex organ), and an expression, here on the face, that tends to temper what could be a too brutally martial attitude.

Let us go back to the Henry VIII iconography. The virile power of the sovereign is highlighted not only by the display of his corpulence and the ostentatious presentation of that part of his body used for procreation but also by the pose. In the full-length portrait we brought up, the legs are therefore wide apart, while one hand is set above a short sword. The other hand, however, forcefully clutches gloves. In another famous portrait of the same king, framed just above the sex organ and again by Holbein, the hands again grasp vigorously, one the pommel of a sword, the other gloves.[139] The choice of this accessory is anything but anodyne. In the sixteenth century, gloves, appearing in numerous paintings, notably Italian ones, are among the signs in clothing of what will much later be called "distinction," what Norbert Elias defined as "*courtoisie*."[140] In fact, the combination of sword and gloves is found in the portraits of Henry's rival, Francis I.[141] In paintings depicting the king of France,[142] however, the essential difference is that Francis is not clutching any one of these objects. He delicately places his hands on them: hands that the painter has intended to be solid (the fingers are wide, rather short in comparison with Italian portraits) but also immaculate, manicured, with small nails forming a perfect oval.[143]

LEG AND CALF

The obviously masculine strength exhibited in the portraits of the English king is mitigated, then, in France by a softness that might be called "elegance." Virility becomes a composite of controlled strength and social comportment, manifested in clothing and gesture that are "*courtois*."

Outside of France, the evolution of the male portrait confirms this combination. In sixteenth-century Florence, competing with the very male model invented by Titian and Bronzino, Pontormo around 1518 and Giorgio Vasari a few decades

later each proposed an ideal vision of Cosimo the Elder of Medicis and Lorenzo the Magnificent.[144] In the two paintings the loose clothing reveals nothing in the area of the sex organ, no sword appears, the heads of the Medicis are seated and not standing, and their gestural attitude is relaxed. They are pensive, their faces bent slightly forward, their hands interlaced (Cosimo) or nonchalantly at rest (Lorenzo). Is it because these are posthumous depictions? The idealization of these illustrious dead men undergoes a practically abstract treatment, which does not stress their masculinity but shows them in the *otium* of the sage—with clairvoyant reflection, which might also be called *prudential*—rather than in action. In Spain royal iconography evolves no differently. Whereas Titian, with a few exceptions,[145] immortalizes Charles V, then Philip II, in armor and with the emblems of power (*bâton de commandement* and especially lance, sword, and helmet[146]). Velásquez, a century later, chooses a sober black outfit for Philip IV and places next to him a hat; and in his hand is a glove or a letter, casually held with his fingertips.[147]

It is, however, in France that the most significant transformation comes about. Following the portrait of Louis XIV with his brother and mother that we spoke about, the iconography of the king evolves rapidly. In 1648 Henri Testelin depicts him as still a very little boy, alone, seated in an elevated position, holding in one hand a *bâton de commandement* and delicately holding in the other a crown of laurels.[148] His ermine-lined mantle is high-cut: a bit of the puffed-out pant can be seen, as well as, most especially, a leg girded in a white stocking, the knee nicely rounded; the fine foot is covered with a shoe of the same satin as the stocking and pointed. At the other end of the king's life, at a time when he was suffering from gout and appeared nearly incapable of moving, his portraits by Hyacinthe Rigaud celebrate the same part of his body: the legs, visible up to the top of the thigh, girded in stockings, and the calf turned outward and highlighted by the grace of the high-heeled shoes.[149] In a context that beginning with Henry II accords more and more importance to celebrations, this transformation can be explained by the role played henceforth by dancing. Louis XIV, to be precise, shows himself to be an excellent and passionate dancer in his youth. The sovereign, who founded in 1661 (a few years before he stopped performing) the first troop of professional dancers,[150] is the inventor and promoter of at least one "*pas*" that bears his name: the "*pas royal.*" In 1653, his appearance as Apollo in the *Ballet de la nuit* earned him the nickname that he kept forever: the Sun King (*Roi-Soleil*). A watercolor[151] depicting him on this occasion exalts what the Italians call *sprezzatura*: a gracefulness preferred over virile strength, a body closer to the figures by the artist celebrated as the "divine Raphael" than to those of Michelangelo, whose male vigor is judged at the time as

"dreadful" (*terribilità*). The king moves his arms away from his chest; his hands are free, and his fingers are harmoniously raised. A short skirt highlights his legs; ornaments draw attention to the calves; and his feet, in heeled shoes, are placed one in front of the other in one of those positions codified during the period as part of the dance that was destined to be called "classical."[152]

The characteristics of the portraits of Louis XIV are already partially present in those of his father. In *Louis XIII Crowned by Victory*[153] (1628) Philippe de Champaigne depicts the king in armor, a helmet set down near him, in the Italian tradition (Titian) of the sixteenth century. But the prolonging of the corset by greaves substitutes for the highlighting of the area of the sex organ; the area of the legs are covered with supple thigh boots. The heel is raised, and the toes are pointed at a right angle in a choreographic position. The male gesture of the hand on the hip is subtly transformed: the fingers do not rest on an accessory, but the fist is turned at a right angle, the back side of the hand and not the palm rests against the costume. Around the same time, in England under the reign of James I,[154] dance has a more decisive influence. In the divertissements arranged by the court for itself called "masks," the king opened the ball before the noblemen around him: his body is the prime mover of the spectacle, as his authority governs the whole of England. The architect Inigo Jones, master of royal architectures, takes part in these ballets by designing costumes for them. Under the influence of these spectacles, mythological portraits come into fashion. In 1620 and 1621, George Villiers, first Duke of Buckingham, a favorite of the King, has himself depicted by Antoon van Dyck as Adonis.[155] His loose hair floats over his shoulders; he is to a great extent nude, covered only by an antique-style drape. Finally, the painter has captured him in the action of walking, one foot behind, leaning on his forward leg and swaying, in the style of a classical statue with a gesture he makes of bending toward his bride (herself costumed as Venus).

The evolution that affects the courts also concerns the civic sector. In that part of the European population that belonged enough to the elite that it could imitate the codes of nobility and order portraits, elegance is favored over the assertion of strength. In the portrait that Rubens paints of himself with Isabelle Brant on the occasion of their marriage, the focal point of the bridegroom's outfit is located in the lower part of his body: in his legs, girded in bright orange stockings and crossed.[156] In the paintings by Rembrandt that we have discussed,[157] the hand sits backwards on the hip and holds no accessory, much less a sword. A century later, when dance is no longer the frame of reference, at least for men, the latter are no longer caught up in the fluidity of choreographic movements, but a code of self-presentation appears, made up of reserve and discretion—much closer to the

traditional comportment required of women than to the fierce attitude of the portraits of the sixteenth century.[158] The body is reduced rather than amplified by the painter, and the arms are no longer held out from the chest but clenched against it. What is more (and this pose characterizes male portraits only), one hand is pressed against the breast, or rather just below it, at the level of the stomach.[159] This gesture, which is noted so often in the images of the Emperor Napoleon and for which a medical explanation has even been invented,[160] is seen with great frequency during the second half of the eighteenth century and up to the middle of the nineteenth.[161] Tracing its history would take us too far afield chronologically. It is remarkable, however, that Ingres's work shows the last vestiges of it. While the *Portrait of the Count Amédée-David de Pastoret*, a great civil servant during the Empire and then under the Restoration, combines two attitudes—one hand on the belt, above the sword, and the other on the stomach, a thumb in the waistcoat,[162] the *Portrait of M. Bertin*,[163] a few years later, adopts a completely different schema. Ingres has the model pose in a seated position, a posture that emphasizes his virtual obesity. He paints him with his legs spread, despite any sense of grace or even decorum.[164] Above all, Bertin seems to be on the alert, his short broad hands leaning on his knees so as to be able to get up quickly, to abandon as quickly as possible this posing session that can only seem to him a waste of time. This is because the man, director of the *Journal des débats* and thus one of the first magnates in the history of the press, embodies a generational type that is quite different from the noblemen of the *Ancien Régime* or of the public officials of the beginning of the nineteenth century. He is a "captain of industry"—the warrior metaphor makes sense. Ingres understands him so well that his *Portrait of Bertin* has become an icon: the emblem of physical power and vigor, the image of the obviously formidable male; a reincarnation of Henry VIII[165] at a time when power belonged more to the men of media and money than to politicians and soldiers.

ONE PET: THE HORSE . . .

The masculine specificity of models is, however, not figured solely by the configuration of their body (i.e., the equilateral triangle, the square), the definition of a type (the leonine man), or the elaboration of a pose (more or less aggressive or refined). Functioning as significant accessories, two pets characterize the virile portrait.

The first of these animals is the horse. In a society in which moving about and engaging in warfare—in other words, in all the activities of influence and

responsibility—are tied to the possession and the mastery of a horse, the collective perception is that virility and an aptitude for riding are linked. What is called the "centaurization"[166] of the masculine half of humanity has an early influence in a boy's life, or at least in symbolic representations of it. The little male child has scarcely forsaken the sleeping gown that he wears during his first years before he is given a wooden horse: this is the one that, of all the toys, figures most frequently in boys' portraits.[167] A little later, the child has lessons on a real horse: the theme of the horseback lesson is essential for future kings (as in Diego Velásquez's painting, *The Infante Baltasar Carlos*) or even for the petty bourgeois. Again at the beginning of the nineteenth century, a scene of family life shows the horseback lesson given to the son by the father while the little girl remains next to her mother on the doorstep, observing.[168] In his engravings of the "ages of life," consisting of images of human existence in the form of a stairway going up and down, the young man who is approaching the age of twenty is depicted on horseback. Equestrian education is the mark of adolescence, and acquired horsemanship the sign of accession to adulthood—the equivalent of the driver's permit for today's youth, but a permit to be had by boys only.

From then on, the pictorial celebration of a model as horseback rider, called the "equestrian portrait," may be considered an ideal form of the virile portrait. This type of portrayal is, in fact, reserved—or virtually reserved—for men:[169] the decorum imposed on women who mount on horseback forbids adopting the ancient model of the general on horseback in a portrait, even in the case of a sovereign. The impossibility for women of "straddling" a horse results in a serious handicap: the horsewoman cannot ride fast; she cannot lead troops into battle. This situation gives an indication, conversely, of the portrait of the ideal male: a rider astride a horse, off in a gallop whose rapidity galvanizes his troops. *Bonaparte Crossing the Alps at the Grand Saint-Bernard Pass* by David[170] and *An Officer of the Imperial Horse Guards Charging* by Géricault[171] exemplify this iconography—in both paintings the pant molds the thighs and the boots clearly squeeze the animal's flanks. In other words, the beauty and vigor of the leg are highlighted.

Again, though, it is necessary to look carefully at the paintings. As with the virile portraits that are head-and-shoulders or full-length, two types vie with one another, in accordance with the position of the horse. While the sculptors capture the animal most often in a peaceful stance, stabilized on three or four legs, the painters, who do not have to worry about the physical equilibrium of their figure, generally prefer a more dynamic stance, the mounts rearing on their hind feet. One variant, miniscule to the eye of the neophyte but quite significant for experienced

spectators, presumed to belong to the elite who were used to the rules of equitation, has to do with the animal's legs. In battle scenes or portraits that evoke the military prowess of the model, from Titian's *Equestrian Portrait of Charles V*[172] to *An Officer of the Imperial Horse Guards*, the hind legs are spread apart from each other, one leg in front of the other,[173] and the front legs are not aligned; the painter insists on the spirit of the mount, rearing or ready to kick, and its excitability reflects the horseman's ardor. In battle or hunting scenes involving horsemen, the horses' stances are sometimes improbable as a result of being twisted: the realism of position is less important than the impression of movement that must be given.[174] In other paintings, however, the horse's position is that of a trained beast, under control and on display. This is called the *"levade,"* in other words, the adoption for a few instants of immobility and unstable balance, the back hand curved at the level of the hips and the front hand raised, with forward feet folded in. It is this stance that the riding instructor is teaching to little Balthasar-Carlos in the painting by Velásquez that we discussed; it is the one that the same painter captures in his most famous equestrian portrait of the child;[175] and finally it is the one that the same artist chooses both for Philip IV and for Olivares.[176] The *levade* is depicted at more or less the same time at the other end of Europe, in Flanders, then under Spanish domination: Jacob Jordaens devotes two scenes to the positions being taught and practiced in sketches made to serve as patterns for tapestries on the theme of *The Equestrian School.*[177] Spirited horse or dominated horse, the choice of one stance or another has the same meaning as the poses that we examined for human models. They express a virility that is the representation of power, whether brute or refined by self-control. The man on a spirited horse is a warrior-horseman, Marcus Curtius hurling his mount into an abyss in order to save Rome, or that *enchiridion milititis christiani* whom Erasmus speaks of and who might be embodied by Saint George. The person who gets his mount to perform a *levade* is the product of a "civility" obtained through a long education: a gentleman capable of participating in that other divertissement prized by the courts beginning in the Renaissance, equestrian choreography and horse ballets.[178]

During the period that we are examining, the image of the warrior on horseback does not disappear; it remains very much present, as we have seen, in the Napoleonic saga. For all that, the equestrian figure evolves most often toward a mode of representation removed from the effigy of the fierce combatant. Van Dyck's *Charles I at the Hunt*[179] is, from this perspective, remarkable. The king is "at the hunt," but he is not engaged in hunting: the point of the painting is not at all to show him in combat or to display his strength or poise. As though he is

a "gentleman farmer" or an aesthete, Charles admires the landscape or the lands that are his dominion, since he is king. To this end, he has dismounted from his horse, which a valet holds still—although the animal is more interested in trying to graze than in breaking away. Charles, luxuriously dressed, a sword at his side but in his doublet and not in armor, is standing, leaning casually on his cane. His hand is on his hip, palm turned to the outside, fingers elegantly holding gloves. The figures of the elegant courtier, the dancer, and the cavalier have finally been brought together; gracefulness, the Italians' *sprezzatura*, has won out over male energy, which is simply suggested by the decorative sword and the peaceful horse.

. . . THE OTHER, THE DOG

To engage in hunting requires a mount, but also the presence of dogs: one of Velásquez's *Philip IV as Hunter*,[180] almost exactly contemporaneous with the portrait of Charles I by van Dyck, shows the King of Spain, not on his horse or next to it, but with a rifle in his hand, standing, with a dog by his side.

In fact, the figure of the dog appears with some regularity in the portraits of men. It is the substitute for the horse, suggesting the same qualities (ability to fight, whether in the context of war or of the hunt), and it replaces the horse, in particular when the model is painted in an interior. The dog is no doubt present also in the female portrait: thus, in the portrait of Arnolfinis by Jan van Eyck,[181] the image of the couple at home, a little long-haired dog is painted in the foreground next to the wife. The dog is present in funerary décor, both for men and for women; it is regularly found, in sculpture, at the feet of the male or female recumbent figure. For men, the dog is sometimes replaced by a lion, which never occurs in the case of a deceased woman. Now, this difference is of great importance: if the dog is emblematic for both man and woman, the one that appears next to the former is not the one sitting next to the latter, and it does not have the same meaning. The dog by the woman is what might be called the generic "pet:" a creature of small size, regardless of the model's age. A companion animal in life, it symbolizes faithfulness in the paintings, and in a certain manner the piousness of the person depicted: are not friar preachers nicknamed *domini canes*, "dogs of God?" The woman accompanied by her little dog is thus the guardian of the temple, in other words, of the home and of the family and its faith.

Conversely, an adult man is never accompanied by a small dog. Although very little boys are sometimes depicted with an average-sized animal, the dog grows up

with them, and one could maintain that the privilege of being painted with a large dog is a sign of accession to the age of male maturity. In any case, the animal that accompanies adult men in paintings is always either a large dog or a tall, slender hunting dog, such as a greyhound. As early as the fifteenth century, such dogs are painted, a little after 1400, ostensibly by the Limbourg Brothers, in the entourage of the Duke René, for the calendar of the *Très Riches Heures du duc de Berry*,[182] then later in the century by Mantegna in the fresco depicting the Duke of Mantua and his entourage at the Palace of Mantua. In this last painting, a large dog naps right under the duke's seat.[183] The sixteenth and seventeenth centuries mark the high point in the representation of virility by a dog. In Germany, Hans Holbein the Elder completed full-length effigies of the Duke and Duchess of Saxony. A very little white dog with long combed hair flanks the wife. The husband, martial in his not very discreet yellow and red outfit, his feet practically at right angles, unsheathes his sword: a large mastiff sniffs the ground at his feet.[184] In Italy, Titian, who paints, incidentally, a little boy between a big female dog nursing and a male Labrador,[185] depicts a dog in a male portrait at least three times: for Frederick Gonzaga, a dark, bearded leonine man, sword at his side;[186] for an unknown man, a handsome Casanova in a flattering pose holding his lance suggestively in a canvas in the Kassel Museum;[187] and for a full-length portrait of Charles V at the Prado.[188] In this last painting, the sovereign, his hand on a flywhisk and not on a sword, pets rather than controls a huge white dog that he holds by the collar. Confidently, the animal raises its head toward its master: its muzzle draws attention to the area of the man's sex organ, in other words, his codpiece, which Charles's right index finger also seems to point to.

In the seventeenth century, the most beautiful and important portraits of men with a dog are painted by Antoon van Dyck in an England smitten with Italian painting and therefore filled with Venetian examples. In 1637, the *Portrait of Charles I's Five Children*[189] places the heir to the throne, Charles Prince of Wales, in the center of the painting. The boy, still a child, places his hand on the head of a monstrous dog that comes up to his chest. Other aristocrats as well, grown men like Philippe Le Roy or Thomas Wentworth, First Count of Strafford,[190] young adults like John Stuart, Duke of Lennox and of Richmond,[191] or adolescents just at the age of puberty like Prince Rupert von der Pfalz,[192] are painted by van Dyck with a dog.

Shall we follow this line of thought to its logical conclusion? In Spain, a bit later (1656), the extraordinarily celebrated painting by Velásquez, *Las Meninas*, might well set up the same symbolic relations—and it would then be charged

with an element of dynastic criticism. As we know, the work depicts the painter in the process of working on a large canvas that we see only the back side of: it is perhaps a portrait of the Spanish royal couple, since the faces of Philippe IV and his second wife Marie-Anne of Austria can be seen in what seems to be a mirror in the background.[193] What we are allowed to see, in fact, is mainly the image of the little *infante* Margarita Teresa (born in 1651), accompanied by her retinue. Since Balthasar Charles had died ten years earlier, Margarita's elder sister, Maria-Teresa, daughter of Philip and his former wife, is then—albeit only in appearance—heiress to the throne. The peace negotiations with France that begin that year include the secret project of a marriage with Louis XIV, accompanied by the fiancée's renunciation of her dynastic rights.[194] Margarita, consequently, becomes the one who represents the future of the monarchy. Unlike France, Spain does not exclude women from dynastic succession. But this situation, accompanied by rigid restrictions,[195] could not be enjoyed by the Spanish nobility, who were attached to male supremacy as much as to the dogma of "*limpieza de sangre*"—purity of blood. Let us look, then, at the painting: positioned near the *infante* is a dog, quietly lying down. If the child were a boy, this dog would be the expected emblem of a nascent virility and therefore a gauge of the aptitude to rule. But this is a girl, a charming princess whom her maids in waiting (the *meninas*) shower with attention. The animal one would expect to be next to her is one of those little dogs that we generically call "pets." But next to the dog, which we learn from the documents responds to the name Iago,[196] is a male or female dwarf, typical of men and women very often present in the European courts, whom Velásquez painted several times and who, along with buffoons, were supposed to amuse the great but also make them hear what their counselors would not dare tell them. So, while the female dwarf stays calm, the little man—named Pertusato—pushes the dog with his foot as though to make him leave: to chase an intruder away, to denounce an imposter?[197]

THE COMMON MAN: COMPORTMENT IN SOCIETY

The men we have spoken about until now are ideal types: gods or demi-gods (Hercules, Adam, or the abstract figures from treatises on proportion or anatomy); kings and noblemen; or personages from an elevated social rank intent on financing, at times repeatedly, their portrait or that of their offspring. In order to grasp, through figurative evidence, the meaning of virility in everyday behavior during

the modern era, we must turn to other paintings: genre paintings that bring to the fore common people. The Northern schools, during the sixteenth and especially the seventeenth centuries, offer the first and most frequent example of this type of representation, which was denigrated in southern Europe. Children's games, drinking sessions, peasant banquets, and household feasts intended for the entertainment of a bourgeois public repeat motifs and situations like so many clichés. In Italy, a few paintings, notably ones relating to childrens' education, furnish important indications as well.

In all these works, treating life from one end to the other, the fate and the behavior of the sexes are differentiated. Little boys, then men, and little girls, then women, are placed in different situations, and the painters assign them specific attitudes, somewhat unintentionally—without seeming to reflect in any manner whatsoever on the meaning or the impact of the way they vary genders. The divergence between boys and girls goes without saying, beginning with the age of childhood play and schooling. Male children are depicted with toys that, besides the wooden horse, a short sword, or a drum, imply aggression or at least that assume motion and noise; little girls are shown with a doll or holding a bouquet. Paintings that depict groups of children allow a discreet place for little girls, generally relegated inside or next to houses.[198] In *Children's Games* by Breughel,[199] the scrappers—those who sit astride a barrel, who straddle a fence, or who play at hoops—are all or almost all little boys: the outside—public squares or urban streets—is their playground.[200] The education of boys and girls occasions a similarly contrasting iconography. That of girls is done at home, by women: the model for this is Saint Anne teaching Mary to read. As for little boys, they are again destined to leave the home: they go to school. Matthäus Schwartz, a Nuremberg banker of the sixteenth century, was so taken with beautiful clothes that, in the middle of his life, he charged a painter to establish the visual chronology of the outfits that patterned his existence; he has himself depicted as a child at the time he is coming home from school, sitting down, his little satchel next to him, busy doing his homework.[201] In engravings and sometimes in small paintings in the North, the motif is a working-class school: the children, all male, are shown as restless and dirty, more interested in playing than in learning—and they get whipped for it. The conclusion one draws from this type of painting is that a little boy has a restless body into which a soul must be forced by means of physical punishment. In Florence, in the Hospital of Innocents where orphans or abandoned children are taken in—and these are more frequently little girls than little boys—a fresco by Bernardino Pocetti commemorates the life of the institution.[202] While a few

orphans are shown praying in the foreground, the back of the painting is devoted to an evocation of how the boys spend their time. They are seen in the dormitory, in the refectory, and in the classroom: the large, undifferentiated group is formed by small personages evidently engaged in an active social life.

The behavior of adult men and women is also seen as different in genre paintings. The man is shown as an animal of a decidedly sociable nature, but also with a body that is quite tangible. In fact, as soon as they are dealing with common folks, the painters show a particular interest in anything that is organic. Far from idealizing their models, they often endow them with heavy layers of flesh that no soul would be able to imbue with spirituality. However, they do it differently for each of the sexes. It is very rare that women are painted in the process of swallowing, but *The Beaneater* by Annibale Carracci depicts a peasant stuffing himself with vegetables.[203] Few women's faces are shown with wide open mouths: on the other hand, the motif of the *Yawner*, a man's face deformed by the stretching of the mouth, is frequent in Flanders beginning with Breughel.[204] Until the late nineteenth century—e.g., *The Absinthe Drinker* by Degas—artists were not in the habit of depicting drunken women: a painting by Pieter de Hooch, which depicts a young woman with bleary eyes whom a self-serving man has made to drink too much, would be an exception.[205] Conversely, men, sole tavern customers, gulp down innumerable steins of beer. In the *Peasant Feasts*, one of them who has eaten or drunk too much is shown vomiting. A woman is sometimes holding the unhappy man's head[206]—the reverse situation is never painted. Similarly, the subject of the smokers' den, so popular in the North during the seventeenth century, with painters Adriaen Brouwer and then David Teniers, involves men exclusively.[207] In these scenes they are inhaling tobacco smoke, puffing out smoke rings, filling up their lungs and their bellies, using their mouths for anything other than speaking—in short, drinking too much, eating in excess, yawning excessively, and undoubtedly hollering in brawls. The characterization of the lower-class adult male places an emphasis on the organic; in the man of the common folk, and in particular in the rustic man, there resurfaces naturally the boy-animal that education has not tamed.

The series of paintings by Jacob Jordaens, so unusual to our contemporary eye, which depict family feasts under such titles as *The King Drinks* or *As the Old Sang, so the Young Pipe*, provides a commentary that is no different. The family depicted is Jordaens' own: his wife, his in-laws (the master who trained him, Adam Van Noort, and his wife), and his children. It is not possible to imagine in these paintings any hateful intention: at most there is an irony not without tenderness. Relying on

the proverb on which the title is based, "As the old sang, etc.," the commentators analyze these paintings as examples of the continuity between generations, an idea underlined by the moralist of the period, Jacob Cats. Cited in the catalogues, a maxim by Cats taken out of context—from a famous treatise on marriage[208]—may, nevertheless, be understood in a bawdy sense that Jordaens would have been likely to appreciate: "It is certain that time will finally reveal [. . .] in man his innate nature." Among the musical instruments, only wind instruments are depicted, and they are being used solely by males. This is not by any means an accident: in the Middle Ages string instruments were regarded as symbolizing the spiritual pole of man and wind instruments his carnal urges. Now, the old man, like the women, is satisfied by singing: the use of the past in the maxim signifies that his aptitude for making use of his organ—his instrument—is now only a memory. But adult men play the bagpipes, precisely the instrument that the Church speaks out against most explicitly, and little boys, certainly not little girls, have a go at the flute.

In a self-portrait motivated by an even more pronounced sense of self-mockery, Jordaens shows himself blowing on a bagpipe.[209] His brow is wrinkled, and the lower part of his face is distorted in the effort needed to get the maximum sonorous volume. That paunch, highlighted in the sixteenth century masculine outfits and armors for noble models, is again found in the form of the stomach and lungs, swollen with food, liquids, and air; here it is used to characterize virility, humorously, mockingly, in its most trivial modes of expression.

In the paintings, the refining of the common man is decidedly very slow. A settling out that lasts an entire lifetime leads the young man, full of flesh and humors, toward a completely different physical type. Again, the evolution is remarkable by dint of being in contradiction with that of the woman. The painters depict old women in genre scenes or in type portraits that, in other periods, would be characterized as "mugs" (*trognes*), or caricatures. From Leonardo da Vinci or Metsys (*The Old Duchess*[210]) to Goya (*The Old Women*[211]), the older woman appears in paintings as a madam or a delayed coquette who shows off her charms even when she is over the hill. The model of Saint Anne, regardless of the efforts made to promote it, is powerless to hold these negative suggestions in check. On the contrary, thanks to Saint Jerome, whose role we have seen in reshaping the virile image, the old man establishes himself as a positive figure in a much more edifying type of painting, i.e., religious pictures. Leonardo[212] or Dürer,[213] at the beginning of the sixteenth century, provide admirable examples of an iconography that culminates in the seventeenth century with the Caravagesque School, particularly in Spain with Ribera:[214] that of an ascetic old man, beardless or with the beard of a

sage, whose gauntness always symbolizes the renunciation of sensual pleasures—in short, a virility devoid of its fleshly substance, and thus distilled and confounded with philosophical renunciation.

THE HUSBAND AND HIS WIFE

In a Christian social order in which, outside of Catholic priests and monks, the man is expected to leave his parents and to establish a home, the construction and expression of virility are indistinguishable from the situation of being married. The adult male is defined by his function as husband, and the portraits of couples, which grow in number, particularly in the North of Europe at the beginning of the modern era, attest to his position in the home and most especially in relation to his wife.

Prior to the appearance of these portraits or, at one time, coterminous with them, families—the man and the wife with their children—are shown in the paintings in the form, principally, of donors. From the fifteenth to the beginning of the seventeenth century, when this iconography (frequent, in particular, in works on wood) emerges, spreads, and then declines, women and men are generally separate. In paintings of several panels (polyptyques), men are shown on the left from the spectator's point of view in the most noble area of the painting, that area in which artists locate paradise in a *Last Judgment*: the side that is to the right of God. Thus, the male occupies the place of a potential chosen one. When the man and the woman are placed on the same side of the painting for various reasons, the wife is depicted behind the husband, farther away from the sacred figure they are supposed to be seeing or praying to. Such is the case with the *Triptych of the Annunciation*, known as the *Altarpiece of Merode* by the Master of Flémalle (Robert Campin),[215] in which Saint Joseph occupies the right panel, while the sponsors of the work, a man named Ingelbrecht and his wife, are depicted kneeling in a small courtyard on the left panel.

More interesting are the conclusions that may be drawn from the portraits of couples. Dating from 1434, the one said to be of the Arnolfinis by Jan van Eyck referred to above, is the first known example of such subject matter, and moreover is totally compelling. Generally accepted as a work commemorating the engagement of the Bruges banker of Italian extraction, Giovanni Arnolfini, and the young Giovanna Cenami, the painting was recently analyzed as a self-portrait of Jan with his wife Margaret, pregnant with their eldest son, also named Jan.[216] From our

point of view, identification of the couple matters little. What is more important is that Giovanni, or Jan, is situated to the left of the painting, and Giovanna, or Margaret, to the right—in other words, according to the usual division that places the man on the right side of God. Above all, the configuration of the room, where the woman and man are placed, is entirely different. The wife stands before a large enclosed bed (in *Annunciations* this bed with drawn sheets is a symbol of virginity), bedecked at the top of her head with a statuette of Saint Margaret, patron saint of childbirth.[217] Near the bench with a back rendered more comfortable by a pillow, the painter has positioned the young woman's slippers—red mules made to skim along carpets, such as the one covering the floor by the bed. Giovanna or Margaret is painted as mistress of the household and a childbearing mother. As for the husband, he is the support of the future family. He is taller than his wife (and made taller by his high hat), and he holds her hand in his—not the reverse. His vocation, above all, destines him for the outside world. He looks at the assumed spectator (or the painter), while the wife lowers her eyes toward the floor. His warm brown clothing is that worn to go through the streets, and used woolen leggings are carelessly arranged next to him (why put them away if he is about to put them back on?). So, everything in the décor near the man makes one think of the outside: the window on the left and the ray of light on the leggings, which suggests an open door. The husband, no more than the male child, has nothing—or little—to do inside the house.

In the seventeenth century, in the North of Europe—in Flanders, in the United Provinces of the Netherlands especially, and slightly less so in England, i.e., in the Protestant societies of the North and in those nearby geographically—portraits of couples, whether separated to be hung side by side or together in the same setting, became quite popular. Some of these portraits celebrated the moment of marriage. One of the most beautiful, *The Honeysuckle Bower*, depicts Rubens when he is first married, with Isabelle Brant. The husband is seated on the left—which we know is not fortuitous. His pose, casual in appearance (crossed legs), is actually calculated to show off a typically virile beauty (the red beard and the calves girded in orange). His hands are arranged in a no less fortuitous fashion, one on top of a sword (improbable accessory for a painter), the other holding his spouse's hand (as in van Eyck's painting). Finally, Rubens is seated higher than Isabelle: he dominates, affectionately and gracefully, but without any possible ambiguity.[218]

The family portraits painted by van Dyck (couples alone or with their children and sometimes with other relatives) depict the spouses either both seated, the husband on the left and higher than his wife,[219] or following the same lateral

arrangement, the man standing and the wife seated in an armchair[220]—but never the reverse. The difference in height between the spouses is increased, and what might be called the man's lot to be on the move is all the more affirmed, since the woman's seated position assumes that she remains immobile.

Though more austere, Dutch matrimonial iconography is clearer on the division of roles. The most remarkable paintings celebrate the couples not at the time of marriage or even when they are in their prime, but glorify them in their mature years. In other words, they often show the man and wife as elderly. These portraits may have been painted on the occasion of marriage anniversaries; this is so, in any case, when the spouses have offspring and want to leave them a memento. These are, in a way, preposthumous effigies of ancestors: their value as models is considerable. Rembrandt left the most perfect example of this type of painting with the *Double Portrait of the Mennonite Minister Cornelis Claes Anslo and his wife Aeltje Schouten*.[221] Done perhaps for the thirtieth wedding anniversary of the couple, the painting captures the two in the pastor's study in the middle of a conversation. More precisely, Rembrandt depicts Anslo (on the left of the canvas and in a slightly elevated position) as he speaks, and he paints his wife listening. This division of roles is consistent with the domestic life style such as it was conceived of in the matrimonial manuals of the day, and in particular in the *Treatise by Cats*. The husband is the one who makes the decisions. When he grows old, he acts through words: he is the one who knows; he guides the weaker soul and the duller intelligence of the one who is supposed to be his docile companion.[222]

THE LOVER AND HIS MISTRESS

If the husband is the one whose manly vocation calls him out of the house, and if at home he nevertheless directs, decides, says what is good and what is bad, the lover, in the erotic realm, is also the one who, of the partners—understood here to be of different sex—takes the initiative: paintings and other forms of visual representation teach us that the honest woman, in this domain, is devoted to putting up with it, or at least to letting it happen.

It is, of course, not to the portraits of couples that we need to turn to examine sexual behavior. With one exception, however: the very unusual *Self-Portrait as Prodigal Son* that Rembrandt paints at the beginning of his career (he is 19) and that shows him in the company of Saskia, his first and brand new wife.[223] There

is nothing less affected than this double portrait, in a context—a work on the border between genre scene and religious work—in which the moral conclusion is in fact antagonistic to the hero. Rembrandt has painted himself as a young, conceited, luxuriously dressed man, decked out with a feathered beret and armed with a sword; he is seated in precarious balance and is holding Saskia on his lap—and patting her backside. With the other hand he raises a mug of beer, toasts to our health and to that of his companion; we are clearly at the tavern. The body movements (the caress, the glass raised high) are the man's prerogative, and it is evident that the position (the woman seated on the man's lap) could not be reversed.

Much more often, it is within history paintings (historical, religious, or mythological) or else in the pornographic engravings that begin to crop up at the beginning of the sixteenth century[224] that we can get a glimpse of couples' behavior. In almost all cases, the man takes the initiative. Desire, often prohibited, emanates from him (as in the story of Bathsheba or the story of Suzanne). It is so powerful that it may lead to rape (story of Lucretia). The victim rarely comes out of the misadventure unscathed or proven innocent (Suzanne). More often she is powerless to refuse his body, and she has no choice but to kill (Judith and Holofernes) or commit suicide (Lucretia). All these subjects are so frequently chosen by painters or ordered from them that it would be fruitless to cite examples.[225] Narratives in which a woman takes the initiative are much rarer and, as would be expected, they provide subjects much less frequently to painters. It is as if the boldness of a female sexual initiative were so horrifying that huge obstacles appeared to its depiction. The Old Testament episode in which the wife of Putiphar tries to attract the young Jew, Joseph, into her bed is made the object of large-scale projects only rarely—and then with modesty, to the point that they may be called euphemistic. There are very few, if any, of these frescoes or paintings—the protagonists are so modestly dressed and their gestures so elliptical that one would be hard pressed to recognize the subject.[226] The seduction of Joseph is shown suggestively only in works of smaller format—images that can be discreetly examined: thus, vignettes illustrating Bibles, notably in Germany; a pornographic engraving from the seventeenth century (Joseph flees as fast as his legs will carry him, not forgetting to caress his temptress's sex organ); or, a very small drawing by Rembrandt that is hardly less daring.[227] The two other narratives that bring into play a woman's desire illustrate less the moment of pleasure that the lover has when he hands over his weapons than his own later punishment. Such is the case for the story of Samson, more or less summed up, from

Andrea Mantegna to Rubens,[228] by the episode in which the exhausted hero gives in to sleep while Delilah cuts off his hair (metaphor of a castration, at least provisional, since Samson wakes up without his virile strength). The same goes for the episode of Hercules giving in to Omphale by using the spinning wheel in her place, an occasion for Rubens, in his youth, to paint a gigantic canvas in which the muscular demigod is placed at the feet of the beautiful woman, in a humiliating, completely ridiculous position.[229]

In works devoid of moral intention or pretext, paintings that depict gods' lovemaking or drawings and engravings that show, with complete illicitness, couples copulating, the artists spontaneously depict the love-play as carried out and directed by men, if not for their sole pleasure, at least at their exclusive initiative. A number of engravings, as well as some paintings, present a satyr watching a naked nymph asleep—in banned prints, besides watching, the satyrs masturbate. But the inverse situation, that of a woman ogling an ephebe, is rarely evidenced and treated then in a surprisingly modest manner. Endymion, loved by Selene, never awakens to satisfy her desire, and Eros, secretly observed by Psyche, wakes from his sleep to run away forever. In the paintings by Jules Romain in the Te Palace in Mantua, which are among the most explicit that may be found on walls during the sixteenth century, and in those by the Carracci brothers in the Farnese Palace in Rome, frescoes almost as precise at the end of the century, the man draws the woman toward him, not the reverse. In the case of Jules Romain, the man prepares to penetrate the woman, his enormous penis rising up as he climbs up on the bed where his partner is sleeping;[230] in the case of Annibale Carracci, who is more discreet, the man draws her toward him, holding firmly to her thigh and pushing back her shoulders.[231] The message of the pornographic images is the same: the man governs the position of the woman, on whom he imposes at times acrobatic postures; or he presses down on her with his weight, as in a very indiscreet engraving by Rembrandt, *The French Bed*.[232] By contrast, we never see the woman clearly choose a posture and impose it on the man. The male prerogative of inciting love is expressed, finally, in works in which the underlying erotic theme can be understood only by the spectator who knows how to decode the gestures: in *Ulysses and Penelope* by Primaticcio,[233] the wife of the King of Ithaca recounts to her husband the years gone by—in accordance with a gestural code understandable at the time: she makes her point by moving her fingers. So, Ulysses, at this point, is tired of her speaking: he raises his hand and strokes his chin—a very old gesture, just as coded, which is the imperative mark of amorous desire.[234]

THE FATHER OF HIS SONS

In the home that he governs, the man is not only the guide for his wife and the one who decides on the acts in bed. He is also, as a consequence and by Christian and social duty, a family man.

Now, painting does not depict him fulfilling this function in the same manner with his girl children as with his boys. The tie that binds the man to his male descendants is evidently given priority over the tie that links him to his daughters. Such is the case since the beginning of the history of the portrait up until at least the eighteenth century.[235] In paintings with donors, the arrangement of husband and wife also corresponds to that of the children: the sons, living or deceased—sometimes stillborn—are placed on the father's side to the left of the work, while the little girls, living or deceased, are kneeling next to their mother on the right side.[236] In Venice during the sixteenth century, this division becomes less strict with Veronese: in the *Cuccina Family Presented to the Virgin by the Theological Virtues*,[237] little girls and little boys blend together and men and women are on the same side; in *The Pilgrims of Emmaus* in the Louvre,[238] two little girls are even in the center, and they are playing with a big dog (in fact, it looks like they are washing it), while a little boy cuddles a much smaller animal in his arms, perhaps a puppy. But in another version of the painting, the infraction of the usual arrangement includes a major correction: the animal with which the little girls are playing is a female dog that shows conspicuously, almost obscenely, her full breasts—perhaps a way of recalling the girls' gender and their future destiny as nurturing mothers.[239]

In the family portraits that are no longer those of donors, the respective position of boys and girls remains, for the most part, respected. The sons are painted next to the father, the daughters play or stand calmly next to the mother.[240] When the father is painted on the right, which begins to happen in the North in the seventeenth century, the boy he has engendered stands by his side.[241] When the family has only one child and it is a girl, the man remains alone, and the child is on the wife's side.[242] This schema can be scrambled by the arrangement of the whole group of children next to the mother, particularly if the children are young. The male babies are in the mother's arms. But the inverse does not appear—there are no family portraits in which the father gathers next to him his daughters and sons while his wife appears in the same painting. Finally, the portraits that group one of the two parents with children produces identical distinctions by gender: a mother or a grandmother can be depicted with her daughter or granddaughter—she can also be depicted with a male infant. The boy, from the time he walks, appears necessarily

next to the male parent: paintings thus show frequently and very early—beginning with Italy in the fifteenth and sixteenth centuries—the father accompanied by his son[243] and even a grandfather with his grandson. The old man with a child by Ghirlandaio in the Louvre provides a remarkable example of this type of painting.[244] But there is no stand-alone portrait in the early modern period, so far as we know, of a father with his daughter.[245] The world of men and that of women are rigorously separated, even when considered from the point of view of family ties: the genealogy of families is established according to connections based on gender—the father, one might say, is really only the father of his sons.

5

THE VIRILE MAN AND THE SAVAGE IN THE LANDS OF EXPLORATION

GEORGES VIGARELLO

THE DISCOVERY of "new" beings and bodies in the Americas at the end of the fifteenth century initiates for the first time an endless play between models and counter-models. Whether alterity is disparaged or extolled, European judgment speaks systematically about itself: a physical and moral excellence clarifies over time in accordance with this glance aimed beyond the horizon—an image of virility included. The savage as benchmark may accordingly say more than is apparent about what is expected of the "perfect" man.

"Fine stature," "graceful movements"[1]—the first savages encountered by Christopher Columbus in the West Indies seem first of all to correspond to an aesthetic "excellence" [cf. fig. 5.1]. The spectacle of "very well-proportioned"[2] bodies apparently suggests the principal physical values of man. It is not as though the word "virile" were used here, a term still considered nearly useless in the Western world, so thoroughly and incontestably identified as it is with the grown man. The dictionaries do, however, provide details. "Courage, strength and vigor"[3] are required: physical strength, moral strength. The savages, at first sight, would correspond to the model.

That is before we take into account the inevitable distance involved in the Western gaze. Too much disparity: the apparent absence of religion and law and their wandering and destitution relegate these beings for a long time to the margins of the human model, to the point of likening their comportment to that of demons and animals. The savage, then, is but a counter-model, the inverse of what society expects of the full-fledged man.

A new tolerance is needed, along with new knowledge, and finally a maturation of benchmarks—those of modern thought, those of Enlightenment thinking—in order for these interpretations to change. The counter-models may be inverted, civilized sensibility appearing "feminized" and

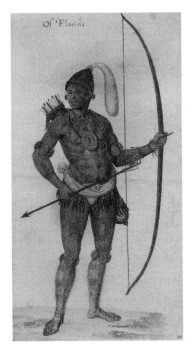

FIGURE 5.1 JOHN WHITE, *INDIAN OF FLORIDA*, AFTER A DRAWING BY JACQUES LE MOYNE DE MORGUES, SIXTEENTH CENTURY, LONDON, BRITISH MUSEUM.

"Fine stature," apparent muscles, and making use of weapons, the "savages" of the New World might have appeared to the gaze of the first "conquerors" like so many models or examples of virile affirmation. Their nudity, scarifications, body painting, and "strange" trinkets very quickly tipped the image toward one of a naturalness made ugly and inexorably degraded: a quality inconsistent with virility.

Source: © The Trustees of the British Museum

savage sensibility becoming "virilized." An image suggestive of man's excellence may arise from the savage world itself. Were not the hygiene specialists of the eighteenth century said to be inspired by the rugged ways of the savages in renewing the principles of strength and fertility? Confrontations with nature, frugality, cold exercises, or baths—these very practices of the Oronoco or Labrador Indians would become so many grounds for inspiration. "Pretext" behaviors, in truth, they apply more to the ideological debate than to in-depth exploration of the newly encountered societies. They show, in particular, how through them, Western society talks about itself, how its own images of virility become richer and more complex: a nearly imperceptible emphasis on the place given to liberty, to individuality, to self-improvement. Mirror or counter-mirror, the savage serves a purpose other than his own.[4]

There remains a moment, at the very end of the eighteenth century, when these images of savage "virilization" lose pertinence: the moment when civilizing certainty magnifies progress, when steps etched out for advancement toward something "better" can be made out. It is also the moment when the savage lands are

no longer simply obstacles or areas of resistance to the advances of a civilization drawing its "logic" from the Enlightenment itself.

THE "DISCOVERY" OF THE SAVAGE AND IMPOSSIBLE VIRILITY

The Spaniards of the "Conquest" admit their astonishment before what they consider to be slenderness and sureness, even bravura, if not pride. The descriptions pause over the sturdiness of the savages. The long evocation of the *Floridians* by François de Belleforest in 1575 is a good example.

> Well-proportioned limbs, of median stature, a little taller than we are, broad-chested, strong arms full of energy, they also have feet and legs apt for running; and they have nothing that is not well-proportioned (except for their broad face, though not in the case of them all), large black eyes and a quick, steady gaze; they are fairly weak but sharp and subtle of mind and also agile—the greatest runners on earth.[5]

It is impossible, though, with these first witnesses of the sixteenth century, to simply apply occidental categories about man to these beings from distant lands. The behavior of the "Americans" is too far removed from that of their visitors. Their tastes repel. Their violence revolts. Their abandonment of God horrifies.[6] Other categories are imposed sub rosa, reversing the first look, cancelling any sense of power—categories close to demonic and animalistic.

THE NATURAL MADE UGLY

Are these apparently vigorous bodies not systematically transformed by unrestrained gestures? Several of the savages smear their bodies playfully, "boring the nostrils and lips, nose and ears,"[7] adding scars and colors, pendants, diverse rings, marveling over the tiniest bit of metal or mirror. Their state of extreme poverty, moreover, adds "credulity" to "simplicity."[8] Their physiognomy is worn away by some incomprehensible and "unbelievable"[9] treatment of their shape

and their skin, their luster thus wavering between pleasant and "monstrous."[10] It is the savage beast that one thinks of in connection with these beings who are devoid of everything: those who eat the most sordid of foods, "roots, rats, mice, worms, salamanders and snakes . . .";[11] who have no place to sleep but the earth, "lying on the bed of the earth-mother to all animals";[12] who have no law other than "natural instinct"[13]—all the more so since, ignorant of all religion, "without knowledge of God or of His law,"[14] they would also be ignorant of all values. All at once it is difficult to apply "normal" categories of the human to a being who would seem "animal:" "courage" would be simply the determination of the beast; strength would be mere brutality. André Thévet's implacable evocation of 1558 confirms this in a few words:

> America is inhabited, aside from the Christians who have been there since Amerigo Vespucci, by marvelously strange and savage people, without faith or law, without religion, with no civility, but living like senseless beasts, remaining naked all the time, men as well as women, until the time, perhaps, they are frequented by Christians.[15]

Their sexuality, were it conspicuous, could also scarcely symbolize virility. That sexuality remains "lust:" a completely primitive frenzy recalling once again the animalistic. Indian life is given over to "libertinage."[16] The lack of "faith and law" provokes debauchery and lasciviousness. Descriptions abound of Indian men "running around at night" from hut to hut, or of Indian women "offering themselves to sailors"[17] for insignificant gifts: "They are very libidinous . . . , live according to nature, and are more inclined to be Epicurean than Stoic."[18] This pointed criticism, moreover, shows in passing the importance given to "control" in the European and classical image of virility: control over frenzy, self-assurance over amorality. Another occasion, finally, for raising doubts is the role given to "savage" women by these first Europeans. Were a number of them not supposed to have "gone to war with their husbands?"[19] Do they not temporarily abandon their children in order to fight better? This creates a decisive flaw: the borders between the sexes change if, as in the Guinea of André Thévet in 1575, "women train for war no more nor less than men."[20]

The creatures of the lands of exploration are thus seen as so "rustic," apparently, that a number of Spaniards were actually hesitant about their status as men, to the point of questioning the "necessity of baptizing them."[21] No virility was possible in

this case. "True" courage, "true" valor assume here a reference to honor as much as a reference to law, of which the savage world could give no evidence.

THE NATURAL MADE CRUEL

The picture darkens when acts of violence are mentioned. The word "courage," for example, though used sometimes, now loses its sense. The actions of these people show madness, paroxysms, and a love of blood: not bravura now but barbarity, not valor but cruelty. The scenes into which the Europeans fall under the savages' blows are then transformed into atrocities. The murder of Mendeña's men, for example, one day in 1568, as they draw up to the coast of New Guinea to stock up on water, is almost "commonplace:" "The Captain's bursar went on land with nine crew members [. . .]. They perished, cut into pieces by the Indians: these savages cut off the heads of some, an arm or a leg of others. The unfortunate men could not get any help."[22] The slaying says it all, from the accumulation of suffering to the cruel art of torment.

The expression alone of the savages was already seen to be a sign of cruelty. Witness accounts abound of the "cruel look"[23] of a number of them, or of their "hideous, terrifying, infernal" look;[24] or, quite simply, of the bestial reflection of their look. "Their expression is almost like that of a savage beast."[25] From which originates this double distancing from humanity: the animalistic presence, the infernal presence. Satan, "prince of pride,"[26] is regularly evoked by these voyagers imbued with Christian views. His intervention would explain superstitions and atrocities. It would also explain the "deceptions" and "illusions" of which these "wretches"[27] were seen to be the object. Jacques Chartier, for example, suspicious of certain ceremonies among the savages of Montreal, can justify these practices only as demonic action: "It should be known that these people recognize no other God but Satan and do not know what eternity is."[28]

One practice people were convinced about from the outset would be the final blow in estranging the indigenous from everything considered human: that of "man eating."[29] There is no hesitation, for example, about the origin of the meats drying in the several villages encountered by Amerigo Vespucci in 1568: "Salted human flesh hung from the rafters of the houses."[30] Cannibalism would conclusively confirm the atrocity—a major crime that would definitively demonize its authors:

> These peoples are barbaric, anthropophagous, eaters of human flesh; they devour one another when they can take prisoners of war and even when they are not openly at war, when they manage to capture someone for treason.[31]

THE NATURAL MADE DOCILE

There remain, however, savages and nations permanently lacking any kind of aggressive attitude, places where gentleness and a welcoming attitude prevail. Some of these beings were thus seen to be less "cruel," more "likeable," less like "wild animals," and more like "sheep." Vespucci dwells upon these encounters in which any type of violence appears to be unknown: "The inhabitants are very gentle, very kind, in no way offensive."[32] The scenes of landing also have their "happy" aspect: the man who fell from the French boat, for instance, in New France, whom François de Belleforest tells about being picked up by the Hurons, was "stripped naked, warmed up in front of the bonfire and sent back to the boat unharmed."[33]

It is nevertheless impossible, even here, with these first eye-witness accounts, to detect any virile attitude in the "opposite" positions. Gentleness is immediately interpreted as possible submission. "People" deprived of everything can only be fierce or submissive: their "gentleness," then, would itself be dependency. It is the acceptance that the New World voyagers dream of: "These peoples are extremely credulous and good, and it would be easy to have them embrace Christianity."[34] In a much more profound way, it is total domination that the voyagers dream of in the face of manifestations of kindness and welcome. Hence the very tendentious interpretation when confronting any compassion, the will to see it as only weakness and relinquishment: "If they are treated in a gentle, friendly manner, they will turn out to be docile and manageable."[35] The conciliatory attitude reinforces all at once as never before the project of conquest in the Europeans' view that remained exclusively fixed on domination. Which is confirmed by Christopher Columbus's constant calculations:

> With no more than the sailors who are on my ships I can explore all these islands as master. The inhabitants are without weapons and naked; they are fearful: thousands of these poor people flee before three of our men. They are made to obey; they will initiate and they will carry out all the jobs demanded of them. We therefore have only to teach them how to build cities, dress themselves and adopt our customs.[36]

The resistance of the savages makes them swing toward the "non-human," while the vaguely conciliatory attitude makes them swing toward the "sub-human." No virility, then, despite their slenderness and their vigor. But it is a way of suggesting that for the "voyagers" virility supposes in this context civility, religion, and law.

"MODERNITY" AND THE UNVEILING
OF A "PRIMITIVE" VIRILITY

These images of animalism are faintly kept in the Western consciousness, encouraged by territorial conquest and its everyday "dehumanization." In 1681, *Le Mercure galant* does not hesitate to describe the American savages as "cruel men devoid of reason, whom our fishermen are obliged to hunt like Beasts, since, outside of their fierceness, they have bodies covered with hair, armed with marvelously long, hooked nails."[37] The mythic narrative becomes established to the point of revisiting the image of bodies, which promotes stigmas and animalistic signs.

The succession of encounters, on the other hand, and the development of exchanges, although often hostile, imperceptibly lead a number of observers to temper these images of intense dissymmetry. Recognition of quality may be in order. A particular "strength" of the savage, a "virtue" even, may furtively be evoked. "Non-voyagers," philosophers or thinkers add their critiques as well. The perspective may become more elaborated, and opinions may be reoriented—even if it is still the specific ideals of the Western world that are the first ones to be projected here.

EUROPEAN "CRUELTY," INDIAN "FALSE INNOCENCE"

Witnesses' accounts, first of all, change course. The increased attention paid to tools, to clothing, to weapons, the consideration of food, of "preparations," of "wooden houses covered with palm fronds," for example, "clay pots and weavers' looms," "flutes, drums and wooden spoons"[38]—all these evoke the presence of sophisticated techniques and know-how, marking a distance from the sole reference to animalism Hence, more attention paid also to moral conduct. Queiros, for example, at the end of the sixteenth century, insists at one point on the "courage of these brave island-dwellers,"[39] who "never shrink back" in combat, in spite of their certain defeat. Valor and courage were seen to be prominent, traits of a "whole" man, though glimpsed more than clearly highlighted—especially since the main image remains that of individuals impervious to morality and ignorant of "God and his law."[40]

"Depreciation" is dominant, in any case, in the sixteenth century; it is actually so striking that the first valorizations of the Indians in no way change that initial image. The texts of Bartolomé de las Casas, for example, magisterial defender of the Indian's physical integrity in the middle of the sixteenth century, confirm this.

Las Casas denounces for the first time Westerners capable of the most dreadful atrocities. Blind violence, with him, changes sides. "Harmful works and depopulation"[41] are provoked by the Spaniards, not by the savages. The Indians are victims, more assaulted than assailants, more "innocent" than violent. This reversal is crucial: "Few narratives" could ever be "more terrifying in their simplicity."[42] The Europeans become "ferocious beasts," "pitiless" tyrants, "monsters" incurring ravages and devastation: "It was into the dwellings of these tender lambs [. . .] that the Spaniards, as soon as they met them, entered like extremely cruel wolves, tigers and lions famished for several days."[43] Las Casas's texts leave their mark on the Western conscience by the account of the massacres—by the account, simply put, of the extermination [fig. 5.2]. They do not, however, trigger a reflection on any kind of savage virility. Their perspective always remains captive to an attempt at

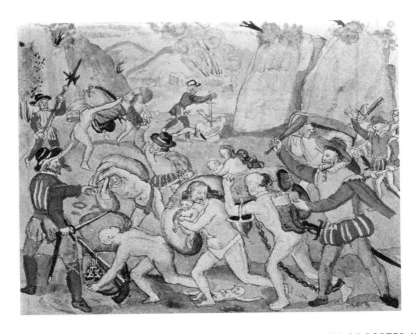

FIGURE 5.2 THE MASSACRE OF INDIANS AT CHOLULA ON THE ORDERS OF CORTES, 1519.
European cruelty was denounced as early as the sixteenth century. Bartolomé de Las Casas was the first to compare the "conquerors'" conduct to that of "fierce beasts," pitiless tyrants, or bloodthirsty monsters. Animal nature has here changed sides. The Europeans have been perverted. Yet these "savages," however innocent and destitute, nonetheless remain beings who, by dint of ignoring God, are doomed to damnation.

Source: William Clements Library, University of Michigan, USA/Bridgeman Images.

the religious conversion of the peoples visited or conquered. Certainty is unshakable, even in the view of the rare defenders of the Indians in the sixteenth century: "Whatever qualities are found in the peoples of the New World, they are reprobates."[44] It becomes all at once difficult to designate a "true" strength, clearly confirmed, clearly realized, in these "foreseaken" beings.

THE "BODY OF PLEASURE"

An ambivalent vision, in any case, could not help, in time, taking hold of certain witnesses. A tradition is established with narratives that are out of the ordinary, yet striking, suggesting a possible proximity with the peoples visited. That of Jean de Léry is one of these: "one of the rare sixteenth-century voyagers to experience the nostalgia of the New World."[45] A Huguenot without a fortune, fleeing French repression, Jean de Léry sojourns on the Brazilian coast in 1557 with fourteen "Genevans" sent by Calvin to offset the Catholic influence. At issue was the critique of violence committed by "partisans of the Pope," along with the reorientation of the image of the savages as resolutely bestial, the very image used to justify European violence. The religious quarrel is thus carried on in the narratives of the American voyages.[46] Léry knows, moreover, how to reverse a number of "Catholic" testimonials, for example the habitual condemnation of naked bodies, which becomes open to challenge once confronted with what Léry judges to be the "dishonesty" of certain Europeans:

> I maintain that the artifices, make-up, false wigs, frizzed hair, long tooled collars [. . .], and innumerable other trifles that girls and women from over there fabricate [. . .] are of incomparably greater potential harm than the nudity of savage women.[47]

Léry's reticence, on the other hand, is evident in the face of drinking sprees, fist fights, and the torture of prisoners. He has trouble understanding what he calls the Brazilians' "vindictive" spirit, this manner of taking it out on anything that resists, to the point of biting "with bare teeth like rabid dogs"[48] a simple stone that they have tripped on in their path. The savagery of the Brazilians is "fascinating and threatening."[49] It is unnerving, suggesting "the Western phantasm of witches [. . .] and child-eaters."[50] It brings into existence a land of sinister, ill-defined dangers.

There is yet an astonishingly sensual account from this Huguenot traveler, an unspeakable sympathy whose evocation is exceptional in the sixteenth century. Léry suggests the existence of a charm lying beyond words: the quasi-underground sentiment of an accord with the visited beings. He manifests an emotion—even experiences something erotic. Simply listening to the savages' singing voices, for example, creates a destabilizing moment that he asserts, yet practically without being able to define it. It is the spell provoked by a Tupi gathering:

> Such a joy that, not only by hearing harmonies so carefully measured by such a multitude, but also, especially, the cadence and refrain of the ballade, each couplet drawing together their voices saying: *heu, heuaire, heura, heuror, heura, heura, oueh,* I was transfixed by it; but also every time I recall the sounds, my heart trembles, and it seems my ears are once again filled with them.[51]

Michel de Certeau has stressed the originality of this perception: this very special rapture that confirmed otherness while also going beyond it. A "body of pleasure"[52] wins out here, the one conferred upon the savages, and also the one overtaking the visitor himself: the sight of the naked women, the voices, the smells. A virility peculiar to the savages in this case? Yes, no doubt, for those who know how to prolong the celebration, how to establish themselves in a kind of aestheticization of the day: an eroticized letting-go that is the total opposite of the everyday work of Westerners. Savage society thus becomes an "object of pleasure." This is what creates the nostalgia of the voyager upon leaving Brazil or his emotion upon recalling the memory. Here the West encounters an unknown that involves more than virility; actually, a kind of rapture and emotion. Jean de Léry succeeded in evoking this secret aspect, this vaguely defined sensibility, which travel literature will henceforth be unable to ignore totally.

MONTAIGNE, ORIGINAL "VALOR," INDIAN "VALOR"

The real originality, however, in the sixteenth century comes not from travelers but from philosophers. Montaigne, reading and interpreting the travel accounts, exchanging words, through the intermediary of his "spokesperson" and with savages transported to Europe, initiates a completely different mode of thought, a totally original reflection that will surely have several repercussions as well: it is no longer a simple emotion over the contact but a reasoning about man, no

longer the darkness of the devil or the sorcerer but the simplicity of origins. Interest changes. An "infant world"[53] emerges. Two universes confront each other: the old and the new. An original view also emerges of the savage, reinforced by an imagining of origins:[54] that of a golden age, placing in opposition "natural virtues" and "debased" ones, "original naturalness" and our "corrupted taste."[55] There was no indictment against these "new" peoples, whose simplicity was seen as derived as much from "vigor" as from "virtue."[56] No anathema either, except against a European orthodoxy judged to be imprisoned by its own "example and pattern," powerless to get past its "opinions," those of the "country we live in:"[57] "[. . .] there is nothing barbarous and savage in that nation, from what I have been told, except that each man calls barbarism whatever is not his practice."[58] Montaigne is certainly one of the first not to "bring into these debates the religious question,"[59] thus promoting the comparison "on equal terms" between old world and new world.

Montaigne suggests a "first" universe in which two values alone would hold sway: "valor against their enemies, amity toward their wives."[60] The male is central actor, for example, the one from whom things and people devolve.[61] The attention man pays to woman also is here, as compensation for the masculine "reign." There is, above all, courage, planted firmly by the utopian vision as much as by the noble ideal, to the point of appearing independent from any idea of conquest or spatial domination. This creates an irenic image of wars waged solely for glory, "the advantage of being the one left master in valor and in virtue."[62] It also gives rise to the insistence on a primordial intrepidness, strictly mental, independent of any prior physical force: a steadfastness resulting from the strength "not of legs and arms" but rather from strength of "soul."[63] Gratuitous virtue or noble exigency would remain at the center.

Montaigne also thinks of this valor in accordance with a very precise relation to the feminine. He lingers over polygamy, esteems its symbols, and advocates its acceptance, just as Jean de Léry had lingered, with the same certitude, on such topics as the prestige of the man measured by the number of his wives and the value of the wives measured by their enthusiasm—enthusiasm in finding new female companions so as to "increase their husbands' honor."[64] This notion of founding virility on the number of one's wives would be as obvious as it was hushed.

The savage becomes for the first time an example specifically of virility: for his physical courage that is always honored, and for the number of his wives that is always stressed. He is an entirely symbolic model, of course, whose main point to remember is the exclusive priority given to the masculine, as reflected in the

emphasis on courage and honor. The savage, in spite of himself, speaks about the world of those who are observing him.

THE CLASSICAL UNIVERSE AND THE ANCIENT HORIZON

The picture proposed by Montaigne is decisive, although it remains isolated for a long time. It is all the more unusual in that religious exigencies dominate the image of the savage in the classical world. The accounts presented by the Jesuits demonstrate this, divided as they are between a laudatory and a pejorative vision, taken over as they are by the will to judge and to evaluate.[65]

Their *Curious and Edifying Letters*, written first to justify the missionary enterprise, remain, over several decades, hamstrung by one certainty: the savage peoples are possessed by demons. This is stated clearly in the title of one account of 1634: "On the reign of Satan in the lands and the diverse superstitions found there, established as first principles and fundamental laws of the State and conservation of these peoples."[66] It can mean only one thing in the eyes of the authors of the *Curious and Edifying Letters*: the constant and perverse presence of the evil one. There is no human or virile affirmation in this case. Wars and ravages are explained by this evil action, such as, in 1652, the rebellion of the Iroquois against the nations that "had given them sanctuary," attacking them with "mischief," betraying and destroying, to the point of "increasing day by day the terror of their name."[67] Meanwhile the "converted" savages would be swinging toward the other aspect of the human—to become the only ones capable of true courage, like the "few Canadians" in 1692, swimming off with an English flag, "in spite of the gunfire they were under," before "carrying it, on the spot, to the cathedral"[68] of Quebec. Baptism, in other words, is seen as the exclusive access to virility: the virility of strength, of "legitimate" violence, and of combat.[69]

The Jesuits' proximity to savage life, by contrast, inexorably enriches their perspective.[70] They allow themselves at times to be captivated by the "grandeur" of the beings visited. They agree about their physiques: "Well-built, tall, with good posture, well-proportioned and agile, nothing effeminate is apparent in them."[71] They also agree about their morals, revisiting their readings of the classics from college, that is, those of Plutarch, Tacitus, and Cicero: "I saw on the shoulders of this people the heads of Julius Caesar, Pompey and Caesar Augustus...."[72] Hence these comparisons based on "strength" between "here" and "there:" "Those little squires one sees elsewhere are but cardboard men, compared to our savages."[73] Hence also

the rift in the descriptions of the *Curious and Edifying Letters* from the middle of the century. Two men were seen to coexist in "every Jesuit missionary:"

> First off a priest who sees the savages as monsters and almost as demons, and then a former professor of rhetoric, or at the very least a former professor at the College of La Flèche, who cannot stop thinking of the Latin poets and historians deep in the American forests.[74]

A true change of perspective, however, takes place in certain testimonials at the end of the seventeenth century. They engage a theme until now ignored: liberty. These testimonials come not from those who have their hearts set on conquest but rather from those motivated by their choice to share the life of the "new" peoples. Louis-Armand de Lahontan is one of them, a man of lower nobility, who sets off for Canada with French Navy troops in 1683 at the age of 17. A few years later and after diverse military commands, Baron de Lahontan launches out on a solitary voyage going up a tributary of the Mississippi that he calls "long river."[75] The letters and memoirs that he leaves of this voyage evoke savage comportment from an angle neglected until then. "They are not familiar by any account with the term dependence; they cannot even bear this terrible word."[76] He stresses, instead, the "enslavement" of the Europeans, thus giving evidence, in particular, of the vast psychological shift analyzed by Paul Hazard in *The Crisis of the European Mind*:[77] that gradual reconsideration, beginning at the end of the seventeenth century, of fidelity to the Church and to the king, that slow rise of doubt and of liberty. A suggestion "simplified," no doubt, by Lahontan, it promotes a critique of monarchy: "When one has the misfortune of falling into the hands of one of these oppressors, the Tyrant must be dethroned."[78] The theme is all the more forceful from this adventurer because his status as ruined lower nobility highlights his indictment of royalty, kindling his critique of those who "depend on the authority of one single person."[79]

The issue of renewal is patent: to the old references to honor, now add those made to liberty;[80] go beyond the moral horizon of the nobility for the more social horizon of "equality." Not that this liberty is analyzed profoundly here, as illustrated especially by the absence of any "subordination."[81] Not that virility is clearly detailed either. That virility, though, could not be imagined outside of a refusal of any submission. Lahontan's savage "pretext" allows him to suggest the first "rebellions against any constraint"[82] at the very heart of the old society.

There is no doubt that the image of the savage is pressed into the service of different causes at the end of the seventeenth century. Confined by some to the

demonic universe, it is projected for others into the universe of liberties. Tradition wins out in the first case; the sense of necessary autonomy wins out in the second. The change conveys by itself the shake-up of a world, even though the savage has yet to be studied with any clarity or specificity.

THE ENLIGHTENMENT AND THE VIRILE MYTH

The Enlightenment inevitably complicates the image. The theme of progress changes everything. The thematic oppositions are no longer the same. References are no longer inclined toward the religious or the virtuous man but rather toward a civilizing advancement, that of a continually improving "better"—with a new alternative outlining two possible aspects of savage life and virility. The savage may become a model whose strength and fertility could inspire the practices of a civilized man in search of some vigorous regeneration. The savage may also, at another level and once having adopted a measure of civilization, be the one whose wandering and destitution bear witness to primitive "lacks." These are two visions by which the Enlightenment establishes itself along two different axes. One choice will prevail, certainly. Western thought will go toward the second, once the universalist aim of the French Revolution is affirmed and once the American advance on Indian lands has become overpowering. At the dawn of the nineteenth century, finally, the savage is, above all, the model of destitution.

VIRILITY AND REGENERATIVE IDEOLOGY

The parallel between savage "grandeurs" and ancient "grandeurs" persists at first in the eighteenth century. The reflections of Jean-François Lafitau on the *Customs of the American Indians Compared with the Customs of Primitive Times*[83] demonstrate this clearly. The comparison with Lacedaemonian practices is systematically taken up, particularly its physical and moral harshness, its vigor from men and only from men: "The father of the family harangues the youths every morning and keeps an eye on them, as well as on all the exercises of these young men, whose life is no less harsh than that of the Spartans."[84]

The statement has all the more force in that it corresponds to a shift: that cultural moment when the hygiene experts of the eighteenth century, judging the

old vigor lost, argue for renewed strength. The denunciation is unusual, focused, and aimed at rampant depopulation: imagined, actually, more than materialized, feared more than borne out. It is nothing other than anxiety linked to the new notion of progress:[85] the fear of its inversion, of its failure. "Demographic" preoccupation or worry about "procreation"—these tensions increase even more toward the middle of the eighteenth century, kindled by the obscure sentiment about a lowering of the birth rate and those "dire secrets spreading through our countryside:"[86] *coitus interruptus*, a greater solicitude toward the child an attempt to limit the hardships of childbearing, the fatigue brought on the mother, and the burden of siblings.[87] The new expectation advocates the inverse: vital population growth, fertility turned into a symbol, comparison of an individual's health with that of his descendants, association of a nation's resources with the resources of its manpower. Strength would be procreation-related as well as health-related: a token "of abundance and wealth"[88] according to the first great census-takings attempted in the middle of the eighteenth century.

Reference to the savage then becomes a physical and moral argument, an example of regenerative practices, particularly since humans across Europe would be equally affected. Men and women would prove to be less robust than before, men in particular: "The corporeal constitution of Germans today, while perhaps the best there is in Europe, corresponds only slightly to the idea that Tacitus gives us of those vigorous [early] Germans."[89] Or that of noblemen, whose former armor demonstrated robustness that soon became a weakness: that of "generations of men softened by idleness."[90] The proportions of the body change. The "beautiful Greek statues"[91] are forgotten. Meanwhile, the varied exercises of the savages could offer some recourse. Travelers of the eighteenth century, moreover, manifest a veritable "fascination for the Amerindian body,"[92] as Stéphanie Chaffrey shows in a recent thesis. Rousseau's view synthesizes these aesthetic and voluntarist references. Plutarch's Romans and Spartans and Lahontan's and Lafitau's savages exemplify rustic manners, as they point up possible renewals. They serve a polemical rhetoric: "Multitudes of peoples wash their newborn infants in rivers or the sea without any other procedure. But ours, softened before being born by their mothers' and fathers' idleness, bring with them as they come into the world an already spoiled temperament."[93] The theme would serve as a restoration of vigor: the "free and proud" model of the savage substitutes for the "weak and fearful"[94] one of the civilized man. It is obviously a utopian vision, whose point of departure is a "denunciation." More than ever, it is the world of the observers themselves—the view of their own reality—that is ultimately the main point.

HIERARCHY OF CIVILIZATIONS?

This opposition between the fecund savage and the effeminate civilized man gains enough force in the 1760s to orient the view of the explorers themselves. We see how Bougainville's account of his long journey of 1768 presents a picture of happy existences, to the point of claiming they illustrate some kind of human ideal. The Tahitians, for example, were seen to suggest by their stature an unequaled power: "Never have I encountered anywhere men better built or better proportioned; to paint Hercules or Mars, no finer models could ever be found anywhere."[95] Physical perfection is brought up again by Diderot, extending Bougainville, by insisting on bows that only the Tahitian would know how to string or the long runs that only the Tahitians would know how to accomplish.[96] Strength as primary virtue, especially "ancient" strength, was admired by readers of the classics.

The theme becomes complicated, however, with the explorer crossing countries and drawing comparisons. The Tahitians, once frequented for any length of time, are already eliciting other interpretations: "There are nowhere in Europe such great rascals as the people of this country."[97] An "inequality" is also asserted regarding Tahiti once the society has been observed for a long time. Travelers note the phenomenon "in cruel disproportion"[98] insofar as the subjugation of slaves and underlings to unquestioned masters is tolerated. An appreciation for the "gaps" among civilizations will win out in the final analysis for a number of these thinkers for whom the Enlightenment remains the major marker. Social observation has become more rigorous than it was in the seventeenth century. Antoine de La Martinière's *Great Geographical, Historical and Critical Dictionary*, in its edition from the second half of the eighteenth century,[99] is the best illustration of this. Peoples spread out according to their level of "knowledge," "politesse," and "technology." The "wandering" savages of North Canada could not be the same as the Mexicans conquered by Cortez in 1521, those whose cities were composed of gardens and palaces, public squares and streets, or temples "rising magnificently above other edifices."[100]

Diderot himself, far from his fiction in the *Addendum to the Journey of Bougainville*, claims to take into account, in his texts of 1775, the "distances" between civilizations and their effects:

> Perhaps a more interesting object of curiosity is to know or to examine [...] if the condition of natural man, given over to pure animal instinct, whose day spent hunting, nourishing himself, producing his likeness and resting, becomes the model for

all his days, is better or worse than that of this marvelous being who picks out the quilt to sleep under, spins cotton and silk to clothe himself, has changed the cave, his first dwelling place, into a palace, learned how to vary his commodities and his needs in a thousand different ways.[101]

This questioning involves a distinction by degrees. It focuses on the advancement toward something "better," a development of civilization, an unfurling of sensibility. It is no longer the old age of a world but the genesis of progress.[102]

THE ISSUE OF "FECUNDITY"

Michèle Duchet has made a point of this change of perspective. The American savage is judged from the start to be "impaired" by his social organization, his technical apparatuses, and his geographical constraints:

> Immensity of the horizons, dispersion of the Indians, multiplicity of languages, difficulty of communication between different tribes, weakness of the American man and harshness of nature, the aging population and its historical backwardness.[103]

From this perspective, the work of the Abbé de Raynal, collaborated on by a number of encyclopedists, among them Diderot, d'Holbach, Saint-Lambert, and Naigeon, takes on a key meaning. *A Philosophical and Political History of the Settlements and Trade of the Europeans in the East and West Indies*[104] was seen, according to Grimm and his *Correspondance littéraire* of 1771, as a "major book."[105] Surveying opinions and debates, voyages and discoveries since the sixteenth century, the text settles, in successive editions from 1770, and especially in the major one of 1773, on a position about the image of the savages that is largely shared by the men of the Enlightenment at the end of the eighteenth century.

First comes the theme of tolerance: the insistence on "fierce legislation" established by the colonists, the reduction of the "unfortunate peoples" to "scattered remains."[106] Then comes the theme of knowledge: encounters and discoveries were to have had a "relativizing" effect, the possible source of social reviewing, of a "moral revolution."[107] They were also to have suggested bodies of knowledge: "The ignorance of the savages has, in a way, enlightened the civilized."[108]

Such a context, however, leads to revising the image of savage virility. The collaborators on the *Philosophical History* are attached, outside of any religious

reference, to the everyday life of these faraway peoples, their physical exertion, the oddness of their tools, the harshness of their work. They attempt to objectify their behaviors, albeit in an "ideological" more than an "ethnographic" manner. They judge these lives to be exhausting owing to the people's interminable confrontations with hunger and danger. From that point they turn into a weakness the harshness that Rousseau had presented as vigor. It is a mythic vision again whose logic is that of the ascendancy given to "progress:" savage wandering versus civilized sedentariness, "overwhelming" work versus moderate work, dispersed individuals versus populous groups. Even more, the presumed paucity of the savage groups and the presumed small number of their children would prove the generational decline of these peoples: "Canada is therefore not deserted due to the niggardliness of nature but to the lifestyle of its inhabitants."[109] The continually repeated search for resources, receding in any case, would weaken the "seeds of life:"[110]

> In a climate where men are more voracious than nature is prodigious, time and the faculties of the human species are absorbed by fatigue, which damages procreation.[111]

It is not just the harshness of the climate that would contribute to procreative constraints: "The air and the earth, whose moistness contributes so importantly to vegetation, gives them little heat for generation."[112] Far from being strong, the savages were seen as worn out; far from being fertile, they were seen as anemic. The theme of virility has in fact been inverted: "They are less suited for procreation, and they feel drying up in themselves the seeds of life."[113] Only civilization would allow for strength and sensitivity, a perspective to which the French Revolution gives renewed vigor as well as a universalist aim. New models have been imposed: "Propriety is now the element necessary for all social life, whereas Enlightenment thought, despite its multiple tendencies, allowed at the beginning that there could be different types of human societies."[114]

Another culture dawns, other horizons open. The United States of America repeats this theme of the weakness and degeneration of the savages at the end of the century in accordance with a precise vision: to shrink the presence of the indigenous peoples, to fix them as an "obstacle to the advancement of the nation coming into being and bearing the values of modernity."[115] Negative otherness again finds its customary power. The critique of French thinkers and that of American administrators have obviously not the same content: a tolerance exists on one side that

is absent on the other. Their claims are nevertheless both made in the name of the Enlightenment, both situating the savage on the failed side of progress.

Inevitably, there remains a "happy" tradition of the encounter, of which Jean de Léry is one of the initiators. The texts of Jonathan Carver[116] and William Bartram[117] continue this tradition at the end of the eighteenth century. The account especially of Bartram, the learned Quaker botanist traversing the Indian regions in the 1770s and commissioned by a sponsor to draw the flora and to collect samples, admits to an "elective affinity"[118] with Amerindian culture. Sensitive to the "majesty of Creation," he insists on the "free life at the heart of nature" and evokes a quasi-cosmic force from the primitive world. The power would belong to that universe of beginning times. The model would be tilted toward the ascetic and resistant Indian. These are so many uneven images, however, that become marginal at the turn of the century in a society affirming the "irrefutable superiority"[119] of the European over the savage. The voyages of exploration are once and for all undertaken in the name of a hierarchy of civilizations. The new encounters with the inhabitants of Tasmania, New Zealand, or Timor show them suffering from destitution to a life-threatening extent.

The savage people of the lands of discovery, who could serve—so everything seemed to suggest—as an example of virilization, regularly changed image during early modern times. A being inhabited by the devil, he could not, for a largely religious society, embody a model for the first "discoverers." As a vigorous, free being for a society eager for demographic ascendancy in the middle of the eighteenth century, his modes of behavior became, for the hygienists of the Enlightenment, a litany of regeneration. Then, becoming a being of destitution for a society inventing the notion of progress in the second half of the eighteenth century, he lost all resonance as a symbol of strength. At once model and counter-model, the image of the savage nonetheless shows, in its transformation, the enriching of the theme of virility in our modern world: the undisputed domination of man, to which is added a growing expectation of liberty and sensitivity.

6

UNEASY VIRILITY IN THE AGE OF ENLIGHTENMENT

COMMON FOLKS' VIRILITY

ARLETTE FARGE

UNDER THIS rough heading, "*Virilités populaires*" (common folks' virility[1]), and by the association automatically made between the two words placed side by side, there would seem to be no harm in imagining groups of men—artisans, workers, porters—crudely hunting female game not by consent but as a violation. Not to mention the facile idea that quickly comes to mind—that this masculine, hence savage group of men, without education or faith or integrity, constantly assert in the street, at work, or at home the brute force of the strong man, dominant and in top form sexually. A whole imagery from far away—from pulp fiction to engravings or illustrations—guilelessly accompanies this animalistic vision of a loud-mouthed drunken group who are therefore virile.

The *Encyclopédie* is more complex in its definitions: "Virile is whatever belongs to man, or what is peculiar to him." The word "virility," in contrast, does not appear, whereas man is defined as "a sentient, reflective, thinking being [...] who lives in society, who has a kindness and a meanness proper to him, who has devoted himself to rulers and who has established laws for himself." Here there is more reflection as well as a distancing or a gap as regards stereotypes that come down in torrents not only on common folks but also on that sexual part of them, necessarily virile in the crudest sense of the term.

This perception of a popular virility automatically situated outside of traditional models of civility and politeness is actually just the reflection of

the extreme inequality produced by the Enlightenment: rich and poor knock up against their own images. The first see in the sexual practice of others only an animalistic routine, so that the master-slave dialectic and the sexual exploitation of the weakest seem to pose no moral problem. In this same schema, the more economically privileged can see common folks' behavior only as crude albeit necessary activities. Within this system of thought, the woman of the people may be easily constrained, indeed even bought by the more prosperous, just as it seems natural for the man of the people to manifest before her a virility stamped with force, violent savagery, and indeed all sorts of degrading behavior believed to be consistent with "common folks' nature."

This maze made up of half-truths, of phantasms, and also of lived realities must therefore be untangled in order to understand not so much what the virility of men is in the eighteenth century as the manner in which men experience their masculinity and their clearly domineering relationship with women. Light also needs to be shed on the set of their gender roles within and outside of marriage. Similarly, we should try to analyze how masculinity and virile force are perceived in working-class society.

MODELS?

Even if they are not well-educated, men of the people live from birth to death in a society that forms them and imbues in them codes of conduct that they may at times follow or reject. Caught up in unstable economic situations (except, no doubt, in the artisanal world) or in search of work, they share the conditions of life that are added to those that familial, juridical, ecclesiastical, and monarchical institutions seek to impose on them. They put up with the precariousness and dilapidation of uncomfortable lodgings, and the majority are shaped by the necessity of leading a "nomadic" life. "Nomadic" should be understood here to refer to the economic need, owing to work or the search for work, to be constantly on the move, from morning until evening, which entails walking along roads or rivers or going from village to village as far as the capital and back again. This "wandering" is one of the most flagrant and impressive modalities of masculine life (doesn't the journeyman travel around the country after completing his apprenticeship?). Through wandering, men have encounters, good or bad, socialize, and meet up with the opposite sex.

Life in a monarchy means that the king and the princes are regarded and judged shamelessly by the people, despite the fact that the latter must submit to the formers' orders. The royal model must diffuse omnipotence and an absolute sovereignty, which are manifested essentially through several attitudes, of which strength, power, the requirement of male primogeniture, and the luxury of leisure are most conspicuous. Sex and power are twin figures offered to the public.

War, hunting, the pleasures of the flesh, and the attention paid to the arrival of a male heir are so many forceful models. The people know, as they watch the king, how to combine and judge all these elements. They show a certain admiration for royal sexuality, and they brood upon learning that the king is not procreating; they know the king's mistress but worry if the king (Louis XV, for example) departs from the frame imposed by his function by bringing his mistress to the battle front rather than his wife, the queen, as he is supposed to do. They know that every royal hunt is a ceremony in which animal blood and sex go well together. They hate it and get angry when sexual debauchery and luxuriousness impel the life of the court toward excessive spending and when the royal escapades end up inciting disgust. The royal model, always on display before the people, must be situated in a framework large enough for sexuality to be dominant, strong, ensured but not too debased lest it run the risk of bringing on misfortune to the country.

Everything was passed on to the Regent because it was known that he would not reign for very long. As for the Church, which is both politically and religiously powerful, it imparts its morality, prohibiting nonprocreative sexuality. Priests and curates, in their sermons as in their teachings and catechisms, diffuse codes of conduct that compel the woman to submit to the man in marriage, although they themselves do not follow them. Based on the questions posed to those who come seeking the sacrament of penitence, the confession manuals reveal a number of sexual attitudes to avoid and wipe out any inclination toward impulsive and uncontrolled desire. The rules of marriage are enunciated, and adultery (that is, when committed by women) is inveighed against. The landscape is clearly delineated: fear of the woman and anxiety in the face of her sexuality and sexuality in general. This model is very much in force, although we now know[2] that priests and curates gladly whittle it down and that parishioners, while worried about the devil, disobey the principles with abandon.

The juridical, civil, and penal institutions have not yet forged the Napoleonic Code or the penal code establishing a clearly determined social and sexual order, even if, at the end of the century, a number of legal treatises on marriage, adultery, and other such issues come into being.[3]

The charge of adultery is very much codified, or at least it is intended to be. Only the husband may stipulate it, but the essays or tracts seem to find, at times, that the husband should be able to summon up sufficient "force" to avoid such problems. He is thus reminded of his virility. Sir Des Essarts expresses this opinion brilliantly in Cause 197 of his *Causes célèbres*, "Charge of adultery:" "There is no situation more distressing than that of a husband who is forced to demand the authority of the law to put an end to his wife's disorderliness. . . ."

As for Fournel, he writes, "The husband is the natural inspector of his wife's mores" in his chapter indicating the persons having the quality to file suit, and he refers to a number of arrests that ratified this principle and were reported by Brillon, Bouchet, Barder, and others.

The marital establishment is juridically standardized. As for working-class society, it also constructs its rules, if only out of economic concern: a wish for inheritances that are not broken up or split into pieces and control over the choice of husband such that groups of young men are able to keep available the number of young women who may belong to them. Charivaris,[4] as we shall see below, correspond to this will for social control over working-class sexuality.

Pulp fiction, notably the "Bibliothèque bleue," and wood engravings diffuse in great waves throughout the provinces of France severe, brutal, ironic, and malicious sets of ideas about women, who are at times celebrated for their kindness, at other times vilified for their cunning, their cruelty, their reproaches, and their vileness. They are worse than snakes, and men are obliged to correct them. Too bad for the men who do not succeed because of lack of strength, authority, or assumed virility. The direct descendant of the sixteenth- and seventeenth-century sorceress, this "incomplete male" that woman is causes fear "because one secretly recognizes that she has more mental resources than one is willing to acknowledge."[5] They are thus just as honored (because they are mothers) as vilified, through a binary literary system that has been studied for a long time.[6] Nevertheless, if one reflects a bit on all these models, and notably the one diffused by the "Bibliothèque bleue," one might propose that a part of the excess of working-class virility (if it may be expressed in this manner) also finds its source in a fear with regard to women, itself orchestrated by the wider society, because of the biological power that they have in bringing children into the world. In maternity there exists perhaps a feminine "excess," perceived this way by the male world.

The Enlightenment cannot be summarized by its monarchical, ecclesiastical, juridical, or literary models, for every man or woman in society employs models as much as he or she goes beyond them, brackets them, or breaks through them. This

century, said to be philosophical and progressive, also contains in it all the charming and scintillating, playful, cruel, and mocking hazards of the libertine spirit. Libertinage in the strict sense of the term[7] can scarcely be the prerogative of the Great. Its star-spangled lineage and its aristocratic convictions, sprung from the desire and the will to possess freely, influenced the entire society in the same manner as society, to the benefit of the Great, was drawn down to the carrying-on of the hoi polloi. Out of the libertine model, hated by those classes disfavored by the comfort of their lifestyles and the irresponsibility of their conduct, there emerges though a burst of liberty that pervades society as a whole, something of an effervescence and a sensuality enjoyed day by day by all sectors. This sensuality is driven by drastic conditions of precariousness and promiscuity that increase desire and ephemeral pleasures in order to forget time. Men and women are taken up into this hurly-burly that Fragonard captured in painting; women, like mounted butterflies, were often its bitter and tragic victims. On occasion, they would also participate in this enthusiasm, mixing political fervor with sensual fervor and the desire for liberty with affairs most disastrous for them. It remains nevertheless the case that, in this particular context when libertinage was king,[8] men of the people received an inheritance on which to base various types of virility that history had already granted them, although they could live tranquilly in this century that was "pleasing" to the worlds of both men and women, even if the inequality between these two worlds was flagrant.

We must stress this inequality between classes if we are to understand anything about common folks' virility. The latter can become all at once part of everyday life only if one understands that it is immersed in radical social inequalities at the core of society. The forms of commoners' virility are all the more brutal as the social, economic, and gender inequalities remain in force and the violence of the Ancien Régime remains an inevitable way of life. Virility also becomes a form of power and a means of gaining recognition.

It would scarcely be fair to assert that the practices of common folks' virility are "learned" from childhood on, since for the more comfortable social classes, the codes of civility, writing, and *savoir-vivre* (whether libertine or not) are definitely learned. The historical entrenchment of misogyny and the difficulties of everyday life create certain internalized lifestyles. In working-class milieus, virility is not a code to follow at all cost but rather an ordinary way of living one's masculinity, strongly ingrained, even if men on the whole have also admitted that excessive violence toward women is to be condemned. But their real world, like their imaginary one, is filled with images of women to possess carelessly, and the narratives that

we know about working-class sexuality make use of as many phantasmal moments as actual lived moments. The violence amidst which commoners live continues, beginning with infancy, from family to street, maintaining the child and then the adolescent in a relationship with girls in which physical, verbal, and sexual capabilities are to be proven immediately and to be asserted with force. The spirit of conquest blends with the freedom of desire: the sensual atmosphere of the time stamps behaviors, and the models coming from above liberate the most timid. A glance at the public gardens of the eighteenth century and at the events that take place in them on a daily basis explains how the man of the people and virile banter go together, for better or worse,[9] and how the sexual lives of this or that group crisscross, leaving men with an air of being on the prowl.

VIRILITY IN THE PRIME OF LIFE

The practices and forms of virility are characterized by a discontinuous temporality, not only for reasons of advanced age but also because of the very different manner in which people view badinage—the taunts and spats, the surprises of love, the willingness to settle down in marriage, and paternity. All these moments are captured by so many different forms of virility, experienced either in front of others or in secret, intimate relations. Location, on the one hand, and reputation, on the other, also lead to very different behaviors.

The postulate on which everything is based, and which is perpetuated by medicine, is man's superiority over woman, men's excellence in relation to women. In his work *On Women*, published in 1772, Denis Diderot stresses women's pain and suffering, since they cannot attain sensual pleasure without affective motivation. The *Encyclopédie,* in the article on "*Femme*,"[10] in which Diderot, Jaucourt, Abbé Mallet, and Desmahis contributed an opinion, remains prudent and sensitive on this issue of domination over women. The cruelty of laws crushes them, and their fragility is no help in making them happy. Men and women of the people are not spoken of, but it is understood at the same time that women as a set are an incomprehensible group, delicate and given to hysteria, without ontological substance, yet favored recipients of love and of pleasure.

These leading ideas, expressed everywhere in intellectual as well as other spheres, influence the forms of common folks' virility. They imbue these forms with a liberty all the more impressive in that the feminine field is watered down to the shapeless,

the malleable—to ontological nonexistence. The absence under the Ancien Régime of a period called "adolescence" allows the young boy to quickly begin his activity of superiority, in which the force of his body is complemented by his will to authority. Since the body is also a social and political way of being[11] when one is not part of the upper classes, the young man, his masculinity affirmed and carried forward each time, takes his place socially and politically within the community of youth who watch him, reassure him, encourage him or, inversely, denounce him if certain codes are not observed. The "joy of being male," to use Maurice Daumas's expression,[12] spreads at a young age in a climate of "wild in the streets" in which every woman is to be had, so long as she is pleasing—and even if she lacks that. It is a sort of "hysteria" of liberty and happiness, which is not possessed by all poor people who are not so free and not so rich. Seduction and its consequences—the sexual act—are carried out briskly by young workers, companions, seasonal laborers, and farm workers, who scarcely hesitate to take their pleasure right where they find it: in the village, on the road, next to cabarets or inns, in the fields, in the taverns, or in the midst of the harvest. It is like an immense *fête galante* that turns out not to be so festive for everyone. The testimonials from men of the people are rare; thus, the *Journal de Ménétra*, discovered by Daniel Roche and published and annotated by him, has a certain exemplary value.[13] It is also an example that every historian knows he must be wary of, since it is isolated, and Ménétra might be suspected of a veritable phantasmal enthusiasm, leading him to recount more, no doubt, than he actually did.

"Every day I looked to make new conquests [. . .], and I had a good time with girls, half who were taken willingly, the rest by force."[14] This sentence is one of the keys to this life of youth unfurling from one place to another, from home to work and from one search for girls to another; "we wanted to see if we couldn't find some female game:" that is unequivocal, and the "we" means that there exists a community of males that is lively and tumultuous, ready for brawls and for deflowerings, on nights of pleasure with other companions or friends of the road: chatting, talking, exaggerating one's exploits, or keeping them quiet. In any case, the public aspect, whether hushed or blabbed, is essential. It constructs the reputations of honor but also those of a good worker. Living is taking the woman as soon as one can, "half by force, half by consent:" virility comes from what makes the man "stand up."

"Ah, what pleasure it is when a girl is taken on the spur-of-the-moment:" not expecting it, taking the "girl" and then, as a good companion, asking his happenstance friend or companion in misfortune if he wants to take over: "I ask a Burgundian who was there if he doesn't want to take advantage of the situation. He says I've heated her up too much."[15]

Here is thus brought together the mythology and the reality of masculine virility. We must be honest and wonder at the same time what could constitute the half-forced, half-compliant assent of the woman. Is she this passive game that virility seems to relish? The introduction—even for a second—of the idea of force (hence constraint) cannot correspond to female desire. Is the woman, in these working-class milieus, such an easy supporter of men? Judicial archives inform us (a bit) on this point. Certainly, there are lives of women, servants, day-workers, inn servers, and farm workers, who really cannot resist this type of assault but who pay for it exorbitantly: giving birth to an unwanted child and having no economic future. There are other women, drawn either to enjoying pleasure or to prostitution, who undoubtedly know how to control virile urges by appropriate procedures for *coitus interruptus* or methods of self-protection. And still others resort to the option of abortion. But is this happiness?

A large number of these women[16] fall into the category of "seduced and abandoned women."[17] Their "fragility," according to Diderot, suddenly drew them close to the man who lusted after them, and they fell for his words. Life taught them a few months later that the man had gone, leaving his seed in the maternal belly. Who are they? They are women who also fantasize about masculine presence. They know very well how to remember and recount how, in the initial moments when the acts of seduction are under way, they were touched by gestures, the sounds of voices, little gifts such as rings, gentle words, ribbons, baubles and books, caresses and promises, sweet words (which they had never known in their lives). When they recount this before the police commissioner, one thing appears clearly: they expected from the man no doubt his virility and protective strength, but they were also touched by that moment of sweetness when the man was the seducer, showing attentiveness and sweet talk. Life is a narrative: that of the man is as much one of brutal virility as one of being inclined toward the delicate charms of femininity about to blossom. It is impossible to know anything about the forms of common folks' virility without taking as much interest in groups of brutal, boasting, and faithless men as in men who are perhaps trying to know about women's bodies and female expectations.

Having fun with the girls at the inn and everyday whores[18] at times runs up against "friendship:" "I knew of love only in sensual pleasure and not in perfect friendship." At this precise moment, the problem appears: for the virile man of the people, "becoming attached" makes him like a gang of galley slaves attached by their chains. Friendship and love, however, seep into one another. At the first moment, the virile man flees them; he says he has no time to lose or, more likely, has

no desire for it. He most especially does not want to restrain his vagabond sexual pleasure, the very essence of his life, nearly consistent with the libertinage of the great. "She wanted to go straight to perfect love; I rushed everything and took off as soon as I was done."[19] Cynical good-byes occur as well; Ménétra during one such adventure passes by the door saying: "She wishes me bon voyage and I wish her a large progeny."[20]

What can be said, except that we are really not very far from Choderlos de Laclos's *Liaisons dangereuses*? One must not "adore" or "love" or head for "perfect love" in order to remain among the virile youth of commoners, and the formidable masculine entourage finds it easy to bear this in mind.

Taking pleasure, fooling the girls, having fun, slipping from one girl to the other, then taking off fast, refusing any attachment, playing around in a gang—these are the forms of ordinary social relations clearly taken up by the male populace. We should add the taste for the group-acquisition and sharing of girls. As Daniel Roche says in his afterword to the *Journal de Ménétra* to characterize the glazier's lifestyle: his ordinary relations are sexualized; "every day, he writes, I would make new conquests."

If one takes away the vanity and also contentment that envelop this text, one perceives that sexuality is "taken" easily but is not given, and that it is given priority and nourished by a very particular atmosphere in the eighteenth century: that of a desire for liberty, male solidarity, and innumerable acts of private and socialized violence. The gangs, the associations of friends or other youths, whether young neighborhood men or school children, form identifiable groups, hotheaded and aggressive, for whom the virile capturing of women is a fundamental prize. Emulation among young men, challenges carelessly made to feminine sensibility, life in the streets, and strikes and tension in social relations make of sexuality a sort of hunting ground legitimated for all men. The "charming affairs" and the "banter with no outcome" are part of a grammar of masculine conduct. The virile dimension develops most of the time out of this—i.e., that which uses force to get women and glorifies in this stratagem, while at the same time trying to be "just as well-known for it" by women. This poses quite a few other questions.

The terms "hunt," "game," "conquest," and "flush out" give the enterprise a warlike, ludic aspect, whereas the usual picture that the man has of the woman is one of great depreciation. That is part of virility; as a "girl chaser" (the way Ménétra speaks of himself), there is no question of paying attention to the world of women, especially in front of other men. "I want to show them all that women in general are not

worth very much."[21] If they are not worth much, there is no cause to be responsible for the acts committed against them or with them. Besides, the man of the people is hardly worried about the other affairs that the women he takes up with might have had. Sometimes a servant who has just "served" one man can serve another; that is called "the remainder:" "I took the remainder from the French guards. . . ." No question of fussing over a woman's needs or of giving in to her whims: the virile man expends his energy in every direction for himself and not for anyone else. The woman is absent from any sexual sharing. That does not stop certain women, as always, from liking to be accosted and sought after, and Ménétra acknowledges the pleasure that gives him if he manages to maintain control and clear domination. He adds, unsure of himself, that he knows very well that he has to go fast and obey "the ardor of his temperament rather than his reason."[22] His reason tells him, in effect, that there is nothing reasonable about it.

Taking advantage of occasions as soon as they come up is a current practice in which reflection plays no part, and the legal proceedings that follow from abandoned, then pregnant, women show just how gender roles work. The man's method of defending himself is to assert that the woman he took was worth nothing and was going with everybody.[23] It is a paradox: virility could be conceived as pride in having won over relatively honest women, which increases masculine prestige. But that is not the reasoning: the man has done nothing wrong since the woman amounts to so little, accustomed as she is to receiving the "gift" of the sexual act from numerous men. This so-called feminine habituation does not seem to diminish the man's virile reputation. Virility, therefore, is not measured by the honesty of the relations, even if rough and hurried, but by the acquisition of a well-filled dance card.

It cannot be ruled out that the libertine model of certain princes of the Court may have influenced popular masculine behaviors, and vice-versa: capturing, using one's charms, possessing carelessly, freeing oneself from any prohibition, triumphing over the weaker sex, being socially and economically dependent, thus generating a dependency in the end with regard to self, being involved with violence and earning one's reputation in the eyes of others—all of these attitudes have something in common with the libertine milieu and the novels of the period. The man of the people, denied by the monarchy, poor, economically unstable, reasserts his power through a virility practiced with audacity, although he is careful not to lose his honor thereby. He manages both, in a value system shaken up under the Ancien Régime, economically as much as morally. As for the aristocratic libertine, he plays with ease on language and uses deception and sweet talk to win feminine

submission. Once won, it hardly matters whether the woman's body is taken physically or the sexual act accomplished.[24]

ONE DAY WE REALLY MUST SETTLE DOWN: VIRILITY IN MARRIAGE

Fleeing love and attachment, denying feelings, taking and not being taken—this is virility before marriage. Such is the practice everywhere, in domestic quarters as in public places as a whole—streets, roads, rivers, fields, fountains, intersections, vineyards or village squares, taverns or inns.

One day, however, by dint of pleasures taken, candles blown out in haste, runs between inns,[25] and some concessions; among linkmen on the river, in churches, in taverns, and on towpaths crowded with beauties, time passes and issues its injunctions: you have to settle down economically and socially in order to subsist and develop.

One day, however, other factors enter in: family pressure, advancing age, the will to become stable and to try for some kind of economic success—in this situation taking a wife is the only path. It is called going under the "yoke of marriage," losing one's freedom, freezing the image, stemming one's ardors ever so slightly, without abandoning the internalized idea lived a thousand times, of the flagrant male domination over female space. It will be necessary to abandon little by little the youthful haunts, the groups of laughter and obscene jokes, to enter into family life.

It may even be—and this is not the simplest explanation—that love has come knocking at the door and suddenly stops the usual running around. Before the choice of marriage and marriage itself, a time of hesitation develops during which the man is not supposed to abandon his virility or conduct in any other way. He still goes toward the woman, of course, but now adopting, rather sheepishly, under duress, at times happily, thoughtfully, another sexual grammar, another affective and amorous cartography.

His virility of youth is not prepared for it: until now, virile meant being on top of the heap in strength and power. If one has to marry, other ways of maintaining virility must be invented or followed. While he has continually wanted to avoid "the woman who acted the prude and who wanted to rush toward perfect love,"[26] never to be in the clutches of anything other than "pleasure," now the man is either touched by love or obliged to put an end to his escapades. Will he still be able to

have fun with the shopkeeper? Perhaps he will, but only once he has established his virility as head of the household, which is quite another matter. It is no longer about dominating *women* but about dominating *his* woman. It is not simple because the literature of the day, whether it is pulp fiction or *belles lettres*, is driven by the emotion that men are sometimes faced with in dealing with their wives. Louis-Sébastien Mercier knows quite well how to describe this strange state: "The control that a woman has over a man is always flattering to her self-esteem; but what a glory or benefit to the woman who, for the pride of her sex, gets satisfaction from seeing a statesman on his knees."[27] And even if, in the juridical sense, the husband is the master of his wife's person, it must be realized that, once settled, the man of the people also fears for his reputation, whose loss would incur a definite economic cost; that is, he worries (in inverse proportion to his youth) about the possible escapades of his wife as well as his own.

In marriage, virility is hamstrung by certitudes and worries: he is the master, he has the power; the wife is dominated, but she is not necessarily submissive. He holds for himself certain attitudes of youth, and his sexuality may be broken by the obligation of fidelity, even if it is compensated for by masculine liberties that are never condemned.

The space of marriage and the home, as precarious as they may be, organize definite gender roles, maintained in the face of others within the promiscuity created by that precariousness. Everything can be heard in the buildings at the doors of lodgings opened to each other, everything is known, intimacy does not exist, and running around a lot does not look good. The "debauched" woman, like the abusive man, is scarcely acceptable once certain lines have been crossed that each and every one seems to agree on more or less. This fact casts a cruel light in the judicial archives on the way the man acts toward his wife. All historians have recognized the rough acts of violence committed day after day by husbands against their wives; it is a violence that mirrors the continual abuse that erupts in the suburbs and in artisans' boutiques, in the streets and taverns, in the markets, and in the midst of numerous ports on the Seine. If the violence is social, if it is not a way of life but a means of physical survival and of taking political action, it is normal that it might inhabit the marital space, caught as it is in the economic, social, and political framework.

There is a question: are all mistreated wives the victims of violence deriving from the core of society or from virile conduct in which male domination is the norm? To such questions the police archives can sketch out answers that are, of course, not certain. It would seem that the man of the people is all the more master

in his home because he lacks any power outside it. It so happens that he disposes of his excess power at home in proportion to the absence of his political and social liberties. The familial domain would be the territory in which masculine power is wielded, even if many wives resist this arrangement—a resistance, it should be said, after many years of marriage. Moreover, violence and virility are not synonyms; one can be violent without being virile, and vice-versa. Naturally, the police archives detail hardly any but the portraits of violent individuals. One thing is certain as one reads the declarations of husbands accused of violence: the wives got what they deserved. "She just got the slaps she deserves, she fights me so much," says one. Another, having injured his wife quite disgracefully, replies to the commissioner that she has no reason to be in a bad mood and that "he wants to dominate her at any cost." On the charge sheets a stereotypical phrase used by the court clerks comes back often in cases of men's maltreatment of women: " . . . that he wanted to show he was master, that he will always break her resistance, that the wife is meant to obey, that her usual angers are only the result of her feminine weakness, which he is suited to control, etc." More serious, or more precise, is some maltreatment that involves a veritable perversity—a perversity that no doubt could not be seen when, as young men, they would hurriedly go from one girl to another. Here, within marriage, there is no need to hurry, but rather a need to coexist and keep one's desire keen. It is thus frequently noted that women come to complain about transgressions that humiliate them, as for example if the husband comes home accompanied by his mistress and makes his wife watch their lovemaking or makes her take part in it. Often the sexual humiliation is a trophy brandished by the man to win female submission and to show that he is master. In 1785, Jacques Loriot is summoned before the commissioner for the deplorable attitude he has shown toward his wife, the plaintiff.[28] "He took her into the courtyard, in front of everyone, right in the court, one January day, pulled up her skirts in the cold, forcing her onto her knees to be steady in the cold, then, pressing on her bladder, he got her to urinate and then made fun of her. He repeated to her that he was the master." The two aspects, Sade-like violence and excessive violence merge, but the absolute desire to be the master, displaying his domination in terms of obscenity, tells a lot, in spite of everything else, about this battle between male and female bodies.

There are many complaints in which married women find themselves at the mercy of husbands who like forbidden pleasures. Thus the 1775 case of Élizabeth Hure, 17, domestic servant in the home of a gilder of the Faubourg Saint-Martin. Her master will not stop "playing with her" by asking her to help him make his bed. His greatest pleasure is also to take a walk with her in the gardens, in the sight

and with the knowledge of everyone, including his wife. "She would take walks through the streets until ten o'clock at night, and he would play with her in those streets; when she refused, he would strike her with his cane, and then he would bring her into the bedroom with his wife." Pregnant, she gives birth to a little boy whom the master's wife takes away from her and gives to her husband.

In certain ways of manifesting virility there is an audacity and provocativeness destined to be seen by the public, the circle of friends, and the neighborhood. Something like a prideful arrogance comes into play. And referring back to the above example, we see that the gesture of the husband's wife, coming to give her husband the fruit of his sin, is at once a mark of submission toward him and perhaps an act of vengeance, an act of upsetting feelings and roles.

Whatever the case may be, with all this emphasis on virile possession among the poor in the eighteenth century, we can also focus on another form of virility, more bourgeois or aristocratic, which targets women of the people. It is not unusual that a person of note, say, a lawyer in Parliament, finds enjoyment and pleasure in the possession of a poor woman. Here there is a kind of dual virility: the domination brings all the more pleasure in that it is wielded on what the upper class calls the "riff-raff" [canaille]. To hell with precautions or with what people will say: the extreme pleasure is in rubbing shoulders with these lower classes, often projected as fantasized images. The gutter is attractive, so they believe, and it sends forth a perfume of innocence that has been lost.

In 1776 Commissioner Crespy received a woman brought in a laundry wagon by a police watchman. Her name is Barbe, originally from Strasbourg, and the watchman has found her tied to a tree. Thanks to an interpreter, the commissioner finds out that this woman had come to Paris to find a job and that a "gentleman in a carriage with a valet" picked her up, promised her a position, and then wanted to "force her immediately." Upon her refusal, the man got angry: the woman got away and was immediately caught by the valet, who tied her to the first tree they came to, shoving "a wadded cloth into her mouth that blocked her throat."[29] The story is novel-like but full of meaning: the aristocrat gets the woman of the people without encountering any obstacle and punishes her if she refuses.

In this atmosphere of a predatory and reckless virility, there remain, in spite of everything, codes to respect. Women who are excessively maltreated by their husbands may go before the commissioner and win damages with interest and legal separation. The dispute over who wears the pants, the case of the woman beaten by her husband—these are customary events but ones whose boundaries must be set. An anonymous text from the end of the eighteenth century, lacking a precise

date, is entitled *Grievances and complaints of badly married women*: "The husband is master of his wife's person, of her dowry, of her rights. His lot is despotism, [. . .] that of the wife is obedience and submission; [. . .] this absurdity should not hold down in the irons of rigid slavery the wretched wife. [. . .] Let the man be the chief but not the master." Written after the Revolution and at the time when discussions and debates are taking place about divorce, this text by anonymous women does not hesitate to evoke "male tyranny" and gives voice to "the painful cries of these unfortunate women." The text was no doubt written by cultured women, but something is expressed that crosses class divisions: the pain of being face to face with "masters" or "tyrants."

ARE VIRILITY AND VIOLENCE INDISSOCIABLE?

"Desire always has to do with violence," writes Michel Delon,[30] and masculine identity harks back to the phantasm of omnipotence. There even exists a kind of ritualization of violence in the will to capture, abduct, and sometimes abandon. The man of the people does not have, as the libertine, the possibility of putting into operation a whole arsenal of games, pleasures, gifts, or simply language. Virility is practiced as something obvious, and also as a desire to be on a par with other males or at times even to surpass them. Being virile means existing as a man for three people: oneself, one's neighbor or coworker, and the woman. Judicial sources reinforce, of course, the impression of violence, since they keep account only of those cases in which the abuse was the current trend, notably in examples of the mistreatment of women. On this subject, moreover, one might reflect: it is not certain that wife-beating forms part of virility, even though it might seem normal or usual. Submission and domination can also be part of many other processes in which virility seems unconcerned.

But one thing is certain: working-class virility cannot be discussed without taking account of the social context itself, which is marked by extreme violence. The street, the workplace, the buildings, the prisons, the hospitals, the cabarets, the studios, as well as fairs and markets and even walkways are places of a great deal of violence. Brawls, beatings, and disputes take place night and day,[31] almost continuously; Paris of the eighteenth century is a very tumultuous place. Under these circumstances, it would be difficult to imagine that male-female relations elude this violence, which is an integral part of commoners' life conditions. Therefore

assumption of the masculine role is based also on how the man has lived during his youth and then during his adult life, when power relations are just as violent as class relations. In a tough, impoverished, unstable society, a man receives and constructs his virility without moderation: violence seems a usable tool once some disorder or an instance of injustice appears. It is used as much to defend oneself in the street, in one's home, or on the road, as in relations with other people. In this framework, though, it so happens that the woman possesses a slight privilege: social norms, respect for the mother, and knowledge about her supposed weakness sometimes protect her.

In these continually difficult relations between men and women of the people, virile violence often acts as the means of reestablishing the social and sexual rules that have been brushed aside. The charivari, for example, draws together bands of young males pursuing, often cruelly, couples who have gotten married in defiance of the traditional rules of power between the sexes. An older man's marrying of a young woman takes away from the lot of young males of the village or neighborhood a "unit" that they could have chosen. The race for girls is a huge affair; displacing the order of this legitimate race provokes the young men, who, expressing their violence, make known the intangible force of the right to virility. An older woman's marrying of a young male removes from the male community one of its forces: the response to this disordering is virile. Associations of youth (or "youth abbeys") and networks of friends, the real agents of access to women and virility, are employed for this protest. As was said earlier, this does not prevent the man from having to be also a poet, musician, and a playful, funny, and sensitive person, and these qualities correspond more and more to social expectations as the century progresses—a century smitten at once with freedom and affectation, complete with swings and hair ribbons. "He played the mandolin for her and sang a few verses, engaged her in conversation, kissed her hands, telling her that she was pretty, fresh as a rose, and he also kissed her in the kitchen:" this is Madeleine, 20 years old, who is speaking; she is a cook seduced by the manservant.[32] Two paintings by Fragonard, *The Bolt* and *The Swing*, are emblems of a voluptuous century, when a woman could be "taken" by force and sensuality or be captivated by ruse and frivolity.

The customary places where men and woman of the town meet highlight without a doubt the roughness of virile manners. The cabaret is one of the principal places where games are played, where jibes are hurled at one another, and where men stop to drink and make up work contracts. Drunkenness is the usual companion: every incident is full of drama, the choice of a female companion, jealousy

among men, disputes about going up to the maid's room. Every new arrival happens in a tense atmosphere, in sight of suspicious clients. The men look each other up and down and call out to one another; the fights and settling of accounts get going fast and at times end up in the street, unless a sort of absurd compact between men attracted to the same woman makes them draw lots (or go "heads or tails," as noted in one of the police reports). Daniel Roche, in his afterword to the *Journal de Ménétra*, writes that a "public square culture" is pervasive in the eighteenth century and that it is constituted by important gestural and aural manifestations. Jokes, drama, and fights are added to a passion for firecrackers and flares and fairs, where men and women play their part. In the same way, work days increase the chances, on street corners as well as church squares and river banks, for furtive or short-lived encounters: accosting a woman, even when she is accompanied, including with her husband, is a commonplace and ends in a fist fight. The watchman of the Enfants Rouges [market] separates two servants fighting out of jealousy, and the one, Roland Pernet, bursts out in anger: "Now there's a fine monkey business, to want to marry my mistress." In another instance, an accosted woman cries out that "she will never allow herself to be kissed by such an ugly man." It is important to note that women often oppose resistance to this sort of assault; they wish to choose and demand this liberty for themselves. Besides, they can be loud-mouthed, and they know how to make use of serious violence.[33]

On the roads and around the villages, men who travel by foot are taken from one port to another by ferrymen and look for a chance at pleasure found off the cuff in the fields, hidden from view, with peasants and women busy with seasonal work. The "clandestineness" favors this sort of sexual escapade; here again, the village police and local courts can sometimes help women who have been deliberately attacked.

So, should we take up again the expression "public square culture" or should we instead look into the manner in which public spaces, life conditions, masculine fraternities, even when not continued, are so many elements constantly staging the confrontation between the sexes in a climate of violence and extreme instability? Besides, we must take into account a major element in the life of couples that explains the abrupt expression of virility. A very old study by Gérard Bord on divorce during the Revolution[34] shows that one of the most frequently used motives when asking for divorce is the *absence* of the spouse, his abandonment, the fact of not being heard from. Thus, absence (wars, work, seasonal moving around) is a situation that throws off balance affective and sexual behaviors as a whole, and if the man is "absent" from home, he cannot be considered a full-time bachelor.

Similarly, a woman with an absent husband is the object of a great deal of attention. Absence is a social phenomenon that paradoxically creates encounters; the modes of virility increase during these periods.

FEAR OF IMPOTENCE AND CUCKOLDRY

After these descriptions of a rather glorious virility and the supposedly noticeable appearance of love developing into a social value along with a "feminization of love,"[35] we should move on to what thwarts this virility. Exactly in the way that a number of people worry terribly about being buried alive, a majority of men fear impotence. The "literary reveries"[36] of such writers as Rétif de la Bretonne, Casanova, and Sade, each in a different genre, create an imaginary climate in which super-potent men are capable of seducing and satisfying every woman without taking a break. Constantly announcing one's sexual feats shows how much virility feels threatened. Men fear evil spells beating down their sexuality, and this fear reaches the point of obsession, as was observed by Pierre Darmon in his book on impotence.[37] The archives are full of examples in which men suffer from having their virility struck down, and numerous treatises are used to find the means of testing male impotence. In some respects, libertinage accentuates this fear, even though most of the libertines have managed to transform raw sexuality into an invention of sensual relations between men and women. It remains nonetheless the case that the *Journal de Ménétra* leans more toward physical performance than toward the search for sensual delight. Physicians themselves weigh in on the question—for example, Drs. Antoine Petit and Samuel-Auguste Tissot.[38] A good deal of correspondence, conserved as archives, testifies to this particular moment when impotence cast a shadow over the delightful pleasures of the eighteenth century.[39]

Jean-Joseph Menuret writes the article "Impotence" for the *Encyclopédie*. He notes: "It is a malady in which men of a certain age are not capable of the sexual act, or at least cannot accomplish it correctly. . . ." Remedies are not necessary, and the whole thing involves the fear of the spell, continues Menuret, adding: "I will simply say those people that they should not have their feelings hurt; the best explanations make no impression on them as they charge headlong toward ridicule. It is proper to be nice to these people, to appear convinced of their accident." Here Menuret approaches the idea that many of the events of this type come from a hyper-superstitious climate and an obsession more psychological than it should be.

Belief in spells or not, it is nonetheless true that in the lusty climate of the Enlightenment and with the relative ease of encounters between the sexes, impotence is surely one of the most common male maladies.

The cuckold and the beaten man—the two sometimes going together—are no easier to live with than impotence. An affair noted in the police files seems revelatory of the difficulties existing in relations between the sexes. Joseph Boudhon, lapidary merchant residing on the rue du Grenier-Saint-Lazare, complains about his wife. He says that he was happy to marry her and that they "lived fairly well together." But after six years the wife started to take certain liberties and was caught in *flagrante delicte* with a young surgeon. Joseph Boudhon tried to put his wife back on the proper path, but he "was surprised the see how little effect his efforts had made on her spirit, since the wife then came at him with extreme anger, beating him and treating him like the most wretched of men." The woman did not accept her husband's remarks, refusing the traditional relationship of husband-master over submissive wife. The case was transferred in 1765 to Commissioner Legretz.[40]

For Pierre Meunier, innkeeper and landlord, the matter appears differently. His wife is, according to him, inappropriately bossy, and she scolds him constantly. One morning in 1770, after he bought some things at the market, the wife judged that he had paid too much and went at him, forcefully punching him and scratching his face as she insulted him. He leaves Commissioner Maillot's office and practically excuses himself for his declaration: "He could not help coming to tell us what was going on at his home and to complain out loud about his wife's rage." Back home, his wife having learned where he went, greets him by striking him with a rod. There is a new interview with the commissioner and an interrogation of the wife, who "denies having wanted to injure him but [says] that she felt provoked by the bad things her husband was spreading about her, which happens every time he starts drinking." Two days later, Pierre Meunier stands down, excusing himself for his "impulsive moment without thinking."[41]

Of course, these complaints are infrequent, but they do exist; they illustrate the lifestyles of men and women of the people that give rise to disputes about domestic power, recriminations against male authority, the consequences of drunkenness, and the male fear of failing at his manly duty by risking complaining about being controlled. Within the marriage, demands for freedom or sexual breathing room are not borne well by the two partners, for they lead to being accused of having a bad reputation. Any equilibrium proves to be fragile between a virility aiming at a good time but expressed only through violence and the desire for breathing room, which can never again be like what youth allowed before the time of marriage.

The controlling woman is an absolute evil, they say: is she not the one they call "virago" (*vir-ago*: "I act as a man"), inverting the order of gender roles to the point of threatening the social order? It is another matter, as Louis-Sébastien Mercier pithily puts it, to fall under female control in the bourgeois class, which is perhaps less easily intimidated: "The control that a woman has over a man . . . gives him more charm, and his character is elevated." And, astonishingly, Mercier adds: "just as a woman is in her element when playing the dominant role, she seems born to palace intrigues."[42] This is tantamount to recognizing the existence of domination in women and the charm involved for a man to succumb to it. At the same time, there is consequently a need for bold virility to contain this feminine taste for power so as to establish or restore the normal order of things: the man directs the woman in her force and her spirit, virility giving him naturally the means for doing so.

Concluding is not easy on a subject so specific as this one, since while male domination is a fact recognized by everyone, it is also subject in the eighteenth century to a good deal of questioning. On the other hand, it seems perhaps ineffective, in interrogating domination, to borrow one of society's most hackneyed *topoi*, the association poor man/coarse man/coarsely virile man. Masculinity, like femininity, is a function of the sexual being. This masculinity comprises precise roles in the social community and, like femininity, depends on customary sets of opinions and practices.

Virility—or its forms—is often the result of war-like feats, in which force belongs to man's bellicose mode. In the eighteenth century, the masculine (or even virile) model is rather to be understood within the libertine world that, for political reasons, borrows from aristocratic libertinage its capture/submission mode, which was all the rage in the courts of Louis XIV and Louis XV. The elite never expected and therefore never saw what came from individuals born of the people: grossness, abusive force, and male domination. But then, what could they really expect when they were offering themselves as models of integrity?

After that time, men of the people lived in a swamp of social and economic disorder, a really unstable situation, a fascinating, top-down world of external provenance, issuing to men the injunctions to "take," "abduct," and "subdue." They were not necessarily obedient to it, but in this impoverished life riddled with insufficiencies, as in earlier centuries, a sort of masculine monarchy was being organized that witnessed the "culture" of the great, their ideas of pleasure and happiness, grabbed on the go as a matter of course, pushing marriage off until middle age.

Once married, family honor is at stake, along with the necessity of economic prosperity; the woman's role is a major asset. She is required to safeguard the home;

therefore, obedience is expected, along with force and strength, whereas the man believes he is required to act in accordance with the imposed forms of his executive power. That power is often reflected by everyday acts of violence and social suffering. The male makes himself male, with all the consequences that entails for the woman, who often endures violence. Nevertheless, "common folks' virility" is not a *topos*; nor is it necessarily based on brute violence because it is associated with the working classes; it is one of the expressions, among so many others, of a masculinity forged at the core of social misery and under the banner of people of the realm who are more perverts than "*honnêtes hommes.*"

One should never forget the infinite modality of successful loves or the figures of rebellious and resistant women seeking to distance themselves from the traditional, stifling model imposed on them, according to which they are weak (and too violent), unfit for thinking (and too cunning). They struggle often in this dead-end rectangle, yet common folks' virility cannot be discussed without bringing them into the foreground.

MEN OF FICTION

MICHEL DELON

THEATER ATTENDANCE and the reading of novels assume a growing importance in the life of eighteenth-century society. The spectating and reading public broadens socially. It seeks in the fictions, no doubt, a representation of its existence, but also an explanation of its fears and its desires. Such is the interest in masculine characters, staged in the theater or depicted in the novel throughout the century: they tell of the slippages of the imaginary. They can be grouped around three figures: the father as embodiment of an exultant virility, the eunuch and castrato as his opposite, and the adolescent who, in finding himself, suggests a masculinity different from virility.

The mid-century play by Diderot, *Le Père de famille* (*Father of the Family*), claims to be a double statement—poetic and moral. As a bourgeois tragedy, it rejects the superposition of two hierarchies, that of the tragic over the comic on the one hand, and on the other that of the nobility, which arrogates to itself the privilege of grand sentiments, over the vile commoner and bourgeois who are doomed to ridicule. In Diderot's first play, *The Natural Son*, a year earlier, the hero struggles between desire and duty, between fidelity to a friend and love for his friend's fiancée. The arrival of the father in the last scene resolves the conflict. Both the hero and the woman he is aiming to marry recognize the man as their father. Incest is avoided and order re-established. Morally, the father organizes around himself a family without a maternal pole; he is caught between authority and the new values of individual sentiment. Virility is defined by reproduction, physiological and social.

Le Père de famille tells of the mutation in the father figure through the rivalry between two characters, M. d'Orbesson, the actual father and widower, and his brother-in-law, Commander d'Auvilé, who is rich and childless. The father has two children, each one engaged in a love relationship. The son spends his nights chastely next to an unknown beauty, whom the elders suspect of being an adventurist. The daughter is in love with a poor, worthy man, chosen by the father. The commander represents the tradition that favors marriages of convenience, alliances between well-born young people, unions of fortunes. He calls on his brother-in-law to stand

up for the values of birth and authority. The father tries to. He pretends to impose his will on his son. "Give up your plans; I will it, and I order you to do it by all the authority that a father has over his children" (II, vi). The son protests: "Authority! Authority! That's the only word they have." The "they" refers to the father and the uncle, and more generally to a patriarchal society in which children are subordinate to the elders, in which disobedience is threatened with exclusion. To the son's denunciation ("Fathers! Fathers! There aren't any. . . . There are only tyrants"), the father responds with his curse: "Go away from me, ungrateful, unnatural child. I curse you: go far away from me!" He corrects himself quickly, though, and refuses to use the actual coercive measures employed by his brother-in-law, who solicits a royal warrant. The play ends with the failure of the commander and the configuration of the family unit around a loving father, respectful of his children's amorous choices and preferring to renounce his fortune. The son recalls to the father that he was also at one time a son in revolt, affirming his youthful virility: "When you wanted my mother, when the whole family rose up against you, when my grandpa called you ungrateful child and you called him, from the bottom of your heart, cruel father, which of you was right?"

One might relate the play to the personal situation of Diderot, who is supposed to have imposed on his children his matrimonial and professional choices and who brought to the stage his own father in the *Dialogue of a Father and His Children*. The cutler of Langres appears in it as the moral center in his little town. The philosopher has trouble establishing theoretically his autonomy. He belongs to familial tradition, without, however, adopting all the beliefs of his father. Any swerving from or refusal of authority becomes part of a general configuration that Maurice Daumas names the "Des Grieux syndrome" and that Jean-Claude Bonnet characterizes as the "paternal curse."[43] The syndrome, which gets its name from Prévost's novel, *Manon Lescaut*, refers to the conflict between the adult who commands authority and the young man who must assert his autonomy, that is, his own virility. Des Grieux follows Manon Lescaut, exiled in a New World that turns out finally to be identical to the Old World. The competition of generations is invested in an opposition between two types of society, either founded on tradition or else on the individual. Throughout the century, the conflict is expressed in a paroxysmal and obsessive scene: in the article "Curse" that Diderot wrote for the *Encyclopédie*, he hailed the painter Jean-Baptiste Greuze's diptych, *The Ungrateful Son* [fig. 6.1], and *The Son Punished* (1777), contemporary bourgeois scenes, repeating or rather parodying the noble ancient mode in his *Emperor Severus Reproaching Caracalla His Son for Trying to Assassinate Him* (1769), and Rétif de La Bretonne publishes

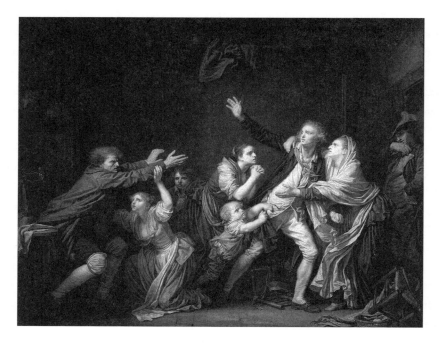

FIGURE 6.1 JEAN-BAPTISTE GREUZE, *LA MALÉDICTION PATERNELLE* OU *LE FILS INGRAT* (THE PATERNAL CURSE, *OR* THE UNGRATEFUL SON), 1777, PARIS, LOUVRE.

Paternal authority, bourgeois version. The father disowns his son, who has enlisted in the army and leaves his family. The women intervene as powerless peacemakers. Greuze later paints the return of the guilty son, who arrives too late and finds his father dead.

Source: © Leemage

The Paternal Curse. Virility supposes procreation and conflict, being inscribed in history as a sequence of generations and as a personal adventure. From the *Story of the Chevalier Des Grieux* to the *Père de famille*, familial space is emptied of all maternal authority, of all feminine counterbalance. Virility becomes essential as masculine rivalry between generations, a passing of the torch from fathers to sons. In Greuze's sketch for his *Ungrateful Son*, which Diderot describes for the *Salon de 1765*, the female figures have only a role of interposition: the mother holds the embraced son around his body, a daughter holds back her father by his coat-tails. In *The Son Punished*, the sisters merge together, and the mother settles for showing to the returning son his father on his deathbed. The confrontation of the Emperor Septimius Severus with his son Caracalla, which Greuze presents at the Salon of 1767, is criticized by Diderot on technical grounds, but the canvas tells the virile

truth of the scene: the women have disappeared; the struggle for power takes place among the men.

The aesthetic writings of the Encyclopedist recall figures from pagan and biblical antiquity, most often staged by dramatists and artists. The sacrifices of Iphigenia and Jephthah show girls dragged onto the altar by their father's orders. Diderot describes the scene frequently:

> At the moment that Calchas raises the knife over Iphigenia's breast, the horror, compassion and pain should be shown as intensely as possible on the assistants' faces; Clytemnestra, furious, will lunge toward the altar and, despite the soldiers' arms holding her back, struggle to grab Calchas's hand and interpose herself between him and her daughter; Agamemnon will have his head covered over by his mantle ("Composition, in painting," *Encyclopédie*).[44]

As interpreted by Lagrenée in the Salon of 1765 the biblical version does not even distinguish between father and priest, between the body ready for love and the body to be immolated: "In the middle of the canvas an illuminated altar: next to the altar, Jephthah, leaning over his daughter, his arm ready to bury the dagger into her breast; his daughter stretched out at his feet, her neck exposed, her back turned to her father, her eyes lifted toward the sky." Virility is expressed either materially by the knife or morally by the priority accorded to superior interests over familial sentiment. When the son is substituted for the daughter, the relation becomes ambivalent. Cultural memory confuses Lucius Junius Brutus, who establishes the republic in Rome and condemns to death his sons, guilty of complicity with Tarquin the tyrant, and Marcus Junius Brutus, adoptive son and assassin of Caesar. Voltaire composes in succession two tragedies, in which he is recalling Shakespeare, *Brutus* (1730) and *The Death of César* (1733). The Brutus who strikes down his father (Marcus) avenges the sons of the first Brutus (Lucius), who were condemned to death by their father. In the sixteenth and seventeenth centuries, the rape of Lucretia captured the collective imagination. The eighteenth century seems more fascinated by the oath of those who swear to avenge her, and also by the execution of sons as their father watches. The knife that Lucretia used to commit suicide passes through the hands of the men of her family. It will be turned by Brutus against his own sons. At the end of the Ancien Régime, two painters, Jacques-Louis David and Guillaume Guillon-Lethière, tackle the same subject: how to depict the heroic virtue of the father who orders the death of his sons? Lethière chooses the moment of public execution. David prefers a private scene: the Consul's return home as they bring back

his sons' decapitated bodies. The women grieve in the illuminated part of the scene; the Consul endures the shock of his decision, hiding his pain in the shadows.[45]

The example chosen by theoreticians of painting since Antiquity as the most difficult to depict is the fact of the father sacrificing his offspring. Can a heroic virility be shown in the sacrificing of the simple physical bond? The painter Timanthe was to resolve the difficulty by hiding Agamemnon's features behind a cloak or a veil. Interdiction, the capstone of art, conceals this virility that takes the form of the violence of infanticide. In some interpretations of the judgments of his sons by Brutus, the Second Consul turns his eyes away from the execution. Caesar similarly hides his face so as not to see the gesture of his patricidal son. Diderot returns obsessively to this veil by Timanthe that defines the aesthetic act and that corresponds in classical rhetoric to reticence or aposiopesis, silence or a blank suggesting what cannot be said. More generally, the century that rethinks the function of the father and that of the king chooses this image to invoke the fundamental prohibitions of social life, the massacre of subjects by their sovereign, or incest. The *Encyclopédie* denounces "St. Bartholomew's Day:"

> This is the day, forever execrable, when the crime unheard of in the annals of world history, plotted, pre-meditated, prepared for two whole years, was carried out in the capital of this realm, in most of the large cities, in the very palace of our kings, on August 24, 1572, with the massacre of several thousand men. . . . I have not the strength to say any more about it. When Agamemnon saw his daughter come into the forest where she was to be immolated, he covered his face with a piece of his cloak. . . .

Charles IX, having no descendants, is not worthy of his monarchical function. The main erotic narrative of the period, *Le Portier des chartreux* [*Doorkeeper of the Carthusian Monks*], evokes the reunion of brother and sister. The sacrilegious Carthusian monk who by monastic vow has renounced fatherhood refers though to Agamemnon to express the rapture of incest.

> May I be permitted here to imitate the Greek sage who, depicting the sacrifice of Iphigenia, having exhausted on the assistants' faces all the expressions that characterize the greatest pain, covered Agamemnon's face with a veil, deftly leaving to the spectators the pleasure of imagining the expression that might characterize the despair of a loving father who sees his blood spilt, who sees his daughter immolated.

The height of transgression, incest announces the end of carefree years for the narrator, who will pay for his excesses of virility. Neither Charles IX nor the monk is a father; yet they are compared to the father of Iphigenia. Through this image, the idea of an all-powerful father, imposing his will and desires relentlessly, has become unbearable.

A second figure constitutes the antithesis of procreative virility, that of the eunuch or castrato. However, a truth that is difficult to tolerate might be revealed about it. In 1721 Montesquieu publishes the *Persian Letters*, which construct a play of comparisons and contrasts between the Orient and the Occident, public life and private life. Usbek the Persian has abandoned the despotism of his country in which arbitrary decisions threaten every person's life. He has also left behind his seraglio, where the women are kept under surveillance by eunuchs. As the plot unfolds, the tyranny of the despot becomes a distorting mirror through which the vices of the absolute French monarchy are revealed. The eunuch, who cannot be included in any kind of economic or familial time frame, serves as an image of the evils brought on by the Church by accumulating wealth that does not circulate in society. Usbek is able to criticize the political regime of his country but not to call into question the tyranny that he exercises over his seraglio. Being away from home, he gets no more enjoyment from his wives than do the eunuchs. He experiences with regard to them only "an insensitivity that leaves him without desire" and "a secret jealousy that is eating away at him." From that point, the eunuch becomes less the antithesis of the male than the revealer of the impotence that haunts the male. He is the truth behind the despot who tyrannizes his subjects, who reduces his wives to the state of simple playthings. The novel ends with the indictment by one of Usbek's wives, who commits suicide in order to defy her oppressor and to attain her freedom:

> How could you believe that I would be so credulous as to imagine that I was put in this world only to adore your whims, that, while you get away with anything, you would have the right to extinguish all my desires? No, I was able to live in servitude, but I have always been free: I reformulated your laws by accessing those of nature, and my spirit has always held firm in its independence.

Alain Grosrichard perceives in this text a "Discourse on the origins and foundations of the inequality between the sexes" and a denunciation of the illusions of virility.[46] The claim of virile omnipotence turns out to be impotence.

Did the same reasoning make of Heloise and Abelard the preeminent couple of the century? The castration of the lover is no longer the unsteadying of omnipotence but the confrontation of love with its prohibitions. An amorous masculinity is sought against patriarchal virility, in complicity with feminine feeling. Editing, translating, and imitating love letters are never-ending. *Heroides* and epistolary novels are in fashion.[47] Pope chooses to give voice in *Eloisa to Abelard* to an abbess of the Paraclete, in love and melancholic, sensitive to landscapes and the seasons. The poem had no fewer than twenty-six translators and imitators in French. Most readers are enthused. Only Mme. Du Deffand protests in a letter to Horace Walpole: "Be Abelard, if you wish, but don't ever count on me to be Heloise." This context explains the title adopted by Jean-Jacques Rousseau for the French novel that met with the greatest success in Europe, *Julie, or the New Heloise* (1761). Saint-Preux, the private tutor, and Julie d'Étanges, the pupil, fall in love and become lovers. The difference in social rank creates an insurmountable barrier between them. The prohibition is expressed with the reference to the figure of Abelard, exorcized by Saint-Preux: "I've always sympathized with Heloise; she had a heart made for loving; but Abelard has always seemed to me to be a wretch who deserved his fate, knowing as little about love as about virtue." Rétif de La Bretonne gives a try at diverting somewhat the success of *Julie* in *The New Abelard, or Letters of Two Lovers Who Never Saw Each Other* (1778). Castration is the metaphor for the separation of the young people, engaged to one another by their families and becoming acquainted by correspondence. More interesting for anyone who is wondering about the metamorphoses of virility is the novel by a woman, Fanny de Beauharnais, *The Supposed Abelard, or the Test of Feeling* (1780). The heroine, married at 13 to a rather crude man and now separated from him, is in no hurry to remarry. A suitor, the Marquis of Rosebelle comes up against her refusals when a rumor is spread about his impotence. At the end of a clandestine affair abroad, he is changed into an Abelard by a jealous and brutal husband. The handicap becomes an advantage in the eyes of the young woman: "Believe me that, loving you as I do, even Abelard could still be happy!" Rosebelle is limited to a short, toned-down courtship that substitutes for the virility of genital possession: a loving complicity between man and woman. The lovers end up getting married and consummating the marriage to their mutual satisfaction.

A secondary character in *The New Heloise* shows this same evolution of manifestations and preventive measures. Milord Édouard Bomston, amateur musician, brings back from Italy a "virtuoso" who serves him as manservant. Regianino sings and plays the violin quite well. He initiates his master into Italian music, but also

Julie and Saint-Preux, who know only French classical music. It is the discovery of a natural, captivating, immediately moving art. The whole group becomes excited about these Italian airs and takes classes with Regianino. Saint-Preux's enthusiasm is nuanced with a bit of reticence:

> I had only one regret; but I couldn't get over it; it was that someone other than you was making sounds that moved me so, and that it was from the mouth of a vile *castrato* that the most tender expressions of love came. Oh, my Julie, is it not up to us to claim everything that belongs to the feelings? Who will feel, who will say better than we what a soul in love should say and feel? Who will know how to deliver in a more touching tone the *cor mio*, the *idolo amato*?

Rousseau keeps the term a vile *castrato* in Italian [rather than *castrat*, the French term], which is picked up again and again by French travelers in Italy and which he repeats himself in the article "*Castrato*" in his *Dictionnaire de musique*:

> It so happens that, in Italy, there are barbaric fathers who, sacrificing nature for their fortune, hand over their sons to have this operation, for the benefit of plea- sure-seeking, cruel people, who dare to seek out these wretches' singing. Let us leave to the honest women from large cities the modest laughter, the disdainful air and the amusing comments of which they are eternally the object; but let us hear, if possible, the voice of modesty and humanity that cries out and rises up against the infamous practice, and may the princes who encourage it in their searches for once be ashamed for doing damage, in so many ways, to the preservation of the human species.[48]

The article condemns this assault on the population, and morality masks the aes- thetic point of view, but the narrative discloses the force of emotion from the singer who has given up his virility. Rousseau ventures to compose a kind of *Paradoxe sur le chanteur* (*Paradox of the Singer*).[49] For Diderot, only the actor, capable of dis- tancing himself from feelings, would know how to represent them; for Rousseau, only the singer, who cannot experience physiologically amorous feelings as others, attains a perfection of amorous expression. Regianino is but a metaphor for Cla- rens, the novel's micro-society in which amorous energy is channeled and trans- muted into a diffuse affection and a moral invention. The interdiction that Julie's father had expressed upon meeting Saint-Preux has been internalized by the young woman who married M. de Wolmar, but by accepting the return of Saint-Preux

among them after a long absence, the married couple attempt to override the opposition between personal feeling and the social order. A new Abelard, castrato of social life, the hero tries out a virility transformed into social action and moral gratification. The death of Julie and the interrogations that hang over the future of Clarens prove that the novel is not a dupe of its own illusions.

The eunuch and the castrato are no longer just exotic figures found in fiction and that travelers discover in the Orient or, less far away in Italy. They are perhaps a repressed truth in every man. Impotence has always been a motif of literary invention, from Petronius's *Satyricon* to the French comic novels of the seventeenth century. It appears as an exception to the virile rule, an error of the organs, or a form of madness, indeed an enchantment, a taking over of the male body by malign spirits. The diabolical explanation of knotted aiguillettes loses its credibility in the eighteenth century. The failure of the seducer, incapable of putting his promises into operation, appears no longer so much an unfortunate digression or an exception to virile law as the norm of a transformation of sexual life into a simple worldly spectacle. The libertine novel, of which Crébillon no doubt created the model, shows an aristocracy emptied of its meaning, given over to a permanent amorous parade.[50] The war of *politesse* follows the reality of the battlefields; control over female bodies replaces the reality of political power. Good society in novelistic fiction is no longer only a string of ephemeral relationships on display. Libertine glory resides in rumor, in the appearance of seductions. Crébillon portrays this circulation that accelerates to dizzying speeds in an oriental tale, *Le Sopha* (1742). The narrator is that piece of oriental furniture, adopted by high society in France, on which fine fortunes are consumed. The sofa is the privileged witness of a sequence of lies and amorous negotiations. While the slaves appear as effective lovers, reduced to the status of sexual playthings, the men of the world, preoccupied with their glory, are beset by an ennui that contaminates desire. The central chapters of the novel detail the repeated fiascos of a seducer who, by dint of killing time, has ruined his sensuality. He possesses a little house that constitutes the most favorable setting for his enterprises. He has attracted to the place a young woman who requests only to be seduced, and he shrinks from what she is expecting of him. "No sooner had she exalted at her triumph than she saw him faint. Twenty times she was ready to give up hope, which seemed to appear to her only to disappoint her afterward, ever more cruelly." The shame or the culpability of the swooner turns into a challenge by the mocking, shriveled little master that recovers its impotence as a paradoxical control over female desire. The amorous negotiation becomes a travesty in which

each of the partners tries to profit from the disappointment in relation to what society may say about it.

Impotence becomes a useful experience for the masculine condition. In *Tanzaï et Néadarné* (1734), another oriental story, the hero must go through an initiation test. He has married the most desirable of princesses; he is getting ready to consummate the marriage:

> All at once the most flattering words flew through the air, the sound of sighs was repeated in the chamber; Tanzaï believed he was already at the height of his desires, when, with the same urges, he no longer felt the same potency. In vain, astonished by so unexpected an accident, he held the princess tightly in his arms. In vain, with the most tender of caresses, he tried to remedy his misfortune. Everything inflamed his ardor; but nothing restored to him what could prove it to the princess.

He first has to try dissociating physical desire from love, attraction from beauty. With a plainer woman he has to repeat over and over the amorous moves that he thought were earmarked for his wife. It is a virility emptied of its meaning that asserts itself in the embraces that the young man suffers through passively. Parallel to this, running counter to the traditional stereotypes of male and female roles, the princess goes through the same experience with a man who abuses her innocence. The oriental tale's plot allows for the intervention of fairies and genies that cast evil spells, as in ancient religions, but the essential point for Crébillon is to suggest the fundamental discrepancy between male and female desires and the weight of social and linguistic models on gestures believed to be so intimate.

Impotence seemed to be the antithesis of amorous life, an interruption, momentary or lasting, of libertine activity. Instead, it becomes one of its modalities. Nastiness is no longer just a bitter compensation for an impotent and jealous husband, once sexuality is no longer limited solely to phallic penetration. Sade takes up and sidetracks, at the end of the century, the whole tradition of the libertine novel. His castles and convents are often inhabited by small groups of malefactors for whom he draws up a medical typology. The hypervirility of the red-blooded ones is complemented by the active and imaginative impotence of the melancholic and lethargic ones. Polymorphous and perverse, both groups collect various manias, among which is passive sodomy. Thus, the Chateau de Silling hosts the four accomplices who retire there for 120 days of stories and practice sessions of all human passions possible. The virility of the Duke is superlative. His sex organ is "endowed with the faculty of unloading his sperm as often as he wanted in a given

day, even at his age, then 50." In a nearly continual state of erection, this member measures "eight inches just in girth by 12 in length." This fantastical hypertrophic size is by no means the norm for the libertines. The bishop, his brother, possesses a "very ordinary member, small even." The President, 60 years old, "completely indifferent, absolutely stupefied," is satisfied with "the depravity and unsavoriness of libertinage." As for the financier, his sex organ is extraordinarily small. "It is hardly two inches around and four inches long; he no longer gets a hard-on at all; his ejaculations are rare and difficult, and not abundant." Impotence is no longer a handicap for the libertine, a shame that must be hidden; it actually becomes the condition of a libertinage of the mind, reasoned and criminal, a paradoxical glory one can boast about. There is no physiological determinism that restrains sexual activity; physical stature and age only extend the range of manias and diversify the whims. A similar structure is found in the Convent of Sainte-Marie, where poor Justine believes she will find asylum and comfort. Among the four rogue monks into whose hands she falls, Clément seems to bear a name that corresponds to this hope. Encountering such a promise, he has a "temperament so worn out" that he is "out of condition to procure pleasures other than those that his barbarity gave him a taste for." "Temperaments," in the old medical sense and the modern sexual sense, are so many variations and challenges to the lubricious imagination. Virility is no longer to be confused with the size of the sex organ, with the stiffness of the erection, or with the number of ejaculations; it is expressed in the aggressive expansion of desire, in the hold maintained on the greatest number of bodies and minds; it can even be embodied, no doubt, within the novelistic imagination of a Sade, in phallic female characters of whom Juliette would be the prototype. While anatomy furnishes a model capable of establishing a norm and defining sexual identities, the disjuncture of desire opens the field to limitless libertinage.

It would seem difficult to reduce the complexity of human life to the simplicity of the division between masculine and feminine that medicine and law would like to establish. Scientific curiosity during the century paid special attention to species that represented transitions among species. The polyp among animals and the sensitive plant among vegetables seem to be missing links that ensure continuity from one kingdom of nature to the other. The promotion of the adolescent plays a similar role in humanity, between childhood and adulthood, between the world of women and that of men. Literary invention lingers over describing bodies that combine qualities that cannot easily be made compatible. The adolescent or young male retains something child-like or feminine in the virility that he asserts. One poetic portrayal of this ambivalence can be found in *Jerusalem Delivered* by Tasso,

one of the classics of classical Europe.[51] In Canto I, Rinaldo appears as child and adult; in mythological terms, he is Mars and Eros.

> But these and all, Rinaldo far exceeds,
> Star of his sphere, the diamond of this ring,
> The nest where courage with sweet mercy breeds:
> A comet worthy each eye's wondering,
> His years are fewer than his noble deeds,
> His fruit is ripe soon as his blossoms spring,
> Armed, a Mars, might coyest Venus move,
> And if disarmed, then God himself of Love.[52]

Rinaldo possesses alternatively the fragile body of a child and the force of an adult. His armor, military material that transforms him into a warrior, represents the erection that makes out of tender flesh, offered to caresses, an instrument of aggression and penetration. Rinaldo thus becomes the image of a masculinity that knows by turns erection and dispersion. The episode about Armide recounts the feminization of the hero, who becomes a passive, dependent lover. To remind him of his duties, his companions appear before him "decked out in their portentous armor." They provoke him with their warrior virility:

> So fared Rinaldo when the glorious light
> Of their bright harness glistered in his eyes,
> His noble sprite awaked at that sight
> His blood began to warm, his heart to rise,
> Though, drunk with ease, devoid of wonted might
> On sleep till then his weakened virtue lies.[53]

The adolescent is interpellated, summoned to take his place among the warriors, to become a man. Conversely, the body of Clorinda, who is disguised under male armor, finally returns to its proper form, reconciled with the world order, with the law of the sexes and of the just faith.[54] A return to sexual norms follows the melee and confusion. The painters of the classic age have lavishly illustrated such scenes from the poem.

Voltaire transformed this model inherited from Tasso. He preferred Hercules and Adonis over Mars and Eros, the hypervirility capable of deflowering 11,000 virgins and the passive masculinity that gives in to feminine hands. The image returns

several times in his writing in the register of a playful worldliness intent on amusing itself on the margins of official discourse and grand genres, epic or tragic. The mythological references are noble, but the expression supposes a freedom associated with burlesque and stories of family life. Canto X of *La Pucelle* recounts the flight of Agnès Sorel, who has taken refuge in a convent. She is welcomed there by a nun whose name says it all; she is called Sister Besogne [Hard Work] and reveals that she is a man still young enough to be able to cross-dress:

> My sister *Busy* [*Besogne*] was a lusty youth;
> He joined with Hercules his force, the grace
> And winning softness of Adonis' face;
> Nor yet his one and twentieth year he knew,
> As white as milk and fresh as morning dew.
> The lady Abbess for some private end
> Lately selected him to be her friend,
> Thus sister Batchelor lived within the Gate
> Nor spared his pretty flock to cultivate;
> So great Achilles, as a maiden drest
> At Lycomedes court was greatly blest,
> And by his Deidamia's arms carest.[55]

The body contrasts with the face; the religious clothing shows off the one, the better to conceal the other. The opposition is also one of high versus low, of religious norm versus the impulses that it pretends to hide. *Ce qui plaît aux dames* [What Ladies Like] is a story in verse, inspired from English sources, composed in the same decasyllabic meter as *La Pucelle*, in the mock-heroic style. The hero is a young penniless knight, who can pay in kind:

> Sir Robert's entire possessions were
> His old armor, a horse and a dog;
> But he had received as an advantage
> The brilliant gifts of the prime of life;
> Strength of Hercules and grace of Adonis,
> Gifts of great worth prized in every land.[56]

With *La Princesse de Babylone*, we move from the Middle Ages to a fabulous Orient, but the type of young man remains the same. The king seeks a husband

for his daughter; the trial consists of knowing how to string Nimrod's bow. Three kings present themselves from Egypt, India, and Scythia. The last one outdoes the first two: "his naked arms, as nervous as they were white, seemed already to bend the bow of Nimrod."[57] The first two competitors fail the test. The Scythian tries out in turn.

> He united skill and strength. The bow seemed to have some elasticity in his hands. He bent it a little, but he could not bring it near a curve. The spectators, who had been prejudiced in his favor by his agreeable aspect, lamented his ill success and concluded that the beautiful princess would never be married. (6–7)

A stranger then appears who takes up the challenge.

> He had, as has been said since, the face of Adonis on the body of Hercules; he had majesty along with grace. His dark eyebrows and long blond hair, a mixture unknown in Babylon, charmed the assembly: the whole amphitheater stood to see him better; all the women of the court stared at him with astonishment. (Ibid.)

The handsome stranger manages, of course, to string the bow. "Babylon rang out in admiration, and all the women said: What luck that such a handsome young man should have such strength!" "As has been said since:" the formula is beginning to become a cliché.

L'Histoire de Jenni is one of Voltaire's last tales. It brings in once again the same figure. The hero appears as a young Englishman wounded in Spain. Two Catalan women, not the timorous sort, surprise him as he's coming out of the bath, in the manner in which Mlle. de Kerkabon and her friend Mlle. de Saint-Yves spied on the Ingenu awaiting baptism, naked, in the middle of the river. The curious women check out the Englishman:

> His face was not turned toward us; he took off a little cap under which his blond hair was knotted, and it fell down in large curls on the sexiest curved back I have ever seen in my life; his arms, his thighs, his legs were of a solidity, finesse and elegance that approach, upon my word, the Belvedere Apollo in Rome, a copy of which is at my uncle the sculptor's.

The narrator's friend blurts out an exclamation that makes our Apollo turn around.

It was even worse then; we saw the face of Adonis on the body of a young Hercules. It was all that Dona Boca Vermeja could do not to fall over backwards, and the same for me.[58]

The uncovering of the male body is done in two stages: a callipygian Apollo, then, "even worse," a phallic Adonis-Hercules. The mystery of the male body lies in this duality and in the transformation of a penis into a phallus, of a proffered passivity into an offensive virility. *La Pucelle d'Orléans* had already evoked the "strange metamorphosis" of the young nun into a demanding lover in the warmth of the bed:

> The penitent had scarce on couch reclined
> With her companion, when she seemed to find
> In nun a metamorphosis most strange.
> Doubtless she benefited by the exchange.
> To scream, complain, the convent to alarm
> Had proved a scandal only fraught with harm;
> To suffer patiently, be silent too,
> To be resigned was all that she could do.[59]

The title *Ce qui plaît aux dames* seems to play on a phallic reference. Sir Robert promises 20 *écus* to the lovely Marton to sleep with her, but fleeced during the embrace, he can no longer pay her. Now he is prosecuted for rape, to be condemned shortly unless he can answer the question of "what woman has desired throughout time." An old witch may whisper the answer to him, but she also has her requirements: it is up to him to give himself to her henceforth. The old woman is toothless, with a sooty complexion, short, bent over, leaning on a cane.[60] She acknowledges it herself: "I seem to you perhaps disgusting, / A bit wrinkled and even slightly smelly." In the name of honor, the knight resigns himself, and the miracle takes place.

> She was Venus, but Venus in love,
> The way she is when, with disheveled hair,
> Her eyes bathed in happy languor,
> She waits for Mars to come into her arms.

This transformation of the old woman into Venus, this reversal of sexual need into amorous expectation, corresponds to the metamorphosis of the adolescent body

into a sexual body, of cuteness into virile force. The relationship within the couple reverses. A disturbing feminine physiology is sublimated into desirable beauty. The answer to the question asked is that woman wants to remain the "mistress of the household." Pursuing life outside is for the man, while domestic life is for the woman. The double story of gift and price to pay leads to the idea of gender complementarity and to the constitution of a couple.

In the portrait that Tasso proposed, the two states, masculinity proffered and offensive virility, were alternatives. In the formula consigned by Voltaire to the status of a cliché, they coexist as a troubling paradox, even if the presentation of the character is made in two stages. The alternatives bring together a body and a face, as the low with the high, the inside with the outside, physical force with a concern about social presentation of self, the physiological substratum with the moral sublimation of drives, sexuality with *courtoisie*. The handsome stranger in *La Princesse de Babylone* strikes the public with his dark brow and his long blond hair, "an unknown mixture of beauty." As for the little curious ones in the *Histoire de Jenni*, they start by admiring the hero's blond hair, which falls down "in large curls on the sexiest of curved backs" before seeing him turn around. The male body has a front and a back, associated with activity and passivity respectively, according to the normative division. This duality, running counter to a whole virility without flaw, haunts the century; it is repressed in the form of physiological hermaphrodites[61] and exorcized as an ephemeral digression from adolescence, as feminine phantasm or as reprehensible male passivity.

At the end of the Ancien Régime, the image of the adolescent is embodied in two figures that are met with extraordinary success: Chérubin, one of the central characters of Pierre-Auguste Beaumarchais's theatrical plot, and Faublas, hero of the novelistic saga by Jean-Baptiste Louvet. Chérubin appears in *The Marriage of Figaro* (1784) linked to robes, to ribbons, to femininity. He cross-dresses to hide in a group of young peasant women. This femininity allows him to court all the women in the play, from the youngest to the oldest, including Suzanne and, of course, the countess. Disheveled, in the latter's bedroom, he sings to the military tune by Malbrough a romance that foretells a funereal future. He must himself put on, one after the other, a young peasant woman's costume and a brand new officer's outfit. Suzanne comments on his cross-dressing: "But just take a look at this snotty-nosed kid, how pretty he is as a girl! I'm jealous of him! . . . Ah! How white his arm is! Whiter than mine! Just take a look, madam! (*They compare arms.*)" Beaumarchais wondered about what age to give to this "inconsequential snot-nose," old enough to be troubling in his declarations of love, young enough

for the play not to slip into sauciness. He presents him in a premiere of the play as "impish and passionate like all clever children of 13 or 14." He is more specific in the preface: "When my page is 18, with a lively, ebullient character that I've given him, I will be guilty in turn, and I shall show it on stage. But at 13, what does he suggest? Something sensitive and sweet, neither friendship nor love, but a person who takes something of each." Beaumarchais rejected in silence, between the second and third play in his trilogy, the transformation of Chérubin into an adult. *La Mère coupable* [The Guilty Mother], 1792, brings the setting back from Spain to France, changes the Andalusian exoticism into revolutionary urgency, and the comedy into drama. Turned into Léon d'Astorga, Chérubin has had a child with the countess and gone to war and gotten killed. The passing time dissipates like an illusive dream the marriage of opposites, peculiar to adolescence and the political dizziness of the eve of the Revolution.

The point of departure in Louvet's plot illustrates the same paradox. Faublas discovers love while he is dressed up as a girl for a masked ball.[62] He spends a good part of this long novel in a female costume: the seducer most often seduced and passive in the hands of his mistresses. He becomes a man by seeming to renounce the status of virility. His sexual potency is linked to his feminine appearance. At the beginning of the second part, "Six weeks in the life of the Chevalier de Faublas," out of energy, he experiences his first sexual breakdown, but he recovers quickly. He invokes Venus. "O Venus! Venus, you wanted—for the amusement of the fair sex and my long adolescence—you wanted for Faublas to be seen, at the age of 17, as the coming together of several qualities ordinarily incompatible. With the pretty figure of a girl, you gave me the vigor of a grown man."[63] This vigor has its mythological equivalent in "the prodigious strength" of Hercules, in "the fabulous talents of the husband of 50 sisters" and its novelistic translation in the sequence of erotic adventures of the hero-narrator. The paradox is also that Faublas is a libertine but in love with a single woman, a seducer but idealistically faithful to his wife Sophie. These qualities are hardly compatible—he acknowledges it himself. The equilibrium becomes more and more unstable and less and less tenable as the novel goes on toward the final catastrophe. The contradictory hero, who does not want to grow old, sinks into madness. He comes out of it only after a therapeutic cure and an exile. The novelist himself cannot reconcile the libertine tone with the new revolutionary virtue; he who adopted the aristocratic pseudonym of Louvet de Couvray becomes Citizen Louvet, while the figure of Hercules will soon be monopolized by means of the proletarian radicalization of the Revolution.[64] The knight, side-tracked by the world falling apart, is no longer worthy of being a Hercules; he will have to learn

to become a husband and father. The sexual tightrope act of Chérubin and Faublas ends badly, with the death of the first and the madness of the second, recovered thanks to the control re-established by the father and the wife's force of will. The "love called Socratic," explains Voltaire in the *Dictionnaire philosophique*, is but a contempt of nature, a transient confusion between masculine and feminine. "When age has made this resemblance disappear, the contempt ceases."

The success of Beaumarchais's play as well as of Louvet's novel can be measured by the number of their imitators. Most of the plays written in the wake of the *Marriage of Figaro* are sequels, follow-ups after the wedding. Chérubin has become an adult, in the military.

> That delicate complexion, that fine white skin, is now burnt by the sun. That thin, feeble voice, which has become a deep-throated voice, masculine and sonorous. . . . He has grown up, gotten fat, darkened . . . , yet is still charming.[65]

Adonis steps aside for the benefit of Hercules. The imitations of Louvet similarly hesitate to prolong the suspended time of their model and hesitate to make a grace last that really must remain ephemeral. *Love and Gallantry in the Style of Faublas* makes a go of it, announcing the reference right in the title.

> Théodore was not yet 20 years old . . . his features were masculine and regular, his physiognomy at once soft and animated; his slender frame, built in fine, manly proportions, foreshadowed, under the curved contours of adolescence, a forceful character ready to develop: in sum, he was such that he could satisfy all tastes; and the Adonis who charmed the vision of the most chaste beauties, brought together by more lascivious eyes, suggested the qualities of another no less famous demigod, one who (pardon this blasphemy, miladies) practically never feared the rivalry of the first.[66]

All the adjectival pairs combine opposite qualities: regular but masculine, soft but animated, curved but muscular, chaste but lascivious. The Revolution, which hushes feminist demands, establishes a new norm and limits masculine ambivalence to the sole period of adolescence or else brings down upon it a suspicion of perversity.

A second reduction of the threat represented by Adonis-Hercules for virile omnipotence consists in seeing in it only a feminine phantasm. From Psaphion, a courtesan of Smyrna, to Theresa the philosopher and to Sade's Juliette, erotic literature of the eighteenth century willingly gives voice to female narrators who reject

grand sentiments in order to hold fast to physical realities. They are not satisfied with fresh little faces, they want bodies that hold the promise of a smile. In *Psaphion, or the Courtesan of Smyrna* by Meusnier de Querlon (1748), the female narrator falls in love with a young slave. "Sunnion, originally from Crete, was of a stocky build, but had a touching face, and was at the happy age that still preserves the grace of childhood under the vigor of youth." The girl gives herself to him, becomes his mistress: "He was Alcide with the features of Hylas. Four times I expired under his thrusts; four times I saw him, expiring himself, re-ignite on the pyre of his ashes."[67] In the first portrait, the child remains latent under the young man, in the second it is the man who is revealed under the youth. *Venus in Heat* (1771), as the subtitle indicates, is the "life of a famous courtesan." If she accepts the mythological reference, it is to welcome her lover "as Adonis, when the goddess receives him in her arms," but waiting until Adonis becomes Hercules at work. This lover must leave; his successor insinuates himself in this double comparison. "Elegant figure, beautiful skin, a face of Adonis, vigor of Mars, of an inconceivable suppleness and speed."[68] Gradually, as the adventures unfold, the narrator appears more and more demanding. In Rome she will admire the Venus de Medicis, which fills her with a certain jealousy, and the Farnese Hercules, of which she wants copies for her lovemaking. Back in Paris, she does not hesitate to summon two men into her bed. "My lovers . . . united their powers, and I found that this manner is better even than what the Italians call *la forza d'Ercole*."[69] Her memoirs are published under a fictional double address: "Luxurville, in care of Hercule Tapefort, ladies' printer, 1771" and "Interlaken, in care of William Tell, Year 999 of Swiss Independence." The Swiss exoticism enhances the ancient nostalgia. Swiss peasants, raised in the open air, who furnished soldiers to European armies and concierges to aristocratic hotels, were considered solid fellows, a change from the prettified dandies of the salons. Nerciat ironically makes explicit the sense of the masculine hybrid. Lolote remembers her amorous initiation. She is fascinated by the first male body that appears before her eyes. The young man comes into her convent cell, dressed as a nun, as in the poem by Voltaire. He gets undressed:

> Practically with wings, he was an angel, or else picture the Belvedere Apollo, but endowed with a *cock*! Ah, what a *cock*! It was the first time in my life I had seen one in the flesh; never, alas! was I lucky enough to find its equal.[70]

The Christian reference gives way quickly to the pagan reference, and the angel minus wings becomes an Apollo plus sex organ, with the innuendo that it is erect,

as an unfurled wing that helps take flight. The cock [*vit*] comes in the narrator's vision [*vue*] and ensures her life [*vie*].

Literature of sentiment is not left behind in this production; it is simply more discreet. The novelist Fanny de Beauharnais renders the cliché more decent by concentrating the tension on the look alone:

> Never had such a charming face been presented to Eugénie's eyes than the suitor sent by the Duke. His stature was tall, svelte and noble, his features soft and in perfect harmony; his hair was splendid, his eyes fiery and at times full of pride; they were *alternatively* the eyes of Mars and those of Eros.[71]

Desire is linked to surprise; eroticism thrives on paradox, on the springing up of virility in a body that seemed still child-like or feminine. But the oxymoron lessens bit by bit. Mme. de Charrière and Mme. de Staël, raised in the same reformist milieu, react differently to the cliché. In an epistolary novel of 1793, Mme. de Charrière gives voice to a young, virtuous officer of the Republic and has him reject the libertine phantasm of a perfect seduction, denying any freedom of resistance to his victims. The phantasm would be androgynous. "I disdain . . . those libertine novels, dishonest weavings of seductive errors, in which every young man is depicted with the strength of Hercules and the grace of Adonis, in which the lowliest harlot is a Laïs or an Aspasia."[72] The sylph, devoid of a visible body, as if beyond sexual difference, is revealed in eighteenth-century fiction as the perfect seducer, invisible and seeing through the secrets of all his conquests. Similarly, Adonis-Hercules would be a pipe dream that condemns women to being subjugated victims or consenting harlots; the mythological reference would be an illusion masking contemporary realities. In a novel from revolutionary year VII (1798), the Countess de La Grave, who has becomes Citizen La Grave, has the melancholic hero described by a rival: "I saw with my own eyes the lovable adolescent who found a way to tame the little female tiger. Imagine Adonis in the clothes of Mars. Little scoundrel! It becomes you well to please the woman I have chosen for myself!"[73] The rejection of the model is not, however, shared by all female novelists. Certain ones embrace the idea of a man who is touching because he assumes his femininity and, at least at certain moments, renounces an omnipotent virility. Corinne, Mme. de Staël's heroine, sings about a strictly hermaphroditic beauty that unites "in turn, in statues of men and of women, in the warrior Minerva and in the Apollo Musagetes, the charms of both sexes, strength with softness, softness with strength, a favorable mix of two opposite qualities, without which neither one would be perfect."[74] The

formula, in the rhetorical as well as chemical sense of the term, is dear to Mme. de Staël's heart. Between Minister Necker's paternal model and amorous experiences, she picks it up again in *De l'Allemagne*: "I don't know which combination of strength and softness" makes "of the same man the unshakeable protector and the subjugated friend of the woman he has chosen."[75] This subtle ideal is of the order of a *je ne sais quoi*, no longer just face and body, heads and tails, but also even days and odd days, night and day, a play of reflections or a constantly renegotiated compromise of difference.

The Adonis-Hercules figure may swing completely to the feminine side. A novel of emigration applies the oxymoron to a young woman who is forced by events to dress as a man and who finds herself, with her lover, enlisted as a soldier. While *The Loves of Faublas* takes place in France before seeking a denouement in Poland, *The Loves and Adventures of an Émigré* takes us over to the side of the counter-revolutionaries and provides a reverse example of the cliché. Cross-dressing is linked to emigration at the crossing of the border. It is the young man who tells the story:

> Sophie, whom I had seen only in the clothes of her gender, charmed me in the outfit that she had just put on, by the beauty of her forms and her easy-going air. She was the pretty Chérubin, as Beaumarchais imagined him, that charming page whose youth is about to begin and who turns every woman's head.

He later adds: "Sophie had the air of a young man of 16 with a delicate complexion." Wandering across Germany, the two exiles are forcibly recruited into the Prussian army. An officer, sympathetic or seduced, offers his mount to the lovely transvestite. "He was delighted by the poise with which he sat there. This young man has got the basics of horseback-riding, he said."[76] The lovers become cavalrymen in the same regiment. Sophie performs wonderfully.

> In one of those unforeseen encounters, frequent among light troops, we were attacked by a corps of Polish soldiers, far greater in number; I was surrounded by three enemy cavalrymen; I was about to succumb: Sophie rushed to me, knocked one off his mount with a pistol shot, cracked the head of the second one and, by placing her saber against his chest, forced the third, to give himself up as her prisoner. The action, which took place right in front of a superior officer, delighted this young cavalry soldier with such an interesting face and who seemed to have scarcely enough strength to handle his heavy weapon. He was made brigadier on the battlefield, which remained under our control.

The narrator comments on the courage of his mistress, which he needs to put in perspective in order to re-establish gender order.

> They admired Sophie's courage. They said of her: He is as handsome as Adonis, he is as brave as Achilles. They attributed to a vain desire for glory her extreme, rapid effort, which was out of desperate love. If this woman had all the charm of her gender, she had just as much of its softness, its physical weakness and its timidity. My peril raised her above herself; had she been attacked, she would not have had the daring to defend herself.[77]

The young woman is changed into a soldier, but she turns back into a woman in a third stage. She gets her military courage from love, and her feats nurture the feelings of her companion.

> I was overjoyed by Sophie's triumph, and the motivation for this triumph made her all the dearer to me; she had become my superior, and never was a leader obeyed with greater precision.

The amorous emotion arises from a slippage between two identities, from the oxymoronic play between the availability of Adonis and the strength of Achilles, Mars, or Hercules, but when the contradiction is embodied in the female body, the cliché assumes an unusual historical situation. The digression must quickly be returned from, and the two sexes must return to their traditional positions.

A third reduction of the oxymoron consists in denouncing its pernicious effects. Adonis-Hercules is a man-object, manipulated by others more skilled than he. Such is the rich hunchback who, rejected by a charming girl from the rue Saint-Jacques, sets out to avenge himself.

> One day, as he crossed the Place Maubert, he encountered this young sturdy man of the Marketplace whose fine figure was admired by everyone. He was a handsome dark-haired man, the size of a grenadier, whose white face had all the grace of the opposite sex, assuming a colossal, male beauty.[78]

He takes on the job of transforming this sturdy man of the Marketplace, moved up from his native Auvergne, into a presentable match. He has him marry the girl he wishes to avenge, only to reveal to her the base pedigree of her husband. Shocked by the scandal, she separates from the young man, who enlists in the army. "The

unfortunate man, carried away by his courage and his despair," dies heroically in a naval combat during the Seven Years' War. The transgression of sexual difference has been superimposed over the transgression of social hierarchy. The separation of the spouses, despite the birth of a child, and the masculine bravura at war re-establish order. A similar model organizes Rétif's great literary success, *The Perverted Peasant*. The young man comes up to the capital from Bourgogne, just like the sturdy Man of the Marketplace from Auvergne. He is taken in hand by a defrocked monk and thrown into the market of Parisian seductions. He is obliged to become the lover of rich aristocratic ladies: "You have definite talents to succeed with them; a boy built like you, with so interesting a face that unites the grace of Adonis with the worthiness of Alcides, could really find some haughty protectresses in Paris, and in our century!"[79] As the title announces, the peasant who dreams of being a success [*parvenir*], like his model in Marivaux's work a half a century earlier (*The Parvenu Peasant*), gets lost in Parisian libertinage and drags his young sister along with him in his calamity. He is deceived by his protector, who sexually abuses him. He sinks into all sorts of trafficking and finds himself punished in that overly seductive body of his. He ends up blinded in one eye, crippled, reduced to misery, and returning to his native village to die.

The mythological reference turns out to be of little worth. The heroic dignity of the ancient Greek demigods is compromised in this circulation of a man-object, in this male body to rent and sell. The theater is the image of this commercialization of beauty, but society life as a whole becomes an arena of spectacle. A novel on the eve of the Revolution describes a spectacle of equestrian acrobatics, put on by a father and his son. The noble art par excellence of equitation has become an exercise for tumblers.

> His son, 25 years old, brings together the freshness of an Adonis with all the suppleness of a gladiator and all the vigor of a Hercules. He is ordinarily dressed in outfits that are short, elegant and tight, which cling with precision to every part of his body and which give the feeling of nakedness in front, in back and up and down, in the most unequivocal manner possible. It is in this outfit that he performs his exercises, in turn, on one, on two, on three, on four horses, doing dances on a galloping horse, jumping, bending, stretching, stepping aside, famously placing the point of his right foot on the horse's saddle, the other leg raised behind, the chest bent forward. . . . The women's satisfaction is a sight to see, along with their intoxication when he appears; just watch how their active, libidinous curiosity moves them forward, to the right, to the left, makes them lean, stretch high, twist their neck, to

stare at more directly and in a better light, the forms of the handsome young man, who makes their eyes sparkle and their breasts heave![80]

The text produces a double play between human and animal bodies, masculine and feminine. The horse rider imposes his rhythm on the animals and the female spectators. He shows off, physically and symbolically, his virility. But his double status as Adonis and as Hercules, as cavalier heir to the military tradition and as an actor selling his performance, indicates that we have entered into the bourgeois world, into a marketplace banalization of mythology.

Another man-object, a professional dancer who shows off on stage, parodies a courtesan: "The curtain has just gone up. Vestris delighted everyone. This man, said Derville, has a spirited movement in his legs. It's a pity that that's the only place he has it. . . ." The opposition between high and low consummates the divorce between body and mind.

> "Hey, it's not every day, is it, that you find someone charming, well-built—in a word, *nice*—who is nothing but an imbecile." And he was pointing with his eyes at the same time to a young man who had the head of Adonis on the body of Hercules, and whose stupid look and dazed silence seemed to say to all the women: "Ain't it the truth, I'm really handsome?"[81]

We have moved from the actor to the man of the world, from theater in the strict sense to the figurative sense. The hall and the stage reflect back on each other as in a mirror. The young fashionable people in the salons cannot escape the downward slide first affecting the professionals, then little by little contaminating the elites. While the fathers in power conceal themselves in black outfits, being neither Adonis nor Hercules, the waltz displays the sons' anatomy—for example, this young man, "with the head of Adonis and the body of Hercules, swinging tireless legs gracefully, his thighs stretched out, with the supple Nankeen cloth tracing their contours perfectly."[82] There is something suspicious about this visibility and about the detail of the organs below the belt, from the loins to the thighs and backs of the knees.

The cliché ends up being devalued when it is taken up by Sade. It could not escape the novelist's attention, since he makes of it a characteristic trait, capable of inflaming the desire of libertine sodomites. Such are the valets and lovers of the Marquis de Brassac, whom Justine meets. The faithful Jasmin is not described, but another of his men, named Joseph, is "beautiful as an angel, insolent as that

hangman and membered like Hercules."[83] "This is really the beauty of the fallen angel" (Jean Molino).[84] It is no longer a face and a body that do not seem to go with him, but a body and a sex organ at odds with him. La Dubois, robber of his estate, praises to Justine one of the thieves of her band, a womanizer and crook. This young man, so well-membered, as Sade says, so well-hung, as we say today, steals the scene. The cock [*vit*] seems to be a conjugation of the verb "to see" [*voir*]: "Oh, regarding the fourth one, you will admit that he is an angel; he is too handsome to do this job; 21 years old; we call him the Roué, and that's what he will be; with the aptitude for crime that he has, such a fate will surely be his; but it's his cock, Justine, it's his cock that you have to see; you can't imagine the idea of an engine of this caliber; look at how long it is, how thick it is, how hard it is."[85] In other words, this is an angel turned criminal who could be taken for the hangman or for Hercules. The virility that changes with masters in complete control becomes a consumer object with servants and sex workers. The portraits of Joseph and of the Roué are parallel, one in a noble, mythological style, the other in a more popular, more direct style. The angel with the monstrous phallus constitutes an antonymic alloy that appeals to the novelist's imagination. In a later episode, among the young men recruited by the King of Naples for his orgies, we find an adolescent of 20, "membered like Hercules, with the face of Eros." The portrait turns right away into the act. "Ferdinand gives it to him; and he gives it back."[86] In a décor fostered by ancient memories, the context of the court calls on mythologies and a sustained level of language, but the reader may translate the classic comparisons in crude terms. Homosexual desire functions as an oxymoron, a feminization of the most virile, reversal of active and passive, of physical and moral, a play between the norm and its transgression. A "roué" is a man of the people condemned to the punishment of being slandered—that is, before suggesting the vicious elitism of the court libertines who aspire to be just as criminal without risking the same punishment. The roué of *La Nouvelle Justine* is slandered both literally and figuratively; language rediscovers its force of imagery, just as the body comes to life in a movement that transforms it before our very eyes. To be "beautiful as an angel, membered like Hercules," is to display an erection, a brutal sexualization of the body, a metamorphosis of forms, seemingly apt for admiration and caressing, in a physiology that suggests the carnal link, penetration, gashing. The formula gives rise to a virility of violence.

All the preceding citations are taken from texts that Sade could not sign by name. They belong to the pornographic or esoteric register, distributed clandestinely; but in a novel that is acknowledged by Sade, such as *Aline et Valcour*, the

phantasm remains present. A traveler describes the inhabitants of a utopian island in the middle of the Pacific named Tamoé.

> This gender [the male] is in Tamoé generally handsome and well made; when he reaches his tallest size, he is rarely less than five feet six inches; some are larger, and rarely do their measurements throw off the balance of a regular proportionality. Their features are fine and delicate, perhaps even too much so for men. . . .[87]

Five feet six inches (corresponding to nearly 1.7 meters) is the size that Bougainville noted in Tahiti: "Never have I encountered men better built or better proportioned; to paint Hercules and Mars, no finer models could ever be found anywhere."[88] Sade adds to the portrait that he finds in Bougainville's narrative a *délicatesse* and a finesse that are "perhaps" excessive in contrast with savage virility. The "perhaps" is to characterize the commonplace regimen of the text. The military maneuvers carried out by the young islanders are marked by the "greatest precision and the most pleasant nimbleness," and their wrestling matches and fist fights by "poise and grace." Precision and poise remain within the masculine stereotype; nimbleness and grace fall outside it. The monarch of the utopian island later points out to his visitor that these young men are "well endowed in everything" by nature. "There was no country in the world where virile proportions had reached such a point of superiority. . . ." In this acknowledged novel, as in the clandestine works, the movement goes from ostensible virility (size, stature) to an implicit femininity and suggests finally an aggressive hypervirility. The male proportions are in fact disproportionate with respect to female organs. "Through another of nature's whims, the women were so ill-formed for such miracles that the god of the hymen never triumphed without some help." The contradiction lies in nature, which necessitates the *help*, that is, artifice. The context in *Aline et Valcour* remains apparently the heterosexual norm, but the novelist's imagination brings in the figure, now perverse, of Hercules-Adonis.

Virility is subverted, like all values, whether they are honor or virtue. It is split into a power, which is experienced as arbitrariness and brutality, and a physical seduction given to prostitution. Fiction in Sade avoids realistic representation in order to put on display the compensatory reveries of an individual who has spent the main part of his adult life in prison but also the collective obsessions of a non-egalitarian society. Outside of his particular case, fantastic literature plays on sexual motifs to suggest everything that social reality cannot acknowledge. Among mythological figures, the eighteenth century also chose the character of Tiresias,

punished by Juno with sex changes that are as sudden as they are unpleasant. His misadventures are reported at length by the poet Malfilâtre. At the moment of consummating his marriage as a man, he is changed into a woman:

> But what wonder! What sudden disgrace!
> With all my senses enlivened by desire,
> And as the building pleasure took hold,
> A mortal coldness spreads and chills them:
> I have lost the use of them ...

Conversely, at the moment of being possessed by his or her lover, she or he turns back into a man. The change of sex is experienced as an adversity. Tiresias seems at once deprived of all sexual satisfaction yet capable of comparing the orgasm peculiar to each sex, at the request of the gods themselves:

> The two pleasures of husband and wife,
> What is the difference between these two pleasures?
> Which one seems to you both keener and sweeter?[89]

The novel's reveries are able to reverse the value of the mythological motif and transform fatalism into a new freedom. The Abbé de Choisy, an expert in transvestitism, imagines at the end of the seventeenth century the *Histoire de la marquise-marquis de Banneville*. A young marquis is raised as a girl; habit takes precedence over nature with him. The marriage that his rank obliges him to would be a catastrophe had he not had the good luck of finding a fiancée who claims to benefit from the same liberty as he does. The Memoirs of the Abbé de Choisy are published after his death in 1735; they further elaborate these examples of gender reversal, which are devoid of any tragic element. An anonymous novel systematizes such games; it appears in 1700 and reappears in a form twice as long in 1807. *Semelion* is subtitled "A true story:" the fantastic aspect of changing sex at will is not apparently the result of any exoticism. The plot begins precisely with the siege of Paris, in a France torn apart by religious strife. It seems to express a refusal to choose one direction over another and therefore to grow old. Semelion is "scarcely 14 years old." He saves an alchemist who entrusts him with an elixir allowing him to change sexual identity at will. The subterfuge during these times of permanent danger quickly becomes an erotic stimulant. Hiding in a convent with his mistress, he changes sex with her. Semelion, lover of Mlle. de Saint-Martin, becomes Mlle.

de Saliez, mistress of Saint-Martin. No need anymore of the Olympian gods to pose the question of difference: "Three months had already gone by when Saliez, in order to know which of the two sexes savored greater pleasure in love, took back his own and restored Saint-Martin to his original state."[90] Responding as Tiresias did, the hero regularly adopts a female status. His adventures move along, and he masters his power with greater and greater brio and more than a little cunning. Historical reality and tragic danger approach when King Henri IV falls for him in his female form. They are separated quickly, and Semelion leaves for Italy with two young women.

> To increase [their pleasures] and at the same time maintain a kind of equality among them, it was agreed that there would always be two men and never only one woman, and that the women would take turns being that one—which was done regularly to their great satisfaction.

A second part moves more conventionally to Constantinople. After a breakdown of melancholy and impotence, Semelion recovers his way of life. He takes advantage, in place of the sultan, of all the resources of the seraglio. The re-edition of 1807, contemporary with an edition of the Memoirs of the Abbé de Choisy, attempts to extend the charm of this sexual weightlessness. "Famished for love," Semelion repeats the three-way combinations in Turkey, Greece, and Spain. He again meets the alchemist from the beginning, who experiences with Elizabeth of England the liaison that he himself had avoided with Henri IV. The denouement consecrates their double marriage with a quadrille, which, one wonders, might constitute a conformist regression with regard to the preceding threesomes. It seems unnecessary to change sex to enjoy one another's assets: "Slanderous tongues of that period had it that the friendship between Semelion and the philosopher was so great that everything was shared between them, and that their wives, charmed by such a lovely union, did everything within their power to maintain it."[91]

Was this novel unique from the beginning to the end of the eighteenth century? At the end of the century, a narrative reprises its plot, but the hero this time is originally a young woman who is taking vows. Her recluse's imagination makes her desire a sylph who fulfills her and leaves her as a gift the power to change sex each year, until she or he, Éléonore or Éléonor, confides his/her secret to a partner. The change is double by comparison with *Semelion*. A woman who changes into a man, retaining something of an original nature, replaces a man who conquers her femininity; the change of sex is no longer free and voluntary; it is henceforth

an automatic alternation. The character experiences pleasure with partners who are at one time of the same sex and at another time of the opposite sex without being able to distinguish between hetero- and homosexual couplings. The opposition between pleasure and pain itself seems at times undone. The perfect success of certain couplings rejects the categories of virility and femininity, as expressed by a prior who is made happy by the young novitiate: "No, you are not a man, you are not a woman, you are an angel."[92] The references, borrowed from Rome, meet up again with the Adonis-Hercules phantasm: "Never had Hadrian lavished such praises on the handsome Antinous. If the mixture of force and grace still charms us in non-sensate marble, may the prior be pardoned for not being able to take in, without culpable desires, these beautiful forms of virile youth." Guilt reappears. Virility seems to dissolve, when it is re-established by the reaffirmation of an essential distinction between the two sexes. The sylph suggests the phantasmatic nature of any story.

We cannot dismiss such novels and Sade's entire *oeuvre* as simple cultural aberrations. It is fairer to position their phantasmatic radicalism along the arc of fiction that swings between real and imaginary, between the norm and its margins. On the one hand, literary invention follows the evolution of the father's status, from simple authority to affection, along with the timid approach by men to this "surplus love" analyzed in women by Élisabeth Badinter.[93] She suggests that the ideal of compatibility between the habits of war and the customs of the court is undone with the end of the Ancien Régime. Conscription and social normalization simplify the masculine condition. It is therefore, on the other hand, up to fiction to explore all desires, all reveries—those unsatisfied or repressed in social reality at the same time as those produced as an outlet by that same society. Virility plays at giving up its prerogatives; it experiments with their limits and their unexpected assets. The adolescent and the libertine, in the process of turning perverse, constitute the blurred, uneasy, fascinating limits of virility.

7

THE CODE OF VIRILITY: INCULCATION

THE TRIUMPH OF VIRILITY IN THE NINETEENTH CENTURY

ALAIN CORBIN

THE PERIOD covered by the next seven chapters corresponds to the era during which the virtue of virility has the greatest influence. The system of representations, values, and norms that constitute this influence wins recognition at the time with such force that it could not really be challenged. Initially, the accent placed on sexual dimorphism by the Naturalists, the saga of the revolutionary and imperial armies, and the frequent reference to illustrious men of Antiquity all contribute to the diffusion of a code instilled in boys from an early age. Courage, indeed heroism, willingness to die for the country, the quest for glory, and the necessity of responding to every challenge are essential to men whose laws reinforce their authority within the family.

The physiologists, then, contribute to the solidifying of this set of values. They make it known to man that everything destines him for energetic action, for growth, for involvement in the social fracas and for domination. They advocate vigor in conjugal relations. The cowardly, the soft-hearted, the feeble, the impotent ones along with the sodomites are more than ever objects of contempt. The proliferation of places for male cliques—college, boarding school, seminary, the singing club cellar, the brothel, the guardroom, gun room, smoking room, various workshops, and cabarets and waiting rooms for political meetings and hunting clubs—constitutes so many

theaters for the inculcation and flourishing of those traits that make up the figure of the virile man. The pervasive practice of dueling, jousting among the working classes, the basic confrontations between military men, students or civil servants inside theaters—all give proof of the same hold these values have at the core of virility. Man is key—everywhere; in groups, men hollering and men holding their liquor—all confirm the virile community.

From a very early age, the boy is supposed to start hardening. Quite often he must bear the separation from his mother and his family, prove his ability to put up with cold and with pain, keep back tears, and take teasing and punishments without blinking. Beginning with infancy, he is often confronted with scenes of violence. The good Martin Nadaud himself admits to having contributed to the death of one of his little friends from his village in the Creuse. Later, Jules Vallès witnesses as a child the terrible brawls indulged in by young men of the Auvergne sitting around the cabaret.

Well before the establishment of mandatory military service, right after the defeat of 1870–1871, the review of conscripts is the occasion to show off one's virility, indeed the strength of one's erections. The masculine look confirms the influence of the code. The ostentatiousness of moustache, whiskers, then of the beard goes along with the adoption of body postures that show off virility. One's virility is thus affirmed at the seashore by an ostensible disdain for cold water and the practice of energetic swimming.

During the second half of the century, despite hairline fracturing, the code does not really loosen its hold. Man's authority does not weaken within the private sphere. The experience of the barracks spreads—the horsing around and the initiations, sexual as well as martial. In workshops and on construction sites, it is good to prove one's endurance to fatigue, to show one's ability to accomplish dangerous tasks without taking too many precautions. This indifference demonstrates, besides skills, the possession of virile qualities. Colonial expansion and the adventures that accompany it, including great wild beast hunts, give rise over and over to scenes of heroism.

The fear of degeneration and regression, two major phantasms that haunt the elite, necessitate the firming up of the virility of youth during the last decades of the century. This is evidenced, especially in France, by the creation of school brigades (pre-Boy Scout military groups for teens, 1882–1890) and hunting clubs. In the schools of the Republic, the exaltation of patriotism, the development of the great national narrative during history classes, and geography lessons that contribute to a love of the homeland prepare young men for the sacrifice, for that act of consent, today unimaginable, which historians note during the battles of World War I. Even

priests, beginning with the vote for the law of the "backpacking curates" (1889), find themselves dragged into this tide of the exaltation of virility.

To understand very well what this exalted virtue represents, it is essential to go back to what it was then based on. At the end of the eighteenth century, the Naturalist scholars explicitly make it necessary for man to feel himself a member of that species that dominates Creation. "Be a man, my son!," the fundamental injunction, means implicitly: be the Adam of Genesis upon whom was bestowed the mastery of all things. In the nineteenth century, this injunction of virility underpins man's activity. The man is obliged, constantly, to manifest it by his actions. From this perspective, virility is identified with greatness—an essential notion, superiority, honor, strength—as virtue, self-control, a sense of sacrifice, and a willingness to die for one's values. Virility spreads through exploration and the conquest of new territories, through colonization, through everything that shows control over nature, and through economic expansion. All of that constitutes greatness.

By the same token, virility is in part linked to death: heroic death on the battlefield or the field of honor of the duel, death brought about by the worker's exhaustion, or death of the man being worn out by his wife, since for the man, as doctors continually point out, *eros* and *thanatos* are intimately connected. Virility does not constitute a simple individual virtue. It orders and vitalizes the society whose values are inherent in it. It results in effects of domination—of which that exercised over woman is but one element. It structures how the world is represented. For the individual of this era, it constitutes not so much a biological given as a set of moral qualities that need to be acquired and preserved—qualities that a man must know how to show.

This is why virility is not synonymous with masculinity. It is defined not only as the opposite of femininity. Many individuals show a lack of virility and yet give no reason to question their "masculinity," a term that dictionaries of the time almost forget and that cannot be found in the common language. He who hesitates to get into the assault on the day of the battle; he who chooses to get a replacement because he has drawn a bad number in the draft lottery; he who was unable to save his comrade from life-threatening danger; he who does not have what it takes to be a hero; he who shows no ambition; he who remains indifferent to excelling or to the prestige of a medal of honor; he who ignores emulation because he does not seek superiority; he who has trouble keeping his emotions under control; he whose speech and writing style lack confidence; he who refuses women's advances; he who performs coitus without ardor; he who refuses group debauchery—all these men lack virility even though their masculinity would not be challenged.

On the other hand, certain women know how to show virility because they have a sense of greatness, of honor, of sacrifice for the nation. They agree to go into combat, indeed to duel, and show clear courage. At the end of the century, Joan of Arc and Charlotte Corday are among the most exalted heroic figures in French history.

However, a close study shows clearly that, well before World War I, fissures threaten the hold of this code that involves basing one's domination on the Other, whether it is the enemy, the soldier from the barracks, the apprentice from the workshop, the mate from work, the wife, or the mistress. The loosening of prohibitions that weighed women down, their newly granted liberty to move about, to put themselves on display in outdoor cafes, to attend theatrical plays by themselves, to play sports, to spend time without their husbands or families in towns with thermal baths and spas, to look inside anatomy museums, to read novels of sentiment openly, to get their *baccalauréat* and then take courses at the university—all this pushes back male privilege, disturbs the unfolding of scenes of collective virility. Even in the marriage bed, the husband no longer feels that the same forms of domination are conferred upon him. Flirting, on the other hand, blurs the division of gender roles. The novel ostentatiousness of a homosexuality that has just been given its name and the catalogue of perversions that the first sexologists unroll add to the confusion and elicit reactions.

The figure of virility that at the start of the nineteenth century was part of an aesthetic, that of the sublime, harmonizing with the Romantics' attraction to magnificence, the experience of limits, the poetics of enthusiasm, revolt, and renunciation, must be redefined from here on in—even if the connection that tied this virtue to authority, to solemnity, and to a certain radicalness is not really questioned.

The confusion that sets in at the end of the nineteenth century prepares for what will develop in the final chapters of this volume. During the twentieth century, the figures and objects of admiration radically change. Showing courage on the battlefield has little by little lost its prestige. The culture of conquest has subsided. Duty and the willingness to die have become obsolete. The value placed on individual life has little by little won out, in the West, over ideas of holism. The definitions of honor and greatness have been, in a way, turned around. The spirit of conquest and the desire for colonization have been gradually shouted down. Presentism has put to rest the grand national narrative, chilled any memory of the reference points modeled in bygone days, those which made of history a design for living. Compassion has changed forms. The evangelical abnegation of missionaries has ceded its place to the devotion of members of charitable organizations.

For all these reasons—and there are others—understanding what virility represented in the nineteenth century has become difficult, indeed impossible, especially from the point of view of young people. That system of obsolete values may even provoke indignation, which leads to the denial of any kind of comprehensive history.

How can we imagine, from this point on, that so many men consented to suffer and to die for the nation; pushed that far the spirit of abnegation and sacrifice; looked death in the face during duels; desired to exercise domination over peoples they judged to be inferior; manifested a spirit of conquest; and made love vigorously while showing indifference toward the women, thus depriving them of the finer points of eroticism? To answer such questions, let us be careful not to forget that the twentieth century challenged—not in any systematic manner, of course—the complex web of values that constituted the triumphant virility of the nineteenth century.

· · · · · ·

CHILDHOOD, OR THE
"JOURNEY TOWARD VIRILITY"

IVAN JABLONKA

Youth is but a journey toward virility; this goal—and this goal alone—must always be kept in view. The family enjoys the child who amuses and charms it; but society needs men, and a virile education must prepare him for that.

J.-B. FONSSAGRIVES, *L'ÉDUCATION PHYSIQUE DES GARÇONS* (1870)

WHAT A long road the little boy has to travel before becoming a man! Hairless, slender, weak, prepubescent, he possesses none of the attributes of virility—"that squared form, that well-developed thorax, that solidity of muscle, that masculine, self-assured air that characterize the grown man."[1] He seems to be still under the influence of femininity, and even adolescents—such as Mozart's Cherubino, who sings in a mezzo-soprano voice, or Dalida's Bambino, sent back into his mother's skirts—are rejected by women because they are too young to love. But this is the point: they are not ignorant of love, and they already dimly perceive the mysteries of sex. The ambiguity is there, and a pedagogue after World War I is struck by it: it comes from "that mixture of virility at the core of the soul and a delicate fineness of features."[2] From inside the frail envelope of the boy, the man breaks through. From then on, the latter, still at the starting point, must not go astray or decline. This preadult, which is what the *puer* is, must be taught the codes of virility; he must be given the keys to the brotherhood that he will soon join. Under penalty of being restricted for life to the limbo of childhood or to the softness of the gynoecium, the little boy must be made to conform to the main masculine stereotypes—bravura, honor, loyalty, the will to dominate, and a superiority complex in relation to women. The virile age is prepared from childhood.

THE CODES OF VIRILITY

THE SABER AND THE PANTS

Just as angels are reputed not to have any sex organs, children seem to be, in their first years, outside either gender. Until the age of two, boys and girls wear long dresses, undergarments, and bonnets. The catechism manuals are addressed to "little children" without distinguishing gender, and everyone can recite certain fables. An infinite number of stories, narratives, encyclopedias, and manuals are aimed at children "of both sexes." But this generalization is misleading: in fact, the apprenticeship in sexual difference and the inculcation of virile commandments begin very early.

At the end of the nineteenth century, pedagogues taken with Rousseauism discover the spontaneity, the curiosity, and the need for movement that characterize the toddler. Pauline Kergomard, founder of the Republic's nursery school and Inspector General from 1879 to 1917, advocates a mixed instruction, as in a family in which brother and sisters grow up together. But it is at the behest of the difference between genders, for one benefits from the presence of the other:

> Boys moderate their physical forces, the exuberance of which could degenerate into brutality; they become courteous; girls, of a more timid, more fearful temperament, harden, become brave, skilled in physical exercises, while their brothers become adroit in finger exercises. The boy learns, almost without thinking, that the duty of the stronger is to protect the weaker; the little girl begins with him her apprenticeship as counselor and consoler.[3]

Coming into contact with little girls, the little boys' "natural" qualities develop; they lose some of their defects. While the former peacefully play with dolls or play shopkeeper, "boys' games—chasing after one another, fighting amongst themselves, taking prisoners—clearly satisfy in part their predator instinct."[4] Organized by adults, the games allow them to convert their energy into masculine civility. To be sure, gymnastic exercises are often the same for all: the children have to turn their heads left and right, bend their bodies forward and backward, stand on tiptoe, and whirl their arms around. But certain behaviors are clearly gendered. Little girls are asked to greet gracefully: they bring their hand to the mouth, lower it to the waist, and release the arm. The little boys' greeting is also done in three stages,

but the meaning of the gestures is different: they bring their hand to their caps and bring it down to waist level before placing the arm at rest, the cap at hip level.[5]

The apprenticeship of roles is also carried out with the help of toys—sabers, drums, and marbles for the boys, dolls, baskets, and dust cloths for the girls, which allow children to mime adult occupations [cf. fig. 7.1]. The poorest have no need of toys to amuse themselves, like the youngsters in *Carmen* who march "heads high like little soldiers." Similarly, nursery rhymes and bedtime stories contribute to the definition of virtues assigned to boys. The collections narrate the exploits of little men who constitute so many examples to consider and imitate. Thus, Hector, 12, "is not a sissy." On the way to school he saves his little brother from a carriage passing at full speed; the hero has his foot crushed, but he does not regret his act of courage.[6]

Most often, the narratives show foil characters who are not doing what is expected of them. Cowards, mean kids, absent-minded or unruly or disobedient ones, they upset their mothers and are scolded by their fathers. Henri is scared

FIGURE 7.1 CHILDREN PLAYING IN THEIR ROOM. IN *LA JOURNÉE DE GINETTE ET RAYMOND* (A DAY WITH GINETTE AND RAYMOND), EARLY TWENTIETH CENTURY.

A little boy gallops on a rocking horse while a little girl quietly plays at having a tea party, both under the watchful eye of their governess. Activity, bearing, clothing, and colors—everything in this image corresponds to a code of stereotyped sex roles.

Source: © Leemage

of the dark; when the wind rushes down the chimney, he hides thinking he hears the bogeyman; he senses wolves behind every door and, when taking a stroll, he trembles as he walks; he fears dogs, flies, and spiders. Before being sent to boarding school, his mother chides him: "You celebrate getting a saber and a gun, when New Year's comes; but everyone will make fun of such a well-armed soldier who's afraid of his shadow."[7] A song tells the story of one sulky little boy:

> Who whines every minute;
> He always wants to get his way,
> And argues for the slightest thing.

Another little boy is violent:

> He has a mean-looking face;
> People run from him as from a grouch,
> He pouts when everyone is singing
> REFRAIN: He's Mister Puncher,
> He stays in a corner,
> For, if you get near him,
> You get a clout.[8]

A mother buys her son "a lovely sword with a tin-plated blade and a copper grip," but little Paulin uses it to strip the apple tree; his godfather gives him a gun, but the scalawag shoots dried peas at the dog, the cat, and an old lady. His father "made him stand in the corner for all to see, telling him that he'd get no more toys."[9] Cowardice in place of courage, sulkiness instead of cheerfulness, aggressivity in place of courteousness, and lack of discipline for lack of obedience: the ideal child is sketched out by negative comparison, already endowed with the qualities that every man should have.

But fake guns and uniforms that children are given should not be taken as authorization for them to imitate soldiers all that faithfully. Numerous stories present us with misguided youngsters who, by dint of wishing to play like men, transgress the boundaries of virility allowed at five or eight years old. Little Jules receives a beautiful tin-plated sword from his father; but he can only use it after he has learned his lesson, and he is not allowed to arm or command his little friends, "for his dad had told him that he didn't want him even to pretend to fight."[10] In another example, upon opening up his "charming lancer costume" with its elegant helmet, the red pants with black piping, the braided jacket, the epaulettes and the sword, Léon feels

"overwhelmed with joy." With his friends he makes for himself a three-cornered hat with plumes out of paper, after which he blackens his cheeks with a burnt cork. The little troop turns up in the henhouse: "Attention! Present arms! Ready, set! Fire!!!" A chicken is skewered, and the rascals just barely miss getting a whipping.[11] Even more serious: a little boy keen on tin soldiers and miniature canons one day steals a pistol from his father, a former military man, and goes off to play with his cousin. He tells him, laughing: "Stand right there in front of me, don't be a chicken, stick out your chest, that's right; aim! fire!" And the cousin drops dead.[12] Toys allow the child to prepare himself for virile dealings, but if they are misused, they become instruments of disobedience, stupidity, even homicide. There is therefore a tension between the virtue that must be assimilated through them and an imprudent imitation that one must refrain from. The toddler who plays too literally, not perceiving the difference between virility-as-model and virility-as-interdiction, incurs the wrath of adults. In this regard, initiation stops at a certain threshold.

Clothing goes along with the boy and signals his growth. In ancient Rome, the adolescent of 16 wore the virile toga at the time of the *liberalia*, a ceremony celebrated in the spring on the Forum and the Capitol. During the Revolution, some invoke this example to give "boys and girls, who are not yet gendered, an identical outfit, completely undifferentiated." The light, healthy, inexpensive, national uniform was to be worn until the adolescent exchanged it for the clothing of the young man or the young virgin.[13] In fact, it is at the age of two or three that clothing styles—at least in well-heeled milieus—tip the little boy toward his father's universe. According to treatises on clothing and other fashion manuals, the boy's dress should be composed of a shirt, pants, a vest, and a coat or jacket. There are, then, especially designed for little boys, pants and gaiters (from two to three years), jackets (from three to five years), tunics and sailor suits (five to eight years), waistcoats (eight to 12 years), coats and overcoats (nine to 12 years), and ceremonial outfits (for adolescents).[14] More elaborate patterns allow the manufacture of a coat for boys two to three years old, a Russian kaftan for four-year-old toddlers, a simple smock and bloomers for a little boy of five, an ulster for the eight-year-old child, or a double-collared sailor's outfit for the 11-year-old boy.[15] Certain tailors use a "method exclusively for little boys from three to nine." One can choose among four outfits: the faux vest (an ordinary jacket with short pants), the short suit (same thing, but with a real vest), the tartan (for little boys from three to five, in which "the skirt takes the place of the pants"), and the anorak (for little boys from one to two).[16]

The gender differentiation of the clothes is not justified by nature, since, as one tailor remarks, "if you measure the bust of a little girl of normal size, around six

years old [. . .], you realize that there is, so to speak, no difference between the proportions of the little girl and a little boy of the same age."[17] The wearing of pants in place of the long gown therefore relates the little boy precociously to the man; besides, "the child's underwear does not differ in design in any way from men's underwear."[18] It is not surprising that from then on pants become the virile toga of Modern Times:

> You're not going to recognize me anymore . . .
> Just look at me! I've given up
> The gowns of a girl, to put on
> Pants! I've been spoiled:
> How I love these pants,
> Which make me look
> Like Dad! For they are made of the same
> Cloth, our two pairs of pants! [. . .]
> Gowns make you think of layette . . .
> It's ridiculous, nasty . . .
> It makes you look like a little girl.
> It's not at all masculine [. . .]
> Pants! It's only men
> Who wear them, right?
> And so, though we are still children,
> We want to follow in their footsteps [. . .]
> Now, I no longer have to
> Hold someone's hand
> In the street. I'll be allowed
> To go my own way by myself.
> Like men. For in sum,
> I truly believe we are worth it . . .
> And besides, aren't you a man
> When you wear pants?[19]

THE VIRILE SOUL

As the child grows up, the requirements become more precise. Virile instruction, already well under way, enters into a more moral phase. There are qualities and

values that the adolescent must face in order to be able, a few years later, to play the role expected of him. His duty consists above all to love God, his parents, his brothers and sisters, his homeland, and his work. Christian morality expects the boy to be good, upright, chaste, and submissive (and this is why it gives as an example young children who "die happy" in Jesus Christ).[20] In this regard, the discipline of *collège* (junior high school) is excellent: as a professor at the Institut Catholique recommends in 1890, one must maintain the "good habits from *collège*: soberness, early rising, contempt for sybaritic ways. Pump air into your lungs and exercise your muscles, but remember that the spirit has its needs just as the body does."[21]

In every social milieu, virile training traditionally includes its obligatory passages—salacious jokes, bawdy songs, drinking, brawls, and duels.[22] It is to avert these rituals that the education manuals promote spiritual strength, dignity, conscience, and purity of morals. It is about fostering the triumph of another form of virility, "Christian virility:" being a man is possessing moral strength, that *virtus* that makes the *vir*. Virility should not be considered the privilege of explorers, colonists, industrialists, and all those men who take up practical careers. Virility is first the plenitude of moral life; it is the firmness of the man in his intention ("*justum ac tenacem propositi virum*," to quote the famous words of Horace). Physical exercise contributes no doubt to the formation of the man; but "it is in the soul that virility resides."[23] At the beginning of the twentieth century, the curate Saint-Vincent-de-Paul refuses to think that "characters are going into a slump . . . and that soon, as far as men go, there will only be 'big softies;'" but, conversely, he states that "to take on a virile character is not to work on becoming a man of wood or of stone."[24] The path is therefore narrow: to become a man worthy of the name, one must avoid softness as much as hardness, passivity as much as unruliness, and open one's heart to the emotions without thereby becoming effeminate. In the same vein, among Protestants, we find numerous homilies entitled "Be a man:" "*Being a man* means having that courageous virtue that does not shrink either from suffering or from sacrifice."[25] One takes the road to virility "through thought and through faith,"[26] by respecting one's parents, serving humanity, and being "strong enough to remain upstanding and pure."[27]

Christian education has its counterpart in lay morality. The values acclaimed by the Revolution outline a model of virility—loyalty, honor, courage, and love of homeland—that takes into account the softening of mores: "Woe to him who is born with a nasty, quarrelsome character," proclaims a *Republican Manual* intended for the education of children. "Let us maintain always an even-tempered character."[28] Schools during the Third Republic, empowered by the decree of 27 July

1882 to promote a "moral education," publicly recognize these same virtues, along with modesty, self-respect, spirit of fair play, energy, perseverance, and courage in the face of misfortune. The fair-minded school boy "never cheats at games" and, "in competitions that take place at school, he uses only honest means for getting first place."[29] The virility that children are imbued with is measured and the coarse elements are filtered out. Anger has its dangers, aggressivity is not tolerated, and "the duel is forbidden because it leads both to suicide and to homicide."[30] Bellicose virility is allowed only in the context of revenge, so true is it that dying for the nation is "the most beautiful fate, the one most worthy of admiration." Take the grenadier who at the Battle of Magenta fights with three bullets in his body: "may we know how, if necessary, to forget ourselves so heroically in favor of the nation."[31] To the boys of the upper division (11 to 13), the example is cited of the abnegation of the artillery general Saint-Hilaire, who in 1675 becomes disconsolate at the loss of Turenne as he himself is dying, and it is recalled at the same time "what man owes to his country: obedience to the laws, military service, discipline, devotion and loyalty to the flag."[32]

More efficiently perhaps than school teachers' morality lessons, the reading manuals put into motion a philosophy of virility that conveys, beyond the qualities supposedly belonging in particular to the stronger sex, the primacy of males. In the pantheon of "*tours de France*," including *Le Tour de la France by Two Children* (1877), *La France en zigzag* (1882), *Jean Felber* (1891), *Jean Lavenir* (1904), and *La Famille Aubert* (1920), there are only three women—Joan of Arc, Jeanne Hachette, and Thérèse de Lisieux, whereas from Vercingétorix to Napoleon, from St. Louis to St. Vincent de Paul, from Parmentier to Pasteur, France can boast of hundreds of great men. The world of the *Tour de France by Two Children* by Mme. Augustine Fouillée is "strangely masculine. . . . With the loss of Alsace, the wounded nation was to be fundamentally an affair of men."[33] In fact, the characters of *Tour* cover the whole spectrum of masculinity. The paragon of adolescent virility is the protagonist—André, 14, "a rugged boy, so big and so strong for his age that he seemed to be at least two years older," while his brother Julien, "a pretty child of 7, frail and delicate as a girl," was still under the influence of childhood femininity. Étienne, the clog maker, has "a harsh, loud voice" that softens as soon as he recognizes his friend's children. Fritz, the forest ranger, is "a large old gray-bearded man," but he owns a beautiful map of the *département* drawn "by the chief of staff of the French army"; he encourages André to study it attentively, for, "when you want to be a man, you have to know how to get out of a tight spot by yourself." After spending his money in a cabaret, the drunk carriage driver "beats his horse with his fists, and

he would do the same to any bystander who contradicted him." M. Gertal, "a big hillbilly from the Juras," is a merchant who is very cautious with his money, but he is an honest man, touched by Julien, who requests an umbrella by way of salary; in the course of the voyage, he teaches the boys how to take good care of their horses and how to make their savings grow. The captain of the *Perpignan*, a sailor from Roussillon, is gruff and "quick as gunpowder;" he reprimands the children, but he is "a good man deep down" and finally hugs Julien as he lifts him up with "his two Herculean hands."[34] With the exception of the carriage driver, these father surrogates constitute variations on the same theme: with their good points and their faults, they dispense common folks' virility, at times rough but always under control and ultimately reassuring.

Contrary to what is implied by certain initiation rites in vogue with young-sters, becoming a man does not consist, then, in acting gross, brutal, boastful, or querulous but rather in being good, modest, and hard-working. The lifestyle manuals aimed at youth give a concrete translation to the precepts of a Christian or pro-Republic education adapted to everyday life. In his *Address to a Young Man* (1834), the Italian poet Silvio Pellico prescribes the deepest respect for girls and women: "Don't let yourself take the slightest liberty with any one of them, in ges-ture or word, which might bring any profanation to her thoughts or any agitation to her heart."[35] If delicateness and gallantry are required with women, aggressivity, the source of brawls and duels, is proscribed for men: "Arguing is allowed only on condition that you end up ceding, convinced by the arguments, the rhetoric or the eloquence of your interlocutor."[36] Instead of measuring oneself against the other boys like roosters, one must cultivate what is called *self-control* and *fair play* (in English in original), along with solidarity and camaraderie. For the sake of peasants' and workers' sons, the former president of the *Société d'émulation* of the Jura describes the uncouth child: "The bully hurls coarse language. He is a coward who abuses his strength. . . . He yells, swears, stamps his feet, grows impatient or starts quarrels."[37]

Just as there is a virile ethos, there is a virile *hexis*, or disposition: this consists not of manifesting one's passions and strength but of keeping on one's face "a look of tranquility, or harmony."[38] At table, gluttony is absolutely prohibited. More gen-erally, the position of the body should remain decent and modest: it is unseemly to speak loudly, to gesticulate, to raise one's brow with insolent self-confidence, to twist one's moustache or to affect "the stiffness commanded of a soldier under arms."[39] As is explained to young policemen, "the stiffness of posture is often a manifestation of vanity or of pride," and it is gross to "express one's joy in loud peals

of laughter or in noisy hand-clapping."[40] In order to be really virile, there is no need to ape military men: the authentic man agrees to civilize his mores.[41]

VIRILITY PINNED TO THE BODY

For the little man to grow properly, he must be held up by props of lawful virility— no escapades among peers, or charivaris, or balls, or cabaret friendships but rules and framework, in other words, punishments, sustained activities, and, for the most privileged, studies.

AT THE SCHOOL OF LITTLE MEN

Like the family, school and *collège* are domains of physical violence. The boys are disciplined by hand, with the switch, the rod, and at times, the lash and the whip. Maxime du Camp was withdrawn from his first *collège* because a monitor struck him and drew blood. At the end of the 1830s, his geometry teacher "punished ruthlessly those who did not pay attention to his lessons." After this teacher was heckled, several students were put on bread and water in freezing cells, with 1800 verses from Virgil to copy in one day. And the writer concludes bitterly: "I understand school boys' hatred for these prisons in which their childhood is locked up on the pretext of education."[42] At the end of the nineteenth century, an old man of the Nantes region recalls that, in boarding school, around 1830, corporal punishment "was meted out to us as if we were galley or Negro slaves." The teacher yells, "You bunch of jackasses!" and strikes the students' backs with his whip. A few mistakes in the recitation of a lesson result in lashes on the knuckles. The most stoic claim that it does not hurt them, but "the tears that fell from their eyes when the executioner, exasperated by their bravura, redoubled his effort, angrier still, were an eloquent disavowal of the sincerity of their assertion." While these violent measures were aimed at hardening the boy, other punishments, conversely, turn him into a girl to humiliate him, for example condemned to "inside-out jersey," that is, to wear his outfit with the lining on the outside, and when he "acts like a brat," the bad boy is supposed to sweep the classroom with his hands.[43]

Voices are raised in condemnation over these practices. At the end of the 1820s, hygienist doctors such as Pavet de Courteille and Simon de Metz take sides against

corporal punishment in school (or "*pédoplégie*"). Several educators advise parents not to resort to physical force and to moderate punishments. In the middle of the century, one of them writes that the progress of civilization does not allow the use of corporal discipline. The moral effect of the punishment must be greater than the physical pain; otherwise, education would be but "a sequence of barbarous acts." Since beating is not a principle of education, it should not be premeditated, and thus the whip must be banished from the home. In the case of absolute necessity, one can discipline by means of taps, slaps, or blows with a rod or cane "found nearby."[44] "The child is not an enemy to bring down," affirms another pedagogue, "he is a dependent person to be raised." He must therefore be sensitized to filial and fraternal love, to charity and to respect for the rights of others. By way of punishment, instead of striking, one can take a privilege away from the bad boy (for example, eating at the table with his parents).[45]

The use of the whip declines throughout the nineteenth century. In the royal *collèges*, corporal punishment is forbidden. The statute of 25 April 1834, applicable to local primary schools, prohibits hitting students; punishments must be limited to reprimands, being assigned bad points, not being allowed out for recess, forced kneeling, and temporary dismissal. As for the regulation of 19 January 1887, it absolutely prohibits corporal punishments (even though they are not enumerated).[46] However, numerous partisans of educational violence can still be found. It has one irreplaceable quality: it trains the youth by increasing the boy's strength. At the beginning of the twentieth century, a curate disapproves of permissive parents: "It is not unusual to hear certain parents formulate appraisals of this kind: 'This child has no bad quality; you couldn't believe how innocent he is. He is as sweet and orderly as a girl.'" For the clergyman, it is precisely by raising boys indulgently that they are turned into girls, soft, delicate beings inclined toward ingratitude and anger. In order for a boy to remain a boy, one must "accustom him to be hardened [rather] than augmenting his weakness and raising him in warm fuzziness."[47] On the eve of the World War I, writing a preface to a work by a doctor who refuses to see children broken in by degrading punishments, Maurice Barrès writes: "Let us not rush to curse those old forms of discipline [the rod, time-out, the whip, standing in the corner]. There is good in them, for they formed our fathers, who were very brave men and remembered them without resentment."[48]

While the use of corporal punishment decreases, the virilization of children does not disappear from schools as a result. Summoning the shades of Lycurgus, Solon, and young Romans from the Field of Mars, partisans of the Republic, beginning at the time of the Revolution, recommend dispensing military education to

boys. The law of 27 Brumaire Year III (9 November 1794) ordains that they will be "trained in military exercises, overseen by an officer designated by the investigating grand jury." It is true that military education is introduced into Parisian *lycées* in the late 1860s, but it is the Third Republic that provides it with its full scope. In 1871, a circular from the War Ministry recommends organizing military exercises in *collèges* and *lycées*. In January 1880, physical education becomes mandatory at school. The great Ferry Law of 28 March 1882 stipulates that, for boys, public primary school teaching includes physical education and military exercises.

This training is dispensed, it should be noted, at the time of the "school brigades" created by the decree of 6 July 1882. In 1881, the War Minister handed over gratis to public education "120,000 early model guns in the war arsenals to be appropriated for use in the public schools." Lacking cartridges but equipped with authentic mechanisms and rounded-off bayonets, they allow boys of 11 to be instructed in shooting as well as in the assembly and disassembly of firearms. The boys may then parade with arms before the civil and military authorities to the sound of the drum, the fife, and the bugle, singing *La Marseillaise* at the top of their lungs. By 1886, the school brigades have gathered 44,000 students in about 50 *départements*.[49]

The brigades of children arouse enthusiasm. In 1881, Paul Bert demands before the school teachers "the little gun that the child will learn how to use beginning at school," and two years later he files a project for a law requiring that military instruction be prolonged from 13 to 20 years old so that the boy does not forget the use of firearms after he has left school. Following his example, an officer in the territorial army affirms that military exercises represent the "complement to that virile education that should provide citizens to the Republic and soldiers to the Nation."[50] In 1883, the review *Le Livre universel* organizes a contest about "military education at school." Open only to school teachers, sponsored by the Minister of Public Instruction, and endowed with a first prize of 1000 francs, it invites candidates to determine "if this education is such that it will develop in the child civic virtues; if it should augment his physical strength and the sentiments of discipline, dignity, and morality, without which there is no citizen worthy of that name."[51] The winner of the contest, honored by parliamentarians and Ferdinand Buisson, responds in the affirmative, since "school can prepare [the child] for the regiment by trying to make his character virile and improving his mores."[52]

By fortifying children's patriotism, their virile formation is thereby ensured. These exercises help them to grow morally and civically by inculcating a sense of dedication and order but also favor their physical development. As one teacher

explains, children will learn to endure deprivation, fight against fatigue, confront danger, march along tough roads, climb into trees, find their way in the woods, or even hide behind bushes:

> Under the beneficial influence of this military education, the child's physiognomy is stamped with character, his temperament is fortified, his muscles develop, and his lungs swell with pure air and fill his heart with generous blood.[53]

In *Le Drapeau*, a poet glorifies the patriotism of "budding soldiers" parading in a "hairless male brigade,"[54] and Henri Chantavoine, in *The Children of the School Brigade* (1891), pays homage to the "little children/Of the old homeland"; they will give the nation "in ten years/A young, hardened army." To that end, they train their "little arms/To avenge the honor of France." Along with moral education comes virile strengthening: the child who marches with his gun is a soldier and a citizen in the making.

PHYSICAL EDUCATION AND SPORTS

Even though the school brigades were eliminated in 1891 because of insufficient funding, physical education remains an indispensable element in curricula. Its foundational texts are *Gymnastik für die Jugend* (1793) by Guts Muths, revised throughout the nineteenth century, *Die deutsche Turnkunst* (1816) by Ludwig Jahn, "father of gymnastics," and in France, the *Manuel d'éducation physique* (1913) by Georges Hébert.[55] Besides the fact that it forms patriots and prepares them for war, physical education helps cultivate virility in boys. Numerous hygienists and pedagogues recommend making all exercises obligatory in childhood (walking, jumping, running, rope- and pole-climbing) in order to "form robust men"; girls are exempt, "obliged as they are, later, to engage in sedentary activities."[56] For Jean-Baptiste Fonssagrives, professor of hygiene at the University of Montpellier, children's education should be Spartan. It is ridiculous to see them crowded around the heater like little old men; they should be urged outside, regardless of the weather, to blunt their sensitivity to fatigue. Fonssagrives presents the results of two types of education, of which virility is the touchstone: there is, on the one hand, the "sensitive child," weak, overly comfy, selfish, and, on the other hand, the young Comanche who, from age 3, has "a forehead continually dotted with bumps and legs blackened with bruises." Naturally, Fonssagrives has made his choice: "The

child is a little man, and there is not one detail of his education that should fail to focus on his future virility."[57] By the end of the century, there are 20,000 members of 300 gymnastics clubs in France; they "valiantly pursue the physical and moral regeneration of French youth through Physical Education."[58]

Physical exercise can be complemented with games and sports. Lawn tennis, a forerunner of tennis, is appreciated because it assumes strength, dexterity, a good eye, and quick judgment. "However, the skill involved consists not so much in hitting the ball vigorously as aiming it in such a way as to fool the opponent. . . . This unusual type of combat is not without its pleasures." The *"jeu de barres"* is "the image of war. Two armies face off, defying one another by sending out of their camp the best runners of their light troops, until, following several skirmishes, a general battle is begun."[59]

Even if they do not use the warrior vocabulary, the Jesuit priests take an interest in these games, which are appropriate for channeling boys' energy: "Playing well at once develops physical strength, prepares for serious study and powerfully combats immorality."[60] Fencing is recommended for the education of youngsters, not only because it lends flexibility to the legs, develops the chest, and sharpens sight but also because it constitutes

> the most suitable means of ensuring the observance of those ancient virtues, now so forsaken: respect for others, human dignity, and dignity of the citizen, which is measured by the greatness and the strength of the nation [. . .]. Isn't this, after all, about our children, robust men and vigorous soldiers? It is therefore necessary, from an early age, to inspire in them a love of virile exercises that develop their limbs, ensure their health, prepare solid recruits for the army, able to bear up under any struggle and valiantly confront any danger![61]

Similarly, horseback riding eliminates "fear, cowardice, weakness," while habituating the child to dexterity and sociability.[62] Since they fortify the body and infuse a whole set of moral qualities, ball games, fencing, and horseback riding constitute a school of discipline and strength. They enter thus into the definition of masculinity, and their practice is part of a skill set and a *savoir-vivre* that are best acquired as quickly as possible:

> It is appropriate for a young man to know how to handle arms of every type, the foil and the sword as well as firearms [. . .]. Horseback riding is a noble exercise that develops bodily movement and virility of character.[63]

VIRILE INSTITUTIONS

It goes without saying that these activities are socially differentiated. While fencing and equitation bring to the elite a portion of their chivalric baggage, the popular milieus instead prize boxing, wrestling, soccer, and cycling. Gymnastics has the advantage of being able to be practiced without any heavy equipment, for example, within the local school. But even before the young man gets to the army barracks, where he will round off his virile apprenticeship, several institutions allow the child of the lower classes to conform to the requirements of his gender.

The agricultural penal colonies, booming since the July Monarchy, aim to filter out the defects that led the good-for-nothings to pilfering and vagrancy, that is, to transform a bastardized, cynical, or dangerous virility into a positive, useful masculinity. According to the bourgeois who supervise and observe them, the children arrive at the colony "pale, disheveled, looking like ghosts. . . . Their features are too often battered and deformed; their look is not open but evasive, they seem wild, not intelligent; the expression on their face is equivocal, the forehead low."[64] But soon the lessons in morality and the example of their monitors purify them and teach them to become worthy, honest, and respectful of others and of themselves. In the early 1840s, a future colony director proclaims himself convinced that order and discipline, work and games "can serve to regenerate young hearts that are more hardened than corrupt."[65] Songs specially written for the residents of boarding schools and agricultural colonies celebrate a cheerful, lively virility:

> With bag in hand,
> I run through woods and moorlands,
> Briskly, full of vigor;
> I attack till out of breath,
> Both burrow and rabbit;
> For I am a straightforward hunter,
> Halli, hallo, halli, hallo!
> For I am a straightforward hunter.[66]

Above all, the fresh air soon helps the young city dwellers get better; the farm work fortifies their bodies and gives their limbs vigor and dexterity. In 1831, the Society of Charitable Associations boasts about the effects of the countryside on fragile constitutions: "Several children who had remained weak and languid in the refuges found strength and good health working in the fields."[67] Many arrived ill at the colony,

but the fine air, the field work and the hygienic practices skillfully implemented [...] have already caused so beneficial a reaction to the constitution of several of them that we take credit for now being able to be doubly useful to these children and to society by returning to it, rather than feeble and corrupt beings, honest, robust men.[68]

On 13 June 1865, Jules Simon speaks in praise of the farm colonies before the legislature: it is "salutary to impose on the culprits the work that is most natural to man, the most virile work, that which is most fortifying at once for the soul and for the body, that which is done in the fields, under the sun."[69]

Gymnastics comes in to complete this recovery. It aims at strengthening boys' bodies while draining their violence. The colony at Saint-Hilaire is equipped with a gymnasium where the children exercise: they box and use the *canne de combat* and various pieces of gymnastic apparatus.[70] In 1883, the colony at Mettray distinguishes itself during the gymnastic competition by winning first place in military maneuvers and second place in weight lifting.[71] According to Aimé Vandelet, author of a treatise on "rational physical education among young inmates," exercise helps soften "the most rebellious natures"; the youngsters are taught "cleverness as well as fairness in their struggle for existence."[72] With eugenic undertones, a visitor to the colony at La Motte-Beuvron explains to an assembly of livestock breeders how gymnastics can increase adolescents' strength. Man can be modified "like the animals that are subordinate to him. He will devote himself to athletic exercises and augment the power of his muscles, which will ensure him success in those struggles so dear to our neighbors."[73]

Marches and parades, in effect, complete the formation of boys. In several establishments, such as Le Bouard et Mettray, the campers carry out maneuvers, being made to march in lock-step, even when going up the dormitory stairs. At Cîteaux, the return from the fields is done in military order by squadron to the sound of the fife and drum.[74] The campers train in the handling of arms and in fencing, and they are led on military tours by means of a topographical survey of the covered terrain; once a year they parade through Dijon with drums and bugles, flags waving. At Mettray, as in the other colonies, physical education and discipline prepare "the campers quite naturally for taking their place in the ranks of the army."[75]

After a few months at the colony, the debased boys thus recover the good qualities of their gender. Thanks to fieldwork and gymnastics, the young inmate gets ready to become a soldier-laborer, capable all at once of cultivating and defending the soil of the homeland. The degeneration of the little beggar has given way to

a fierce power, which awaits only the sergeant's signal to beat down the enemies of France. The eruption of a controlled virility marks the success of regeneration. Conversely, the child who is impervious to the benefits of the colony remains under the reign of atrophied masculinity. At Boussaroque, a camper who has tried to run away is made to suffer "the shame of a sort of female accouterment."[76] In *Miracle de la rose*, Jean Genet, incarcerated at Mettray, sets out a universe of "bosoms" and "foam-rubber gadgets" offered to the desires of young males.

In decline by the end of the nineteenth century, the agricultural penal colonies are replaced, in this pedagogy of virility, by other institutions aimed at working-class children. Open-air schools, in fashion between the two wars, try to fortify these children by putting them on a hygienic-dietetic regimen. Although coed, these schools put into currency a discussion about the physical blossoming of anemic and pretubercular boys. In 1922, during the first international congress of open-air schools, a participant recommends, on behalf of Major Hébert, the installation of playing fields with a jumping pit, wrestling arena, exercise bar, climbing rope, and balance beam as well as a swimming pool of makeshift construction.[77]

At the same time as they praise energy and robustness, these institutions manifest a certain mistrust of virility. They encourage behavior that could be characterized as previrile; in other words, they pave the way for the man of the future. But in no instance do they aim to bring to fruition the male, endowed with all his attributes and all his passions, within the boy or adolescent. The partisans of the agricultural colonies repeat this in every register: fatigue in the fields is salutary because it "dispels dangerous thoughts and procures beneficent sleep."[78] Physical education is "a sure prophylactic against disorders and vicious habits of youth," for it brings about "a slight physical strain at an age when the senses are awakening."[79] Virility must be prepared for, but without haste.

SUBLIMATING SEX

PREMATURE DESIRES

Following Samuel Tissot, the famous author of *Onanism, Essay on the Illnesses Produced by Masturbation* (1764), all the doctors and ecclesiastics of the nineteenth century warn about the dangers of puberty. The effects of masturbation are innumerable and dramatic. The child loses weight, becomes pale, difficult, and ill-tempered; his face is haggard, with circles under his eyes, which are constantly

lowered; his movements are slow; he is stooped and drags himself about without energy; his short, agitated sleep brings him no repose. These doldrums are accompanied by various indispositions. In addition, masturbation debases the boy morally: the guilty adolescent rebels against God by lowering himself below the level of the beast.

Above all, by exercising one's virility too soon one uses it up and diverts it; by wishing to become a man early one is condemned to never being one. By dint of being scattered,

> man's seed will be of inferior quality [. . .]. The boy who seeks a hasty maturity by means of perverted practices succeeds only in causing himself weakness and illness, whereas the one who observes carefully the laws of hygiene develops normally and becomes a vigorous boy who will reach virility without going through any trials or anxiety.[80]

The portrait of the young man who has remained pure contrasts in every respect with the frightening one of the perverse youngster who has had the weakness of initiating himself alone around the age of 14 or 16 because in the description of the former

> his conscience is clear, his intelligence lucid, his manners open and naïve, his memory excellent, his cheerfulness keen and his complexion shiny. . . . Look at this young man: every one of his movements denotes strength and suppleness; he still has happily control of himself. . . . All his time is divided between his studies and salutary, enjoyable exercise.

Remaining continent, he has preserved his vital fluids, and "his youthful energy has been entirely employed toward his legitimate goal, the development of his constitution."[81] Precociousness is thus a danger for physical development: weakened by the loss of energy, the masturbator is not really virile and never will be.

From then on, the watchword is all-embracing: the vigilance of adults must not be relaxed for a single instant. There are several ways of keeping watch over the boy who is tormented by the changes in his body. Keeping him in the dark would result only in stimulating his curiosity and driving him toward vice, even toward libertinage. By contrast, by subjecting him to intense physical activity, he goes to bed thinking of nothing other than sleep. His clothes should be roomy, especially around the genital area, which should be kept from any rubbing. For this reason,

it is appropriate to leave boys in skirts for several years, forbidding servants from making fun of them because of their outfit. . . . Watch closely the moment of their awakening, and do not allow them to stay in bed awake, or to go into other children's beds or into the bed of the person sleeping next to them. They should be lightly covered in bed, depending on the season, since extreme heat excites the senses excessively.[82]

More generally, a wise mother should avoid food and drink that are stimulating, get rid of suggestive novels and paintings, and forbid her son's befriending smart-alecky individuals.[83] Besides the fact that cleanliness helps boys avoid getting irritations in the wrong places, it is necessary "to teach them from a very young age not to play with their privates. Without telling them the reasons why, their hands should be kept away from those places."[84] As for the spanking, it dangerously excites children's desires—as witness Jean-Jacques Rousseau, disciplined at the age of eight by Mlle. Lambercier.

Onanism is not the only misbehavior that can be spotted—and fought against—in the child. The phrenologist Franz Gall reports that he saw a little boy of three throw himself "not only on little girls, but on women, and order them audaciously and obstinately to satisfy his desires. He had in his private parts, which were not prematurely developed . . . , more than momentary erections."[85] Boys of ten have inappropriate gestures or, without displaying an erotic desire directly, pretend to be men already. One brandishes a rabbit's foot, saying he wants to brush his penis; according to a friend, "he took it in his hand saying he would put it in his sister's navel." Others, victims of bad examples, become smokers or alcoholics. The child "hears that, when you smoke, you're a man." Some parents share the Sunday after-dinner liqueur: "The kid wants some, so we give it to him. He's a little man."[86]

But it is just as serious to manifest a precocious virility as to be lacking in it. A doctor, author of a thesis on sexual perversions in the child, cites the case of a boy who manifests only "feminine tastes:" he plays with dolls, does knitting or needlepoint, likes to dress up, speaks in a falsetto voice, and seeks the company and caresses of men; with adolescence, he lets his hair grow long, dresses like a woman, makes up and uses perfume.[87] Pubescent boys dream of giving themselves to mature men. At the end of the nineteenth century, a psychiatrist examines a homosexual epileptic of 18, whose father confides this to him:

From the age of six, he took pleasure in seeing men, mainly men equipped with well-marked sexual characteristics, beards, deep voice; later, he sought opportunities

to see men naked, and his first genital stimulation took place at this sight. When puberty set in, his tastes became more marked; he sought friends who were older than he and seemed more developed. . . . It was not until he was 16 that he understood that he was different from his friends. He opened up about it to his confessor, who reassured him and encouraged chastity in him.[88]

In the interests of morality as well as their virility, young men are encouraged to remain virgins until marriage. Christian education advises six methods of "preserving chastity:" avoiding bad company, guarding against external sense stimulation, consideration of our own final ends, praying, regular taking of sacraments, and rejecting laziness.[89] But how to convince a young man to remain chaste?

> He is scarcely out of childhood, when he is abandoned as if he had the experience and strength of a man. . . . Prompted by the energy and ardor peculiar to that age, he is exposed to dangers whose seriousness he does not examine with sang-froid.[90]

Several arguments can be launched in favor of abstinence. There is first pride. A father counsels his son who, because of his youth, wants to experience intense orgasms. His father responds:

> That's great! Then you cease classifying yourself among the elite of the nineteenth century; you follow the crowd; you imitate the sheep that goes where the others go. . . . You experience the desire to enjoy life; I don't believe you have a better means of achieving that goal than to follow your duty, your whole duty, and nothing but your duty.[91]

On the other hand, the young man who has followed the dissolute ways of his sensuality disappoints his family and soils his wife and children in advance. He "leaves a stain in the midst of these four figures: a mother and a daughter, a wife and a sister."[92] Above all, he risks ruining his health, as numerous apologues predict:

> A young man, having received a Christian education, had the misfortune of being dragged down by the torrent of pleasures; he gave in to excesses of every kind; and, after having compromised his future and lost his reputation, he was confined to a bed of pain by a cruel sickness, the sad fruit of his disorderliness. . . . The young man confessed, received extreme unction and, at the moment of receiving communion, he made an effort and said in a stifled voice: "Oh, all you present for my last

instant, especially you who have children, know that the evil consuming me and from which I will die is the effect of unrestrained libertinage that perverted friends taught me. Pardon me; pray for me to the One who will judge me."[93]

At the beginning of the twentieth century, some doctors and forward-looking pedagogues recommended providing boys with a form of sexual education. According to a member of the Society of Pediatric Hygiene, "nothing is worse than leaving to friends, to servants, or to haphazard encounters the business of initiating the child into the mysteries of the union of the sexes and of procreation." A family chat, which blends religious teaching with scientific advice, turns out to be indispensable, especially for combating the attraction of "certain shameful, unnatural vices" widespread in the *collèges*.[94] This discussion, to take up around the age of 14 or 15 when curiosity is awakened, constitutes the best fortification against vice and debauchery. Its objective is "by pedagogical means, to subordinate genital instincts to willpower."[95] Every treatise on "human mechanics" should be "instructive and educational" and remind the reader of "the dignity of the sexual functions."[96] The young man will remain chaste if he has illustrated for him the dangers of venereal diseases, the stigma of "love merchants," and the abjection of the act: "Spare yourself the indelible, degrading stains of debauchery. And if one day you happen to be tempted to give in, lift your thoughts right away toward the idea of truth, beauty and goodness that each of us should have."[97] On the eve of World War II, clergymen advise fathers to put forward to their sons of 12 to 15 the cold medical truths:

> The father carries within him the seed of life, which is destined to fertilize the mother's body. . . . It is necessary for you to know that you, too, carry in your flesh this precious seed. It is contained within that part of your body called the penis, and it is for this reason that you must especially respect it and keep it away from impure views or touching. When your body, which is still only a child's body, turns into an adult body, you will be immediately aware of it. Seeking to get outside, the seed will bring about in your penis a special movement aimed at facilitating its ejection. Know, therefore, that if one day you perceive in your body a movement of this kind, you mustn't be surprised or frightened.[98]

So, true virility consists of restraining one's virility, not in displaying it more or less boldly, as Frédéric Moreau and Deslauriers do on a jaunt at the Turk's—the "secret obsession of all adolescents."[99]

VIRILE PASTIMES

The best way to contain sex is perhaps to sublimate it, that is, to give the slip to the adolescent's emotions by way of healthy activities. Study enlightens while keeping the body busy. As explained by an instructor at the École Normale Supérieure at the end of the nineteenth century, knowledge allows accession to "intellectual virility." When the mind is trained, not only is it protected against dangers that might assail it, but it is also in a position to reproduce itself: "Intellectually, you will feel like you are fit to spread the life that you carry within you."[100]

Dreams of adventure constitute an even more captivating outlet. Alfred Mame Editions, beginning in 1845, Hachette's *Bibliothèque rose* collection beginning in 1855, and Herzel's *Magasin d'éducation et de récréation* beginning in 1864, publish stories for young people signed by prolific authors such as James Fennimore Cooper, Jules Verne, Gabriel Ferry, and Paul du Chaillu. Their import is pedagogical, since each experience, each human or animal encounter, and each landscape serves as a pretext for instructing the reader; but above all, they deliver a "virile moral."[101] In his story "At Sea," specially dedicated to "young boys," Captain Mayne-Reid takes them on a trip to the middle of the Atlantic, at the side of a 16-year-old hero grappling with sharks, storms, and every sort of peril.[102] But young readers are also led into explorations, hunts, polar expeditions, "modern voyages," adventures "that make the heart throb in a healthy way" and cover the world from Timbuktu to Eskimo villages, passing by the giant trees of California and Japanese teahouses. These adventures could only temper "the young generation that was to remake France."[103] For these breathtaking accounts, with their dangers, their trials, their life in the open air, and their moral about courage constitute so many virile initiations: "The adventures actually function to bring out the man in the child—and they do so in a particularly virile sense, since they manifest the ideal of a hardened man."[104]

These readings transmit the codes of masculinity—courage, physical stamina, sang-froid, and the drive to protect. But the environment in which they are established continually emphasizes its occidental, civilized character. In *West Africa* (1875), Paul du Chaillu invites his "young readers" to travel with him to the "place of savages." The narrator is received by a Negro king dressed in a single red uniform, without a shirt; covered by tattoos, he wears large earrings and smokes a nasty pipe. Another king walks around without pants in a simple redingote. Always drunk, full of vanity, he thrashes his subjects; but he hurries to leave his plantations "with the welcome news of the arrival of a white man." A ball is given in the visitor's

honor, but the more frenzied this charivari becomes, "the more fervor the men put into their gambols." They become delirious when their king begins to dance in turn.[105] Grotesque petty kings, dances of idolatry, and villages of cannibals bring into relief, by contrast, the polite and civilized composure of the European.

In the *Magasin d'éducation et de récréation* of 1890, we follow through several episodes the escapades of "young adventurers from Florida." The intrepid Harold, 15, asks his young cousin to blow the trumpet twice in case of danger. During a storm, when the youngest children begin to cry and to pray, Harold reassures them calmly. Why this spiritual strength, this self-assurance in the leader of the pack? Harold is of robust constitution; his education has been neglected but he lived with an old Indian and so "he could have lived in the forests like savages."[106]

This literature reflects the grounds for a scale of races according to which the white man is superior to the Indian, who in turn is superior to the Negro. But these descriptions convey less the white man's domination over the indigenous man (or man's domination over woman) than their encounter with these different races—to the advantage, of course, of the young European, who comes away enriched, greater, and in a way legitimated. In *The Children of Captain Grant* (1867) by Jules Verne, young Robert, carried off by a condor, is saved by an indigenous Patagonian of large stature, dressed in "a splendid coat decorated with red arabesques, made with the neck and legs of a guanaco, sewn with ostrich tendons," and whose face shows "a real intelligence, despite the bric-a-brac that decorated it." After several vain attempts, Robert and his friend succeed in understanding that the indigene's name is Thalcave, which, in the Arauca language means "the thunderous one." This same Thalcave is the one who, after having successfully guided the little troop, says to Robert at the time of good-byes: "And go now, you are a man!"[107]

At the heart of masculine youth, several models go head-to-head. The good-for-nothing who smokes or plays hooky, the stubborn kid on his own, the rascal from the street, and the young delinquent all display virile pretensions. Even in boarding schools there lurks the attempt to embrace an errant virility. In *Au collège*, a story "for young boys" published at the beginning of the twentieth century, Pierre is called "imposter" and "snitch" by his roommates because he prays at the foot of his bed before going to sleep. He is placed in quarantine. Jacques, leader of the conspiracy, is a dunce who frequents the cafes. "Big and robust, he has a loud mouth and a sharp tongue. . . . He is the veritable leader of a band of petty rebels who are just asking for the chance to do something silly." Fortunately, Pierre meets a newcomer, Paul Vidal, who soon becomes first in the class and who wants to be a missionary.

Pierre was dumbfounded. He had always imagined missionaries to be superhuman men, with herculean strength and extraordinary courage; and this skinny, puny little boy, who seemed timid and ill at ease, had the ambition to become one of these pioneers of the gospel and of civilization![108]

Thirty years later, Pierre has become the principal of his former *collège*; he "seeks to fulfill all the duties of his charge as a patriot and as a Christian." Jacques has failed in every job that he has tried; he ends up being enlisted in a colonial regiment. As for Paul Vidal, he has become a missionary in central Africa and he is a "vigorous, industrious man, always in a good mood."[109] To choose the best model of virility, appearances are not be trusted: it is the delicate boy, steadfast in his will and his faith, who concealed the real man, and he is the one who manages to reconcile fearlessness, dominating energy, and piety.

The Boy Scouts, founded in 1908 by Robert Baden-Powell following the Boer War, purports to offer boys life training. It is about giving boys an education that combines a clean life, endurance, self-control, kindness, and loyalty; still, we should be careful not to rush things. As Baden-Powell declares, "the boy who apes the adult by smoking is never going to amount to much good; a strong, healthy boy has a soccer ball at his feet."[110] If he follows the law of scouting, which commands him to be always friendly, courteous, good to the weak and to animals, disciplined, good-humored, brave, resourceful, and tenacious, the scout will become a happy, healthy, and useful citizen. At the time of the second international congress of scouting, held in Paris in July 1922 (one month after the first congress of open-air schools), Baden-Powell defines soccer as "a game for boys, but a game such that, if you play it steadfastly, according to the rules, for several years, you should one morning wake up A MAN."[111]

Exploration, voyages of discovery to unknown lands, fights to defend the weak, moving rescues, emergency assistance to the wounded: whether one follows the heroes in one's imagination or embodies them oneself, whether one reads of the adventures or acts them out in the neighboring forest, the result is always the same. Much more than the wooden sword or little tin soldiers, these activities develop boys' sexual characters while keeping them in check; for the preman is no longer a little boy attached to his mother's skirts but an adolescent who moves forward "with all the energy of his nascent virility to conquer the universe."[112] Would there not be, then, substitutes for sex for young men full of vigor who manage to reconcile morality with pleasure in this way?

From the little boy to the grown man, there is thus continuity as much as there is breach. The former takes an example from the latter, steeps himself in the codes and the rules of his gender, all the while mediating among diverse models in competition; yet the precursory signs of virility in the little male are not a license to fight, give orders, or have an orgasm: virility develops like a fruit that the boy cannot relish precisely because it does not have the requisite maturity. Knowing everything yet being ignorant, suffering in order to dominate, imitating without living—such are the exigencies to which the bourgeoisie subjects its children and those of others, to ward off all at once both effeminacy and out-of-control virility. Later, when the little man has grown up, there will be time for him to guide his own son. Once an adult and on his own, he will manifest his virility as he sees fit, by drinking, by swearing, by fighting a duel, or by growing a moustache. As for pleasure, the lifestyle manuals have a lot less to say about it because it belongs to the realm of privacy and flourishes from now on in bedrooms and brothels.

8

THE DUEL AND THE DEFENSE OF VIRILE HONOR

FRANÇOIS GUILLET

IN THE 26 March 1885 issue of the *Gazette des tribunaux*, we read:

> Two boys, aged 15 and 14, having had a violent argument, resolved to end the disagreement with arms. And yesterday afternoon, in the Bois de Vincennes, in the presence of three of their friends, the two boys took up swords. Both were slightly wounded; their honor saved, they each went home to their family after having made up on the combat site.[1]

Throughout the century, virility declines in terms of the values whose often painful inculcation must be undertaken from an early age and that are expressed most intensely by individual combat.[2] Because these values are, above all, moral values, respect for them constitutes the full-fledged man. This morality in action requires, to be sure, that no provocation go unpunished. Yet it also demands that the reparation be accomplished according to rules that guarantee the certainty of the encounter and the equality of the combatants. Among the qualities demanded by the ritual of the duel are courage in the face of danger and, above all, sang-froid and self-control, which the combatants must demonstrate. The duel is thus a trial of truth: it manifests in front of everyone, and first of all before the very eyes of the combatant, that he does indeed possess those qualities, and it reveals in this way the man of honor—that is, the real man.

HONOR AS THE BASIS OF THE FIGHT

THE SENSE OF HONOR

As described by Alfred de Vigny, veritable theoretician of honor and of the "poetry of duty,"[3] honor appears, in point of fact, as a cardinal virtue, the very essence of virility. There are innumerable testimonies to the deference, indeed veneration, toward this sentiment. "Such was the first fight bestowed upon me by this honor that became the idol of my life, to which I so often sacrificed my repose, my happiness and my fortune," writes F.-R. de Chateaubriand in *Mémoires de ma vie*, after recounting how, as a child, he did not hesitate to stand up to the authority of the school principal where he was a boarder in order to escape the whip, a punishment that he judged to be dishonorable.[4] In the triple sense of self-esteem, the ethics of conduct, and the estimate of honorability, virile honor models the masculine condition and imposes its law. C.-A. Sainte-Beuve compares individual combat to a conspiracy that one carries out despite the doubts one is beset by: "On the eve of a conspiracy, as with a duel, there is no way of getting side-tracked; one senses deep down in one's heart that this is not true, not right, and yet human honor keeps its hold and one continues."[5] Numerous also are those testimonials from people constrained to sacrifice themselves to a ritual of honor that formally conflicts with their convictions and ideals. F.-V. Raspail, editor of the *Réformateur*, ardently pro-Republican and a defender of workers, is thus trapped, on 30 December 1834, into fighting against L. F. A. Cauchois-Lemaire, editor of the journal *Le Bon Sens* and also a Republican;[6] P.-J. Proudhon, despite a stubborn resistance, has to exchange two bullets on 1 December 1849 with the deputy of la Montagne, Félix Pyat.[7] Jean Jaurès cannot shirk from the fight forced on him by Paul Déroulède at the Spanish border on 7 December 1904.

Characteristic of virile honor, and beyond the masculine condition of the nineteenth century, a painful conflict runs through these personalities. For the law of honor is not only contrary to Christian morality, reaffirmed forcefully throughout the nineteenth century by the Catholic Church as well by the Protestant churches;[8] it runs counter also to "right reason,"[9] as E. V. Toussaint writes. Adopting a nuanced position on the question of honor, whose importance and legitimacy most agree on, the Enlightenment philosophers incontrovertibly condemn the violent demonstrations aiming to defend it—in particular the vestige of "Gothic barbarism"[10] that is the duel. In *La Nouvelle Héloise*, Julie makes resounding objections wishing to stop Saint-Preux from fighting for her against Milord Édouard:

Thus virtue, vice, honour, infamy, truth, and falsehood, all derive their existence from the event of a duel; a drill hall is the only court of justice; there is no other law than violence, no other argument than murder: the only reparation due to insulted men is to kill them; and every offence is equally washed away by the blood of the offender or the offended. [. . .] Do you intend to destroy the truth, by killing him you would punish for having told it?[11]

The masonic lodges have the same position. The French Revolution will end up, in the eyes of part of the public, heaping opprobrium on this practice characteristic of an aristocracy gone awry[12] and soon to be likened to the counter-revolution.

Proudhon offers a detailed illustration of this internal conflict thanks to the notes that figure in his *Carnets*, which were not intended for publication. His affair is inscribed amidst the extremely strained relations that prevailed between la Montagne and the anarchist theoretician. On 24 November 1849 E. Madier, an orator of the clubs, had written Proudhon a letter in which he expressed the view that *Le Peuple*, a journal edited by Proudhon, was getting soft, the proof of which was the withdrawal of Proudhon's name from the masthead of the journal. He then lashed out at la Montagne's sectarianism by recounting that he had written for a banquet a toast on the right to work. Although it was accepted unanimously by the relevant commission, the toast was rejected, again unanimously, the day it was to be read on the pretext that the subject should be reserved for Félix Pyat, who had not come to the banquet. "Oh aristocracy of democracy!" he concluded. Proudhon published this letter in *Le Peuple* on 25 November, following it up with an explosive commentary attacking, in particular, *La Révolution démocratique et sociale*, L. C. Delescluze's journal. On the evening of 25 November, in the halls of the *Assemblée*, Pyat approached Proudhon and called him an "abominable pig," provoking a few punches in return. The very next day a challenge was sent to the pugilist.

For a long time Proudhon the thinker resists: "For me, the sentiment of honor is not to be confused with reason," he writes. "Anything that does not come to me through reason, through my principles, does not come to me at all."[13] He adds a little later: "I want, in a word, to reason out *my affair*, as I reason out everything I do. I want to be sure whether I'm right or wrong before I fight." He finally gives in, however:

The time has come for me to respond to the insults, the life stories, the quips, the anonymous letters and the challenges to duel.—I have stood firm against the outrage, believing that my self-esteem (my honor has nothing to do with all this)

wasn't worth a single line of rectification. I have concerned the public only with my idea, never with myself . . . ; it is inevitable.—I have a duel to get out of the way.[14]

Two days later, on the 29th of November, workers sleeping on the landing prevent him from leaving his hotel room on the rue de Beaune to go to the meeting place. On the thirtieth he manages to get away from them but then runs into the police commissioner from the Assemblée, Commissioner Lyon, who intervenes. On 1 December, finally, the encounter takes place:

An absurd, ridiculous comedy. It was up to us, after having exchanged a few excuses back and forth, to rise *above* the duel. The people demanded the duel: our thousands of friends stood in the way; it might imperil the Republic if ordered. The witnesses did not understand it that way, and we gave into prejudice by each exchanging two bullets.[15]

The law of honor triumphed over reason, but also over ridicule, the denunciation of which, with respect to the duel, returns constantly in the writings of commentators and which a number of novelists and playwrights stage and use as a comic technique.[16] It vanquished the very real fear that Proudhon felt when he opens up his *Carnets* before the fight and writes a long, self-indulgent evocation of his life, emphasizing how useful it was to the weak and wretched. "My entire life is an effort of courage," he writes; and later, "I am still poor, so many poor have I to support."[17] Most of those who have left their testimony agree: undergoing the trial of the duel is a frightening experience, all the more frightening in that it has no rational basis.[18] Objects of all sorts of ridicule, the parliamentary duels, for those who undergo them, are no anodyne affair. In August 1887, the journalist Arthur Ranc expressed anger in *Le Matin* about ironic commentaries denouncing the refusal by Jules Ferry of particularly severe conditions—probably calculated to be rejected—that General Boulanger's witnesses wanted to impose on him, for he had characterized the ex-War Minister as "the café-concert Saint-Arnaud." Ferry's witnesses preferred a combat on command, with twenty-five paces from each other and the exchange of a single bullet, over a fire-at-will combat that goes on until one of the combatants is wounded. The journalist writes:

A duel at twenty-five paces on command! What a joke! No, it's no serious matter unless you're there; but when you're face-to-face with the little black hole, the distance doesn't seem exaggerated, and during the few seconds that the order lasts,

you have all the time to reflect. I do understand that there are heroes, flame-eaters who pride themselves on not feeling the slightest emotion on the field of honor; I don't know how that happens; they never fought and will never fight, and no one has ever seen them expose themselves to any kind of danger.[19]

Proudhon himself gives the cause of this irresistible force of honor:

> The suspicion of cowardice is mortal in France, and it is known that this suspicion is not eliminated by the duel, no matter how ridiculous it may be; moral courage gives no credential to a courageous man. Neither devotion nor work—nor any kind of virtue—can be a substitute for the feigned insensitivity of a brave man in the presence of a pistol shot![20]

To refuse a duel is to open oneself to the suspicion of cowardice and to risk, for that reason, being denied the status of a man. In a system of gender representation founded since the late eighteenth century on the opposition and complementarity of man and woman,[21] a man's cowardice conveys a defect of virile capacity and moves the individual closer to the opposite pole; it threatens to place him in the category of the "third sex." Considerations of the eunuch's cowardliness are a commonplace of philosophical and medical literature since the seventeenth century. "It is known that eunuchs are, in general, the basest class of human beings: cowardly and dishonest because they are feeble; envious and nasty because they are unhappy,"[22] writes P.-J.-G. Cabanis. Insults appear, namely in a certain number of cases of duels in the nineteenth century.[23] After calling honor "virile modesty," Vigny writes: "the shame we feel if we lack it is immense."[24]

Georg Simmel, in his analysis of honor, emphasizes that, if the specific contribution of religion is to lead the individual toward making his salvation his duty, that of honor is to lead the man toward making his social duty his personal salvation.[25] To be no longer a man is to risk social death by the loss of a capital whose symbolic character, as Pierre Bourdieu has demonstrated, in no way implies that its disappearance is devoid of concrete instances.[26] By disclosing an individual's inability to sustain his dignity, that is, to defend the consideration and the status on which his self-esteem and respect from others are based, incompetence also implicitly reveals an inability to protect those who are dependent on him—wife, children, family— or to maintain a tie of solidarity with the particular group he identifies with. All run the risk of being sullied for a long time, if not forever, by the dishonor to which their relative or friend has exposed himself. Incapable of facing the looks of his

comrades after being sequestered in his quarters, which makes it impossible for him to meet on the field of honor a young man he had a run-in with during a play at the Théâtre de Beauvais, Officer Lequien, page for the Royal Guard, prefers to blow his brains out on 15 July 1823.[27] Denounced by the radical press, Ferry's refusal to duel would contribute to his defeat in his run for the Presidency of the Republic.

One must be endowed with an exceptional soul, that of a saint or a philosopher, says Philippe-Antoine Merlin, prosecutor at the Court of Appeals during the Empire and eminent jurist, to risk the opprobrium heaped upon anyone who refuses the confrontation:

> Place a man of honor between the infamy that his name will be associated with, if he shrinks from the proposition of a duel, and the scaffold where, if he accepts, his head will fall under the blade of justice; and judge for yourself which choice he will naturally make, unless he is graced with one of those great souls that always know how to bend the most profoundly rooted prejudices in the face of reason, that is, unless he is an exceptional and, unfortunately, very rare case.[28]

For individual combat allows not only the dismissal of the specter of public stigmatization. It also takes on an aura of virtue by appearing like a gift of self. It constitutes, as explained in the House of Peers on 12 March 1829 by the Marshall Duke de Raguse during the discussion of the project of the Portalis law on the suppression of duels, "a noble and reasoned sacrifice of a life one holds dear, but which one lays open to risk in order to preserve an even more precious good."[29] It is in this way that the duel is different from suicide.

The concern about honor is not only a heavy constraint weighing on men of the nineteenth century. An instrument of social conservatism,[30] it is also the bearer of positive values by identifying—regardless of the social stratum one comes from—membership in an elite that is subject to ethical demands more rigorous than those imposed upon common mortals. Particularly marked in those groups that are mainly, if not exclusively, masculine, such as the army, youth at school, or politicians, these demands and this sentiment do not, however, have clearly circumscribed limits. They are likely to concern all men as men, that is, to concern the gender opposite from that of women. Among the qualities that distinguish the man of honor, the contempt for money, whose roots are in the nobility, prohibits a duel motivated by such a cause (except for gambling debts), and prohibits profiting from an affair of honor. In its preparation for the proposed law by Clausel de Coussergues on the suppression of duels, in 1819 the commission on laws of the Deputy Assembly

foresees the possibility of paying damages and interest, adjudicated as compulsory, to the poor, "for we must imagine," it says, "cases in which a *délicatesse*, quite natural to the French heart, might make [duelists] fear appearing to demand or to receive blood-money from a husband, father or child."[31] This is because the laws of honor take a higher priority than the laws of the market. This opinion is shared by most men of the nineteenth century, including those doctrinarians in power during the July Monarchy. Rémusat explains, with regard to the 1840s: "Business became essential, but it seemed like it was fine with the boors: the Ministries of Commerce, of Public Works and even of Finance were given up to second- or third-rate men— men without talent."[32] Bourgeois honor, a favorite theme of Émile Augier's plays, which depict the so-called school of "good sense" in the 1850s, is not unrelated to these conceptions; the playwright describes it as based on integrity.

Honor derives from an ethic of responsibility and autonomy that delineates, as its counterpart, a feminine ethic based on submission and marked by the influence exerted on women by religion. "How is it that a man who is not Christian will refrain from committing a robbery that remains unknown?" asks Vigny. "Invisible *honor* stops him." For the writer, who propounds a line of argument tirelessly repeated throughout the nineteenth century, including Simmel's analysis, "honor is the sole basis of man's conduct and replaces religion in him."[33] Some duelists, on the point of dying, do not hesitate to refuse the succor of religion at the risk of being deprived by the Church of an ecclesiastic sepulcher.[34] Honor serves as prop to the elaboration of a lay morality—masculine, pro-Republic—of which Jules Michelet becomes the spokesperson when he directs these remarks to students: "There is an authority superior to all others, that of honor. Know how to die of hunger. That is the highest of arts, since it grants freedom to the soul."[35] Counting numerous duels under his belt, the swashbuckler and free thinker Georges Clemenceau appears as the worthy representative of this current of thought—he for whom action alone provides a reason for living and who likens the Republic to a freedom that includes, in his view, the practice of dueling.[36] As the backdrop to the bases of the Republic's ideology—individual liberty and equality—the duel corresponds to the Republican project aimed at forging a free citizen, especially in the military domain, where it is a matter of excluding the machine-soldier who, because he is subjugated, is incapable of taking the initiative on the battlefield.[37] Paul Bert, Minister of Public Instruction, declares in 1882 that Republican military education "is the surest protection against militarism, that type of automatism of body and mind so admired by the great exploiters of man," for "it develops the qualities of the truly free man."[38] The antifeminist theoretician Otto Weininger

confirms this link between freedom and virility when he writes in 1903 regarding women who have adopted male habits, such as wearing pants, and who have homosexual relations: "The degree of emancipation and the degree of masculinity are one and the same thing."[39] The adoption of these habits marks, in his view, the moral and intellectual superiority of these women in relation to the ordinary representatives of their gender.

FAMILY HONOR

The French Revolution aimed at abolishing the duel as a manifestation of nobiliary honor and replacing it with a citizen honor, just as it aimed at putting an end to all forms of privilege by establishing civil equality and by suppressing, with the law of 19 June 1790, all honorific distinctions and all signs of feudalism, such as coats of arms and liveries. It must be noted, however, not only that the entry of reason into politics failed to put an end to individual combat, but that political battles instead increased this custom. For many observers, following the example of Philippe-Antoine Grouvelle, author of a 1790 pamphlet against dueling, it is the intrusion of women into public life, source of discord and conflict, which explains the persistence of a practice characteristic of an aristocracy subjected to the "despotism of women."[40] This conviction goes together with the construction of a political narrative that stresses the virility of a citizen whose regeneration[41] is marked by the absence of all stigma of feminization.[42] The duel thus holds an ambivalent place in revolutionary parlance. A barbaric custom, worthy of the gladiators, it is also the expression of an excessive refinement not without ties to the dissolution of mores of the second order: "an equivocal, bizarre amalgam of our fathers' gross mores and the corrupt refinement of ours,"[43] as explained by the same author.

From revolutionary pamphleteers to the jurist Gabriel Tarde[44] in 1892, women are actually cited as the principal instigators of duels and fights because of the concern they have for their reputation and for the favors they lavish on the winners or, at least, on those who have shown courage. The image is a cliché: the recollections and memoirs of retired soldiers of the Revolution and the Empire, for example, are filled with accounts of how a duel allowed them to win or keep the heart of a woman.[45] Nothing indicates, to be sure, that women do not share the values of honor that men are believed to support, but these declarations of women's responsibility express above all a keen anxiousness about their intrusion into public life.[46] The liberalism that inspires revolutionary reforms, in particular equal rights for

individuals, is conveyed by new rights for women, such as the recognition of their civil status as persons, but it has as its counterpart an emphasis on attitudes about the incommensurable differences between genders based on nature.[47] The winning of political rights runs up against these attitudes, which lead to the exclusion of women from political clubs and the army.

The redefinition of the places and roles for women and men that accompanies the Revolution[48] is part of the law of 1819 on defamation in the press, which clearly distinguishes public from private life; it is by no means favorable to female honor. Noble ladies under the Ancien Régime could appeal to the marshals' court or the "*point d'honneur* court"[49] created in 1566 by Charles IX in order to regulate the disputes between nobles but which was abolished at the time of the Revolution. There was one notable condition, however: that a man be implicated in the appeal.[50] In the system outlined by the Napoleonic Code of 1804, reinforced by the suppression of divorce in 1816, it is to the husband, "known as sovereign, absolute judge of family honor,"[51] or to the father that women are supposed to turn in the case of an insult or a personal offense. Not all women obey this injunction. Some, of humble means, do not hesitate to throw down the glove and provoke men into individual combat in order to defend a personal honor that they judge to be irremediably compromised, as shown by rare cases that come through the courts.[52] Such aggression was to no avail, however, since a fundamental prohibition, stressed by anthropology,[53] forbids combat between a man and a woman. "We don't know how to use weapons, and we're not allowed to challenge our husbands to a duel, which is quite right! They would kill us, which would give them too much pleasure,"[54] writes George Sand in 1835 in reference to her legal separation from her husband; like the large majority of women of her status, she hardly calls into question this system. Along the same lines of the exercise of political rights, the use of weapons by women is a transgression.

Female honor remains restricted to a sexual purity whose principal manifestation is modesty and the loss of which places in danger the family's capital of honor.[55] It is men who should take care of this capital by preserving from insult the members of the family who are dependent upon them—the wives, whose conduct they are responsible for, the mothers and sisters, and the forebears who have become too weak to defend themselves. In this very traditional schema, wherein the man's principal function is to be a protector, the duel constitutes an irreplaceable instrument in the eyes of numerous authors who are alarmed by proposed laws aimed at cracking down on its use. Lodged at the heart of a society concerned about avoiding any excessive intrusion of the state into private life, as had happened during

the Revolution,[56] the duel provides the means, side-stepping a trial, of "fencing off private life with a wall," states the Minister of Serre defending his proposed law of 1819 about the press. It is a way of not forcing into the open "that aspect of families that is most inviolable and sacred," as a *Globe* journalist writes regarding a proposed law filed in 1845. They are responding to the fear, so strong among the ruling classes of the nineteenth century, of the unveiling of one's personal life. Moreover, the duel against the lover, the seducer, or the provocateur is in keeping with the spirit of the penal code: article 324 exonerates in practice the murder of the wife or of her lover discovered by the husband *in flagrante delicto* at the conjugal home. It manages to avert the threat of public exclusion that weighs on the head of the family and allows the man to recover his virility through his protective function. At the beginning of the twentieth century, the philosopher L. Jeudon opines:

> The duel exempts the husband from the suspicion of being lenient; it rehabilitates the wife for whom an honest man goes to the defense in the face of risk and peril; it can, finally, revive a wife's love and esteem for the one who has risked his life for her sake.[57]

In accordance with the idea that it constitutes an instrument of civilization, the duel, moreover, is a means of better ensuring the respect due to women for contributing "to the maintenance in society of the politeness and consideration that constitute society's charm, preventing insults and grossness from holding sway."[58] This is because individual combat represents a code of traditions that is strictly regulated to mitigate the contradictions, aberrations, and omissions that pervade the five codes (civil code, penal code, code of commerce, code of civil procedure, and code of criminal instruction) according to a champion of the duel, who speaks out against the proposal in 1829 to make it an offense.[59] It is thus inscribed in that tradition of gallantry that according to Claude Habib characterizes the relations between the sexes at the core of the French aristocracy, which witnesses its expansion at the same time as its exhaustion by the beginning of the nineteenth century.[60]

It is certain that the archives, from the beginning to the end of the century, are not lacking in examples of fights motivated by family honor, for example the Aimé Sirey affair. Sirey had been beaten in a duel with his cousin because the latter had accused his uncle, Aimé's father, Jean-Baptiste, of having ruined the Marquis de Saillant, whose fortune he managed. The lawyer for the accused, Maître Crémieux, evoked the Code de Chatauvillard, published in 1836, the first and most influential of the French works devoted to the ritual of individual combat and

to the jurisprudence on the point of honor, when he declares: "When a father is offended and he is older than 60, his son must fight in his place."[61] On 23 October 1818, in Lombes (Gers region), Lord Sardac, at the urging of his wife's family, challenged Antoine Garçon, who had eloped with and married, against her parents' wishes, a Mlle. Sartagex, Sardac's sister-in-law.[62] In another example, in 1819, in Pont-à-Mousson, an officer kills Lord Lacaille with a pistol shot. According to the prosecutor's report, he had slandered an honest young woman whom the officer was about to marry; the family of the so-called Lacaille recognizes the young man's wrongs and does not press charges.[63] And it is in fighting his mistress's husband, on 16 November 1903, on the Île de la Grande-Jatte in Neuilly, that Henri Lantier falls, the last man to die in France as a result of dueling.[64]

PROTAGONISTS OF THE CONFRONTATION

THE SOCIETY OF MEN

Brandished like a flag, this function of the duel, instrument in the defense of women and family, has a history marked by a few episodes on which the development of the press, in the second half of the nineteenth century, makes a considerable impact.[65] While they allow for the legitimation of individual combat, these affairs are nevertheless far from being the cause of the majority of duels that are inventoried in the surveys conducted during the century, whether official, such as the one by Minister de Serre in 1819, or unofficial, such as the one conducted by Édouard Dujardin in 1891.[66] The persistence of the duel after the Revolution, which coincides with the values of honor permeating society, is caused not solely by the fact that individual combat allows for the protection of the "social *délicatesse*"[67] that eludes the definitions of the code and that cannot be protected by general laws. Even when it is about a woman, the duel is unquestionably first an affair of men and fits into the modes of social mores peculiar to the masculine world at a time when the separation of the sexes is particularly marked.

In the new public sphere delineated in the nineteenth century, men occupy a preeminent place. It is within this half of humanity that we see the construction of forms of sociality on which political democracy is built and whose matrix is, according to Maurice Agulhon, the sociality of the masonic lodges. Significant in this regard is the development of circles, based at the beginning of the century on a masculine egalitarianism that distinguishes them clearly from the salons. These

circles, marked by the use of tobacco and male privilege, excluded women, thus earning the circles criticism from conservatives and regrets from Dr. Véron, who deplores the self-indulgence that this absence causes:

> The circles and the clubs that increase in number each day distance us from the society of women; we evade their sweet, sustained intimacy; they are forced to be put to sleep by the shamelessness of our mores and habits, indeed even by the narcotic smoke of our cigars.[68]

The absence of women characterizes political society as well. The momentous fight on 12 November 1790 between the Duc de Castries and Charles de Lameth marks, despite the hopes of Philippe-Antoine Grouvelle,[69] the triumph of the values of honor [fig. 8.1]. The Parisian rioters who destroyed the Duc de Castries' house for having wounded their champion in the left arm stole nothing, and for this Mirabeau cries out: "Now that's honor—real honor!"[70] But this is not the honor of the royalist provocateurs. The patriots are quickly faced with the same dilemma as that which Proudhon would have to confront a few decades later; like him, they are

FIGURE 8.1 FRÈRES LESUEUR, *DUEL ENTRE CHARLES DE LAMETH ET LE MARQUIS DE CASTRIES EN 1790* (DUEL BETWEEN CHARLES DE LAMETH AND THE MARQUIS DE CASTRIES IN 1790). EIGHTEENTH CENTURY, PARIS, MUSÉE CARNAVALET.

Source: © Leemage

forced to accept the challenges laid down to them. The duel thus becomes one of the manifestations of that incessant reiteration of civil war that characterizes the French nineteenth century but also one of the instruments of political combat in France, as in Europe and the United States.[71] At a time when no structured political parties exist, when factional alliances and personal friendships are difficult to distinguish, and when every critique of an opinion or political decision takes on the appearance of an attack *ad hominem*, individual combat establishes itself among the rites of political life.

While the duel is mainly prevalent from the Restoration to the early 1830s as a practice that takes its place alongside street fights and insurrections and allows for a settling of accounts, especially among the "*demi-soldes*" (laid-off officers) and their royalist adversaries, the July Monarchy (1830–1848) marks the moment when this method of resolving conflicts gets established at the center of the political world in France. After an eclipse under the Second Empire, recourse to individual combat becomes one of the characteristics of the Third Republic, accompanying the reappearance of parliamentary debates in public. Hailing often from journalism or law, where individual combat is a current practice, the pro-Republic political class seizes on it as an instrument of legitimation of its power and as a distinctive sign but also as a demonstration of its refusal of any form of indenture. The feeling of honor, says Georges Palante in an article in *La Plume* in 1902, "finds refuge in individual consciousness. And there is in that consciousness the little flower of nobility that redeems the baseness and bad deeds of the troop."[72] As emphasized by Jean-Noël Jeanneney, the duel addresses the concern, embedded in the French elite, about conserving for the individual and his free will their rightful place at the core of a modern world subjected to the regime of capitalism and threatened by anonymity; individual combat averts these perils.[73]

The duel constitutes, above all, at the time that the press is developing, a means by which politicians may show themselves in combat gestures. Being political thus becomes a manifestation of virility and allows, through the ordeal, the force of one's character and the depth of one's convictions to be attested to. Proudhon has a bitter experience of this, like many politicians before and after him, but some do not hesitate to use the publicity afforded by the duel to forge a path to the heights of power. Such is the case of General Boulanger, who fights the royalist Baron de Lareinty in 1886 before provoking Ferry in 1887. The weapon of the duel, however, can turn against one who uses it imprudently and reveal a double edge: the serious wound that Boulanger sustains in the neck during his duel with Charles Floquet on 13 July 1888 marks the beginning of the political decline of "General Revenge."

Virility and honor are also the basis of the aspirations of a group whose permeability with the political world becomes more accentuated during the Third Republic (1870–1940) and that is the victim of social opprobrium backed by recurrent accusations of corruption: the journalists, whose image is frequently compared in the novels of the early nineteenth century to that of prostitutes.[74] In France, where literature and journalism are closely intermingled, the duel assumes several functions. First, it is a certificate of honorability that proves the probity of the man who accepts the challenge. The individual combat expresses, moreover, the aspirations of the journalist to accede to the more distinguished, more prestigious status of writer and expands the particular modes of his métier: concerns for style and taste take precedence over any quest for reliability of information.[75] As proof of the ideals of the political press, the individual combat intersperses its political fights, particularly during the first years of the July Monarchy, and becomes a veritable professional lifestyle that generates numerous victims, among whom is Armand Carrel, whose death on 22 July 1836 takes on an emblematic character. The deficiencies of the law of 1881 on the suppression of defamation encourage at the end of the century personal attacks carried out with the violence that culminates in the great crises experienced under the Republic. The *Boulangiste* crisis, the Panama crisis, the campaign by *La Libre parole* against the presence of Jews in the army, and most particularly the Dreyfus affair—all are punctuated by individual combat.

THE MILITARY-VIRILE MODEL

Honor is the object of preferential treatment that corresponds to the rise of what Gil Mihaely calls the "military-virile model."[76] The nationalization of honor process that takes place during the revolutionary wars,[77] stimulated by the great victories at the beginning of the Napoleonic era, makes soldiers the principal repositories of this collective sentiment, symbolized by the creation of the Legion of Honor, whose motto is "honor and homeland." The favors enjoyed by the army and the return of honorific perquisites under the Empire[78] facilitate the military's appropriation of an essentially nobiliary ethic whose most spectacular feature is a permissiveness, indeed a contempt, with regard to the laws and sanctions that apply to other men. Individual combat, in all its forms, constitutes in this regard a characteristic trait of the military culture with which the numerous recruits, of the most diverse origins, are confronted. An initiation rite promoting *esprit de corps* and an

instrument of cohesion and discipline among the troops, the duel is congruent with the lofty idea that soldiers and officers make of military honor, continually glorified in the military manuals, and that distinguishes them completely from the "civvies."[79]

Numerous veterans transpose this lofty idea into civil life, doing the most varied jobs and constituting familiar figures in the social life of the early nineteenth century as well as in the world of novels and plays.[80] The respect for the uniform they have worn is not an empty phrase. Because he had performed in the Théâtre de Toul with paid actors, a half-time officer in 1819 provokes a duel between a sub-lieutenant from the regiment of the hunters of Ardennes, who criticized his conduct, and an ex-petty officer, student of the notary of Toul, who defended him.[81] As another example, exercising the profession of wigmaker, considered too close to servant status, earns former Sergeant La Croix, medal-holder of the Legion of Honor, a threat of prosecution by the Prime Minister in 1813.[82]

The duel takes its place among the many acts of violence that military and ex-military men were guilty of toward the civilian population. In the boulevard plays that involve soldiers, recourse to dueling marks the individual with honor and often allows him to marry the one he loves. In *Fanfan le Tulipe*, performed at the Théâtre de la Gaîté in 1820, a duel against his beloved's father, a former soldier, foreshadows the courage that Fanfan, who is not a soldier, will show when the Spaniards threaten the village where he lives in the Pyrenees and that will allow him to win the hand of his beloved.[83] The comparison between the nobleman and the military man on the basis of values of honor is expressed in numerous plays in which the bourgeois typically furnishes a counter-example, in accordance with a social imaginary on which the existence of the bourgeoisie as a social class is partially based during the first half of the century.[84] There are few duels inventoried in the judicial archives during this period and beyond that do not involve at least one military man, whether as a combatant or as a witness, but his adversaries are often those bourgeois whom the theater sets up as archetypes of the coward. However, it is true that many of them, during the first half of the nineteenth century, have been in the army. Thus, in Auch, in 1818, according to a police officer, those young bourgeois who repeatedly confront the soldiers stationed in the town have, for the most part, already served.[85]

Beginning with the July Monarchy, the growth of the army's social prestige, expressed especially by appearances (such as the outfit or the facial hair that is adopted gradually by civil society),[86] accompanies an evolution of military honor, which takes a decidedly conservative turn. A captain writes in essence in 1839

that, faced with a materialist, effeminate, and hence decadent society subjected to the reign of speculators and debaters, the army appears as an institution that has remained pure because it is the only one to have preserved the cult of honor and the religion of the flag.[87] The discussions provoked by the vote on the Niel law in 1868 emphasize recourse to this type of argument among the authoritarian *Bonapartistes,* partisans of a law stipulating that all young men, even the "good characters," would be obliged to serve in the National Guard. Besides a fusion of classes that would allow for the attenuation of social conflict, it is the virilization of young men from the elite that is invoked to justify a vote for the law.[88]

"JEUNESSE OBLIGE"[89]

The rise of the military model contributes undoubtedly to the promotion of youth that the start of conscription helps to better delineate. Even if, by means of replacements and re-enlistments, the nineteenth-century army is far from being composed only of young men, youth seems to be the age of the warrior, a time specific to its modalities and to the male gender. The age of sexual vigor, the awakening and importance of which Rousseau describes in *Émile,*[90] youth is a particular time of life, roughly between 18 and 30, which precedes settling down in marriage. Within the urban upper classes, it is a time of freedom that corresponds to a period of study or, for many young noblemen, to a period of temporary service in the army. While youth is inscribed in the process of individualization that affects society as a whole, the highlighting of this time of life owes a great deal to the notion of generation, whose emergence coincides, moreover, with the inception of history as a discipline in the 1820s.[91] Born amidst the tumult of a century that "separates the past from the future,"[92] wrote Musset, the notion of generation is formed in the temporal shock constituted by the events of the Revolution, the Empire, and then the Restoration[93] and finds its embodiment in the generation of 1820, studied by Alan B. Spitzer.[94] Political combat, of which the fight against the gerontocracy is one of the symbols,[95] helps legitimitize the existence of this urban masculine group whose spokespeople are the youth in the schools.

Like soldiers, students constitute a closed group for whom the duel appears as one of the rites of appropriation, without, however, taking on a systematic character. Such was the case in the German student associations at the end of the century. A tradition that goes back to the Ancien Régime, when students had their armories and demanded the right to carry a sword as one of the old university

perks,[96] individual combat falls within a specific lifestyle whose features Jean-Claude Caron has studied; they are marked during the first half of the century by a constant demand for freedom—freedom of behavior as well as political freedom. It is part of the recurrent forms of juvenile agitation that affect the university as well as secondary education,[97] in which violence is not absent and in which the rod, alongside the sword, is an often-used weapon. It constitutes, above all, a form of political protest whose apogee is represented by the Restoration and the beginning of the July Monarchy. Having the advantage of being much more difficult to suppress by the authorities than collective demonstrations, the duel is congruent with the ethic of honor. Michelet calls on students to remain faithful to this ethic, allowing them to think of themselves not only as an association but also as an aristocracy. It acts as a consolidating factor when the students fight their main political enemies: military men, and more particularly an officer corps that successive purges constituted as the principal support for the monarchy. Provocations and duels between students and soldiers are a constant of urban life, at least since the end of the Ancien Régime.

There are other groups, however, besides soldiers and students. Alain Corbin has shown that the agitation affecting Parisian and provincial theaters during the Restoration was the result not only of these two groups but also of a population of sons of merchants and sales clerks[98] whose activity spread out in Paris from the Palais-Royal to the rue Montmartre by way of the rue Vivienne. Beyond this particular group, there is a whole set of young, educated, active men who also seize on the duel as a means of settling accounts. Young lawyers, notaries, bank employees, and civil servants are familiar with it; for all of them, as for journalists, invoking this characteristic rite provides support for a virility—and consequently an honorability—that are not always guaranteed.

Such is the case with sales clerks. This typically urban population is embodied in the character of Calicot, put on stage in 1817 in the play by Eugène Scribe and Henri Dupin, *The Combat of the Mountains, or the Folie-Beaujon*,[99] written on the occasion of the installation of roller coasters in Paris. Calicot is a caricature of the milieu of sales clerks, young employees who are often learning their métier in a store or trade before having a future business of their own with the help of their parents. Denouncing the flamboyance of the character, who takes on military airs by sporting spurs and a moustache, the play provokes the ire of those who are ridiculed by it: two weeks after the premiere, several hundred store clerks besiege the Théâtre des Variétés every night for a week beginning on the 27th of July, carrying on a "war of Calicots" that consists of whistling, yelling, trying to interrupt the

performance, and threatening the main actor, Brunet, until the police intervene. Four of them are sentenced; only one, a 17-year-old, attends the hearing.[100]

These groups of young men comprise the principal actors in the confrontations that punctuate urban life during the first half of the nineteenth century, one of whose issues is the control of a public sphere symbolized by the theater, the prime locus of provocation. These conflicts are innumerable, at times giving rise to collective fights—often planned, although rarely carried out. Nearly 150 young men, students and soldiers, thus gather in 1821 outside Poitiers for a fight that the police and departmental commander put an end to before it begins. The liberal camp, heralded by the students, receive the support of the former head prosecutor at the imperial court of Poitiers, Béra, who provides lodging to one of the student leaders, a man named Mérand, as well as to the Pontois lawyer, a protégé of the liberal deputy Voyer d'Argenson.[101] As reported by the prefect of police, in Paris in 1819 officers stopped four journalists from Benjamin Constant's newspaper, *La Renommée*, all fencing masters and provost-marshals, from dueling four of the king's guards.[102] To be sure, political motives play an important role in these confrontations, but quarrels over who came first and hurt sensibilities are often the determining factors: slanderous statements behind a person's back, insulting letters, refusals to greet and obstructions at the entrance or exit of a theater form the ordinary themes of these conflicts.

Among the conflicts one particular category stands out: that concerning women. Not those honest women whom we are obliged to protect but women of "proclaimed honor," to use the phrase of a judge of the circuit court, regretting that in 1840 one of them had prompted the death of a young man who was going with her.[103] Only these women seem to fit in a public space that is a privileged place for the display of virility. As in the country, balls are the usual locations for these confrontations, which are incited by jealousies and rivalries found behind many affairs, such as the duel in which an actress is at issue, and during which one Sir du Barrel kills Sir Royer in the early 1810s in Grenoble.[104] In addition to coquettes, women of easy virtue, and actresses, there are the prostitutes, common objects of conflict among soldiers; we know how difficult it is for these women to establish themselves on the social ladder through marriage. It is unquestionably the individual combat and the frequenting of these women that make up a part of the initiation rites permitting the candidate to accede to the category of "male."

With its often festive character, individual combat easily evokes other practices also benefiting from great tolerance, indeed from encouragement on the part of authorities who seem to consider this misbehavior a necessary evil. The

confrontations between students and soldiers recall, in a very attenuated form, the collective violence carried out by young backwoodsmen organized in certain regions into youth groups in which the adolescents become exposed to an aggressive virility.[105] Incited by old men who claim to have done much the same at their age and "stimulating the point of honor," these are groups in Le Quercy made up sometimes of hundreds of young men who confront each other in collective combats, throwing stones or using bats, often leaving men wounded or dead on the field of honor.[106]

The duel is not, however, for this age group, a triumphant manifestation of virility. The violent behavior also seems to stem from a sentiment to which doctors and commentators accord a great importance during the first half of the century and which they connect to the youthful condition: the sentiment of ennui, often correlated with attempted suicide.[107] "Exposing oneself to danger lifts the soul and saves it from the ennui into which my poor admirers seem to be plunged; and this ennui is contagious."[108] This sentence, which Stendhal has Mathilde de La Mole speak as she judges the insipidness of the letters sent to her by her suitors—young men who have never seen actual acts of greatness—demonstrates the importance of this theme in literature. Beyond the romantic aura that surrounds death by duel, illustrated by the death in 1832 of the young mathematician Évariste Galois, resorting to individual combat, a symptom of masculine ennui, highlights the emptiness and absence of perspectives of a generation that was the first to consider itself "lost."

In the early 1850s, ennui changes, however, into a social revolt when Jules Vallès declares through Vingtras: "I don't understand, though, why people are afraid of a duel. Is it because I would have the opportunity of being the equal of a rich man, and even of making that rich man bleed, making him bleed a lot, were the sword to hit its mark?"[109] Far from being, as the novel (*Le Bachelier*, or The graduate) unhesitatingly presents it, a noble means of forcing the doors of destiny and ensuring one's ascent on the social ladder,[110] the duel marks the personal defeat, a few years later, of Vallès's hero: the fight that he carries out against his comrade Legrand is no longer for him but for the ultimate manifestation of his dignity as a man.[111]

THE PARADIGM OF THE DUEL: A SOCIAL EVENT

With its ritual refined and codified down to the tiniest detail, individual combat seems like the expression of society's upper-class civility: is it not referred to as

"oligomania" by Pierre Larousse in his *Grand Dictionnaire universel du XIXe siè-cle*?[112] Its sophistication aims precisely to distinguish it, both in its motivation and in its procedure, from the brawl or the tussle, unregulated ways of settling accounts that common folk are usually given to. Thus, people are to fight each other only wittingly. Abel Goujon explains in his *Manuel de l'homme de bon ton* (Manual of the Man of Good Taste), published in 1821:

> People often fail to get what the true point of honor is; one must learn to distin-guish the true from the false, so as to propose and accept a challenge only on occa-sions when honor has really been harmed.[113]

The rites that accompany individual combat allow the establishment of a radical differentiation from fighting with a knife, that "ignoble" weapon, or even more so from barehanded combat, which suggests an animality that the common folk are never very far from in the eyes of the ruling class.

The duel thus makes up a part of the claim for exclusivity in matters of honor on the part of the ruling class. The journalist J.-B. Rosemond de Beauvallon of the *Globe* is called in judgment before the circuit court for having killed in a duel his colleague Alexandre Dujarrier of *La Presse* in a duel on 11 March 1845. Alexandre Dumas is called to the witness stand as a friend of the victim. The writer also sets forth how a tribunal of honor composed of four peers of France, four deputies, four men of letters, and four great noblemen were brought together with M. de Bondy, Prefect of the Seine as the presiding member shortly after the Dupin rul-ing of 15 December 1837 that put an end to the impunity from which duelists had benefited since 1819 in the eyes of the circuit court. Far from recognizing the new jurisprudence of the superior court, which postulated the application from then on of the provisions stipulated by the penal code for damages, wounds, or death inflicted during a duel, all the members of the tribunal of honor wished to stick to the principles, says Dumas, contained in Chatauvillard's work.[114] In wishing to keep the state at one remove from the conflicts that were agitating Parisian high society, the temporary institution (the tribunal of honor) took for its model the marshals' court, or court of the "*point d'honneur*," created in 1566, and seemed to align itself with the old demand, made by the nobility during the modern period, for the re-establishment of the judiciary duel.[115]

There is little basis for this claim of exclusivity. While the revolutionary govern-ment wished to substitute virtue for honor, as it wished to eradicate the old forms of politesse,[116] the institution of the Legion of Honor in 1802 and the revival of

courtly etiquette signal both as preeminent social values. But honor is not only, from the time of the Consulate, a value partaking of lifestyles and contributing to the coherence of a profoundly renewed ruling class. It also constitutes a claim that derives from egalitarian aspirations, of which the Revolution is the matrix and which explains the frequency of resorting to dueling among the educated urban classes, in particular among the legal and commercial professions that furnish, under the July Monarchy, the managers of the National Guard.[117] The line between duel and brawl is sometimes tenuous. Many duels scarcely respect the arrangements prescribed by the customs and codes. They are aligned with the multiple forms of violent confrontation that punctuate the everyday life of men of the first half of the nineteenth century, in which military men often play preeminent roles. From this point of view, taking in a large number of French men during the wars of the Revolution and the Empire, the military world plays the role of first contact or melting pot for the forms of confrontation practiced in social strata at times remote one from another.

The circulation of the values of honor in society is indeed one of the characteristics of the nineteenth century. The working-class elite does not deign to respond to provocations from soldiers, such as a certain Daugerat, a printing press worker, who in June 1819 duels against a petty officer of the Royal Guard who had insulted him at a ball at the Barrière du Maine.[118] In terms of performances, honor and the defense of honor are also themes particularly valued by the vaudeville shows seen and read about by a public that takes on a bourgeois character only by the second half of the century.[119] Virility and honor come together in the refusal, opposed by certain social groups, to be confused with a servile domesticity associated with women, and they fuel certain conflicts. A prime example is the movement of bank tellers at the Banque de France demanding in 1878 the right to wear a beard and moustache.[120] Is virility not a form of nobility offered to all men?[121]

Typical of the world of men, the use of weapons is an illustration of this shared culture of virile honor. Despite royal prohibitions, Arlette Farge tells us, use of the sword is far from being the exclusive prerogative of noblemen and military men in eighteenth-century Paris. The historian notes that during police interrogations,

> what comes out clearly is the pressing sentiment that the sense of honor can be truly defended only with recourse to the prestige of weapons and challenges: in the suburbs as well as in the Marais, many conflicts are resolved with the sword, sometimes even in the cabaret.[122]

In Languedoc during the Enlightenment, the situation is hardly any different: the most unassuming bourgeois, provoked by a sharp word, feels obliged to present a written challenge as soon as he is called a "scum,"[123] explains Nicole Castan. In the country, the gift of a knife, like that of a club, such as the young Breton's famous "*penn-baz*,"[124] symbolizes accession to virility.[125] Clubs and canes, substitutes for the sword in the hands of Parisians, allow men to "imitate the chivalric order"[126] writes Farge. They show up in the 1800s as the favorite weapons of the young men of Caen, who learn how to handle them at the same time as the sword.[127] Agricol Perdiguier describes the terrible use of these weapons by groups of friends during battles in which one faction opposes the other, noting in passing that "the friends who, as a point of honor or as a sign of false glory, admired, extolled and supported horrible fighters at the time, never did anything but curse crooks and thieves."[128] As for firearms, they are quite widespread in the countryside, beginning with the Napoleonic wars.

The paradigm of the duel, an honest encounter between two men motivated by honorable intent, organizes a number of confrontations carried out with various weapons or barehanded during the first half of the nineteenth century. While in rural Quercy the challenge often elicits an ambush as a response, it also takes the form of a veritable provocation to a duel. François Ploux describes how, during the 1820s and 1830s, certain adversaries resort to the written summons with witnesses or seek to confront one another on equal terms by deciding in advance on a fist-fight to the point of exhaustion or a fight with stones or firearms.[129] Public duels with stones on the village square, before a crowd of onlookers, recall the sword fight described by Nicole Castan on the evening of 20 June 1779 on the Place de Castelnau-Montratier, in the same region, before a number of spectators[130] or the series of duels in Auch, in 1818, before a gathering of residents, between the sol-diers billeted in the town and a bunch of particularly skittish young bourgeois on the question of honor. Other duels take place more discreetly, without the public security of spectators. On 27 September 1836, on the moonlit streets of Metz, two workers, one a wood turner and the other a founder, confront each other; lacking real swords, they use a foil from the armory and a bow broken in half to increase its sharpness. One witness is killed.[131] In 1826, Agricol Perdiguier faces off bare-handed with one of his friends, following modalities that have no comparison with encounters between more distinguished persons. The day after the challenge, at dawn, each accompanied by a witness, the two men decide to meet after having agreed to stop with the word "Enough!" And it is with the phrase "*En garde!*" that they begin a fight that will end, after Agricol wins, with making up over a drink at the nearest inn.[132]

"*La savate*," or kick-boxing, that art of fighting that arose at the end of the eighteenth century in the Parisian suburbs, takes a great deal—at least in its more refined form with a slipper worn—from sword-fighting and dueling [cf. fig. 8.2]. In his *Mémoires de Léonard*, Martin Nadaud describes how, after his departure from the Limousin and his settling in Paris, he is led to work out assiduously during the winter of 1834 at the gym of Instructor Le Mulle, located on the rue de la Vannerie. Regular visits were necessitated by the need to be respected by Parisian workers or those from other regions. In his account, written a long time

FIGURE 8.2 JULES DESPRÈS, "SAVATE" (KICK-BOXING), *LES FAITS-DIVERS ILLUSTRÉS*, 29 MARCH 1906. "AT THE SAME INSTANT, THE OTHER GUY TURNED ABOUT WITH AMAZING AGILITY."

An art of combat born, it would seem, in the Parisian slums at the very end of the eighteenth century, kick-boxing becomes codified during the first half of the nineteenth century, when numerous gyms open in the capital for a very diverse public. Nicknamed "gangsters' fencing," kick-boxing is popularized because it is used by Rodolphe, hero of the *Mystères de Paris* (by Eugène Sue), whose publication begins in June 1842 as a serial in the *Journal des débats*.

Source: © Kharbine-Tapabor

after the events and at a time when he frequented another world, Nadaud uses *point-d'honneur* language to evoke the numerous scuffles between workers in the building: "There were those battles between workers, as today there are duels among people of a certain class, who would consider themselves dishonored were they to refuse to cross swords with any challenger."[133] Alexandre Dumas claims, moreover, that it is the mix of people of different backgrounds at the public balls, such as the Franconi ball, and the impossibility of raising the common man to the level of the duel with sword or pistol, that encouraged upper-class men to learn the art of kick-boxing, at which they surpassed their antagonists from the working class. And, according to the same author, it is by means of kick-boxing that fights were settled and, in the milieu of pimps, men confronted one another in disputes over a girl. Taking place at dusk, in the presence of witnesses, these encounters constitute something "no less curious to watch than a duel,"[134] attests the writer, a regular spectator. Again in 1879, it is by claiming to have been involved in a duel with knives that Joseph Gastin justifies the murder, in a Paris street, of Matthieu Arnaud, former fellow inmate who had taken from him his mistress, a prostitute named Faciot.[135]

RITES AND RITUALS OF INDIVIDUAL COMBAT

"NO ONE WRONGS ME WITH IMPUNITY"

As with all political affairs, the inside of the National Assembly and the salons and the press outside of it act as an echo chamber for the Proudhon and Pyat affair. But this affair hardly differs in principle or in development from a number of anonymous confrontations sprinkled throughout the nineteenth century. Variable in its modalities according to social milieu, the ethic of honor is based in general on the theme of respect, summed up in the old nobiliary motto *nemo me impune lacessit*— "No one wrongs me with impunity"[136]—and is expressed through a code of conduct; the knowledge of how it works and the aptitude to decode its signs reveal the man of honor. Transgressing the code functions from this point of view as a signal and requires a response, giving the troublemaker formal notice that he should justify his attitude. The ethic of honor thus orders and models speech, attitudes, looks, and gestures in all life situations. It requires a response to the challenge and to the insult in a society in which getting compensation by resorting to the law, which is quite vague in any case,[137] is not only confessing the affront publicly but

also avoiding one's manly responsibilities and compromising even more seriously one's honor by agreeing to sell it for a sum of money.

The provocation may take various forms. In parliamentary milieus, it is expressed in the form of the *mentis*—the equivalent of the *mentita*, the usual formula that provokes the challenge in the Italian code of honor,[138] which is the allegation of a lie aiming to restrain the author of an offensive statement and forcing him to fight in order to maintain the truth of what he claims or else to be judged and possibly dishonored. In military circles, at the beginning of the nineteenth century, a song started at table while someone else is singing or a glass of wine poured *en quarte*, that is, with the hand turned to the right, is enough to cause a fight—recalling the relatively flimsy reasons for combats of honor in the rural society of Le Quercy, which start out, most often, at the cabaret or the inn.[139] When large sums of money are involved, gambling constitutes a frequent cause for quarrel as well, from one end of the social ladder to the other. The marked tendency in the upper echelons of society toward a refinement in the forms of politesse, associated with the will to contain the violence within acceptable limits, leads, however, to a stricter and stricter codification of offenses liable to provoke a fight. The *Essay on the Duel* by the Count of Chatauvillard, published in 1836, establishes a precise hierarchy of offenses, to which correspond responses that fit each one; simple offenses, offenses with insults, and offenses with blows and injuries are all differentiated.[140] In any case, injury to the physical integrity of the person, in particular to the head, seat of the ego, is irremediable.[141] Whether it is real—the slap—or simulated—the glove thrown across the face or an excessively fixed look, the act urgently requires reparation.

"I felt as though I could not be left under the burden of this injury that was dealt to me in front of witnesses:"[142] this declaration made in 1828 before the circuit court by a homicidal duelist, called a "rascal," underlines the impact provoked by the affront to the offended man, who is seized by a feeling of shame that literally prevents him from living. As a moral imperative, only combat allows for the wiping away of shame that results from the degradation; it alone makes whole the offended man's honor by reinvigorating his virility. Along with its supporting element, sensitivity to insult, honor is thus the principal support of man's dignity: therein lies its usefulness, but also, in the eyes of Vigny, its beauty.

> That is perhaps the greatest merit of honor: it is so powerful yet always beautiful, regardless of its source! . . . At one moment it drives man such that he cannot survive an affront; at another it drives him to hold on dramatically, with a grandeur

that repairs and wipes away the defilement. . . . It maintains, always and in every case, with all its beauty, the personal dignity of the man.[143]

Under these conditions, the result of the combat matters little: is not dying in a duel the best means of proving one's dignity and therefore one's virility? It is customary at the end of the combat to be reconciled with the adversary even as one is dying and to acknowledge in him an equivalent honorability. The duel forges, in this mutual acknowledgment, a shared virility.[144]

From this point of view the development of the press during the nineteenth century considerably increases the occasions for conflict. Clearly separating injuries to public persons (which fall under a jury trial and in which truth must be established) from the injuries to private persons (which fall under the correctional tribunal or the police tribunal and about which it is forbidden, in the higher interest of public peace, to verify whether they are based on fact), the laws of 1819 and 1881 on the suppression of misdemeanors by the press make of the duel an otherwise more efficient means of ending a campaign of slander or a difference of opinion in the press. In addition to the fact that it allows the offended party to recover his honor immediately, individual combat obliges the offender, weapon in hand, to stand by the truth of what he has written or, if he refuses the encounter, to be dishonored by implicitly acknowledging his lie. The public person's stature in no way prevents recourse to this type of settling of conflicts; as agent of collective honor, honor of a group, of a party, of a guild, indeed of a nation, the public person is obligated, on the contrary, to defend it resolutely. When the Prince d'Orléans publishes in *Le Figaro* an article reproaching the Italians for their defeat in Adoua against the Ethiopians, thus allowing Africans to triumph over a European army, the Count of Turin, member of the ruling Italian family, challenges him at once. The press of the Peninsula wastes no time celebrating the victory of Italian skill and courage when the count, on 15 August 1897, inflicts a wound in the abdomen to the person who had defied the whole of Italy.[145]

The importance accorded to virile honor is amplified, moreover, by the social instability and confusion that characterize democratic society, of which journalists are the major agents. Maine de Biran or de Tocqueville have evoked the anxiety that clutches the man of a democratic society, faced with a feeling of insecurity, accompanied by a social standard that sharpens his sensitivity and kindles conflicts of honor.[146] This modernity is, above all, urban. In his *Philosophy of Modernity*, Georg Simmel emphasizes that, in view of the multiplicity of human relations he faces, the inhabitant of large cities must show a reserve, whose internal aspect, he writes,

is "a slight aversion, a hostility and mutual repulsion that, at the moment of any type of close encounter, could turn immediately into hatred and combat."[147] The city, with its cult of mobility, modifies the human psyche, says Richard Sennett; the disappearance of transcendent principles augments the impact of apparently insignificant offenses, which become moral absolutes.[148] In this new urban culture, appearances and manners take on a crucial importance, for they convey the truth about the person and reveal, in particular, the man of honor. The culture of honor spreads in England with the appearance at the beginning of the nineteeth century of the urban "gentleman," whose wealth is no longer tied only to land holdings but to money as well, and whose stature is based upon mastery of such codes of conduct.[149]

HOW THE FIGHT PROCEEDS

It is after having gotten advice from wise, prominent people, military men especially, who belong to high society, that in 1836 the Comte de Chatauvillard brings out his *Essay on the Duel*. The *Essay* becomes a reference and a model for numerous treatises that appear after 1870 and express the attitudes of the fencing circles that proliferate after that date in the large provincial cities and, above all, in the capital. Comparable in their intent and in their organization to the manuals of politesse published around the same time,[150] the codes of honor and the dueling codes amount to a work of vulgarization. They endeavor to indicate to readers the conduct to follow in case of an offense, then in case of a duel, and often contain lessons aimed at preparing the person who must defend his honor in the special fencing practices (which are actually rather sketchy) used in individual fights. Like the imperial justices for penal law,[151] they intend to bring some order to this jurisprudence. Such an example is A. Croabbon, who in 1894, in his *Science du point d'honneur*, wishes to propose to people who have the right to apply Chatauvillard's code, that is, witnesses, arbiters, and honor juries in the *point d'honneur* court, a basis for interpretation.[152]

One should not confuse "two adversaries who, aided and abetted by four honorable men, bravely and loyally face death rather than forfeiting their rights regarding the affront to their dignity," with "two wretched drunkards who charge one another, armed with a knife, in a cabaret,"[153] declares the journalist and politician Bernard Adolphe Granier de Cassagnac in 1842 during the trial in which he is charged with firing a shot into the thigh of Deputy Théobald de Lacrosse one month earlier. Provoked by a sufficient and honorable motive, the individual combat proceeds in accordance with a ritual whose codification, growing stricter

and stricter, requires and highlights that will power characteristic of the man of honor. It is because of his inability to maintain his composure, rushing headlong and imprudently into the sword of Charles Floquet, that General Boulanger witnessed his leadership qualities discredited by public opinion.

The rule barring duels without prior agreement distances the moment of the combat from the moment of the provocation; it is prepared for, as a function of the gravity of the offense, by witnesses, real confessors for the two adversaries, and guarantees the legality of the confrontation. Out of a concern for maintaining a level playing field for the combatants, an inspection is performed of the weapons' legality: only swords and pistols, whose use spreads at the end of the eighteenth century, and, to a lesser degree, the saber, are considered legal weapons, which excludes the rifle and especially the revolver, considered a feminine weapon and therefore a weapon for cowards. The inspection also concerns the modalities of the combat, which is placed under surveillance. For the duel with a pistol, the requirement of fairness imposes such arrangements as the distance between the adversaries, the size of the sight, and the simultaneous nature of the firing or the requisite immobility of the combatant in front of the opponent's weapon when there is a provision for firing by turn [cf. fig. 8.3]. For the duel with a sword, fairness makes absolutely imperative the absence of foul play and a stoppage of the fight in case of a wound, which places one of the adversaries at a disadvantage. Certain conventions entail the combatants' death, such as the affair in Caen in 1818, in which a young notary clerk and an Englishman residing in the city draw in turn from a sack containing two pistols, one charged and the other not charged, and then fire simultaneously.[154] The cases are nevertheless rare in which death is the explicit end of the combat: being face-to-face with death is enough to restore one's honor.

Based on this proclaimed equity—this virile fraternity—which is, however, far from always being respected, the rites that accompany the individual combat aim to avert the accusation of murder, which is morally unacceptable. One figure along these lines runs through all the literature devoted to the duel: that of the gangster, a regular visitor to the armories and a specialist in provocation, whose preferred victim is the honest head of household. Dr. Descuret, in his *Medicine of the Passions* dating from 1841, makes of him one of the expressions of human passion in its most bloodthirsty form, which shows, he says,

> to what level of ferocity man may be led when he places no restrictions on his predilections. . . . Killing is, for this kind of man, a need, a habit; we have seen some who grow dispirited when they have spent a week without going out on the field of

FIGURE 8.3 GEORGE SCOTT, *A DUEL WITH PISTOLS*, 1815.

In the duel with pistols, the focus of the ritual is the moment when the combatant must stand still and face his adversary's weapon. The impassability required in the face of possible death reveals the real man capable of overcoming his fear.

Source: © Mary Evans Picture Library

honor. I knew one who would often fight three times in a single day. . . . Occasionally wounded, he became distressed about his suffering only because it prevented him from assuaging his rage; but, once recovered, he would run around public places, his head high, a threat on his lips and his eyes blazing, like those of a ferocious animal stalking its prey.

The man, adds the doctor, "had the same fate as most like him: he was killed in Dieppe by a young sailor who had never once in his life handled a sword."[155] Virility consists not only in abjuring the spinelessness of the weak man but also the violence of the brute and the criminal. The morality of honor actually appears, from this perspective, to be an objective of civilization.

JUSTICE AND HONOR

The protection of honor involves a transgression of the rule of law, just as it involves a violation of moral rules. In view of the significance of this value, justice, when it is upheld, has a great deal of difficulty enforcing the principles of reason on which the penal code is based, as it is often caught, in rural societies, in the meandering of unspoken judicial modes of settling conflicts among groups, families, or individuals, who tend to instrumentalize the institution.[156] While they often complain about the indulgence shown by juries with regard to conduct directed by honor, the judges themselves are nonetheless sensitive to it. During the trial charging Aimé Direy for killing with a saber his cousin Alexis de Durepaire, after having been slapped in 1835, the head judge of the circuit court of La Seine remarks: "It must be agreed that he made the duel inevitable by the way in which he behaved: a slap, given our mores, requires harsh reparation."[157] The court of appeals will take nearly 20 years to impose its new jurisprudence on the courts.[158]

This understanding affects the jurors even more so. Selected from honorable, prominent persons according to modalities that vary over time but that do not rank solely members of high society, the circuit court jurors grant to honor an attention that is expressed in a refusal of continuances, when there are still prosecuting juries, and in the systematic acquittal of homicidal duelists, except in cases of obvious unfairness, most by often invoking self-defense. And though, as a consequence, the public prosecutor's office is led to order continuances much more frequently than before, the Dupin arrest hardly changes in practice the result of their deliberations, which wins the consent of the majority of public opinion. When, on 21 May 1838, the circuit court jury of Calvados acquits the law student Philippe Calmet, along with his witness, after a duel in which his classmate Charles Luard was killed, bravos echo through the courtroom, and the acquitted men receive affectionate acknowledgment from a crowd of friends and strangers—a "violent revolt of common sense," writes one commentator, "against a jurisprudence that claimed the duelist, accidentally homicidal, was tantamount to an assassin."[159] The attitude of French juries is hardly any different from that of English juries. When the vote for Lord Ellenborough's Act in 1803 could have allowed the condemnation of duelists by handing down a death sentence for, among others, not only attempted murder but also assault of a person with a deadly weapon,[160] the juries across the Channel refused to consider this law applicable to individual combat.[161]

This schema, in which the mores expressed by the institution of the jury run counter to the law, is far from involving duels in the strict sense of the word. In

1819, the general prosecutor at the court of Nancy writes to the Minister of Justice concerning a circuit court trial held in 1817, during which he had the function of public prosecutor and the accused was a laid-off officer who had killed a veteran military man in a duel: "I spoke to Frenchmen who, in spite of the laws, consider as a point of honor the obligation to respond to a challenge or to avenge an insult, even a single indecent expression."[162] To the great displeasure of judges, the provocation is often considered an excuse for acquittal. The head judge writes that it is by maintaining self-defense, even though the arguments had established that there had been provocation only on the victim's part, that the jurors of La Drôme acquit, in February 1838, Jean Aubert, stone mason, after he delivered a mortal blow with a knife to Sir Estour as they left a café in Saillan on the evening of 19 September 1837.[163]

The same goes for confrontations conducted in accordance with modalities similar to those used in individual combat. Defending the duel in the circuit court of Meurthe-et-Moselle in 1834, the lawyer for a plow hand from the village of Maise, near Lunéville, wins the acquittal of his client who had killed another plow hand in a face-to-face combat in which each, armed with a stone, had thrown at the other simultaneously.[164] In 1838, a man named Jean-Baptiste Curé is acquitted in the circuit court of La Meuse after bludgeoning to death a man with whom he had quarreled.[165] While many confrontations in working-class milieus seem to be guided by the model of individual combat, the nobility and local people of prominence, often close to the peasants, do not hesitate to liken the popular modes of conduct to those used in their world, thus designing the contours of a common culture of challenge and violence. Responding to the head judge of the appellate court of Riom, who inquires of a local squire about the reasons why the jury of La Haute-Loire had acquitted 10 out of 18 defendants accused of crimes against persons during the first session of 1834, the man replies:

> The enlightened men of this district are themselves under the influence of the character of the inhabitants. When you speak to them about the violence of country folk or the terrible use they make of knives, which they use as daggers, they tell you casually: these are the duels of our peasants; they are prompted in these deeds by the same point of honor that prompts military men and upper-crust people on the field of honor. In this way, they are quite indulgent and have a great deal of trouble condemning those who commit crimes against other persons.[166]

9

THE NECESSARY MANIFESTATION
OF SEXUAL ENERGY

ALAIN CORBIN

THE CODE of virility is proclaimed with particular clarity thanks to the complicity that unites men when they are gathered together inside the guard-room[1] or in a cabaret for singing groups.[2] These are the much-frequented places of licentiousness that evoke or precede a visit to the brothel. These same *topoi* are openly expressed, not in the text of the erotic novel, subject at the time to meticulous censoring, but in that of bawdy songs as well as in various risqué pamphlets and collections, for which Alfred Delvau's *Dictionnaire érotique*,[3] published in 1864, had long served as a model. The virile code is also expressed bluntly in masculine correspondence and in a more muffled way in the pages of personal diaries. Such are the three privileged means of access. That said, the set of injunctions that define the code and that are essential for the man is modulated in accordance with the social subtleties of civility, the stages of seduction, and the pleasures expected from each type of female partner.

The images and the norms of virility that these diverse texts convey are aligned, in terms of consistency, with the procedures of inculcation previously analyzed. They are in accord with the most ordinary and most easily available dictionaries, all based on the affirmation of male superiority and domination.[4]

Paradoxically, taking into account the ubiquity of the theme of romantic love in poetry and the novel, the code to which man should unconditionally conform, according to the previously cited sources, involves, above all, the refusal of tender feelings, of that "sentimentality" that according to Alfred Delvau "excludes infidelity and pleasure in favor of some kind of ridiculous ideal—good for novels and girls' boarding schools." "When a man says to a

woman, 'I love you,' he means, and she understands him perfectly to be saying, 'I'm hard as a rock, I have a liter of sperm in my balls and I'm dying to discharge it into your cunt.' "[5]

Antisentimentalism is proclaimed in a particularly lucid and salacious manner in the course of the bawdy song. "The less love you have, the better you fuck" is a repeated assertion; here the ultimate foolishness of the woman is in no way perceived to be an obstacle to pleasure.

In a word, everything in these texts is at a remove from the tone of the letter LII addressed to Julie from Saint-Preux in the *Nouvelle Héloise*, one of the texts most cherished by female readers of this period and even more so by proponents of conjugal spirituality, which was being revived in certain sectors.[6] The need to fuck is considered, within masculine quarters, an essential constituent of virility. It justifies the audacity and salaciousness of certain behaviors.

The virile man is obliged to "get" women, to "possess" them in the full sense of the term, that is, to "get enjoyment from them," to "make use of them," to keep them "under his thumb." Such depictions of relations can be connected to how copulation takes place. The woman, one reads again in Delvau's dictionary, "in effect belongs to the man during the whole time that he is holding her under him, pegged to the bed with his spermatic nail."[7] We might draw attention to the figure of Hercules, popularized as the ideal husband during the Revolution.[8]

The vigor and energy required of the man are in accord with doctors' injunctions. A certain violence and a quickness of the act, which are thought to be favorable to the force of the ejaculation, are expected of the individual who is in complete possession of his virile qualities. The bawdy song exacerbates, in this regard, phantasms. In them it is all about "piercing the partition," "busting the cylinder," "fucking the blood out"[9] of the partner. From that point, a number of formulas become usual: "to fuck your balls dry," "to enter up to the hilt," "fuck like an unbridled ass." Delvau summarizes in a lapidary formula what must be done: "fuck energetically, without worrying about anything else except cumming well."[10]

This imperative vigor impacting upon the woman's body excludes any failure: it disqualifies the weak, the sodomite, anything against nature. For the partner, dominated and submissive, there is no possession of the man. The woman climaxes, Delvau assures us, but "it is not because of the man"—an essential distinction, in his eyes.

Such primacy granted to vigor and energy relegates to the meager status of uninteresting and "sweet" the practice of cunnilingus (without penetration of the cock)

as well as all the preliminaries; thus, what was then called "little goose," or foreplay, is dismissed unless it involves bringing the man back into action. On this score, that code of virility, in its commonness, contradicts the refinements and tempo that characterized certain erotic novels of the eighteenth century;[11] it diverges even more so from the technology advocated by the sexologists of the following century. And of course, this exaltation that is continually harped on of vigor, of the stiffness of one's erection, of the force of one's ejaculation, also aims to exorcise the fear of any weakness and of any failure.

This set of ideas about displaying virility is justified by the conviction, repeated continuously, that the woman climaxes automatically from the thrusts of the fully aroused male; it involves, rather curiously, the certainty and even primacy of vaginal pleasure, whereas doctors underscore, for their part, the importance of clitoral orgasms.[12] Be that as it may, the woman is presented in the literature as always waiting, as endowed with a radical wantonness—a term that is applied to her rather than to her partner. Wantonness, one reads in Delvau's dictionary, is the special prerogative of the woman; her nature is to be "thirsty for orgasm"; her genital organs are permanently like the mouth of a woodchuck that never sleeps. People speak of "wanton women" and much less frequently of "wanton men."

She who needs to be persuaded refuses her happiness. Virginity constitutes a "heavy burden that every girl who aspires to be a woman gets rid of willingly."[13] Fucking a young girl is "feminizing" her—an affirmation in accord with medical opinion since the last third of the eighteenth century. Such a conviction turns out to be consistent with the didactics of the erotic novel begun with the *École des filles* in 1655[14] as well as with commonplaces concerning the wedding night.[15] The man is thus obliged to satisfy the woman, to procure the pleasure that she expects from him, like a charm.

The hymn to the penis—to the "cock"—is fundamental in the predominant depictions of virility. It is the only part that is really desired by women of a body whose beauty is never exalted in these texts; quite the contrary, it is depicted as ugly. This would make female wantonness paradoxical were it not for the keen desire to be penetrated and filled. An analysis of erotic lithographs of the period is significant in this regard: the man remains clothed, with the exception of his erect penis, which arouses the ocular craving of his partner [cf. fig. 9.1].[16] More than 150 terms refer to the male organ in the Delvau dictionary alone—proof, were it necessary, of this focus on that organ. It is the "rock candy," the "meat of love," and more trivially the "blood sausage" "that every woman would like to have ten yards of in her body."[17]

FIGURE 9.1 ANONYMOUS, ITALIAN, *ÉROTISME. LES HUÎTRES SONT APHRODISIAQUES* (EROTICISM: OYSTERS ARE APHRODISIACS), CA. 1880.

In the private room of a restaurant, as elsewhere, there is no need for the man to get undressed. All that counts is his erection, whose vigor will be maintained by the umpteenth platter of oysters—shellfish considered at the time to be aphrodisiacs.

Source: © Leemage

The preceding sets out the virile depiction of how bodies come together. In Delvau's compendium, there are ancient metaphors, notably that of the horseback ride. The man "mounts a woman;" the latter is a "mount." "To ride" one's partner is to lead her "to pleasure by great thrusts of that protrusion that we"—note the tone of masculine complicity—"all have."[18] Another series of ancient metaphors—that of the furnace, the oven, the brazier, or the cauldron—to designate the heat of the female interior is also dwelt upon in the eclectic texts of the early nineteenth century. One bawdy song, for instance, refers to "Suzon's stove."[19]

The warrior metaphor, which had died out of eighteenth-century parlance, makes a comeback. It now tends to foray into the field of representation. Images of martial vigor and sexual prowess are knitted together with the exaltation of the nation. They express the certitude of a sexual superiority that was seen to be in the nature of the Frenchman. This chauvinist feature[20] continues through the end of the century, as shown by a reading of *The Little Bible of the Young Married Couple* by Dr. Montalban. These metaphors, of course, are closely associated with the schema of domination, defeat, and wounding that the woman undergoes.

To be in a state of erection is, from this perspective, "to be well-armed." Deflowering is "breaking down the barricade, with bayonet out." "To nail," "to bang" a

woman is to fuck her. One goes on the assault, one assails one's partner. She is fucked "sword-knot style," which comes to "mounting her brutally without any sort of foreplay." The vocabulary of fencing is just as pervasive in the language of virile gatherings as that of the sexual assault; "to give a woman one's best parry," "to push one's point," is "to prick her with one's unsheathed sword."[21]

This system of images, this hymn to vigor, these allusions to victory and defeat tend to justify violence, simulated though it may be. They loom over the assessment of rape, which at the time was supposed to end in pleasure. The violence inflicted on the woman[22] is at times called in bawdy songs "blissful outrage."

There is another metaphor that does not contradict this imagery radically: that which likens coitus to a labor, to "hard work."[23] From this perspective, the virile member is identified with or compared to a tool, a handle, an axe, a plane, a nail, or a poker with which the woman "lets herself be worked on." A long series of verbs designate this "hard work." They speak of screwing, stuffing, skewering, or threading a woman; it is, above all, a question of shaping and molding her.

The exaltation of male brutality in men's speech is in accord with a new writing of desire that comes out in the literature of the early nineteenth century.[24] Certain authors depict the man as a being who is, just at the sight of womanly forms, overwhelmed by an insatiable and possessive avidity. The fascination caused by the whore and by infernal beauty, the theme of the rough feel and the rawness of orgasm, and the link established between death and desirable flesh suggest that when placed in comparison with bawdy songs and obscene pamphlets, a renewal in the modes of stimulation of male desire is taking place—or at least is being spoken about. This would tend to validate those claims that Sade's writings therefore constitute a palimpsest against which virile emotions are shaped.[25]

This system of images and norms leads, of course, to a counter-model of the complete exercise of virility. Thus, Alfred Delvau speaks out against what he calls "plain old bourgeois," a mixture of soup, beef, and stew—that is, the conjugal act performed in the manner of a green grocer; it is tantamount to saying "daddy-style fucking." In effect, contrary to doctors' opinions and advice, the real arena of virility in this didactic literature is extraconjugal. It foregrounds the "girl," the servant, the seamstress, Margot the peasant girl, and secondarily the mistress.

The virile performance that is demanded could not, let us repeat, leave the woman indifferent. The virile member, however ugly it appears, suffices for her pleasure. According to the author of the article "Génital" in Pierre Larousse's *Dictionnaire universel*,[26] just seeing the erect penis turns her on. It has nothing to do with aesthetics. Female satisfaction is described less as a desire gradually excited

than as an automatic, irrepressible pleasure produced by an organ of metonymic significance. The "cock" is a "catalyst," giving "a godsend to the woman who trembles with joy from it." It is the man's duty to sow "his oats" in the woman "who would die from deprivation without this ration of love."[27]

This satisfaction, following the same system of images, can—should?—lead the woman to "divine ecstasy." The real triumph of the man is to see "the whites of her eyes," that is, see her "faint" from the impact of genital orgasm or to work her over until she is, quite simply, "speechless," that is, until she "faints under the man in the excess of orgasm that he produces."[28] It is not so much the paroxysm of male pleasure that holds one's attention here as the eventuality of the partner's extreme delirium, the dazzling manifestation of virile prowess.

This scenario, consequently, stresses to the utmost the difference between masculine and feminine. It reflects the accent on dimorphism that characterizes this period. It specifies, through action, the images of the bodies and the organs of copulation that define the virile norm. It represses the rest, that is, feeling, refinement, and the exaltation of the masculine aesthetic in favor of the imperatives of vigor and the calculated performance. It imposes a depiction of the woman as waiting, as having necessarily to be satisfied—exorcising in this way the fear that she evokes. The relative inferiority of the man as regards orgasm is compensated for by the demonstration of virile force. To triumph over the woman and produce an orgasm in her that quenches her thirst casts into oblivion the potential fear of failure, of an inefficient erection, or of any mishap. This demonstrates that the virile organ wins out over the dildo, which, according to Delvau, constitutes the only serious rival of the man[29] whose vigor is unfortunately limited.

Stendhal admits on 2 September 1811 that his love affairs have always been troubled by the concern about playing a role,[30] the one demanded by the code of virility. Let us try to grasp the manner in which this code becomes essential in sexual relations, whose directions it dictates, and how it determines the measuring of self-esteem, the consciousness of shortcomings, and the potential for suffering. Is the necessary conformity of what is demanded of the man, beginning in childhood, a source of delectation or does it become a burden?

The usable sources come from a close-knit cultural elite composed of individuals capable of analyzing themselves, confiding in one another and noting, day after day, their emotions. The epistolary relations between men constitute the primary corpus accessible with a view toward tracking such objects. We will highlight here two networks of authors—without actually excluding other individuals—who have also been the subjects of scholarly studies, which help us understand

them better. The first is composed of Stendhal's friends, whether former college classmates or older men whom he was led to frequent; the second is composed of Flaubert's correspondents, the set of "boys" from Rouen, that is, mainly friends from his youth. Such networks cannot claim—it goes without saying—to be truly representative, but an attentive analysis allows us to find out the manner in which the virile code was assumed by real-life beings as opposed to fictional characters. To be sure, for anyone looking to pick out the attitudes, pleasures, and suffering associated with conformity to this set of norms, this epistolary writing may appear biased: it constitutes in itself a literary genre[31] subject to a compulsory offhandedness when it is a question of women. The discursive situation (letter-writing) tends to give primacy to carnal relations; it imposes the adoption of a crude tone and thus forces sentiment to be attenuated, if not silenced. In addition, we are dealing for the most part with the writing of bachelors,[32] who, it is true, thrive on adulteries, at times conjugal ones.

The first features essential to an analysis of the epistolary accounts among men are the refusal of any kind of sentimentalism and an irony with regard to those who do not adopt the same attitude. This posture is in accord with the proclaimed refusal of any commitment. On 3 June 1829, Prosper Mérimée congratulates his English friend Sutton Sharpe: "I have it on good authority that you are not one of those people who want in love only tears, sighs, letters, and the occasion to make touching declarations to the rocks and woodlands. It appears that you need *substantial* pleasures." Even more clearly, the same Mérimée writes to Édouard Grasset on 24 December 1833 with regard to the latter's platonic love affairs: "In spite of all the experience you might have of the destructive effects of coitus on love, coitus is always imperious and wants to be satisfied. So, for that reason, I predict coitus in your future, if it hasn't already taken place."[33]

Statements of the same sort can be found in the correspondence of Théophile Gautier. Gustave Flaubert writes, but to his mistress this time: "I despise gallantry; ... that perpetual confusion between panties and the heart makes me vomit."[34] He allows for only carnal satisfaction or, in a pinch, passion. "All I want from you as a woman," he writes to Louise Colet, "is your body; leave the sentimentality to the old folks."[35] Admitting a potential love in the course of correspondence between men is opening oneself up to jokes. Stendhal says that this reticence explains the exaggerated praises that young men openly lavish upon the "girls."[36]

Logically, these correspondences, which in keeping with bawdiness proclaim the simple necessity of free copulation, are interwoven with derision toward matrimonial relations and regular coitus.[37] As for the Goncourt brothers, they take

offense at the "glorious immodesty" of conjugal interiors and get irate over the "sleeping magistrate" position practiced by the husband.[38]

In the course of this correspondence a very ample place is reserved for accounts of victories, for the enumeration of women "to be had" as well as women who have been "had" to adopt Stendhal's vocabulary, as well as a place for the description of the audacity of the caresses that allowed the man to carry off the affair. These accounts are almost always accompanied by a description of the partner's behavior, her sensual qualities, or her potential or regrettable lifelessness; appreciations are modulated according to categories of women.

Following the same logic of good camaraderie, the letters are sprinkled with propositions or stories concerning exchanges of partners. "I have a tall woman," writes Mérimée to Sutton Sharpe, as tall as me—quite beautiful besides—lovable and a good girl. I would like to pass her to you so that you can cast your spell on her. I also had a Spanish refugee who would do the trick for you. . . . I will get her back for you if you don't like the tall one." Mérimée is simply returning to his correspondent the favors that the latter provided him with in London the year before. A little later—October 1832—he writes, this time to Stendhal, that he's given away Pauline to Sharpe, who "was very satisfied with her." He adds: "I'd like to be able to put her at your disposal."[39]

Even more frequently, as revealed by reading these letters, brothel addresses are exchanged. "The good Leuboi should go to Paris," writes Alfred Le Poittevin to Flaubert on 26 November 1843; "I promised him the exact addresses of la Guérin, la Lebrun, la mère Arnoult and la mère Leriche. I remember that la Guérin lives on the rue des Moulins, but I don't have the number [. . .]. Give me also the name of Champlâtreux's former mistress, who is at la Lebrun's, and where you fuck her."[40] Maxime du Camp's correspondence teems with such exchanges. Elsewhere, the letter-writers seek the availability of rooms suitable for their lovemaking. On 20 October 1832, Mérimée contacts Édouard Grasset: he needs a certain location between noon and 3:00 "next Tuesday."[41]

Another commonplace is found upon reading these texts, one that imitates and warps the code of civility. Instead of inquiring generally as to the health of one's correspondent, it is better thought of to find out about the state of his genitals. Likewise, a number of letter-writers begin by informing their correspondent about their activity. "I haven't gotten a single hard-on since I've been in this God-forsaken country," writes Gautier to Eugène Piot on 27 July 1836, "and Gérard [de Nerval] is always in an alarming state of erection, walking with his lance always *en garde*. . . ."[42] Poor needy Mérimée writes to Édouard Grasset during one of his sojourns in the

provinces: "My state is alarming, and you will find out one of these days that I have been arrested for committing an indecent act with an artilleryman."[43]

A great deal more space is taken up, however, by keeping count of exploits and bragging. At times it is simply a matter of calculating the time required to "have" a woman.[44] A number of letters expound on the bold deeds of conquest. Alfred de Musset attacks ladies in the window wells of drawing rooms. He brags of having let out, point-blank, to one of these society ladies, in a tongue-in-cheek confiding tone: "Madame, I've got a hard-on for you; would you like to check it out for yourself?"[45] This audacity is not so surprising if one thinks of how, according to Stendhal, old Lafayette likes to "grab the ass" of young girls as they leave society receptions.[46]

Mérimée gets amusement from relating the war-like episodes that allowed him to conquer a very beautiful woman, but one who is "deplorably modest." "A battle waged to get her into her nightgown, another battle to keep a candle in the room. All these battles are won by me; I fuck her, and it feels like I'm sleeping with the Duchess de Broglie."[47] Aiming to be instructive, Stendhal explains with a wealth of details the way to assault a woman, who in truth is consenting but who puts on a suitable show of resistance; it is a method taught him by his friend Percheron, who, he says, is an expert in such matters.[48]

Maxime du Camp is without doubt the least sparing in details on this score. The epistolary account of his first lovemaking with Mme. Delessert—on a chair, while his partner was indisposed or pretended to be so as to hide her age—is done with a meticulous precision intended to delight his friend Gustave.[49] Between men, comparing mistresses' talents is permissible. "You would be wrong," writes Flaubert to Louis Bouilhet on 8 December 1853, "not to frequent the latter [Louise Pradier, alias Ludovica, his former and future mistress], who, *entre nous*, can pull off more beautiful fucks than my muse [Louise Colet, his current mistress, whom he is leaving]."[50]

Announcing a female deflowering or congratulating a correspondent for such an exploit constitutes another commonplace in accord with the code of virility. "Following your worthy advice," writes Gautier to Eugène de Nully in 1836, "at long last I just recently deflowered dear Eugénie [Fort]; I had quite a bit of fun; at least I won't have that remorse on my conscience anymore."[51] Mérimée had written to Édouard Grasset on 26 October 1831: "you have deflowered her [young Mary], and you are really happy. She will never do you as much harm as she did you good by allowing you to put your mizzenmast into her stern."[52]

Sometimes the intensity of sexual life is indicated laconically. "We are fucking like crazy," writes Alfred Le Poittevin to his friend Flaubert on 28 March 1843,

referring to his relations with "a little girl" named Anna.[53] Conversely, the letter-writer sometimes deplores the precise obstacles that have hindered his lovemaking. On 4 January 1842, Eugène Fromentin receives a missive from his brother Charles telling him about his run of bad luck. "The game," he writes, seemed just about won against Louise, the wife of one of their friends. But it was held up "due to a lack of suitable location. I would otherwise have made the attempt at once, but it was materially impossible, unless we were to do it on a chair—not very comfortable, and difficult to maneuver;" especially since the couple was interrupted by a servant and then by the lady's younger sister. Charles concludes: "I'm waiting now for the finale. I'll let you know...."[54]

Naturally, boasting leads the writer to point out to his correspondent the scope of his scores, the number of times getting off in one night or during the extent of one visit. "I fucked three women and got off four fucks—three of them before lunch and the fourth after dessert [...]; young du Camp got only one fuck," details Flaubert to his friend Louis Bouilhet with regard to his stay in Beirut[55] with Camille Rogier, postal director. Earlier, Gustave had detailed to the same correspondent the scores racked up with the famous courtesan Kuchuk-Hanem: "As for the fucks, they were very good. The 3rd was especially brutal, and the last one with feeling."[56] There is no need to illustrate here this commonplace in the correspondence between men any further.

But there is another popular subject: the one that consists of evoking the parties at the "girls'" place (brothel). The account outlined by Mérimée of the night spent at la Leriche's on 14 September 1831[57] in the company of Delacroix, Musset, Sharpe, and Viel-Castel is well known by every specialist of literary history. In the letter addressed to Stendhal, the writer works hard at detailing the conduct of the actors: Delacroix's debauchery, Musset's paroxysmal attitudes and impotence, Horace de Viel-Castel's "tough-guy eloquence".... This text adds a great deal to our knowledge about virile states and behavior under such circumstances. We could also cite, on this score, the letters of Flaubert evoking la mère Guérin's establishment.

In this correspondence between men, there is no embarrassment to be detected about going to a prostitute. On the contrary it is well thought of to declare the attraction one feels toward the "girls." Mérimée, Stendhal, and Gautier never run out of praise for them. On 25–28 May 1832, Mérimée boasts to his friend Stendhal about the evenings spent in the company of kept girls, no doubt "high style" ones. "It's really a lot of fun," he writes, "and quite superior on many points to polite society: (1) these women are pretty; (2) they're not stupid; (3) some sing beautifully...; (4) they are just as elegant as society ladies...."[58]

The tone, it is true, is not always so enthusiastic. An aging Gautier tells his friend Julien Turgan about his former haunts, as well as the habits of solitary isolated men: "you go to the brothel all day long," he writes, "to have the semblance of a human relation"; "but," he adds, "despite that, copulating in these houses does not create a bond between two people."[59]

That said, the hymn to the whore is in accord with the praise of foolishness, proclaimed in the bawdy song. According to the Goncourt brothers, the painter Gavarni recommended stupid women for lovemaking;[60] they spare the man from receiving inept missives sent by bourgeois women in love. In certain letters an attraction can be found for "spring chickens," extolled by members of the singing clubs. Mérimée thus evokes, in a letter to Requiem on 19 June 1835, the young prostitutes of London, "as white as swans, as soft as satin," including "a child fresh as a white rose petal," with an average age of 17.[61] Allusion is made by Mérimée to the pleasure of seeing lesbians in action at la Leriche's brothel.[62] Later, when the time comes for exotic—if not colonial—adventure, Flaubert will describe, on the contrary, his disgust at seeing negresses at an Egyptian whorehouse.[63]

Some of these letter-writers are given to a more refined analysis of the pleasures and disappointments experienced at the brothel. A reading of their letters allows for a better understanding of what constitutes, at that time, the modes of stimulating male desire with regard to the prostitute. Musset, judging by his correspondence, oscillates constantly between society ladies and "girls" [cf. fig. 9.2]. In the course of his lovemaking, which represents a model of virile debauchery, he reveals the search for the absolute in and through the flesh. With this prostitute-lover,[64] it appears that the paroxysm of orgasm brings deep distress to his brain and unleashes a furor, which at times becomes sadistic. This thirst, this rage in fact, which goads him toward nocturnal beatings, at times in a temporary installation inside the brothel, is tranferred by Musset into certain of his works, such as *Rolla* or *Namouna*. These manic-depressive episodes are, in his case, imbued with the distress of incomplete orgasms. Frustration becomes an omen of death and destruction—as if, writes Frank Lestringant, the obsession with "*la petite mort*" [little death, or orgasm] expanded into greater death. "I felt," Musset affirms, "that so long as the body was under the clothing, the skeleton was under the body."[65]

The range of pleasures that Flaubert feels in his relations with prostitutes is quite subtle. Along with it are comingled the pleasure of hearing oneself accosted, solicited by a group of street walkers; that of discovering, in a poetic recapitulation of the history of carnal relations, the sacredness of biblical copulations and the fragrances of ancient Egyptian women; that of waking up in the bed of a female

FIGURE 9.2 FERDINANDUS, "ALFRED DE MUSSET CHEZ LA FARCY," IN *MÉMOIRES DE M. CLAUDE*. PARIS: ÉDITIONS JULES ROUFF, 1884. Alfred de Musset frequented prostitutes, to the point of sometimes lodging at the brothels. He is here depicted at la Farcy's. The poet with the sad look has come to get over the infidelities of George Sand; she advises him at the time not to subject his still weak organism to excessively strong jolts of pleasure.

Source: © Kharbine-Tapabor

stranger after experiencing the intensity of the spasms and sensing at times that actual feelings have seeped into the orgasm; and more than anything perhaps, that of feeling how much, finally, it is all in accord with the bitterness that resides inside all things.[66] In his eyes, a man is not a man if he does not know what it is to spend the night with a whore and to wake up next to unknown flesh and bones that have already been the grazing fields of a great number of males.

Such sentiments help us to understand the attitude of the young men who have decided to stick with prostitutes[67] or to give themselves over only to that which, in some way, is linked to venality: lovemaking with servants, hotel maids, and any accessible—indeed resigned—bodies, without having to go to the trouble of seducing. The attraction for secondary loves, the temptation of the "model," which Delacroix gives into, prefigures what Krafft-Ebing will call "apron fetishism" much later.[68] It is the figure whose model Zola outlines in Le Trublot in the world of fiction.[69]

With such partners, a certain violence is shown to be necessary, although none of these letter-writers finds anything wrong with it so long as satisfaction covertly slips into the social chase after working-class girls and women, who are expected, in the imagined coarseness of their embrace, to bestow upon the man a new vigor. Let us not forget that, within the elites, the infant, the boy, and then the young man have habitually had their bodily needs satisfied with the help of women of the

people: wet-nurse, nursemaid, servant-initiator; the prostitute is located at the end of this chain.[70] Having recourse to her services fits into the logic embodied in the virile experience. From this point of view the "girl" fulfills a desire for carnal sincerity manifested by her accessible nudity.

All of the preceding is linked to a *topos* of the travel account and, more generally, of any spatial narrative: the concern for pinpointing the geographical distribution of the beauty and the ugliness of women. Medical literature of the late eighteenth century is cluttered with hundreds of pages devoted to this goal.[71] When they undertake a trip, the letter-writers are concerned with never failing to find out first of all the addresses of brothels in the towns where they are planning to stay; sometimes they inquire about the "girls'" rates, unless their correspondents have told them on their own.[72] Communication of such information enters normally into the correspondence. "Are there whores in this city [Algiers]?" asks Gautier of Eugène de Nully; "are they pretty? Are they ugly? How do they fuck, how much do you pay them, do they have pox—and who or what do you screw?"

The trip itself is often subject, more or less explicitly, to the desire to meet a certain type of woman. If Nerval and Gautier take the route to Flanders, it is to "chase the blond"[73]—a quest that actually turns out to be quite disappointing. The traveler is supposed to inform his correspondents back in Paris, out of *politesse*, about the quality of the women and the relation he has built with them. "You must, my friend," writes Musset to Tattet, "educate yourself when you travel. If you don't sleep with the girls at the inn, you will never be anything but a simpleton."[74]

This is the way erotic Germany is pictured for the young Stendhal, Spain and the provinces for Mérimée. In Valencia, the latter writes, "One piaster will get you a very pretty 15-year-old girl. . . . For a ten-spot I had one guaranteed to be a virgin. . . . I spent twenty-one days in Valencia without getting bored, but I got in some thirty fucks. I had[75] four girls in active service, all of them called Vicenta—St. Vincent is the patron saint of the town." On the other hand, in Barcelona, the "Catalan women are fat, short and not well-built, unlike Valencian women who have curved backs and are white, svelte and well-built."[76] Thus does Mérimée recommend Valencia to Stendhal. His survey is not limited to Spain. His correspondence is teeming with information on the feminine geography of Germany and England. In Aix-la-Chapelle, on 3 July 1836, he writes to Royer-Collard: "beautiful skin, big dumb eyes and very sharp features but soft to the highest degree . . . , till now I've tried the women of Hesse, of Nassau and of Prussia. Those of Hesse get the laurels."[77] The women of London, according to him, "have no ass, but fifty pounds of tits that slip through your fingers—they're as hard to hold onto as pancake batter."[78]

This Inspector of Monuments does not fail to describe in his correspondence to his friends the resources of each provincial town and the torment that, at times, he suffers. In Marseilles, he writes to Royer-Collard, "The whores are incredibly dirty. They have unusually thick yellow stockings, garters below the knees, etc. All these monstrosities, you know, will encourage an erection only under certain circumstances." In Besançon, his situation is "abominable," as he confides to the same correspondent on 23 May 1836: "I'm going to have to wait till the month of July to get some women."[79]

Gautier surveys Italy; his estimate of the geography of beauty and ugliness is, it would seem, subject to artistic and literary models. But he gives in with pleasure to a Rabelaisian vein, directed toward his correspondents, which leads him to describe with outrageous obscenity the easy women of Venice as well as the form and texture of Roman women's breasts.[80] In Flaubert's case, he outlines with precision the erotic geography of the Nile; there is no need to go on about that. But he also knows how to observe and describe the riches of the European towns in which he sojourns, whether it is London or Naples. "In soft Parthenope I can't stop getting hard," he writes to Camille Rosier on 11 March 1851. "I fuck like an unbridled ass . . . ; maybe it's the closeness of Vesuvius that heats up my ass . . . ; I was offered little girls ten years old, yes Sir, young children . . . they even proposed little kids. . . . But I refused. . . . I'm sticking to ladies, to mature women, to fat women."[81]

When a letter-writer is obliged to stay for a long time in a provincial town, his correspondent expects him to report the raunchy anecdotes that will allow him to get an idea of the debauchery the inhabitants go in for and to measure the degree of intensity of virile practices in that remote spot. The funnier these accounts are, the better. "Trivollier," writes Stendhal on 28 January 1806, "is giving me lessons in the art of getting women without a scandal." He "had a woman in Grenoble for four years without anyone's suspecting. Same for me—I can't get too comfortable; it's almost always doggy-style, behind the door with a rubber. . . ." "For the rest," Stendhal adds in his journal on 2 February, "all women have lovers seen by and known to everyone. . . . Very few have not been unmasked, once in their life, by a shocking affair."[82]

There remain the confessions about those failures, those attacks on one's virility, which we shall return to below. In men's correspondence, only the "fiasco" is mentionable, not proven impotence, that "fuck-beggary" that stirs up anguish and that, nevertheless, insidiously lurks behind one's words. The funniest and most common consist of making allusions to others' failures. That said, there is scarcely

any correspondence that does not contain the account of one personal failure, whether it is Sainte-Beuve, Musset, or Delacroix. Mérimée suffers a great deal over his disastrous night in the company of George Sand; but who would ever think of impotence in connection with him? Gautier confesses his fiascos at least twice. Stendhal goes further into an analysis when he is treating his lack of success with Alexandrine, following his platonic passion for Métilde. The scene occurred, to be sure, in a separate room, but it was practically public, since the failure took place during a party at the home of the madam, Mme. Petit, and was accompanied by secrets from the girl involved. This fiasco made such an impact that the wretched Stendhal earned from it, by his own admission, the reputation of a "fuck-beggar" (impotent man).[83] Perhaps this is why he would be so intent on devoting an entire chapter to "fiasco" in his treatise entitled *De l'amour*.

The letter-writers' attitudes toward their experience of the pox are also shown to be ambiguous. The allusions to the symptoms make up part of men's boasting, which is reflected in the words to a bawdy song destined to be long-lived: "And you don't give a damn about catching the pox, you don't give a damn so long as you get in a fuck." The chancre is proof that a man has acted with intense, audacious, even intrepid virility. But, at the same time, an anxiety pops up or is verbalized clearly that men no longer fear to admit. On this score, there is complicity at the heart of masculine culture.

Flaubert's confessions addressed to his friend Ernest Chevalier as they figure in the letters written to him in 1849 have been brought up several times. Let us listen, nevertheless, to his declarations: on 6 May Gustave says he is "being eaten away by the pox, whose origin is lost in the abysm of time. It's no use treating the symptoms that are getting better, as the pox keeps reappearing here and there."[84] Quite so: in 1844 a "fine pox" was discovered that had to be "treated with mercurochrome rubs."[85] On 14 November 1850, Flaubert describes to Louis Bouilhet from Constantinople the suffering that his chancres have caused—chancres that, happily, are all better.

> I suspect a Maronite of having given me this present, but it was maybe the little Turk. Is it the Turk or the Christian. . . . That's one aspect of the Oriental question that the *Revue des deux mondes* has no notion of. We discovered this morning that the Young Sassetti has the clap, and yesterday evening Maxime [du Camp] discovered . . . what looks to me surely to be a bicephalous chancre, although he hasn't fucked for six weeks. If it is one, that makes the third pox he has caught since we started out. Nothing is so good for the health as traveling.[86]

Even more frequent than such confessions in the course of men's correspondence are the warnings and the procedures to follow. Among men, it is good to point out to one another the possible, probable, or proven poxes contracted by women with whom the correspondent may be led to frequent. Stendhal and Mérimée, in particular, are fond of such calls for caution. Gautier, under the influence of these warnings, prefers masturbation to penetration during his lovemaking with a young prostitute in Venice. Once arrived in Padua, he says: "you'd have to fuck there with condoms made of galvanized sheet metal to be sure of being protected."[87]

At the end of reading thousands of pages of this correspondence between men, a connection becomes evident between the tone, the contents of the letters, and the *topoi* that make up virility according to the terms of the bawdiness previously evoked. But the same code is manifested in other ways when it is about missives exchanged between a man and a woman, especially between a lover and a mistress. A virile posture, of course, is essential at that point, but in accordance with other procedures. It is no longer a matter of positing a distance with regard to sentiment; quite the contrary, the declarations expected by the female partner should allow an amorous passion to show through, expressed, if necessary, in a tone imbued with religiosity, a transposition of that inspired by conjugal spirituality. "How good and beautiful you were yesterday!" writes Sainte-Beuve in 1831 to his beloved Adèle in a letter that also reveals their carnal arrangements; "and what eternally delicious memories that half-hour in the corner of the chapel will leave in me . . . ; it was your amorous words that permeated me, but which had a pious sadness in conjuring the separation and widowhood with which we live." Were obstacles to crop up to their love, affirms the author of *Volupté* (Sensual pleasure) in a romantic surge, "we could die together in each other's arms."[88]

In these love letters, it is not a question of salacious secrets—apart from Flaubert's. There is no flashy casualness: it is no longer a matter of provoking hilarity. On the man's part, a writing demonstrative of the ardor of his desire is essential. Daring allusions to the boldness of caresses lavished upon the partner or exploits accomplished during recent encounters and the rush stimulated by the wait, which are then exacerbated by the imminence of meeting, are intended to agitate and excite the partner. This ardor, these allusions, and these references must remain the man's prerogative to the extent that they are consistent with the code of virility. On the other hand, modesty forbids the woman, most of the time, from admitting her stormy sensations, except as a vague formulation, often accompanied by complaints about masculine

disdain with regard to "caresses of the soul." "They don't own up to their senses," laments Flaubert. "They mistake their ass for their heart."[89]

Bonaparte's well-known letters to Josephine illustrate this model of virile writing. The turmoil, the delirium, the fever of the husband who expects also to be a lover are conveyed by the furor of caresses destined for the breast, the "little belly," the "devilish little thing," the little "black forest" on which he bestows "a thousand kisses," "lower, much lower than the heart." "My soul is in your heart," concludes Bonaparte on 17 June 1796.[90] It is understandable that a fervent husband might have believed it decent to write to the young Désirée Clary the year before: "a heart wounded by a virile man's passionate outbursts was not worthy of you."[91]

Vigny dares to put his virility more clearly on display in his correspondence. He writes to Marie Dorval that he gets an uncontrollable erection just from thinking of her body. He dreams of her brown thighs; he imagines being "deep within her." At the end, he cums on the letter he is writing to her and transcribes in a breathless, disjointed language the emotions he is feeling amidst the spasms, to the point of not being able to see straight.[92] The actor Flechter carries on with his mistress, Virginie Déjazet, a correspondence that shows long-distance masturbation.[93] Flaubert, who can never resist a boast, often interwoven with bitterness, likes to recall in his letters to Louise Colet the intensity of the reactions he has elicited. He thus evokes the "euphoria of the body and the joyful spasms that keep us in ecstasy!"[94] On 15 August 1846, he writes to his mistress: "I want to glut you with all the joys of the body, wear you out from them, make you die from them. I want . . . you to admit deep down that you never dreamed of such transport,"[95] and on 23 August: "you remember my violent caresses . . . ; I made you scream two or three times."[96]

The tender Aimé Guyet de Fernex himself does not hesitate, in his innumerable letters to his lover, Adèle Schunck, to evoke, not without *délicatesse*, the reactions that he elicits: "If I am sometimes the lava of Vesuvius, you are not always the ice of the Alps," he asserts on 12 May 1830;[97] Adèle admitted to him on 12 September 1826, "I can still feel your burning caresses," and four days later: "As for the rest, I'm used to how you go about it, and I've made unquestionable progress." Indeed, Aimé appreciates playing the virile role of instructor of sensual pleasure. Quite a bit later, on 13 September 1837, his mistress congratulates herself again: "the new discoveries that you have helped me make prove the force of your talent, and if the pupil can be credited with improving, what shall we say of the teacher?"[98]

At times, in the course of the epistolary exchanges of this type, the woman dares to make a direct allusion: "Everyone tells me that my eyes look tired," Adèle confides to her lover from whom she is temporarily separated; "Aimé, if I don't say

more about it to you, it's on account of decorum. I suppose, dear Friend, that three weeks away from your thrusts will make my complexion brighter and my eyes will regain their sparkle."[99]

Certain women—although quite rarely, it is true—when it is not a question of prostitutes, do not hesitate to reverse the roles. The perturbed Marie Mattei applies herself to stimulate Gautier's ardor by the unvarnished expression of a burning desire and by a description of her lesbian love affairs: under the sun "I feel myself twisting to your thoughts [. . .]; you can feel how much my whole body is trembling . . . ; close your eyes and you will see mine that beg you so ardently to open your arms to make me die." The next day she asks: "What did you do to me that makes me desire you like this?"[100]

Marie Dorval, who incidentally makes fun of the "little rise" that Vigny shows himself capable of "from time to time" (based on Léon Séché's claim), responds to her impassioned lover in the same shameless way on 11 January 1837. She asks him not to speak of love in his letters, unless it is that of the soul: "Oh! May the other one return quickly! It returns only when I say that to you. . . . Farewell, farewell. . . . I kiss your mouth, your eyes. I can no longer see straight. I'm going to bed."[101]

Beyond the masculine-feminine roleplay there is a context in which we may access the effects of the code of virility on the individual's inner self in greater depth. The number of times the word virile appears in the diary or datebook becomes central in our inquiry. The obsessive analysis and the measuring of successes or failures allow us to grasp the weight of the injunctions placed upon the individual—especially as, before mid-century, these forms of writing about the self were not yet destined for publication.[102]

The most obsessive refrain in the course of these self-avowals is the acknowledgment of the *need for women*. Benjamin Constant says that this need gnaws at him with particular intensity. "I cannot do without women," he concludes in his journal on 11 February 1805; "they provide me with a real benefit, and deprivation of them upsets all my physical and moral faculties."[103] On the 13th he writes that he wants to have the girl from the day before yesterday return to the Herbages, his residence . . . "worse comes to worst, I'll send her back with some money; I absolutely cannot do without women. This need grows stronger and becomes more frequent each day." The next day he states: "the more I see women—I'm talking about 'girls'—the more my moral and physical faculties are active, and the less I feel depressed, melancholic or distressed," and on 16 February: "My usual foolishness, a need for women, even more moral than physical, has taken hold of me with a prodigious keenness, and I have been haunted by the desire to ensure constantly at my side the beautiful

forms that relieve me of all that I shamefully had recourse to—prostitutes—and that led to my misfortunes last summer."[104] Thus, Constant prefers to work out, even if it is half of his fortune, an "arrangement." On 27 March he has discovered a "little girl" with an angelic face with whom he admits, the next day, to be bizarrely and ridiculously busy. On 13 April he proclaims: "That's exactly what I need: if I can arrange with her not to take up any time [...]. As for the rest, freshness, beauty, superb forms, charming hair, the most beautiful teeth in the world: all is brought together here."[105]

A few months earlier, on 4 January 1805, he had already felt in the grips of a dilemma: "A paid mistress is too boring for me to be able to find anything in common with her except the sole relation she is here for [...]. A worker? There is some difficulty finding any [...]; the simplest thing would be for me to do without. Except for the insomnia and these imaginings that become so bizarre when the deprivation persists."[106]

The year before, on 2 March, he had begun with this assessment: he could not live with Mme. de Stael for a thousand reasons, including an "insurmountable one: I need women. Germaine makes no sense. . . . I therefore absolutely need a woman. I need her politically. That's the only way I will have a peaceful, normal existence in France."[107]

"I'm going to need a mistress," Delacroix writes in his journal on 14 June 1824, "to calm the usual carnal urges. I'm really tormented over it and am bearing up under noble struggles against temptation when I'm in the studio. Sometimes I long for the first woman who might come along"; and on Saturday the 19th he notes curtly: "great lack of sex."[108]

Although he proved that he was capable of going without a woman, Stendhal, too, recognizes the benefits of periodic satisfaction. "I have gotten over my love for Minette," he writes on 9 November 1807. "I sleep every three or four days, out of physical need, with Charlotte Knabelhuber,"[109] a girl kept by a rich Dutchman. He adds: "I was satisfied with myself on that score." We have already made allusion to Mérimée's suffering when he is unable to satisfy his need for women.

The acknowledgment of this need, in accord with the doctors who keep on warning about the harmful effects of abstinence and recommending the "frequenting of women," elicits the regulation of prostitution, theorized by Alexandre Parent-Duchâtelet. The Augustinian notion of necessary evil justifies the system.[110] Thus, seen as a physiological medicine concerned with the good working order of each function, satisfying this need is considered a therapeutic measure. This is why Benjamin Constant, on 19 October 1812, states his disappointment: "I got

married in order to sleep a lot with my wife and go to bed early. I practically never sleep with her, and we stay up until four in the morning."[111]

Copulation soothes the imagination and, on that basis, allows the man to keep his mind clear. "I took advantage of her," writes Delacroix, referring to his model Émilie Robert, "and it's made me feel a little better."[112] Such, in the eyes of Flaubert, is one of the missions of the "slut."[113] Michelet, growing older, analyzes at length in his journal the benefits that he has drawn from his lovemaking with his wife Athénaïs. Following the logic that was formerly that of Lucretius, the diarists recognize that coitus alleviates the distress provoked by passion. In short, copulation lets one forget about love when love becomes too obsessive. "I've got to get cured of this—it's like a sickness," writes Constant in 1814, having wept half the night thinking about Juliette Récamier, who is being coquettish: "Let's see some girls, let's use them up." The next day he cheers himself up: "Let's calm down, then. I saw a girl; I shall see another one this evening, and again tomorrow, until a woman's hand repulses me. . . ." On 20 September he persists in his strategy: "Looked at a girl with extreme repugnance. But I shall continue to exorcise the she-devil from my imagination."[114]

Lovemaking even helps overcome the seductiveness of the memory of bygone love affairs. It is with this thought in mind that Alfred Le Poittevin imagines spending three days in Le Havre and Honfleur, in the places of his youth, with a "slut" he would choose ad hoc and would let go of upon his return.[115] Stendhal, for his part, adds to the preceding advantages the power of coitus to cure the soul's sorrows: "If I broke off with Lady S. (Simonetta), I would immediately have to take up with a little lady of that caliber, so as to leave no time for melancholy to set in."[116] On this topic he remembers Uncle Gagnon, who enjoined him in advance that when left by a woman he must declare his love, within twenty-four hours, to another woman, even if she is a chambermaid.

The need to copulate appears at that point evident, as it is recognized and admitted by women themselves as being inherent in the virile condition. It is built into the way they picture man. In the world of fiction, Julie worries about the means of satisfaction that Saint-Preux could choose. She disapproves of his resorting to prostitution, advises against masturbation, and dreams of marrying the man who deflowered Claire, her best friend.

In the course of her correspondence, George Sand worries over the needs of her lovers.

"Oh, I beg you on bended knee," she writes to Musset on 29 April 1834, "[. . .] no more girls! It's too soon. Think of your body [. . .]; don't surrender to pleasure until

nature comes urgently to demand you to; yet don't try to use it as a remedy to ennui or sadness; when it's not the best experience, then it's as bad as it can be."[117] Three years later she admits to Michel de Bourges the intensity of her own needs, which are such that the doctor who lets her blood has ordered her to take a lover. Thus, she would pardon her correspondent for cheating on her if it were a question of a physiological need of the same order: "Can that woman," she asks about a rival, "be used to soothe your insides the way a streetwalker would?" "Perhaps your needs are more urgent than mine." George imagines her own role as therapeutic. On 20 April 1837, she writes to Michel de Bourges that she wants "to relieve [your] sensual desires often so as to prevent you from breaking down"[118] until old age saps him of his juices.

The realization of how great the need is often prompts men, in private, to resort to girls, models, servants, and all the women who belong to categories likely to relieve men's urges; such a realization evokes those "arrangements" that Benjamin Constant places so much hope in.

This recognition of the obsessive need encourages the meticulous accounting of performances, but this time no longer out of braggadocio but with the objective of reassuring oneself, in one's inner self, of exorcising all fear of the waning of one's seductive powers or of one's virile potency. The pervasiveness of this accounting, such as it becomes salient during the first two thirds of the nineteenth century, constitutes a major historical datum. It informs us better than anything else about the force of the injunctions of the code we are concerned with at a time when according to Stendhal everyone is pursuing the type of happiness best adapted to his organs.[119]

This accounting, whose precision stupefies today's reader, bears on a series of givens; first of all on the total number of women one has "had" throughout one's existence, a number often compared to that posted by other men among the diarist's acquaintances. Mérimée[120] very often frequented actresses, working-class coquettes, adulterous strangers, and, especially during his travels, brothel "girls," but he also kept account of those he possessed. Stendhal, disdainful—yet farsighted—with regard to such arithmetic, writes on 17 June 1807: "I do not place my capital on having women. Martial [Daru], between the age of 18 to 31, has had approximately twenty-two women, twelve of whom actually after a one-night affair (this detail leads one to assume precise talks between the two friends). I'm 25; in the coming ten years I will probably have six women";[121] he compares this total to that of the horses he will mount.

This type of accounting is accompanied by the evocation of "repeats" during one's sexual life, that is, the interweavings and counterpoints that are dwelt upon,

for it is rare for these diarists to have only one woman during a long period. Putting aside Musset's erratic behavior, this concern to record a network is characteristic of Alfred de Vigny: the counterpoint of his lovemaking with Maria, Julia, and Lydia is noted in his datebook with the greatest precision.

It may happen that in the course of this intimate writing the estimate of the duration necessary for "victory" and then the indication of the duration of the liaison are written down. Stendhal relishes, in particular, such tallies, just as he does not fail to record with extreme precision the time of anniversaries of his conquests, going so far as to write the dates on his suspenders. Often, this recollection is associated with that of the places that have been the arenas of his successes.

"Milan. 21 September [1811], at eleven-thirty, I bring off that victory desired for so long [. . .]. After a very serious moral combat, in which I played at misfortune and almost despair, she is mine, 11:30"; a success won after an assault lasting seventy minutes, since Stendhal notes that he got to his mistress at 10:20. He concludes: "this victory was not easy"[122]—thus reinforcing his virile satisfaction.

In truth, the preceding might be considered banal and insignificant as a behavior specific to the nineteenth century. After all, when sex surveys are taken today, men and women are asked the number of sexual partners they have engaged with in the course of their lives[123] with one exception, however. Now the calculation is required from individuals who make up a sample, whereas it was spontaneous on the part of the nineteenth-century diarists, and women of the period were not given to such calculations or at least did not admit to it.

What characterizes the first two thirds of the nineteenth century, on the other hand, is the accounting of coituses and "the number of times getting off." This precision in the measuring of virile potency is probably unparalleled throughout history, and it is surprising to note how much this memory-based practice—which presupposes a head count in the field—is shared. The Prince de Ligne (*Mémoires*, Brussels, 1860) evokes this kind of arithmetic only on the occasion of his confessions, which suggests that the precision of this memory exercise has some connection with the habit, at least among children, of keeping track of sins of lust.[124]

The authors of several of the journals that make up our corpus record the number of their copulations and indulge in a recap calculation by month and year. They pay a great deal of attention, it would seem, to these scores—sometimes marked in a coded language, as in the case of Constant and Michelet, who kept an anxious eye on decreases and complimented themselves on increases. The first of these two diarists' journals allows us—since the code used is finally cracked—to reconstitute the rhythm of the activity. A half-century later, Michelet shows to his

Athénaïs the diary in which the summary of their performances appears for each year, from 1849 to 1861, a memory-based procedure that Lignac recommended beginning in 1772.[125]

On 24 September 1857, Michelet was already writing: "I did not hide from her [yesterday] that I had noted and precisely characterized each of the divine moments that I had in her—very varied moments: whether sublime or profound, or powerfully magnetic, with feeling, warm, soft, tender or charming at the living treasure where I enter."[126] In a word, Athénaïs knew from that point on what to look forward to.

By way of example, here is what is written in the text regarding 1866: "Better year than 1865 (when hems).[127] Total 46."[128] By comparison, in 1865 he had coitus 40 times and in 1864 only 37 times. Michelet regrets that he did not keep track this way with Pauline, his first wife, and that he let the memory of his pleasures thus slip away:[129] "So many years, so many orgasms and so few memories!"

The calculation most frequently recorded by the diarists remains that of the number of "times getting off" during the same encounter. We have already noted the totals marked fairly regularly by Mérimée, especially during his stay in Valence. Stendhal is not far behind, especially when his scores please him, as though he had a particular need for reassurance: "29 April 1829. Thursday, around eight o'clock, I did it four times." On 22 March 1830, Giulia gives herself to him: "one time, a first time." Later, on 1 December 1833, with Clémentine, "from ten-thirty to midnight: twice at my place."[130]

But the most delicious—for it is the most reassuring, even more so than the account and the memory of "victory"—is the number of female orgasms. It is important, first of all, that it be greater than the number of virile swoons. "I Maque that one or two every day,"[131] notes Stendhal on 17 March 1811, lover of the "sweet, amiable Angeline Bereyter," "she five, six and sometimes (in English) nine times."[132] Vigny, it would seem, is reassured and delighted when Julia, fucked in his studio in the Batignolles, declares to him: "You are a Hercules." He actually feels the need to note the compliment on 16 July 1838. Michelet, frustrated by the rarity of Athénaïs's orgasms, whose dates he recalls regularly and whose anniversaries he celebrates, remembers with regret the multiplicity of Pauline's.

In truth, in the recording of virile performances and, secondarily, female ones, the arithmetic is only one piece of information. The diarist feels at times the need to dwell, with more or less delight, on the circumstances and even more so on the partner's willingness. Vigny notes the time of his lovemaking in his datebook. Michelet always does the same, while matching up the notation of meteorological

data with the supposed effects on his woman's disposition, more so than on his own. In particular, he accompanies the temporal precision with judgments on the appropriateness of the moment. "On Saturday, 3 [September 1864], upon returning from a walk, at three o'clock, though tired, q. r [retro?], my bedroom, poorly chosen time, incompl." On the 24th of the same month: "At seven o'clock in the morning, in that first light when everything can be seen better, before the veils and ornaments, *vidi, inivi, rursus inivi. . . .*"[133] The 22nd: "On returning from the library, four o'clock, while waiting for our visits in her anteroom." On 9 April 1865: "At noon, not very easy at first, but inside, and the ej. (ejaculation) double or triple in prop. [proportion?] to the time. I felt the force of the Indian word: the one that grows in the womb."[134]

These citations illustrate the attention paid to places; Michelet is not the only one to remember them. Vigny rarely fails to record the setting for his lovemaking. Tuesday, 14 August 1838: "Maria—*At the gymnasium,* fucked in front of the statuettes." Wednesday the 15th: "evening at the gymnasium." Thursday the 16th: "Fucked Lydia (his wife). Morning. Julia in the Batignolles." Saturday the 18th: "Morning, in the Batignolles, at Julia's."[135] Michelet takes care to situate more precisely his coituses: on Athénaïs's rug, next to the fire, on the little chair that he bought for this purpose, on the edge of the bed, in the grass, or on a "patch of lawn." Sometimes he evokes the rhythm of the scene; thus on 3 October 1858: "I didn't even have time to put a rug under her knees . . . I came harder than on Friday," and the next day he notes, "I slept soundly." Elsewhere he evokes his fear of the servant's bursting in, which disturbs but perhaps might spice up, his pleasures. Vigny specifies that lovemaking with Maria, and especially with Julia, took place on an armchair, a chair, a sofa. On Monday, 10 September, he notes: "Morning. Fucked Julia in the armoire [*sic*]. On a bed. On a chair." Of course, the positions assumed are also at times recorded, unfortunately in a coded manner in Michelet's journal. As for Vigny, he sometimes recalls them clearly. 9 April 1838: "Julia sitting on me. Shot on her belly." Thursday, 20 September: "Morning, Julia. Farewell (he is going back to the Touraine). Fucked standing."[136] Similarly, Vigny records at times the duration of the coitus. 17 June 1838: "Morning—In Montmartre. Maria . . . fucked. Two hours"; 6 July: "Morning. Julia, in the Batignolles. Fucked an hour and a half continuously." The historical interest in such details is in the need the man feels to note them.

Flaubert, for his part, keeps in the forefront of his memory the woman's forms, the olfactory and tactile impressions furnished by the partner's body as well as the modes of stimulation. Years later, he recalls these types of sensations in his correspondence.

Michelet measures attentively and appreciates the woman's docility, and he remembers it. He notes the physiological state of Athénaïs's organs. On 17 November 1862 regarding his first wife he writes: "her charming docility came back to me, along with her eagerness to submit to my needs," "I cannot think about Pauline without thinking of my Athénaïs. . . . The one made me cum by her tremendous climaxes, the other, whose sex organ rarely speaks, gives nonetheless the exquisite delight one has in entering into a mind. She feels, makes me feel, the most delicate of orgasms; the finest spark bursts from the desire and the pleasure that she gives."[137]

More generally, the men—here the authors of our corpus—keep an eye on and record the woman's reactions and techniques in bed. Vigny notes on Sunday, 8 July 1838: "Julia—Batignolles—Fucked—shouts: God! God!—Nervous trembling!"[138] The reader perceives the diarist's virile satisfaction. Stendhal boasts in his journal about having "inflamed" with his caresses the daughter of the owner of the *Chasseur vert* inn: "She is the first German woman," he writes, "whom I saw totally exhausted after climaxing."[139]

What is undoubtedly most important to us here is that the diarists sometimes analyze virile emotion and pleasure. The recording of the intensity of orgasms or of potential disappointments is seen, unfortunately, much more rarely than the counting up of copulations and orgasms. Nevertheless, Michelet plans a great project to be called "the private diary devoted to the physical life of Athénaïs and Jules." It will have, he claims, a completely different significance from his books devoted to *Amour* and *la Femme*.[140] As he sees it, this diary is intended to be specifically about virile orgasm and the pursuit of the "inventive erection."[141] Unfortunately, its richness cannot be fully analyzed here; it is worthy of a separate volume.

A half-century earlier, at a time when the influence of the amorous marriage, still lingered, the union that Mme. Roland enjoyed with her husband, Benjamin Constant, inspired in the latter a hymn to the pleasures of the conjugal union, at least as it was experienced in the first years. Michelet, fifty years later, exalts, in turn, conjugality, alone capable, in his view, of leading man to the heights of orgasm:

> The mistress you mount or caress for an hour on your way somewhere, whom you enjoy without getting to know—is one thing . . . ; it is another thing to have a woman whom you know deeply, whom you see day and night with all your senses, whom you see get up, go to bed, sleep, eat, whom you know deep down to the core, who is candid, loving, who is open to your curiosity and wants to be more filled with you, more blended with you. . . . The mistress is just coitus, and short-lived! The beloved woman, perpetual enjoyment.[142]

Much later, on 8 July 1865, after Jules has "entered" Athénaïs at noon, completely dressed, and as the spouses, after a time interrupted by an ex-chambermaid, have taken up their lovemaking again in earnest, Michelet is elated: "How much more does the woman make me cum than a girl, a fresh new child whom you haven't molded, shaped, impregnated, made yours!"[143] Expressing himself in this way, à la Pygmalion, he brings to light a mode of stimulating male desire and virile emotions that can be found in others, although less vibrantly, but which contradicts the *topoi* of bawdiness.

As for Stendhal, on the other hand, following the example of doctors, he connects the intensity of man's pleasure to novelty. On 10 August 1811, he was certain, the day before, to be sleeping with the pretty Angéline, his mistress, to whom he confides with regret, "I can't get hard without some effort or cum unless I'm thinking of another woman—Mme. Daru—who, conversely, though inferior in every way, gets me into a superb state."[144] In agreement with the doctors who dread excess, Musset, for his part, keenly fears the paroxysm of pleasure. When his nerves are shaken, he is afraid of what he might be capable of doing. Back in Paris, the day after his break-up with George Sand, he admits fearing that if he goes to one of the girls, he might strangle her "at the moment of crisis [orgasm]."[145] This is what prompts us to attribute to him the writing of *Gamiani, or Two Nights of Excess*, a very popular erotic novel.

In a completely different register, particularly familiar to doctors, Michelet evokes—without, unfortunately, being able to experience it with Athénaïs—the virile pleasure elicited by the desire and idea of procreating: that exuberant moment in which the male has the impression of transmitting a life and shortening his own in so doing; in short, of abiding by the exigencies of the species. As for the hymn to the male emission that "completes" the woman,[146] it is in accord with everything that, in doctors' views, relates to getting pregnant. Michelet writes on 5 March 1856:

> The most desirable woman is the most sensitive one, and the most sensitive to a certain male; she is the one who, soaked for a long time with his seed, with his thought, remains similar to him, loves herself by loving him, desires herself by desiring him and feels incomplete and empty when she does not have by her side her male, who, alone, completes in her his own personality.[147]

He dreams in his coituses of "savoring the deepest depths" of the woman, without violence[148] and without haste;[149] in a burst of lyric sincerity, he asserts: "the sea, my wife's cunt: my two infinities."[150]

Michelet's tone may make us smile today, but for a comprehensive perspective one must refer to the great texts. It is from their specificity that one may grasp the emotions of an epoch. In the area that concerns us, Michelet's diary, because of the acuity of its analytic project, constitutes a most advantageous means of access.

At the end of this stroll through the network of pleasures and anxieties, except for the few hymns to the excitement of conjugality, what stands out is the coherence of the code of virility, the behaviors it enjoins, and the contradictory emotions it governs. Public bawdiness, male haunts, epistolary secrets, and better than anything else the writing of one's inner self are in accord with the recognition of a role that often can change into a burden. Such is the background sketch of virile attitudes extending right into the twentieth century, except that, in the course of a few decades, cracks will show up and then grow deeper, notably around the time that runs from 1860 to 1914. At that time, old anxieties and new worries alternate with each other and at times overlap. This surreptitiously modifies the set of behaviors that has just been described.[151]

10

MILITARY VIRILITY

JEAN-PAUL BERTAUD

THE VIRILITY of a civilian is an offer of life, that of a military man the pursuit of death. The soldier works his body and fashions his mind in order to be prepared for the most abominable violence. From the eighteenth to the nineteenth century, firearms make considerable progress but they do not take down all combatants. In battle, the charge at knifepoint becomes entrenched. This moment of intense aggression in which flesh is cut into and throats are slit requires the warrior to have the talents of a contract killer: to act quickly and without compunction. Thus, when the cannons quiet down, soldiers inspire in their compatriots as much fear as fascination. For the bourgeois of the Directory, soldier and good-for-nothing are the same. Service men are "like Mars in combat gear going to a bawdyhouse party." When drunk, they adopt the most indecent attitudes "toward the servants of Venus," stop every woman indiscriminately, treat them like street walkers, and threaten to beat up their husbands.[1] Under the Empire, passers-by step out of the way of veterans. They fear an abrupt outburst of savagery from an individual with a face and skull fashioned with scars.[2]

What to do to contain the fury necessarily drilled into the soldier's body once peace returns? How to make an honorable man out of the warrior whose physical strength and mental universe are devoted to the art of skewering his fellow man? Circles of thinkers and power-holders in France outfit the military man with a virility capable of being modified according to circumstance. The virility that possesses the worker-soldier during peacetime changes so as to suffuse the body of the virtuous warrior. In the first case, the soldier's virility, imitative of ancient Rome, is turned toward the useful tasks of clearing, colonizing, or Frenchifying conquered territories. In the

second, it makes of the warrior an individual ready to be martyred for the homeland, embodied at times by a man who is there when needed. The military man not only sees his human dignity restored, he becomes a superman. His virility is shown off as an example to other citizens. Yesterday he was accused of contributing to the "degeneration of the race," and now he is being learned from as the declining virility of citizens is revived and the nation is regenerated.

Everywhere the renown of military virility is celebrated: in the press, in literature, in the theater, in painting, and in poems and songs. Nevertheless, when it is a matter of presenting the military man in an act of war, the media always respect the same rule: they sterilize the battlefield. In order not to offend public sensibility, wounded, mutilated, or bloody bodies are exposed as little as possible. The specificity of the métier of fighter becomes blurred, and the singular masculinity of the warrior partially diminishes.

But is it really true, as the propaganda would have us believe, that military men devote all their strength and energy to the exclusive service of the country? In the ceremonies that precede or follow acts of war, do the officers and the troops sacrifice themselves to the cult of the nation or to that of their clan's virility? Do they regenerate a languishing nation or transform it into a killing machine? Is the impotent man any less a soldier or warrior than the draft-dodger? From Sébastien Mercier's theater and Balzac's *Comédie humaine* to Abel Hermant, Lucien Descaves, or Georges Darien's novels, the male is the one who deserts. The figure of the dissenter never supplants, however, the figures of the soldier of Year II (1793), Napoleon's soldier of the guard, or the Zouave of the Second Empire. In France, as in other European countries, in the nineteenth century public opinion recognizes that the real man is made inside the barracks.

THE MILITARY PHILOSOPHER AND THE FARMER-SOLDIER

Denouncing war and condemning the soldier, the eighteenth century never stops presenting war as a scourge. The *Encyclopédie*, in an article by Jaucourt, denounces it as the "fruit of men's depravity," "convulsive and violent malady of the political body." It stifles the voice of nature, of justice, of religion, and of humanity. It gives rise only to robbery and other crimes; with it are linked fear, famine, and

desolation; it tears apart the soul of mothers, spouses, and children; it ravages the countryside, depopulates the provinces, and reduces towns to dust.

War can be outlawed. Once sovereigns, enlightened by the bright lights of the century, understand that their glory depends on their subjects' happiness and on respect for people's rights, they will no longer try to augment their power or increase their authority inequitably; they will agree to put an end to the misfortunes of war and to the outbursts of man's vilest instincts. The abbé de Saint-Pierre's hope for perpetual peace reflects that of Grotius, who, the century before, believed that a federation of princes was possible that would establish peace on the continent. Let the monarchs meet, unite their efforts, and name arbiters to regulate disagreements, and war will disappear!

Denunciation of war brings with it rejection of the warrior. The antimilitarism already present in the writings of Fénelon increases in 1763 after the reversals suffered during the Seven Years War. Indicters of war, the *philosophes* consider soldiers to be lawless men without faith, libertines because they are accustomed to an existence that exempts them, in large part, from common laws. Often drunk and at times streetwalkers' pimps, soldiers show a gross virility close to bestiality. Bearers of the chains of despotism, they should regenerate or disappear. In 1744 Voltaire, in his *Funeral Oration for Warriors Killed at War*, speaks out against them while he praises the officer, who is "often adorned by literary culture and even more so by gifts of the spirit." The troops, he explains, are mercenary murderers who have abandoned their villages, prompted by the spirit of debauchery and the desire to plunder. "Taken as a group, they form the proudest and most imposing spectacle in the world; each taken individually, in the inebriation of their brutal fantasies, with a few exceptions, they are the dregs of the universe."[3]

A few years later, the *philosophe*'s vision changes. While the patriarch De Ferney still stigmatizes soldiers' vices, he worries over the fate of those he calls "Alexanders on two bits a day."[4] The public's attitude toward military men also changes. Contemporaries are alarmed over the acts of violence that they suffer in the course of their apprenticeship in the métier. In wishing to develop in the soldiers a warrior virility, the army makes punished slaves of them, meting out, for the slightest misdemeanor, rifle butt blows or blows from the saber. Why be surprised that some of them try to escape their situation? In the *Encyclopédie*, under the article "Defector," Saint-Lambert asks for the abolition of the death penalty for deserters, and Marie-Antoinette weeps at the performance of the *Déserteur* by Sébastien Mercier.

Other plays, such as *How to Be Happy, or the Benefactors*, present soldiers whose virility gains in virtue what it loses in brutality:

One cannot be an honest man and a bad soldier.
That glorious state, in consideration
Of all its obligations,
Requires virtues more regular
I would say even more austere
Than other professions.
The slightest carelessness is punished
Rigorously but fairly.
Just the appearance of vice
Deprives you of the honors of society
From which you are excluded, as a useless member;
The soldier's first duty is the easiest
Since it is devotion to his king.[5]

The play *The Two Grenadiers*, performed in Paris in 1786, shows the high regard earned by military men: Suzanne, a grocer's daughter, dies of jealousy at the announcement of the upcoming marriage of her cousin, a village judge's daughter, to a young soldier who brings together virility and morality.

P.-L. Béranger, in a yearbook taking a census of the acts of courage accomplished by Frenchmen, reserves a choice place for service men: the intrepidness displayed by soldier Thion for the Touraine regiment, the generosity of the French Guards, the honorable traits of the grenadiers of the Normandy regiment, and a grenadier's grandeur of spirit provide for ample articles. Access to public gardens remains prohibited to dogs and prostitutes. It is no longer prohibited to men in uniform.

The general evolution of sensibilities and military men's participation in works of public interest, such as the digging of the Canal de Bourgogne or the fighting of fires,[6] explain in part the reversal of public opinion toward soldiers, henceforth recruited more in France than abroad. Hunger, rather than crime or the fear of punishment by or flight from the police, motivates their enlisting.[7]

There is a modification of society's view of the military man and an intellectual change on the part of certain officers who become philosophers and embellish their métiers with a new ethic. They endeavor to be all at once honest men and men of war, to bring warrior spirit together with fine sentiments, and finally to

unite military honor with social utility. For them, the soldier or warrior's virility is acquired more by physical exercise than by maneuvers repeated in excess. It is conserved thanks to a moral education motivated by a love of country. Military virility takes on the colors of patriotism, and the soldier becomes a citizen.

In 1769 Colonel Godfrey Zimmerman, speaking to officers, encourages them to be virtuous, for only a tranquil conscience allows one to confront and surmount "the fear created by muskets and artillery." Accordingly, he explains, the principal virtue is "honor." The officer's honor surely resembles that of the knight anxious about his reputation, respecting his word of honor, and keeping widows and orphans safe from the perils of war; it is, above all, "the honor of serving his prince and his country and the glory that should be brought to him because of it."[8] And it is up to Zimmerman to add that the officer should "sacrifice coolly the delights of society, tear himself away from the arms of his parents, his friends, the wife he adores and go expose himself cheerfully to the perils and excessive exhaustion that are inherent to his station."[9]

Proud of serving his prince and his country, the soldier is both a citizen and a patriot. Armand, in the play *How to Be Happy*, affirms it before his captivated spectators:

Born a citizen, the love of Fatherland
Circulates with the blood in his heart;
But if he has proposed to be its defender
It is a double knot that binds him;
His talents, his virtues, his glory, his pleasures
He must sacrifice, even in old age
To this finest title he remembers continually
Right up until his dying breath.[10]

The citizen soldier is called upon to curb and channel a virility that, prompting him to fearlessness, leads him to expose his life and that of his comrades at arms. "Warrior virtues," we learn in *The Military Man in Solitude, or The Christian Philosopher*, "are not exactly based on the contempt that one has for life." The warrior must demonstrate firmness of character and presence of mind to maintain, "amidst the confusion and horrors of combat, self-control and freedom of the senses"; these virtues allow him to "conduct usefully all the deeds of intrepidness in the good service of the king."[11] Avoiding temerity, "which is the death of honor,"[12] the good military man is moderate, humane, and just. He aspires, as a result, to become

more a great man than a hero. Authors have recourse to the Bible to emphasize that "the Maccabees, those great men who took back oppressed Judea, were nonetheless as admirable for their moderation and greatness of spirit as for their wondrous acts and their great deeds."[13]

Voltaire adds to his *Summary of the Century of Louis XIV* the story of the Chevalier d'Assas [cf. fig. 10.1]. Surprised by the enemy and threatened to be put to death if a single word escapes from his mouth, the chevalier does not hesitate to die, pierced by arrows, shouting: "Auvergne is mine; here are the enemies!" A hero, the chevalier also figures in the parade of great men, since by his death he saves his friends. Military men venerate even more Marshall Catinat, called Father Thought, because of his wisdom in the leadership of men. In 1685, in his fight against the

FIGURE 10.1 DEATH OF NICOLAS, CHEVALIER D'ASSAS, NEAR CLOSTERCAMP, IN 1760.

Nicolas, Chevalier d'Assas, captain of the Auvergne regiment, who was surprised by the enemy near Clostercamp in 1760. Ordered to keep quiet so as not to give the alarm, he preferred death to silence and so warned his companions. His action made him at once a hero, a courageous warrior, and a great man willing to sacrifice himself for his friends.

Source: © Leemage

Vaudois, he prefers dialogue to violence. Constrained to combat, he risks one thousand dead, yet he knows how to be humane with regard to the vanquished. Louvois orders him to set the country of Juliers on fire and bleed it to death. He refuses. In retirement, he lives modestly on his property, swapping his sword for pruning shears and spade.

Humanity is again at the heart of the military teachings promulgated to the future Louis XVI by Masson de Pesay, a young cavalry officer: it is better to spare the blood of the vanquished, he declares, than to show off a vain bravura.[14]

Military virility gives out when patriotism does not motivate it. It becomes corrupt if inhumanity overtakes it, warns *The Citizen Soldier*. This work, appearing in 1780 and undoubtedly written by Joseph Servan, also contributes to the fashioning of the new archetype of soldier and warrior virility. It explains that as citizens soldiers should show themselves to be not only "beneficent, true, humane and fair toward others" but also useful to them. Servan recommends that they "give comfort to the poor man in his labors" and, if necessary, help him "plow his field, repair his walls and dig his ditches."[15]

The philosopher military man dreams of transforming the warrior into a soldier-laborer once peace returns. The government would save money that way, as Servan explains:

> It is out of love for public welfare, for glory's recompense, that the State must get defenders ready. But it is essential that this order not be undertaken at the expense of everyone else; and if it is necessary to ensure sufficient subsistence to each soldier while at the same time he must be compensated, then the militia must be employed so as to help the state support him.

It is therefore appropriate to habituate young recruits, even at the tenderest age, to the rough, difficult jobs of the countryside. "From that point, this part of the population" will get "subsistence," will fertilize "the uncultivated lands, and, far from being costly, as at present," it cannot help "being infinitely useful to the state that it is charged with defending." The soldier, who will thereby gain in physical strength and patriotism, will be able to say: "This land that I inhabit was made fertile by *me*, and it is *I* who have made it more beautiful."[16]

Thus, from the pen of officers moved by the spirit of the century appears an entirely new image of the soldier, of the development of his virility, and of the goals he should attain. War was the feat of professionals; Servan and the Comte de Guibert, the most famous tacticians of the period, want it to become the affair

of the whole nation. Since all citizens are called to be soldiers and all soldiers to be citizens, it is appropriate to call more on their sentiments than on their muscles, more on their reason than on the automatism of their limbs, and much more on their patriotism than on an aggressiveness on demand. They will try less to be athletes than to be virtuous men. In a few lines, Servan paints the ideal portrait of the soldier when he advises those who are supposed to instruct him: "Don't be afraid of making him cowardly. Start by making him humane. If you have succeeded in inspiring in him a love of country, nothing will be able to diminish his courage."[17]

Here is where the image comes alive, and the utopia becomes reality. In 1789, soldiers take an active part in the Revolution by mutinying or by refusing to fire on the insurgents.[18] Many of them are named patriots. But the nation acquires a new sense: it is the land in which citizens live, free and equal, forming a sovereign people.

CITIZEN SOLDIER AND GLORIOUS WARRIOR

At the same time that the French Revolution grants the citizen the right to bear arms, it imposes on him the duty to use his arms to defend the country. Thus, from 1791 to 1793, battalions of national volunteers suddenly appear. They arise, they say, to "give a hand" to the regular army, which helps to bar the route of sovereigns working as a coalition against a France dissenting from the established order of the continent. Soon there are not enough volunteers left, and the nascent Republic, dominated by Jacobins, decrees on 23 August 1793 a mass call to arms. All young men between 18 and 25, single or widowed, and without children are required to serve the flag. The passage from adolescence to adulthood takes place from then on in one space, that of the training camps. The young recruit is supposed to acquire there a virility at once military and civil. As a soldier, he hones his strength, develops his stamina, and forges his physical resistance. As a citizen, he votes for the Constitution, participates outside the service in political groups, and elects his leaders, administrators of his unit, and members of the panel of court judges. Motivated by the Republican spirit, the conscript learns, above all, self-effacement and absolute devotion to the fatherland. Loving it, sacrificing oneself, and agreeing to die for it form a triad, the first proof of the enlisted man's virility.[19]

To achieve this successfully, the conscript is aided by a noncommissioned officer. A master at arms, the latter instructs him about his new station. As a pedagogue

of civic spirit, the noncommissioned officer educates the conscript in order to make of him a full-fledged citizen. To help him vet in one single gesture both the body and the mind of the recruit, the noncommissioned officer uses a guide: *Instruction for All Ranks of the Infantry*. The Committee on Public Welfare, which is behind this manual, seeks to transmute into reality the concepts of the Enlightenment and those issued by military philosophers like Guibert.

The marshal, using the anatomical and physiological knowledge of the time, issued rules suited to the formation of the combatant. He recommended not to impose them by force but to explain their objectives to the recruit. For the military instructor of Year II (1793), the soldier's body becomes a political issue. He makes the conscript understand that the required postures and gestures have a meaning. Marching in step, lining up by forming attack columns and in defense blocks, loading the ball in the barrel of the rifle, and folding the bayonet for hours on end allow the soldier to remain safe at the moment of danger, to save his comrades, and ultimately to defend the city. At the same time the military men educate their corpsmen to become the best instruments of combat; they learn that they belong to a community of citizens subject to rules that they themselves issued. Not caring for or training the body is injurious to others, breaks the bond of fraternal citizenry, "fails to uphold the social order by endangering humanity, which is its principle,"[20] and, in the end, betrays the democratic republic.

To complete the civic education, delivered on the basis of techniques of combat, the instructor turns to a public reading of the Declaration of the Rights of Man and Citizen, the Constitution, and the laws concerning military crimes and misdemeanors. He thus imbues the soldier with this truth, that "his obligations are no more burdensome than those of the citizen: like him, he is subject only to obedience to the laws, and in the military state, as in the civil state, anyone who disobeys the law is a dangerous individual who must be cracked down upon." The head of the Second Battalion of the Tarn lectures thus:

> When a soldier obeys his leader, it is certainly only the law he obeys and not the individual, for his leader can order him only to carry out a law. The soldier who disobeys his leader is at odds with him in relation to the law that he agreed to and is culpable in the eyes of society, whose harmony he disrupts.[21]

The mode of virility imagined by Saint-Just and the other members of the Committee on Public Welfare is not only destined for the young recruits, it is also supposed to serve to regenerate corrupt citizens. A Jacobin military man

explains, for example, that the army transforms "the egotists and schemers, the shameless bachelors and the children who married before the age of consent in order to get out of the draft, the indolent, independently wealthy and the rich businessmen, that whole throng of idle, useless men, that whole aristocracy of munificence."[22] During the reign of the despots, he writes, the army was "a mode of imprisonment and rehabilitation of indigents"; under the authority of the sovereign nation, it is the great container "of aristocrats of wealth, the place of their education in civic virtues and their gradual affiliation with national glory." "The *muscadin* throng (anti-Jacobins)" spread across the core of the battalions will give rise to good citizens, to soldiers whose strength will be directed entirely toward the common good.

> Necessity is a tempering that can be applied to all ages, to all temperaments, to all circumstances: habits give way to other habits, and fatigue hardens. When the rich have the honor of finding themselves comrades with the sans-culottes, they will have but one position to choose: that of falling wholeheartedly into line. Equality is such that measures taken affect all indiscriminately: the poor have opened a career, may the rich follow their example: may they themselves deign to fight to conserve their person and their property.[23]

The Revolutionary government uses all the media at its disposal to illustrate the virility, at once warrior and civic, of the military man, which makes of him a model citizen. Following the example of the press, which reports acts of courage, the theater becomes a pedagogical space. Plays bring to the stage warriors whose bravery is sustained only by patriotism. In a lyric show, for example, put on at the Théâtre National de l'Opéra on 27 January 1793, the courage of the soldiers of Valmy is presented in this way:

AN OLD SOLDIER (addressing the municipality)
Back in the days of our youth
We braved bloody conflicts
Now the sadness of old age
Ties down our weakened arms.
Heirs to our courage,
Our sons have greater destinies;
They have an advantage over us;
We were not republicans.

THE MAYOR

You warriors who fly to combat

Respecting the law, you merit victory.

Virtue makes real soldiers:

In virtue lies glory—

Spare the blood of humans;

Sanctify war by conquering peace;

With laurels on your forehead and olive branch in your hands,

Deliver and calm the earth.[24]

By featuring young men who enter into service when their elders are no longer alive, their courage augmented by republicanism and by the magnanimity that warriors must be imbued with—by taking up the themes of *La Marseillaise* in another manner, the play displays virtuous virility. It reproduces the speeches addressed to the army by representatives on mission. Their words emphasize that "the people, in whom sovereignty resides, require that all its members be virtuous, incorruptible and pure."[25]

As for the songs composed for the conscripts, they describe "the intrepidness shown to garner the laurels of Liberty," celebrate "valor united with justice," and "male virtues ready to be immolated to defend the fatherland." They ultimately reflect the words "of warriors drawing their strength at the altar of the fatherland under the banner of liberty."[26]

Reprised in chorus at civil festivals, the songs unite soldiers' energy, vigor, and physical and moral vitality with the steadfastness of the citizens and their representatives. Thus, in Collioure, on 25 July 1793, the festival celebrating the presentation of the constitutional act to the people gathers together the representatives of civil and military authority, the members of popular clubs, and individuals of every age and both sexes. Together, they form a *tableau vivant* of the union of the soldiers' physical qualities and the virtue bestowed upon them by the citizens.[27]

Ceremonies mark the formation of the half-brigades in which the veteran soldiers of the King are mixed with the national volunteers and the conscripts. They take on the look of veritable civil masses attended by the inhabitants of neighboring communes. The representatives officiate with the Declaration of the Rights of Man in hand. Conforming to the cult of the fatherland, they celebrate youthful combatants. They recall the sacrifice of the young martyrs for liberty and recommend following their example. They preach hatred of kings and tyrants, those "Lilliputians" whom "the young Hercules" will succeed in overthrowing through their

bravery and their love of country. The representatives have the soldiers acknowledge their flags. They are decorated with inscriptions embroidered by mothers, sisters, or friends who, intoning *La Marseillaise*, recall "that victory rushes in to the masculine tunes of the Fatherland."

The young martyrs most often evoked by the representatives of the commoners are J. Bara and J. A. Viala. Their courageous deeds are among the first to figure in the *Collection of Heroic Actions of French Republicans*, the catechism of civic virility distributed in the schools as well as to the army.[28] Both boys were 13 years old; Bara was killed in Vendée by Royalist peasants, Viala in a fight that pitted him against the Federalists. The Convention proposed that they be placed in the Pantheon. Robespierre, becoming more particularly attached to the person of Bara, emphasizes:

> It is not possible to choose a greater example, a more perfect model to excite in young hearts the love of glory, of the Fatherland and of virtue, and to prepare for the wonders of the rising generation. . . . The French have heroes of 13 years old. It is liberty that produces men of so great a character.

That two adolescents scarcely beyond the stage of childhood should be presented to soldiers as models of virility is something of a surprise. The Jacobins, to be sure, objectify the two heroes in order to oppose the cult of Marat, whose political and social message worries them. They use them, above all, to show that a hero can be of any age,[29] that all men, made of the same stuff, are capable of bravery and of self-abnegation when motivated by patriotism.

Men only? Women are not totally excluded from the textbooks of heroism. But they are presented more as helping the wounded than as firing the shots. When Léonard Bourdon, author of the *Collection of Heroic Actions*, brings female citizen Barreau onto the stage, it is to introduce her and to emphasize that she is taking care of her wounded husband: "There, providing the care of conjugal tenderness, she proves that she has not given up the virtues of her gender."[30] Most of the women who accompany the army are actually regarded less as potential heroines than as persons suspected of "distracting the courage of the warriors and tainting the source of pure French blood." Willingly puritanical, the Jacobin exhorts soldiers to stay away from the girls, who are considered agents of tyranny. "Remember," he tells them, "despots favored debauchery and corrupted men only in order to degrade them and to drag them into the most vicious servitude. . . . Can he who loses his senses for an instant be responsible for his actions or for himself?"[31] Sexuality should practically be left asleep until the moment, says the Jacobin magistrate

to the soldiers, "when you find delight in a dear companion and, in peace, you give us a robust generation worthy of holding up your reputation, your works, and the Liberty of the Republic."[32]

Once Robespierre, Saint-Just, and their friends fall, the Convention and the Directorate Republic that succeed them show less eagerness to transform the soldier's body into a tabernacle of virtues. The governors very often apply the advice given by Carnot in *La Soirée des camps*. This newspaper, distributed to the troops some time before the fall of *l'Incorruptible* [Robespierre], points out that the conscript was, above all, a soldier and that his duty was to devote himself to the apprenticeship of his station.

Plunging into foreign lands and no longer receiving visits from deputies, soldiers fall under the control of their generals. The latter, in the armies that they command, gradually substitute group spirit for civic spirit. The honor of each army, of each half-brigade, and of each battalion is to be preferred over the virtue of the citizen. Leaders such as Bonaparte take advantage of this to create and sustain the cult of personality. At the time of the commemoration of the days of the Revolution, the army still celebrates the cult of the fatherland but the ceremony can scarcely hide the festival of the clan. The virility of combatants is glorified just as much and sometimes even more than the nation. Everything changes when Bonaparte is made First Consul. To govern, the general imbues the public spirit with military values. The military man's body and his virility again become political issues.

HONOR, GLORY, AND VIRILITY

Napoleon Bonaparte receives a society entirely transformed by the Revolution. No more orders or states, just a single people, a single nation in which each individual, henceforth freed from any constraint, possesses a liberty limited only by that of his neighbor. Money, which has become the sole criterion of social distinction, smashes to bits the fraternity born of revolutionary struggle. Individualism reigns. How to order or govern such a scattering of wills bent most of the time on the frenzied pursuit of profit? How to renew the concept of social utility; how to teach again service to the State? In Bonaparte's view, it is by borrowing the honor that has taken refuge in the camps. Aimed at the good of the State and Nation, that honor contains the qualities of the knight and the virtues of the citizen that allowed the soldiers to crown themselves with glory.

Lucien Bonaparte, Minister of the Interior under the Consulate, conveys his brother's thoughts well when he says:

> Incompetence upset everything from the inside, and genius repaired everything from the outside; furor was in the forum, heroism was in the camps; *proscription* (summary execution) brandished its sword in our countryside, and our soldiers, uniting humanity with courage, came to the aid of the vanquished enemy. Freedom, veiled everywhere, was no longer but a Fury for the groaning nation, but the shouts of victory raised at our borders pushed back the victims' groans on the inside and shielded us from the world's derision.[33]

Honor must therefore infuse the entire civil society, lead to the necessary union of everyone's energy, and inculcate the citizens with the duty of self-sacrifice for the common good, for the *res publica* embodied from now on by the First Consul. The citizens, living in an atmosphere pervaded by the flashes of victory and having nothing on the horizon besides honor, will acquire a new virility.

Bonaparte makes of honor a veritable institution by creating the Legion of Honor on 19 May 1802. Its members are first "military men who have rendered major service to the State in the war of Liberty," then citizens "who, through their knowledge, their talents, their virtues, have helped establish or defend the principles of the Republic or helped people love and respect justice or the public administration." Civilians who belong to the Order take part, in a way, in the sacred essence of the soldier and are metamorphosed into "honorary military men," to use J. P. Sartre's expression.[34] Among soldiers, magistrates, administrators, artists, and the most distinguished scholars "graced with the same distinction, there is seen a sort of fraternal equality; and this favorable system of unity will be propagated throughout society."[35]

It must first affect the children of the legionnaires. "That segment of young men whom we might have to argue about because of their softness, companion of great affluence"[36] will also enlist in the army. They will join the hundreds of thousands of young men, aged 20 to 25, whom the draft, created under the Directory, summons annually to serve. Under the aegis of honor and glory, they all undergo the initiation rites by which they will pass into adulthood.

The type of military virility presented by Bonaparte borrows at once from the Ancien Régime and from the Revolution. The First Consul—then Emperor—places it under the patronage of Latour d'Auvergne. Bringing together the qualities of the Ancien Régime military man with those of the revolutionary soldier, Latour

d'Auvergne responds to the political issue of the day, which is oriented toward the "bringing together of parties." Born in Basse-Bretagne in 1743, Théophile-Malo Corret de Latour d'Auvergne comes from a hybrid branch of the Bouillon family, to which Turenne belongs. A sublieutenant in 1767, he lives a life divided between the silence of the writing desk and the furor of the battlefields. Fascinated by historical and linguistic research, he writes several works in which he studies the relations between the dead and living languages of Europe and the Celtic language. A first-rate military man, he participates in 1781 in the ranks of the Spanish army in their fight against the English. In 1792, refusing to emigrate, he is captain in the army of the Alps and the first to enter Chambéry. In 1793, at the head of eight thousand grenadiers, he forms an "infernal column" that throws the ranks of the Spanish army into panic. "He has the gift," say the soldiers, "of enchanting the bullets!" In 1797, Latour d'Auvergne, retired from the army, refuses the rank of general offered to him. He comes out of retirement to replace the last of his best friend's sons called up by the draft. The First Consul gives him an honorary saber and dubs him "first grenadier of the Republic." Latour d'Auvergne dies on 27 June 1800 in Bavaria, pierced by a lance. The army is in mourning for three days, and the soldiers take up a collection to buy a silver urn to hold his heart. It is deposited in *Les Invalides* during a grandiose ceremony presided over by Bonaparte. He is inscribed forever on the control registry of the 46th half-brigade; every day, at the calling of his name, a sergeant responds, "Killed on the field of honor!"

Members of the *Tribunat*, or the persons in charge of making the funeral oration for the hero, characterize him in several different ways. They depict him, first, with traits resembling those of Catinat. He is the "great man." He made for himself, writes C. Léger,

> a military morale . . . ; it was based on virtue and wisdom. He became accustomed to fighting without anger, vanquishing without ambition, without vanity; he respected the misfortune of the prisoners he took, and he honored their courage; he protected the peaceful, trembling farmer, too often the victim of armies' passage.[37]

He brought together, adds M. de Cubières,

> the vitality of Caesar with the modesty of Epaminondas. . . . He sought everywhere brilliant actions; he was wrapped in glory by his composure, his intrepidness and his prudence. Montaigne distinguishes two types of courage, military valor and

philosophical courage; Latour d'Auvergne possessed both to the utmost, and it should not be thought that the first was only a blind and often dangerous enthusiasm; it was always accompanied by prudence. He endangered himself often, but it was more to animate his comrades than to endanger them.[38]

To the quality of the great man who unites bravery with circumspection, manages the life of his soldiers, and respects people's rights, Latour d'Auvergne adds the precepts of the military philosopher. A man of the Enlightenment, "he pondered the works of Pufendorf, Grotius, Montesquieu, Rousseau and Mably."[39] J. Debry writes:

> A veteran has said that a citizen who dies for his country serves it more in one day than he could have served it during his whole lifetime. What can be said, then, of the man whose studies were continually related to public utility and who, forgetting about himself each day of his life, devoted all his days to his country? We will make public the fact that he knew the principle of real heroism: a philosopher in the camps, he demonstrated through his knowledge the excellence of a free institution; he fought relentlessly and without ostentation to establish it.[40]

A courageous soldier, a friend of humanity, "Latour d'Auvergne defended," says one anonymous writer, "the honor of his nation and the legitimate claims of a free people."[41] Above the "parties," this fallen aristocrat who chose to go to war for the Republic was "intoxicated by enthusiasm for the public good."

Soon the three colors of the flags of the Consular Republic are adorned with the inscription "Emperor, Fatherland, Honor," and the half-brigades are transformed into imperial regiments. In the gallery of heroes, the soldiers killed on the battlefield of the Grand Army (Napoleon's army, 1804–1815) take their place next to Latour d'Auvergne. Teachers teach their pupils that all the strength at their disposal must, following the soldiers' example, meet "their obligations to the Fatherland, a word that may not be taken lightly and that holds within it the greatest affection." Primary school teachers elicit admiration from children and adolescents "for the warriors who devote their life to the fatherland and the supreme leader on whom the destiny of the Empire is based."[42]

The School of the World Open to Youth of 1805 traces an idealized portrait of the man of war. The soldier, asserts the author, is trained to show "a noble boldness that lifts the man above the greatest of perils, a sudden ardor that catches fire with all the more fierceness as the dangers are prodigious, a fervor so quick and so keen

that it makes, all at once, the mind sharp, the fist invincible and the body fast and dependable." Disdainful of the riches and frivolities of this world, the military man is made of rectitude and good faith, candor and loyalty, wisdom and steadfastness. He gives proof for the young *collège* and *lycée* students of "the pure interior satisfaction of the man who has never strayed from the paths of honor."[43]

Repeating almost word for word the *Essay on the Principles of Military Morale*, written forty years earlier by Colonel Zimmerman,[44] Professor P. Crouzet, addressing the students of the Military *Prytanée*, explains that "virtuous love itself, despite all its power and the strength of its bonds, cannot carry off its young captive, the ardent pursuer of honor." While love prepares for him only caresses, pleasures, and parties, the warrior prefers to it "the fatigue, the danger, the iron, the blood, the carnage and the death" that honor presents to his imagination. The professor continues with an incantation to honor, "which comes not only from that grandeur of courage that helps us brave every danger but also from the severity of the principles that attach us to our duties. Its temple is a strong spirit; its sanctuary, a pure conscience; its form of worship, the practice of all the virtues."[45]

Teachers have *lycée* students put on plays in which the soldier's virility, glory, and honor are intermixed. In a dialogue in verse, a young hero, who is following the traces of his father who died at Valmy, behaves like a Frenchman. "Endowed with an indomitable valor," he regards the earth as a vast field of honor:

Faithful at all times to his flag,
Idolatrous from the cradle of warrior virtue,
And already imagining the bursting of glory,
Before he is a man, he has become a soldier.[46]

Students discover in the *Bulletins de la Grande Armée*, dictated by the Emperor, the heroic acts carried out on the battlefields of Europe. Their teachers draw from them subjects for compositions.[47] Alfred de Vigny writes:

I belong to that generation that was born with the century, which, nourished on bulletins, was always looking at a naked sword. . . . Our professors resembled chief heralds, our classrooms caserns, our recreation maneuvers and our exams military reviews.[48]

The *Bulletin* celebrating the glory of the conquering heroes of Austerlitz is posted on the walls, and the worker with the loudest voice reads it to his companions.

The bourgeois opens it up at the café and takes it home to his living room. The grandfather, his finger on a map, reads it as his grandchildren play with soldiers at his feet. Reproductions of the painting by Louis Boilly that depicts that very familiar scene decorate the walls of more than one home. At the theater, the actors interrupt the performance, and like chief heralds announce the latest victories to the spectators. Mayors read the bulletins to the office staff, and from their pulpits curates, pastors, and rabbis add a religious dimension, making of the combatants' virility something sacred. "The Lord is with us, the Lord formed our arms for war and our hands for battle," exclaims Pastor Pierre de Joux, and the Grand Sanhedrin compares Napoleon's soldiers to the warriors of Cyrus who brought an end to the captivity of the Jews.[49]

Since the warrior's humanity is an element of warrior virility, the press, on orders from Napoleon, describes an epoch devoid of any act of savagery. The soldiers are virile without excessive brutality. The officers in *Le Moniteur* appear to be exemplary leaders. They make their soldiers respect people's rights amidst the fiercest battles. When the English press launches a campaign to denounce the atrocities committed by the French in Spain, *Le Journal de Paris* admits that some soldiers, contending with the brutality of peasants turned fanatics by their priests, may have for a moment lost their minds and been out of control with rage. The journalist asserts, however, that officers quickly intervened to re-establish the soldiers' humanity, which in ordinary times they constantly demonstrate.[50] *Le Moniteur* publishes the speech of a member of the *Tribunat* rhapsodizing about having seen the "politesse of cities" become "a natural thing" in the camps. In the soldier,

> honor, always active, and the mind, always at work and increased by strength and by corporeal understanding, eminently differentiate the man from the brute and grant to invincible souls indefatigable bodies. Discipline and energy, honor and order, obedience and enthusiasm [. . .] are henceforth the Frenchmen's unchanging qualities.[51]

The press enables the French to read about the prowess of the men at arms; painting lets them see it. In the crowd that invades the Louvre or that frequents the painting salons, bourgeois and artisan, older man and younger man cross paths. The husband leads his wife with the children following. They all expect that the works on view will give virtually direct access to the battlefields. Painters of battles, or *bataillistes*, are sometimes military men, like Lejeune, Bacler d'Albe, Chaillot, Morel, or Gauthier, who took part in combat. When this is not the case, Vivant

Denon, who directs the artists, has them meet with general staff officers. With maps and plans laid out, the latter explain the operations to the artists. The painters compete with each other to get at the "historical" core by depicting the "exact location of the action" and by painting the subject in a true and intelligible manner. "The painting by Vernet that depicts the Battle of Marengo," asserts one critic, "is truly historical, for the site, the view, the position of the army—everything has been done based on real life and according to the plan of the battle."[52]

The artists actually unfold before the spectators "a visual *Gazette* or *Moniteur*" in which the horrors of war practically disappear. When sketches are exhibited for the competition on the Battle of Eylau, the police report blames the artists who "have accumulated all manner of mutilation, every variety of a vast slaughter, as if they had to paint precisely a scene of horror and carnage and make war execrable."[53] In 1806 the critic P. Chaussard reproaches P.-A. Hennequin for having displayed in his *Battle of the Pyramids*, " a spectacle of horror, of hideous wounds, of bleeding limbs, of mutilated, palpitating torsos." "These disgusting methods, these gravedigger scenes," must be left "to the English theater; that's where they would find their natural place. But for a nation whose sure and delicate taste ensures superiority in the Arts, these hideous, repulsive objects would have to be hidden—or dissimulated if they were necessary to the subject."[54] At the risk of rendering the virility of the combatants imperfectly, the artist sterilizes the battlefield to deliver a political message: the leader showing his genius and the soldiers showing their bravery together draw attention to their honor in defending the Fatherland, constructing victory and securing with the glory of arms the peace of the Great Nation.

Heroic death is a frequent theme in the paintings. From 1806 to 1814, Denon orders depictions of generals in their death throes six times. Valhubert, for example, seriously wounded at Austerlitz, is captured with J.-F. Peyron's brush as, in a wish to share the fate of the other wounded men, he refuses to leave the battlefield. The last words pronounced by the dying men appear in the guides offered to the public. The visitors to the salon are thus all informed of the exemplary nature of a death for the benefit of Napoleon. In nearly all the compositions, in fact, the wounded expire in the presence and sometimes in the arms of the Emperor.[55]

From the Temple of Mars (*Les Invalides*) to the Temple of Glory (*La Madeleine*), from the Column of the Grand Army to the *Arc du Carrousel* and the *Arc de Triomphe*, throughout Paris the stones "speak" to tell of heroism. Juggling here again the power of the combatants' virility, the monuments dedicated to the cult of Napoleon depict him as sustained by the energy, the courage, and the abnegation of his soldiers. The new public edifices should, following the example of the

Temple of Glory, serve "to celebrate the memory of those who are devoted to the Fatherland and its holy laws. There [at the Temple of Glory], the awards earned for valor will be handed out. There, our bellicose youth will learn a sense of Honor from such illustrious examples."[56]

Theater is another medium in which the triad of honor, glory, and virility may be found. Rougemont, in *The Military Hospital, or the Ill Garrison*, sets out the catalogue of virtues of the man of war. "Valor, composure and boldness" are the first qualities. He expects only "a glorious demise" and fears "a useless death." "Always ready to fight" and "never to give up," his sole ambition is "to surpass all those who have made the career of the armed forces famous." For him, the model of "greatness of spirit" is Charlemagne, of "goodness" Henri IV, of "bravery" d'Assas, and of "modesty" Turenne. Gathering up in himself the valor of warriors gone by, the soldier places his strength in the service of humanity. In *The French in Poland* by J. G. A. Cuvelier, military men deliver Poles out of servitude. In *The Spanish Beauty* by the same author, the hero liberates a village from the oppression of fanatical priests before wedding a village maiden.

Judging by the press and by the artistic productions, the imperial soldier seems to have copied the soldier monk who, a century earlier, was preferred by Dr. Colombier.[57] To be heroes, the old guard soldiers of the Grand Army are nonetheless men who know how at times to be joyous with the bottle and to appreciate the fair sex. Official propaganda does not fail to mix martial virtues with sexuality. The songs, which are often levers of power, boast of warrior exploits and of soldiers' sexual performances. These soldiers are, for most any Jane or Maggie, the masculine ideal.[58]

The sound of the cannon disturbs young love. Rose weeps, the private is sorry to be leaving, but:

Before being born for love
He was born for the Fatherland.[59]

With the return of the warrior comes the promise of shared pleasure:

Love, which delights at all times
In the beautiful country of France,
Love, far from our combatants,
Was alive in abstinence.
Far from the growing laurel
The myrtle was withering.

Along the banks of the Seine
Our army arrives singing;
Glory sends it home
And pleasure awaits it.[60]

But the clarions sound again:

For guarding one's name jealously,
For doing justice to the dancehalls,
For dancing to the sound of the cannon,
For being good at seducing the girls,
And leaving them for their muskets
You can't beat the French![61]

Just as much as the French woman, the beautiful foreigner succumbs to the charms of Napoleon's soldiers. A drum affirms it in a saucy song entitled "Ran Plan Plan Drum Beating:"

One day on my way
In Pomerania I came across
A very pretty village girl
Coming from a neighboring market.
I greeted her gallantly
And spoke to her kindly,
Ran Plan Plan Drum beating.

How the breast heaved
Of my little enemy,
How the pulse beat in my heart
Burning with desire.
Toward a dark, charming wood
I led the beautiful child,
Ran Plan Plan Drum beating [. . .]

Once under the hazel tree
I kissed her passionately
And showed her how to handle the rod;

She meekly learned
Two lessons in an instant.
Ran Plan Plan Drum beating.

The look of the maiden
Was keen and tender;
Are you beating a retreat so soon,
She says to me, sighing . . .
Enemy whom I love so much,
Give another drum roll
Ran Plan Plan Drum beating.

You'd have to be heartless,
Or downright cold to refuse
The young, amiable village girl,
Who wants a triple kiss.
I picked up the movement again
And three times I really gave her
Ran Plan Plan Drum beating.[62]

The image of the soldier of the Grand Army, a super-male motivated by honor and completely devoted to the glory of the fatherland is, in the aftermath of events on an epic scale, revised by the very men who were actors in it and by the new generation who are disappointed not to be able to be like them.

11

VIRILITY IN THE COLONIAL CONTEXT

· · · · · ·

FROM THE LATE EIGHTEENTH TO THE TWENTIETH CENTURY

CHRISTELLE TARAUD

LOOKING CLOSELY at the makeup of the second colonial empires in Africa, Asia, and Oceania from the end of the eighteenth to the beginning of the nineteenth century, one is immediately struck by the eminently virile character of the enterprises undertaken, as much in the production of very structured, normative sets of ideas about the masculinity of empires—ideas in which the question of virility, of course, has its place—as in the elaboration of categories that organize in mirror fashion the relations between Europeans and the *others* perceived collectively. This virile character involves an alterity all the more radical because it is an essential issue, one suspects, in the battles of conquest and in the politics of "promotion" that follow those conflicts. It is therefore necessary—and this is one of the objectives of this chapter—to understand how colonization exemplified and legitimated the European victories during these wars—and particularly in Algeria from 1830 to 1871—according to a mode that could readily be referred to as "virile." Such a mode is tacitly confirmed by Paul Leroy-Baulieu, great theoretician of French colonial expansion, when he writes at the turn of the century: "A society colonizes when, itself having reached a high degree of maturity, it procreates, it protects, it places in good conditions of development, and it brings to virility a new society to which it has given birth."[1]

To this end, we must first shed light on what relates to the foundation of actual colonial mythologies, based upon men, events, and places in the service of national greatness and/or national renascence, aiming to fight simultaneously against decadence and degeneration. These conditions, theorized from the early nineteenth century, notably in medical and scholarly literature, were thought to be due to a softness and feminization purportedly in the process of becoming generalized in men; it is a decadence that France, but to some extent all of Europe has supposedly been engaged in since the end of the eighteenth century. In 1885 Alfred Rambaud, a history professor at the Sorbonne, opines that to fight against the feminization of characteristics engendered by peace (in Europe) and the comforts of modern life, it is indispensable to make a major effort to reconstitute the empire and direct the French people (i.e., the men) on the course to Africa. Thus can the Frenchman elude corruption (of welfare and of advances in women's rights) at the same time that he recovers his virile virtues and warrior instincts.[2]

A VIRILE COLONIZATION:[3]
MILITARY CONQUEST AND "CREATING VALUE"

It is actually the rule of the strongest[4]—and to my way of thinking the most virile—that prevailed during the entire duration of European settlements in Africa, Asia, and Oceania. The new spaces conquered—*a fortiori* through war—were one of the major locales for the affirmation or reaffirmation of virile prowess inserted into the sense of national honor and the territorial integrity of the metropole.

Sparked in the years following the immediate postwar period, this idea of colonization as a "factory" of real men and as a space of national and virile regeneration (the two things being thought of as closely linked, especially in France after the traumatic defeat of 1870 against Prussia) is justly pointed out by Nicolas Bancel, Pascal Blanchard, and Françoise Vergès: "The colony will reinvigorate the bodies bruised by the defeat of 1870. It will restore virility to emasculated, exhausted men."[5] It was already present, however, from the beginning of the nineteenth century in numerous works treating the national *and* colonial question. Thus, in 1874 Paul Leroy-Beaulieu is not afraid of asserting without creating a shock to his contemporaries: "The empire or death."[6] One notices, moreover, a discursive homogeneity in Europe as a whole on this question of colonial space as "vital space."[7] From John Robert Seeley—*Expansion of England*, first published in 1883—to Friedrich

Fabri—*Does Germany Need Colonies?*[8]—everyone agrees that colonial expansion has become *essential* to Europe and that Europeans are engaged, as obligated by social Darwinism, in a "struggle for existence" from which the strongest peoples will emerge "naturally." This is what leads Maurice Rondet-Saint, in his book *In Our Yellow Empire* published in 1917, to say: "Let us know how to be strong, self-confident and virile. And Indochina will remain forever a French land."

THE WAR OF CONQUEST AS A FACTORY OF AGGRESSIVE, OSTENTATIOUS VIRILITY: THE EXEMPLARY CASE OF ALGERIA

The war of conquest,[9] notably in Algeria (1830–1847), was in fact marked by extreme brutalization.[10] Unable to hold the interior of the country,[11] the French were reduced at this time to a limited occupation manifested by acts of cruelty and barbarity. Pellissier de Reynaud, who did not have any particular weakness himself for the "indigenous" wrote: "The Arabs must have thought that we knew how to slit the throats of women and children but that we dared not attack armed men on guard."[12] This configuration of the war of conquest introduces brutal practices that are translated, on the side of the colonized, by an equivalent brutishness. Thus, in the accounts of conquest or in the first works on Algeria that appear immediately following the conquest, a great number of references can be found to the fact that the "indigenous" are wild "beasts," ferocious "animals" against which extraordinary measures can or must be taken. These measures are well-known in the Algerian context; they consist of impounding lands, administrative internment, collective punishment, *enfumades* (annihilation by smothering with smoke), mutilations, and summary executions.... Eugène de Pellissier de Reynaud writes in this way about the massacre of the tribe of Ouffias[13] by the Duke de Rovigo: "Returning from this gruesome expedition, several of our cavaliers carried heads at the end of their lances."[14] A list can thus be made, among French colonial conquests outside the Algerian case itself of the number of decapitated heads proudly displayed as trophies by French soldiers and their local allies: Ataï's head in New Caledonia at the moment of the great Kanak revolt of 1878 and Rabah's head in central Sudan in 1900 at the Battle of Kousseri [fig. 11.1]. This is a matter—make no mistake about it—of a takeover through the degradation and mutilation of indigenous bodies, which marks the virile prowess of the conquerors. For the colonized, besides being likened to beasts, are also feminized. In Algeria, one of the main acts in this symbolic feminization

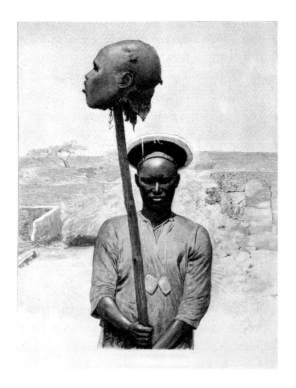

FIGURE 11.1 "THE DECAPITATED HEAD OF RABAH DURING THE MISSION OF ÉMILE GENTIL." *L'ILLUSTRATION*, 9 MARCH 1901.

At the Battle of Kousseri (Chad) in 1900, Rabah, Muslim leader of the insurrection, is killed. His decapitated head is placed at the end of a pike as a trophy.

Source: © Kharbine-Tapabor

involves recourse to disarming the male population in a country where every real man, notably in the interior, possesses a knife and above all, when he can afford it, a gun. In the cities, however, disarming is nonetheless felt by the indigenous to be an insult to their manliness. Thus, upon entering Algiers, the French troops "invite" the Turks to lay down their arms and divide up the booty among themselves. "In the courtyards of the palace of the Kasbah, the victors proceeded to distribute the arms.[15] Each man chose at will guns from the Janissaries, Turkish artillery belts, *yatagans*, and pistols. Rare arms with pearl and coral decoration and sabers with gold and silver sheaths were separated from the lot," writes Jean-Toussaint Merle in 1831.[16] Disarmed, the Algerians are also forced to carry out an act of allegiance in procedures of surrender that often resemble "unions" in which the European is

the man—powerful, virile, and victorious—and the colonized man is the woman—weak, passive, and vanquished. These practices of allegiance in front of numerous military and civil agents of colonial power are then generalized, beginning with the establishment of the Code of the "*indigénat*" in Algeria in 1881, which regulated the humiliation and servility of an entire society.

If it is a factory of virility, the war of conquest is also a sweatshop for the French soldiers owing to its harshness, its severity, and its perilousness for them. On this point all the testimonies of the period converge and agree. For while violence and brutality are the current practice on the French side, the soldiers are also often the victims of such practice. Numerous descriptions, including that of Saint-Arnaud, actually report the violence and the horror of surgery carried out in a horrendous climate: men are dying like flies from hunger, from cold, from sickness, and from the retaliation visited on them by the Algerian combatants, who also do not shy away from chopping off heads with their *yatagans*.[17]

Those who survive, however (and they are often few in number according to the data furnished by the Minister of War in Paris and the leadership in Algeria),[18] can then proudly reclaim their full-fledged manly status, having given brilliant proof—by fire and by blood but also by their physical and moral resistance—of their valor, their bravery, their vitality, and consequently their virility.

In the face of numerous perils, the war of conquest is also marked, finally, by the triumph of the colonizers' attitude of indifference, beyond force itself, as a mode of settling and governing. They are indifferent toward what they make the other undergo, and by extension make themselves undergo; this indifference becomes a virile attitude. Thus, in his *Letters of a Soldier*, Colonel de Montagnac can write: "Your stupid, idiotic newspapers of France are really funny—it's enough to make you die laughing, if it weren't so pitiful. Colonel Pellissier's *enfumades* exasperate them. Those are just the sentimental means that have to be used to please them."[19] Here, sentimentality—delegitimized as feminine—is rejected because it is contrary to the fixed goal: to make war and conquer Algeria. For being a man in vanquished Algeria, one can see, is "being able to pack it all up without flinching," it is "hardening oneself," it is having perfect "self-control" in the most extreme and destabilizing situations. However, it is also being able to temper what one does according to the racial hierarchy and the moral relativism that have currency from the beginning of the war. To be convinced of this, one need only read or reread, among others, Alexis de Tocqueville's *Letters on Algeria*.[20] Therefore it is not surprising, in this "anything-goes regime," later generalized to the Empire as a whole, to find numerous "misdemeanors" that are the result of men's giving in to abandon

and/or encouraged to make use of an aggressive, ostentatious virility that is one of the hallmarks of French power overseas.

THE MILITARY-VIRILE MODEL AND THE RIGHT OF THE STRONGEST

Brutality, strength, and virility therefore form a foundational triptych of the war of conquest.[21] In this respect, France is by no means unique. For if the Algerian colonial war was cruel, what may be said about those wars carried out by the British,[22] the Germans,[23] the Belgians,[24] and the Dutch[25] in their respective empires? During the Indian Rebellion from 1857 to 1858, British repression in India led not only to the pillage and ruin of the city of Delhi but also to the rape of women and the systematic execution of men who participated or were suspected of having participated in the rebellion. The last Sepoys condemned by the British army in July 1858 were attached to canons and blown to bits. In the case of France also, the war that is led against the bestialized, feminized indigenous is supposed to be in the hands of "real" men—symbols of hegemonic masculinity inasmuch as they embody physical strength, rational militarism, male camaraderie, pugnacity, reason, self-control, and abnegation. This is clearly demonstrated by the paradigmatic figure of Thomas Bugeaud [cf. fig. 11.2]. Everything about Bugeaud, in fact, conveys the idea of a triumphant virility. The set of markers of virility peculiar to the nineteenth century,[26] are actually embodied in this man, considered by many at the time of the conquest of Algeria as an exceptional individual of extraordinary bravery who carried out the "Algerian saga" almost single-handedly. This is clearly emphasized in the book by Albert Paluel-Marmont quite symbolically titled *Bugeaud: First Frenchman of Algeria*.[27] Bugeaud is strength, muscle, poise, conviction, confidence, bravery, and honor, but he is also the brilliant symbol of the French military-virile model.[28] He attains the rank of Marshal of France in 1843 in the colonial context or what was commonly called in Algeria the "regime of the saber." It is a model in large part feudal and virile which the "indigenous" are supposed to understand because it "would correspond" to their habits and customs, as the colonist Villacrose explains quite well in 1875:

> The Arabs did not understand the Republic. It was only an abstraction in their
> eyes. It was a regime synonymous with weakness, the golden age of thieves, brig-
> ands and highway robbers. The Republic has as its emblem a woman, a weak being

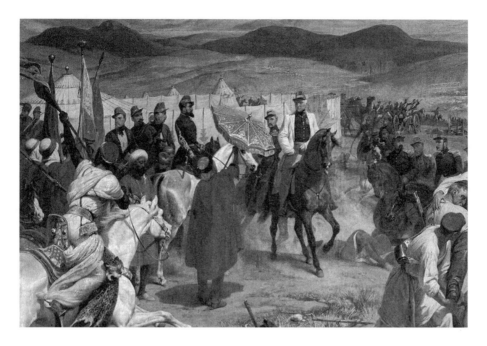

FIGURE 11.2 HORACE VERNET, *VICTOIRE DE L'ISLY.* NINETEENTH CENTURY,
VERSAILLES, CHÂTEAU DE VERSAILLES, DETAIL.

The Battle of Isly, won by Marshall Bugeaud against the Moroccan troops of Sidi Mohamed abd el-
Rhaman, eldest son of the sultan on 14 August 1844, is one of the major turning points in the Algeri-
an war of conquest. Here, Si Mohamed, symbolically seen from behind, has gotten off his horse and
closes his parasol—sign of his power—to surrender to Marshall Bugeaud, depicted frontally, who
dominates him with his piercing, haughty gaze.

Source: © Leemage

par excellence and whom the indigenous man thinks nothing of. Arabs have asked
me a hundred times who that bust was, placed in the court of the justice of the
peace in Dellys, depicting a woman's body, with breast uncovered and head covered
with a Phrygian cap, very much resembling the *cachouche* (Bedouin coiffure), and
I can't begin to describe the look of stupefaction and of deep distrust expressed on
their face when I told them it was the Republic. They could understand the bust
of the emperor. The epaulettes, the large sash, the waxed mustache struck them. At
least it was a man . . . but a woman! Oh my![29]

It is a model that will be perpetuated thereafter thanks to other great figures of
the French colonial conquest: Louis Faidherbe in French West Africa from 1854

to 1865, Joseph Gallieni in Madagascar from 1896 to 1905, and Hubert Lyautey in Morocco from 1907 to 1925.

Similarly, this military-virile model found in nearly all of Europe aims as much at fostering the expression of leaders' heroism and bravery as forming "true" men[30] in the throes of the action, including by setting the troops in competition with one another.[31] This was the case for Herbert Kitchener for Great Britain, who put an end to the Madhist revolt on 2 September 1898 at the Battle of Omdurman by crushing the troops of the sultan Abdullah Al-Taashi. He was later one of the heroes of the second Boer War from 1898 to 1902. This is the way it was for the War of Atjeh, in the middle of the nineteenth century in the Dutch Indies, where, as justly recalled by the historian Henri Wesseling, it was not the technical superiority of the Dutch that helped them win victory:

> The decisive maneuver was the act of the Marechausse Corps, which did not use the famous *Maxim* (machine gun) but rather the saber, primitive arm par excellence. Their commander did not hesitate to send men into battle without firearms to develop in them an authentic warrior valor.[32]

A VIRILE COLONIAL SOCIETY?

In the same vein, it is important to state that in numerous places in its beginning—and most especially in Africa, where European possessions were few in number prior to the nineteenth century—colonization was often the result of explorers who set up bases for future colonial states, which were only later to be officially reattached to colonial metropoles. These men, acting on their own behalf and/or in the interest of their respective nation, such as Georges Goldie (1846–1925) in Nigeria or Cecil Rhodes (1853–1902) in Rhodesia for Great Britain, were able to put together immense colonial domains in which their personal power was often wielded indivisibly [cf. fig. 11.3]. Their sagas are one of the marks of the success of their operations: one thinks here of Cecil Rhodes going to negotiate by himself, deep in the hills of Matopos, the surrender of the Ndebele leaders on 21 August 1896. Another example of this type, but this time in Asia, is the Briton James Brooke (1803–1868),[33] who after having the title of rajah of Sarawak presented to him by the Sultan of Brunei for his help in crushing the revolt of the Dayak becomes an essential local power there, including of the British government, until his death in 1868. The personage was so celebrated, moreover, that he inspired Joseph Conrad's *Lord Jim*.

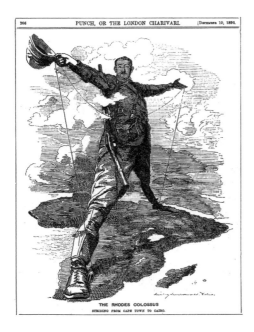

FIGURE 11.3 LINLEY SAMBOURNE, "THE RHODES COLOSSUS." *PUNCH*, 10 DECEMBER 1892: CECIL RHODES, STATESMAN, FINANCIER, AND IMPERIALIST, CARICATURED AS A COLOSSUS CRUSHING AFRICA.

To conquer is a virile act. Accordingly, Briton Cecil Rhodes is depicted here as a colossus dominating Africa as well as the "devourer" of the continent.

Source: © Mary Evans Picture Library

If men—their adventures, their experiences, and finally their entire lives—could embody in the colonial context a virile ideal in the literal sense of the term, the way colonization forges itself could also be considered such an embodiment. Thus, in Algeria, the colonial administration, and most particularly Thomas Bugeaud, who was one of its most tireless partisans, advocates a model of military colonization organized around the profile of the soldier-colonist or soldier-laborer who made, in bygone years, the grandeur of Rome. The values linked to this model are clear and claimed from the beginning by its followers: land, work, patriarchal family, and fatherland. Here, the social question intersects with the colonial question.[34] The descriptions of the period advance the fact that the city-dweller, and in particular the proletarian of European industrialization, is ill-adapted to rural life, unsuited to making a good colonist, and therefore not legitimate because of being "soft," "feminine," or "passive" in the face of events. Thus, a colonial director in Algeria writes the following critiques with regard to the colonists he is responsible for: "Doesn't understand a thing about farm work." "Is awfully scared of his ox." "A drunk. Doesn't do anything." "Has only daughters for children."[35] The typical portrait of the colonist established here is scarcely flattering and corresponds more or less to the idea one has at the time in France and

in the rest of Europe of the city-dweller who comes from the lower echelons of society. The comparison in the early days of colonization between the dangerous, "barbarian" classes from the interior and the "savage," "indigenous" people from the exterior shows to what extent the French imperial project was subject from the outset to a double discrimination based on class and race. And this was not only because the colonized lands became the preferred places for the deportation of those called "rejects" at the time (criminals, prostitutes, orphans, political opponents) of European societies. It was also the way the French colonial administrators derided the deportees of 1848 because they did not know how to plant a single tree, except that of liberty....

Besides this, in May 1849, in Saint-Cloud, Captain Chaplain complained of having only "unruly colonists who don't know how to do anything but shout and make noise and who should be expelled from the farming colony."[36] Here, then, the question is the construction of a colonial society based on values, especially virile ones, which would be a force of economic, political, and social regeneration and transformation. From 1830 to 1900, the colonial administration undertakes the creation of a singular people whose focal point is the coming into being of new men, revitalized and revirilized by their taking root in this new France, whose very difficult conditions will form one of the most recurrent colonial mythologies: the saga of the first colonists of the Mitidja Plain. Jean-Baptiste Piolet summarizes the enterprise in these terms in 1900: "Emigrate then, you who don't know what to do; emigrate far, go populate our colonies, where you will become transformed men, men of energy and willpower, the future heroes of revenge."[37] This idea of new people is based not on "fusionism,"[38] as the Saint-Simonians had hoped, but on strength, resistance, and determination to triumph over the hazards of the indigenous milieu and to establish a line.[39] In the narratives of this first phase of colonization, virility is continually called upon to exalt rural colonization through the figures of "warrior colonists" from the interior who live in the shadow of their guns, thus pushing back the constant raids by the indigenous populations, which led Thomas Bugeaud to say: "The colonizers have to be very warrior-like in such a country."[40]

In the cities also, while the project of rural colonization collapses rather quickly a virile culture will start to form, coming from the working classes that settle in Algeria and the product of the fusion of diverse yet homogeneous Mediterranean patriarchal traditions[41]—French, of course, but also Italian, Spanish, Maltese, and Greek. These traditions will give birth to the figure, often caricaturized, of the "*pied-noir*,"[42] a loud-mouth and a braggart, a sentimental macho, and a ladies' man.

Thus, Louis Bertrand, successful author of the time, retracing the society of Algiers during the *Belle Époque*, highlights the figure of this stroller on the rue Bab-Azoun:

> A man in his sixties, nicknamed "Flowerpot" because of the perfume he sprayed himself with: "With red ear and ruby complexion, a flowing mustache, an enormous carnation in his buttonhole, bigger than the officer's rosette, and his waist pinched in a dolman with white ticking, he moved forward with a victorious step, swinging his cane and pelting the ladies with killer looks."[43]

This society, hybrid by its very structure and yet a melting pot of the French nation as shown by the "assimilation" of the Europeans themselves,[44] was not without conflicts among communities. Such conflicts replayed in a minor key those between the colonial powers themselves and were often manifested, collectively or individually, in a virile manner. This is what makes J. Saint-Germès say that the "Algerian Frenchman" is a typed category of virility (including in comparison with the metropolitan Frenchman) that is "more male" and therefore superior.[45]

Outside of the Algerian case colonization is, above all, a world in which Europeans often cohabit with each other. Civil or semicivil societies—but also penal society[46]—establish the basis of relations among men who train necessarily in a virile manner on the battlefield, in the penal colony, in the stadium at school, in the café, or in the brothel. Hierarchies, social contacts, relations with the indigenous are all constructed based on a determinate hegemonic masculinity from which one cannot depart without losing, along with one's status as a man, a certain number of privileges linked to one's dominance. In this world where the white male takes precedence, virility also comes back into play constantly in the recurrent obsession over the absence of women. Composed most often of military men, administrators, and colonists, colonial societies that were shaped throughout the nineteenth century in colonial spaces have in fact first and foremost a masculine demeanor. Except in the heavily populated colonies where European women were more numerous, as in Algeria for the French Empire,[47] it was mainly local women who took care of the colonizers or colonists. These women became an issue of virility for at least two reasons. They are first, because of their status as conquered women, under the yoke of a form of the "right of coitus," which is the victor's ransom, the link between the land to colonize and the female body to penetrate, as historians and anthropologists have posited for a long time. To have sexual relations, consensual or not, with the women of the *others*—to "possess" them in the primal sense of the term—has, in effect, always been a means of asserting the sexual prowess of the dominator,[48]

a tool of colonial hegemony. Second, beyond this essential aspect women are also often projections of a desire for sexual otherness—the colonies being thought of as "sexual gardens of Eden"—whose source is, in particular, in orientalism but whose presence is also accentuated by the scarcity of European women.

Thus, mixed sexuality and cohabitation were commonplace in the colonial empires, at least in the first phases of conquest and of its promotion, inasmuch as numerous governments later prohibited their nationals from marrying.[49] "Housekeepers" (mistresses) in Madagascar, the Belgian Congo, or the Dutch Indies, *congaïs* (concubines) in French Indochina . . . the "liaison" with an indigenous woman was all the more favored by the local authorities. As Amandine Lauro for the Belgian Congo[50] and Stéphanie Loriaux for the Dutch Indies[51] remind us, European wives were reputed not to hold up in the climate and milieu, did not give birth to healthy children, and put pressure on their husbands to return to the metropole. By contrast, the "indigenous wives" could help the colonial official and/or the colonist achieve a better acclimation, aid in his getting to know the society and the language,[52] and channel the ardor of his carnal desires, all the while giving proof of his virility in the framework of reproductive sexuality; the mixed race children were not always stigmatized as such, depending on the place and the period.[53] As an example: for France, the governor general of Senegal, Louis Faidherbe, in 1858 "marries" a woman "of the soil" with whom he will have a son. Subsequently, when moral colonization is established at the end of the nineteenth century, these mixed inter-racial marriages are considered to be problematic—not only because they are illegitimate but also because they reduce the distance between the colonists and the colonized. Still, whether tolerated in secret or prohibited,[54] they continue to exist so long as questions of virile prowess and of the sexual and colonial order of things continue to be played out through them.

"DEVIRILIZING" THE "INDIGENOUS"

The reason the virility of some of the Europeans is continually affirmed with such vigor, including in the eminently problematic domain of intercommunity sexuality,[55] is that it has often been so severely tested by future colonized peoples who continually resisted European penetration and as a result inflicted bitter although irregular defeats on the colonizing armies. For the French empire one thinks of the revolt of Emir Abdelkader (1832–1847) but also of the resistance of King Behanzin

in Dahomey or of the battle of Kousseri, in central Sudan, which pitched the troops of Rabah against those of Lamy. Other defeats include: for the Dutch Indies, the Javanese War in 1825 led against the Dutch colonialists by Dipo Negoro; and, for the British empire, the Madhist revolt organized by Mohammed Ahmed, the Battle of Khartoum in 1885 in which the British General Gordon was killed, and the signal British defeat at Isandlwana by the Zulus in 1878. Finally, the defeat of the Italians at Adoua against the troops of Menelik II also had a considerable impact as much on the colonizers as on the colonized. Reducing the indigenous, disarming them, "devirilizing" them, and domesticating them becomes henceforth one of the springboards to a domination that also takes root in their common practice of feminization.

UNHEALTHY BODIES IN UNHEALTHY SPACES WHERE THE WORK ETHIC IS ABSENT

The morbidity of the climate, which is abundantly evoked in the available sources, corresponds to the morbidity of indigenous customs. A large number of descriptions in the nineteenth and early twentieth centuries assert supposedly proven connections between polygamy, abandonment of one's wife, pederasty, syphilis, alcohol/hashish for the Maghreb, and opium for the Far East.[56] Thus Dr. Jacobus writes in 1927 in his book *The Art of Loving in the Colonies*, among a chorus of authors who largely share his opinion: "The African climate encourages cruelty, fierceness and moral degradation." Hence the necessity of practicing in the colonies a moral and racial hygiene that would combat as much the evils of the climate (and notably the heat that seems to greatly increase "shameful appetites" and "vices against nature") as the evils of social pathologies (pederasty, prostitution, diverse addictions) with the objective of resisting what is then called the "curse of Africa." In these climates (African and Asian, presented as deleterious) it is not surprising to encounter diseased bodies, notably those suffering from syphilis (the great fear of the nineteenth century)[57] that have deteriorated (scrawniness, filth, and stench are commonly associated with the indigenous) and are affected by effeminacy and moral degeneration, the two being linked particularly in the medical and scholarly literature of the nineteenth century.[58] These are sick, deteriorated, and degenerate bodies that encourage, moreover, for a number of authors of the period, the laziness—presented as atavistic—of the indigenous.

In a colonial society under construction in which virility and work are systematically associated (a virile body is a healthy, productive body) emphasis is placed on

the "innate laziness" of Arabs, who are often presented as "infected." The term used here in the form of a delegitimization/"devirilization" that is supposed to explain not only the "decadent" and "vicious" state of their society but also—and this is what especially interests us—their defeat at the hands of the French conquerors. In Algeria, this link is clearly established from the time of the conquest through the reification of racial categories:[59] "sensual" Arabs/"brutal" Berbers. Why did the Arabs in the cities capitulate so quickly before the warrior ardor of the "saber-carriers" of the African army? Because they were hunkered down in the wantonness of their oversized harems where wives were jumbled together with concubines, eunuchs, and male escorts. As for the Berbers of the interior who maintained their courage and honor (as witnessed by the difficult progress of the African army outside the colonial front in Kabylia and the Sahara), why were they vanquished? Because they remained outside the domain of reason and progress and consequently they remained tied to a "fierce," "bloody," and "primitive" virility. In both cases, however, it can be seen that the Arabs and the Berbers are supposed to be incapable of resisting their instincts and/or of controlling their desires. They are thus de facto excluded from "civilized" or "rational" virility to which men are supposed to adhere in metropolitan France, at least in well-off milieus, beginning with the Third Republic.

THE "PEDERAST/HOMOSEXUAL" AND THE "SEXUAL PREDATOR:" TWO ANTIVIRILE FIGURES?

Another prominent place of "devirilization" of the colonized is the domain of sexuality. In effect, it is as a result of two gendered and racialized figures—the more or less effeminate pederast and the sexual predator—that indigenous virility is questioned in colonial societies. As proof of the "brutal" and "primitive" character of the "sexual predator's" sexuality, nineteenth- and early twentieth-century authors often point out the morphology of the indigenous man's genital organs. Thus, the hypertrophic penis of the Arabs is regularly commented upon.[60] Dr. Jacobus, dissecting Arab cadavers in the 1920s in the medical school amphitheater, explains: "The penis (of the deceased Arab), instead of having retracted and grown smaller like that of the European, still presented as considerably developed."[61] This anatomical characteristic, assumed to be widespread, makes of the indigenous man a male with "monstrous member," endowed with a sort of "stake of eighteen to nineteen centimeters in length by four or five in diameter." It was seen as causally related, in an obvious manner at the time, to his manners, presented as "abnormal,"

"aberrant," and "primitive." The excess of the Arabs' sensuality, for example, is commonly discussed by the authors, who explain the existence of harems and polygamy by the excessive license of their manners. The enlarged genitalia are similarly evoked to criticize forcefully perverse sexual practices such as bestiality, necrophilia, and active sodomy, including with women, and acts of violence and of course rape. Joseph Maire thus stresses, in his *Memories of Algiers*: "Rape is one of the familiar distractions of Arab men, who practice it not only on their wives whose puberty comes late but also on young boys."[62]

As concerns relations that are strictly pederastic, they are presented as a common practice among the indigenous as noted in 1840 by F. Leblanc de Prébois: "[Arabs] are murderers, thieves and forgers, and they are all given to pederasty."[63] Often associated with the "passive" role, the indigenous pederast is also classed with the feminized; this distinguishes him clearly from the "sexual predator," who is always "active," even when engaging in sex among men. It is a contagious feminization affecting the moral health and virility of the colonial peoples and the colonists, as noted by Franck Proschan for French Indochina, who also demonstrates brilliantly the precariousness and fragility of heterosexual identity for the French male in the colonies.[64] For the aggravating factor is that the European who has "given in" to the indigenous pederast has become a "moral slob," damaging to the prestige of his race and the honor of his country. In so doing he has violated the principle of distancing (between the white man and the indigenous man) on which the entire colonial order is based. This challenge, however, allows for a reversal of the stigma: the effeminate indigenous man thus "contaminates" the Frenchman or the European and, to a certain degree, by taking possession of him, jeopardizes French virility. Nevertheless and despite what was just said, the general schema put into operation with regard to the sexuality of the indigenous is that they are, in fact, either "too" virile or "not" virile "enough," which is a convenient way to delegitimize them as "normal" men; they are, in effect, excluded from that "just right" virility, symbol of a sort of "sexual civilization" under construction. And they are relegated in the domain of sexuality, as in so many others, to the "bestiality" and "perversity" of their practices and to the "savagery" and "primitivism" of their manners.

A "CASTRATING" DOMESTICATION

Furthermore, the "indigenous" also fall within the scope of attitudes toward and practices of domestication (which, by extension, are attitudes toward and practices

of feminization). These are embodied in the recurrent, paradigmatic figure of the young indigenous *boy*, who is the symbol of the domestication of men by colonization itself but also by its agents.[65] For the boy, who is above all a man for the home, may also conveniently become a "servant for the bed" when necessary or wished for. In this respect he is fully comparable to the ancient figure of the odalisque or to those more recent figures of the homemaker or *congaï* (Vietnamese girl).[66] Literature of the nineteenth and early twentieth century is actually filled with examples of these domesticated, indigenous *boys*, effeminate and sexualized, who are used, with or without their consent, as "sexual objects" [cf. fig. 11.4]. In point of fact, domestication, which concerns not only the indigenous boys but the whole of masculine society, was first made possible by the native men's surrender, which in the context of the wars of conquest was an obvious act of "devirilization"

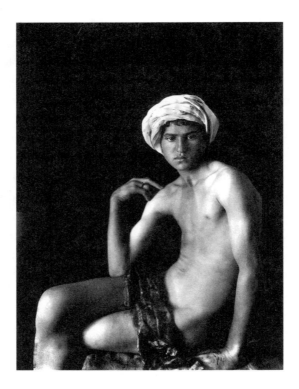

FIGURE 11.4 PORTRAIT BY LEHNERT & LANDROCK. EARLY TWENTIETH CENTURY.

Picture showing the homoeroticism of a young Tunisian ephebe by two colonial photographers. This type of image reinforced the idea that homosexuality among men was widespread in the Maghreb.

Source: © Musée de l'Elysée, Lausanne

of some (the vanquished colonized men) and an act of victorious penetration by others (the soldiers and conquering colonists). "Devirilization" of men may therefore be considered an actual tactic of domination that marks, physically and often violently, the new category of hegemony that is then established. This violence, whether physical or symbolic, is meted out as much upon the men as upon their women. Once they cannot protect themselves, they are no longer considered "real" men and are relegated throughout this period to a "soft" and "effeminate" category. This low status often makes them spectators to acts of violence, including sexual ones, that the women must suffer. For the conquerors, by virtue of the rule of the strongest, are not satisfied by taking arms, riches, and lands. They also must stamp their imprint and by the same token their triumphant virility right in the women's bellies. The sources again convey this reality. Thus, Sir Hérisson, former officer in Algeria, describes in these terms at the end of the nineteenth century the troops he commanded during the war of conquest: "Men (one could say 'real men') who want nothing more than to pillage and rape. What a singular battalion! It is made up entirely of soldiers condemned by the war councils and who are finishing up their stint; I have never seen such scoundrels, but also never seen anything so fun-filled and so funny."[67] Émile Zola points out the same thing in *The Earth* in 1887 when he tells the story of two peasants, former soldiers in Algeria: "(the latter) had shared memories of Bedouin men's ears cut off and threaded into prayer beads, as used by Bedouin women,"[68] a thinly veiled allusion to the rapes they had committed against Algerian women.

The devirilization of indigenous men is embodied, moreover, in a series of phenomena (domestication, herding, subaltern annexation[69]) and symbols of colonial power. For the domestic, devirilized indigenous man is no longer a full-fledged individual: he no longer has an identity. This results in the recourse to catch-all names or racist nicknames (*bicot, niakoué, nègre* [nigger]) that are consequently compared to a malleable object that can be used and abused in all good conscience (note, for example, that the colonized man is never addressed with the formal, respectful form of "you"). This is why one of the virile symbols par excellence in the colonial context is the *chicote*.[70] Msgr. Puginier, eminent member of the Catholic Church in Indochina, explains it this way: "God makes well that which he makes; He made rattan grow next to the Annamite Mountains: so it can be used."[71] *Chicote*—a sort of displaced phallic symbol—summarizes in an exemplary manner the connections I have elaborated in this chapter between virility and colonization.

Indeed, the *chicote* is the symbol of the system of domination of which this domesticated "barbarian," "savage," "primitive" is a part and which orders his

world. If properly supervised—in the army, at work, in church, he will be of great service to the colonial and metropolitan order. This is what will happen in France with the organization of the "black force" by General Mangin during World War I, in which the "domesticated barbarian" was solidly enlisted in the same way as the "new men," both products of colonization. By the time of the huge eruption of 1914–1918 both groups had internalized through a masculine identity in which strength and virility are constantly mobilized the forms of "brutalization" in the socioeconomic relations peculiar to colonial societies.

FROM THE "WORKHORSE" TO THE "SUBURBAN RIFFRAFF": A "DANGEROUS," PHANTASMAL VIRILITY (1960–2009)

Beginning at the end of World War II, an image is gradually superimposed in France over that of the colonized man of the 1920s and 1930s: the image of the workhorse, "the labor man," the neo-proletarian, all part of the essential engine of economic growth during the Glorious 1930s. He is an unskilled worker and therefore invisible and interchangeable (as pointed out by Abdelmalek Sayad in his book *La double absence*[72]), whose working conditions and circumstances of livelihood are often precarious and dehumanizing. In this case, everything conspires to relegate these men to a kind of "degraded" and "impoverished" virility. Reduced to their bodies—and to the brute, muscular force they can get from it in jobs in mining, construction, dock work, or the auto industry, these men are often also stuck in cleaning jobs associated with femininity. This creates a sort of blurring of virile identity, which is further highlighted by "*clochardisation*" (the process of becoming destitute, homeless), staying in workers' hostels and in slums on the outskirts of large metropolitan areas and the "sexual misery" in which a large portion of these men live. For single men or men who arrived by themselves the question of sexuality is posed with some urgency. In French society, which is still basically characterized by the need for racial and gender segregation, these men's sexuality (otherwise extremely controlled by the police as Emmanuel Blanchard shows)[73] is often channeled into illicit relations with young unemployed men or dropouts (whether homosexual or not) who prostitute themselves for various reasons (money, sexual desire, gambling...). Thus, Régis Revenin[74] cites the testimony of a young "professional male prostitute" who points out, during the 1970s, the importance of his Arab clientele:

There is a very well-known theatre, on Boulevard Magenta [...], "Le Louxor." [...] Exclusively Arabs. [...] They would pay 20 and 30 francs. [...] The door closes, they get laid, bang! The guy leaves, and another one comes in who starts all over again. [...] As for me, I got a kick out of it! [...] I enjoyed it. [...] There was another theatre also, "Le Bosphore," between République and Saint-Martin, I think [...], and then I did the saunas, but not the chic saunas [...], among others "Le Voltaire," and there business is very good. Lots of Arabs, especially on Saturday. And they stand in line outside the door.[75]

In this case, however, the reversal of social roles is accompanied by problems for the French authorities, "for the Arabs—who are presented as 'tops'—become the subjects of the sexual relation, while the young Frenchmen who adopt the 'female' role are totally objectified and subjected." This conflicts very clearly with both the sexual order *and* the colonial and postcolonial order. For what causes a problem in this context is not so much the question of sexual orientation (besides, the great majority of these workers do not define themselves as "gay," even though they have numerous sexual relations with other men) as that of gender. Who is the man—demonstrating his virility vividly through the act of penetration—and who is the woman?

In an attempt to find a solution to this problematic situation, which makes of Arabs hypervirile men and supposed contaminators of French youth, the French authorities showed partiality toward those illicit sexual relations consistent with gender rules. This is why traditional female prostitution—especially though not only when it is furnished by women who come from formerly colonized territories—was largely encouraged. This also explains why, after the closing of the brothels in 1946 out of a concern about the development of mixed couples (whose number is supposed to have been infinitesimal on the mainland as well as in the former colonies),[76] and in order to channel men considered to be "sexually uncontrollable" to the point of "bending over" other men if women are not available to satisfy their needs, tolerance continues for clandestine brothels and houses of prostitution in the working-class neighborhoods of Paris. For example still in operation are the slaughterhouses of the Goutte d'Or—*Le Panier fleuri*, 8 Boulevard de la Chapelle; *Chez la veuve Bonnet*, 106 Boulevard de la Chapelle; *Carmela*, 74 Boulevard Barbès; and *La Charbo*, at the intersection of Rue de la Charbonnière and Rue de Chartres, which keep on running from the late 1940s to the 1980s. At *Le Panier fleuri*, as a matter of fact, one of the "factory brothels" of the Goutte d'Or, sexual relations are reduced to a strict minimum, as stressed by Véronique Willemin:

The clientele is not rolling in dough. Workers, soldiers who are penniless (especially the *Bat'd'Af*, the Infantry battalions of Africa) and immigrants stand in line for love. On crowded days, the line spills out onto the sidewalk. "Quickie—cheap;" one client after another, their fly already open. Behind a curtain, the girls supervise. After each coitus, they sponge down the oilcloth covering the table used as their work area. The sex act is reduced to a strict minimum. Foreplay is totally nonexistent; the man has between three and five minutes to cum. For some, the excitement is so great that they just can't wait—in which case there is no lovemaking, no penetration. It happens all too fast on their way up the stairs.[77]

Here, then, is the foundational triptych of the nineteenth century, only made more concrete and with force: "laboring classes, dangerous classes, lecherous classes." Reduced to "sexual inadequacy," presented due to their ethnic origin as "atavistic," and confined to a discriminating, dehumanizing, and castrating socioeconomic status, these "labor men" are also asked to accept the condition allotted to them without flinching.

To escape from this impasse, these men will gradually reconstruct their virile identity by means of the struggles carried on during the 1970s: the antihierarchy revolt of the OS (Special Organization, or Algerian independence movement) on Devil's Island (Senegal) in 1972, the general strike against racism in 1973, the movement against the Marcellin-Fontanet circular of 1972–1974, and the rent strike in the SONACOTRA residences between 1974 and 1980.[78] Their goal is to improve the men's living and working conditions but also to reclaim "working-class pride" in terms of trade-unionism and politics, which is a token of their rebirth as full-fledged men. This working-class, immigrant virility—which is the object of phantasmal projections in French[79] and European[80] societies—will be consolidated, beginning in the late 1960s, in a unique location: the suburbs, and in a particular type of housing, the projects.

It is in this context that there emerges in the 1970s (against a background of curtailing of worker immigration in 1974, recurring economic crises, mass unemployment, and the rise of the *Front National*) the first generation of young Frenchmen born of immigrant parents. These "young working-class men from poor neighborhoods," as they are called at the time, are often hostile to the lifestyle and the modes of thinking and being of their elders, the *Chibanis*. As pointed out by Morniss H. Abadallah, "they show a certain contempt for the social order regulated by the rhythm of the factory and develop a lifestyle based on getting by, showing off and driving around at night."[81] Within this youth group from the "zone,"

French and immigrant, a virile culture will develop, both "criminal" and militant, constructed against a society of economic, political, racial, and sexual exclusion, represented paradigmatically by the police officer in charge of re-establishing order and safety in the neighborhoods or controlling IDs and "profiling" in the city centers. In 1983 these radical youths (though not yet radicalized) march for equality and against racism. However, their efforts are rewarded with little success. Because of the failure of lawful integration, in large part tied to the perpetuation of racist stereotypes arising from the colonial period, the movement hardens during the next generation.

Beginning in the early 1990s, the theme of urban violence emerges with force in the so-called difficult neighborhoods. At the core of this violence, at once real and phantasmal, is a virile culture embodied in the figure of the "thug," presented as exclusively "aggressive" as modeled on the film *La haine* (Hatred) by Mathieu Kassovitz released in 1995. We slip at that point from the recurrent theme of insecurity, a joint product of juvenile delinquency (graffiti, thefts, setting cars on fire, acts of violence at school . . .) and a certain "riot culture" symbolized by gangs, to the theme of impossible integration. At the heart of this debate, the extremely racialized and sexualized figure of the "Arab boy"[82] takes shape. From this time on, he personifies in French society the *summum* of violence: verbal (through rap, in particular), urban (as shown by the riots of October and November 2005), and sexual (as seen in collective and "gang" rapes committed in basements[83] and assassinations of young women in the poor neighborhoods);[84] and homophobic violence intended to show the hyperheterosexual character of these young men.[85] This virile culture, associated with "primitivism and violence of manners," with "sexual savagery," and with "religious fanaticism"[86] inserted into a masculine sociality considered "archaic" and "barbaric" brings full circle this long progression begun with the Great War of 1914–1918.

Thus, the "riffraff" in postcolonial France of the 2000s would be considered, by politicians, the media, and public opinion, as worthy heirs to the indigenous men of the colonial period. Given the resemblance of the portraits, one cannot help but be struck by the perpetuation of this virile image, thought to be negative in society as a whole yet often proudly reclaimed by a certain number of young men and constantly used to delegitimate and stigmatize those "other" men who are always doing "too much" or "too little." They are thereby excluded from this "just right" virile man who was supposed to be representative, since the end of the nineteenth century, of the "civilized" man par excellence.

12

THE BURDEN OF VIRILITY

· · · · · ·

THE INJUNCTION OF VIRILITY, SOURCE OF ANGUISH AND ANXIETY

ALAIN CORBIN

TOTUS HOMO semen est—"Man is semen through and through"—this aphorism by Fernel, "the Galen of the sixteenth century," has often been cited. It is useful to return to this fundamental phenomenology to understand what is meant by virility and to perceive the aura of anxiety that surrounds it. It is the erection that confers upon man his dignity, his character; the erection demonstrates his importance; it is the basis of his domination.[1]

Beginning in the second half of the eighteenth century, at the time when the dimorphism that differentiates man from woman takes greater hold, distinct norms are formulated based on gender. Medical writing, like novelistic literature, stresses more than ever before the flows that afflict women,[2] despite the belated discrediting of the double seed theory. Woman is perceived to be subject to perpetual discharges. Richardson's Pamela sheds streams of tears, and soon the travails of menstruation increase along with those associated with lactation. In erotic literature, woman never stops fucking. The breast acquires, by the end of the eighteenth century, a metonymic significance, and the well-known debate concerning the benefits versus the harmful effects of breast-feeding follows this same logic. So the woman, subject to wetness, is therefore encouraged to flow. It is quite the opposite for man, who by the dawn of the following century is called on to control his fluxes and to contain

them, whether they are tears or sperm.[3] A proof of virility is controlling one's pleasure, regulating one's sexual energy. The penis and the nipple, both erectile (a morphological similarity often highlighted at the time by the authors of medical treatises), structurally and physiologically identical, are subject from then on to an asymmetrical regulation, reinforced by the ideology of the family.

The man who claims to be a solid, self-sufficient citizen has the duty of mastering a well-maintained and -managed body. Joachim-Heinrich Campe in Germany and the "pedagogues" who claim to follow him subscribe to this logic with enthusiasm. They advocate strict discipline. The body should be trained to resist desire in order to avoid the loss of semen and, more generally, the dwindling of virile prowess.

But in this history, let us repeat, nothing is simple. In fact, basing their views about eroticism on moderation, clinicians and physiologists keep denouncing during this same period the risks and harmful effects of abstinence. To avoid them, practitioners recommend that young men, prone to the "solitary vice" and threatened with the agony of impotence, return to "frequenting women." Yet such a recommendation does not keep them from denouncing, for their part, the excessive loss of sperm and insufficient control over discharges.[4]

The importance given to that "prolific liquor" leads once again to the practice of masturbation insofar as it conflicts with the norms just mentioned and provokes anxiety linked to seminal loss. The "solitary vice" has been the subject in recent years of numerous works; therefore it is pointless to go back over that history except to examine its ties with the history of virility.[5] At the dawn of the eighteenth century, the publication of *Onania*, whose foundations in moral theology have been well documented by Patrick Singy,[6] launched an antimasturbation crusade as well as the trend of private letters devoted to the pangs of the solitary vice.[7] In 1760, with the publication of his *Onanisme*, the Swiss doctor Samuel Tissot steps away from moral theology and adds a new depth to the campaign that he associates more broadly with the crusade for respecting Nature's commandments.[8] The success of the work was accompanied by a boom in the practice of epistolary consultation, which allows us to survey the modalities of masculine anxiety. Indeed, Tissot turns melodramatic. His work on onanism is laced with frightening predictions; he presents a catalogue of medical cases that describe the dissolution of the human being in streams of sperm.

The work had an enormous impact. Fifty years after its appearance, numerous scholars vouch for the fact that it is still being widely read by young men—something the majority consider to be beneficial and the rest detrimental.[9] At the same time, the antimasturbation campaign enriches the manufacturers of restraining

devices, while confessors, doctors, and pedagogues struggle in unison against what they consider to be a scourge endangering young men's health and virility.

During the second half of the nineteenth century, the intensity of the campaign is reversed. It would be an overstatement to claim that the panic has disappeared, since, as we shall see, the fight benefits from new weapons. That said, the thesis develops that masturbation is innocuous. In 1875 James Paget opines that, when practiced at the same age and with the same frequency, masturbation poses no greater danger than regular coitus.[10] In 1899, Charles Féré also puts into perspective the drawbacks of the solitary pleasure, which, in his view, are far from being constant and vary according to the individual. He warns nevertheless against the habit and its excesses, recognizing that masturbation could develop not so much into disorders linked to the loss of semen as neuroses in people predisposed to it. He cites in this regard authors who have linked the practice of the solitary vice to adolescent psychosis (disorganized schizophrenia), even to cases of hysteria in young men.[11] According to Havelock Ellis, who uses the term autoeroticism, indulgence is in order since masturbation is inevitable. Shifting the problem, though, Féré notes that innocuousness does not necessarily mean legitimacy.

That said, a number of historians have shown that by the end of the century the panic has not disappeared. A perusal of standard dictionaries and French vulgarizations of the topic clearly proves it. In Great Britain, most notably, the anti-masturbation campaign persists [cf. fig. 12.1].[12] Quite heated during the last quarter of the century, it reaches a peak around 1900 and remains at a high level until 1914 before ebbing between the two wars. Up to that point the question continues to be debated within the public schools and boarding schools. Anxiety about it affects mainly the upper and middle classes. What is more, the struggle is tied to the actions of a group of "social purity movements."

What is new, then, is the psychological refinement of the campaign, the deepening of the sensory perception of self, body, and the emotions. The essential is still there—that gray area constituted by the reality of sexual experiences. This history must stop being centered on scholarly and normative discourses. It must from now on take into account the dissemination of these texts, their modes of consumption, as well as the room for maneuver available to each individual.[13] In this regard, confidential letters, along with medical case histories, comprise substantial and largely unexplored sources.

We shall consider case histories in connection with a nonexistent yet tragic medical classification: involuntary seminal emission. The individual who believes himself infected feels a threat to his sense of virility. This disease is at the top of the

Representing the last stage of mental & bodily exhaustion from Onanism or Self-pollution.

FIGURE 12.1 "REPRESENTING THE LAST STAGE OF MENTAL & BODILY EXHAUSTION FROM ONANISM OR SELF-POLLUTION." IN R. J. BRODIE, *THE SECRET COMPANION: A MEDICAL WORK ON ONANISM OR SELF-POLLUTION . . .*, LONDON: R. J. BRODIE & CO., 1845, PLATE 2.

This is what onanism leads to in its final stage. It is a matter of dread still very significant in 1845, nearly a century and a half after its denunciation as an actual disease.

Source: Wellcome Library, London

list of anxiety-producing items caused by the uncontrolled discharge of "prolific liquor." Denounced since Antiquity, described by D. Tauvry in the seventeenth century and then by Weismann (1772–1782), the involuntary seminal emission remains practically unknown by practitioners until the appearance between 1836 and 1842 of the three-volume treatise edited by Professor Lallemand.[14] The doctor presents 150 cases of patients infected by this disorder, which consists of the inability to control the discharge of sperm during the night and especially during the day; the patient, moreover, experiences no sensual pleasure. The stages of the disease, described with precision by Lallemand and later by William Acton and other specialists,[15] had already been experienced and spontaneously recognized as unsound by the young man we shall call Mr. X between 1815 and 1821, well before the publications of Dr. E. Sainte-Marie (1817) and Professor Lallemand. This case shows with particular clarity how intense the suffering could be for an individual faced with the prospect of an uncontrollable loss of virility.[16]

Mr. X is from the provinces. His father, probably a doctor, possesses a library containing scientific works. The family, residing along the banks of the Loire, leads a comfortable life, which allows the patient to frequent thermal stations and eventually to go to Montpellier to consult Professor Lallemand. The young man had masturbated for the first time, without the urgings of any particular person, at age 11. Admonished by his friends, he quickly abandoned the practice. His strong constitution seemed to promise a brilliant future. Then, on 25 October 1815, at the age of 16, he noticed, upon awakening, that a seminal emission had taken place while he was asleep; a similar discharge was repeated for the next eight nights after this fateful awakening.

Although, let us repeat, he had no knowledge of the disease described by Dr. Sainte-Marie in 1817, Mr. X imagines spontaneously that he is stricken with an illness that compromises not just his virility. "When I saw my health, my happiness, my life drain away like this," he confided six years later in his memoir, "I could not help shedding tears; a cold sweat covered me from head to toe, and I glimpsed death; I actually called out for it fervently."

Thus begin six years of torment for him. During this long suffering he experimented with all sorts of remedies, without confiding his secret or asking for help from any of the people around him. He plunges his penis in cold water. He binds his foreskin. He wraps a tourniquet around his penis. He puts together protective or supportive devices that he keeps striving to make better in order to avoid nocturnal emissions. He reads scholarly works—including autopsy reports—in the hope of finding remedies. He who was an atheist resorts to praying in order to find a cure. He turns to therapeutic masturbation. Nothing helps. So he thinks about becoming a carpenter, then a laborer, in order to find through contact with common folks the necessary energy to overcome his nocturnal emissions; however, he cannot take the fatigue caused by manual labor for very long. Ferrous baths turn out to be just as ineffectual as dips in the Loire, which are too cold for him. At one point Mr. X tries several diets. He falls back on an old recipe consisting of consuming huge quantities of substances that evoke semen or are known to stimulate its production, whether milk or eggs or figs. He fills himself with wine, judged to be fortifying. None of this works. He examines closely the changes in his appearance, his "cachet." He runs his hand over the bumps on his body, counts his wrinkles, which he reads as so many signs of approaching death. He thinks about suicide. Finally, he isolates himself, far from his mates. He takes refuge in an "obscure hideaway" to lament his state, to invoke death, and to devour in solitude certain "cooling down" books.

In 1821 a miracle takes place. Professor Lallemand, whom he had come to consult, attributes his disease to roundworms. Once cured, Mr. X goes to medical school and performs brilliantly. At Professor Lallemand's bidding, he writes a long memoir relating in detail his six years of "agonizing suffering." It would be difficult not to agree with his mentor that this was a kind of cenesthetic analysis[17] of the greatest interest, worthy of comparison with the long diary pages written by H.-F. Amiel, who was also tortured by the loss of sperm, voluntary or involuntary.

"*Spermatorrhea panic*," to use the title of the article cited by Ellen Bayuk Rosenman, spreads throughout Europe between 1839 and the decade from 1865 to 1875. However, it is not unusual to find it described in France in some of the most commonly used dictionaries[18] up to the end of the century. In sum, the disappearance of this as a medical classification is quite difficult to date: some go so far as to claim that it was not abandoned in Great Britain until the end of the century.

Ellen Bayuk Rosenman has undertaken a subtle analysis of the subject, which she conducts in terms of a history of the representation and perception of virility. In her view, it is, above all, about a cultural phenomenon, a malady invented to embody specific, dated forms of anxiety linked to the wish for a medicalization of sexuality and to the desire for scientific investigation for which nocturnal emissions furnish the occasion. Rosenman believes, rightly no doubt, that this panic conveys a global anxiety concerning virile sexuality. Science and popular opinion at the time assimilate masculine identity with the force and copiousness of ejaculation. Spermatorrhea, a manifestation of the subject's inability to control his discharges through willpower, represents the greatest failure of the self-control that constitutes virility; hence the importance of this illness in the perspective of this book. Sperm, situated here at the core of the anguish, is at once that which constitutes virility and that which compromises it. Involuntary seminal loss, diarrhea of semen through all the orifices—mixed with urine, with excrement—an overflow of the internal outside, manifests and characterizes a set of breaches in virility. It is loss of control of the body, loss of power over oneself, loss of self-confidence. The therapy practiced by Lallemand, i.e., cauterization of the urethra to restore sensual pleasure by making the erection more vigorous and the ejaculation less precipitous, may be perceived as an act of violence against the male body in order to restore fully its virile stiffness.

The maximum anguish, however, concerns male impotence, the total negation of virility, since the penis no longer grows erect—or no longer ejaculates or else has lost its projectile force; another potential pain is that elicited by the loss of "prolific power"[19] or sterility.

The inability to control ejaculation may be natural, organic; this would impose—and facilitate—resignation; this is just what Dr. Parent-Auber suggests, in 1852, in his discouraging reflections on the aging of man: "as soon as procreative power disappears, life breaks down, bit by bit, and death is not long in coming."[20] Sexual breakdown assumes a great significance, since, according to doctors who treat the subject, virile prowess determines physical force as well as the richness of mental activity.[21] Its loss means a "weakening of thought:" the soul of the impotent man loses its energy, its insight, its memory, its judgment,[22] and enthusiasm wanes along with life's poetic allure. The man who sees himself as incomplete sinks into melancholy, leaving himself with a distaste for everything; his sensibility dims. Such is the picture painted by doctors of the early nineteenth century.[23]

Now, depictions of the agony of impotence like that of the pain provoked by sterility, anaphrodisia, and frigidity have their history, which is rooted, at the very least, in the opening of the modern era. From the sixteenth century to 1677, the date of its suppression, the "tribunal of impotence"[24] is in operation in France. At this time sexual breakdown is situated in the sphere of evil spells and diabolic hex knots of impotence; it is seen in the perspective of the Fall, which, in the eyes of St. Augustine, was manifested through the organs, notably the sexual organs, refusing to obey the will of the subject. This tribunal mainly considers conjugal nonperformance, of which the wife is the victim, since she has the right to ask for her husband to discontinue his concupiscence and carry out the act summed up in the formula: "get hard, enter, moisten." Based on this, the impotent man finds himself all at once guilty of cheating, of sacrilege—marriage is a sacrament—and of torture. His wife, who is actually devalued on the matrimonial market by his behavior, can claim damages with interest. Her union, which has become the suffering of an innocent, allows her to bring charges before the (official) ecclesiastical tribunal. The magistrates are able to have her hymen inspected, have the husband's erection tested, that is, test that "elastic tension" which defines virility. If deemed necessary, the tribunal judges the "congress," the union of the two spouses, until the husband penetrates his wife and ejaculates—a humiliating test that can go on for hours.

This drama of impotence provides the occasion for a public demonstration of the collective anguish elicited by breaches of virility. The coupling enjoys sensational publicity. The street takes on the look of a county fair. People rush up to the tribunal. Some, like the Marquise de Sévigné, await the results of the test in their carriages. Others debate about it in the salons. In the course of the disputes, ecclesiastics and doctors exercise their power together. As for the unfortunate husband, he experiences the "strange drama of isolation fed to the crowd."[25] His

fate places him in the long extensive company of reprobates of the Baroque age. In this matter, however, the drama resides in the "flubbing" rather than in incurable impotence.

Such is also the case with the erotic memoirs, novels, and anecdotes of the seventeeth and eighteenth centuries. What we find evoked or narrated in these works derives from that fiasco to which, as we have seen, Stendhal will later devote a chapter of his *De l'amour*. It involves the moment of surprise and shame, but also of truth, which reveals the weakness of a subject whom no mask, at that point, can cover. The attempted coitus is an act of a real being, alone, before a witness-examiner. At the outcome of the test, the woman's disappointment spells the failure of male domination; it establishes a scornful memory. The fiasco or "flub" is perceived and described as traumatic. It opens onto a litany of excuses and may furnish, among men, the occasion for bitter dirty jokes. This tiny somatic incident, seemingly insignificant, inflicts a deep wound on the subject, for it shakes up values judged to be essential and attacks markers of identity. To measure its seriousness, one need only think of the virile phenomenology of vigor, ardor, and courage seen at the time as vital. This momentary failure of control over one's body suffices to provoke anguish. The meaning of the accident, to the extent that the subject acknowledges it, is determined by the ideology of virility.

In France during the first half of the nineteenth century impotence ceases to stand for an accident or a series of "flubs." Doctors of the period take a long look—with some enjoyment—at this medical condition. They scrutinize anatomies, attempt a repertory of physical signs of the condition, and interrogate the patient at length about how his failures came to pass and on the nature of his sensations. They propose a catalogue of causes. They place blame, in particular, on masturbation, excess of venereal pleasures, and overextended abstinence. They invent and try out a host of remedies. They put orthopedics into operation (artificial penises), apparatuses—such as Dr. Mondat's famous "*congesteur.*" They regulate the patient's diet, prescribe aphrodisiacs, and imagine all sorts of remedies and stratagems: baths, exposing the privates to hot steam, lying on electric beds, scolding. . . . Most of all, for what concerns us, they enumerate the damage of the failure of virility. They stress the difficulty of the avowal, report scenes of tears, and evoke suicide attempts. Later, scholars such as Parent-Auber and Seraine work on setting up a typology of impotent men. Féré attributes the condition at the time to a predisposition resulting from degeneration.

Coterminously, there is a thematic swerve in the world of the novel.[26] The appearance in 1822 of *Olivier, or The Secret* by Mme. de Duras, then that of *Aloys,*

or the Monk of Mont Saint-Bernard by Astolphe de Custine initiate the evocation of that proven impotence (*"babilanisme"*) so well analyzed by Stendhal in his novel *Armance*. Impotence "becomes then a constituent, irremediable affliction, embedded in the deepest part of a fractured nature."[27] It becomes the material of tragedy. The comic side of the fiasco has given way to seriousness; accident has been transformed into destiny. Impotence henceforth derives from the domain of the unspeakable, from mysteriousness. It imposes the secret, the impossibility of avowal of his suffering on an individual reduced to a "life without life" because he likens "the living being to the virile being." In the novels mentioned, the heroes have mourned over the loss of any hope of recovery; their impotence, which has become their destiny, has the status of their essence.

One can see why, from that point, the scene of impotence disappears from these works. No need to relate a fiasco, since the certain failure pervades the entire story and leaves the subject facing an uphill battle against the powerlessness to talk about it. It is the latent anguish that constitutes the essential here. While the tribunal of impotence was founded at the request of women, the request fades in the novels cited. It is never made explicit, since the woman remains in theory satisfied.[28] The problem is refocused from then on on the impossibility of desire and amorous passion within marriage.

After the triumph of the Third Republic, notwithstanding the relaxing of the censor, the picture remains practically unchanged until the end of the century—with the exception that the quest for the roots of impotence by doctors grows more intense owing to the exploration of new fissures that determine the early warning signs of this male identity crisis, which is well sketched out by historians.[29]

Cultural history is made up of inertia, gaps, and overlaps. Thus, the history of sexuality reveals a series of recurrences as yet poorly elucidated. Curiously, a certain theory was extensively discussed at the beginning of the nineteenth century because it was seen to be linked to a humoral reading (since outmoded) of physiology. It finds favor again, just as proto-sexology is germinating. It concerns the conviction that a reabsorption of sperm takes place inside one's body, and that this process is beneficial to all the characteristics that define virility. In 1819 Professor J. Alfred Fournier, criticizing Tissot, who held this process as true, jeered at the claim of reversing sperm and even more so at the invigorating value attributed to this substance, which, based on credible evidence, no direct observation had ever verified. Sperm, in his view, no more determines puberty than it maintains intellectual vigor.[30]

During the last third of the century, in the domain of medical vulgarization, the idea of retaining sperm takes hold again, now associated with the return of the

conviction that abstinence is harmful. Is it a question simply of the uneven development in the diffusion of branches of knowledge, of the phenomenon of some kind of inertia? Does this return result from the hold of moral norms extolling young men's chastity and the retention of sperm? Does it only reflect new knowledge in the domain of the circulation of fluids inside the organism and its psychological consequences? Only highly specialized historians of medicine will be able to answer this last question, which evokes Freud's future notion of sublimation.

Whatever the case may be, now the potential agony of abstinence, once denounced by clinicians, especially by the anticlerical ones, and by physiologists from Paris and Montpellier, creates new debates. In 1865 Dr. Louis Seraine writes: "The man who has sperm reabsorbed into his body is under the sway of a *powerful tonic*, and he is never as capable of great resolutions and advanced thought as when he has saved it up, as a benefit to his intelligence."[31] Sperm, abundant throughout the organism, confers, moreover, physical strength. In a word, he who has been able to avoid the discharge boosts his virile qualities. According to J.-H. Réveille-Parise, often quoted, sperm constitutes "life in its liquid state." This is manifested not only in the process of procreation. Alexandre Mayer emphasizes, in effect, that this substance maintains life as much as it conveys it: "The reabsorption of the fertilizing liquid," he writes," imparts to the whole constitution a constantly renewing energy and a *virility* that helps prolong life."[32] Thus, sperm should be carefully preserved: during youth first of all; it is a way at that time, writes Dr. Seraine, "to save up one's sexual force,"[33] to preserve one's future virile prowess and hence the quality of one's progeny. The specialists repeat that young Germans, according to Tacitus, owed their vigor to chastity, and that the same went for medieval chevaliers. Christoph W. Hufeland, it may be recalled, at one point shared this type of conviction, which was strengthened by the certitude of the connection established since the eighteenth century between the development of civilization and a dire loss of youthful strength. Young men dissipate their strength, again writes Dr. Seraine, and "the result is that they are no longer real men."[34] From that point, the diatribe mounted under the Third Republic against the "drained little men" is not surprising.

The economic model governs these convictions: managing one's sperm as a good head of household is preserving one's capital. Seraine cites an old practitioner dispensing his advice: "From twenty-five to thirty-six, live on the revenue; from thirty-six to forty-five, save; from forty-five to the end, carefully hold onto the capital."[35] Such an aphorism is in accordance with the Anglo-Saxon model of the Victorian period recommending "restraint," even in coitus, for ejaculating is spending;

hence the necessity for *self-control*. Such notions as these are found in the immense oeuvre of William Acton. Up to the age of 35, writes Louis Seraine, man is in a growth mode. The following decade corresponds, according to him, to the "period of virility or of status quo"; after 45 begins the stage of "decadence."[36]

The denial of the pathology of abstinence, then on the upswing, the conviction of the harmlessness of chastity and of virginity, which the Italian Paolo Mantegazza proclaims for his part in *Hygiene of Love*,[37] and the relaxing of the link, formerly strong, between retention and impotence, favor the articulation of medical norms and lifestyle rules that support and transmit moral theology, whose hold is then weakening. We might also cite, in this regard, the writings of British scholars Seved Ribbing—*Sexual Hygiene and Its Moral Consequences*—or L. S. Beale.[38] Both recall that Newton, Pascal, Leibniz, Kant, Beethoven . . . managed to remain abstinent, just as did the great warriors, models of virility, Scipio the African and Bayard. According to this logic, writes Féré, the doctor no longer has to prescribe to his young patients, as did his predecessors, "the frequenting of women"; quite the contrary, he is obliged to urge them to save up their strength. Note that sports, then on the rise, are supposed to facilitate abstinence. Mme. Avril de Sainte-Croix, champion of an association of morality, thus boasts of dealing with her seven sons through exercise and sports.

We still have to take up the difficult analysis of how the growing hold of the concept of degeneration affects images of virility, the norms it induces, and the new forms of anxiety it causes.[39] We must bear in mind that the tragic aspect of scholarly discussions that develop from 1857, the publication date of Bénédict-Augustin Morel's work (see note 116), seeps into society only gradually, despite such transmitters as the novel and the everyday practice of doctors; the risk of overestimating its significance is therefore great.[40]

A notion that turns out to be essential is that of predisposition, the "hereditary tendency to acquire" or the "congenital defect" that maintains the threat of a future pathology without the hope of any recovery. The notion of degeneration brings ancestors into the discussion and implicates their culpability. It suggests the existence of whole families that are victims of "congenital perversions," which are related to teratological families. "Predisposition" may provoke defects that afflict the foundations of virility. This morbid effect is conveyed at times by deformation; this is the case with hereditary syphilis (*hérédosyphilis*), theorized by Alfred Fournier, and then by his son Edmond. The portrait these scholars sketched of the "*hérédo*" (as they called the man stricken with this disease) verges on teratology. On the evidence of the first of these doctors, the unfortunate man possesses

only "rudimentary testicles."[41] Such traces of degeneration might also afflict the victims of an alcoholic heritage. A number of individuals keep a close watch for many years, from their innermost being, for the appearance of signs of a morbid heredity. Ibsen devoted his play *Ghosts* to this type of silent threat.

Even subtler, then, is the scholarly picture of sensorial parasthesisa and of all forms of pathology of the emotions.[42] Charles Féré thus draws a picture of the agitation that demonstrates that "the sex organ is on the way to dissolution." In 1899 as a symptom he cites cruelty when it appears to be necessary for sensual ejaculation and "erotic rage" against the woman when an orgasm is slow in coming.[43] But the most often denounced among "sensorial idiosyncrasies" remain those "aberrations of the genetic senses," of which Michel Foucault has since underlined the historical importance during this time when "proto-sexology" was coming into being.[44] It is enough here to evoke those "perversions" that are perceived at the time as obvious attacks on virility.

The feminization of men also preoccupies scholars. Charles Féré denounces it generally. In his view, the standardizing of education and teaching correlates with the standardizing of sexual characteristics. The essential thing, according to him, is still the threat of "inversion," defined by Karl Westphal in 1870 in his book *Congenital Inversion of Sexual Feeling with the Morbid Consciousness of the Phenomenon*. Féré ties it closely to degeneration.[45] "Often," he writes, "inverts like to cook, to knit, to embroider; they like jewelry, clothes that draw others' attention by their color and their form; they slavishly follow fashion . . . ; they like to dance, and virile pastimes repel them. Their tendency toward feminization is often manifested in the sound of their voice . . . ; a man's inability to whistle has been seen as a sign."[46] Now, inversion ignores the organic characteristics that in the past defined "*antiphysique*" or pederasty, from doctors' perspectives. It is a question of a simple perversion of the sexual instinct. Inverts suffer, inasmuch as some of them cannot bear any contact, smell, or interaction with women. Westphal points out that the idea of suicide tempts them at times. In a word, feminization—like virago-like qualities in women—is characterized by an "inversion of the psychic person," by an anomaly in tastes, games, and grooming that is manifested as early as childhood. "In abnormal relations," the invert "feels like a woman," so he "seeks the passive role, the succubus, in anal or inter-femoral coitus." The invert goes to great lengths "to take on aspects characteristic of the other sex"; he "does not forget the corset that draws in his waist and tends to make the chest and the hips stick out." "He seeks out partners with marked sexual characteristics: carriage drivers, butchers, circus horse riders, etc."[47]

There is no need to insist, since the extensive scholarly discourse devoted at the time to the inversion of the sexual instinct places such emphasis on how it undermines representations and norms of virility. The same goes for sexual algophilia, analyzed in particular by Krafft-Ebing, and which he calls masochism in 1886[48]—to Sacher-Masoch's great displeasure. Playing a passive role in the love act, demanding of the woman humiliating treatment, is at first perceived as a breakdown of virility [cf. fig. 12.2]. Indeed, the bibliography devoted to this "perversion" is considerable. Féré, who sees in it especially the effect of a congenital predisposition, includes it in his catalogue of pathologies of the emotions, stressing the importance of the "passivity" in the matter. The patients are "whipped, pinched, struck, kicked by the object of their passion, lick her feet, etc."[49] William Acton recommended not whipping children so as not to sow the seeds in them of such a disorder of the procreative organs.[50]

Should fetishism, as baptized by Alfred Binet in 1887, be listed in the catalogue of the types of breaches of virile norms? A reading of these same proto-sexologists would lead one to think so.[51] Thus, the Swiss theoretician Auguste Forel classifies this behavior among perversions of the sexual instinct, inasmuch as the quest for women's handkerchiefs, gloves, boots, hair, and clothes acts as a substitute for the

FIGURE 12.2 WOMAN ASTRIDE A MAN AS IF HE WERE A HORSE. SEXUAL ROLE-PLAY, CA. 1880.

What becomes of the code of virility when the man is reduced to the status of a horse, thus illustrating one of the "perversions" described by Krafft-Ebing?

Wellcome Library, London

normal accomplishment of the virile act.[52] This conduct is analyzed as a sign of the refusal to confront coitus or else to see a woman's entirely naked body. The police officer Macé considers these individuals, in 1882, as effeminate.[53] J.-M. Charcot and V. Magnan "suspect" them, in 1882, of homosexuality.[54] Paul Laurent perceives them as "monsters by default," regards their behavior as organized around an absurd ritual, and calls them impotent onanists.[55] Krafft-Ebing attributes the pathology to degeneration, Binet to a means of stimulating desire, a precocious sexual fixation arising from a trauma that caused passage to one extreme of a normal love relation.

Let us end here this partial review of the catalogue of perversions, developed in detail at the time—without forgetting, however, that each of them derives, in one way or another, from a challenge to the then dominant code of virility.

Without much basis in information furnished by scientific discourse, a cohort of historians has already located—let us recall—a crisis of virility, or of masculinity, to use the vocabulary of the history of gender. It is useful to go back to what, in the larger scheme, this crisis is supposed to be based on. The most obvious source is a growing fear inspired by women, the fact of the unexpected threat they pose, the new requirements and demands they formulate, their now persistent presence in places that were formerly those of a community of men, the unusual authorization granted to them to look at, to read, to attend the theater, to move about freely, to display themselves, and the blurring that takes place from then on between the honest woman and the prostitute.

While higher education was still restricted to men, notably in the universities and the medical schools, the first female students appear during the Second Empire (1852–1870). At the same time the feminist movement spreads,[56] a clear threat in the eyes of a number of men. For a long time doctors had emphasized that the woman was stronger than the man in the course of lovemaking bouts—a virile inferiority that still appears in the nineteenth-century *Dictionnaire universel* by the strict Pierre Larousse. This threat to virile power helped justify male domination in the love act—all the more so because, by extracting his sperm, the woman was seen as hastening her partner's demise.[57] From now on the sexual fear that she inspires is based on other evidence. *L'Ève future*, to use the title of Villiers de l'Isle-Adam's novel, is not only Eve the temptress and corrupter from Genesis, redeemed though she may have been by Mary and the repentant Mary Magdalene. Henceforth many women do not hesitate to show their desire, going against traditional norms of modesty. The new urbanism facilitates this ostentatiousness. The layout and clearing of the *grands boulevards*, which encourage new modes of walking around, the

spread of outdoor cafés, the development of nightlife,[58] the abundance of lights, the depiction of enticing female silhouettes on pervasive posters, the renewal of modes of solicitation, indeed, of provocation, modify the relations between the sexes and impose on men new warnings at the same time as they permit new pleasures. The establishment of divorce,[59] the growing attraction provoked by the "flesh of the other"[60] and the impact of crimes of passion, the reorganization of methods of solicitation by prostitutes seen in the new success of houses of ill-repute and the relative decline of neighborhood brothels, inside of which resigned naked bodies on display for the taking, force the man to prove his powers of seduction in new ways.[61] The rise of flirting blurs sexual roles and identities in the sense that initiatives are shared, manifestations of male dominance are attenuated, the injunctions of the code of virility loosen, and female exigencies are expressed and become more refined.[62]

The new permissiveness granted to women to read works of popular medicine, of which Dr. Montalban's *Little Bible for Young Marrieds* may serve as model,[63] and to revel in novels that openly evoke carnal union, the development of the practice of honeymoons,[64] the daring of playwrights who stage adultery and feminine desire—all this suggests new erotic needs to wives or at least leads them to allow caresses modesty forbade until then. I have been drawing attention to the eroticization[65] of the conjugal couple for a long time, while moralists endeavor to sketch the model pro-Republic family based on a union more egalitarian than before. Many men find themselves, as a result, subject to new demands and therefore to new forms of anxiety. The rise of contraception, the open demand for protection, "wombs on strike" (*grève des ventres*)[66] proposed by certain militants, and the debates concerning abortion despite the vigorous campaign of the populationists bear muffled witness to this upheaval in behavior.

In the background, fear of syphilis is growing. Syphilis fuels nightmares and provides material for an extensive literature.[67] Woman, symbol of this new tragic drama, personifies the scourge in the works of Félicien Rops, as well as in the nightmare of Huysmans's Des Esseintes.[68] On stage and in the opera an outpouring of hysteria spreads, the type that Charcot stages at the Salpêtrière Hospital, as well as those female "defects" and malfunctions that are perceived as so many threats to men. Symbolist art multiplies the depictions of female sphinxes, devourers, and sirens who drag their lovers into the abyss.[69] In general, the depictions of women that spread or twist their nudity on beds of leaves or of moss, who spring out of tree trunks in the form of wood nymphs, who appear as evil girl-flowers, or who form closed circles as if they had no need of male partners, symbolize the growing

threat represented to men. It would take a Percival to resist. To stick just to French literature, the "demi-virgins" of Marcel Prévost, Daudet's Sappho, the "Princesses of intoxication and ivory" of Jean Lorrain, the heroine of *Supreme Vice* by Sâr Peladan, Rachilde's *Animale*, not to mention *Venus in Furs*, manifest clearly—for these are for the most part works by men—that the time has long passed for the tranquil domination over women expressed in letters that men exchanged at the very beginning of the century.

All this leads us to wonder if virility, such as it is felt by the men of that time, is not, above all, a network of anxiety-producing injunctions, often contradictory, to which one must, in one way or another, give in, whether through the control of one's impulses or through the unbridled exercise of one's sexual vigor. This is all a way of reassuring oneself about one's biological, moral, psychic, and sensual identity, and especially a way of demonstrating to others and to oneself an amazing control over those organs that, while certainly vigorous, are truly subject to the virile man's will. In a word, it is a way of erasing that which, in St. Augustine's view, constituted the dire consequences of the Fall.

HOMOSEXUALITY AND VIRILITY

RÉGIS REVENIN

The word "homosexuality," invented in the German language in 1869,[70] does not appear in France until the 1890s from a scholarly writer, but it is not widely used or actually popularized until after the World War II. Up to the beginning of the nineteenth century, the terms most often used still take on a naturalist or religious connotation: "sodomite" or "*antiphysique*." The word "pederast," still rare before the nineteenth century, a time when it improperly comes to mean "homosexual," becomes current from then until the 1950s and 1960s in France as elsewhere in the West. Other expressions like "invert" are also frequently used, principally by the elite, with the working classes being more comfortable using a more familiar, argotic register: "butt-fucker," "faggot," "*pédé*," "queen," and "queer." Other names, then, are not met with great success in France: "Uranian" or "*uraniste*," "*simili-sexuel*" and "*unisexual*" in particular.[71] In other respects, the period is very rich in lexical content concerning homosexuality.

In this chapter, the generic term "homosexuality" is to be understood as the set of affective, amorous, cultural, social, and/or sexual relations between men, whether or not they define themselves as homosexual, whether they have exclusively or occasionally homosexual relations, and whether or not we are dealing with sexual relations for pay. Homosexuality is in no way an ahistorical or universal category,[72] but that does make our project any less burdensome.

As recently as the eighteenth century, "sodomy" (a very broad juridical category, including anal relations but more generally relations not intended for procreation) was a crime punishable by death: hanging in England, drowning in the Netherlands, burning at the stake in the rest of Europe. This is because sodomites go against divine law and defy nature; they are perverse in the sense that they refuse coitus for procreative purposes; the identity of the sodomite, then, is constituted principally by the wrong done to natural law and not by a preference for an individual of one sex or the other.[73] In this sense, sodomites undermine the foundations of Ancien Régime society. However, the conviction that the punishment is too severe, and even more that it provokes dangerous publicity for relations against nature, leads at the end of the eighteenth century, very probably under the influence of Enlightenment thinkers, to the idea of decriminalizing sodomy.

In France, six executions for the crime of sodomy take place in the eighteenth century, most of the condemned men also being guilty of murder. In Paris, most of the time the morals police give a talking to the arrested sodomites or sentence them at most to a few days in jail.[74] So as of 1791, France, a revolutionary and liberal power, abolishes the crime of sodomy, considering that it is a victimless crime, in a word, an imaginary crime, as are blasphemy, witchcraft, heresy, or even sacrilege.[75] Elsewhere in Europe, Prussia promulgates its new penal code in 1794, punishing sodomy by imprisonment, flagellation, and at times banishment for life. With the penal code of 1787 the Austro-Hungarian Empire establishes sanctions of imprisonment, forced labor, and flagellation against the sodomites. The Netherlands does not punish acts against nature in any specific manner until 1730, but it is the last country in Western Europe to execute sodomites as late as the beginning of the nineteenth century. European legislation undergoes great transformations at the end of the eighteenth and the beginning of the nineteenth centuries, significantly modifying the juridical status of homosexuals. Napoleonic territorial expansion nevertheless had the effect of diffusing French penal law throughout a great part of Europe: the Netherlands and the Italian and German states.[76]

Meanwhile, penalization of homosexual relations is in process at the end of the nineteenth century: Germany punishes pederasty within the framework of its new collection of penal laws in 1871, England in 1885.[77]

One might say that a consensus, a "bargain," has been reached at the end of the eighteenth and in the course of the nineteenth century that begins to come apart: nonpenalization of homosexuality in exchange for homosexuals' discretion, that is, for their invisibility, their nonappearance in the public sphere. This bourgeois conception of the separation between public and private spheres, applied to women as well, is smashed to bits with the advent of homosexual modernity, that is, the revelation of a homosexual world and of specific territories at the heart of the city set aside for homosexuals, beginning at the end of the nineteenth century throughout the West.[78]

In other respects, the repression cannot be limited solely to the power of surveillance and public coercion (registries, round-ups, trials), the attempts at censoring and self-censoring, and the burying and obliteration of homosexual reality; just as oppressive—if not more so—on an everyday basis are ostracism and familial and social disapproval, fear of losing one's job, or the attention necessary to maintain one's respectability. In any case, the Parisian morals police keep tabs systematically on pederasts beginning in the 1840s and 1850s; certain archives prove that a more home-grown registry had already been started in Paris and in the provinces at the beginning of the 1800s, no doubt as a result of the police state established by

Napoleon. While sodomy is no longer punished from 1791 on, the magistrates do not stop using the battery of penal laws at their disposal to penalize those practices between men on the basis of such offenses as indecent exposure in public (article 300 of the penal code), attack on morals (articles 331 and 332 of the penal code), or corruption of minors (article 334 of the penal code). Indecent exposure in public, the most widespread offense among homosexuals in the nineteenth century, consists of having sex in public at a time when few people can host at home owing to a lack of privacy in working-class lodgings.[79] In France, beginning in the 1840s, trial court judges and police officers in the field demand of the civil powers specific legislation to punish homosexuality as a crime in itself.[80]

However, since police surveillance, registries, and judicial punishment are not completely effective in France, medicalization of sexual deviants becomes the solution to the homosexual "problem," not so much anymore as a practice between men but as an entire personality type.[81]

In a passage from the first volume of his *History of Sexuality*, now a classic, Michel Foucault locates the invention of the figure of the modern homosexual by the psychological sciences:

> We must not forget that the psychological, psychiatric, medical category of homosexuality was constituted from the moment it was characterized—Westphal's famous article of 1870 on "contrary sexual sensations" can stand as its date of birth—less by a type of sexual relations than by a certain quality of sexual sensibility, a certain way of inverting the masculine and the feminine in oneself. Homosexuality appeared as one of the forms of sexuality when it was transposed from the practice of sodomy onto a kind of interior androgyny, a hermaphrodism of the soul. The sodomite had been a temporary aberration; the homosexual was now a species.[82]

So social observers become very much interested in this "manner of switching masculine and feminine inside oneself," this "sort of internal androgyny," this "hermaphroditism of the soul" evoked by Foucault. And while effeminacy was no doubt always struggled against, probably since Antiquity, it was only in the nineteenth century that the association is taken for granted between effeminacy and male homosexuality.[83] It is true that as late as the eighteenth century an effeminate man—defined as someone biologically male taking on "physical and moral characteristics traditionally attributed to women,"[84] at times as a caricature—is often an aristocrat, a libertine, or an actual heterosexual (even though the term is improper[85]) who has been subjected to the influences of women.[86]

In the seventeenth and eighteenth centuries, the borders between the sexes, among the aristocracy at least, appear much more tenuous. First, in terms of clothing: certain noblemen wear ribbons and use make-up; abbots cross-dress.[87] One thinks, of course, of the Chevalier d'Éon (cross-dresser of the late eighteenth and early nineteenth centuries).

Nor is there any denying that for several centuries here and there effeminacy has been one of the fundamental recurrences of homosexual and prehomosexual cultures, embodied, for example, in the figure of the queen.[88] But why and how did this association between gender (masculine/feminine) and sexual orientation (in this case, homosexuality) gradually sink in? How did effeminacy become the rule for the male homosexual? The historian and sociologist Michael Pollak suggests in *Homosexuals and AIDS* that effeminacy among gays is the result of homophobic or antihomosexual oppression.[89] Of course, certain homosexuals' taste for things feminine (at times to an outrageous extent) is long-standing; it belongs in part to what forms the basis today of gay identity,[90] and effeminacy could not be summed up as a simple internalization of homophobic imaginings—all the more so because "queen culture" can be understood and experienced as a form of resistance to the heterosexual social order. In any case, from one end of the nineteenth century to the other, homosexuality is thought of in terms of gender and not in terms of sexual orientation, each partner having to fill the role according to the heterosexual model of either the "woman" or the "man." Not crying or not masturbating means maintaining control over one's emotions, self-control—a prime value of virility in the nineteenth century, as Alain Corbin notes.[91] Yet the male homosexual is actually associated with tears, or at any rate with a certain sentimentality, and with masturbation, at least based on scholars' observations. Could effeminacy constitute the common denominator among homosexual "worlds"[92] in the nineteenth century more or less throughout the West?

According to the historian Randolph Trumbach, "the gay minority, with its subculture and its (sexual) roles" arose in Northeastern Europe during the years 1690 to 1725. Its most characteristic trait is "the appearance of the effeminate adult male as dominant actor." He thus situates the emergence of a homosexual "minority," made up essentially of effeminate men, in France, England, and the Netherlands from the late seventeenth to the early eighteenth century. According to Trumbach, up to the eighteenth century the typical sodomite would have been the debauched male or libertine, a man penetrating indiscriminately (male) adolescents and women. However, beginning around the middle of the eighteenth century, general opinion would have had it "that any man who engages in sexual relations with another man is an effeminate male who belongs to a third intermediate gender (between masculine

and feminine), who renounces his right to be treated as a dominant male and . . . is exposed to well-deserved contempt as the member of a species composed of male whores." For Trumbach, then, this opinion reflects the real behavior of homosexuals: modern sodomites were thus seen as "effeminate males who congregate in illicit urban cultures."[93] Historians Trumbach and Rictor Norton demonstrate the existence in London, from at least the 1720s, of this new culture of effeminate sodomites who imitate women's behavior and often take feminine names.[94] Maurice Lever, Jeffrey Merrick, Michel Rey, Michael Sibalis, William Peniston, and myself have also thrown light, in historical works, on these same subcultures of effeminate men in Paris during the eighteenth and nineteenth centuries.[95]

Nevertheless, while admitting that "the prototype of homosexual love in medical and popular literature" focuses on effeminacy, the sociologist Gert Hekma insists, for his part, that this image masks the diversity of homosexual lifestyles in the past as well as the tastes and fantasies of homosexuals:

> Different forms of male love existed in the eighteenth, nineteenth, and twentieth centuries alongside each other; the one was not superseded by the other, and different styles developed in and among themselves . . . It would be . . . a mistake to conclude from the publicity given to queens that their style actually set the tone for all homosexual subcultures [. . .].[96]

MEDICINE AND HOMOSEXUALITY: THE ADVENT OF THE CONFUSION BETWEEN EFFEMINACY AND MALE HOMOSEXUALITY

Were there, consequently, before medicine's investment in the homosexual question during the nineteenth century, homosexual cultures and identities whose principal characteristic would have been effeminacy?

Although scholars use the same terms to refer to different phenomena, several theories of homosexuality, often confused, gain currency during the nineteenth century. The pioneers on the issue come from legal medicine in the early nineteenth century, followed by the alienists and other psychiatrists in the second half of the century and the theoreticians of the "third sex," who advocate for the innate character of sexual inversion. But in their concern for the juridical and social legitimation of inversion they remove from it the notion of degeneration. Finally,

psychoanalysts appear who promote instead a "culturalist" account of homosexuality, favoring a relational explanation between parents and children over hereditary or organic causes.[97]

Still considered a sin in the eighteenth century (the "*antiphysique*," the figure of the homosexual during the Ancien Régime, goes against nature and against divine will by not complying with the design of reproduction and becomes the object of a massive semantic outpouring around horror, debauchery, and monstrosity) and often included under the juridical category of "sodomy" (in force in France until 1791), sexual acts without a procreative aim become sexual perversions. Scholarly writings as a whole, like a recycling of natural ideas, are based on the idea of a normal sexual instinct that will necessarily draw an individual toward someone of the opposite sex.

Julien Chevalier, student of the famous Dr. Lacassagne,[98] is the author of the first thesis in French medicine treating homosexuality (defended in 1885 and published in 1893). A military and colonial doctor, he propounds the principle according to which inversion is congenital, but he does not totally rule out acquired inversion: based on his calculations, acquired inversion is caused by the laziness of youth (prostitution), by the fear of venereal diseases, or by the absence of women. For him, the normal sexual instinct would be dependent on a generic center situated in "the cerebral cortex not far from the olfactory center," charged in a way with conducting and programming sexual behavior. He therefore allows inversion as an anomaly obstructing the natural law of attraction between the sexes, postulating that the less sexes resemble one another, the more they attract one another. He distinguishes three types of homosexuality: acquired inversion, considered a transient vice or perversity; secondary inversion, acquired by one's métier (prostitution, extortion) or as a result of the milieu in which one lives (urbanization, promiscuity, colonization . . .); and finally, innate inversion, that is, the perversion or malady that is total, generally present and visible from childhood.[99] Chevalier's entire pyramid is nonetheless based, as can be seen, on the general law of attraction between the sexes, itself influenced more by gender than by biological sex. In this sense, the reality of homosexual experiences can be reconciled with this law if one admits as true and verifiable by sources (at least in the case of certain homosexuals) that effeminate men attract virile men and vice-versa.[100]

In a society more and more centered around moral and hygienic preoccupations, perturbed by the question of low birth rate—particularly advanced in France (exacerbated by national rivalries after the French defeat by Prussia in 1870–1871 and the loss of Alsace and the Moselle and by class conflict and the revolutions of

1830 and 1848), sexual abnormality becomes the prerogative of medicine, which makes it a social problem, an entirely new phenomenon. The homosexual then becomes, beginning in the middle of the nineteenth century, the paradigmatic figure of the male pervert. A few decades later, not daring to publish them himself, Émile Zola entrusts the autobiographical secrets of a young homosexual Italian aristocrat to the French doctor Georges Saint-Paul, who publishes under the pseudonym of Dr. Laupts. The writer prefaces the work, explaining in detail his choice:

> Dear Doctor,
>
> I see no harm in your publishing *The Novel of an Invert*—on the contrary, I am very happy that you can do, as a scholar, what a simple writer like myself has not dared to do. . . . I was then going through the roughest period in my literary battle; critics called me a criminal every day, a person capable of every kind of vice and debauchery; so, can you see me becoming at that time the editor responsible for this *Novel of an Invert*? First, I would be accused of having totally made up the story out of personal depravity. Then, I would be roundly condemned for having seen in the affair only base speculation regarding the most repugnant of instincts. . . . But, as luck would have it, dear Doctor, one night as we chatted we got into the subject of the human and social evil of sexual perversions. And I entrusted you with the document that was lying in one of my drawers, and that's how it has finally been able to come out, at the hands of a doctor, a scholar, someone who won't be accused of trying to create a scandal [. . .]. [101]

Legal medicine is the first at that time to show interest in homosexual practices, notably with regard to questions relating to sodomy and rape. The debates are focused around the presentation, in a judicial setting, of scientific proofs likely to affirm whether the indicted individual has had relations against nature by the presence of physiological traces on the body: a cone-shaped groove from the buttocks to the anus; signs of hypotonia of the sphincter; signs of sphincter trauma; funnel-like deformation of the rectum; signs of infection (rectal gonorrhea, in particular); the presence of sperm or blood in the anus for "bottoms"; and deformation of the penis for "tops." Following up on Samuel Tissot's work on onanism,[102] legal medicine also emphasizes the physical marks supposedly produced by homosexuality much more than on the physiological or psychological causes of this new sexual perversion.

Considering that pederasty is a school of crime, to borrow the words of Ambroise Tardieu,[103] it is important to put into operation efficient means of

fighting against its propagation. Thus, psychological explanations are not in fashion in France, unlike in Germany, where the jurist Johann Casper[104] highlights the feminine characteristics of homosexuals, whom he goes on to name the "hermaphrodites of the mind," advancing as early as 1852 the idea that homosexuality is innate (more than a decade before Westphal's famous treatise of 1869).[105] Conversely, the organic explanation developed by Ambroise Tardieu beginning in the 1850s, the French response to German work on the homosexual question in the context of national rivalries in Europe, endeavors to describe the physiological characteristics that prompt recognition of homosexuals, whereas Johann Casper places more emphasis on a homosexual psychology. Physiological, organic, or neurological explanations have gone full steam ahead for a long time in France, whereas psychic explanations are considered ipso facto as German.

The nineteenth century is also the century of competition between medical power and police and judicial power. The suppression of sodomy and homosexual acts by French penal codes (those of 1791 and 1810) precede by several decades the period when legal medicine looks into the homosexual question to turn it into a social problem, at the very moment when the French district and appellate courts are starting to distinguish between heterosexual and homosexual relations in evaluating attacks on public morals. From 1843, the French doctors Guillaume-André-Marie Ferrus, Achille-Louis Foville, and Alexandre Brierre de Boismont begin getting interested in the mental state of pederasts,[106] while in 1849 the French alienist Claude-François Michéa writes, again well before Karl Westphal, a pioneering article on the "the pathological deviances of the sexual appetite,"[107] which received little attention at the time. Although he is listed in the police registries during the 1850s as being a pederast,[108] he hardly believes in the idea often put forth as recently as the early nineteenth century (despite the work of Samuel Tissot) that "excessive imagination" causes sexual aberrations and leads necessarily to madness and then to a painful death.

For Michéa, then, the cause of pederasty is to be sought in certain physiological ailments. In his opinion, perverse behavior was thus the result of a perturbed organic functioning: following perverse sexual acts, the brain would not be irremediably affected, as was believed in the case of masturbation, but it would no longer function normally. Michéa considers that "*philopèdes*," the term he prefers over pederasts, are by nature feminine for a very simple reason: some of them were believed to have a rudimentary uterus. He is the first to classify homosexuals according to a broader typology of sexual deviances, which he organizes in this way: (1) Greek love or the love of one individual for another individual of the same sex (a very widespread

anomaly, in his view); (2) bestiality (somewhat less widespread); (3) attraction to an inanimate object; and (4) attraction to human corpses. For Ambroise Tardieu, the cultural characteristics of the pederast are the ones to be highlighted: ambiguous looks (effeminacy . . .), specific tastes that would give him away, specific clothing styles, and particular behaviors, all allowing easy identification. It will take two decades before we finally reach the end of exclusively organic explanations. The alienist Paul Fabre, in his article on male hysteria (1875), presents the neurological inversion of gender thus: a female brain in the body of a man.[109] He mixes sexual attraction for the same sex, effeminacy, and hysteria—an association that does not appear in the medical literature, it would seem, until the second half of the nineteenth century and is later taken up by Jean-Martin Charcot, then a world-wide expert, and Victor Magnan, a very prominent neurologist. Paul Fabre, under the influence of August Klein's thesis in medicine,[110] then revises his opinion and judges that effeminacy is not present in all hysterical men.[111] This theory holds sway, however, for a long time.

One of the essential characteristics of the period, which is most probably not outmoded until Sigmund Freud's time, lies in the scientific division of pederasty into two principal currents: one, the predominant one, is biological, establishing that all perversions (including homosexuality) are innate forms of degeneration; the other is based on a psychological principle focusing on acquired traits. This latter theory is often discredited because of the slight interest paid to theories about the consequences of excesses of imagination or desire seen as too closely linked to works on onanism, a great "problem" of the eighteenth century. The line between conceptions giving priority to acquired traits, on the one hand, and those giving priority to innate or congenital ones, on the other, remains tenuous, the innate theory having at times the function of legitimating homosexuality in countries where it was criminally repressed (notably in Germany, with the works of Magnus Hirschfeld on the "third sex").

It is in this context that the theory of the "third sex" emerges at the end of the nineteenth century. It is based on the idea that one is not really a man from a social perspective when one "decides," as an individual who is biologically male, not to be interested sexually in women and to behave deliberately like a woman, inverting sexual roles and gendered identities. The schism, or more exactly, the juxtaposition, with past theories lies in the fact that from now on the center of gravity is located not only in sexual behaviors and their social consequences (notably, in terms of criminality and delinquency) but also in the whole personality—that of an individual capable of desires contrary to the norm, as presented in French literature, particularly by Honoré de Balzac.

The first to be interested in the causes of homosexual relations are German scholars. Following the lead of Johann Casper, the jurist Karl Ulrichs, convinced that his own homosexuality is an innate phenomenon (situated in his brain or in his testicles),[112] develops the idea as early as 1864 that male homosexuals are beings endowed with a woman's soul enclosed in a man's body; their desires are therefore oriented quite naturally toward men and cannot, for this reason, be repressed. Taken up in literature (for example by Marcel Proust in *Remembrance of Things Past*), this line of thought then evolved into the idea that virile homosexuals are beings irresistibly attracted by effeminate men (and vice-versa). In this sense, Karl Ulrichs also makes of homosexuals a "third sex" with the same status as women and men. Although he fails finally in his project of decriminalizing acts against nature in Germany, his theory nevertheless has an enormous success, since in 1869 Karl Westphal will rebaptize as a "contrary sexual instinct or sense" the term "uranism" invented by Ulrichs; he considers that research on the congenital phenomenon is fundamental, seeing in the love and sexuality between men a mental illness necessitating therapy, not wrongheaded police and judicial repression. Westphal actually rises up against the penalization aimed at homosexuals, believing that they are prompted by their impulses. In the same naturalizing perspective, though not considering that sexuality between persons of the same sex is a perversion, Magnus Hirschfeld,[113] German psychiatrist and himself a homosexual and militant for homosexuals' rights, becomes the greatest defender, by the end of the nineteenth century, of the theory advanced by Ulrichs. Along with woman and man, a host of sexual types would make up the "third sex" in his view: hermaphrodites, androgynes, homosexuals, and "transvestites" (cross-dressers and transsexuals).

From then on, homosexuality is considered as contrary to heterosexuality, since it is henceforth based on an inversion of the normal sexual instinct. Beginning with Richard von Krafft-Ebing, in fact, many classically draw a distinction between perversion (based on biology and not considered to be widespread) and perversity (an overly pronounced sexuality related to vice and judged to be very widespread).[114] Among the classic necrophiles, pedophiles, and zoophiles four types of homosexuals appear: psychic hermaphrodites; real homosexuals (affected by sexual perversity and therefore vicious, very often presented as tops and married); effeminate homosexuals (affected by sexual perversion, therefore sick, frequently bottoms, and behaving like girls since childhood); and "intersexuals," who present an evident dysfunctionality that is physical as well as hormonal, placing them anatomically close to women (in facial form, voice, and body).[115] In fact, Krafft-Ebing connects homosexuality clearly to an etiology of degeneration as defined

by the Franco-Austrian alienist Bénédict Morel,[116] a theory also taken up in France by Charcot and Magnan,[117] who emphasize the cerebral origin of homosexuality, a result of posterior cerebrospinal ailments. Charcot and Magnan, moreover, are the first in France to speak truly of sexual inversion. They are, therefore, in a certain way the French pioneers of the psychiatrization of homosexuality, notably when they liken fetishism to inversion. The fetishist phenomenon is analyzed and detailed a few years later by the French psychologist Alfred Binet (1887), who distinguishes it from homosexuality, or at least makes homosexuality one fetishist perversion among others and opts clearly for an acquired over an innate pathology.

Believing, for his part, in the innate character of homosexuality, the English sexologist Havelock Ellis,[118] who is the first to propound a richly detailed and positive work on homosexuals, may be considered one of the pioneers of modern sexology. His main work, *Studies in the Psychology of Sex*, published in several volumes between 1897 and 1906, influenced most contemporary theories of sexology, including psychoanalysis.

Contempt for homosexuals—all being merged together under the category of effeminates—betrays in reality a profound, renewed hatred of women and for so-called feminine values. In between the lines of writings on the effeminacy of inverts we should no doubt read the misogyny of doctors and, by extension, of society as a whole. Appearances being presumably linked to moral characteristics, the effeminate homosexual inherits all the psychological flaws of women: excessive nervousness, gossiping, jealousy, swaying of the hips, attraction for fashion, jewelry, and sparkling objects in general and perfume and make-up, a particular type of voice, and specific hair styles [cf. fig. 12.3].[119]

Theories of male homosexuality were thus propagated through literature and the press. This process of diffusion of images of homosexuality was necessarily long, lasting about a century from the beginnings of the medicalization of homosexuality in the first decades of the nineteenth century. Furthermore, the dual categorization of sexuality resulted in homosexuals becoming conscious of their existence as a specific social group by means of a triple process of "essentialization" (reification of homosexuality thought to be natural, although socially abnormal), "exclusivization" (creation and reinforcement of the dichotomy of heterosexual/homosexual), and "specification" (differentiation of the homosexual personality from the heterosexual personality, especially in terms of gender). This process continually grew in importance during the twentieth century fostered no doubt by scholarly discourse but also with an emancipatory aim by collective homosexual demands, most often along the lines of identity politics. It is fair to assume that this medical taxonomy

FIGURE 12.3 MIKLOS VADASZ, CARICATURE. *L'ASSIETTE AU BEURRE*
(BUTTER DISH, FRENCH SATIRICAL MAGAZINE), 1 MAY 1909: "WHAT A DIFFERENCE
BETWEEN THE CENTURY OF AUGUSTUS AND THE CENTURY OF FALLIÈRES
(FRENCH PRESIDENT AT THE TIME)!"

A man taking care of his body, a feminine value par excellence, is suggestive of homosexuality, in the social imagination.

Source: © Kharbine-Tapabor

fixed, in part, sexual and gender identities, very probably favoring the emergence of the gay rights movements in the sense that it allowed interested parties to identify themselves and to categorize themselves more easily.

LITERATURE AND HOMOSEXUALITY: VIRILITY IN QUESTION

Thus, there are very few who will follow the example of the French writer Marc-André Raffalovich,[120] a homosexual and the companion of John Gray, model for Oscar Wilde's Dorian Gray, by taking up arms against the fact that nineteenth-century doctors mention and describe only feminine homosexuals, often associating sexual passivity with effeminacy, in line with the heterosexual schema.

Raffalovich distinguishes virile homosexuals from effeminate ones, noting that their physical as well as mental aspects—or even their attitudes—differ clearly.[121] However, numerous doctors like to classify all homosexuals in the category of "effeminate," first because effeminacy—as gender inversion—is what shocks the most; and then because it is more "showy," more noticeable, and therefore ultimately perhaps more reassuring for doctors who seek absolute control of homosexuality and for the police who keep watch on it. Challenging the theory of degeneration, stressing the fact that most homosexuals have not been sent to prison or to asylums and that doctors are basing their views on a few clinical cases not completely representative of homosexuals of the period, Raffalovich defends the idea of a fluidity between normal and abnormal, acquired and innate, homosexuality and heterosexuality, dissociating effeminacy from male homosexuality. He advocates education and chastity for unisexuals (the term he prefers to that of homosexuals, inverts, or pederasts), who, in his view, are no more libertine by nature than heterosexuals; he also refuses to accept effeminacy, the idea of which he perceives to promote an image of moral laxness and indecency on the part of certain homosexuals. In 1896 he writes in *Uranism and Unisexuality*: "It is because of women that inverts and perverts, who should be put away in nursing homes or penitentiaries, go out in the world and become a hotbed of infection."[122]

Raffalovich, who calls for equality among sexualities in *Uranism and unisexuality*, henceforth makes use of the term "homosexuality" rather than "inversion." This is because "homosexuality" does not refer to the inverse of gender norms but to another sexuality and, at the same time, sweeps aside the notion of effeminacy. He defends a virile homosexuality in the manner of Adolf Brand, German anarchist writer and militant for homosexual rights. Creator in 1896 of one of the first homosexual reviews, *Der Eigene*, and collaborator of Magnus Hirschfeld, Brand distances himself from Hirschfeld and campaigns for love between men as an attribute of virility, experienced on the basis of the scouting model, while also reclaiming models from antiquity.[123]

From 1894 to 1913, Raffalovich writes a regular chronicle in the *Archives d'anthropologie criminelle et de psychologie normale et pathologique*, a review edited by Alexandre Lacassagne. It is in one of these articles that he mentions "rue V . . . ," no doubt rue Vauvilliers, near Les Halles in the center of Paris,[124] where there was to exist—as in la Villette where the municipal slaughterhouses of Paris were located—a virile homosexuality, not very visible and not noticeable because of the clichés about the supposed effeminacy of homosexuals:[125]

What stands out clearly—and this is what is difficult to explain—is that it is in the world of muscular, broad-shouldered men that this passion thrives. The butchers of la Villette, the muscle men of the fairgrounds and especially the strongmen of the market almost all practice this vice. Many are tops, but there are also many bottoms among them. . . . Contrary to popular opinion, . . . this passion is thus not to be attributed to inadequate organization or to weakness of nerve. Those men are pure brutes, like Hercules, who hate women the most and who also seek out strong men; for what they can't stand in that world is the little Jesus, or the weak individual. Huysmans' Des Esseintes[126] is an exceptional case. . . . *Les Halles* are the true den of deviant loves, and, from this perspective, Zola's *Belly of Paris*,[127] which shows nothing for sale there but food, is really worthless, devoid of serious study.[128]

From Nicolas Edme Restif de la Bretonne to André Gide and Marcel Proust, the literary depictions of homosexuality are extremely varied. Restif de la Bretonne evokes homosexuality at times in his work *Nights of Paris, or Nocturnal Spectator* (1788–1794), a picture of Parisian pleasures and debauchery. He describes effeminate men as soft, voluptuous beings who have come to resemble women. Following the example of his contemporaries, he seems to present a defense of pleasure, and he places on the same plane the taste for women and the taste for boys.[129]

Before all the theories of inversion, the Marquis de Sade, in *Philosophy in the Bedroom*, entrusts Dolmancé, assumed libertine and notorious sodomite, with the job of presenting passive sodomites (who cannot be said to be homosexuals) as having the physical qualities of women:

Examine the way he is put together; you will observe radical differences between him and other men who have not been blessed with this predilection for the behind; his buttocks will be fairer, plumper; never a hair will shade the altar of pleasure, whose interior, lined with a more delicate, more sensual, more sensitive membrane, will be found positively of the same variety as the interior of a woman's vagina; this man's character, once again unlike that of others, will be softer, more pliant, subtler; in him you will find almost all the vices and all the virtues native to women; you will recognize even their weaknesses there; all will have feminine manias and sometimes feminine habits and traits. Would it then be possible that Nature, having thuswise assimilated them into women, could be irritated by what they have of women's tastes? Is it not evident that this is a category of men different from the other, a class Nature has created in order to diminish or minimize propagation, whose overgreat extent would infallibly be prejudicial to her? . . . Ah,

dear Eugénie, if only you knew how deliciously one climaxes when a heavy prick fills the behind, when, driven to the balls, it flutters there, palpitating; and then, withdrawn to the foreskin, it hesitates, and returns, plunges in again, up to the hair! No, no, in the wide world there is no pleasure to rival this one: 'tis the delight of philosophers, that of heroes, it would be that of the gods were not the parts themselves of this heavenly orgasm the only gods we on earth should reverence![130]

Honoré de Balzac also evokes diverse figures of homosexuality in his novels, in which effeminacy (as linked to homosexuality) is not central: a veiled college relationship in *Louis Lambert*; the relations of certain aristocrats with their servants in *The House of Nucingen*; the prison affairs surrounding the character of Vautrin; and also the sexual ambiguity of *Cousin Pons*. Balzac does not appear to pass Manichean judgment on love between men, as he was reproached for during the Custine scandal.[131] He evokes them discreetly or directly without passing any definitive judgment. He describes deep affective relations that contrast sharply with the prostitution associated with homosexuality and with the world of prisons. Vautrin, figure of the criminal pederast, like Pierre-François Lacenaire, the embodiment of police chief Vidocq, maintains very close relations with Eugène de Rastignac (in *Père Goriot*) and keeps up a very particular affection for Lucien de Rubempré (*Lost Illusions*, 1837–1843, and *The Splendors and Miseries of Courtesans*, 1834–1847); he is that "half-man half-woman," that "woman *manqué*,"[132] endowed with a weak spirit, manipulable, soft, cowardly and pretentious, "effeminate in terms of [his] dalliances." He fails at everything he undertakes, from his literary work to his very suicide. The personage can easily be likened to those whose names appear in the police registries and are considered "men-women" under the yoke of a strong man.[133] This "third sex" is embodied even more so in *Balzac's Human Comedy* by Théodore Calvi, the young blond with blue eyes, Vautrin's former cellmate, disguised as a woman and known by the nickname "Madeleine," the "young Corsican sentenced to life for eleven murders at the age of 18" and who would not have escaped the death penalty were it not "for certain protections bought for a fortune"[134]—protections comparable to that homosexual "Freemasonry" found in people's speech, even more clearly during the *Belle Époque*.[135]

Théophile Gauthier also uses this notion of "third sex" in *Mademoiselle Maupin* (1835), a successful novel that saw several editions, in which he narrates the story of an adventurous woman cross-dressed as a man, with whom a chevalier falls in love, a sentiment that repels him because he thinks he's dealing with a young man. In *Lucien Leuwen* Stendhal makes several more or less discreet allusions to

homosexuality. The main character is a boy endowed with a certain softness of character and accepting of his fate. He is reminiscent of the character of Octave in *Armance* (1827), a feeble boy who flees women, even though he is not clearly homosexual. But what is the link with homosexuality at a time when sexual ambiguity is so characteristic of certain novels of the 1830s?[136]

The *Belle Époque*, recalling the imagery of Antiquity, cedes to the trend of the ephebe, for example in the popular novels of Achille Essebac,[137] which tell of chaste adolescent love between boys. The journalist and nationalist writer Jean-Gustave Binet-Valmer, son of a psychiatrist, voices in his novel *Lucien*, published in 1910, the harshest indictment of effeminate homosexuality—aiming not exclusively at ephebes:

> (The homosexual has) very fine white skin, without any splotches or blemishes, curved forms, hairless chest—and a little plump around the breasts, fine shoulders, curved waist . . . and that precious elegance in grooming, and that bowed chest, and those timid, affected gestures, that feminine way of sitting sideways on a chair . . . and above all that elusive look, that shameful look![138]

The features of inversion distinguished by scholars have here a strong influence.

Conversely, in *The Immoralist*, dating from 1902, André Gide expresses very cautiously through his hero Michel—as though needing to confess his own sexuality—the strong feelings he experiences looking upon the adolescents of Algeria.[139] A fairly unknown work, *Saül*, is taken to be the first explicitly homosexual French play.[140] Written in 1896 but staged only beginning in 1922, the drama in five acts presents an old man smitten with an adolescent as well as love between two adolescents. It should be noted that Gide excludes any notion of femininity in the homosexual relationship, exalting instead a type of pederasty from Antiquity— that of physically virile ephebes—while rejecting inverts, transvestites, prostitutes, effeminate men, and other "men-women" depicted or imagined by Proust, Lorrain, Huysmans, or even Pierre Loti.

Gidean homosexuality is first of all a virile camaraderie,[141] drawn from Antiquity, and not only in a colonial context, since Gide is the author, for example, of *The Wood Pigeon* (1907), in which he describes his relationship with the son of one of the servants of his friend Eugène Rouart, a politician and writer, in the countryside of Toulouse.[142] Other homosexuals, such as Marcel Proust, prefer to depict effeminate men, men with affectations attracted to more "virile"—and more heterosexual—men, such as soldiers, young proletarians, thugs,[143] veritable phantasms for

homosexuals of the *Belle Époque*, especially those from the upper classes. In Proust's work, the homosexual is that feminine soul lodged by accident in the body of a man, an idea directly inspired by medical studies of inversion. But since Proustian pederasts, in principle effeminate, seek gender difference among men, homosexual affairs soon become impossible, for the woman lodged inside the man's body is looking for a virile man, who according to this theory will love only real women: "at the bottom of all this there persisted in M. de Charlus his dream of virility, to be attested if need be by acts of brutality,"[144] and the narrator of *Remembrance of Things Past* will add:

> I now understood, moreover, why earlier, when I had seen him coming away from Mme de Villeparisis's, I had managed to arrive at the conclusion that M. de Charlus looked like a woman: he was one! He belonged to that race of beings, less paradoxical than they appear, whose ideal is manly precisely because their temperament is feminine, and who in ordinary life resemble other men in appearance only [. . .].[145]

Homosexuality, moreover, cannot really exist, since the homosexual has within him this "internal woman" attracted by heterosexual men: the homosexual would thus be a heterosexual, even if Proust recognizes that two inverts are sometimes obliged to satisfy each other together in the absence of a real man:

> It is true that inverts, in their search for a male, often content themselves with other inverts as effeminate as themselves. But it is enough that they do not belong to the female sex, of which they have in them an embryo which they can put to no useful purpose. . . .[146]

That being the case, the principle of the "internal woman" is rather absurd, and Proust acknowledges the diversity of forms of male homosexuality throughout his work. Lesbians would thus be seen as the only true embodiments of homosexuality because they seek beings of the same gender, unlike male homosexuals who are in search of gender differences in their partners, in accordance with the principles of the heterosexual schema.[147]

A record of Marcel Proust can be found during a police raid on the brothel run by Albert Le Cuziat, in the company of two soldiers, no doubt male prostitutes, during the Great War:

> List of persons identified in the course of the raid carried out at the Hotel Marigny . . . , detected as a place serving as a haven for homosexuals and where

there is drinking after hours. —DRINKING SESSION . . . Bottle of champagne and 4 glasses. PROUST Marcel, 46, person of private means, 102 Boulevard Haussmann. PERNET Léon, born in Paris, 3 April 1896 . . . private first class in the 140th Infantry Regiment. . . . BROUILLET André, born in Nention (Dordogne), 5 March 1895 . . . corporal in the 408th Infantry . . . residing 11, rue de l'Arcade. The three above-named persons were drinking in the company of the man named Le Cuziat (Albert), proprietor of the hotel.[148]

EFFEMINACY: COMMON DENOMINATOR OF ALL HOMOSEXUAL CULTURES IN THE EYES OF AUTHORITIES?

Thus it is not hard to understand why the public archives (police and judicial) and gray literature (bureaucratic documents) are teeming with homosexuals who show little or no virility in terms of the stereotypes in force, since, after all, effeminacy is a sign that is easily recognizable and controllable by the authorities.

Whether it is Louis Canler, former head of National Security (*la Sûreté*) in the 1820s, Félix Carlier some forty years later, or Gustave Macé at the beginning of the Third Republic, police officers emphasize in their memoirs on homosexuals their feminine aspect as well as the fact that many engage in prostitution for the easy money, that is, out of laziness and lack of energy, which is contrary to the traditional values of virility in the nineteenth century. The central idea is that homosexuality is the outgrowth of prostitution and crime. Gustave Macé writes this:

> their effeminate appearance makes them easily recognizable. . . . Their outfits are tailored so as to mold their form, their neck is uncovered, their eyes are made bigger by eye-liner, and their face, covered with rice powder, attracts the attention of passersby. . . . Nearly all of them, beardless or freshly shaved, walk as couples, laughing very loud like prostitutes.[149]

At the same time, early nineteenth century police, especially in Paris, distinguish clearly between homosexuals, referred to by the term "*tante*" and bearing female first names, and "pederasts," who are not described as effeminate but rather as libertines, sometimes married and from the upper classes, sometimes single and from the working class. Class criteria are central here. These individuals, then, have

relations with homosexuals considered to be more feminine, frequent prostitutes at times and are most often tops, and therefore they do not consider themselves homosexuals.[150]

The judicial chronicler Albert Bataille, in 1886, tells about the trial of a homosexual criminal:

> [He] does not have the effeminate appearance of his fellows. Only the voice has the tender inflections that lead one to make out in the bearded, slightly unkempt personage the former stroller of the Boulevard Bourdon. . . . Women were of no interest to him.[151]

In spite of the legality of homosexuality in France, several scandals erupt in the country at the end of the nineteenth century, notably the Bains de Penthièvre affair, which leads not only to a trial but also to a sensational press campaign.[152] The establishment located on the rue de Penthièvre in Paris was under surveillance by the morals police from 1889 to 1905[153] as well as in 1917.[154] The last police report before the police raid of 8 April 1891 and the trial of 2 May 1892 before the 11th circuit of the criminal court of the Seine (Paris) are fairly confusing as to what is really going on—but eighteen individuals are nevertheless arrested, including the manager and two employees of the baths, for public indecency, as indicated in the following description:

> The steam bath establishment run by Monsieur DUPUY, 30 rue de Pentièvre, having been brought to my attention as the meeting place of pederasts who engage there in obscene acts, I set up a surveillance unit there from 3 to 6 at night, which yielded the following declarations: Fifteen clients were there; they addressed each other as "tu" and also addressed as "tu" the garçons who knew them all. These individuals, of whom several appeared to be valets and servants, all had the appearance of pederasts: their language, their dress, their affectation in showing their nudity and the names they showered each other with, such as "My dear," "My girl," "Slut," etc., left no doubt about this. In the steam room these individuals who were seated on the benches touched each other indecently and engaged in mutual masturbation. No act of pederasty was alleged, but due to the darkness that prevailed in that room it was not possible to see exactly what was going on. The garçons are well aware of the clients' actions and encourage them. One of them had this to say: "Today I am a pedicurist, and I am going to trim Madame's corns," then he sat down in front of one of the clients and started to go about the operation. No man

seeming to belong to the wealthy class was noted during the surveillance exercise in this establishment, which became the subject of a service report dated 14 May 1889, in response to a note from the 2nd Bureau of the 1st Division, 3rd Section, on the preceding 27 April.

<div style="text-align: right">Police Commissioner, Head of National Security.[155]</div>

Journalists place special emphasis on the fact that the accused men were supposedly all foreigners. Actually, the theme of the homosexual traitor to his country becomes classic, with the help of a popular press that was booming at the end of the nineteenth century—a traitor because he is talkative; a woman because he is inverted. These prejudices still prevail at the time of the famous Eulenburg scandal that breaks out in Germany between 1907 and 1908 and that involves the aristocracy (including people close to Wilhelm II) and high-placed dignitaries of the German army, establishing the idea that homosexuality is a "German vice"; or again with the Redl scandal. The brilliant and very ambitious Colonel Alfred Redl, one of the heads of the Austro-Hungarian secret service, is obliged to reveal to the Russians secret documents, in particular some concerning Galicia (a region of the Austro-Hungarian Empire), for they are blackmailing him, threatening to disclose his homosexuality and his relationship with a young officer. The Austro-Hungarian leadership wishes to avoid the scandal and forces Colonel Redl to commit suicide in a hotel room in Vienna in 1913.[156]

The historian André Rauch demonstrates in his work that virility is a concept that evolves and develops gradually throughout the nineteenth century. With the Revolution and the Empire emerges the myth of the soldier, the man who embodies virility par excellence. He is synonymous with bravery, altruism, and honor and is supposed to show strength, especially in the sexual act with women. In the pamphlets of the revolutionary era, this image is seen to arise of the "virile, powerful patriot adept at conjugal sexuality."[157] For all that, certain homosexuals distinguish themselves brilliantly during the Great War, and this figure of the (homosexual) hero tested at war is in conflict with all the antihomosexual clichés. This seems all the more surprising in that the homosexual is often defined in police reports as leading a "depraved, lazy existence," having a "mental weakness," affected by "nervous depression," and a victim of "alcoholic atavism (and an) excess of pleasures during youth"; to put it briefly: in a state of physical and moral degeneration. In this sense, the figure of the homosexual seems to be in total contradiction with that of the soldier, that "real" man with the attributes of courage, determination, discipline, dynamism, honor, and physical and mental self-control.[158] Such are the values that

constitute the prerogative of the hero ready to endure anything and to offer the ulti-
mate sacrifice in combat. While an anonymous letter from 1915 denounces a "male
brothel [. . .] on rue de la Bourse (where) a battalion of miners (and) soldiers (meet)
[. . .] whose age is that for serving the country otherwise,"[159] a long police note on
homosexuality evokes the rehabilitation of the homosexual by gunfire:

> The war has already furnished us with a few comforting examples on this subject.
> Quite recently, a young soldier decorated with a military medal and a Croix de
> Guerre was arrested. Prior to mobilization, this young man frequented pederasts'
> milieus, and he was so entrenched that he was arrested for it and sentenced to
> 4 months in prison and banished from the country. It is by virtue of the judg-
> ment passed in his absence that he was arrested again during a leave that had led
> him to Paris. The pain of this young man, regenerated by the war campaign and
> by his heroism, was profound and sincere. The police officers who had arrested
> him [. . .] behaved more seriously than usual with regard to their prisoner, realizing
> that the latter had been rehabilitated through confrontation with the enemy and
> that Justice was best served by not holding him.[160]

The war and bravery in combat thus redeemed the "errant ways" of yesteryear.
Beyond these poignant examples, there remains another paradigm. Polar oppo-
site of the good soldier, a shirker and coward due to his "feminine" nature, the
homosexual is also often suspected of not being a real Frenchman. Thus, the young
homosexuals located in Paris during World War I are called "descendants of Ger-
mans" and "false Parisians" by the nationalist newspaper *L'Intransigeant*.[161]

By contributing to the rapprochement of men with each other, by creating vir-
ile camaraderie, by bringing to the fore a whole set of homoerotic images (high-
lighting of male bodies, warrior virility by wearing the uniform, cult of the naked
muscular body), World War I heralds the phantasm of the young proletarian. This
virile camaraderie is reminiscent of the bonding within youth movements.

As for the Penthièvre Baths scandal, it is unique because it allows the press as a
whole to indicate clearly its hostility toward the accused and toward homosexual-
ity in general by using antihomosexual clichés, following the example of the judeo-
phobic stereotypes: the Jew is rich and miserly, the homosexual is effeminate and
perverse—with a spin on social class, and the idea that the bourgeois and aristo-
crats would debauch young men of modest means.

In England, the trial of young male prostitutes of London cross-dressed as
women and suspected of sodomy (Ernest Boulton and Frederick W. Park), the

Cleveland Street affair (1889–1890) implicating well-known aristocrats who have had relations with young working-class men, and then the trial of Oscar Wilde (1895) all bring to the fore homosexual effeminacy, very closely tied to shady milieus of the English capital, where important issues of class and gender are at play. On both sides of the Channel, then, the same amalgams can be found, widely disseminated by the popular press: corruption of the working classes by the ruling classes, effeminacy and degeneration of the aristocracy, laziness, decadence, dandyism, expensive tastes, and sexual relations between generations.

In France, the taste for adolescents becomes famous with the trial of the writer and poet Jacques d'Aderswärd-Fersen, who, charged with indecent exposure and corruption of minors for having held orgies with young men in his apartment on Avenue de Friedland, is sentenced to six months in prison in 1903. A few months earlier, he had already been the subject of regular police surveillance, following the arrest of a young male prostitute, 15, with whom he was thought to be having sexual relations:

> The result of the interrogation of B. [is that] he had relations with Baron de FERSEN. . . . I think, furthermore, that there is cause to stipulate an investigation . . . of the homes where B. has taken his johns, and finally an investigation of Baron de Fersen, who appears to be a pederast.[162]

CAN THE HOMOSEXUAL BE VIRILE?
THE WORD OF HOMOSEXUALS

On the subject of sexuality, the archives of the Parisian Préfecture de Police show how much medicine influenced—particularly during the 1910s—police and judicial institutions. A report entitled "Notes on pederasty," most probably dating from the end of the 1910s, takes up the conclusions and classifications of medicine: "Pederasty is thus divided into two main classes: the 'ACTIVES' and the 'PASSIVES,'"[163] even when a police report from 6 June 1907 points out "the kind of pederasty that is so typical."[164] Xenophobia and nationalism are found in such reports as well, in the denunciation of "youthful offspring of oriental families (who) go to our schools (and) are no strangers to this demoralization" and of those "foreigners who remained in great numbers (during World War I) in Paris and who make up this swarming, detestable world."[165] The police report evokes also the "familial

promiscuity" that "predisposes people to loose morals" and denounces "unwhole-some reading material:"[166]

> He seems predestined for this vice, which does not show up in him until after ado-lescence, when he has tasted or abused the raptures of onanism and female rela-tions [. . .]. Pederasts are [. . .], naturally or not, passive, with affected manners, feminine in appearance. Their eyes are insolent, their voice soft [. . .]. They use too much make-up and perfume. There are some also who make use of narcotics [. . .]. It is necessary to recall that, in our opinion, there exists only one type of true pederast: the "ACTIVE" pederast, whose condition seems to us to pertain to medicine rather than to criminality (while) the passive pederast, generally very young, is imbued with the active's neurosis and shares his manias [. . .]; is madness contagious among certain minds?[167]

Some homosexuals and male prostitutes also like to be called by feminine nick-names. Félix Carlier makes mention of this phenomenon as early as the years 1850–1870; it is also frequently found in police reports of the *Belle Époque*. One report from March 1866 indicates that

> these are their names: . . . Jules RENAULT, called Rigolette . . . , CARRÈRE, called la Pie . . . , DHAMANN Achille, called Madame de Maintenon . . . , MAR-TINEAU Léon, called Léontine . . . , La Marseillaise . . . , Morning Star . . . , La Armandière . . . , La Francisque . . . , La Bébette (male hair stylist),[168]

while a letter of denunciation mentions "several young men with feminine nick-names" who "are drawing attention to themselves by their scandalous shouts and gestures" on the Champs-Élysées during the summer of 1895.[169] Some nicknames refer to a character trait or a physical defect; others to a geographical or social ori-gin; still others make reference to characters out of novels or plays; and others yet to names that refer to acts committed, like Georges Guignard's nickname, "Clara the Robber,"[170] who was seen as "a thief and a skilled master singer."[171] Mimick-ing a certain form of femininity seems to be one of the traits of the nineteenth-century homosexual subculture. Talking to each other and speaking about oneself in the feminine are also ways of voluntarily assuming one's difference. This trait is all the more characteristic in that during the eighteenth century, effeminacy does not seem to be part of common representations of homosexuality. It is also a means of making oneself visible, of making oneself stand out. This use of feminine

nicknames, in any case, is already attested to in the eighteenth century in certain sodomite circles.[172]

The Paris police archives, and in particular the registries entitled "Pédés" (Faggots) and "Pederasts and others,"[173] offer in this regard exceptional material on the everyday life of Parisian homosexuals, their practices, and their vocabulary. Giving free rein to their pens, police officers convey an important aspect of the social history of homosexuality at a time when, by gradual accretion, the descriptions, the scientific hypotheses, and the theories are being elaborated around a behavior about to become an identity such as we know it today. As early as 1853, we can thus read, all spelled out, from the pen of the "morals agents," what will be, about ten years later, the theory of Ulrichs, cornerstone of the notion of inversion:

> He is a pederast of the exclusive type, one of those men who have only a male form yet actually have a female mentality: they are referred to by the name of gossipy *tantes* (the other pederasts call them Whores); these pederasts have had since childhood the same tastes as women; they like to dress up as women, and during adolescence they avoid relations with the latter. Once men, they know no other love than that against nature, and the idea of a simple sexual intimacy with a woman makes them sick to their stomach. *Sir Backer is the dandy* tante*, the yellow-glove* tante*, the fashion-*tante *and among the most flaming queens*. He's a pretty whore. He is, in fact, a very handsome man.[174]

Here it is evident that the morals police formulate in another way "the woman's soul in the body of a man," the very definition of the "third sex." In the portrait they draw, the police stress a childhood of effeminacy, the period of life to which the medical corps and psychiatrists devote all their attention. During the *Belle Époque*, Dr. Benjamin Tarnowsky proposes, in view of men's "wrong ways," a radical educational method aiming "to repress coquetries and any external manifestation of femininity" in effeminate men, concluding that "when the little boy has been repressed in time, when his first female imitations have been made fun of,"[175] he quickly turns away on his own from this "vice." This being the case, not only do the homosexual initiations among male adolescents not go against virility, they most probably even contribute to the apprenticeship of the codes of masculinity. They avoid also any precocious practice of heterosexuality, which is not encouraged in the nineteenth century because girls are not available during a period when there is still fairly little judicial (and even medical) control over sexual perversions, especially among the working classes, which are undoubtedly

more liberal than the bourgeois classes, constrained by an obligation of social honorability and respectability.

Conversely, male homosexuality among prisoners, judged to be very frequent, is experienced in a "macho" manner, as vouched for by the observations of the military doctor René Jude[176] or by those of Dr. Charles Perrier.[177] Sexual roles are in this case clearly defined and divided up according to a traditional gender schema (masculine/feminine). The female role ("passive") is often taken by the young male prostitutes incarcerated for indecent exposure, while the "active" role, that is, that of the "man," who is actually not considered to be homosexual, goes to the eldest, to the most "virile." The "caricature" of heterosexual relations is rather significant for a unisex milieu where virility is exalted to the highest degree and where an intense hatred of women can be noted. The "passive" (bottom) comes out of the sex act diminished, having had to take on the role of the "woman," with everything that implies in terms of denigration and dishonor. A man is *necessarily* active, a woman *necessarily* passive; the one gives, the other receives. This signals and demonstrates a possible destabilization of sexual and social norms: if the man consents to "be the woman," the master may thereby find himself under the sway of the servant, and, the social order is upset as a result. This is why, throughout the nineteenth century, the police pay particular attention to the crossing over of class barriers; they are prompt to reaffirm (political) order amidst (sexual) disorder.

For that matter, it is probable that certain homosexuals adhered to this division of sexual roles and identities. It appears, however, that relations between men are at times experienced in an egalitarian manner and at times in accordance with traditional laws of gender: such and such homosexual is effeminate and fulfills the "passive" role according to the traditional equation of active male and passive female.[178] It is not so much their so-called "feminine" physiological and/or psychological characteristics that are actually seen to cause their homosexuality, in an innate manner, as the fact that, culturally, these same characteristics (innate or not) are taken as traits of homosexuality, or at least of gender inversion, which itself is associated with homosexual orientation. These characteristics have thus been amplified by individuals in order to conform to a model of homosexuality then in force (effeminacy, for example, since the middle of the nineteenth century, but later virilization of homosexuals in the 1970s) in accordance with the social milieu. Science has always linked apparent gender and sexual roles in the couple according to a woman/man dichotomy. Nevertheless, the archives show, contrary to scholarly opinion, that homosexuals do not always have a determined role in the sex act.

> The man identified as LE DANT . . . , store employee, . . . was arrested on 24 Janu-
> ary 1903 around midnight on the Boulevard des Italiens at the time he was engaged
> in "*antiphysical*" solicitation. LE DANT, who has already been arrested twice for
> the same reason, declared that he adopted both positions.[179]

In fact, the stereotype becomes so powerful by the end of the nineteenth
century that even Magnus Hirschfeld's theory of the "third sex," a strategy aimed
at decriminalizing homosexuality in Germany by naturalizing it, helps put for-
ward a "man-woman" by establishing for a long time the cliché of the effeminate
homosexual.

The beardless face is a sign of suspected nonvirility and therefore of potential
homosexuality throughout the nineteenth century, as demonstrated by the study
of historian Gil Mihaely.[180] Marking the passage from childhood (smooth face) to
adulthood, facial hair (mustache, beard) enables distinguishing between the sexes.
It also symbolizes sexual force, fecundity, possible paternity. . . . To blur these dis-
tinctions is to throw into question one of the pillars of society. Thus, a police report
dating from 1905 evokes

> the bar situated at 16 quai de l'Hôtel de Ville . . . frequented largely by the accused
> man's compatriots . . . ; the latter, mostly servants (valets, coachmen, etc.), because
> of their profession, have shaved faces, which could have led neighbors to suppose
> that they were dealing with men of unmentionable morals.[181]

In the same way, a police report from 1904 concludes that the Hotel de Caen in
Paris "is one of the best kept establishments on the rue de Provence, and, although
a certain number of café garçons lodge there, nothing abnormal was noticed in
terms of pederasty."[182] The medical clichés about this are recurrent, and not only
with regard to homosexuals. Everything is categorized by science: for example, in
1907 Dr. Jaf, pseudonym for Jean Fauconney who studied the "homosexual ques-
tion" a great deal, writes that "men with a large nose also have a large penis (and)
are braver and more robust than others but also more absent-minded and more
stupid."[183] The nicknames that homosexuals take on during the *Belle Époque* can
also be seen to highlight the penis.

The 83 Boulevard du Montparnasse affair, which erupts in 1904, reveals to
the public at large a somewhat astonishing "engagement party or rather wedding
party." The events related in the press allow us to gather that nineteen homosexuals
assembled there to "celebrate apparently the nuptials . . . of the 'young spouses.'"

One of them, the young Léon Spilka, 16, is described in the police report as a "very pretty little wonder"; he most likely plays the female role, that of the "fiancée,"[184] in accordance with a pederastic schema from Antiquity. Though lacking any kind of legal validity, this union shows to what lengths certain homosexuals will go in their wish to appropriate the institution of marriage, a pillar of the heterosexual and patriarchal order. It is probably also an indication of the wish for social normalization and for nondifferentiation, the opposite of what the authorities do in categorizing them as separate beings. The writer Edward I. Prime-Stevenson writes at the time, during the *Belle Époque*, that:

> the happiest ones, assuredly, are the numerous uranists who do not desire to flee society or to flee their own selves. They know what they are and understand what is natural and the mental stress of their situation as homosexuals. They are sure of the legitimacy of their rights, even if these rights are not granted to them in the countries where they live. They lead their lives in relative peace, as much respected by others as they respect themselves, since they are in luck, either by enjoying some personal liberty or by applying the necessary check on their instincts.[185]

The 83 Boulevard du Montparnasse affair is also interesting because it throws light on the homosexual tastes and phantasms of the *Belle Époque*: the ephebe, the "apache" (little hoodlum), the soldier. The attraction to the uniform, civil or military, is quite remarkable: almost all the guests at the party are dressed according to their gender. The more "virile" are outfitted as horse-guards, health aides, Zouaves, highlanders, Arabs, "hoodlums (blue fatigues and overalls)," while the younger ones are dressed in a completely "feminine" manner, some in dresses.[186] Thus, the *Belle Époque* brings back into vogue Antiquity and the ancient figure of the virile ephebe by highlighting the adolescent bodies dear to Baron Wilhelm von Gloeden [fig. 12.4].[187]

Modern homosexuality (since the nineteenth century) is in reality the result of the superimposition of older forms (ancient pederasty, virile friendship, sodomy) onto new forms (effeminacy, inversion, homosexuality) that make up the relations between males, much more than a strict medical or psychiatric "invention" of sexual abnormality or deviance. It is, in other words, an ultimately paradoxical sedimentation of the most virile codes and values of each period and of new medical research showing the homosexual as an invert renouncing any masculine manner, even reappropriating the norms of femininity. Thus, prior to the end of the nineteenth century, one could very well be homosexual and/or have

FIGURE 12.4 WILHELM VON GLOEDEN, YOUNG SICILIANS, CA. 1900.

The ephebe: a homosexual phantasm. Here, young Sicilians pose for one of the greatest photographers of the male nude, Baron von Gloeden.

Source: © Fratelli Alinari Museum Collections-von Gloeden Archive, Florence

homosexual relations without necessarily showing publically any so-called "homosexual" behavior, that is, behavior supposedly contrary to the traditional norms of virility, such as being effeminate or affected. While sodomites and pederasts of past centuries were most often married and heads of household, living what we contemporaries would likely consider a kind of clandestine (or "closeted"), indeed hypocritical, existence, the life of the modern homosexual has become very difficult to reconcile with family life or marriage, at least until the social upheavals of the late twentieth century. That being the case, it is not to the point to say that all homosexuals became effeminate during the twentieth century, passing from the shadows into the daylight, following the advent and massive diffusion of medical theories of homosexuality. It is over the whole course of the nineteenth century that in fact ideas (at times perceived as utopian) of fluidity and mutability of the identities and the categories of sexuality and gender, of which Judith Butler is fond,

became a reality in the public sphere.[188] In *Corydon* (first published in secret in 1911, then officially in 1924), André Gide denounces all the clichés of homosexuality of his era, including effeminacy.[189] He actually defends a virile pederasty, part of the natural order, in opposition to Marcel Proust's effeminate inversion, which was very much inspired by the medical theories in fashion. So Gide is accused of bringing homosexuality out into the open: that (male) homosexuality exists is one thing, and surely no one seriously imagines eradicating it; but it must remain paradoxically imperceptible and therefore certainly not feminine.

13

THE GREAT WAR AND THE HISTORY OF VIRILITY

STÉPHANE AUDOIN-ROUZEAU

THE TREMENDOUS break represented by the Great War in the history of the West, and particularly in that of Europe, is well known. Can the same be said about the history of virility? It seems that in the first stage the massive mobilization in August 1914 was the culmination of the gradual affirmation of an "image of man" that in the nineteenth century had linked more and more closely the referent virile with the warrior ethos of Western societies. A broader and broader militarization of young men, to the point of leaving no one exempt from military service in certain countries (as in France after the law of 1905), running in tandem with a military build-up that was socially exalted more and more, played a decisive role in this plan. "When conscription becomes widespread," notes André Rauch correctly, "the weight that the nation as a whole puts on boys of draft age becomes an obligatory passage, a distinctive quality of virility."[1] On top of this military obligation there is also the idea of dying for one's country, that "relatively new ideal, with its war element," whose emergence George Mosse discerned in Europe by the end of the eighteenth century: "Heroism, death, and sacrifice on behalf of a higher purpose in life became set attributes of manliness,"[2] he wrote, after having pointed out that "a messianic element was introduced into the formation of the male body, never to leave it entirely."[3] That is indeed what is at play during the summer of 1914 in that toppling of European societies during which payment of blood tribute was not discussed because it had become indisputable. In this sense, while a "calmed masculinity"[4] gradually became the rule at the end of the nineteenth century, it is actually the model of *warfare* virility that prevails at the time of the immense European mobilization of summer 1914. As Françoise Thébaud writes, "the war, which puts each sex back in its place, is then called on to regenerate and revirilize nations and to reveal to women their 'true nature.'"[5]

Even so, modern warfare bore within its flanks many other challenges to the military-virile model, of which the summer of 1914 signaled, in a way, the apogee. A whole warfare ethos, closely linked to this model, was turned completely upside down by the new efficiency of firepower and by the prolonged terror that its use gave rise to. A century earlier soldiers did indeed fight "standing up straight"[6] on the battlefield, in a vertical position imposed by the technological requirements of combat but which was also highly acclaimed and valued by the military men themselves. Thus, the virile stance, carefully inculcated within the group, came to stigmatize any protective attitude when faced with projectiles: the barrage of bullets was supposed to be confronted standing up, with an impassibility characteristic of battle courage. The aesthetics of the uniforms spoke eloquently, moreover, of the concern for the greatest possible visibility amid danger, all the while aiming to highlight the male body, further heightened by modern hairstyles. It is this scenario of warfare virility that the battles of the Great War destroy in a few weeks of fighting—and for good. The upright body stance is succeeded by the *prone body* position, the soldiers having no other solution before the iron wall created by modern armaments than to throw themselves to the ground and curl up, sometimes for hours at a time. As for uniform aesthetics, there is obviously no more question about it: beginning in 1915, the last traces of bright color disappear from the clothing, along with the brilliant objects and headgear designed to emphasize the warrior's silhouette. The soldier of trench warfare is henceforth conscious of his powerlessness in the face of the intensity of the firepower and reduced to enduring his own terror. The skills resulting from training and experience and the resources gained from physical courage bear little weight from now on in the face of the anonymous, haphazard shots that characterize modern combat. Above all, one must *suffer through* and try to survive the "butchery," or the "slaughterhouse," to take up the terms used in the writings of so many surviving witnesses.

This is the way that Gabriel Chevallier, in *Fear* (1930), evoked in characteristic terms the particular form of discrediting of the self induced by modern bombing:

> The men who laughed were nothing but hunted game, animals without dignity whose carcass acted only by instinct. I saw my comrades, wild-eyed, shove one another and pack together so as not to get hit alone, shaken like puppets by jolts of fear, clutching the ground and burying their faces.[7]

Later, lifting the last veils, the author returns with even greater emphasis to the collapse of self-esteem characteristic of modern warfare:

The greatest of horrors . . . is that fear lets the man keep his ability to make judg-
ments. He sees himself at the lowest stage of ignominy and cannot get up, cannot
justify himself in his own eyes.

I am there. . . .

I rolled about in the depths of myself, in the deepest darkness where the most
secret part of the soul is hidden, and it's a filthy cesspool, a slimy darkness. That's
what I was without knowing it, what I am: a guy who is afraid—who experiences an
insurmountable fear, a fear to make him beg as it crushes him. . . . For me to come
out (of the trench) they'd have to force me, kick me out. But I think I'd agree to die
here in order not to have to go up those steps. . . . I am scared to the point of scarcely
holding onto life anymore. Besides, I hate myself. I was counting on my self-esteem
to pull me through, and I lost it. [. . .] I'm ashamed of this sick beast, this wallowing
beast that I've become, but all my resilience has been shattered. I'm afraid to the
point of abjection. It makes me want to spit on myself.[8]

Thus, the realities of the battlefield were such as to demystify to the core the ste-
reotype of warrior virility, gradually constructed during a century of Western soci-
eties' militarization. In the early 1920s, in conquered Germany's Weimar Republic,
the work of Otto Dix offers an extreme example of this demystification. Let us
take the example of the *Match Seller*, painted in 1920 [fig. 13.1]: at street level, on
the sidewalk, a large injured war veteran—a human trunk without arms or legs,
with bones sticking out from the stumps. The "man," if we can call him that, has
been *deposited* there, a case of matchboxes around his neck, into which passersby
are supposed to throw money necessary for the wretch's survival. The passersby,
of whom we see only the legs, are in a hurry, indifferent. Among them—supreme
cruelty—are the legs of a woman, who also passes by, forever inaccessible. In any
case, the mutilated man cannot see her because he is blind. A dog urinates on him.
In the gutter nearby, a piece of garbage, indistinct, can be seen. And that is just
what he has become, this veteran of the great conflict whose body has been shat-
tered by the effects of modern artillery. It is a far cry from the self-portraits as a
soldier that Dix painted at the beginning of the conflict, when he had volunteered
to go to the front: for the former *Freiwilliger* (volunteer), no greater collapse of the
military-virile myth is imaginable.

If one must speak of devirilization, then it is actually in the *bodies of the
soldiers* that it ought to be principally sought rather than in the readjustments
of the gender barrier linked, for example, to the new status of women and to
the transformations of male roles within the family sphere. For it is true that

FIGURE 13.1 OTTO DIX, *THE MATCH SELLER*. STUTTGART, STAATSGALERIE, 1920.

The absolutely devirilized German war veteran, dehumanized as well: a piece of refuse left by the conflict and the defeat.

the Great War "dismembered the males," to use historian Joanna Bourke's pithy expression.[9] "Dismembered" is here taken in the strict sense of the word—lacerating of the arms and legs, leaving no course of action other than amputation when the limb had not already been blown off on the battlefield. France counted 100,000 disabled veterans at the end of the conflict, and England estimated 41,000 disabled, among whom 69 percent had lost a leg, 28 percent an arm, and 3 percent both.[10] These figures may seem abstract, if not unreal, the moment we forget the visual shock that such a massive attack on the image of man—the young man, the soldier—had on people within the societies at war. Thus, in Brighton, in 1917:

> the sight of hundreds of men on crutches going about in groups, many having lost one leg, many others both legs, caused sickness and horror. The maiming of masses of strong, young men brought home like this was appalling.[11]

On top of the symbolic attack on virility represented by a mutilation visible to everyone, there was sometimes the drama of an actual castration, invisible though it was. The doctor George Duhamel was one of the rare witnesses who dared to describe graphically such an image of loss:

> I had finished with the stretchers and paid close attention to the wounded [. . .]. One of them especially overwhelmed me. He was a short blond sergeant with a fine mustache. He was weeping into his hands with a despair that resembled shame. I asked him if he was in pain. He hardly responded to me. Then, gently lifting his blanket, I saw that the shrapnel had cruelly struck him in his virility. And I felt a deep compassion for his youth and for his tears.[12]

In much greater numbers, it is true, combat provoked other forms of masculine "diminishment"—although these were of the psychic type. Never in the history of modern warfare were there such spectacular somatic consequences as in the period of 1914 to 1918: soldiers who became mute, or deaf, or else blind; others who were afflicted with continual trembling throughout the body, others who were incapable of remaining in a vertical or seated position, having lost the ability to walk. Still others were left incapable of standing upright, having to move around from then on bent over. Others, finally, were simply paralyzed, without, however, the slightest neurological suffering.[13] Very characteristic of the male feeling of diminution—of impotence?—is this testimonial of a former French combatant suddenly seized by an irrepressible anguish, all the more painful in that it was manifested in front of civilians, hence women:

> All at once I felt my forces desert me. I stopped speaking; I felt an unpleasant sensation in the back; I felt my cheeks hollow out. My gaze became fixed, and the trembling returned, at the same as an extreme feeling of discomfort. In the tram or metro I sense that people are looking at me, and that gives me an awful feeling. I sense that they're taking pity on me. A certain woman offered me her seat. I am deeply touched; but people are looking at me and don't say anything. What do they think of me?[14]

In a scene from an English play of 1923 a disabled veteran employed in toy manufacturing drew for himself, in the crudest possible manner, these lessons from his mutilation: "We are no longer men now that half our organs and half our limbs have disappeared."[15]

It is not certain, however, that Otto Dix's view of the former combatant of 1914 to 1918, close as it may be to our current perception of the devirilization of warriors by the war, was shared by a majority of contemporaries of the conflict. The delegation of "*gueules cassées*" (severely wounded war veterans) placed by Clemenceau at the table where, on 28 June 1919, the German plenipotentiary diplomats had to sign the Treaty of Versailles, just like the 2,000 disabled veterans whose procession down the Champs-Élysées preceded that of the troops on Bastille Day 1919, were not there to witness the crumbling of the virile myth. Quite the contrary, they come to embody another version of it, in part new, a sign of the flexibility of the myth: it is a matter of a *painful* virility from this point, but an intact virility, such as will be reflected, moreover, in so many monuments to the dead. "Shot down but victorious:" this is the caption of a British political cartoon published in September 1918; it shows wounded veterans coming down in long lines, one of them naked, perhaps blind, held up with difficulty by an able comrade, another transported in a wheelbarrow.[16] This is really what it comes down to: just like mutilation, the wound was first perceived as a mark of courage and patriotism. Having the same status as military decorations, they both make visible what can only be seen once one is outside the restricted group of comrades from the trenches: courage in combat, that central criterion of warfare virility. As the *Liverpool Chronicle* asserted on 27 June 1917, the handicapped soldier was not "less a man but more of a man."[17]

It is in this way that in England during the war parades of mutilated soldiers were used to encourage enlisting: photos of young men with both legs amputated, looking into the camera proudly, a bit mockingly, were there to elicit not pity but admiration. In the same way, sporting events were organized for the mutilated and preserved by the cinema: images that lift the heart today, a reaction that is nonetheless completely anachronistic. Joanna Bourke is right when she writes, "Amputation was normalized."[18] So it was that, in all the warring countries, a response to the virile myth of the combatant was women's supposed inclination to marry a mutilated soldier. The military-virile myth got a great deal of its strength, no doubt, from the denial that contemporaries of the conflict were shown to be capable of.

This is why another image of the Great War, German again, could be counterposed on all points to the *Match Seller* by Otto Dix. It was done three years earlier in 1917 by the painter Fritz Erler in order to illustrate the poster for the sixth war bond, whose financial success it was aimed at ensuring. Indeed, it was not the caption ("Help us win! Buy war bonds") but rather the *image* that ensured the success of the operation [fig. 13.2]. Like an apparition, the soldier seems to jump out of the frame, equipped with that famous steel helmet that had replaced the pointed

FIGURE 13.2 GERMAN PROPAGANDA POSTER FOR WAR BONDS, 1917.

An innovative image that met with considerable success: an early triumph of the "new man," forged in the crucible of the great battles of the preceding year.

Source: The Granger Collection, New York

helmet from the beginning of the conflict, with his gas mask and his hand grenades tucked into his pack; this was really a man from the front lines, perhaps belonging to the assault troops. The young warrior seems to be cut off from the war décor, a bit in the background, represented by the barbed wire of "no man's land." His face with its regular features as well as a sensual mouth is turned toward the horizon— the horizon of German victory or that of death; one cannot tell. His very bright eyes, wide open, literally sparkle in the shadow of the helmet's visor, giving his gaze an almost ecstatic glow: this is the "man of steel" forged in the furnace of the great material battles of the year 1916, who knew how to survive; no longer a man, but a *transformed* man, a superman practically, lifting the myth of warfare virility to a height never attained prior to the Great War. This is the "new man" of fascism, *avant la lettre*. One should not be surprised to find out that Fritz Erler became one of the painters preferred by Hitler, whose portrait he painted.

It is in this way that in Germany during the war the military-virile myth was the object of an astonishing rearmament—or should one speak of a ritual reloading?—all the more exacerbated, no doubt, in that it was a denial of the new reality of the battlefields. But it was a denial whose performative dimension cannot be underestimated: the German troops that charged over the top of British and

French trenches between March and July 1918 were largely in conformity with the virile myth embodied so well by the icon painted by Fritz Erler, the same as those who fought from a more and more desperate position between the summer and autumn of that same year. The myth persists, moreover, after the defeat, within the *Freikorps*: those who continue the combat on the Eastern front of the vanquished Reich, those who carry on inside against the revolutionaries and who massacre them in 1919 and 1920. Without a gap, this same myth will be engraved at the very heart of the Nazi ideal of virility.

It thus seems to us that a significant dent in the "militarization of virility," achieved well before the Great War, was made through the experience of World War I, at the very least for the long term: it was not destroyed by the war, even though it was paradoxically not re-established by the four years of conflict. As the historian George Mosse has said, "the masculine ideal in its social function remained intact [...] and was furthered by the World War I and its aftermath. [...] The myth and not the reality mattered, as it had throughout the construction of modern masculinity."[19] Indeed. We still have to attempt to follow the vagaries of the myth and reality of masculinity through the war activities of the twentieth century as a whole and into the first years of the following century.[20]

14

ORIGINS AND TRANSFORMATIONS OF MALE DOMINATION

IMPOSSIBLE VIRILITY

JEAN-JACQUES COURTINE

What has happened to the American male? For a long time, he seemed utterly confident in his manhood, sure of his masculine role in society, easy and definite in his sense of sexual identity. [. . .] Today men are more and more conscious of maleness not as a fact but as a problem. The ways by which American men affirm their masculinity are uncertain and obscure. There are multiplying signs, indeed, that something has gone badly wrong with the American male's conception of himself.

ARTHUR M. SCHLESINGER, "THE CRISIS OF AMERICAN MASCULINITY"[1]

THIS DIAGNOSIS formulated by the historian Arthur Schlesinger could well have been written today. It dates, however, from a good fifty years ago and thus situates right in the middle of the twentieth century the recognition of a major crisis in the identity and image of man. Whether he is American is of secondary importance, for the entire male segment of Western civilization experiences this malaise around the beginning of the 1960s, a period marked by so many upheavals in the definition of gender identities.

The perception of virility is a major issue and a crucial indicator of this sense of masculinity in crisis. This will come as no surprise to those readers who have been attentive to the history outlined in the preceding chapters. They have seen the formation and transformation, between anthropology and history, of a "dominant archaic model," to borrow Françoise Héritier's phrase:[2] an anthropological base made of extremely ancient though still

present configurations, which assign a "differential valence" to the sexes and ensure a hegemony of virile power[3] founded on an ideal of physical strength, moral steadfastness, and sexual potency. They have noted that this male domination does not proceed from any natural condition, but that it is deeply embedded in the condition of culture, language, and images, as well as in the behaviors that the latter inspire and prescribe: "the longevity [of these structures] implies [their] effective transmission,"[4] that is, a transmission of these invariants as invariants.

It is really in these terms, therefore, that the question of the history of virility is posed: the set of social roles and systems of representation that define the masculine, like the feminine, can be reproduced, exactly the same, only if virile hegemony seems to belong to the natural and ineluctable order of things. Writing the history of virility, then, to use Pierre Bourdieu's words, is "taking as one's privileged object the historical mechanisms and institutions that, throughout history, have continuously wrenched these invariants away from history."[5]

The purpose of the next nine chapters is thus to retrace the history of an erasure of history. And this is why our focus here can be only on virility, not on masculinity. For, if we wish to write the history of unequal structures, archaic in origin but still present, whose transmission over the long term supposes the transformation of history into nature, then there is hardly any other word suitable for the project than "virility." A point that will become clear through the rest of this volume, devoted to the years 1920 to 2010, is that a history of masculinity predominant in the Anglo-American historiography that initiated it,[6] came about only as a result of and complement to the project of women's history; and that history deserves credit for not having wished to remain unattached. But the history of virility is not to be confused with that of masculinity: "masculine" was for the longest time no more than a grammatical term. In the nineteenth century and still in the early twentieth century, men are not exhorted to be "masculine" but "virile"—"real men,"[7] people would say. That "masculine" came to take over "virile" is precisely the sign that something has certainly changed in the empire of the male.

Is virility, then, actually in crisis? The century just over and the one just begun do seem to be the arena of an endemic crisis with such frequent relapses that it seems to be uninterrupted and to penetrate into the private preserve of male domination: war, relations with the opposite sex, and sexual prowess.

Since the end of the nineteenth century, from the 1870s to the Great War, the specter of devirilization has been haunting European societies: degeneration of male energy, loss of strength, proliferation of defects. Virility is in danger, and the

nation along with it. The militarization of virility[8] will witness with the war its tragic apogee: the devastation of bodies undermines the military-virile myth and places masculine vulnerability at the heart of a caring culture. World War II and the final colonial wars will finish off virile enthusiasm for warrior prowess and put to an end the heroic quest for sacrifice and glory. Another crisis looms, this time on the work front, during the interwar period: the worker is dispossessed by continual advances in machine culture; his skills are downgraded by unemployment during the Depression; and, more generally, he feels the overwhelming of his virile energies by the rise of conformism and bureaucracy in urban mass society.

The situation becomes all the more critical as virility is confronted throughout the century with challenges to its most ancient privilege by the awakening and the progress of gender equality and the advances of feminism. Women's attaining of new rights beginning in the 1960s and 1970s, the readjustment of gender roles in the public and private spheres, the repudiation and then the condemnation of acts of violence against women—all this serves only to stir up masculine anxieties more: there is worry over losing paternal authority, fear about the effects of a "society without fathers" given over to the all-powerfulness of dominating mothers. All the more so since the domain of sexual impotence has been extended: since the beginning of the twentieth century and the invention of psychoanalysis, then later the emergence of sexology, impotence has stopped being likened to a simple mechanical breakdown and now implies a psychological failure in which the entire history of the human subject is implicated. Women's liberation and the liberalization of mores have had, in this regard, paradoxical effects: masculine competitiveness has grown with the desire to satisfy partners who have the right, like everyone else, to an orgasm; the massive distribution of pornography has reinforced erectile obsessiveness at the same time that the hyper-medicalization of failure has contributed to spreading, with the demand for mechanical and chemical prostheses, a culture of impotence. Now at the beginning of the twenty-first century, virility seems dissociated from the male body of which it has been for so long the emblem: whether as merchandise, performance, travesty, or parody, to use Judith Butler's astute observations.[9]

There is thus a paradox about virility today: How do we understand that a representation based on strength, authority, and mastery should end up seeming fragile, unstable, and contested? The following chapters endeavor to respond to the question by comparing this assessment, first of all, with the reality of historical facts: one should not forget that the twentieth century was just as much the site of great virile eruptions—of which totalitarianism constituted the apogee, part of

what George Mosse has called the "brutalization" of societies by war. And as for that paradox about virility: it is the result of a contradiction between the "dominant archaic model" and the set of political, social, and cultural transformations that have demanded, throughout the century, of men as well as of women, a redefinition of sexual identities that makes room for equality and sharing. For everything indicates most recently that, while the traditional forms of male domination and their share of ordinary acts of violence have not disappeared, they have a harder time seeking the shelter of indulgent silence, complicity, and indifference.

All this has contributed to a chronic instability of masculine identity, even though it is not enough to make of virile man an endangered species. It would seem more accurate, then, to say that virility has entered into a zone of cultural turbulence, a field of uncertainties, a period of mutation. And in the end, it is hardly surprising that this should be the case. The model was actually based on nature, on the body, built on an image of physical strength and sexual prowess on the one hand and an ideal of self-control and courage on the other. This is tantamount to saying that there has always been the model's dark side: the fear of bodily vulnerability, apprehensiveness of sexual failure, and the shadow of moral collapse. Bourdieu, it would seem, grasped it well:

> Male privilege is also a trap [. . .] that obliges every man to affirm his virility in every circumstance [. . .]. Virility, understood as a reproductive, sexual and social capacity, but also as an aptitude for combat and for the use of violence, is above all a burden. Everything works together to make of the ideal of impossible virility the principle of an immense vulnerability.[10]

Do today's men intend to bear much longer this millenary burden, or do they wish to lighten their load—even if it means giving up its advantages? The following chapters are devoted to the history of the contemporary quest for this impossible ideal.

· · · · · ·

ANTHROPOLOGY OF VIRILITY:
THE FEAR OF POWERLESSNESS

CLAUDINE HAROCHE

THEORIZING MALE domination, Françoise Héritier needed no more than a few lines to propound the hypothesis of a "dominant archaic model" dating back "to the origin of our species." It establishes figures that develop over time and that institute variable yet continuous forms of profound inequalities between men and women. Men exercise, through and in the name of virility, a persistent domination, visible and insidious, over women.[11] Following the lead of Lévi-Strauss, Héritier has studied the anthropological origins of male domination. "At the foundation of society," she stresses, anthropologists discern "a stranglehold of men on women of their group and on the brides whom they will get by exchanging them with the sisters and daughters of other men belonging to other groups," thus proving that "a greater value (is) accorded socially to that which is supposed to characterize the male gender."[12]

Against the background of the origin of male domination, however, the general question of domination is outlined. Regarding patriarchal origin, domination is at work in tribal societies and feudalism, it underlies the absolutism of the Ancien Régime, and finally with the advent of democratic societies, it appears at the very heart of the equalization of conditions.[13] Regardless of the historical moment, virility is synonymous with strength, or at least assumes it: physical, symbolic, but also moral strength. One speaks of strength of character, considered and esteemed as an essential trait of masculinity. The latter is to be conveyed by certain abilities: the aptitude for giving orders and for rational decision-making, considered necessary for the exercise of power. Virility is also to be revealed by certain attitudes: self-control, firmness, and endurance.[14]

INSIDIOUS MALE DOMINATION

Although laws in Western democratic societies have managed to challenge the visibility of domination by way of questioning its "natural" character, limiting its

intensity, and removing from it certain excesses, they have not been able to suppress it completely. Where, then, does the persistence of inequality between men and women come from, including in societies that recognize equality as a value, an ideal, or indeed a right? For this domination is maintained in forms that are most often insidious and difficult to combat[15]—forms that prolong a profound and tenacious inequality between men and women as regards the wielding of power. Its origins, as Halbwachs suggests, in forgotten lifestyles, mental states that have vanished, ancient but persistent images, whose beginnings can only be roughly calculated:

> Ancient institutions have lost a part of (their) mental content. (Their) existence and (their) character cannot be understood without remembering and taking up again the collective thinking that gave rise (to them), a thinking henceforth diminished and reduced but capable of being revived.[16]

Virility is the central element in the memory of male domination. The latter is equivalent to virile domination, without, however, being limited to it. It can be put into play without a man's being physically virile; it is enough for him to be mentally virile, knowing how to exercise to his advantage the physical virility of others.

It is this mental domination, its modes and structures, its insidious forms of application, and the reasons for their persistence that we are going to focus on. Having struggled for a long time throughout history to be granted, in certain countries, equality as a civil right, women have sometimes benefited from juridical, political, and, more rarely, social and economic rights. However, despite the laws promulgated in their favor, this equality—often only formal—was accompanied by a transformation of the forms of inequality: women were less accepted, less tolerated than they had been previously in Western societies as the forms of domination became more carefully dissimulated and at times scarcely discernable. Women actually remain the target of inequality, in point of fact, on the basis of a usually insidious domination that operates in private places just as much as professional locales, institutions, and businesses. These forms of power are difficult to decipher, confront, and limit: they nonetheless make it possible to understand the persistence of male domination. For herein lies the most contemporary of paradoxes: even though it has receded in many places, this domination has continued and even made progress precisely in its insidious forms thanks to a general decline in measures for mediation.[17]

Paternalism and arrogance are at the heart of this domination. The insidiousness is imbedded in the implicit value judgments passed on women: when serious, men are considered profound; conversely, women who are serious see themselves treated as bluestockings. When ambitious, men wield power legitimately; to attain the same goal, women are deemed manipulative and, when they win their case, *arrivistes*. Diffuse, indeed indefinable, certain behaviors cannot be easily categorized any more by the men who observe them, manifest them, or experience them than by the women who endure them. Nevertheless they constitute persistent social facts. Thus, apparently insignificant details make it possible to grasp crucial, most often unnoticed elements of the institutional functioning of societies. The repetition of what may seem anecdotal or haphazard may then reveal manifestations of domination that are constant.[18]

Insidious domination refers then to the problematic, inevitably imprecise definition of the social fact.[19] But beyond the social fact, the even bigger question must be posed regarding the social activity that Weber studied when he undertook to establish the categories of sociology. Weber stressed the limits of interpretive sociology by noting the existence, beyond functional relations and rules ("laws"), of "something more that remains forever inaccessible."[20] Thus, there are relationships of domination based on the persistence of models of disparaging behavior, of infinite, subtle disqualifications: a man glances mockingly, derisively, in a fixed or furtive way, at a woman; when a woman takes the floor, a complicity of male looks occurs and eyes are raised up. These are ordinary forms of insidious domination. Or again: the tone at times with which a man addresses a woman may be inappropriate, familiar, debonair, or falsely jovial; he may make deprecating, paternalistic statements, even if the tone remains suave and the attitude good-natured.

While the law manages to limit or indeed to punish certain forms of inequality, other forms strongly resist. Freud made a point of it: civilization "expects to prevent the worst atrocities of brutal violence by taking upon itself the right to employ violence against criminals, but the law is not able to lay hands on the more discreet and subtle forms in which human aggressions are expressed."[21] Numerous observations have recently shown the persistence of facts determined by Bourdieu about fifteen years ago.[22] He had taken as an example a large number of organizations that function "as quasi-families" in which a boss, "almost always a man, exercises a paternalistic authority, based on affective envelopment or seduction." He added: "overburdened with work and taking on everything that happens in the institution, (the boss) offers generalized protection to a subaltern, mainly female personnel."[23]

Examples and testimonials abound. The places and the situations are different, yet the basics invariably recur. Thus, Grésy relates the story of the experienced nurse who takes the initiative to introduce a beginning nurse to a surgical operation. The boss arrives and begins to yell: "You are irresponsible! Why this girl? It's a minor operation, but still!" The nurse replies: "You certainly accept interns who have logged three days on the unit."[24] "Perhaps," he says, but "they are doctors." Mortified, she then confides to her young colleague that "he would never doubt the professionalism of a male nurse."[25] So, there she is, doubly disqualified as a woman and as a professional.

Elsewhere, in a subcontracting auto body shop this time, Sophie tells the following story about the man in charge: "He trains the guys without bawling them out. With them it's like the ceremony of the journeyman with his pupil." One fine day the boss calls in one of the managers. It was reported to me that "you often call Sophie the blonde. Why?" Response: out of "kindness," to avoid being brutal, so as not to call her idiot "all day long."[26] So, the boss replies, "That's really a kind of insult that you're leveling at her." Not at all: if he calls her "blonde," "it's because she has a child-like aspect, she seems delicate and fragile." "She is not fragile," replies the boss. "It's you who are making her fragile with this continual disparagement." She is perfectly qualified and competent; you just have to learn "how to act without bawling her out."[27] Conclusion: the man confides in a witness to the scene that he doesn't understand a thing and doesn't know what to call her anymore. To be a blonde or else be nothing.

Another professional scene during a meal: a bon vivant, convivial, jovial man, has exemplary behavior except with one woman who has an important position. "Never, though, can she catch his eye. The slightest remark or the tiniest laugh" are addressed to "her male assistant," never to her.[28] It is an insidious deprecation. She does not exist.

Inappropriate closeness, annoying familiarity, purposeful grossness: all these stories present obvious situations of surreptitious deprecation. Other forms of insidious deprecation are at work in duplicity: phony courteousness, exaggerated cordiality, excessive politeness. Thus it is when "Madame" is uttered persistently: the woman is addressed by subtly excluding, or at least ignoring, her professional standing; her status as woman is called attention to, and she is thereby reduced. Or again, the use of the formal "you" form toward women in professional or social circles in which the informal form is always used out of esprit de corps. In another place we see the same mores during a meeting at the Finance Ministry about a failing business at which a sole woman is among the participants; she, too, observes

that "since her arrival, three months ago [. . .], she is looked at without being seen. It is as if she were transparent!" She notes that one of the men in charge "is always very polite with her, with an attitude a tad ceremonious." The topic of this meeting is the fight against Asian competition, "the reduction of profit margin on washing machines." This is the moment the man chooses to turn toward her for the first time and call for her testimonial: "For housewives don't want to be taken in. You certainly know what I'm talking about, Madame."[29]

The last scene takes place in the army, at a leadership meeting that includes a woman: she tells how one of the commanders, alternating between "aggressive remarks and bawdy jokes," keeps on contradicting her on technical details. "May I sit next to the loveliest of the regiment? Really, I find your beauty outstanding today!" he exclaims loudly, with a jovial air. Disillusioned, fed up, she wonders how she might react: "What could I do but keep a forced smile on my face? . . . Impossible to speak the same language with him."[30] So, the insidious forms of male domination thus establish, with in the system of conversational exchanges, an unacknowledged asymmetry in the very use of words. By means of this process, Grésy adds, that women's self-confidence is attacked and eroded.

THE COHESIVE VIRILITY OF FRATERNITIES: RESTORING PRIMITIVE TIES

The insidious forms of male domination thus result from a contemporary imbrication of the secular exigencies of the virile tradition and the egalitarian principles of today's democratic societies. Before that, however, if we want to grasp the maintenance of these unequal forms, the question remains as to their origin as well as the intermediaries and the historical crucibles that have been essential to their perpetuation. Tocqueville, for example, was able to grasp the stages of a general dynamic of domination in the Western societies that were destined to become democracies. He accomplished this by retracing the forms of power, moving from the social state and the democratic institutions of the Middle Ages to the Revolution and then on to democratic institutions, and he was thus able to discern the successive apparatuses of political and social domination resulting in the historical stabilization of psychic tendencies toward dependency. Thus it continues in the same way, from obedience to the lord in feudalism, to dependence on the king in absolutist society, leading to the valorization of independence, then on to the sufficiency of

democratic societies, in which, from then on, in effect, "each person undertakes to be self-sufficient to himself/herself."

It will have become apparent that the method we are using here may be called genealogical. It consists of discerning, in the most contemporary forms of domination, what Max Weber once called the "specter of vanished beliefs," that is, the weakened presence and attenuated brutality of earlier forms of male domination. Indeed, it is clear that the perpetuation of the insidious forms of deprecation that impacts women in contemporary institutions cannot operate unless a network of mechanical solidarity among men is maintained. In today's organizations and enterprises one still perceives the residue of yesterday's fraternities.

Here, then, is another moment in this genealogy or, if you wish, in this historical anthropology of virility that we now must take up. Observing fraternities, from the aftermath of World War I to the first manifestations of World War II makes it possible, in fact, to make out the basic traits of virility's historical existence as the core of male domination. Fraternities reveal essential elements of the virile apparatus: that of the exclusion of women, which includes the process of forming a solid confederacy among men-brothers, inseparable from a hierarchy among equals, and before that inseparable from traces of the authoritarian patriarchal model.

Let us go back to the small groups of men organized into fraternities in the early twentieth century. Sociologists, anthropologists, philosophers, and psychoanalysts who lived at the time pointed out in their writings the troubling character, as early at the end of the nineteenth century, of this period of profound transformation of the family in the context of massive industrialization and urbanization and economic, social, and political crises. These writings contain the seeds of analysis of mass totalitarian phenomena. On the whole these writers were sensitive to the exercise of power at the heart of the family (in Horkheimer's view), to the wielding of power in small groups, and to the potentially threatening character of relationships in certain communities, in fraternities in particular. For Weber: fraternities provide examples of clearly expressed virile behaviors and character traits. The goals of the youth movements in Germany give proof of the greatest aggressiveness as well as the most breathtaking idiocy in their continuous exalting of virility. They illuminate men's relations among themselves as much as their relations with women.

Certain writings by Weber, devoted precisely to questions relating to small groups, convey a definite pessimism about the nature of the social bond. In 1919, he notes the troubling ambiguity in a democratic society of the communal functioning of certain "small circles."[31] He discerns paradoxical processes composed,

on the one hand, of contempt, rejection, stigmatization, and repulsion, and on the other of myth-making, attraction, fascination, and veneration. Weber stresses that these mechanisms go back to the absence, the retraction, indeed the denial of self-autonomy and self-value, and so he concludes that "community activity" may pose a threat to democracy, underlining the fear most often experienced in the face of difference.[32] He thus evokes, with regard to these small circles, their quest for exceeding limits, for transcendence, and for fusion in the atmosphere of disillusionment that pervades the period: elimination of distances, "man-to-man contact,"[33] and the fusional search for body-to-body coexistence with the cult of the leader.[34]

Informed by the experience of World War II, other works are devoted to youth movements, to those fraternities that constituted in a certain manner the crucible and future of the rise of Nazism.[35] These groups appear as "a protest against the lack of vitality, warmth, emotions and ideals. They aspire to develop fusional contact."[36] The transcendence of self is manifested in them by a passionate and confused engagement, exhilaration, and a desire for fusion, explicitly based on virile ideals. "Each man accorded considerable importance to the group spirit, an importance vaguely felt but fervently expressed in excursions, singing and campfires, which they considered experiences aimed at restoring primitive bonds," states Lacqueur pointedly.[37] The behaviors involved appear fundamentally as responses to forms of archaic anxiety in the face of new forms of life, of existence, and of potential emancipation. In the face of the perils of individualism's dispersal and the uncertainties of a changing world, there is the attempt to recover, to regroup, and to meld into the all-powerful nature of a collective male body the strength and energy of each man—thus to forget the fear of powerlessness[38] lurking within each one.

Peter Gay analyzes at length the extolling of courage and energy that in the nineteenth century would end in a veritable cult of strength and of virility. He also stresses that, "far from being an invention of the modern period, (this cult) attested to the resilience of aristocratic ideals."[39] It is in this way that "men felt obliged to prove . . . , from adolescence, virile qualities, boldness, physical strength and endurance when exerting effort or suffering." They aspired to become tough, strong men and counted on the prestige that constituted the sense, the goal of their existence. These men "felt compelled to display and continuously reaffirm their manhood from the time they were striplings" to avoid "dreaded failure," otherwise known as powerlessness (or impotence), and "to prove their hardihood, their sheer physical strength, and their tenacious endurance. . . ."[40] Gay adds, finally, that "the alibi

of manliness proved at best an uncertain mechanism for the liberation of aggressive impulses."[41] Offering a specific mixture of naiveté, indeed adolescent silliness, and Machiavellian pragmatism, the youth movements would establish, in a lasting manner, extremely intense power relations between the strong and the weak, as much in terms of hand-to-hand fighting as in terms of affective relations, whether involving love or hate. Prompted toward self-transcendence, the members of these movements had to submit just as much to implacable rituals of obedience and submission, which were going to affect the very formation of the virile ego.

One may perceive more precisely in this way the sense of virile solidarity that persists today and the trace, however innocuous, of insidious manifestations of contemporary male domination: a way of standing together, of furnishing through collective aggregate formations a response to powerlessness that each isolated individual worries about. One can see clearly, moreover, how the formation of political masses, with which Freud was concerned in his *Mass Psychology*, relies much more than is ordinarily thought on this model of virile gathering together and hence on extremely ancient forms of masculine aggregates. Elias Canetti grasped perfectly this link, indispensable for anyone wishing to understand the genesis of fascism, between the virile solidarity of limited groups and the unleashing of deadly violence in the power of the masses.[42] Further evidence is found in the fact that the effects of this unleashing were, in the various interpretations that could be proposed at the end of the nineteenth century, generally attributed to female mob hysteria. Here we can see one of the recurrent manifestations of forgetting—or more probably, of repressing—the presence of a dominant archaic model at the foundation of a historical phenomenon: this effaced masculine origin was substituted for by a figure of female excesses.

AUTHORITARIAN FAMILLY AND APPRENTICESHIP OF VIRILE POWER

The work of Klaus Theweleit helps us take a step further down the path that we are following. Locating the virile attitudes of fraternities in those of the *Freikorps*,[43] gathering together a great number of observations, he brings to light the existence of specific bodily states that affect the personality and even the construction of the ego. Paying attention to the physical and psychic structure of the "male soldier," he discerns in the latter a "male shell," a closed, hardened, rigid ego fearing above

all the "dissolution of bodily limits," a fear of psychic collapse. He adds that "the fascist State was a reality produced by the body of the 'male-soldier,'" fabricating, through discipline and physical training exercises, a body image that takes the form of a "muscular armature."[44] Theweleit stresses quite rightly that in these imaginary representations, "the shell of the body . . . stands up not only against a threat from the outside, against figures dominated by the 'hum' of reality and voracious femininity . . . but also against the male soldier's own bodily interior, threatened by fragmentation."[45] Basing his inquiry on the fear of loss of psychic integrity, of fragmentation, and of dependency, he concludes that fascist virility should be treated as a type of corporeal economy based on "psycho-physical operations," regardless of the culture in which this type of economy is found.[46]

Theweleit's analyses also put into operation a displacement that helps clarify male domination, not only in terms of male/female relations but also in terms of personality, namely the "mentality" of the son in the bourgeois, patriarchal family. This mentality will quietly lead, by means of the myth-making process of the mother, to a certain type of psychic, bodily, and sexual economy, aiming to capture the sources of energy in work, profit, cost-effectiveness (today increased tenfold) and determining (beyond simply the relation to the mother) the relationship to the wife and to women more generally. The fascist, in fact, is seen never to have achieved a separation from his mother and is never able to constitute an ego in the Freudian sense of the term. This line of thought holds quite a bit of interest from the perspective of a genealogy of virility, of which fascism and, more specifically, Nazism constitute the deadliest banners in the history of Europe: "To consider (them) no longer as the monstrous fruit of a dreadful 'ideology,' but to describe them on the basis precisely of a study of male-female relations in European history."[47]

The anthropological hypothesis of the "dominant archaic model" propounds that men dominate women because they are incapable of reproducing without them.[48] So as not to depend on them, men had no choice but to place them in a position of dependency. Which leads us, as Theweleit had figured, to look into the relation between mother and son. Sons might try to rebalance somewhat the forms of dependency in which mothers find themselves in relation to fathers and husbands who have subjugated them. For sons have, in effect, venerated, made myths about, and at times sanctified mothers, which leads to being able to separate from them only partially. Becoming in turn husband and father, while still continuing to venerate his mother, the son will then reproduce the model by also dominating and subjugating his wife. The process of incomplete separation between mother and

son is at the heart of the constitution of the ego in the fascist personality. It leads to male domination of women, just as it led to the constitution of solid collective male corps and offered on the ancient pedestal of primitive aggregations those persistent phantasms of male all-powerfulness.

Fascism is therefore an affair of state but also a family affair. And the same goes for male domination, just as for the virile ideology that supports it. As Horkheimer stressed in his work, it is the family that keeps watch over the formation of the authoritarian personality and character; it is within the family that submission to authority and "dependence" have been learned; it is the family, finally, that takes part in the reproduction of mentalities required by the traditions of bourgeois society.[49] The father "naturally" exercises power over the family—a power, adds Horkheimer, based on "his economic position and his physical strength with its legal backing."[50]

Within the family circle, the male subject will seek, little by little, through identification with the paternal figure, the certitude—or illusion—of virile power; this is where he will find, through the attachment with his mother and in her acquiescence to patriarchal authority, the confirmation of the legitimacy of this power: reasons to adulate strength and to hate weakness. It is in the relationship with a mother—subjugated, sanctified yet, even so, loved without being respected—that he will be fundamentally divided: attached, in fact, to someone weak and powerless, while he has actually been taught to value power to the highest degree, to hate powerlessness.[51] Apprenticeship of power, repression of weakness: the study of the relation of the son to the mother leads us to take up this question beyond an anthropological and historical perspective and toward a psychoanalytic anthropology of virility.

Men must be strong and what's more, show themselves to be strong. However, while considered by others or considering themselves "naturally" virile, men dread above all else being discovered in their vulnerability, being seen in their powerlessness. In this way, male domination could also be explained as an attempt to dominate male powerlessness. Certain men—in the name of an explicit or implicit virility—are led or indeed are continually trying to put the other in a position of physical or mental weakness, whether it is a question of violence—most likely psychic—insidious domination, or the physical and psychic violence of "authoritarian personalities."[52]

One of the chapters of Freud's essay devoted to the dependent relations of the ego seems particularly interesting from this point of view.[53] Among these relations, Freud will stress that the ego, beginning in childhood, "although it is accessible to all the later influences . . . , nevertheless conserves throughout life the character

conferred upon it by its origin in the paternal complex"; in other words, it conserves the memory of paternal power capable "of standing up to the ego and controlling it." Freud goes even so far as to assert that the paternal figure will ensure and guarantee the wielding of his domination, his hold of the adult ego of the son, who will preserve forever the trace of "the former weakness and dependence of the ego."[54] The memory of infantile powerlessness can never be entirely erased.

PSYCHOANALYTIC ANTHROPOLOGY OF POWERLESSNESS

At the end of the nineteenth century, relations of dependency, the question of power, and the will to power are at the core of a number of writings. Or, to put it in other terms, powerlessness stands out as an object of interest, of worry, but also at the same time the object of continuous repression. It is in this context that Freud takes up the idea of the original powerlessness of the human being.[55]

Adam Phillips, a British psychoanalyst, recently devoted a group of works to the question of all-powerfulness in the manner in which Freud had taken up the question of powerlessness.[56] It seems to me, says Phillips, that Freud, in *Letters to Wilhelm Fliess*, started to defend powerlessness, or at least to recognize it—to defend the fact that, without the experience of powerlessness, "the experience of satisfaction would be impossible." The same goes, we would add, for the relationships with the other, for alterity. Phillips thus stresses that "the problem is not in our nature: parental education makes (it) what it is."[57] He also notes that "powerlessness is the human condition antecedent to bonds of exchange." Continuing his reading of Freud, he then adds that the initial assertion of the "original powerlessness of human beings" had awakened "the need to be protected by being loved."[58] It became, in *The Future of an Illusion*, "the terrifying impression of powerlessness in childhood."[59] Phillips concludes that "powerlessness is more often supposed to be a problem, or something we suffer from, than it is a pleasure, a strength or a virtue. It is not something that we cultivate."[60] Indeed he remarks, that Freud thinks at this point that, "in adulthood, modern men can only turn against powerlessness . . . ; they cannot tolerate their powerlessness or put up with it patiently."[61]

An extreme anxiety appears over the virile condition, which opens and closes with the feeling of powerlessness. Getting rid of the excesses of virile potency could thus come down to recognizing powerlessness, to admitting its inevitable character

in masculine destiny; to seeing in it the foundation of a culture of exchange between the sexes, the possibility of diminishing the exclusions and dominations of virility's herding archaisms. In short, it would mean admitting to powerlessness in order to free oneself from "ego-shells" in the brutality of collective assemblies of individuals of the same sex. Recognition of powerlessness assumes or at least would make a place ultimately for the existence of a connection with the other: in a certain manner, it is the opposite of domination, or it tends to prevent it from being wielded; it is the opposite of the phantasms that accompany the figures of virility. In a way, it limits the way we make images of virility.

Bourdieu, it may be remembered, had stressed that male domination constitutes a "privilege," but also a "trap."[62] Women suffer, generally, explicitly or silently, at times without being able to articulate it, from persistent male domination today in its insidious forms. Could men be seen to suffer also from this domination? In what ways, and for what reasons?[63] The idea of power, of virility, is at the heart of male domination: as an ideal, an aspiration to transcend limits, in strength, sports, sex, money, profit, and everything in a society that refuses—not only to the male gender but to everyone else—the very idea of finitude, the slightest suspicion of powerlessness. But as Françoise Héritier has recently noted, "the result of historical and ethnological experiences is that force alone has never been enough to keep the oppressed in a situation of dependency—except when extermination is resorted to—unless it is accompanied by other mechanisms of oppression that are ideological in nature."[64]

Can we be done with male domination? It is necessary to change the way we look at identities, not to enclose them in "the masculine" or "the feminine," to question in depth the imbrication of power relations and sexual relations: it is necessary to politicize the questions, not to take them up in strictly anecdotal terms. Male domination can be reduced, yet it will never be eradicated. Racism, violence, and cruelty, although unanimously condemned, quietly persist.

Héritier stresses that "a new model should raise consciousness, through education . . . , about the iniquity, the attack made on the human rights of women," adding quite rightly that it "might be for men the liberation from the obligation of keeping up appearances and the chance to portray self-fulfillment in registers other than the sexual register of domination and constraint. . . ."[65] But she then warns: "Attaining equality does not mean doing it by snatching a narrow victory in a 'war' fought against the male gender, which will only defend itself, or by incomprehensible sanctions with regard to the dominant pattern, but by cooperation and alliances" and not only exchange. "It is neither political action nor objective

reason alone that will bring humanity out of the hierarchical vision of the relation between the sexes into which it is submerged. . . . It is action on ourselves."[66]

It is no longer a matter of the power of arrogance, any more than of the power of the weak, but of a long and patient apprenticeship: one that aims at recognizing and accepting powerlessness.[67] It is one that tends to discern in gender identities the question of the same and to distinguish it from that of the similar. Now, any powerlessness is stigmatized today in our today's individualistic world, conterminous with a culture of narcissism in which the values of power, self-sufficiency, and arrogance have intensified if not multiplied: they concern everyone, men and women, in different and also similar ways, in societies that exist amid continually accelerating changes, often unintelligible and hard to control, leading for that reason to major social, psychic, and political questions.[68]

In a world of disrupted gender identities, the lessons derived from the ancient model of male domination could not map out "the path that leads the individual gradually from dependency to independence."[69] Nor is it certain that being imprisoned in new norms of nondifferentiation of the sexes constitutes a desirable path: difference aside, one could thus wish to fight against the inequality of the dominant archaic model while favoring homogeneity, conformity, and conformism.

It is rather, no doubt, by means of the masculine and feminine present in each person, man and woman alike, that the fears provoked by every difference will have to be confronted.

> Life is not simple: not from the masculine point of view or from the feminine. What is more, there is ambiguity: the separation is not always clear; the difference is not always total. Is the limit ever really precise—that limit within or beyond which it is still about the same or already a little different? . . . More precisely: could man be made up only of masculinity? Could masculinity totally define a man?[70]

The point should be clear: virility cannot be a question of anatomy.

15

VIRILITIES ON EDGE, VIOLENT VIRILITIES

FABRICE VIRGILI

IN JULY 2003, Bertrand Cantat, lead singer of the group Noir Désir, was arrested and then tried and convicted for the murder of the actress Marie Trintignant, his companion. The story was the subject of gossip because of the celebrity of the protagonists. It also provoked contradictory opinions about the way in which the violent acts that had caused Marie Trintignant's death were viewed. On one side were those who pointed out the passionate character of the relationship between singer and actress; on the other side were those who listed her death among those of numerous female victims of domestic violence.

Other emblematic cases also made the front page at the beginning of this century: the murder of Sohane Benziane, burned alive in Vitry-sur-Seine in 2002 by a spurned lover, or the rugby player Marc Cécillon who, refusing divorce, killed his wife with five gunshots in August 2004. Some of these examples, in the stir of public opinion, referred more to the violence of the public housing projects, especially in the case of Sohane, than to other violent cases that were just as unusual and dramatic. Because of the personalities involved in the other two cases, it was seen to be a matter of private violence, most often inflicted by men on "their" women—wife, lover, or mistress.

Today there is a consensus for considering at once the reality, the importance, and the necessity of combatting this violence. But how was it throughout the twentieth century and in particular before the 1970s and 1980s, when the feminist movement had not yet given its full attention to these acts of violence in their political dimension, since they were thought to be private, something whose resolution was supposed to remain a family affair? What about the current definition of violence—multiple and weakened in its physical, psychological, economic, and sexual forms—is it effective in describing the previous practices of several decades? If these violent actions actually

existed, what was the perception of them? How could sexual relations required within the framework of marriage be perceived as an aggression when many considered them a form of conjugal duty? Today, when domestic violence is socially recognized and condemned, the denial of these acts is always at work, as much by their agents as by their victims. So one can imagine the force of such a denial at a time when this form of violence was not recognized as such. Questioning male violence against women in the course of the twentieth century is not an easy thing. Few authors have looked into the issue for the period prior to the 1980s. These acts of violence quite often seemed to be accepted so long as they remained below the radar and unpublicized. Only their excessive character in extreme, repeated, or exceptionally public cases rendered such acts visible. It is by means of these cases that a history of violent virility can be constructed in the twentieth century.

VIOLENCE AND MALE IDENTITY

As Anne-Marie Sohn has shown,[1] the relation between masculinity and violence underwent a profound transformation in the nineteenth century. While during the French Revolution men acquired citizenship and a warrior monopoly, there is a gradual passage from an offensive masculinity—to be a man is to fight, to adopt defiant modes of behavior, and to demonstrate one's strength although at the risk of violence—to a controlled masculinity. The army, which trained in techniques of weaponry, taught above all obedience and control; the school gave instruction in the required temperance and the right use of reason to the detriment of anger. The most extreme manifestations of violent acts among "men," such as village and urban brawls and duels, disappeared, or at least lost their qualitative and quantitative intensity. Thus, at the beginning of the twentieth century, the new masculine model that little by little became obligatory was that of a controlled and reasoned relation to violence. However, this change, profound as it was, by no means signified the disappearance of the male use of violence. On the one hand, this type of mutation was charted over time and in individual accommodation to a new social norm. On the other hand, the perception of violence and of its legitimacy varied according to the individual. A man, although the murderer of his wife, declared in 1962, "I never hit her any more than usual!"[2] For this man, the question of legitimacy was not relevant, and he simply seemed surprised by the consequences of his "ordinary" behavior. But—and this is the heart of the subject for the other

protagonists, partners, witnesses, and authorities—what was the level of acceptability for the use of violence by a man against a woman who "belonged to" him?[3] When would the women who suffered this malicious treatment take action to put an end to it? When would the family, the neighbors, the colleagues, the doctor, or the public authorities consider such acts of violence excessive and finally intervene?

Working on the most visible and therefore the most serious cases is inevitable, for the others do not appear in the archives. However, as Daniel Welzer-Lang writes, that carries the risk of "giving credit once more to the myth of the violent man resembling a monster, a bastard, a madman—which, in reality, is the exception." "By providing individualizing or psychological explanations about the violent man, the myth hides the woman's situation of being dominated by preventing her from acceding to the status of subject or rebelling."[4] It is therefore essential to faithfully depict the banality of men's violent acts. By means of describing the most dramatic cases, ways of talking are made available about the violent acts against women in general, about the limits of transgression and the expression of rejection or of understanding, for before becoming serious, these cases were all "ordinary."

Banal or not, it is difficult to sketch a precise chronology of this slippage from an offensive masculinity toward a controlled masculinity. Events can be located in relation to this change, whether it involves the separation of numerous couples during the two world wars, women's access to citizenship, or the shearing of the heads of women accused of collaboration with the enemy. Conversely, the stability of legislation concerning divorce, adultery, indecent exposure, or rape speaks in favor of a time only slightly sensitive to changes before the 1970s.[5] We can distinguish two tendencies in any case: on the one hand, what appears to be a means of maintaining male domination while preserving the social order without excessive disturbance in terms of an adjusted violence, and, on the other hand, acts perceived as the manifestation of an imbalance of masculinity, the disorganized manifestation of an outdated virility. Finally, what about the period opened by the 1970s,[6] and what role does violence play moving forward in relations between women and men?

THE VIRILE ORDER AND THE POSSIBILITY OF VIOLENCE

At the beginning of the twentieth century, French society was profoundly nonegalitarian as regards the relations between the sexes. The basics of political,

social, and family rights remained the prerogative of men. Thus it was up to men to preserve this imbalance, to prevent "their women" (mothers, sisters, wives, daughters) from engaging in behavior that might trouble the sexual, hence social, order. It was up to each man to ensure the good behavior of women, who were still considered legally as well as intellectually irresponsible. Thus, just as the education of a child at times justified a punishment, a reasonable idea that was in the interest of the child, punishment was sometimes called for in order to "hold in check" one's wife, make her respect the man's reputation as head of the household and his male honor. The popular adage, "he who loves well punishes well" justified, in terms of common sense, the use of force at the service of patri-archal power.

ENSURING FIDELITY

There is no lack of proverbial wisdom enjoining men to keep close surveillance on women: "Choose your wife with a velvet glove and guard her with an iron glove." This was the rule for a long time, whether at the cost of punishing blameworthy wives or of punishing husbands incapable of imposing their authority over them. The "*chevauchée*" (royal inspection), used in many places since the medieval period against cuckolded or battered husbands, survived through the beginning of the twentieth century, attesting to the "durability of the scandal caused by incom-petent husbands."[7] But while the problem persisted, social pressure became less demonstrable. Colleagues, a friend, a family member, or else the "rumor mill" con-tinued to inform the cheated husband about his wife's behavior without turning it into an organized exposé.

Thus, Louis, a 33-year-old laborer and a patient of Dr. Daniel Lagache in the 1930s, whose whole circle of friends not only "opened his eyes" but also referred to him as a man unable to re-establish his authority: "(He) hears himself called cuck-old at home or at the shop (where) people are saying: 'I wouldn't take something like that,' (or) speaking to no one in particular they say 'cuckold,' pointing their finger at him."[8]

The medical world, in tune with the immediate post–World War I social scene, transmitted the masculine worry about women's fidelity and obedience.

Professor Levy-Valensi,[9] on the occasion of the conference on legal medicine in 1931, saw in the increase of the number of unfaithful wives the explanation for the growing suspicions of men with regard to the fair sex. Jealousy and its most violent

consequences, including the crime of passion, attracted the interest of professionals, jurists, doctors, and criminologists.

Should this be seen as one of the effects of the great sexual separation of World War I? Couples separated for the war years knew more or less how to get over these trials and, among them, the fear of being abandoned and the fear of being cheated on by a wife left behind. How many men were able to lay blame on their wives for their own difficulty in returning to civilian life? The phantasms nurtured on the front about the life left behind; the lack of understanding about women's greater independence acquired during the long months of their husbands' absence; the remoteness, if not the rejection, of manifestations of women's liberation, symbolized by the "flapper"; the return to homes destabilized by the war: all this explains men's deep worry about maintaining their familial position. The paternal and marital authority of those who had nonetheless just fulfilled their role as citizen-soldier, as male defender of the nation, was being contested, was it not?[10] In accord with morality, the law punished unequally the husband or the wife in cases of adultery: systematically for the woman but only if there was contact with the mistress in the conjugal home for the husband. New conjugal models emerged, rebalancing somewhat how fidelity relates to both sexes. At the turn of the century, an important movement had already appeared for the suppression of any penal sanction against adultery.[11] Other signs showed that a certain image of modernity, represented by extramarital sexuality, was circulating in society. On 25 June 1930, before the circuit court of Indre-et-Loire, a man who, in a written agreement, had authorized his wife, forty years younger than he, to take a lover, justified it this way: "What do you want, that's life! You have to keep up with the times." And when the prosecutor reminded the unfaithful wife of her deviancy, she responded: "Well, I was given permission."[12] The *Zeitgeist* is also evoked by a mother-in-law speaking to the psychiatrist of her unhealthily jealous son-in-law: "My daughter is not modern because she isn't cuckolding her husband."[13]

The anguish of the man over his companion's infidelity could be broken down into a tripartite fear: that of defeat by a rival, that of the loss of "his" woman, and finally that of losing control over the filiation of his progeny. The question of paternal violence and also maternal violence toward the children, including incest, is a subject in itself and will not be treated here; nevertheless, we must stress how much these two forms of domestic violence are interlaced. Children often found themselves at once witnesses to parental disputes, victims of paternal brutality, and the focus of conjugal conflict. If the reproach had to do with the wife's infidelity, the questioning of the children's filiation was close at hand: "He insulted the children,

said that they were bastards,"[14] declares the neighbor lady of a man, as jealous as he was violent, who has just been shot by his wife in June 1939. The interrogation of their children confirms that they were all, in fact, in the line of fire. The youngest girl, ten years old, tells the investigator about the night her mother killed her father:

> Yesterday Papa came home around eight in the evening. He yelled at us because we had already gone to bed. He wanted to beat us, and Mama defended us. He went to bed, then he got up and started to have a fit. I woke up during the night and couldn't sleep because I was too afraid. I didn't leave my room, for Mama had forbidden me to. [. . .] Papa came into our room; he wanted to lash out at us. Mama wouldn't let him. Papa slapped Mama. [. . .] Papa beat us often for no reason; I adore Mama.[15]

The insults spill over like so many blows throughout the home. The imposition through violence of a tyrannically masculine, paternal power in the house reduces all the members of the family to a state of physical weakness and psychic fragility.

MONEY, ALCOHOL, AND HOME

The use of force, physical blows, and fear allow the husband to prevent or to hamper the wife from fighting during a dispute. Being unilateral, brutality confers on the man exclusive power, regardless, finally, of the reproaches brought up. The wife's real or supposed infidelity very often constituted an excuse for the man's behavior, a pretext for asserting his domination violently. Money, alcohol, and home constituted the triangle of submission [cf. fig. 15.1].

Although the household underwent profound changes from the end of the nineteenth century to the 1970s (urbanization, the development of suburban housing projects, enlargement of workers' lodgings, elimination of unhealthy living conditions), it remained generally the domain of the "mistress of the house."[16] While the husband was indeed the head of the family, the domestic territory belonged to his wife. This unequal division between public and private spheres did not stop a number of men from feeling the need to also assert their power at home. While giving up the management of domestic life, they held onto economic and financial control of it.[17] It can be understood, then, that the domicile was at once privileged terrain and the focus of conjugal violence. Disputes took place there in

FIGURE 15.1 POSTER OF THE NATIONAL DEFENSE COMMITTEE AGAINST ALCOHOLISM. ILLUSTRATION BY ROBERT RIGOT, 1950s.

The violence of the drunken man has been a recurrent theme in antialcohol campaigns since the late nineteenth century. While the woman in this poster is graphically a prisoner of the bottle, it is the man who, dethroned by alcohol from his role as head of the family, is thrown back to an animalistic state.

Source: © Kharbine-Tapabor

the midst of which furniture and other objects became so many projectiles and weapons used by the protagonists. Whether it was during the 1940s with Martin and Andrea—"Arguments became sharper and sharper, he would slap her and she herself would throw kitchen utensils at him"[18]—or, two decades later, regarding a domestic dispute recounted in the newspaper *L'Aurore* on 22 May 1962—"Because his wife was such a spendthrift, in a fit of anger (he) kills her with a stepladder,"[19]— the multiple domestic objects compensated for or attenuated, according to who was using them, the physical inequality of the couple. The consequences of these blows often got worse and worse.

Unlike such dramatic events, the domestic tyranny of the *wife*, symbolized over time by familiar objects such as the rolling pin, the broom, the dish, or the vase given to her by the mother-in-law, contrasted with that of the husband. While humor softened the significance of the gestures, already considered excessive, the gender-role reversal was tantamount to denial, but also a warning to men who might let their wives outflank them.

The home was the essential focus of this war of the sexes. Who stayed there, who could enter and leave freely, and who decided on the order of things? In a few

lines, Irène Nemirovsky describes the transformation of a simple country home into a prison:

> Solange has come. I believe her husband is soon going to lock her in. He confined her to the house that they just had built in the country, and there are scenes each time she comes to Paris. He doesn't allow her any visits. He uses her health as a pretext, but, in reality, he is jealous.[20]

Isolation becomes the assurance of absolute power, of an exclusive sexuality, as in a monogamous harem.

In an opposite move, but with the identical logic of control over the domicile: "Louis [. . .] yells at his wife, 'Get out,' and throws her onto the landing, causing an injury to her head."[21] Banishment, signifying male all-powerfulness, remained most often temporary, since the wife was indispensable to domestic economy. Numerous reproaches cropped up around financial questions. So the upshot of the stereotype of the spendthrift wife can be understood. Either revenue was coming essentially from the husband, who balked at contributing the amount necessary to the upkeep of the household on the pretext that his wife was spending too much, or the wife, or the companion in cases of unmarried couples, contributed a substantial amount—if not the majority—to the household income, and the man reproached her for not placing enough money at his disposal. In all such circumstances, financial dependency, sometimes to the point of destitution, was an essential means of control and retribution, prolonged, moreover, after break-ups, as shown by the numerous references to familial abandonment and nonpayment of alimony in the police commission logbooks.

"Inveterate alcoholic, he argued with his partner almost every day over questions of money, for her salary wasn't enough for him to drink as he'd like."[22] It is not surprising to find "drink" in numerous affairs. Whether it was considered the cause of the disputes or the element leading to violence, it was closely associated with violence. The antialcohol campaigns made it one of their preferred themes: "It turns a man into a brute," proclaimed the National League against Alcoholism campaign as early as 1919. Although it is not possible to speak of a policy of preventing domestic violence, these campaigns are signs of a social disapproval of brutal behavior within the family. The talk about alcohol, however, is ambivalent: by denouncing a man who is drunk or an alcoholic, it takes away a part of his responsibility and attributes to social misfortune and sickness the causes of his violence.

The violent alcoholic has for a long time been part of the landscape. Georges Simenon, attentive observer of social life, both small-town and urban, draws several portraits of it, such as old man Sarlat in *Le Coup de vague*:

> He spent his life at the green café tables. . . . Was it true that he beat his wife and that she spent most her days weeping? Was it true that he had almost completely ruined her and that one day or another they would put the farm on the auction block? . . . All these things were rumored, and he, meanwhile, dressed brightly like a man about town, played cards, drank aperitifs. . . .[23]

The rumors evoked by the narrator point to the difficulty of sorting out the attitudes of the neighborhood people.

FAMILY, NEIGHBORS, COWORKERS, AND AUTHORITIES AT THE DOORSTEP

Today, most authors stress the eminently private and hence secret context in which domestic violence is carried out. For Daniel Welzer-Lang, that is its central specific feature: "It is carried out in private, in the privacy of relationships. Except for a few cases of wild outbursts, the violence is not visible except to the protagonists of the scenes where it is taking place."[24]

Aside from a few hundred observations made since the 1980s, he speaks of a "funnel of secrecy." It would consist of five strata, allowing the secret about the violence to be shared more and more broadly. The secret first known only to the couple extends to the children, witnesses of the first outbursts of hostile confrontation. Then it is the relatives and friends who find out about it or are witnesses to it. At that moment, the walls of the family home can no longer stop the wielding of violence from overflowing into the public sphere. Finally, the violent acts move into the social space. Colleagues, social workers, and police officers find themselves implicated in the domestic violence. This schema, established for the current period, is worth discussing in relation to the earlier era, the 1970s to the 1980s. First, because letting friends and neighbors know what a person is going through does not depend solely on that person's own will. This knowledge eludes the exclusive control of the protagonists. Second, because not all acts of violence committed by the husband against his wife were originally considered illegitimate or shameful. Did it not seem easier for a husband to speak up as a "good family man" about what

he had gone through and the discipline that he thought needed to be inflicted on his disobedient, spendthrift, or unfaithful wife?

Édouard Peisson, a popular novelist between the two wars, describes the talk around a neighborhood on the outskirts of Marseilles in which women gather regularly:

> They all recounted their misfortunes, and each one wanted to be more affected by bad luck than her neighbor. The men were harshly abused. [. . .] "Mine is worse than that. He is always at home; I'm the one who feeds him and the thanks I get—a beating."[25]

The tone is closer to a collective escape valve than a hard-to-tell secret.

Whatever the sources, a couple's violence seems to become known to those around them. But the differences are important according to each person and the nature of what they know and the moment they learn of it. The case of Mme. Henriette C. . . , murdered by her husband in March 1949, is significant with regard to these disparities: the family, the neighbors, and the shopkeepers of the neighborhood in Saint Ouen where the couple lived were, in fact, interrogated by inspectors of the criminal unit after the drama;[26] all were aware of the discord in the household. But while the upstairs neighbor got wind of it as early as 1941, the victim's sister-in-law did not learn of it until the end of the war, and the murderer's mother did not find out until a year or two later. A female childhood friend of the husband knew that "he indulged quite a lot in drinking (and) that harmony was not the rule in his married life," but her attention was not really drawn to the matter until four or five months before the crime, when Mme. C. . . called for help from her window. So the friend went up to her place and found her "disheveled, her clothes in disarray, (telling her) that her husband had tried to strangle her and that he had struck her mother who had tried to intervene." As for coworkers, witnesses to the crime in front of a café where they were having a drink with Henriette, they seemed to know nothing about the threats made by the husband. It took, therefore, eight years, from 1941 to 1949, the date of the murder, for those around her to become aware of the violent acts she was subjected to.

What did Mme C. . . go through? There, too, each person had a partial view of things. From across the landing, the neighbor heard her being called "bitch, good for nothing." She confided in her later that she had been slapped. The secrets confided in the sister-in-law were more precise, such as the story about a straight razor whose open blade was fastened to the handle by a string, which she found under

her pillow. In fact, Mme. C. . . truly lived in terror and feared for her life. She knew her husband was armed, since he had bragged about it to a barber.

Finally, the tragic outcome made it possible to learn numerous details, but so long as the homicide had not taken place, what happened in the C. . . household seemed to everyone to be a banal story of discord and a violent husband: it was truly hoped that things would finally sort themselves out—as Mme. C. . .'s return to her husband in 1946 had led people to believe; she had returned after a month's absence because of his insistence and his promises.

As for the authorities and the police, when, how, and why did they decide to intervene? Absent an extended study of the depositions made in the police commission logbooks, it is difficult to gauge the proportion of female victims of violence who complained to the authorities. Why does one note several depositions to the commissioner of the Parisian quarter of Barbès in the year 1935 and none in 1946? A few surveys are not sufficient to draw conclusions about the amplitude, much less the variability of these complaints. Should we see here contrasting attitudes on the part of law enforcement personnel, certain ones taking down the details scrupulously, others urging the plaintiffs to return home with the idea that they could work things out for themselves in the end? Thus, regarding an affair of "slightly violent acts" noted on 1 June 1935 at the Barbès police station, this simple statement is found: "Gone home. Will not press charges against her husband with whom she lives at said address."[27]

In other cases, the interventions and the particulars increase. The acts committed by a vegetable merchant in the Belleville quarter, M. M. . . , are thus regularly brought to the attention of the police. As early as 1922, when his wife leaves the couple's home for the first time to escape his violence, he sends two letters announcing his suicide to the police commissioner and to his wife. In reality, it is only a form of blackmail to get the latter to come back, which she does. Scarcely two months later, another visit by Mme. M. . . to the police at which she "declares that her husband has not given her any money for more than six weeks and requests official intervention so he will provide for her needs and those of his two young children." Violent by nature even outside the family, M. M. . . was sentenced twice in 1926 and 1927 for deliberate blows and injuries and carrying an illegal firearm. In 1931, it was his brother's turn to make a deposition in the logbook, claiming to have been threatened with a knife. Finally, in December 1934, mother and daughter "appear at the police station to report that they have been chased, threatened, and struck."

M. M. . . constituted an undeniable disturbance to public order; and his violence went beyond both the exercise of his authority as head of household and his

rights in the private sector. However, while he was sentenced after complaints by third parties, the members of his family, the perplexed wife and brother, were satisfied with a declaration in the logbook. The disturbance was there; he was known, but the authorities, unable to substitute for the family, did not intervene. Finally, "fed up with the mean treatment that her drunken husband made her suffer, Mme. M. . . killed him with a carpet beater." Once arrested, she was remanded to the circuit court of the Seine, which acquitted her on 3 July 1935.[28] The jurors, and before them the inspectors, considered that M. M. . .'s attitude, far from being the legitimate manifestation of male authority, was simply the behavior "of a violent and brutal man indulging continually in drinking," to such an extent that his murder did not warrant any punishment.

The ambivalence of the protagonists underlines how uncertain the border was between private and public. In the course of the twentieth century, two perceptions were juxtaposed of men's use of force in the private sector. At first understandable, the view gradually became reproachful. There was a shift from punishment, sign of powerfulness, to the violent manifestation of powerlessness.

THE CONDEMNATION OF VIOLENT ACTS OF VIRILE DISTURBANCE

At the same time that a type of male violence was acceptable because it was seen as the means by which a man could have his prerogative respected, that is, his power over the opposite sex, French society seemed more and more sensitive to manifestations of a violence that had become, in their view, reprehensible and illegitimate. In the course of a slow process of women's liberation and the balancing of roles and powers, the practice of domestic violence was to be enclosed in the secrecy of the private sphere, at the risk of making its agent appear to be a man whose brutality revealed an anxiety about his own virility.

"The violent spouse acts not to control but to exercise control."[29] This remark by the demographer Maryse Jaspard poses the problem of the purpose of domestic violence, which is seen to be inflicted not against the other, to ensure one's domination, but rather for oneself, to assure oneself of one's power and virility, to prove one's power. More than the exercising of male domination, violence toward women is seen to manifest certain men's anxiety about not being able to exercise this domination and would be addressed more to the "male self" and to other men than to

women. In the development of psychoanalysis, sexuality was perceived, from the beginning of the century, as an essential component of this anxiety.

BRUTALITY AND SEXUAL IMPOTENCE

The connection was explicitly established between sexual disorders within the couple and violent outbursts. In 1933, Dr. Voivenel saw "the inability to carry out the sexual act, in a context of physical and marital harmony, as the cause of certain flare-ups."[30] Nearly fifteen years later, his colleague Daniel Lagache, in a work that rapidly became and continues to be today a reference book on amorous jealousy, confirmed the hypothesis, illustrating it with numerous cases drawn from his extensive clinical experience. Among them was the story of Lucien, an employee of the Compagnie de l'Est, 48 years old, who had been living with his wife in a second marriage since January 1929. The match deteriorated very quickly, and in the course of sessions he had later with the psychiatrist, Lucien expressed unambiguously his feeling of profound inferiority: "I have a wife, and my cock disgusts her. . . . In the household, she's the one who gave the orders and held the purse strings. . . . At home I was a loser."

The doctor recounts the main stages of the rise of the problem:

> In December 1932, their sexual relations became very infrequent; he often could not ejaculate. . . . He got to the point of such nervousness that he could no longer go to bed without a scene. . . . He told her that she would never belong to another man. . . . The angry episodes started up again: he insulted her and spat in her face, calling her filthy names. He grabbed his wife around the neck threateningly, violently and started to strangle her.[31]

It was after this attempted murder that Lucien was committed. His sexual disability, the debased image of himself, in bed, in the home, but also in the outside world, put him in a position of double inferiority in relation to his wife, but also in relation to other men. That accentuated his fear of infidelity and prompted the most brutal expressions of jealousy.

For Armand, 44, a barber in Le Bourget, violence combined with sexual boasting functioned as a regular form of reassurance of self:

> (He) is unable to satisfy his wife sexually; he is jealous, keeps watch on her, and continuously suspects her of infidelity, seeing her lovers everywhere. Enraged by

her denials, he reaches the point of hitting her and dragging her by the hair; he puts chains on the windows and doors. Each time his professional affairs went badly, the fits of jealousy started up again. He boasted regularly of being sexually superior to other men.[32]

As for Henri, florist in Levallois, he was proud of having married "the most beautiful woman in Levallois" but reproached her at the same time for having thrown a cold blanket on him sexually:

> His doctor transcribes: she never loved him very much. She must have married him for his money. She's a bitch on the prowl and a vicious person. . . . Before his union with her, he had as many as five mistresses at the same time, and he was very active; he has since become passive.[33]

The husband's passivity or the wife's refusal, both perhaps functioning as a negation of virility, threatened these anxiety-ridden men. Was this frustration, this interdiction of their pleasure, the experience of a kind of castration?[34]

There does indeed exist a male anxiety about castration, a phantasm, no doubt, but sufficiently powerful that the legislature has accorded it a specific place in the French penal code. Thus, castration comes under the general system of "Injuries and deliberate blows" (articles 309, 310, and 311) and is governed by article 316: "Any person found guilty of the crime of castration will be sentenced to forced labor for life." Although article 316 applies also to oophorectomy (removal of ovaries),[35] in the case of an operation undertaken by a surgeon against the patient's will, it was surely sexual mutilation that frightened men. And although the cases were very rare, that did not stop certain authors from imagining them to be very widespread: "Castration is not unusual in the case of jealous women,"[36] declares Joseph Levy-Valensi to his colleagues gathered at the congress of legal medicine in 1931. Though a doctor, he nevertheless shared the anxiety of his fellow men.

It is understandable that a psychiatrist or a psychoanalyst would bring out what relates to sexuality more than a police inspector and be more attentive to the circumstances of the drama, or that a sociologist would be more concerned with the social context. Accordingly, source should not distort perspective. There exists a recurrent debate between two analyses of the causes of male violence. One, based on psychology, refers to individual pathologies, explaining such behavior by disturbed personal processes. The other gives priority to the influence of the social context and of male domination. It is logical for each discipline to favor its personal

or social terrain, but why omit interaction between the two? Is not the sexual anxiety expressed by a number of violent men, even those diagnosed as pathological, the revelation of a reaction to relations between the sexes in the process of redefinition and anxiousness in the face of the potential loss of the powers of domination?

Whatever the case may be, this fear of a possible devirilization reaches its culmination with homicide.

THE FORBIDDEN BREAK-UP

Separation constitutes the main solution for putting an end to acts of violence. Let us go back to the beginning of the twentieth century: the recent reintroduction of divorce into the French system with the Naquet law in 1884 gave hope to many for a peaceful resolution to the most virulent conjugal conflicts. Enrico Ferri, one of the founders of modern criminology, along with Cesare Lombroso and Alexandre Lacassagne, wrote in this regard: "Divorce will make homicide disappear."[37] Excessively optimistic, his view was contradicted a few decades later by Levy-Valensi, who asserted:

> When you see how often the bullet accompanies or follows the divorce case, you understand how valid Alexandre Dumas's reflection is: "While divorce separates bodies from interests, it liberates neither hearts nor souls."[38]

Because it has been the inspiration for works of literature, the crime of passion, or rather, "homicidal jealousy" (the nomenclature preferred by psychiatrists) is a motive often evoked in conjugal murders. The current term "crime of passion" undeniably has the effect of adding a romantic dimension to a violent crime. While the homicide dossiers concern cases of amorous relations that end with the murder and/or suicide of one or both partners, one also finds in them deaths that are the result of a long and painful process of battering, humiliation, threats, and fear. And in one case after another, as Levy-Valensi again writes in 1931, "the crime prompted by jealousy has its explanation, if not its justification, in this much too prevalent opinion among spouses that the wife is the property of the husband."[39] Whatever directions the drama took before, the prospect of losing that which was thought to be owned functions as a denial of power, of authority, and of all-powerful virility. Of course, men have no monopoly on killing; various investigations over several decades also bring to light the acts of female murderers. Doctors, jurists, and

criminologists, nonetheless, are in agreement when they stress that the majority of the murderers are male and the victims female. In 1947, Lagache cites a statistic generated "under excellent conditions" based on 122 men convicted of homicidal jealousy: 75 percent of the victims were women, wives, mistresses, or partners, over against 15 percent of the men (lover, husband, partner, or rival), the rest being grouped among outsiders to the conflict (children, parents, in-laws, neighbors . . .).[40] In 2008, a study by the Interior Ministry counted 156 women among the 184 people who had died at the hands of their partner or ex-partner.[41]

Throughout the century, there is a similarity among the crimes when a man wants to prevent his wife from leaving. In 1928, a chemical engineer murders his wife with a bullet to the head after the latter had wanted to leave the couple's home and then get a divorce on the basis of his regular beatings.[42] In 1944, a mechanic strangles "his mistress who was getting ready to leave him to go back to her husband who had gotten out of prison."[43] In 1962, "a worker from the Haute-Marne killed . . . his wife by shooting her right in the head with a hunting rifle; she had taken their two children and abandoned the family home because the man was drinking too much."[44] In 2008: "Two weeks out of prison for violent acts committed against his partner, a jealous, violent individual goes to see his companion. . . . She explains she does not want to go back with him. Unable to put up with this, right in the middle of the street, he stabs her some thirty times with a knife."[45]

Four murders among so many others: each time the motive is to prevent the other from leading an independent existence. They show the wielding of an absolute power, they preclude any negotiation, and they demand a single option: to give in or to die. The woman can be only submissive or dead.

DESTROYING FEMININITY, DESTROYING THE WOMAN

The acts of male violence against women are innumerable, especially if we take into account nonphysical violence. The discrepancy is enormous between a slap from an out-of-control husband and the decapitation and dismemberment of a woman whose body parts are found along or in the Saint-Martin Canal in February 1944.[46]

These acts are at first blows—punches and kicks—but lead to the throwing of objects in the face, or the contents of a glass, a dish, or a bottle, then an iron or the stepladder mentioned above. In other cases, the man uses a knife to strike his companion, increasing the risk of fatality. In the most serious cases, which end with

one of the spouse's death, firearms are found, often the sign of premeditation and sometimes accompanied by the murderer's attempted suicide.

Any of these forms of violence could be the object of particular circumstances. It will be noted, however, that a certain number of them, of varying degrees of seriousness, attest to a wish to attack the image of the victim's female body as well. Throughout the century we can find these destructive actions—actions accompanied by degrading and humiliating words, denying the identity of the women to whom they are addressed. Shortly after the war, a mother testifies to the violent acts inflicted by her son on her daughter-in-law:

> Two or three times I saw him beat his wife, and in the course of scenes that I was present for he really cussed her out. About a month before my daughter-in-law left my home, he called her slut, whore, bitch, and she was so hurt by these words that she hit him on the head with a poker.[47]

A 54-year-old florist cuts off his wife's hair in the middle of the night so that she "can't run around anymore."[48] With blows, other men scar their wives' faces, thus forcing them to stay at home if they do not want to be seen as battered wives. That can also be the modus operandi for what the criminologist Gustave Macé dubs at the beginning of the century the "liquid dagger:"[49] sulfuric acid. The woman's face is disfigured forever because she refused a man, or the prostitute is ruined for her pimp because she took up with another man; thus, either way, the woman is condemned never to be pleasing again. At times the result is death, as in the case of the young woman of 27 who in February 1935 expired at the Lariboisière Hospital after her brother-in-law, secretly "in love" with her, tossed a vial of acid right in her face.[50] The drastic destruction of the face recalls the recent case of Sohane, mentioned in the introduction, but also the process of destruction of one's femininity, at times temporary but enormous in consequences, as were the cases of the shearing of women's hair at the end of World War II.

WHEN VIRILE FRANCE TOOK IT OUT ON WOMEN

In the middle of the twentieth century, male violence came out of the homes, left the interpersonal domain, and began to be wielded in a widespread manner, with the participation of a large part of the French population rising up against women accused of having collaborated with German occupying soldiers. All over France,

close to 20,000 women had their hair sheared, the first ones as early as 1943 during the Occupation, most during the days of Liberation, still others up to the beginning of 1946.[51] People got even, then, by means of purification, specifically with women. Like male collaborators, they could be committed, convicted, imprisoned, sometimes executed, but since they were women, they underwent the supplementary punishment of being sheared. Also because they were women, their connection to the enemy took on a sexual connotation. They were sheared not because they "slept with Germans," but *because they were women* it was figured that they had slept with the Germans. French society in the summer of 1944 had a hard time continuing the war, purifying society, and reconstructing the country. But this reconstruction was not only material and human; it also involved recovering a national identity. In a country humiliated by defeat, men had failed in their duty as citizen soldiers, since not only had they failed to prevent the Germans from "walking right up to them and slashing the throats of their sons and companions" but many of them, brought back to Germany as prisoners by the victors, had also been away at a time when hardships wracked the country. France had to become victorious and virile all over again. It was therefore a matter of telling French women, at the very moment that they were voting for the first time, that even though they were acceding to political citizenship, their bodies were still under masculine control. Shearing, similar to other cases in most of the European countries during the second quarter of the twentieth century, was a virulent male reaction to the gradual but profound changes in gender relations.

WOMEN'S DEFENSES AND RIPOSTES

The history of male violence should not be reduced to a long catalogue of violent acts passively endured by their victims. We have seen that, gradually, the legitimacy of such acts decreased; women have begun protecting themselves little by little and have fought back against their spouses.

The appeal to neighbors and family was not always in vain; leaving with or without the children offered not only an escape but also a means of exerting pressure, showing to everyone the husband's inability to assume his role as head of the family. And finally, in the conjugal face-offs, the blows were not always one-way; although the strength was most often on the husband's side, certain women did not hesitate to retaliate. In the cases of conjugal homicides, female murderers are not

absent; in a quarter of the cases, the murderer was a jealous woman wanting to get rid of a cumbersome husband with the help of a lover or desirous of putting an end to a long ordeal of insults, humiliations, and acts of violence. Take the woman P. . . , who in 1931 mortally wounded her husband in his sleep after eighteen years of an unhappy marriage. Her husband, drunken and brutal, had beaten her frequently since the beginning of their conjugal life. A case of salpingitis (inflamed Fallopian tube), then of gonorrhea, assumed to be from the husband, led her doctors, with her consent, to perform a hysterectomy. Having been diagnosed with a morbid hatred, Mme. P. . . was not convicted but committed to a psychiatric hospital. "In the asylum, she asserts to her friends the legitimacy of her act. She considers her being committed an outrage, demands to be released or to be transferred to the appeals court, and demands the chance 'to prepare her arguments.'"[52] Her opinion is shared by Dr. Levy-Valensi, who concludes his study with these words: "The crime having been accomplished, she is no longer sick; holding her is arbitrary sequestration!" In other cases, as we have seen, the courts acquitted or handed down a suspended sentence to those women who had so radically put an end to their ordeal.

Nevertheless, while individually women opposed these violent acts, while they could count on solidarity with other women, families, or professionals, few examples are known of collective reactions. The renewal of feminism in the 1970s profoundly changed this state of affairs by placing women's bodies at the center of its concerns.

THE REJECTION OF ALL MALE VIOLENCE FROM THE 1970S TO THE BEGINNING OF THE TWENTY-FIRST CENTURY

Since the 1970s, the attitudes of French society with regard to male violence against women have undeniably changed. Though the MLF (Women's Liberation Movement) declared 1970 the "year zero for women," when it is a question of such a far-reaching movement, chronology cannot be fitted into precise boundaries. Nevertheless, in terms of male violence, the 1970s correspond to the conjunction of several interdependent phenomena. On the one hand, the important trend that had been taking shape since the nineteenth century shaping a more pervasively negative attitude toward men's brutality grew stronger, and the rejection of "offensive virility," once confirmed, lowered the threshold for the legitimacy of practicing male violence. On the other hand, a certain number of laws came about to

attenuate the imbalances in a profoundly masculine society: women's right to vote in 1944, the legalization of contraception in 1967, and the replacement in 1970 of "paternal power" with "parental authority." But above all, the feminist movement, alongside the struggle for the liberalization of abortion, challenged the virtual impunity of rape. Although the penal code allowed for the heaviest of penalties against it, in fact convictions were extremely rare, and cases of rape were reclassified as indecent exposure in the criminal courts.

RAPE IS A CRIME

In 1972, during the Bobigny trial that became a trial about abortion, the girl accused of having aborted, Marie-Claire, was the victim of rape.[53] Because she had not pressed charges, the prosecutor cast doubt on the genuineness of the rape during the hearing. But the release of the accused woman and the victory that this trial represented in the struggle for the legalization of abortion left the question of rape in the background. Over the next years, the struggle against rape, while taking a back seat to the fight for open, free abortion, gained more and more importance. The logic was then eminently political, rape being defined as the sexual manifestation of male domination. Various slogans came into prominence: "When a woman says no, it's no," or "Rape is a crime," up to the most radical: "This man is a man; this man is a rapist." In 1976 Susan Brownmiller's book *Against Our Will*, published the year before in the U.S., was translated into French. In her preface, Benoîte Groult stresses the sense in which "rape is not a sexual crime but an act of violence and authority (committed) by normal men."[54] She also brings up the case of the three female lawyers[55] for two young Belgian campers raped in southern France, who succeeded in having the case remanded to circuit court.

It was actually this trial, before the circuit court of Aix-en-Provence in 1978, that led to the denunciation of the discretion, indeed the indulgence, with which courts had been judging cases of rape until then: reduced sentencing, closed proceedings at the request of the accused, and suspicion of consent on the part of the victim. Beyond its judicial aspect, rape was repositioned within male domination:

All acts of sexual aggression suppose a type of relation of male/female domination symptomatic of a certain choice of society. Consciously or unconsciously, a certain number of masculine values have, in fact, come to justify rape as the result of the "naturally aggressive virility" of the man and the "masochistic passivity" of the woman.[56]

As in Bobigny, the commotion stirred up by the trial in Aix led two years later to a modification of the legislation. The law of 23 December 1980 redefined rape as a crime of constraint and penetration: "any act of penetration, of whatever nature it may be."[57] Eliminating the old distinction between licit and illicit coitus, the new law also opened the way for legal proceedings in cases of conjugal rape (judgment of 11 June 1992).

The other "acts of violence and authority," to take up Benoîte Groult's expression, were also fought against, one by one. As in the preceding cases, the feminist movements led the fight together at the political level, through the denunciation of and demand for legislative changes and at the level of concrete aid to women. Thus, alongside the articles, leaflets, or posters condemning the violence of male domination, offices were opened up for consultation and shelters for women who were victims of it. In 1978, the Flora Tristan Center in Clichy[58] was the first shelter for battered women and, almost a decade later, in 1987, a shelter for violent men opened in Lyon, the RIME.[59]

Another aspect of the same struggle, the question of sexual harassment in the workplace, appears in the 1980s. Whether it is about "petting," unpleasant sexual advances, showing of pornographic images, or more rarely touching or attempted or forced relations, these acts echo the struggles against the *droit du Seigneur*, including the best known among them, the struggle of the female workers who painted on porcelain at the Haviland company in Limoges in 1905. In the context of significant social discontent among the working populace of Limoges, a foreman is accused of seducing—one would today say "harassing"—young women in the establishment. The workers join the movement and demand his dismissal. The foreman, Penaud, becomes the center of the conflict, with a "Song to the eminent Penot" denouncing him among the populace:

Old man Penot, the skirt-chaser (repeat)
Spends his time spreading his charms
Every day, we see him
With the brown-haired woman.
REFRAIN
That is why, we say
Down with Penot. Down with Penot
When a girl comes asking
For work at the turbine
Before he asks her name

He touches her tits
And if he is pleased,
Quick—she's hired.[60]

Finally, after a month of conflict, including lockouts, riots, and the intervention of the army, negotiations begin. On 26 April 1905, people are back to work, without Penaud.

Eight decades later, the denunciation of harassment concerns accusations no longer of line managers only but also of male coworkers. After a few cases of harassment feebly evoked in the press in the early 1980s, an investigation by the European Commission revealed that, in France, 8 percent of women were subjected to pressures of a sexual nature on the job.[61] It was brought to the public's attention in 1985: a survey published by *Biba* stressed that now 36 percent of women considered themselves exposed to sexual harassment.[62] The same year the European Association against Violence against Women at Work was founded. Complaints increased, as did the first convictions. In 1992, article 222–33 of the new penal code stipulated: "The act of harassing someone for the purpose of obtaining favors of a sexual nature is punishable by one year in prison and a fine of 150,000 euros."

This growing awareness gradually took part in a redefinition of violence. The image of the "battered woman" and of violence, above all physical violence, was gradually extended to all the other forms of aggression—psychic, verbal, sexual, and economic—each one expressing the brutal exercise of male domination over women as well as a redefinition of the relation of the individual to violence. The definition of violence was expanded to forms other than physical violence and applied to children, but also to men, as shown, for example, by the emergence of the concept of psychological torture during the 1970s.[63]

Whatever the case may be, whether it was about rape, domestic violence, or sexual harassment at work, the 1980s and 1990s were years of a coming-to-awareness on the part of the authorities. Its echo can be found at the international level in the increase of proclamations, and even agreements, conveying this new awareness. In 1993, a joint declaration on the policy against violence toward women in a democratic Europe is adopted in Rome by the member states.[64] In 1995, the Fourth World Conference on Women in Beijing encourages states to "promote research, organize the collection of data and establish statistics on the prevalence of different forms of violence against women, in particular domestic violence, and to encourage research on the causes, the nature, the seriousness, and the consequences of this violence."[65] The following year, in 1996, the World Health Organization launched

the first international investigation; in numerous countries other studies were carried out on this theme, such as the one initiated in France in 1997 by the Secretariat for Women's Rights.

The figures put forward in recent studies show that in France one woman in ten has been the victim of domestic violence in the preceding year, about one hundred of whom died at the hands of their spouse: 0.3 percent of the sample—which was taken from among women ages 20 to 59, or around 48,000 victims—were victims of rape.[66] Without being able to date the shift precisely, we note a new sensitivity to the questions of violence toward women, a more evident social disapproval, and a speedier intervention—and henceforth prevention—by authorities.

PERSISTENCE OF VIOLENT FORMS OF DOMINATION, OR EFFECTS OF MASCULINITY UNDERGOING CHANGE?

The changes that have taken place since the 1970s are real, even though the progress toward legal equality has not been so quickly transposed socially. Within one century, male domination, without disappearing, has ended up diminished in many respects. The way in which people consider themselves men or women has also changed considerably. The care and education of children, politics and political power, higher education, the army and its civil extension, the police, the salaried workforce, sports, and all areas deeply split between genders have lost their exclusivity. At the same time, acts of male violence have been condemned more and more, their legitimacy more and more diminished as their scope enlarged, and the convictions more frequent and more severe. However, not only do they still exist, we sometimes have the impression that they have never been so numerous. The increase in investigations and their supplementary statistics show us the extent of the phenomenon and help us become aware of its seriousness. But how should these figures be interpreted? Does the growth of appeals to information services, complaints to the police, or contacts with social workers signify an increase in violence, a stronger reaction by women who are daring more often "to step up to the plate," or are they the accumulated sensitivity and activity of different stakeholders? Let us be clear: nothing allows us today to compare the number of rapes, blows, or injuries at different points during the century. It is now doubtful, however, in spite of the use of the same statistical tools, that change took place from one year to the next. And that is without

speaking of other forms of violence that are nonphysical and affected by the subjectivity of victims, perpetrators, and witnesses.

The question of a potential "return" to aggressive virility has been posed in several Western countries. In France, this debate was started in the early 2000s with regard to gang rapes, newly named "*tournantes*" (revolving, taking turns). The situation is presented as unusual, limited to the suburban "housing projects," and to youth described as "children of immigrants." These acts of violence were often considered the cumulative result of cultural differences and pornographic saturation.

However, analysis shows that this phenomenon is not new and that gang rapes by "black shirts" in the 1960s had also been widely talked about.[67] Besides, convictions for group rape remain stable for the period from 1984 to 2006, whereas all the other infractions of a sexual nature increase during the same time.[68] Most authors agree in stressing that the collective assertion of a group's virility is a form of initiation found within groups of very diverse social backgrounds.[69] Certain mass media, and not the smallest in terms of diffusion, such as pornography and advertising, rely on a phantasmatic universe imbued with the play of submission and sadomasochism and thus continue to maintain and even to promote the image of brutal, domineering virility and that of a femininity whose coming to fruition takes place by means of male subjugation.

Do these aggressive forms of virility in an age of uncertain identity persist in spite of the general trend, or are they on the decline? Once again, the historical tools are lacking to answer this question.

Are we today confronted with acts of violence whose importance is just being discovered but which have been constantly on the decline for more than a century because of changes in the relations between men and women, as with the place of violence in interpersonal conflicts? Are we witnessing, on the contrary, a resurgence of male violence, a "brutal backlash" from men destabilized by the current readjustments and changes in gender identity, men whose laying aside of violence is now worrying them about their own masculine identity? This analysis was already proposed about twenty years ago by Christine Castellain-Meunier. For her, violence was to be seen as "defensive masculinity" to which those men would turn who were losing their identity markers: "(Man) has trouble expressing himself outside of a relation of domination which the modern woman aspires more and more to take away."[70]

Regarding the persistent difficulty in speaking for female victims of violence, one hypothesis may be put forward about how the main reason for their silence

has changed. If the silence is based on a number of factors—submission, fear, or denial—then we have perhaps moved from a silence of acceptance, from domestic violence considered as being part of the nature of things, to a shameful silence. Could violence henceforth exclude those women victimized by it from modernity, or from a new model of gender equality, perhaps not perfectly enforced but nonetheless operative?

From the dawn of the twentieth to the beginning of the twenty-first century, men have committed violent acts against women, not as they would have acted toward other men, for heinous reasons of politics or rivalry, but because they simply thought it normal and necessary for their standing as men. In the absence of any quantitative element (number of conjugal homicides, real number of rapes and not just reported rapes, complaints of beatings and injuries), it remains difficult to outline precisely an evolution of practices. Are the acts of domestic violence more or less numerous today than a century ago? Do the post-war reunions constitute instances of greater brutality within couples? Are the weapons, the acts, the insults, the forced sexual practices the same in 1920 or in 2010? Though we cannot know about these things for sure, social disapproval of them has nevertheless kept on growing. The understanding of the devastating effects of these violent acts has expanded. The information campaigns have become more numerous, and attitudes and proposed solutions have changed. Since 2004, the violent spouse can be kept away from the family home by the family court judge. "More than 47,500 instances of major deliberate violence against women by a spouse or ex-spouse were recorded by police officers and at police stations in 2007."[71] Widespread in the past, "violent virility" has left the realm of the "usual." It is now anticipated, discussed, and more often punished. The "civilizing process," in the sense of an attenuation of acts of interpersonal physical violence, has had a lot to do with it, and so have the feminist movements, but another major factor is a redefinition of masculine identity as less warlike and more paternal (to summarize quickly)—in other words, in areas that used to be the domains of women.

·
: · ·
· ·
·

16

VIRILITY THROUGH THE LOOKING GLASS OF WOMEN

CHRISTINE BARD

Women have served all these centuries as looking glasses possessing the magic and delicious power of reflecting the figure of man at twice its natural size. Without that power probably the earth would still be swamp and jungle. The glories of all our wars would be unknown.

THE MIRROR of women offers a lovely path along which to trace another history of virility. That ancestral role of women, evoked by Virginia Woolf, reappears in the twentieth century but opposes the formidable progress in gender equality and even contributes to slowing that progress as it helps strengthen dictatorships. Its effectiveness is based on the early internalization of gender norms, which then model desire. But this outmoded magnifying mirror of inspiration, while managing to be compatible with a certain modernity, is seriously challenged. The feminists turn it into a more faithful mirror of reality. Some of them shatter it and prefer to be interested in women. For them, men are the second sex and virility is a secondary question.

It is nevertheless possible to write the history of the feminist critique of virility, even though it is not at the core of feminist thought. Simone de Beauvoir does not ignore the question, since her project is to demonstrate the socially constructed character of sexual difference. Beginning in the 1960s, myths of femininity and also of virility explode. At the time the mirror reflects to men an image of virility that is difficult to accept—their virility: deadly, bellicose, criminal, mutilating. . . . For feminists, virility coincides from that point with sexist behavior: it expresses male domination.

At the end of the twentieth century, another way appears of looking at gender that becomes the central concept in feminist thought: by dissociating sex and gender as well as sex and sexuality more strongly than in the past, a different view becomes possible of virility and of the virilization of women. This was an old-fashioned notion to antifeminists, for whom such virilization heralded the end of the complementarity of genders, the dissolution of heterosexual desire, and therefore the disappearance of the human species.

VIRILITY, OBJECT OF DESIRE

Mirrors, writes Virginia Woolf, are "essential to all violent and heroic action. That is why Napoleon and Mussolini both insist so emphatically upon the inferiority of women, for if they were not inferior, they would cease to enlarge. That serves to explain in part the necessity that women so often are to men."[2] Many twentieth-century women regard virility positively, whether it is a matter of a certain type of body, an attitude, or a way of speaking and thinking about the world, and especially of seeing the relations between men and women.

A SEXUAL DESIRE: THE DISPLAY OF "PURE VIRILITY"

Let us first consider the body—object of desire. Through the looking glass of women, virility presents a few constants that refer back to the model of ancient Greece, still prized in the twentieth century, especially among naturists and gymnasts. This does not rule out certain variants. For the French feminist and pacifist Marcelle Capy, writing in 1930, virility refers to the image of German prisoners during the Great War: "Tall men, broad shoulders, narrow hips, closely shaved face, blue eyes [. . .]. One looks at a man's height, the breadth of his shoulders and his hip measurement. The greater he is in height and the thinner he is below, the more handsome he is."[3] The existence of this feminine gaze is sometimes hidden, as if women of the past, purely objects of the gaze, were devoid of senses and desires. Actually, their commentaries are one of the tribunals of virility. The feminist question posed here is that of the autonomy of the expression of female desire for virility. The mirror was purchased at the store run by men, was it not? Simone de Beauvoir herself defines virile beauty indulgently as "the manifestation of a

transcendence giving life to a flesh that should never fall back on itself."[4] Women consume, as men do, the productions of mass culture (spy stories, adventures, serials) that present very stereotyped accounts of seduction On the little screen of the 1960s and 1970s, it is a more and more sexualized image of virility, always associated with combat, that becomes essential. The similarity between words of love and words of war is imperative and obvious.

In the last third of the twentieth century, one of the most notable aspects of the change is a greater control by women over their sex life. Since the definition of virility is profoundly relational, this evolution is interpreted in terms of devirilization by more conservative minds. But what becomes essential at the turn of the century is instead the representation of virility as a promise of sexual performance. A new type of spectacle is introduced into mass culture: the "Chippendales" host dinnershows that are closed to men. The female spectators feast their eyes and have fun slipping bills into the g-strings of the hunky dancers. Is the man-as-object still virile? Deprived of his status as subject, one might think so, and yet his physique saves him. Muscular, adopting flattering poses, he plays on an apparently inverted situation; the premise is an ultimate reversal: that order will be restored.

"PURE VIRILITY" THROUGH THE LOOKING GLASS OF WOMEN

The French feminist writer Françoise d'Eaubonne remembers her infatuation as a girl of fifteen for "the young Italians in black boots" who went off to war in Ethiopia and became the heroes of her dreams. Such a desire does not place her, however, in a passive position: "I traced in my atlas the banks of the Red Sea and landed there in my dreams with them."[5] The appeal of fascism should be explored. As early as the 1930s, Wilhelm Reich analyzes, against a background of sexual frustration, the impulses behind the channeling of the libido onto the figure of a leader and of repressing or of regulating one's desires. Women help lay the groundwork of the very masculine construction of fascism in its sexual dimension. Leni Riefenstahl, in *Triumph of the Will* (1934), sings the praises of the victorious virility of the Führer.

In the everyday life of the "black years," female desire for fascist virility is certainly present. This virility is embodied in the person of Mussolini. All it takes is a gaze at him for a woman to get pregnant, right? This was a significant joke in a country wishing to boost its birth rate. So women are mobilized. Thus, during the *Giornata della fede* ("day of faith"), organized in 1935 to protest against

the sanctions determined by the League of Nations against Italy, amidst grandiose ceremonies, Italian women give up their gold rings in exchange for iron ones. "So that, in a way that would not be merely symbolic, the gold of feminine faith might be transformed into the steely virile power in of the Empire of Rome."[6] But the action also had a more intimate dimension: the gift of the wedding ring is a means of symbolizing union with Mussolini himself.

Fascism inspires very gendered and sexualized analyses of the relation of dominator to dominated. Sartre defines collaboration, for example, as "a feminine activity, under the effect of the powerful, masculine attraction of the dominating occupier."[7] The misogynist cliché must nonetheless be avoided, which portrays women, as early as the 1930s, as the most ardent supporters of authoritarian regimes.[8] While there is a sexual component to women's support (but also men's) of fascism, there is, above all, a political and social dimension that must be clarified: how and why is it possible for women to support this ideological model of virility?

As early as 1929, Virginia Woolf envisages "an era to come of pure, of self-assertive virility."[9] For Nazism, the match between sex and gender is seen as the privilege of the superior race. The persecuted are reputed not to respect this dichotomy: unfettered, masculinized Jewish women, effeminate Jewish men, and of course homosexuals of both sexes. In the camps, dehumanization can be seen through the forced erasure of marks of gender, and resistance, at times, seen through the maintaining of gender. The hatred of the cross-breeding of "races" is a priority. But many other cross-breedings can be considered, such as that of genders, which is not ignored during this period. Against this anarchy of genders, against the democracy that handed power over to women, that feminized men, and that let the race be bastardized, Hitler stands up for a virile model: "The racial (*völkisch*) State (must be) the arrogant embodiment of virile strength and women (*Weiber*) capable of bringing real men into the world."[10] The State becomes the sole wielder of power and norms, each individual, regardless of sex, bowing before this superior interest in the service of the "race." It is within the framework of this new sociopolitical organization that the Christian model of spouse-mother is recycled, modernized by eugenic obsession. Nazis always need women to hold up the mirror to them. And the first condition is that the women be Aryan. *Weib* ("female") rather than *Frau*,[11] that is, procreators, guardians of the purity of blood, mothers preferably of four boys. "The reward which National Socialism bestows on women in return for her labour is that it once more rears men, real men, decent men who stand erect, who are courageous, who love honor,"[12] Hitler declares in 1935 during a Nazi party gathering. The national socialist party aims to be a *Männerbund*, a masculine

order, united "by the virile camaraderie of war, Freikorps and brasseries."[13] In 1921, women are excluded from it. The encyclopedia of personalities of the Third Reich lists only men. Nazism is, "by its nature, a male movement"[14] (Joseph Goebbels).

FEMALE ACCOMPLICES

This hostile environment does not discourage female vocations any more than the sets of ideas that deny the social existence of women (the phantasm of a world without women) or keep them at home, prohibiting them from higher education and numerous professions. Women take up their pens to defend the model of absolute difference between the sexes: "Whereas man becomes a human being by affirming himself, woman becomes a human being by renouncing herself," writes Guida Diehl.[15] The position of Nazi women frequently contradicts masculine viewpoints: some want to participate in the harshest combat and in running the country. A modest place is made for them, procuring for them the pride of belonging to the "elite" of their sex.

Feminine support of Nazism is in one way the result of the "nationalization of women" during World War I: a total war mobilizing the energy of all.[16] Nationalism does not spare the feminist movements and hardens in the defeated countries. In Germany a "national-feminism"[17] develops, adapting to the new regime, yet violently antifeminist, since it calls on women "to emancipate themselves from emancipation," that "Jewish invention." In 1933, female voters are as numerous as male voters in casting their ballot for the Nazi party. In the following years, Nazi feminist organizations will count as many as twelve million members from six to 60 years old. They pledge allegiance to a gendered order required by the State that would transcend personal ties (which legitimates the denouncing of one's close friends or husband, for example). Organized within a specifically feminine space, the women do not necessarily develop a high opinion of men, who will be "always self-centered, arrogant and ambitious,"[18] according to the *Reichsfrauenführerin* Gertrud Scholtz-Klink.

From the Nazi point of view, the mobilization of women is a success. Valorization of work that is traditionally invisible, maternity and domestic chores, provides women a kind of recognition by assigning them a clear social function. The complementarity of spheres—an ideological reference, for example, to Alfred Rosenberg, who sees man as the architect of the macrocosm and woman as its preserver—would have it that the woman stays home with the family and the man exercises his activity everywhere else. But the family does not elude the State, since

it is the base of the Nazi system. And women participate in Nazi criminal activities. Ten percent of them, for example, work as guards at the camps. Women belong to the SS, which is not just a community of soldiers but an order, in accordance with Himmler's terms. For the historian Claudia Koonz, not only through their direct participation but also through their acceptance of feminine *Lebensraum*[19] German women contribute "in a manner essential to Nazism, preserving an illusion of love in an environment of hatred." There is no "pardon for those born female."[20] The irenic temptation to see women only as victims of Nazism has been jeopardized since the 1980s by work that shows their share of responsibility in that criminal history.

Fascism and Francoism also enable the triumph of virility through the important support of women. These movements draw from their popular traditions and from their history of fostering the ideology of male supremacy. In Italy, intellectuals and artists modernize this machismo beginning in the early twentieth century by eroticizing and aestheticizing it. The *Futurist Manifesto* (1909) wants "to combat moralism and feminism:" a nonfortuitous contiguity. But with the test of time, this transgressive, reclaimed sexism becomes more traditional. The weight of the Catholic Church introduces slight differences by comparison with the German case. In Italy, the Concordat of 1929 forces the State to compromise with the Church, which controls powerful female associations; this reinforces the familial mystique of the fascist regime. In Spain also, the influence of priests should be stressed in the construction of a national set of ideas about virility: God wanted to punish women for original sin, and this is why He inflicted them with the pain of childbirth and submission to male authority. The clergy teach youth, in 1943, that "since woman was formed by a part of man, supremacy of right and force of authority are incumbent on him. . . . Woman was made to love, man was made to command."[21] According to the Latin tradition of machismo, women were "born to keep house, have children and cuckold."[22] In the moral order of fascist modernity, female infidelity is no longer the subject of jokes, and the murder of an unfaithful wife in Franco's Spain goes unpunished.

Fascist women's periodicals do not define virility precisely—no doubt because it is dehistoricized, idealized in the form of an eternal masculinity, and even delineated as a national character trait. The virile myth needs a certain artistic fuzziness. It also needs, as Virginia Woolf pointed out, a magnifying mirror. Finally, with Simone de Beauvoir, let us recall that this virile myth makes sense only as a relational notion, that is, over against femininity constructed as alterity. That is why in the *Giornale della donna* we read in 1930: "According to fascist style, a man who is profoundly virile and warrior-like, must be matched by a woman who is essentially feminine, tender and loving, like a mother, a sister, and a wife."[23]

The National Council of Italian Women does not disapprove of this position. A moderate organization, it sees women's action in La Città mainly as a philanthropic necessity, and certain leaders approve of the recognition that fascism grants to the maternal function. In Spain, the women of Catholic Action and the female section of the Phalange, beginning in 1939, offer their services to the State. They spur women toward the spirit of sacrifice. The speeches of female candidates for political martyrdom, in the end too virile, disappear over time as a more modestly doloroso profile emerges. Gone are those audacious declarations that claimed "a man is never so courageous as when he has a praying woman behind him. If men become heroes, it is because we are working and praying here."[24] The policy of feminization is necessary to the "restoration" of the virile order: the power of men corresponds to women's loss of power by being denied rights and certain jobs and pressured to have children

Antifeminism relies on ideologues. Among the latter, the Italian Gina Lombroso stands out for her influence in the Catholic world. She distinguishes two types of women: the wife-mother-housekeeper, "other-centered,"[25] and the feminist, destined for unhappiness, who because she is dangerous to other women will be weakened by the rights acquired for all. As for man, he is "egocentric in the sense that he tends to make himself, his interest, his pleasures and his occupations the center of the world in which he lives."[26] The justification of a return to order by referring to the "laws of nature" typifies this period, beyond national borders.

VIRILITY AS TRANSCENDENCE: HOMAGE TO BEAUVOIR

It is clear, through her life and her work, that Simone de Beauvoir is not hostile to virility. She feels on an equal footing with Sartre, a rather virile companion (a taste for female conquest, justification for the hold on the world by what corresponds to the dominant male model, virile expression sprinkled with innumerable sexual metaphors[27]), which does not prevent her from taking an interest in the analysis of the female condition. Beauvoir describes in her diary and her memoirs intellectual and material desires that correspond to a virile manner of being in the world. But what interests us is the place that she assigns to virility in the major work of feminism of the twentieth century, *The Second Sex* (1949).

Her work involves a total break with the essentialist and reactionary thought of a Gina Lombroso: being woman or man results from a "situation." The "biological givens" are not left out, for the human *is* first of all his/her body: a simple

development for the male, more complex for the female, who will undergo the alienating physiology of maternity, menstruation, and menopause. But the basic point that the philosopher defends is certainly in the constructivist perspective: "one is not born a woman" (although the gendered body is not denied), "one becomes a woman" ("body subject to the taboos and laws" of a conscious human). She discusses the point of view of psychoanalysis, pointing out, especially in Freud, androcentric improbabilities and hasty generalizations about penis envy in the Electra complex: this involves the "virile claim" about the little girl who reacts upon discovering that she does not have a penis by imagining that she has been mutilated. But Beauvoir does not think that the girl who refuses femininity and identifies with the father will become an exclusive "clitoridian," a frigid partner or a homosexual.[28] In her view, destiny should not be reduced to a struggle between virile-like and feminine tendencies, especially in (hetero)sexual relations: the humiliation of being placed under the man, clitoral orgasm being called infantile, vaginal orgasm called feminine. Beauvoir also reflects on the anthropological value of the penis: to avoid the anguish experienced by every human being, the little boy tends to consider his penis as a plaything in flesh, a double of himself that becomes the measure of his value, a possible source of pride. "Thus, it is consistent to say that the phallus embodies transcendence carnally," whereas the little girl, "deprived of the alter-ego, is led to turn herself entirely into an object."[29] The phallus symbolizes sovereignty and, Beauvoir adds, nothing prevents women, once they become subjects, from inventing equivalents of the phallus.

Through a study of a few writers, she shows to what extent virility is relational. The position of the *One* (male) decides on the position of the *Other* (female). Several configurations are possible, but the destiny of the Other, whether she is equal, woman-child, soul-sister, woman-sex organ, or female beast, is always man, through a sort of altruistic love. The woman is no more than a surface for projecting "his point of view on the world and his egotistical dreams."[30] In Henri de Montherlant's work Beauvoir brings to light an unhappy, misogynous virile archetype; in D. H. Lawrence, she finds a happier aspect of heterosexual virility in the picture of the perfect and mysterious communion between Lady Chatterley and her gamekeeper.

Beauvoir observes that, while "the women of today are in the process of deposing the myth of femininity," "virile prestige is quite far from being effaced."[31] The path that she describes for the independent woman leads to a redefinition of the human couple around the values of liberty, equality, and fraternity. This redefinition will be based on the biological substrate and on a cultural heritage that she

does not deny. In any case, female virilization itself appears to be a dead end. Abdicating one's femininity would be like renouncing one's humanity.

If there is one relationship in which the flattering mirror is essential, it is surely the amorous one. Simone de Beauvoir tries to construct an egalitarian relationship. She gives the image of a free, autonomous woman who follows her path without letting herself get absorbed by passion. But during the twentieth century we hear voices of women who are less sure of themselves, destabilized by their encounter with virility. In her memoirs, Clara Malraux, André Malraux's first wife, analyzes the "psychological abduction" of which she was the object. The same with Sylvia Plath, who has become an icon of feminism. In "Daddy," her best-known poem, she explores her attraction-repulsion for figures of Western virility:

> Every woman adores a Fascist,
> The boot in the face, the brute
> Brute heart of a brute like you

The poetic result is patricide; the act of violence, a case of self-defense, is assumed. Now is the time for anger, after an excessive idealization.

VIRILITY REJECTED

The advancement of gender equality that marks the twentieth century does not take place without a profound questioning of virility. In the eyes of feminists, virility expresses male domination, which they call, depending on the time and their leaning, "masculinism," "patriarchy," and also sometimes "virilism." The spectacle reflected by their looking glass is that of violence, war among nations, and war between the sexes.

"TO TEARS, FEMALE CITIZENS!" ["AUX LARMES CITOYENNES!"]

It is not easy, however, to criticize wartime virility. First of all because women and men live in a shared world, as pointed out by the feminist Bertha von Suttner. Winner of the Nobel Peace Prize in 1905 and a novelist known worldwide for

her book *Die Waffen nieder!*, she sees no difference between female and male attitudes toward war. Feminists, lucid about the metamorphoses of modern conflicts, feel empathy for the men, more often seen as victims than as agents of the huge slaughter that started off the twentieth century. The unequal sacrifice is a source of guilt, indeed of self-censorship for many of the women who, at any rate, join in the surge of patriotism. Women sense an unspeakable suffering that leaves psychic and physical traces: men who drink too much, who have been scared, who weep—and men who have become mute. These flesh-and-bones soldiers upset the warrior stereotype in the eyes of women, who are placed as nurses in private and public places. How can peaceful, loving, and paternal men become "bestial against their will, murderers against their wishes, against their nature, against the will of God?"[32]

Far from accusing men for being men, most feminists denounce the socialization that has made warriors out of them. Why not have children play with firemen and rescue workers? Feminists of the first and second wave agree in their opposition to war toys, so enticing and ubiquitous throughout the century. It is up to mothers, repeat the feminists, to intervene and change the education of boys. Sweden, which prohibited war toys in 1979, is cited as an example to follow.

The apprenticeship of virility also includes a stage of military service, the conditions of which first- and second-wave feminists alike denounce: alcohol, prostitution, emotional solitude, "degrading"[33] treatments, to the point of being "a form of torture" that the French lawyer Gisèle Halimi links to the injunction of virility. The feminist critique is in agreement with the opinion of the youth of 1968, impatient to see the end of military service. Virility is questioned; being discharged is no longer dishonorable. Warfare virility through the looking glass of women posits fixed roles for wife, mother, and daughter. Yet these roles have been transformed. Radical feminists shatter the mirror, refusing to produce "canon fodder," a neo-Malthusian anarchist slogan that cheerfully runs through the century.

War gives men the occasion for proving their virility: the vanity of the uniform, the pride of the "slight wound," courage in the face of death. However, war is no longer "a glorious walk in the park,"[34] notes Clara Malraux. And feminists will endeavor to denounce the horrors of modern warfare, excessive armament, and the huge surge in the number of civilian and military victims. With the recognition of women's rights, they propose an alternate policy for the prevention of conflicts (e.g., changes in education, new economic balances, disarmament). Their international associations represented at the League of Nations and the United Nations are not without influence. Beyond their differences—for there are multiple feminisms

and pacifisms, causes supported by Protestant, communist, anarchist, or even statist militants committed to humanitarian issues—what brings them together is a gendered vision of the ultimate question: women are on the side of life, a supreme value, and men are on the side of death. "Our feminism is too . . . feminine to dream of fights and massacres,"[35] writes the French suffragette Cécile Brunschvicg.

How can men's war-like desires be explained? The biological explanation is not rejected. Testosterone plays a role for the feminist Odette Thibault, who suggests taking a cyproterone pill[36] (which counteracts testosterone) to diminish men's aggressiveness. Madeleine Pelletier highlights the animal aspect of the male instinct. For this reason she allows prostitution, a useful escape valve for men's sexual drives, which, in her view, helps limit the number of rapes. A role that has been integral to men for millennia ends up being confused with an essence: "Beginning with the most ancient prehistoric documents, man appears to us always armed,"[37] notes Simone de Beauvoir. Men as hunters, then as warriors. . . . "Since Cro-Magnon man, where is the evolution?"[38] Despite its new faces, despite the very recent diversity of armies, war remains an integral part of virility. And it is just one more step to saying with the pacifist and feminist militants: "War is the masculine act par excellence. . . . Who wages war, who massacres, who rapes, who tortures?,"[39] or, as Nancy Huston writes in 2009: "Yes, you've got to have a penis and testicles to hack them apart in this way, to rape, to slit others' bodies open with a machete, a dagger or a sword, to rip into them with a machine gun, to decapitate them and to play marbles with their heads."[40] For Huston, it is a question of an "instinct" that is terrible to deny. She also invites re-evaluation of maternity as a source of moral conscience opposable to violence, with all due respect to the epigones of Beauvoir. This debate about violence and the importance in the pacifist struggle of the equation woman = mother = peace brings us back to the question of "pardon for those born female." How do we reconcile, on the one hand, the existence of *Reichsführerinen* or female American soldiers torturing prisoners at Abu Ghraib with, on the other hand, the no less debatable reality of a historical experience of women that places them instead on the side of nonviolence?

Without denying the existence of violence in women (which is wielded against men, among women, against children, and quite often against themselves), it should be recognized that there is no symmetry between male and female violence. Historically, it was first warrior virility that was questioned, then virility expressed by means of violence toward women. Ordinary language actually associates the penis and the gun ("*tirer un coup*" means both "take a shot" and "get off"). "Our bodies belong to us," say the feminists of the 1970s, who defend the respect for the

bodily and sexual integrity of women. For them, rape is an act of violence resulting from patriarchal society, the paroxysmal expression of a relation of domination present everywhere. The rapist, often known to his victim, resembles the "man in the street," a neat and tidy, tranquil family man, the opposite of the dominant stereotype that makes him a recognizable pervert, a stalker, a stranger suffering from sexual deprivation. The battle is juridical: women want rape to be recognized as a crime; but the battle is also intellectual so long as it is neglected as an object of reflection. The dominant point of view is defended by men, convinced that "it's in our nature." The discovery of testosterone confirms this male propensity for aggressive sexuality. This naturalist explanation is always put forward by those who recommend "chemical castration." The feminist priority is to listen to the word of the victims. The message is sometimes heard: Eve Ensler's play, *The Vagina Monologues*, has been translated into forty-eight languages, is performed continuously, and has given birth to V-Day (1998) to fight against domestic violence, rape, genital mutilation, and crimes of honor.[41]

ON THE "LIBERATED" SEXUALITY FRONT

At the time of the sexual revolution, the feminist critique of virility endeavors to reveal the sexism of the most representative authors of this ambiguous liberation. That is the point of the prescient book of radical feminism, *Sexual Politics*, by Kate Millett (1969), who attacks the question by means of literary criticism. Analyzing works by Henry Miller and Norman Mailer, Millett brings to light first, the raw, frank expression of a masculine culture that is usually hushed, which reduces women to contemptible objects, and second, a mystique of virility, which is actualized essentially in the sex act (the "fuck") and sexual phobias (fear of homosexuality, of impotence, of feminization in a man . . . and of America). Millett concludes that women must think through their own sexual liberation.

It is as a sociologist and militant of the women's movement in Germany and France that Alice Schwarzer treats sexuality, specifically an aspect of women's submission that eludes political reflection. In *The Small Difference and Its Great Consequences* (1975), she sketches a very somber picture of heterosexual relations. The looking glass that she recommends is that used now by women in self-help groups to see themselves more intimately with the aid of a speculum and to discover the beauty of their body. The narcissistic reconditioning is accompanied by a demystifying critique of virility:

In this society of men obsessed with virility, it does not take long to find the differ-
ence that we are dealing with. No big difference, in fact. Eight to nine centimeters
in its flaccid state, the experts assure us, and six to eight centimeters more when
erect. And it is in this negligible appendage that virility resides? Is this the magic
force capable of exciting women's desire and governing the world?

Schwarzer believes that there is no anatomical destiny. It is neither the penis nor
the uterus but "power" and "powerlessness" that make us men and women.[42] If
penetration is the "supreme demonstration of virile power,"[43] for the women whose
testimonials she uses, vaginal orgasm remains an uncertain horizon. Thus begins
the denunciation of compulsory heterosexuality.

While Schwarzer, as a Beauvoirian, discerns a difference between genders that
makes heterosexuality problematic from a feminist point of view, for Luce Irigaray
it has more to do with the difference between the sexes. Psychoanalyst and author
of *Speculum of the Other Woman* (1974) and *This Sex Which Is Not One* (1977),
she formulates a theory of female difference on the basis of concrete data, such as
the form of the female sex organ with its two lips that are in constant contact. She
develops the idea of a different orgasm—in women who find out how to achieve
it—a nonlocalized orgasm, with the whole body becoming sex organ, an orgasm
that throws men off balance, an orgasm that she imagines taking place in a special
way, moreover, between women. Men, cut off from their bodies, achieve orgasm
only in a mechanical way.

Within feminist thought and also in militant practices, a new lifestyle is
invented, which in certain circles may move toward an autonomy that distances
itself significantly from the "world of men"—heterosexual or not. This ideal of
autonomy goes beyond sexual relations to liberate women in all respects: affec-
tive, political, cultural, and economic. The form it takes around the 1980s is radi-
cal lesbianism, posited as a political choice. The women's movement, throughout
the West, makes metamorphoses of desire conceivable. The deconditioning pro-
duced by new desires makes new pleasures possible: conversion to homosexual-
ity becomes the powerful symbol of this liberation. While lesbianism evolves into
a politically correct way of living feminism, in the most radical militant milieus
other lifestyles also find their place, among them, the refusal to live as a couple and
the refusal of romantic exclusivity. . . .

The following few examples illustrate the virulence of the critique of virility,
in both senses. Women artists take part humorously in this reversal of the norm.
Austrian actionist and feminist Valie Export performs *Genitalpanik* in 1969 by

FIGURE 16.1 VALIE EXPORT, "AKTIONSHOSE: GENITALPANIK" (ACTION PANTS: GENITAL PANIC), 1969.

A photograph of Valie Export (born 1940). In 1969, the young artist and Austrian actionist entered a pornographic movie house in Munich with her jeans cut out between the legs and a weapon in hand, threatening the spectators and declaring that her vagina was available. The artist thus joins the ranks of the international movement of contemporary art that interrogates sexual taboos and violence in all its forms.

Source: © VALIE EXPORT, photo: Peter Hassmann

entering a pornographic cinema with her jeans ripped between the legs, making her sex organ visible, and a machine gun in her hands [fig. 16.1]. In France, Niki de Saint Phalle performs her series of collages *Tirs* (Shootings), which expresses collective violence (the Algerian War) as much as the violence she suffered when she was raped by her father at the age of 11. Yoko Ono (*Cut Piece*, 1964) makes her audience face their voyeuristic and domination drives by allowing them to come up on stage and cut up the clothes she is wearing. It is a deliberate exhibition of violence, a frequent theme that here takes the form of self-inflicted violence, which is less disconcerting than the appropriation of violence. Contemporary art is undoubtedly one of the areas where we find the strongest indication that taboos against showing the body are disappearing. Among innumerable images of this demystification, let us cite Louise Bourgeois, a smiling old lady carrying a giant phallus under her arm in a photo by Robert Mapplethorpe (1982): it is a dubious tribute, considering the name that she gives her sculpture, *Fillette* (little girl), and the roundness of the testicles, which could well be a pair of buttocks or breasts!

The women's movement provokes a liberating speaking-out for many women who become familiar at the same time with the revolution in contraception. Such

speaking-out is difficult to hear for men, who seem to react, at first, with a deafening silence. Few of them declare themselves feminists. Some men's groups form types of consciousness-raising groups that focus on the analysis of sexuality, but they do not last long. How can the guilt be faced; the feeling of exclusion (the nondiversity of the movement: "feminitude"); the androphobia?

The most famous mark of this androphobic inducement is Valerie Solanas's *SCUM Manifesto*. Self-published in 1967, the little parodic treatise on sexism considers virility as an "organic deficiency:" the Y chromosome (male) is but an incomplete X chromosome (female). Man? "A woman manqué," "a mechanism," "a walking dildo." By nature passive, he is looking to mask his true desire: to be a woman. By firing a shot at the "Pope of pop art," Andy Warhol, in 1968, Solanas gives the impression of putting her pamphlet into practice, aiming at one of the modern figures of virility.

The explosion of mass pornography in the 1970s is considered by a number of feminists to be a response to their movement and their initial victories. These two-bit films and images, usually distinguished from eroticism, are for Benoîte Groult the favored media of "megalo-sexist dreams"[44] and for Luce Irigaray the favored media of the "religious cult of the phallus."[45] They are nevertheless perceived as one of the tangible signs of the end of the moral order. In France, where the fights against sexist imagery have a limited reverberation, repudiation of censorship is the more prevalent issue.

The most coherent attacks against pornography come from the U.S. Women Against Violence in Pornography and Media (founded in 1976 in San Francisco) organizes the first national conference on the subject in 1978, the year of the founding of Women Against Pornography in New York. WAP will become the most influential group, relying on such militants as Susan Brownmiller, Gloria Steinem, Adrienne Rich, and especially Andrea Dworkin, who in 1981 publishes *Pornography: Men Possessing Women*. This leading light of the movement sees pornography as an obvious manifestation of the hatred of women, leading women to hate themselves. While a criminal act in legal terms, rape is a commonplace in porn scenarios. Humiliation and violence excite the consumer. And do they incite men to the act? For Dworkin, there is a connection between reality and fiction, which she sees confounded in "snuff movies," known for showing real rapes and murders. The feminist jurist Catharine MacKinnon holds that the damages caused by pornography are made invisible within the framework of the liberal state: the First Amendment of the U.S. Constitution guarantees freedom with respect to the line between private and public, a line justly challenged by feminism. Antipornographic measures

adopted in several cities in the name of the fight against discrimination are declared anticonstitutional, but the repercussions of this campaign are enormous. Appealing to the state does not have unanimous support; it is even perceived as a grave danger to individual freedom, which is defended by "pro-sex" feminists such as Gayle Rubin, Dorothy Allison, Joan Nestle, Judith Butler, and Pat Califia who challenge the sordid vision projected of women in the antiporn rhetoric: women can become sexual subjects, invent their own pornography, and use for their pleasure the scenes created—it is true—by men and for men. This opposition fuels the American "sex wars" of the 1980s, which become emblematic of the internal divisions among feminists.

CONFRONTED BY THE VIRILIST REVENGE

Montreal, 6 December 1989: Marc Lépine walks into an engineering class, separates the men from the women, and shoots the female students, spewing out: "You are feminists;" "You have no business here" (this place of male higher learning is not for you). Fourteen female students are killed. Then he turns the gun on himself. A list is found on him of feminist personalities to be slaughtered. There can be no doubt: the crime has an avowed sexist character. It is even explicitly antifeminist, which is rarer. In the media, however, it is the claim of individual insanity that prevails. Antifeminism is taken into account only to point out the consternation of men who see the old world crumbling with the "feminist revolution," or to accuse feminists of co-opting the tragedy to their advantage.

For the writer Nicole Brossard,

> the events at the Polytechnic are there to remind us that, from *the politics of the male* (misogyny, phallocentrism and ordinary sexism) to *the political response of men* (antifeminism), the evidence is obvious: men are just as hostile to women when they make no demands (women) as when they make demands (feminists), just as hostile when they take an interest in them (heterosexuals) as when they ignore them (lesbians).[46]

Quebecois feminists then undertake a project of reflection about masculinity. A male collective against sexism is created. The diagnosis can be shared, even if Quebec is distinctive for having undergone very rapid changes in the 1960s and 1970s, for settling accounts with a stifling Catholic tradition, and for developing a vigorous feminist movement.

Marc Lépine's act should be contextualized. In the early 1990s, so-called men's movements develop. These are at first groups of fathers wanting to defend their "rights," such as Fathers4Justice in Canada, the Movement for Parental Equality in Belgium . . . then *Väterauffbruch für Kinder* in Germany (1989), SOS Papa in France (1990). An "International Men's Movement" is created. Books appear: one by the Quebecois psychologist Guy Corneau, *Absent Fathers, Lost Sons* (1989), makes a big splash. The masculinists manage to capture the attention of the media at the time with live-action shows, in which they appear dressed as Spiderman, Batman, Superman The choice of the term "masculinism" shows a desire to make it the equivalent of feminism. The line of argument is based on a reversed looking glass: men are victims of domestic violence, defeated and seeking to take pride in their identity.[47] Returning to psychological roots is one of its engines: paternal attitudes must be developed (i.e., "bonding" with the baby and bottles to sidestep nursing, which puts the father at a disadvantage!). Returning to physical roots is not ignored: masculinism is also a "muscularism"[48] devoted to a cult of superheroes, the "supergenitors," the "super-powerful," embodied by such actors as John Wayne, Sylvester Stallone, and Arnold Schwarzenegger. . . . The masculinists reject, of course, any feminization in man. They call antisexist militants *"pisse-assis"* (seated pissers) and reject gender studies. They rebaptize feminists "fem-nazis" or "fem-sexists" and hold them responsible for false accusations of rape and pedophilia lodged by wives and daughters as well as for the increase in the suicide rate among men. They enjoy a fairly broad influence, thanks to the media, notably the so-called "men's" press (*Playboy, Penthouse*), which goes out to millions of readers. They set their sights also on the health care professions (psychotherapeutic counseling) and education, an area often called into question in the diagnosis of the feminization of society (feminization of professions, coeducation among students, the brilliance of girls who "crush" the boys . . .). Thus in Quebec a secondary school had recently organized a boys' day hosted by police officers and soldiers, with accessories, uniforms, and cars. Masculinist rhetoric plays a role in sexist criminality, generally trivialized in the media.

Masculinism emerges at the time when the American feminist Susan Faludi in *Backlash* (1991) diagnoses a revenge following the feminist victories of the 1970s that give women more autonomy, more control over their lives: facilitation of divorce and coercive measures to expedite payment of alimony by divorced fathers. It is a political turning point in several countries in which very conservative forces have come to power. It also creates a difficult social situation and increases economic insecurity by problematizing the acknowledged role of men

as breadwinners. Women, claiming to be victorious, are then turned into scape-goats, as in the 1930s.

For the moment this social and cultural movement involves a minority, but it nonetheless diffuses its ideas, discernible in extreme right-wing movements that have been regaining strength in the West since the 1980s. Is it a political response to feminism? Certainly, feminists do not hesitate to say, and female voters stand behind them. The gap between female and male votes is an eye-opener for the extreme right. Thus in France in 2002, women in the second round of presidential voting go for the leftist candidate, Lionel Jospin, and not the historic leader of the "*Front national*," Jean-Marie Le Pen, a virility bloc from every point of view.[49]

It is impossible to predict the result of the political battle being waged between feminism and antifeminism, the questioning of virility and its defense. The acquisition of women's rights in the West is important. Each one of them may be thought of as a chink in the wall of virility, assuming a definition of virility as the set of privileges granted by a position of domination.

"WOMEN" VICTORIOUS OVER VIRILITY

In the gender order of contemporary Western societies, with two genders and two sexes, a strict correspondence must be respected. The anthropologist Nicole-Claude Mathieu, analyzing the different systems of sex/gender possible, shows that, in this type of arrangement, gender corresponds to sex.[50] This system is heterosexual and implies constraint,[51] conditioning, and repression from the moment it senses a threat. Institutions keep an eye on it, naming deviances "sin," "crime," or "mental illness," depending on the particular case and time. . . . Late-twentieth-century feminism consolidates all that in the word "heterosexism." Its radical branch, along with the gay and lesbian movement (although relations are never simple), analyzes deviances from the norm differently from then on, inspiring innumerable studies in the social sciences. It is a considerable epistemological upheaval, comparable to that which allowed the emergence of feminist studies of male domination and its effects on women—i.e., a second revolution that turns up in many ways in political theory, philosophy, literature, cinema, and the arts. It is, in short, a new culture, although in the minority, which is spread throughout society. Originally American (San Francisco, New York), it also affects the old world. This perspective, often called "queer," although this name is reductive and contested, leads to

a reformulation of our theme. The looking glass of women becomes a fiction of the old feminism. The "woman subject" goes through a crisis. It is a mystifying standpoint that arbitrarily unites a diversity of perceptions, generally favoring a particular point of view thought to reflect the position of women who are white, heterosexual, middle-class college graduates, healthy and more or less puritanical, ideologically timorous, and who are re-essentializing gender by simply replacing the word "sex," which has become politically incorrect.

The looking glass is not heterocentric; it eludes "straight thought" (1978).[52] What becomes of virility without the men who were its legitimate bearers and who even tried to reserve it exclusively for themselves? Antifeminism, in fact, makes the maintenance of "sexual difference" a priority. The virilization of women is one of its most effective specters. It stands up over time and intimidates those women and men who do not want to upset gender norms—undoubtedly because the notion of "wrong gender" evokes the stigma of homosexuality.

It is not possible to find a single "queer" point of view on virility . . . because the new *episteme* fosters research on diversity and uniqueness, synchronic and diachronic. From "sublime transformations" of gender at the turn of the twenty-first century to rereadings of the past and the quest for those women and men who have transgressed the laws of gender, feminism remains a major source of inspiration, while continuing to metamorphose upon contact with the reproaches leveled at it.

.VIRILITY OF EXCEPTIONAL WOMEN

Throughout the ages women have assumed a male gender, at times going so far as to take on a male identity, which allows them to marry, get work, make more money, travel abroad, fight in the army in a lovely uniform[53] The risk is great when their official sex is discovered. Class renegades, in a sense, they rise up in society by becoming men. They are no doubt better understood than the men who go in the opposite direction, toward a dominated, strongly sexualized position. Certain women dressed as men attain a high level of respectability, usually after death. Such is the case of Joan of Arc, finally canonized, enduring proof of the possible dissociation of masculinity and virility.

It is notable that women become exceptional in circumstances that are also exceptional: the Hundred Years' War or the wars of the twentieth century. War culture uses the image of masculinized women. In the U.S. during World War I, even the delicate "Christy Girls" put on military uniforms [fig. 16.2]. During World War II, it

FIGURE 16.2 RECRUITMENT POSTER FOR THE AMERICAN NAVY, 1918.

The work of Howard Chandler Christy (1873–1952), a very popular U.S. illustrator who put his poster talent in the service of the war effort, this "Christy Girl" maintains a feminine allure but wears a virile uniform—a way of exhorting men to be men (that is, to enlist in the army) and women to take the place of the men who are away.

Source: © CORBIS

is "Rosie the Riveter," in work overalls, with bulging biceps, who symbolizes the virility of female workers. She remains today an icon of the "We can do it" attitude, an integral part of American patrimony and international feminist imagery. [...]

Here is what we may take away from this too brief overview: virility as a personal liberating choice; the political ambiguity of the elitist model (feminist or antifeminist) and the ambivalence of the reactions that it provokes—admiration, stigmatization, repression; the instrumentalizing of virilization in particular circumstances such as war. The exception proves the rule: femininity may remain unchanged.

FROM FEMALE INVERT TO BUTCH

The virility of certain women does not escape the attention of turn-of-the-twentieth-century psychiatry, which is very much interested in gender. It is speculated about through the category of inversion: inversion of desire, which turns toward women, physical inversion, having secondary male sexual characteristics, and psychological inversion, noticeable in the temperament of an "active" partner.

It is surely not an accident that this theory is propounded when feminism takes off. It provides a chance to psychologize—and to pathologize as well—the contestation of male domination. The sapphic vogue of the 1900s, moreover, symbolizes in its way the liberation that is in the process of taking place.

The influence of this theory affects women who love women. Some of them define themselves as having a man's soul imprisoned inside the body of a woman. It is therefore a question of a destiny difficult to assume, socially problematic, but which at least gives them the right to exist. The paradoxical effect of this theory is to render visible those women who have remained out of sight: in Victorian society, lesbians do not exist, and for feminists, these women's passions are romantic and platonic. *The Well of Loneliness*, a novel published in 1928, symbolizes a turning point. It is certainly the most famous novel of "lesbian" literature, initiatory for many until recent years. Accused of being obscene, it is banned in the U.K. for 31 years.[54] The main character, Stephen, born a female, does not identify as a woman and feels drawn to virile activities. His desire is oriented toward feminine women. The autobiographical aspect adds to the power of the novel, which ends with a plea for the right of the "sexually stateless" to exist. The author, Marguerite Radclyffe Hall, takes the pen-name of Radclyffe Hall and is called John. Very masculine, she shows all the signs of aristocratic distinction. She is not a feminist. She is politically conservative. She admires Mussolini, archetype of virility.

In working-class milieus throughout the twentieth century masculinity (or virility, the flashier term) makes up part of lesbian culture. "Jules" in French refers to another type of masculine lesbian who is generally associated with a feminine lesbian. Only the first type of lesbian is visible. The English term "butch," its equivalent, is the one generally used today. Respect for gender codes is *de rigueur* in the designated meeting places. In Quebec in the 1950s to 1960s, any lesbian who is neither butch nor "femme" is actually looked down upon; she is then discredited as a "kiki."[55]

The feminism of the 1970s challenges what is perceived as "roles," a response to the unequal balance of power in heterosexual couples. Butch lesbians put on a show of imitating masculinity that others find alienating, accusing them of getting it all wrong. There is no doubt in this rejection an element of class hatred: chic sapphism was rather a case of androgyny.

It is in the 1980s and especially the 1990s that butch lesbians discover their "pride," which takes on the looks of punk and sadomasochism (S/M):[56] cropped hair, leather garments, and, in some cases, such practices as "packing" (simulating the presence of a penis). It is the period of the dildo revolution, evoked humorously

by the American feminist writer Dorothy Allison, who "confesses" her progress in the "theory and practice of the strap-on dildo," the discovery of specialty stores, and her taste for pornography.[57] "A language of males," to be sure, which she manages as a reader to make gender-neutral in order to see it only as a source of excitation. Porn films, books, dildos, vibrators . . . all these articles are for sale at Good Vibrations, a pioneering store opened by women in San Francisco in 1977.

PRO-SEX, QUEER, AND TRANS

This development in one sector of American feminism is sharply attacked by the antiporn wing. During a conference on feminist studies devoted to sexuality, held at Barnard College in 1982, the organizers prefer to exclude the representatives of the antiporn camp in order to open the debate, they say, and be able to engage in a critique of the new feminist orthodoxy, then under the influence of "lesbian feminism." A new movement takes form, soon called "pro-sex." It gets its inspiration from different minority lesbian experiences in the feminist movement: S/M, the "leather community," the gay and lesbian movement, and the women's movement.

One of its founding figures is Gayle Rubin, author of the benchmark text *Thinking Sex: Notes for a Radical Theory of the Politics of Sexuality*.[58] In 1978 Rubin took part in the creation of Samois, the first lesbian S/M group. She refrains from demonizing male sexuality, the perception of which changes, especially through exchanges with the gay community. She defends pornography and even prostitution (which she renames "sex work").

The philosopher Judith Butler, who teaches at Berkeley, is, in a certain way, Rubin's successor. From the end of the 1980s through the 1990s, her thought dominates what Teresa de Lauretis calls, in 1991, "queer theory." Her major book (*Gender Trouble*, 1990) relies on the example of transvestitism. It is the period when the "drag king" show emerges, which makes of masculinity a performance with a parodic twist. This usually involves a transformation, generally temporary, for parties and contests that crop up in San Francisco bars in 1985, then in New York, London, Berlin Although the phenomenon was restricted to a minority and even largely unknown, as in France, it takes on in the intellectual context at the time an important value and provides an example of the new practices of "gender fucking."[59] But while virility is striking in its successful performances, it is analyzed very little—if at all—in itself. It is nevertheless a revealing looking glass, for it is especially the advantages of virility that are commented upon: a greater facility

for expressing anger and aggressiveness to gain respect. Diane Torr, who hosts the drag king workshops, learns, for example, to walk as though, with each slow, heavy step, her body were taking possession of the space stepped into. Dressing as a man is "empowerment," and in this sense it is feminist. Playing with "plastic cocks" (to use Marie-Hélène Bourcier's phrase,[60] "trash" talk being an important component of this subculture) has tremendous force as well: it is obviously the major signifier of masculinist culture. But it is also the symbol of the growing importance of prostheses in our lives.[61]

The canons of masculine beauty are shattered. Perhaps it is precisely virility more than masculinity that needs to be sought, whether the body is big or puny, large or small, black or white. Standards of virility are found in the *Drag King Book* (1999): suit-and-tie, rapper, cowboys, gay leather men, and let us not forget the Elvis look-alikes.[62] But standards are reinterpreted, parodied, and sublimated in the extraordinary photos by Del LaGrace Volcano, American artist, defined as "gender variant." The looking glass is still there: to glue the moustache on or check out one's biceps, to enjoy the transformation that gives the exhilarating feeling of being able to choose one's identity, or of being able to take on several identities.

More recently, *Sublime Mutations*, with equally beautiful images of changing bodies, demonstrates the multiplicity of sexual types (one symptom: the evolution of the title "Lesbian and Gay Pride," from now on "LGBTQI"—"Bi, Trans, Queer, Intersexual").[63] The last few years have seen the rise to power of the transgender movement,[64] which also interrogates the definition of sexes, genders, and sexualities. Thus, transitioning through surgery is thrown into question and more and more often refused. One can be a man without a penis. A man can be recognized as a man, with a male civil status, in certain countries. Transsexuals have the feeling of being born with a body that does not correspond to their psychological sex. The relation to gender is different for a growing number of "transgendered" people, which is a recent term. Gender is perceived more and more as a broad spectrum and not as a binary polarity. New genders arise. In queer milieus, butch is considered as a gender. "Intersex" refers now to people who are between two genders. Artists like Del LaGrace Volcano desire to construct their own gender

Virility in this context, far from being rejected, is, on the contrary, reinvented. It is distinguished from the masculinity, less phantasmal and more ordinary, to which transsexuals and probably many transgendered people aspire to in everyday life. Similarly, butch lesbians do not necessarily display a virile gender. They simply have a day-to-day masculine look. The dose of testosterone elicits autobiographical stories: Maximilian Wolf Valerio, for example, ex-"lesbian punk rock feminist," having

lived in San Francisco, radically changes her way of perceiving gender: by becoming a man; "he" revamps "his" whole set of ideas about sociality, giving primacy once again to biology to explain sexual difference.[65] The comparison never seems favorable to the female side, the so-called male hormones being credited with producing a large number of positive changes. As regards sexuality, it is metamorphosed by the increase in libido. The process is different for philosopher Beatriz Preciado, who theorizes her experience as a lesbian taking testosterone for a limited period. She situates this adventure in the "post-queer" intellectual context (because, for her, there is no "real anatomical truth independent of the cultural practices of coercive repetition that lead us to be men or women"[66]), in the social context of integrating drugs and prostheses into everyday life ("You think you're bio-women, but you take the pill; you think you're bio-men, but you take Viagra; you are normal and you take Prozac"[67]), and in the "post-porn" cultural context that envelops her book, not recommended for the faint-hearted. Asserting her right to act "as a bio-man," she discovers facets of masculinity invisible to women and openly enjoys the new sensations: "Then there takes over, little by little, an extraordinary lucidity, accompanied by an explosion of wanting to fuck, to walk, to go out, to go all over the city. . . . Nothing but an impression of strength that reflects the increased capacity of my muscles, of my brain."[68] A vast site of political reflection opens up:

> Six months of testosterone, and any bio-woman—not a boy manqué or a lesbian, but any "playgirl," any neighborhood gal, a Jennifer Lopez or a Madonna—can become a member of the male species, indiscernible from any other member of the dominant class.[69]

There we have something that poses a serious threat to the two-gender system, remarks Kate Bornstein (MtF, or "Male-to-Female"), a heterosexual man turned lesbian woman, who welcomes the coming into existence of new men, with or without penises, often endowed with a feminist sensibility and inventing a new masculinity.[70]

Masculinity/virility is not the only avenue of queer exploration. The nongendered in certain "out-gender" performances that occlude any identification mark is also probed in contemporary art. Certain S/M practices (hereafter BDSM: bondage, discipline, domination/submission, sadomasochism) and certain disguises erase the usual categories of sexuality in favor of other identities. In this ludic universe, one finds once again a parodied virility, especially through fantasies about uniforms.

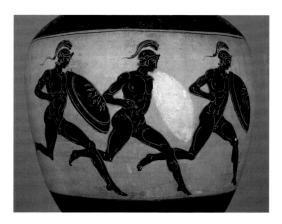

PLATE 1 [FIGURE 1.1] *HOPLITODROMOS.* BLACK-FIGURE PANATHENAIC AMPHORA, 323–322 B.C.E., PARIS, LOUVRE. © RMN-GRAND PALAIS/ART RESOURCE, NY

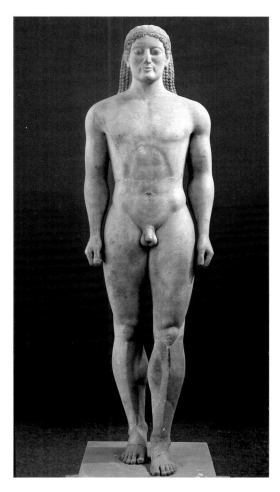

PLATE 2 [FIGURE 1.2] ARCHAIC KOUROS. SIXTH CENTURY B.C.E., ANAVYSSOS (ATTICA), ATHENS, NATIONAL ARCHEOLOGICAL MUSEUM. © LEEMAGE

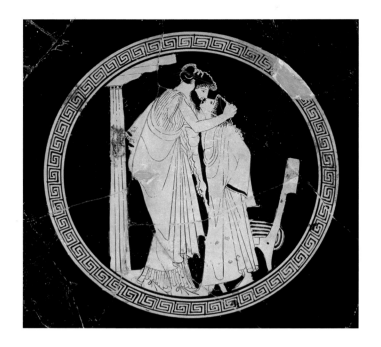

PLATE 3 [FIGURE I.3] MAN COURTING AN EPHEBE. RED-FIGURE CUP BY THE PAINTER OF BRISEIS,
CA. 480 B.C.E., PARIS, LOUVRE. RMN-GRAND PALAIS/ART RESOURCE, NY

PLATE 4 [FIGURE I.4] CARICATURED PENETRATION. ATTIC OENOCHOE, CA. 460 B.C.E.
© MUSEUM FÜR KUNST UND GEWERBE HAMBURG

PLATE 5 [FIGURE 1.5] ATTIC DRINKING CUP (*KYLIX*) BY THE PAINTER BRYGOS, CA. 490–480 B.C.E.,
FLORENCE, NATIONAL ARCHEOLOGICAL MUSEUM. © LEEMAGE

PLATE 6 [FIGURE 2.2] SCENE OF HOMOSEXUAL COUPLING. SILVER CUP, 25–50 C.E., LONDON, BRITISH MUSEUM.
© THE TRUSTEES OF THE BRITISH MUSEUM

PLATE 7 [FIGURE 2.3] MARBLE BUST OF JULIUS CAESAR OF CHIAROMONTE.
FIRST CENTURY B.C.E., ROME, VATICAN MUSEUM,
CHIAROMENTE GALLERY. © LEEMAGE

PLATE 8 [FIGURE 3.1] ITHYPHALLIC STATUE. FOURTH CENTURY,
ARRAS, MUSÉE DES BEAUX ARTS. © LEEMAGE

PLATE 9 [FIGURE 4.3] TITIAN, *ALLEGORY OF PRUDENCE*, CA. 1565, OIL ON CANVAS,
LONDON, NATIONAL GALLERY. © LEEMAGE

PLATE 10 [FIGURE 4.4] HANS HOLBEIN, *KING HENRY VIII*, 1537, PEN AND WASH DRAWING
ON MAROUFLAGED PAPER ON CANVAS, LONDON, NATIONAL PORTRAIT GALLERY, DETAIL.
© BELVOIR CASTLE, LEICESTERSHIRE, UK/BRIDGEMAN IMAGES.

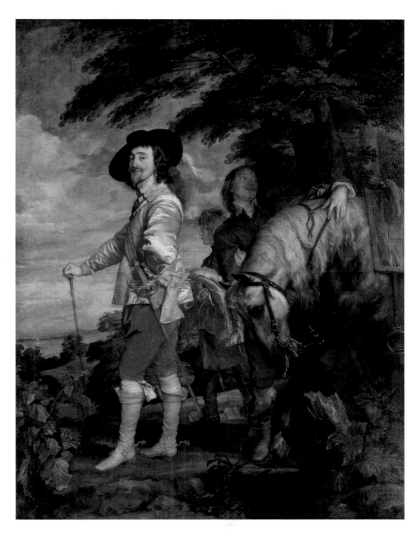

PLATE 11 [FIGURE 4.5] ANTOON VAN DYCK, *PORTRAIT OF CHARLES I, KING OF ENGLAND*,
CALLED *CHARLES I AT THE HUNT*, CA. 1635, OIL ON CANVAS, PARIS, LOUVRE.

PLATE 12 [FIGURE 5.1] JOHN WHITE, *INDIAN OF FLORIDA*,
AFTER A DRAWING BY JACQUES LE MOYNE DE MORGUES,
SIXTEENTH CENTURY, LONDON, BRITISH MUSEUM.
© THE TRUSTEES OF THE BRITISH MUSEUM

PLATE 13 [FIGURE 5.2] THE MASSACRE OF INDIANS AT CHOLULA ON THE ORDERS OF CORTES, 1519.
WILLIAM CLEMENTS LIBRARY, UNIVERSITY OF MICHIGAN, USA/BRIDGEMAN IMAGES.

PLATE 14 [FIGURE 6.1] JEAN-BAPTISTE GREUZE, *LA MALÉDICTION PATERNELLE* OU *LE FILS INGRAT*
(THE PATERNAL CURSE, *OR* THE UNGRATEFUL SON), 1777, PARIS, LOUVRE. © LEEMAGE

PLATE 15 [FIGURE 7.1] CHILDREN PLAYING IN THEIR ROOM. IN *LA JOURNÉE DE GINETTE ET RAYMOND*
(A DAY WITH GINETTE AND RAYMOND), EARLY TWENTIETH CENTURY. © LEEMAGE

PLATE 16 [FIGURE 8.1] FRÈRES LESUEUR, *DUEL ENTRE CHARLES DE LAMETH ET LE MARQUIS DE CASTRIES EN 1790*
(DUEL BETWEEN CHARLES DE LAMETH AND THE MARQUIS DE CASTRIES IN 1790).
EIGHTEENTH CENTURY, PARIS, MUSÉE CARNAVALET. © LEEMAGE

PLATE 17 [FIGURE 8.2] JULES DESPRÈS, "SAVATE" (KICK-BOXING), *LES FAITS-DIVERS ILLUSTRÉS*,
29 MARCH 1906. "AT THE SAME INSTANT, THE OTHER GUY TURNED ABOUT
WITH AMAZING AGILITY." © KHARBINE-TAPABOR

PLATE 18 [FIGURE 8.3] GEORGE SCOTT, *A DUEL WITH PISTOLS*, 1815. © MARY EVANS PICTURE LIBRARY

PLATE 19 [FIGURE 9.1] ANONYMOUS, ITALIAN, *ÉROTISME. LES HUÎTRES SONT APHRODISIAQUES*
(EROTICISM: OYSTERS ARE APHRODISIACS), CA. 1880. © LEEMAGE

PLATE 20 [FIGURE 9.2] FERDINANDUS, "ALFRED DE MUSSET CHEZ LA FARCY,"
IN *MÉMOIRES DE M. CLAUDE*. PARIS: ÉDITIONS JULES ROUFF, 1884. © KHARBINE-TAPABOR

PLATE 21 [FIGURE 10.1] DEATH OF NICOLAS, CHEVALIER D'ASSAS, NEAR CLOSTERCAMP, IN 1760. © LEEMAGE

PLATE 22 [FIGURE 11.2] HORACE VERNET, *VICTOIRE DE L'ISLY*. NINETEENTH CENTURY, VERSAILLES, CHÂTEAU DE VERSAILLES, DETAIL. © LEEMAGE

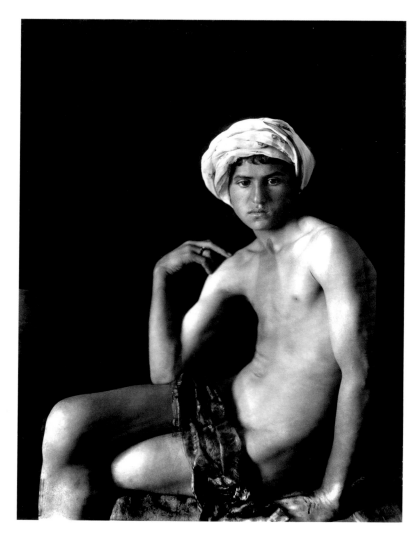

PLATE 23 [FIGURE 11.4] PORTRAIT BY LEHNERT & LANDROCK. EARLY TWENTIETH CENTURY.
© MUSÉE DE L'ELYSÉE, LAUSANNE

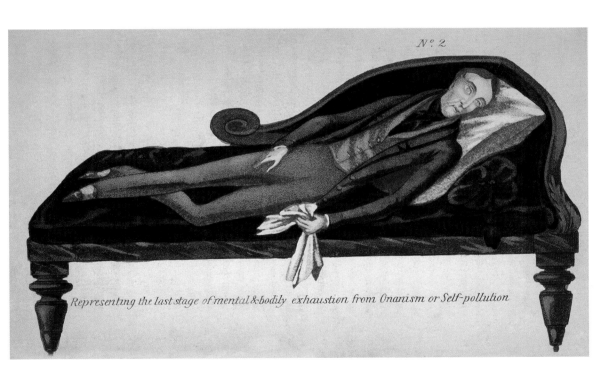

Representing the last stage of mental & bodily exhaustion from Onanism or Self-pollution

PLATE 24 [FIGURE 12.1] "REPRESENTING THE LAST STAGE OF MENTAL & BODILY EXHAUSTION FROM ONANISM OR SELF-POLLUTION." IN R. J. BRODIE, *THE SECRET COMPANION: A MEDICAL WORK ON ONANISM OR SELF-POLLUTION . . .* , LONDON: R. J. BRODIE & CO., 1845, PLATE 2. WELLCOME LIBRARY, LONDON

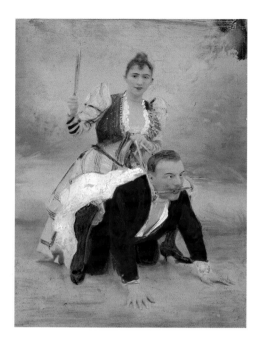

PLATE 25 [FIGURE 12.2] WOMAN ASTRIDE A MAN
AS IF HE WERE A HORSE. SEXUAL ROLE-PLAY,
CA. 1880. WELLCOME LIBRARY, LONDON

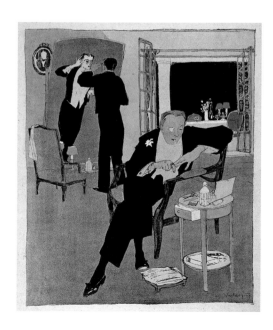

PLATE 26 [FIGURE 12.3] MIKLOS VADASZ, CARICATURE. *L'ASSIETTE AU BEURRE* (BUTTER DISH,
FRENCH SATIRICAL MAGAZINE), 1 MAY 1909: "WHAT A DIFFERENCE BETWEEN THE CENTURY OF AUGUSTUS
AND THE CENTURY OF FALLIÈRES (FRENCH PRESIDENT AT THE TIME)!" © KHARBINE-TAPABOR

PLATE 27 [FIGURE 12.4] WILHELM VON GLOEDEN, YOUNG SICILIANS, CA. 1900.
© FRATELLI ALINARI MUSEUM COLLECTIONS-VON GLOEDEN ARCHIVE, FLORENCE

PLATE 28 [FIGURE 13.1] OTTO DIX, *THE MATCH SELLER*. STUTTGART, STAATSGALERIE, 1920.
© [1920] ARTISTS RIGHTS SOCIETY (ARS), NEW YORK/VG BILD-KUNST, BONN STAATSGALERIE,
STUTTGART, GERMANY/BRIDGEMAN IMAGES

PLATE 29 [FIGURE 13.2] GERMAN PROPAGANDA POSTER
FOR WAR BONDS, 1917. THE GRANGER COLLECTION, NEW YORK

PLATE 30 [FIGURE 16.2] RECRUITMENT POSTER FOR
THE AMERICAN NAVY, 1918. © CORBIS

PLATE 31 [FIGURE 17.2] DRAFTEES OF THE CLASS OF 1920. POSTCARD. © KHARBINE-TAPABOR

PLATE 32 [FIGURE 18.1] *LA DIFESA DELLA RAZZA* (THE DEFENSE OF THE RACE),
5 SEPTEMBER 1938. © LEEMAGE

PLATE 33 [FIGURE 18.2] "THE ARRIVAL—THE DEPARTURE."
LA DIFFESA DELLA RAZZA (THE DEFENSE OF THE RACE), 1939. © LEEMAGE

PLATE 34 [FIGURE 19.2] CONSTANTIN MEUNIER, *FOUNDRY WORKER*.
1920, HELSINKI, MUSEUM OF FINNISH ART.
ATENEUM ART MUSEUM, FINNISH NATIONAL GALLERY, HELSINKI, FINLAND/BRIDGEMAN IMAGES.

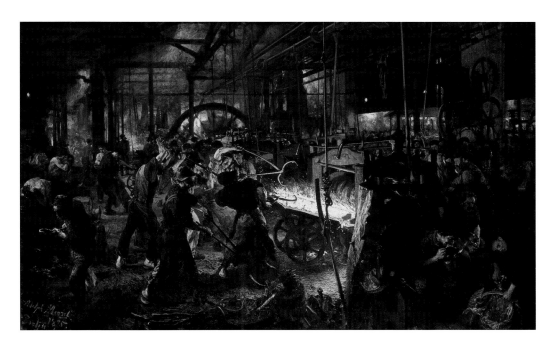

PLATE 35 [FIGURE 19.1] ADOLPH VON MENZEL, *THE ROLLING MILL*.
1875, BERLIN, ALTE NATIONALGALERIE. © ARTOTHEK

PLATE 36 [FIGURE 19.3] *LA BÊTE HUMAINE*, FILM BY JEAN RENOIR, 1938. PUBLIC DOMAIN

PLATE 37 [FIGURE 20.1] BRASSAÏ, *TRAVESTIS DE MARDI GRAS AU BAL DE LA MONTAGNE-SAINTE-GENEVIÈVE*
(MARDI GRAS TRANSVESTITES AT THE MONTAGNE-SAINTE-GENEVIÈVE BALL),
CA. 1932. © RMN-GRAND PALAIS/ART RESOURCE, NY

PLATE 38 [FIGURE 21.2] JOHN COPLANS, *SELF-PORTRAIT SIX TIMES*, 1987. PRIVATE COLLECTION PHOTO
© CHRISTIE'S IMAGES/BRIDGEMAN IMAGES

PLATE 39 [FIGURE 21.3] LOUISE BOURGEOISE, *FILLETTE*, 1968.
NEW YORK, MUSEUM OF MODERN ART. ART © THE EASTON FOUNDATION/LICENSED BY VAGA,
NEW YORK, NY. DIGITAL IMAGE © THE MUSEUM OF MODERN ART/LICENSED BY SCALA /ART RESOURCE, NY

PLATE 40 [FIGURE 21.4] EGON SCHIELE, *SELF-PORTRAIT AS SEMI-NUDE WITH BLACK JACKET*.
1911, VIENNA, GRAPHISCHE SAMMLUNG. © AKG-IMAGES

PLATE 41 [FIGURE 22.1] CHARLES ATLAS, 1924.
CHARLES ATLAS®

PLATE 42 [FIGURE 22.2] A GROUP OF MIDDLEWEIGHTS, MR. AND MISS MUSCLE BEACH
BODY BUILDING AND FIGURE CONTEST. VENICE, CALIFORNIA, 4 JULY 2006. (AP PHOTO/RIC FRANCIS)

The "gender outlaws" are certainly more numerous than generally believed, for the places of possible transgression are multiple and not limited to bodily stakes.

VIRILE PROLIFERATION?

What happens on the margins is quickly recycled into a consumer society of mass media. Thus, in the 1920s, the "flapper" vogue symbolizes the aspiration for sexual freedom: it is essentially of lesbian inspiration.[71] Short hair, which looks disreputable, the masculine cut of clothes, masking the curves of female bodies, which cease being molded by corsets Public opinion is alarmed, moreover, about the "explosion" of homosexuality. This does not prevent women from adopting the flapper mode. The constraint of femininity lightens up, and femininity itself changes, leading to changes in masculine fashion. This evolution is rather favorable to women, if one allows that running in shorts is more practical than in a floor-length dress. The masculine model does not become widespread, however. The unisex mode hardly lasts. Diversity is more attractive. . . . And while Western women extensively adopt pants in the 1960s and 1970s, they cannot (or do not want to?) abandon the classics of the feminine wardrobe. The end of the twentieth century sees even the return of old accessories, such as the corset and stockings.

Women's virility continues to frighten people. It triggers almost automatically a negative aesthetic and moral judgment. A tennis player like Amélie Mauresmo, for example, pays the price for it. It is with reluctance that women who enter the police force or the army are given a uniform. One must "remain a woman" and "assume one's femininity," as if it involved something obvious and obligatory—phrases still often heard today.

A Canadian investigation conducted among lesbian students shows that they are far from perceiving their position as subversive with regard to sexual norms.[72] One in two hides her lesbianism. Their point of reference is not queer culture but the series "The L-Word."[73] Most of them think that they were born lesbians, say they accept their "femininity," are attracted to feminine girls, and think that this improves the image of lesbians. Only 2 percent of them identify as butch. This reveals, no doubt, in the hypersexualized context of feminine appearance, the limits of the influence of feminism, much less of queer thought, as well as the power of heteronormativity and the risk of departing from it. The film *Boys Don't Cry* (Kimberley Peirce, 1999) shows the spiral of violence that ends with the murder

of the young FtM Brandon Teena in Nebraska: one more news item among many others that are homophobic, lesbophobic, or transphobic.

It can therefore be maintained, even today, that "masculinity (or virility) without the man" retains a subversive power, continues to disrupt a binary system that remains coercive for women and men confronted with extreme versions of female and male genders (the bimbo and the body-builder). But this is far from being the only horizon of contemporary feminism. The cost and consequences of working on gender identity, psychic and physical work, can lead to questions. The libertarian background of queer positions raises questions and is perhaps not transferrable to societies that, unlike the U.S., believe in the role of the state and of social regulations. Some feminists deplore the importance taken on by identity politics, "which is hypnotized by the defense or the contestation of the symbolic attributes, be they corporeal or psychic, of one sex, one 'race' or one class,"[74] for this focalization detracts from the larger questions of the present time: environment, neo-imperialism, religious fundamentalism, poverty, and neo-liberalism

"The looking glass vision is of supreme importance because it charges the vitality; it stimulates the nervous system."[75] If Virginia Woolf is right, then all the theses on Western man's devirilization are confirmed, for the twentieth century is that amazing century during which women dared turn the looking glass back toward themselves. This revolution lashes out at all the pieces of naturalized evidence, all the intellectual certainties about what sex, gender, and sexuality are. It cannot help provoking sharp intellectual, political, and emotional resistance. The success of such essays as *Men Are from Mars, Women Are from Venus* puts Judith Butler's influence into perspective and works, no doubt, as a gentle tranquillizer. . . . It is impossible to predict the result of this revolution in process, but if one believes that even in political critique there are different approaches and therefore an alternation of opposing tendencies, it is quite possible that femininity, detached from sex, could become, for all sexes, a legitimate object of reflection and of desire. It would not be the "feminitude" associated with 1970s culture. Will we have to name, then, for the female side that which, significantly, exists only for the pair "masculinity/virility"?

17

"ONE IS NOT BORN VIRILE, ONE BECOMES SO"

ARNAUD BAUBÉROT

"**NO BIOLOGICAL**, psychic or economic destiny defines the figure that the male human being assumes at the core of society; it is the whole of civilization that elaborates this intermediate product between man and superman, which we describe as virile"—this could have been written by Simone de Beauvoir, had she been more interested in the first sex. I do not mean, of course, to be impertinent. At a certain point in a 1972 text, the philosopher herself made the point that her famous formula from *The Second Sex*, "strengthened by more and more advanced studies devoted these past years to childhood," required a complement: "One is not born male, one becomes male." "Virility," she concluded, "is not given at the outset either."[1] Thus, one should consider that the maturation process that leads the male child naturally to the state of the adult male plays only a miniscule role in relation to the slow, profound work of inculcation by which society leads him to conform to the physical and moral characteristics particular to the virile condition.

More than a simple observation, such an assertion was the equivalent of a denunciation. It was part of the "second wave" line of the feminist struggle and aimed at extending to the male gender the demonstration of the alienating character of gendered identities. Since the specific traits of virility were not given by nature but produced by a cultural, social, and political context, men could, in turn, free themselves from the models and roles attached to their condition as males, liberate themselves from the constraints of male domination, and engage in new relationships with women based on equality and mutual understanding. It is from this perspective that the project of identifying the mechanism of virility production took shape. From *The Manufacture of Males*, published by Georges Falconnet and Nadine Lefaucheur in 1975, to *XY* by Elisabeth Badinter,[2] an entire critical literature has

thus endeavored to decode the manner in which boys, during their childhood and adolescence, are led to internalize the forms of thought and the ways of acting that prepare them to take their place in the chain of power relations and relations of domination.

This analytical framework was shown to be just as fertile in the social sciences. Using the same postulate as a point of departure, various sociological or anthropological inquiries undertook the study of the manner in which the imperatives of socialization and educational institutions take charge of transmitting gender stereotypes as well as the reactions of boys to this normative framework.[3] Historians, on the other hand, including in particular the French, have for a long time remained apart from these inquiries. While the history of women met with the success we know about, the male gender remained implicitly understood as the general case and, as such, did not seem to warrant any particular attention.[4] All the more reason why the history of childhood, of youth, and of educational institutions, until recently not very sensitive to the problem of gender, has rarely been concerned with throwing light on or analyzing the mechanisms of production and transmission of the virile character. This is another way of saying that the overview we present here is just a sketch, often made up of sparse material, at the core of which lie vast patches of darkness.

THE LAST GLIMMERS OF TRADITIONAL VIRILITY

If, beginning in the 1970s, we witness a profound questioning of the traditional model of virility, it is actually because this model seems still solidly established. Therefore before analyzing the manner by which the challenge to male domination was able to upset the modalities of socialization and the education of young boys, it is necessary to pay attention to the processes through which, during most of the twentieth century, virile characteristics were inculcated in them. Let us recall first of all that virility is, above all, an attribute of the mature man, husband, father, and head of household. Such an affirmation is virtually a statement of the obvious if one sticks with the etymological meaning of the word. It is nevertheless a useful reminder that the young male is not considered virile before his entry into the community of adult men has been prepared in the course of various stages and validated by diverse rites. In particular, the boy becomes a man because, as the gradual work of biological maturation comes to pass, the institutions in charge of

his socialization transmit to him the virile condition, that is, the set of physical and psychic predispositions that will allow him to play his role as a man once he has attained maturity.

THE FAMILY

First in terms of chronology and because of the depth of socializing work that it carries out, the family occupies a major place in the learning of the qualities and roles attributed to each sex. It is, in particular, within him/herself that the child internalizes the traditional division of tasks between men and women. Nevertheless, the reality of family life depends vitally on its economic and social conditions. Even though the bourgeois model of the domestic confinement of women and the delegation to the man of activities outside the house spreads during the first two thirds of the twentieth century, the majority of women of working age continue to exercise a professional activity.[5] Under these conditions, what is commonly understood as "family life" has only a limited place in the daily life of many children in working-class milieus. In contrast, in the upper bourgeoisie and in a growing portion of the middle classes, childhood takes place within a domestic world whose management and upkeep essentially fall to women. While this milieu contributes, from the youngest age, to the formation of the boy's gendered identity, the recognition of his virility will nevertheless require him to cut himself off from "his mother's apron strings."

It seems particularly difficult to determine the age at which parents' attitudes begin to vary according to their child's sex. Surveys taken in the 1970s, with the aim of throwing light on the stereotypes that influence little girls, suggest that this distinction comes very early. Just 24 hours after their birth, boys are more often called "big" than girls who are of the same size and weight. Their nursing lasts longer, and their weaning and toilet training come later.[6] To be sure, nothing authorizes us to infer from such observations what may be the case for decades prior to the 1970s. They allow us nevertheless to suggest that it is indeed within the family, in a manner that is at once precocious and unconscious, that the first gender differentiations take place and that, even before coming to consciousness of his/her condition as a gendered being, the child begins to internalize the norms that relate to his or her gender.

In formal terms, the differentiation between girls and boys, however, appears later. The custom of dressing all infants in long gowns and letting their hair grow

long until the age of four or five still persists sometimes in rural areas following the Great War. Still in a dress at five years old, Pierre Jakez Hélias nonetheless is already aware of his masculinity. He envies those of his friends who wear pants and impatiently awaits the ceremony of getting his first pair, which will mark his "promotion to the rank of little man."[7] It is not known exactly when the little boys' gowns and the rite of the first pants fall into disuse. This evolution results most probably from the infiltration of urban cultural models into the countryside. Shorts, used in the cities, are a marker of the boy's masculinity in a more precocious manner, but he also keeps them into late childhood [cf. fig. 17.1]. The wearing of pants, delayed until puberty, is then for the adolescent an emblem of his nascent virility. In the same manner as allusions to his hairiness or to his changing voice, pants are signs of the recognition by his family members of his imminent access not only to a new physical state but also to a new social status.

Puberty also coincides with the rites that mark the end of religious instruction and access to an independent, responsible faith. Despite the dynamics of secularization, the Catholic Holy Communion, the Protestant confirmation, and the Jewish Bar-Mitzvah remain important ceremonies in many families. The photograph of the boy in a grown-up suit or the first gift of a watch, symbol of the independent mastery over time, suggests that, in addition to their religious function, these rites

FIGURE 17.1 LITTLE BOY IN SAILOR'S OUTFIT, 1915.
Still common in the nineteenth century, the little boy's dress gradually disappears after the Great War and with it the rite of "*pantalonnage.*" Shorts are the earliest sign of little boys' masculinity, even though they remain a sign of immaturity. With puberty, boys are allowed to wear pants.

Source: © Kharbine-Tapabor

are the occasion to symbolically mark the end of childhood and the passage into a first stage toward adulthood.

The function of play in the motor and psychic development of the child is well known. Toys, which are the prime material support of this, take off in a remarkable manner during the century. It is thus important to look into their role in the learning of gender distinctions and in the internalization of the virile lifestyle by the young boy. At the end of the nineteenth century, the rise of the toy industry encouraged the spread of standard products with a strong gendered connotation. Girls received dolls, layettes, and dollhouses, which demonstrated the attributes of femininity: motherhood and care for the home. Objects and activities directed toward boys were considered specifically masculine: trains, automobiles, and airplanes made out of wood or tin, games of tinkering or construction, and of course war toys. Ever since the end of the Franco-Prussian War, manufacturers had been offering large quantities of canons and military outfits. The Great War, as may be suspected, increased this tendency. Beginning at Christmas 1914, the portion of military toys goes from around one fourth to one half the novelties offered in the catalogues. That of Le Bon Marché for winter 1916 offers, for example, a trench coat with metal helmet, a tank, and a miniature howitzer.[8]

The percentage of war toys declines after the war. New identity markers are offered to the little boy along the lines of adventure and far-flung exploration. The Printemps catalogue of Christmas 1921 presents a teepee as well as Indian and cowboy outfits. The following years there appear little models of the Citroën half-track truck, which was the first to cross the Sahara.[9] During the same period, the Meccano Company, whose products would meet with continuous success up to the end of the twentieth century, systematically displays boys in its ads and catalogues. The metal the toys are made out of, the ingenuity and technical mastery they require, the cranes, the planes, and the trucks that can be constructed make a Meccano toy eminently masculine.

It is undeniable that the toys reproduce a certain number of gender stereotypes and encourage the boy to show, in his play, qualities and behavior that are "virile." However, it is not certain that except during times of war any sign of deliberate intent can be detected. Actually, until the 1950s, the educational value of play is hardly taken into consideration, and parents most often consider it a puerile amusement without much interest for the adult.[10] The way boys' toys conform to standards of virility results probably less from a conscious strategy than from the weight of social conformism and children's desire to imitate adult life in order to imaginatively take on adults' qualities, abilities, and experiences. Finally, one cannot

be so sure that the uses of toys have always been so differentiated as manufactur-
ers' and distributors' commercial strategy would lead one to believe. In the case of
mixed siblings, for example, children have been known to exchange, share, or hand
down toys commonly associated with the opposite sex. However, it remains the
case that, while not being conceived explicitly as tools for virile initiation, toys for
boys significantly contribute to the maintaining of dominant stereotypes and to
an extent impossible to evaluate take part in male children's internalization of the
virile character.

GANGS

Outside the family, the young boy finds, through contact with his peers, groups
that actively take part in his virile initiation. In working-class milieus, gangs of chil-
dren and adolescents get together on the basis of a double affiliation of similar age
and similar territory—village, neighborhood, or sometimes street. Girls, less free
and generally motivated to help their mothers with household tasks, rarely take
part in them. The gang thus appears as an antithesis of the home, which is a female
world in which the boy is forced back into being a child. A certain relation to
masculinity intensifies within him; it is made of toughness, games of strength and
courage, challenges, and self-affirmation. The gang is also the place for initiations:
first cigarettes, jokes, and dirty games that take the place of sexual education, first
tries at standing up to authority, or first petty theft. By taking on the attitudes that
symbolically stand for adult masculinity, those who are still only children from
men's point of view try their hand at asserting their virility in front of their fellows.
On the other hand, anything that might recall childhood or femininity is severely
rejected. An early puberty, particularly in terms of physical attributes or a greater
propensity for vulgarity, brings out a number of virile signs that form the basis of
the gang leader's authority. That authority, though, remains precarious. In a study
based on a gang of young Italian-Americans in Boston in the early 1940s, William
Whyte shows that a decrease in the physical form of the leader is all it takes to
throw his dominant position into question.[11]

In the countryside, gangs of young adolescents sometimes originate from more
formal groups such as brotherhoods, *basoches* (law clerk guilds), or "*abbayes de jeu-
nesse*" (partying youth groups) that are now obsolete. Up to the 1960s they retain
specific functions in community life, particularly in the organization and facili-
tation of village festivals. Ephraïm Grenadou tells how, for the "Feast of Corn,"

village boys get together after supper and hang laurel branches on the doors of local girls. They are also the ones who wear disguises and organize the Mardi Gras carnival or who enliven weddings with their singing and antics.[12] Their behavior as a group on the occasion of votive or patron saint feasts reveals all the ambivalence of juvenile sociability. Drunkenness, loud noise, and brawls are signs of masculinity out of control and are tolerated to a certain extent, for "boys will be boys" (*"il faut bien que jeunesse se passe"*). However, when the nocturnal turbulence of these young men goes beyond the tradition of charivari, the victims are always those whose individual behavior offends the sense of community order: husbands dominated by their wives or out-of-town couples whose age difference is too great. Thus, by the chaotic manifestation of their masculinity, the village youth act like the secular arm of the community as much as the agent of its cohesiveness; by their internalization of collective norms, they show that they are getting ready to fall in step.[13]

Young men also go in such groups to cafés, pre-eminent places for masculine sociability and consequently a decisive step along the path of virile initiation. Drinking alcohol and gambling attest to leaving childhood behind, but they are still not enough to grant access to the status of being a man. The café has its order, which reflects the hierarchy of alcoholic beverages and the codes of conduct. In the Saint-Loup cafés frequented by Ephraïm Grenadou and his buddies, the young men drink cassis mixtures while the Picon bitter, absinthe, or eau-de-vie are reserved for adults. The *"maître-gars"* or "head honchos" who have just returned from military service teach them the art of billiards[14] and thus play the role of an intermediate group in the initiation chain of the café.

YOUTH MOVEMENTS

In the upper bourgeoisie and middle classes, where associating with the wrong type is feared, adolescents are more closely watched over. For a portion of them, youth movements, which grow between the 1920s and 1950s and whose religious or political backing reassures parents, offer a means of temporarily escaping parental control and having a bit of freedom among friends. It is safe to assume, moreover, that the autonomy they offer as part of their activities affords the adolescent a little taste of what gangs are like and a sense of their rampant masculinity.

For the movements themselves, most often not coed, the question of the boy's virile training is far from irrelevant. It is manifested through the clearly displayed ambition of forging a complete man all at once in physical, moral, and for religious

associations, spiritual terms. The Boy Scouts, whose pedagogical methods and organizational format serve as a model for most of the groups between the wars, appears to be the archetype of this virile training through the framing of youths' leisure activities. This training actually has its roots deep in the ideology of *Masculine Christianity*, published in Great Britain in the middle of the nineteenth century. This fruit of Victorian culture conceived of sports and outdoor activities as a means of developing conjointly physical strength, moral rectitude, and spiritual depth in young men and of fostering the rise of a virile, victorious Christianity. At first confined to the posh milieu of private schools and universities, this trend spreads to the greater public and to the whole of the Anglo-Saxon world by means of youth movements such as the YMCA and the Boys' Brigade.[15] The emergence of scouting in 1907 is part of this trend. Baden-Powell, however, who founded the British scouting group, stamps his method with a character more civic and patriotic than religious, which allows him to expand beyond predominantly Protestant countries. The naval lieutenant Nicolas Benoît, for example, founder of the *Éclaireurs de France* in 1911, thus asserts his ambition to complement school work with "a virile education that develops the character, real patriotism, physical dexterity and the ability to adapt to any condition."[16]

An education in virility, scouting is also an education through virility. It bears the mark, in fact, of the psycho-pedagogical currents of the late nineteenth century, which led to the re-evaluation of the role of adolescence in the construction of the adult personality and to the consideration of the drives that accompany sexual maturation no longer as a threat to halt but as a reserve of vital energy to be channeled.[17] According to the Swiss pedagogue Pierre Bovet, the "genius of Baden-Powell" was in the way he was able to motivate the "combative instinct" of the adolescent by imagining adventures and games of conquest and confrontation, to make of them the engine of his civic and moral education.[18] Thus, this pedagogy of confrontation, along with the urgent invitation to the boy to preserve his virginity, demonstrates the desire to put to educational ends the virile surge of adolescence.

The exaltation of youthful energy and vitality associated with sports and outdoor communal life becomes a repeated talking point of nearly all the youth movements between the wars. A new stereotype develops, no longer associated with the status of the mature man, citizen, and head of household but with the physical and moral vigor of the young man, cultivated by an adventurous life in close touch with nature.[19] The power of this model is such that, in mixed movements such as youth hostels, girls themselves become members and adopt masculine attitudes and language. Thus these "hostellers" go backpacking, without make-up or coiffure, having

traded their stockings and skirt for shorts and hiking boots. "The girls, one of their friends recalls, had to abandon the image of the traditional woman and had to give up or even camouflage their femininity behind boy-like looks that are the image of virility."[20]

The potential for challenging the liberal, bourgeois order held in this stereotype explains the manner in which the revolutionary far right appropriates it to construct its myth of the "new man" and to oppose it to a republic of old men that is decadent and worn out.[21] More than an elective affinity, though, here it is a question of a commonplace of the period between the wars. Similarly, when Vichy founds its "Chantiers de la Jeunesse" in order to "remake the youth into virile, healthy, united, and disciplined men"[22] through harsh living, by being close to nature, and through physical education, the old field marshal is simply harking back to the refrain repeated many times by youth organizations of all stripes during previous decades.

TEACHING IN THE SCHOOLS

Primary school, which takes on a growing importance in the life of children and adolescents and remains single-sex for a good part of the century, plays a complex role in the virile education of little boys. Generally more concerned with transmitting an amount of positive knowledge than shaping their budding virility, the school as institution nonetheless takes on the mission of forming a particular type of man. This project is particularly clear in boys' secondary education, which is in charge of reproducing mid-level and superior elites. There, humanities and the study of ancient authors aim at transmitting to the students the mastery of masculine eloquence, an instrument of social domination just as usable in the political sphere as in the business world. In France, for example, the instruction accompanying the 1925 programs recalls this goal of classical education: foster in the *lycées* "the powerful tool of their future conquests, that is, vigorous thinking."[23]

A not insignificant percentage of the *lycée* students continue to go to boarding schools in spite of the recurring criticism made of them and the noticeable drop in enrollments since the end of the nineteenth century. The students there are subjected, for about ten years, to living conditions whose rigor and severity are generally compared to those of a convent or army barracks.[24] This criticism, which has become commonplace, nevertheless warrants being looked at in detail. Outside of the large *lycées*, which impose a regime of strict, oppressive surveillance, there

exists a multitude of smaller establishments in which the prevailing atmosphere is sometimes more easygoing and almost familial.[25] Still, this exclusively male world may be marked by violence. Corporal punishment, though rarer after World War I, persists in the arsenal of sanctions in England and Germany. In France, in spite of its official suppression, it is still used in some cases.[26] But when adult surveillance relaxes, violence may also be wielded among the students themselves. It is usually the act of the older ones, whose physical maturity and ability to imitate supposedly virile behavior justify their domination over the younger ones. Within the boarding school, as in the gangs of young boys, "to make like a man" becomes a means of escaping the bullying and to accede to the status of dominator. In *The Choirboy*, a partially autobiographical novel, Étiemble relates the manner in which the lax supervision in the *lycées* during the Great War and up to the mid-1920s left the door open for the older boys to take advantage of the novices, even abusing them at times sexually. As a student at a provincial boarding school, the young André Steindel undergoes dramatic hazing and thus brutally loses his childhood naiveté. So he adopts the slang and the behavior of the older boys, smokes and drinks with them, brags about having a chick, and defies authority in order not to be seen as a newbie anymore.[27]

The Choir Boy also brings to the fore the agony of bourgeois adolescence, as the boy is confronted with questions provoked by his burgeoning virility that are answered in the debauched atmosphere of the boarding school in a way not possible either in the family circle or in the bowdlerized books that the *lycée* gives him to read. Étiemble agrees here, in a novelistic register, with the criticism repeatedly made by numerous moralists who denounce the absence of any real sex education for the young man. At the end of the nineteenth century, the pastor Charles Wagner already deplored the fact that "young men get to the most critical age without a compass and without direction," and because of parents' and educators' silence they are consigned to the harmful influence of "a nasty buddy" or dirty books.[28] A few decades later, the sociologist Edmond Goblot denounces the bourgeois prudishness and hypocrisy that prompt the boy to lead a double life: outside the family and its milieu, "a life of debauchery that no sign is supposed to give away; within the family, making a display of a wide-eyed naiveté and an improbable ignorance." Like Wagner, Goblot recommends sex education for adolescents that would consist of training in continence and in "resisting the sexual instinct."[29] It would teach the young man how to maintain "his sense of virile dignity and self-respect"[30] by teaching him control over his passions and his impulses. But this ideal is the opposite of the value system current among young men themselves, which, on the

contrary, makes of sexual activity one of the criteria of virility—perhaps as much because it manifests a maturity that allows the adoption of acts of the adult male as because it evokes images of power and domination associated with male sexuality.

Although it does not respond to the appeals of the moralists and maintains an obstinate silence on sexual questions, primary education does not entirely abandon teaching about the body and students' physical development. In continental Europe, gymnastics in school came into being during the nineteenth century at the time when the formation of armies by conscription was establishing a link between military power and the physical vigor of the nation. In Prussia, for example, the invention of *Turnen* (gymnastics) by Friedrich Ludwig Jahn came right after the defeat of Iena at the hands of the Napoleonic armies in 1806. In France, the introduction of gym into boys' public schools in 1880 bears the mark of the humiliation of 1870 and of the Republican project of national regeneration through the schools. Up until the Great War, the army, which possesses at once the experience of physical education and the infrastructure necessary for its widespread diffusion, plays a prominent role in the development of programs and in the training of gym instructors.[31] Its legitimacy, however, is contested, particularly by schoolteachers and civil gym instructors, who generally get better results on professional examinations than the instructors trained at the military school of Joinville.

The introduction of sports as a practice complementary to gym also helps free physical education from its military origins. Beginning with the *Belle Époque*, a whole line of thought, promoted in particular by the works of Pierre de Coubertin on English education, asserts the pedagogical virtues of sports and encourages the proliferation of sports clubs in the schools. In the Catholic youth leagues as well, sports are promoted as a means of fortifying the body and mind of the boy and of preparing him for his virile duties as a soldier, a Christian, and the head of household.[32] This enthusiasm for sports is confirmed in the aftermath of the war in youth leagues as well as in the *lycées*. Strong resistance, nonetheless, prevents the incorporation of sports into school programs. The absence of method and of incremental advancement in the learning process, the reasoning behind competition that may drive the player to exert excessive effort, and finally the focus on special movements, provoke mistrust on the part of physical education specialists. In their eyes, only methodical gymnastic training, based on positive physiological data, can be truly beneficial.[33]

In light of the facts, however, the situation of physical education is not so bright. The very hierarchical world of the *lycées*, where culture and intellectual knowledge take precedence, allows only a marginal position for physical education instructors

and their discipline. As for primary schools, in which lack of training is joined with lack of motivation on the part of the teachers, they are even worse off.[34]

THE JOB, THE ARMY BARRACKS

The aims of the schools as regards forming the complete man do not match the expectations of the working-class population, for whom neither access to basic knowledge, however useful it might be, nor physical education could be regarded as sources of virility. For the peasantry and the workers, the status of man is closely tied to the strength used in a productive activity or in the mastery of a certain skill not acquired at school desks. It is therefore not until the child's schooling ends and he engages in active life that virile formation can truly be started. In spite of its tendency to come later, this starting point is still too early to explicitly indicate the passage into adulthood. At the beginning of the 1950s, nearly one third of fourteen-year-old boys and more than half of adolescents over sixteen are already working.[35] But while the young worker is no longer a child, he generally continues living with his parents, to whom he gives his salary and to whose authority he remains subject.

Professional life often begins with an apprenticeship. When the family has at its disposal some property, as in the case of farm owners or developers and certain craftsmen or small businessmen, one of the sons helps his father with the job of getting ready to take over. But for the majority of boys, the first work experiences consist of accomplishing low-skilled tasks, such as manual labor or farm work. In either case, this is a time of getting integrated into the world of work, of gradual assimilation of the rules and rites that organize it, and of the experience of its harshness and latent violence. Georges Navel thus evokes working in the foundries of Pont-à-Mousson, just before the Great War, and the "men of the foundry, rough on the kids who worked as helpers, using slaps and kicks in the butt to toughen them for the job." Employed as a mason following the war, he himself has to endure the insults and brutality that prevail at the work sites. At another point, it is the son of a carpenter who tells how his apprenticeship with his father in the 1920s is a series of insults and melees.[36] Consciously or not, men thus expect to forge in boys the physical resistance and the moral toughness that will make of them honest workers, and they believe that these qualities alone will allow them to bear up under an entire life of exhausting labor.

In countries in which a mandatory draft exists, it is the barracks that accomplish virile training. Conscription is the final stage before the boy's access to the

status of adult man. It follows the schema of initiation described by Arnold Van Gennep: separation from the everyday world, life on the margins—in the barracks—for a specific time, then reintegration into the virile community and return to a normal social life. During this period, the conscript finishes acquiring physical strength, mastery of weaponry, courage, and the sense of discipline that characterize the complete man. The idea that military service contributes to the "fabrication of males" is deeply rooted in mental attitudes. In 1970, an IFOP (French Institute of Public Opinion) survey thus underlines the fact that 81 percent of Frenchmen over age twenty-four still consider that military service is "useful in the formation of a man."[37]

Conscription is supported, moreover, by a set of rites and traditions that accentuate its initiatory value, from the festive folklore that accompanies the appearance before the draft board to the solidarity that ties the conscript to his "class" for the remainder of his life. "It is with apprehension that parents await the return of conscripts who face the test at the administrative center of the canton," writes Pierre Jakez Hélias with regard to the draft board. In Britanny in the 1920s, as in the rest of rural France, being declared unfit for service amounts to being considered less than nothing and to giving up any chance of finding a wife. "But, when the braggart has done his time in the infantry or the artillery, no girl can outstare him, all the more so because his next test will be marriage."[38] Thus, the draft board functions as a veritable examination of the virile capacity of the future conscript.[39] All the folklore that accompanies the visit of the "class" to the administrative center demonstrates this, from the cardboard medals "good for service, good for the girls," proudly displayed upon leaving the draft board to the traditional drinking sprees and the no less traditional "trip to the brothel."

The time preceding the conscripts' call-up generally produces manifestations that the anthropologist Michel Bozon, describing the ones that were still taking place in Bresse in the 1950s, has called "festivals of virility." On their twentieth birthday, the young men from the same village give themselves over to all sorts of games, contests, and outrageousness. In particular, they go from farm to farm, decked out in feathers and ribbons, performing dances and catcalls in exchange for a drink and a coin to pay for the conscripts' banquet. The banquet consists of a 48-hour orgy during which enormous quantities of alcohol are consumed. Significantly, states Buzon, this festive ritual never makes reference to military service itself. The conscription folklore, which is found in numerous regions and which is carried out sometimes in "conscript clubs," does not function as a celebration for going into the army. It constitutes instead a rite of passage during which young

FIGURE 17.2 DRAFTEES OF THE CLASS OF 1920. POSTCARD.

"Good for the service, good for the girls." The rituals that surround conscription, from the draft board to the folklore of the "class," celebrate less military service itself than the draftee's virility. The barracks completes the virile formation of the young man and marks his definitive attainment of the status of adult male.

Source: © Kharbine-Tapabor

men manifest their virility in an unrestrained manner and announce their imminent entry into manhood [cf. fig. 17.2].[40]

THE MODEL SHAKEN

We have already evoked the way in which feminist criticism, after denouncing the alienating character of traditional models of femininity, endeavored during the 1970s to dissociate masculinity from virile stereotypes. By showing that virility was not a natural attribute of the male but the result of a set of educational and social processes aimed at perpetuating male domination, its detractors hoped not only to open a new front in the fight for gender equality but also "to arm men who want to abandon the classic virile parody" and free themselves from that "terrorist myth."[41]

In many ways, however, the questioning of social models serving as the basis of male domination is only one step in an older and more profound process that leads toward the rebalancing of relations between the sexes. Thus, the changes that take place in the socialization and education of male children during the last third of the twentieth century often stem from a dynamic begun earlier, which permits women to accede to rights formerly reserved for men. Quietly at first, then more openly in the last decades of the century, the pillars of virile education either ceased being the prerogative of young boys or saw their social value decline. One might nevertheless wonder if all references to traditional models of virility have really disappeared from the socializing process from childhood to adolescence or if some of these models persist in new permutations.

THE FAMILY

Of all the institutions of socialization that contribute to the formation of male identity, the family is probably the one that undergoes the most profound transformation. The change takes place simultaneously on several levels. In the first place, the feminist movement brings to fruition its secular fight against the patriarchal model on which the internal order of the family is traditionally based. The 1965 laws concerning marriage settlements and the 1970 one substituting parental authority of both parents for the principle of "paternal power" put an end to the juridical inferiority of the mother. Henceforth, regulation of family life is based on a juridical foundation that no longer recognizes the legitimacy of the adult male's domination.

More fundamentally, the reorganization of male and female roles within the family leads to the emergence of a new model of paternity as well as to a noticeable transformation of the norms that guide parents' behavior regarding their child's sex. Comparison of successive editions of the worldwide best seller by Dr. Spock, *The Common Sense Book of Baby and Child Care* (1946), is, in this regard, particularly illuminating. In the French edition of 1960, the pediatrician explains how, between three and six years old, the boy becomes conscious of his sex organ and of the fact that he will become a man like his father. He observes, imitates his attitudes, starts playing more masculine games, and thus prepares himself "to fulfill his role later as man, professionally as well as morally and socially." The girl, for her part, wants to resemble her mother. She takes care of her doll as she would a baby and takes an interest in household chores. Twenty years later, the same chapter

no longer distinguishes between the sexes and settles for asserting that "children" from three to six years old aspire to resemble "their parents." "They play at going to work, tending house (cooking, cleaning, laundering), and caring for children (a doll or a younger child). They pretend to go for a drive in the family car or to step out for the evening." Just as the little girl observes her mother and wonders what she thinks of her professional job and her household chores, the little boy watches his father and asks himself the same questions.[42]

In a subsequent volume, *Raising Children in a Difficult Time* published in 1974, Dr. Spock introduces a few nuances into his feminist positions. Relying on axioms of Freudian psychoanalysis, he reaffirms the importance of the construction of sexual identity and the fundamental role played by parents in this process. To be sure, it does not need "to be built through an emphasis on differences in clothes or playthings, or on parental reminders of what little boys are meant to do and what little girls are meant to do." According to the pediatrician, the father who refuses to help with household chores or to give a doll to his son only conveys to the boy his unease and his fear of not being considered a man. It is nevertheless important, in order for him to become aware of belonging to the male gender, for the boy to know that "What makes a boy feel securely masculine is loving, being loved by, and patterning himself after a father who enjoys being a man and feels adequate in his competitive and cooperative relationships with other men [. . .]." In the end, according to Spock, what counts is that "the father feel psychologically comfortable as a man and have a good relationship with his son."[43]

While Dr. Spock's prescriptions may not necessarily reflect the reality as it is lived within families, they nevertheless reflect a profound evolution in relations between the sexes and between generations. Thus, the traditional model of virile education, which posits fathers who embody in their sons' eyes a distant authority and who remain relatively detached from domestic duties, is no longer current. Significantly, Dr. Spock substitutes for that model a normative schema based on being at ease and showing affection, but one that remains relatively vague regarding the masculine identity that is to be transmitted.

So, the figure of the "new father," which has gradually become established since the 1970s, emerges as quite complex. On the one hand, it allows the father an emotional and affective investment formerly repressed and reserved exclusively for the mother. "Fathering" thus allows him to weave together the earlier and more intense connections he had with his children, in particular with his son or sons.[44] But, on the other hand, it tends to reduce the specificity of the male role within the family. Moreover, what remains of this specificity includes at that point a contradiction

between norms and behavior. In terms of principles, the equal sharing of domestic chores is socially assured and considered normal by a majority of men. In practical terms, however, participation by men in these chores is still clearly lower compared to the responsibilities assumed by women. A survey taken in the 1980s reveals that even in families dedicated to the idea of gender equality, girls perform three times more of the domestic chores than boys.[45]

Furthermore, the continued rise in divorces since the mid-1960s and the decline of the family unit result in a weakening of the paternal figure and a reduction of his role in the socialization of the children. In over 85 percent of the cases of divorce and in nearly all of the separations of parents in a civil union, custody of the children is granted to the mother, the father then having only simple visitation rights. In 1988 a survey of family situations actually revealed that 39 percent of children of separated parents no longer saw their father and that 23 percent of them saw him less than once per month.[46] Thus, for most of the 15 percent of minors under 15 who were living in a single-parent household, the paternal figure was an absent or relatively remote figure. And then there is the multitude of blended family arrangements. Numerous children share their daily lives with a man who is not their biological father but who can nonetheless take part, to varying degrees and sometimes jointly with the biological father, in their education. The growing number of these situations results in a redefinition of the paternal function and, in particular, in a splitting of the father's functions among several men. The net result of all this is that, for many boys, internalization of male identity and development toward the status of manhood are no longer guided by the tutelary figure of a father embodying the values and attitudes of virility; instead such identification processes follow complex procedures that oblige the boy to find his own models as he overcomes break-ups and contradictions.

Analogous contradictions are found when it comes to that other socializing element, the toy. Catalogues and aisles of specialty stores continue to clearly separate items associated with girls and those intended for boys. Feminist criticism persistently denounces the stereotyped and outmoded character of this distinction as helping to maintain traditional gender models. While girls' toys are still for the most part oriented toward mothering and domestic chores, boys' toys often imaginatively present domination and physical strength, technological mastery, and conquest or war. Noisier, more dynamic, and more oriented toward competition and rivalry, these toys contribute to the naturalizing of the virile attributes of masculinity.[47] The marketing strategies of the manufacturers and distributers are not the only things involved. Granted that they help orient buying practices, these

strategies are also guided by the consumers' own reasoning. Thus, the persistence of virile stereotypes in the world of toys reveals that, in spite of the decline in their social legitimacy, parents and children continue to perceive these stereotypes, at least in part, as ordinary attributes of masculinity. Still, it is safe to suppose that this appropriation of virile character by the toy does not take place without some distancing. Indeed, the dynamic of socialization prompts boys to internalize the norm of gender equality at the same time as it teaches them not to demand virile traits of behavior or to invest too openly in virile values and attitudes.

SCHOOL, WORK, AND THE BARRACKS

At the beginning of the century, as we have said, school only came into play in the boy's virile formation in two ways: through physical education and, less explicitly, through the teaching of the classics in the humanities at the *lycée*. Now, in both cases, this aspect diminishes between the two wars. In the area of physical education, first of all, health objectives override the military issues originally associated with it. Within regional institutes of physical education, charged since the 1930s with the training of gym instructors and secondary school teachers and placed under the authority of medical faculties, the winner is a conception of physical education whose purpose is no longer to increase the strength of the future citizen-soldier but rather to maintain the child's and adolescent's health.[48] In secondary education, then, the feminist demand for equal access to advanced studies leads to the gradual alignment of girls' and boys' schools. The unification of curricula for male and female baccalaureates, achieved in 1924, marks the first stage of a movement that is complete by 1975 with the spread of coeducation in all the establishments of public instruction.

Forms of gender differentiation, however, remain insidiously present. Studies reveal, in fact, that teachers unconsciously adopt different attitudes toward boys and girls. The exercises that they give them, the questions that they ask them, and the sanctions they impose on them help to naturalize the qualities attributed to each gender.[49] Moreover, although the rate of academic success is today higher for girls, the scientific tracks, which are more prestigious, and the preparatory classes for the "*grandes écoles*" (professional schools) continue to take in mainly boys.[50] Nevertheless, the educational institution as such is not predicated on gender difference at all.

The evolution of work in so-called "postindustrial" societies has led to the loss of status assigned to work in the virile socialization of the young man. Prolonging

the years of schooling, first of all, postpones a majority of adolescents' entering into professional activities. In France, at the end of the 2000s, only 5.3 percent of sixteen-year-old boys and 18 percent of eighteen-year-olds had jobs.[51] Of course, those who begin work early generally do so in the industrial sectors as well as in crafts and construction, which are strongly masculinized and in which physical strength, dexterity, and tenacity are still valued. Nevertheless, unskilled jobs and those that bring virile qualities into play are generally discredited and perceived as unimportant career paths. Finally, the gradual opening of most employment activities and functions to women eliminates the impact that integration into the work force once had on symbolically recognizing the status of a full-fledged man.

The same goes for military service, formerly considered to be the final step in the process of symbolically validating virile identity. In France, even before conscription was planned to be suspended, several indicators showed already that its relation to virility was tending to weaken. The 1971 law authorizing women, in times of peace, to volunteer for national service under conditions about the same as for men created an initial breach. Even though it remains relatively weak—from 753 in 1972 to 4407 in 1995—female demand is nearly always twice as high as the number of places offered to women by the army.[52] This suggests that the end of male exclusiveness corresponds less to a wish on the part of the military institution than to social evolution. At the same time, the idea that military service completes the young man's virile education loses credibility little by little in public opinion. In 1970, an IFOP (French Public Opinion Institute) survey reveals that while three quarters of farmers and workers aged fifteen to twenty-four still perceive military service as virility training, less than half of students of the same age share that opinion.[53] This proportion continues to diminish in the following decades. More and more of those called up thus try to escape the barracks by heading toward civil forms of national service: foreign service, national business service, conscientious objection, or even "city services" beginning in 1992. In the mid-1990s, there were a total of over 20 percent of conscripted men who carried out nonmilitary service, seemingly without considering that their masculine identity was at risk of being weakened.

In 1996, President Jacques Chirac's decision to suspend the draft provoked huge debates about the strategic utility of conscription as well as its social virtues. Significantly, however, the question of the virile formation of young men was never brought up. The geostrategic upheavals of the end of the twentieth century and the evolution of military technology also led most European countries that had a conscription system to suspend or eliminate it, as did Belgium in 1992, Portugal in 1999, and Spain in 2001. Thus came to an end a cycle begun two centuries earlier

that assigned to the army a fundamental role in the formation of the masculine identity of boys and to conscription the symbolic value of a rite of passage.

More generally, the social definition of the stages of life changes. A formal rite such as the draft at 20 years old is no longer relevant. From twenty to twenty-five, adolescence draws out into a preliminary phase of postadolescence, during which time young men often try out intermediate lifestyles, between the parental home—which in 2002 was still where 66 percent of young men between twenty and twenty-four lived—and the settled life of a stable couple. More frequent and longer in well-off sectors than in the working class, this phase is not the result of economic constraint. It comes rather from a desire to push back adult life in order to gain a variety of experiences and to take advantage of one's youth for as long as possible.[54]

The valorization of youth and leisure, the weakening of employment statutes, the vulnerability of the family unit, and the waning of the traditional father figure have meant the loss of an important part of the adult male's social status. The young man who matures thus sees his youthful capital dissipate without really being able to compensate for this loss with any gain in virile capital. Various strategies are available to him for prolonging his youth, but they contribute, on a much larger scale, to the gradual dissolution of the borders traditionally separating the age of youth from the age of virility. It thus appears that the cards of boys' virile socialization are shuffled not only because of the questioning of traditional roles and functions between men and women but also because the model of virility toward which this socialization was leading has lost its social relevance and its power of attraction. Virility, considered at this time as a condition or character trait and not as an age marker, has not, however, disappeared from the cultural landscape and the mental universe of young males. In their eyes, certain attitudes and forms of behavior known to be virile retain a real attraction. Nevertheless, detached from the values and norms of global society, they tend to constitute an attribute that belongs to youth culture, differentiating that culture from the adult world more than relating to it.

THE VIRILE CULTURE OF WORKING-CLASS YOUTH

The extolling of virile attitudes may probably be considered a constant in the youthful sociality of working-class milieus. The "youth of the projects," like the black jackets of the 1960s and the hooligans of the 1970s, have a relation to masculinity that in many ways carries on that of young workers and peasants of preceding

decades. The same tendency is found, in fact, in gatherings of gangs that exclude women and require their members to adopt virile attitudes: the same exaltation of physical strength, particularly through fights within the group or against opposing groups, the same propensity for deviant attitudes, and the excessive consumption of alcohol and use of drugs.[55]

Up to the 1970s, however, virile values held a central place in proletarian culture and more generally in the definition of masculine identity in working-class milieus. As places for learning virile behavior, these gangs of young men played a role at the time in the socialization of working-class youth and constituted a step toward their integration into the adult world. Recent socioeconomic development has prompted a decline in traditional workers' jobs, a devaluation of technical diplomas that had granted access to those jobs, and an increase in unemployment, notably among youth. For a segment of working-class youth who are deprived of economic resources and whose academic training is often devalued, virile capital remains the only asset of their own that they can lay out.[56] Now, the evolution of the proletarian world itself tends to discredit that capital in favor of other values, such as dynamism, poise, and a sense of dialogue and responsibility to which girls generally adapt better. Faced with this competition, boys compensate for their deficiency in social skills by falling back on their virile identity and by trying to preserve in their neighborhoods the privileges tied to their condition as men.[57] Girls are not the only ones, however, subjected to the burden and violence of gender stereotypes in the relatively closed world of working-class ghettoes. A veritable mandate to be virile holds sway over boys, and few manage to sidestep it. Those who do must constantly demonstrate their virility and their heterosexuality in order to prove that they legitimately belong to the dominant male group, whose integrating function becomes the sole factor to mitigate shortcomings in social recognition.[58]

The disintegration of populist, working-class, and rural cultures, the social and professional discrediting of virile values, and the erosion of rites of passage between the stages of life make the virile culture of working-class youth move toward the sidelines rather than merge into the mainstream. This explains in part why new forms of anxiety have taken the place of the old indulgence toward the excesses of that culture.

THE VIRILE CULTURE OF THE MIDDLE CLASSES

The prolongation of adolescence and the autonomy it gradually acquired led to greater participation of young men in informal groups of friends of the same

age. In the vast middle class, which at present makes up the main part of Western societies, these groups play a prominent role in the slow transition from the familial world of childhood to adult autonomy. They allow adolescents, in particular, to be exposed to a broader field of experiences, among peers or with friends of the opposite sex, which accompany the construction and affirmation of their gender identity.[59]

This affirmation is also expressed by means of the models that the adolescents choose to follow. Their need for identification often orients them toward figures, real or imaginary, whose gender is displayed in a necessarily stereotyped manner and reflects a clear demarcation between the sexes. These figures provide them with the points of reference and codes to forcefully affirm a masculine or feminine identity uncertain until now. The icons of mass culture—film heroes, pop or rap singers, characters from video games, or sports idols—thus exert a strong power of attraction over young boys, most especially because of the virile values and attitudes that they embody. Aware of this attraction, marketing and advertising professionals frequently turn to actors and champion athletes to establish a symbolic link between the virile imagination associated with them and the brands or products that they are paid to endorse. More generally, "youth marketing" readily mobilizes stereotypes of virility in order to tap adolescents' need for identification and to reach the targeted teenage market.[60]

Consideration of how virile models appeal to teenagers is not always so serene and indulgent. Behind the festive and ludic sociality of peer groups might be hidden more extreme forms of behavior such as acts of violent initiation, use of alcohol or drugs, compulsive or predatory sexuality, and extensive indulgence in pornography. An anxious literature highlights, for example, the dark, dangerous side of American college fraternities or high schools and denounces the harmful effects of unrestrained virility manifested in them. A whole segment of young men from the middle classes could thus be seen, at the end of their schooling, to be totally disoriented and incapable of assuming the familial and professional responsibilities of adult life.[61]

A NEW CULTURE OF JUVENILE VIRILITY?

Considered across a longer span of time, these adolescent experiences bring into play a relation to virility reminiscent of the one traditionally manifested by

working-class youth. Nevertheless, the adoption of these models of virile conduct by teenagers and students from the middle classes provokes new worries. It actually reveals that an important aspect of the socialization of these young men—in whom are invested powerful expectations of success and social promotion and who formerly grew up under the strict supervision of their educators—eludes adult control from now on. These adolescents thus forge a culture of juvenile virility that reinterprets traditional virile stereotypes—mastery of physical strength, ability to dominate women, alcohol, fatigue, or fear of danger—as characteristics specific to youth and which function, to a certain extent, as a counter-culture. It is not, though, a deviant culture. Amply transmitted by the mediators of mass culture, this culture of juvenile virility generates a normative system that has appeal well beyond the realm of adolescence and helps dissolve the classic points of reference in the passage to adult maturity.

The place held hereafter by virile stereotyping in boys' socialization and education is marked by an obvious contradiction. The model of the adult male into which they are urged to grow has become an uncertain figure in which masculinity is no longer characterized by attributes of domination. Fatherhood itself has ceased to appear as a marker of virility, in part because Western societies have put an end to symbolically separating sexuality and procreation and in part because of the devaluation that paternal power has undergone. Finally, most adolescent boys have internalized the social ideal of equality to which girls their age are firmly and rightly attached. Even so, virile values and attitudes have not disappeared from the social arena. Every day, through sports spectaculars, at the movies, or in video games, mass culture conveys icons that symbolize these values and wield their power of fascination over teenagers. The model of masculine identification that used to mark the virile age has thus been substituted for by an imaginary world of virility that is largely disconnected from the ordinary responsibilities of the adult male. The contradiction between the weakness and uncertainty of the male gender on the one hand, and the pressure of virile stereotypes on the other, is the source, according to certain authors, of the troubled relation that many adolescents have with their masculinity.[62]

Nevertheless, the young men who appropriate the virile imaginary conveyed by mass culture are not necessarily duped by it. They adopt, by means of it, a youth culture that is their own and that at times cultivates their conflicted relations with the adult world. Through their experiences of wild, unrestrained virility perhaps they are seeking a means of compensating for the stronger and stronger hold of

educational and social processes and the weight of the norms of a regulated and routinized society. The virile imaginary world allows them to identify with heroes full of strength and bravery and to dream of distant horizons where adventure is seasoned with danger—horizons that once they become adults, most of them will have to give up.

18

FASCIST VIRILITY

JOHANN CHAPOUTOT

Baboonery and animalistic adoration of strength, respect for the military spe-cies, wielders of the power to kill. Baboonery: the stirring of respect when the huge tanks file past. Baboonery: the cries of enthusiasm for the boxer who will win; baboonery: the public's cries of encouragement [. . .]. Baboons, the cretins received by the Italian dictator who then come to me to extol the seductive smile of that brute—a smile that is basically so good, they all say—oh, their womanly rapture as they stand before the fort.

ALBERT COHEN, *BELLE DU SEIGNEUR*

FASCISMS ARE often credited, for good reason, with the project of bringing into being a "new man"[1] after the alleged degeneration of the nineteenth cen-tury and the massacre of the Great War. This new man was in fact more often a man than a woman. While the all too famous alliteration "*Kinder, Kirche, Küche*" is not specifically Nazi and can be found in Germany before as well as after the Third Reich, Italian and German fascisms are distinctive because of their limited esteem for women and femininity. Both could be defined as the project for bringing into being more than a new humanity—a new virility.

EXCLUDING

Fascists and Nazis made man their cornerstone. That woman is a relative being who gets her existence only from entities external to herself is expressed

well by the compliment addressed in September 1934 by Adolf Hitler to members of the Organization of National Socialist Women (NSFO): "The woman's world is limited to her husband, her family, her children and her home." Woman's existence is justified only by the duty she performs for her husband, whose everyday comfort she ensures, and for her children, whose physical development and material education she takes charge of. Woman is and exists only relative to others: to men, whom she serves, and to the new generations, which she nourishes and educates. This is actually the reason why, despite her weakness and her inadequacy—in brief, her ontological deficiency—woman must be "tolerated," as a school manual of the Third Reich points out: without her and her womb, there would be no *Volk*.[2] Her existence, moreover, is made up entirely of inwardness and containment as opposed to man's, which is a projection toward the outside. In the male-female couple, while the woman is relative, the man is indubitably an absolute: source of all moral value, he embodies the essence of the fascist phenomenon.

Fascist or Nazi virility, however, cannot be defined solely by this one-to-one comparison between man and woman, which in the end is pretty banal and traditional. From 1922 in Italy, then after 1933 in Germany, virility is constructed by a series of sharp, blunt oppositions: man is not woman, the Aryan is not the Jew, hard is not soft, the hero is not the bourgeois, the soldier is not the merchant. In Germany especially, the definition of virility does not allow any sense of nuance, of middle ground or transition: mixture is criticized, vague definition is proscribed, and only chemically pure virility is acceptable. To define virility is therefore first to exclude the supposed and actual antitheses of the male being. Man must be sufficiently whole and healthy to know himself how to exclude: exclude the feminine and the non-native.

The meditations of Paul Claudel and several others on the relative portions of *animus* and *anima* in creative intelligence have no legitimate place in fascist and Nazi lands. Virility is radically exclusive of any femininity. This exclusion shows up as women's invisibility. In his long commentary on the literature of the Freikorps, Klaus Theweleit[3] notes that women are practically never mentioned. Veteran combatants of these troops mention only their battle comrades. By hiding it, they deny any sensibility or affective emotion for a woman. The object of their love is named Germany, the village where they were born, their weapon, their horse, or their platoon. A woman is never mentioned, except for legitimate wives, who curiously are never referred to by their first names, as if they could not accede to a full and whole existence. Woman remains, as Theweleit writes, the Nameless One (*die Namenslose*), the one who has no name.

Freikorps combatants are rugged, and the performative anonymity of the women of their lives helps sanitize their identity of any ambiguity: femininity plays no part in their world, and the exclusion takes the form here of repression, or denial. Willing to be semiotic, even psychoanalytic, Theweleit also notes beyond simple concealment an actual disgust coming from the Freikorps toward the feminine element. They appear frightened and nauseated by the ebb and flow: man is the retaining wall against overflow, constancy against spinelessness, substance against disintegration. Inspired by Theweleit, Jonathan Littell has noted, in the Belgian Nazi Léon Degrelle, the same obsession for the opposition between *The Dry and the Wet*,[4] the title of his work on the founder of the Rexist Party, later an officer in the Waffen-SS: the dry, the hard is man. The wet is woman (weakness and menstrual flow), the fleeting, the traitorous, the marsh (Weimar Republican) and the tide (Bolshevik, red). The oppositions have the virtue of being clear and of allowing the construction of an ameliorative virility: man is the example of stability in a world of flow and transience. He is stable and reliable: he does not change sides or his mind; he neither varies nor betrays. Virility stays put and holds things together, just as, in combat, it holds position.

In Nazi Germany or fascist Italy, woman is thus excluded and reclusive: devoted to her husband and her children, she clearly has no right to the society of men. When she appears in public, it is as a marginal, spectating, or specular being. In that monument of the Nazi community, Leni Riefenstahl's *Triumph of the Will* (1935), a film about the Nuremberg Congress of 1934, women are shown only as they gaze admiringly, lovingly at the Führer: they are the simple surface onto which to project his charisma, whose effectiveness can be read in the moved, fascinated faces of the female public. Women are absent from all the rest of the film; the party conference remains exclusively an affair of men.

Femininity is therefore excluded, for it is on the side of the enemy. For the Nazi ideologues and propagandists, only the Nordic race is fully virile: Jews, while they can demonstrate a violence close to masculine strength, possess only a brute, animalistic power devoid of the self-control that is one of the attributes of virility. Jews are for the most part essentially feminine: subject to their impulses, unstable and fickle, they are also subject, like women, to a nature they cannot control. Endowed with a puffy, unpleasing physical appearance, they are diametrically opposed to that chiseled musculature that fascist man acquires through purposeful and long-lasting effort. Feminine, and therefore evasive and cowardly, Jews do not fight against the Nordic race in open combat but prefer to circumvent it by feminizing it. To vanquish Nordic man, the Jew has no other resource but to weaken him by

diluting his virility. This old thesis about Nordic emasculation, which goes back to Nietzsche's *Anti-Christ*, is picked up again here, and anti-Semitism to boot, by the sports theoretician Bruno Malitz, author of the 1934 book entitled *Sports in the National Socialist Idea*. This unyielding condemnation of Olympic internationalism and of European federalism (Coudenhove-Kalergi is mentioned later) posits the equation femininity = internationalism = pacifism = Jewish plot.

> Jewish doctrine has destroyed the strength of our people. Virile strength is its enemy; it dreads it, for it alone can stop the Jews from destroying the world. National socialism accepts the challenge and fights against an effeminate, deleterious Jewry [. . .]. Jewry wishes to soften man by making of him an international, pacifist creature. It uses to that end—with the most Jewish of refinements—sports, that is, combat [. . .] by explaining that peaceful fighting should replace war, that sports unite peoples and make them fit for great peaceful actions.[5]

Exclusion of femininity implies exclusion of effeminacy. Drawing a strict, rigid dividing line between man and woman implies the rejection of any nuance or hybridization, which explains the unenviable fate of homosexuals in Germany beginning in 1933.[6] Penalization of homosexuality certainly existed earlier, in article 175 of the 1872 Penal Code, but that article was revised and made harsher in 1935, the maximum sentence increasing from six months to five years for any homosexual act between consenting adults. The repression of homosexuality is entrusted to the police and to regular courts, which increase their proceedings (8000 per year beginning in 1935), but also to the services of the SS. Heinrich Himmler creates in 1936 a central Service of the Reich against homosexuality and abortion (*Reichszentrale für Bekämpfung der Homosexualität und der Abtreibung*), which takes an inventory of all convicted and denounced homosexuals. The file, which gathers data on over 100,000 persons in 1943, then allows eventual action by the Gestapo, empowered to incarcerate them in concentration camps. Until 1945 this measure targets nearly 10,000 individuals, half of whom do not survive their detention. This high mortality rate of the "pink triangles" has led certain historians to speak of a "Homocaust" and reveals the particular virulence with which the Third Reich took up the question. However, the most recent studies show that, while the Nazis persecuted homosexuals residing in the territory of the Reich (including its extensions: Austria, Sudetenland, Warthegau, Alsace-Lorraine) on the basis of paragraph 175, they did not care much about homosexuals in the occupied territories whose fate is left to the peoples to whom they belong. Whereas Jews are the

object of a universal pursuit and must disappear as a people, only homosexuals of the Reich represent a biological danger for the German corps.[7]

The reasons for Nazi hatred of homosexuality are multiple: a tradition of discrimination well rooted in Western cultures and religions, the prejudices and rejections of the Victorian era and the anguish—almost panic—over the fall in the national birth rate. Not satisfied with being an example of biological denaturing (for a man is intended by nature to couple with a woman), the homosexual deprives the race of the legitimate use of his reproductive organs, which are diverted from their function.

But, on top of this, and essentially, the male or female homosexual is guilty of embodying confusion and nondifferentiation. Perhaps this very nondifferentiation is one of the causes of the following curious, affective sexual phenomenon. Such, in any case, is the opinion of the Reichsführer-SS Heinrich Himmler, in a speech that he devotes to the question on 18 February 1937 in Bad Tölz: "One notes an excessive masculinization in our life. We go so far as to militarize unimaginable things," he asserts. While it is good to militarize the lives of men, whose natural vocation is to be a soldier, one must be careful about mixing genders and let women be women:

> It strikes me as a catastrophe when I see girls and women—mainly girls—carrying around a beautifully packed backpack. It's enough to make you feel sick. I regard it as a catastrophe when women's organizations, women's societies, women's associations get involved in a field of activity which destroys all feminine charm, all feminine grace and dignity [. . .]. We so masculinize women that over time the gender difference or polarity disappears. Then the road to homosexuality is not far off.[8]

To see a highly placed Nazi criticize standardization and military discipline is rather unusual: women should be protected from it. Their role is certainly not to ape men: "masculinizing" them will end up confusing their identity and virilizing them in such a way that some of them will perhaps be tempted to act and to love as men do. The place and vocation of women are elsewhere.

It is possible, however, to take action against the causes of female homosexuality: send women back home, without uniform or backpack, and this perversion will disappear. Since woman is malleable and essentially exists in relation to man, having relations with a man will put her back on the straight path of good manners and toward her biological calling. Inversely, what is weakness and distraction in woman is, in man, perversion. Male homosexuality remains, indeed, an inexplicable scandal. In that same speech, Himmler asserts that Germanic tribes had the custom of drowning homosexual men in the swamps. Faithful to the law of their race, the SS will

follow the ancestors' example and eliminate from their ranks these "abnormal lives," to be eradicated in the manner of "nettles that you tear off and throw into a pile and burn." Homosexuality is "abnormal" because it violates that norm determined to be natural, which is to mate with an individual of the opposite sex and to procreate. The violence of Himmler's speech is in direct proportion to the risk incurred by male communities like the SS (Defense corps) or the SA (Assault section), as seen in one of the founding myths of the SS ethos. On the "Night of the Long Knives" (30 June 1934) SS detachments brutally eliminated the main leaders of the SA. While the pretext for it was the accusation of high treason, the (notorious) homosexuality of Ernst Röhm and his principal lieutenants was its supplementary justification.

Fascist man has sex, then, to procreate. What about, in that case, the man who does not have sex? What about the priest and the monk? Clergymen, both secular and regular, constitute, like the homosexual, another figure antithetical to fascist virility, for they too embody an abnormality: their proclaimed celibacy and abstinence can only be pathological or else conceal unnatural practices. In the spring of 1936, a trial is focused on a Franciscan monastery that the Public Minister accuses of covering up rapes of a novice. The Nazi press covers the event with interest: the claimed ascetic and muscular morality of the Church is nothing more than concealed immorality, which leads clergymen to homosexual violence. Parasitical because he is sterile, the abstinent clergyman holds to his absurd precepts, which lead him to be a harmful, criminal individual. His misconduct discredits Christianity and his message of abstinence or sexual temperance. In a series of articles devoted to the trial of the Franciscans, the SS weekly *The Black Corps* slips in an article on the status of the illegitimate child, claiming that it should be the same as the legitimate child. In 1940 there will be pleas for polygamy, at least in the short term, in times of war: what is monogamy but one more (Judeo-)Christian absurdity that impedes the fertility of the race?

Fascist virility thus has among its characteristics natural mating—mating that should be frequent in order to give children to the fatherland, to the Duce, to the race, to the Führer. But this sexuality that is encouraged to be abundant is not so anarchical as all that: it is standardized not only by gender (man-woman) but also by race. Fascist man is sufficiently in control of himself not to succumb to just any temptation and to know how to exclude what is not worthy of his biology: he knows to repress deleterious desire and to obey the duty and dictates to protect and distinguish the race: he remains eminently active in exercising control over his affectivity.

Sexual relations in the context of fascist virility follow rules established in Germany by the Nuremberg laws of September 1935. The union of an Aryan man with a Jewish woman is henceforth a criminal offence and punished as such. However,

commentaries by the press and by jurists emphasize instead the inverse: the law penalizes more the unions between Jewish men and Aryan women. The punishment should dissuade and come down on the Jewish criminal, the man who is incapable of controlling his impulses and intent on defiling German blood. It is as if the sole purpose of the law, these commentators claim, were to protect the Aryan woman, a passive and feeble object, from the assaults of the subhuman.

In Italy, even though celibacy has been the object of fiscal discrimination since 1926 because it is a behavior judged to be selfish and antipatriotic, setting up house during the Empire with Ethiopian women is prohibited by a decree signed by Mussolini on 19 April 1937. The proliferation of soldiers' and Italian colonists' sexual relations with indigenous women that followed colonization by the Italian Empire provoked the Duce's anger as early as the summer of 1936—well before the racist and anti-Semitic turn of 1938. The punishment ran from one to five years in prison. Marie-Anne Matard-Bonucci[9] has studied the sentences of the Italian courts in Ethiopia, prompted, above all, by the charge of a weak virility: the Italian colonist or soldier who sets up house with an Ethiopian woman reveals a double weakness, with regard to himself and with regard to his people.

Fascist and Nazi virility, then, excludes any element of femininity: not only non-native femininity (Jewish, Ethiopian) but also femininity in itself, which comes to mean a weakness incompatible with the definition of man. More generally, it excludes the foreigner, the non-native.

Non-native means, first, the ugly. Fascist Italy and Nazi Germany celebrate virility by praising its beauty, defined actually in a perfectly tautological manner: the race is beautiful because it is itself, that is, pure of any admixture. This beauty is proclaimed and displayed. Even though fascism and Nazism may seem prudish, nudity shows up frequently in the statuary, whether it is on the Foro Mussolini in Rome or in the annual exhibitions of German art. Coming from a long artistic tradition, scarcely suspected of being pornographic or even simply erotic, the sculpted nude provides the opportunity to show in a public space the aesthetic canon to which man must correspond. The proliferation of athletic, chiseled nudes is supposed to elicit healthy emulation and lead spectators of such beauty to make their flesh conform to this stone canon.

Just as much as Aryan or Italian virility is displayed proudly in all its nakedness, its counter-type is masked, concealed. In *The Eternal Jew*, an anti-Semitic propaganda film directed by Fritz Hippler in 1941, Jewish men of the Warsaw ghetto are depicted decked out in all the traditional signs of their culture: thick caftans, long prayer shawls, numerous cloth fringes, and abundant beards—all traits that weigh

down and conceal. Flesh and muscle never appear, as if they were not allowed to be shown, hidden by heaps of fabric whose exotic expansiveness contrasts with the elegant reserve of German uniforms, impeccably tailored. The ghetto Jews, deliberately filmed after months of food and sanitation blockade, often appear to be pathologically thin: there is a lack of flesh, and muscles have vanished. Muscle has always been absent in the anti-Semitic caricature: the Jewish man is generally depicted with the traits of a fat, flabby man, endowed with a misshapen frame, characterized with bandy legs (which render him unfit for sports) and with flat feet (which exempts him from military service and consequently from citizenship).

Fascist virility therefore highlights form; it is ordered, structured; the counter-type comes under the rubric of the misshapen. In Germany the opposition between type and counter-type is shown in various media, such as printed plates of comparative racial anthropology at the Exhibition of Degenerate Art in Munich in 1937, juxtaposed with the concurrent Great German Art Exhibition: the admission ticket for one is, for educational reasons, good for the other. While on the one side the proportion and balance of carefully polished marble reigns, on the other side disproportion dominates: protuberant lips, accentuated jaws, giant heads with either skinny or obese bodies—the man of the non-native race is the epitome of ugliness. This method of juxtaposition is taken up by fascist Italy when, beginning in 1938, it provides itself also with a racist policy largely inspired by Nazi Germany. The cover of the first issue of the racist review *La Difesa della razza* [fig. 18.1] juxtaposes the profile of an ancient Greek statue, a Semitic bas-relief, and the photograph of a contemporary black man; metaphor of the racist policy, a sword intervenes to detach the ancient profile from its deleterious neighbors.

The ugliness of the counter-type is also a moral ugliness, since the aesthetic is precisely the sign of the ethical. The Aryan or Italian man possesses a beauty that signals his moral value. Nazi literature is inexhaustible on the virtues of Nordic man: a solar figure, he is magnanimous, generous, and courageous; a selfless person, he is altruistic and idealistic, devoted to his community and adept, by means of his capacity for abstraction and generalization, at going beyond his insignificant individuality in order to rise to contemplation of universal interest. Nordic man is no longer a child: he is conscious of his responsibility toward his family, his people, and his race. The Jew, by contrast, appears to be imprisoned in congenital materialism: interested above all in money, he is incapable of devoting himself to intelligence and the exchange of ideas. Immersed in the search for his own self-interest, he is defined by a dark selfishness that makes him prefer short-term personal enjoyment to long-term creation and cultural edification [cf. fig. 18.2].

FIGURE 18.1 *LA DIFESA DELLA RAZZA* (THE DEFENSE OF THE RACE), 5 SEPTEMBER 1938.

The double-edged sword of the fascist State arrives to separate the good wheat from the racial chaff: the Roman man, represented by this ancient profile, is protected by the strength of the State from the Semitic and Ethiopian threat. *The Defense of the Race* appears in Italy at the time of the anti-Semitic legislation of July 1938, an implementation of the Nuremburg laws (1935).

Source: © Leemage

Fascist and Nazi man, thus, excludes. To distinguish himself from the feminine, the ugly, and the non-native, he cultivates his virility by fighting. The entirety of fascist and Nazi imagery confirms that: man fights—against himself, against matter, and against the other.

REVIVING

The celebration of virility orchestrated by fascism is indissociable from the recent historical context that reveals the greatest vulnerability of men's psyches and bodies: The Great War broke and crushed bodies, subjecting the combatants to the

FIGURE 18.2 "THE ARRIVAL—THE DEPARTURE." *LA DIFFESA DELLA RAZZA* (THE DEFENSE OF THE RACE), 1939.

This Italian caricature from the fascist period revives an old stereotype: the Jew enters the city in a wretched state, and he leaves it (for he is a nomad), rich and fat. Beyond the accusation of parasitism, it is the counter-type of virility that this image shows: the Jew, bearded or clean-shaven, is ugly—his aesthetic hideousness betrays his moral meanness. Having arrived bent over, he departs scoliotic and knock-kneed. His body, although clothed in Western style, is not adapted for work: only thievery (usury, speculation) ensures his survival and his prosperity.

Source: © Leemage

reality of their own fall and to the spectacle of one another's extreme frailty. Seventy million of those called up measured their powerlessness against the destructive violence of the war's weaponry. The stories and images of bodies ripped open, dismembered by bullets and shells, and then abandoned to rot on barbed wire or in the puddles of "no man's land" are among the commonplaces passed down from the war. The daily confrontation with death, whose memory is preserved especially by the drawings and engravings of Otto Dix, is also recorded by the cinema. In 1931, the film by Lewis Milestone, based on Erich Remarque's book, *All Quiet on the Western Front*, recalls for spectators man's insignificance in the face of a simple

mortar shell in a riveting sequence that shows two hands gripping onto barbed wire, orphaned from a body blown apart by an explosion.

The traumatism of this seeming insignificance no doubt catalyzed the vitalist celebration of the male body after the war: to ward off its alleged powerlessness, athletic, sexual, and warrior strength was exalted; to exorcise the images of death, a life was celebrated that, through historical references, seemed undying; to make people forget the ugliness of the wounded soldier or the cadaver, the tautological beauty of the Aryan or Italian man was celebrated. People readily saw in fascism and Nazism nervous reactions to the phenomena of a threatening modernity. From the virile perspective, we are probably witnessing the anguished response to a virility under siege, threatened not only by women's liberation and other cultural changes stemming from the nineteenth century but also by technological phenomena—revealed by the Great War—that go beyond man and destroy him to the point of annihilation. The war revealed all the weaknesses of flesh up against steel. The phenomenon is certainly not new, but democratized by conscription and wide-spread mobilization, its amplitude is unprecedented. Fascism and Nazism promise to avert the weakness of the flesh by hardening bodies: the obsessive significance of the metaphor of steel can scarcely be understood in any other way. When Hitler issues the order to "harden" one's body through athleticism, to make it "like steel" (*stählern*), he is speaking as a veteran combatant who has lived through the trauma of vulnerability and of physical expiration. The idea is to take a symbolic revenge against this trauma: man, who was revealed to be weak and spineless in the face of the metal of the death machine, must become the same as that machine.

In this context, persistent references to historic archetypes of virility can also be explained more clearly. Because of its scope and duration, the experience of human vulnerability during the Great War was unprecedented. In the face of this resurgent violence, recourse to past models can be reassuring. Despite the destruction of the men at the front, there exists a masculine permanency, the aesthetic and ethical referent to a virility that survives the trials of history by continuing from generation to generation. In Italy, the referent is Roman: the soldier who in 1935 conquers Ethiopia revives the legionnaire of the Roman army in Africa, just as Mussolini, who attends the procession of victorious troops standing beside a full-length statue of Trajan, carries on the lineage of Roman emperors. Thus the circle of eternal Itali-anness is closed, the Duce affirming the continuity of Roman man in spite of the centuries and the minor accidents of history (e.g., the fall of the Roman Empire, the dividing up of Italy). Nazi Germany makes equivalent claims to Antiquity: contemporary German man brings life back to a stone that, in the artistic heritage

of statuary, has preserved for millennia the canon of beauty of the race. Despite the vicissitudes of history, there remains an ideal of beauty, a potential, preserved by art and by biological patrimony, which can be revived through the practice of good hygiene and fitness. Despite the war, the mutilations and deaths, an eternal masculinity exists whose continuity defies the anguish of transience and disappearance. Giving a speech at the time of receiving, in Munich, a copy of Myron's *Discobolus*, Hitler thus declares to his audience:

> If only you could find a standard of measure for the tasks and accomplishments of our time. If only you could aim toward the beautiful and the sublime, so that our people and our art might hold up as well under the critical eye of millennia. . . . If only all of you who visit this House, could also go to the Glyptothek to see to what extent man, at one time, was beautiful and what a beautiful body he had. We cannot speak of progress unless we succeed in equaling that beauty.[10]

The beauty of the Greek athlete[11] requires and provokes emulation by the contemporary German man: derived from the same race as his Greek ancestor, he must embody and bring back to life the ancient beauty preserved for posterity by the work of art. If he succeeds, Nordic man, spanning millennia, transcends the accidents of his recent history: the carnage of the Great War, that massacre of flesh, is finally a small thing beside this virile stone that has traversed the centuries. The Olympic games of 1936 in Germany were a celebration of this communion of the present with eternity, as were the numerous nudes or projects for nude warriors drawn and sculpted by one of the favorite artists of the regime, Arno Breker. One of them, entitled *The Guard* (*Der Wächter*), expresses particularly well the Nazi virile canon. This nude is syncretic: the warrior's face has the physical characteristics considered Nordic by the racial studies of the time (thick, abundant hair, straight nose, high cheek bones, and square jaw); the folds of his outfit refer to Greek statuary, as does his round shield (*hoplon*), the pride of the Hellenic infantryman, or hoplite; his sword, however, is Roman. Thus, one single bas-relief manages to summarize an entire philosophy of history: Nazi virility is an ahistorical archetype that blends the virtues of classical Hellenism, Roman antiquity, and contemporary Germanness—the Greek, the Roman, and the German participating in the same race.

Another element of this bas-relief solicits the spectator's eye: the musculature of the depicted warrior is massive, indeed magnified. With Breker, we are a far cry from the sometimes-slender ephebe of a Greek virility aiming to be fine and supple. Everything here indicates a dense, rigid massiveness. The art historian Daniel

Wildmann notes that, in the 1920s, a change in the depiction of the male nude takes place in photography:[12] the adolescent body recedes to make room for an adult, muscular virility, no doubt as a reaction to the clear frailty of the male body revealed by the Great War.[13] Breker's sculptures are situated at the end of this evolution: the severity of the gaze, the tightness of the jaws, and the prominence of the muscles express an unambiguous strength, an unquestionable virility [cf. fig. 18.3].

This musculature, moreover, seems to come right out of a plate from an anatomy primer. The perfect physiological design and the impeccable symmetry show no element of individualization: no epidermal texture, no scars, no hairiness, no perspiration. Breker's bas-relief shows not an identifiable subject but a holistic type. The acquisition of muscles should not be for the defense and illustration of a narcissistic individual; it is a duty for the protection of the race. More than a musculature belonging only to one person, Breker's design is an armor that belongs to everyone.

Fascism and Nazism make no secret about it: athletics is not an individualistic leisure activity; it is labor aimed at improving and defending the group. Between 1933 and 1936, before the Olympic Games of Garmisch-Partenkirchen and Berlin are held, an intense promotional campaign in Germany stresses this perspective, expressed well in the pledge pronounced by the Olympic delegation in December 1934: "I renounce all pleasures of life and promise to devote myself to this single

FIGURE 18.3 ARNO BREKER, *REPRISALS*. PROJECT FOR A MONUMENTAL BAS-RELIEF, 1943.

This project for a bas-relief by Arno Breker was supposed to decorate one of the monumental buildings of Germania, the new capital of the Reich. The ideal of Nazi man is shown here in a flurry of muscles and maxillary contractions that has nothing to do with the Greek image of man, which is more concerned with finesse and harmony. The reference to Antiquity is certainly present (the drape, the shield, and the sword), but the Nazi man is all about hyperbolic violence: hypertrophic muscles, an oversized sternum. . . . Breker heralds Conan more than he recalls Praxiteles.

Source: © Kharbine-Tapabor

task: to train and to harden (*härten*) my body, to commit myself totally in order to be worthy to fight for my country."[14]

Athletics are a holistic asceticism: the individual gives up every individual element of passion to devote himself to the community, for which his body is but an instrument.

Sports are a combat with oneself, which implies a struggle not only against pleasure but also against laziness, slackening, and discouragement. They thereby show an essential characteristic of the virile ideal: commitment to an extreme degree, to the point of exhaustion, injury, even death. In a famous sequence from her film *Olympia*, Leni Riefenstahl shows one of the horsemen of the German team, a lieutenant in the Wehrmacht, the victor, yet in a cast after having fractured his arm during a test match that he finished despite the pain. In a story published in 1936,[15] the head of the German Olympic committee, Carl Diem, tells the edifying tale of the Greek soldier Philippides who, after having run the forty-two kilometers separating Athens and Marathon, where the Athenians had just won a decisive victory, died, but not before delivering news of the victory to the city. The essential thing, therefore, for those in charge of German sports, is not just participating: one must win, even if it means dying, for the individual is small, and he dies having sacrificed himself for a community that comes out stronger as a result.

FIGHTING

As might be imagined, the struggle with oneself is just a prelude to the struggle against the other: the fascist or Nazi man is, above all, a soldier. Even those professional categories most removed from the battlefield come out of the military. During his opening lesson at the University of Berlin on 10 May 1933, the philosopher Alfred Bäumler asserts in an amphitheater filled with SA men in uniform that scholars and students are "political soldiers:"[16] the figure of the arcane, distant scholar, cloistered in his ivory tower far from the affairs of the city is outmoded. The contemporary intellectual is no longer contemplative but active: his scientific activity is fighting for the race and the State.

This contempt for the intellect and for the contemplative life combines with an exaltation of primitive, animalistic violence: fascism and Nazism promote a return to the existential fundamentals of life stripped bare, which was first brought out by the real experience, then retold, fantasized, and thematized from the trenches

at the time of the Great War. What the veteran combatants describe is from that point established as an ideal: the awakening of the aggressive instinct ("a thing that one has in the blood, an impulse of primitive man, the very gesture of stone age man as he grabbed hold of his stone axe")[17] is no longer the unfortunate regression of a relapsed civilization but a healthy attitude, which, counter to the alienation of a soothing, feminizing civilization, allows man (the male) to reconnect with his natural being. Seizing the pen is no longer acceptable unless this action is a fighting gesture: the art for art's sake of disinterested reflection is no longer tolerated—pen and book are not refuges or enjoyments but weapons.

The scientific community is, from that point on, no longer a learned assembly of dear, solitary colleagues, but according to Bäumler a *Männerbund*,[18] a community of men trained in solidarity and common combat. *Männerbund* is a concept forged by ethnologists to designate masculine solidarity in traditional societies. From a concept the word became a slogan, in fashion in youth movements and then in the Nazi sphere of influence. The Germano-Nordic race is supposed to be an association of men above all, one in which women have only a role as complement or backup. The highlighting of the theme and model of the *Männerbund* is homage to the community of fighters in the trenches, an ideal community of solidarity and courage. Bäumler, who celebrates Nazi virility, stresses the femininity of Weimar: the community of Nazi males—the horde described by Elias Canetti in *Crowds and Power*[19]—reconnects with the virility of the trenches by promoting anew self-control and the ethos of sacrifice after a decade of slackening and neglect.

Where and how does the new, exclusive, aggressive, and combative virility get constructed and educated, if not in the *Männerbund* of the past and future?

Virility is trained through example and emulation. The endless veneration of the dead in the Great War, of the men from Caporetto and Langemark, serves the purpose of bereavement but also takes on a pedagogical function: those glorious dead before whom the City bows have bequeathed their virtues as a heritage. Self-abnegation in the face of duty and sacrifice even unto death constitute the ethos of the new man.

In order to make the sons worthy of their fathers, the reformers of traditional pedagogy propose their recipes. Hitler, in *Mein Kampf*, cannot find enough hateful words for the high school he never attended. Too abstract, imbued with a weak-willed humanism, school trains eggheads without character or will, at best good for reproducing received wisdom and incapable of creating anything: "What is today called high school (*Gymnasium*) is a caricature unworthy of its Greek model. We have completely forgotten in our education that a healthy mind may in the long

run occupy only a healthy body."[20] A fantasy Antiquity is summoned up again in *Mein Kampf* to justify the main lines of a simple pedagogical reform, which will consist of reducing the number of hours devoted to intellectual material so as to emphasize the role of sports, thus instituting a school of firmness of spirit and toughness of body:

> A day should not go by during which the young man does not train his body through all types of sports and gymnastics. In this regard, it is important not to forget one sport in particular, which is seen by a good many of our partisans as too brutal or degrading: boxing. . . . There is no other sport that trains the sprit of aggression as that one, which requires a spirit of instantaneous decision and which bestows upon the body the strength and flexibility of steel.[21]

Hitler, whose athletic exercise was limited to his fondness for a before-dinner walk, scarcely sets a good example, unlike Mussolini, who does not hesitate to pose bare-chested in some athletic or work activity, on skis or during the wheat harvest [cf. fig. 18.4]. The Duce displays his stocky body to affirm the victory of virility over the destruction of war, over the laziness of peacetime and bourgeois softness, as well as over any women's claims of liberation. As for Hitler, he

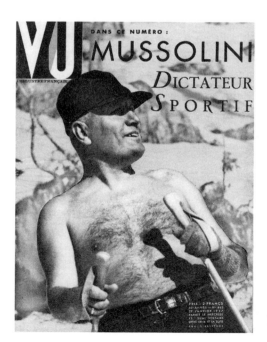

FIGURE 18.4 *VU*, "MUSSOLINI, ATHLETIC DICTATOR," 463: 27 JANUARY 1937.

Playing indulgently on stereotypes about Italian virility, Mussolini takes pleasure in displaying his torso: at harvest time, in the midst of the Battle for Wheat, he grabs armfuls of the crop, and here he poses for the lenses of *Vu* while skiing. Exposed to the elements (snow, sun), the Duce's body personifies the superman of Nietzsche, whom he appreciated but misunderstood. . . . It is this same body that will be hung like a ham from the roof of a gas station and subjected to public condemnation in 1945.

Source: © Leemage

never displays his body and asserts the pedagogical and emulative authority of his virility only by means of a single representational element: the first-class iron cross ostentatiously pinned to his jacket, which vouches pretty well for the essential: his surely undeniable courage during combat in the Great War. Among the higher-ups of the Nazi regime, only Reinhardt Heydrich has himself depicted in an athletic activity, notably as a fencer; a few photographs of Himmler in shorts and singlet are given a go, but they are hardly circulated at all lest people laugh too much.[22]

Primary education should renounce its traditional characteristics and become a *Männerbund*, in the manner of the organizations of the Party and the State, which practice a pedagogy of competitive emulation. Doctrines based on social Darwinism, fascism, and Nazism do indeed stress the beneficial character of placing young men in competition with one another. Solidarity will prevail later, in the face of the enemy; in the meantime, trial by fire. Competition should toughen bodies and harden hearts; soldiers of tomorrow must be trained by the games of today, which, by the way, have an objective quite other than ludic—the elimination from the group of the weaker in body and character.

These principles are applied with special rigor within the schools founded to train the future elite of the Reich: *Adolf-Hitler-Schulen* (dependent on the Hitler Youth) and *Nationalpolitische Erziehungsanstalten* (national political schools under the tutelage of the SS) follow meticulously the precepts posited in *Mein Kampf* by limiting intellectual formation to racial biology, German, and history. This reduction in the number of hours spent on cognitive topics is aimed at reestablishing the ancient balance between spirit and body, ruined by Christianity and by a gutless humanism.[23] The essential part of the time is in fact devoted to a physical and military education, a veritable drill, which, with its portion of humiliation and brutality, is supposed to give birth to a cadre knowing how to obey blindly before giving orders in turn. Ideological teaching, *Wehrsport* (defense sports), and even at times man-hunts that revive the Spartan tradition of the hunting helots,[24] should instill in students an absolute hardness, diametrically opposed to any commiseration or empathy with the weak or the victim. The tradition of the Prussian drill, intensified by the memory of the violence of the Great War, by the Nazi exaltation of fighting, and by the contempt for all forms of weakness, humanism, and pity, ends up being the cult and practice of brute violence, which matches virility with sadism, confounds strength with violence, and makes a virtue of mechanical obedience to the most inhuman of orders.[25] The *Jungmannen* of the Reich's schools for the elite become men at the cost of renouncing all forms of

autonomy of thought or of humanism. The new man does not belong to himself and makes of his body as well as his mind weapons dedicated to the defense of the race of the Reich. Only in this way will men be solidly attached to their comrades and able to found that *Männerbund* whose community is forged by the claimed ethos and the assumed practice of violence.[26]

HARDENING THE CORPS, RESTRUCTURING THE COMMUNITY OF MEN

The fortunes of the term *Männerbund* may provide a supplementary confirmation of George Mosse's theses on the brutalization of European societies following World War I.[27] The warfare acculturation resulting from four years of conflict and an often difficult, at times impossible, mourning over the war dead brought about a persistence of the warrior ethos in Europe, more particularly in the countries that challenged their defeat (Germany) or that protested against a false victory (Italy). In these countries, only by putting on the trappings of the combatant once more could the virility tested by the war be toughened.

The political groups that exploit the resentment provoked by a false defeat or by a mangled victory equip themselves as the first paramilitary militia. The political "militant" is all the more faithful to the etymology (*miles*, "soldier") in that he wears a uniform and has at his disposal a weapon that, even if not entirely comparable to the deadly equipment of the trenches, remains dangerous, indeed lethal (e.g., club, truncheon, or dagger).

After a war that was lost or not sufficiently won, participation in a political militia is the dreamed-of opportunity to win back a certain virile health. The militia offers an ideology and a pride comparable in the civil sphere to the status of soldier in the Great War. Fascism and Nazism continue to maintain the friend/enemy schema in an intensified manner: the war goes on against the dangers of Bolsheviks or Jewish-Bolsheviks; the peacetime state is a trap. Democratic pseudo-pacification aims only at disarming the strong in order to allow enemies to rule the homeland and the race. Fascist or Nazi man takes up arms against this deception and pursues combat, enjoying the prestige of his militancy: the fascist *squadristi* reprise the boastful, indeed nihilistic, motto of the Italian assault troops of the Great War ("*Me ne frego*," "I don't give a damn"), while the SS, the Praetorian guard of the Führer, deck out their caps with a skull and crossbones whose exegesis is

kindly worked out by the weekly SS newspaper, *The Black Corps*. "The goal of this symbol is to frighten the enemy" by signaling the willingness of the men wearing it to accept as well as to inflict death without any qualms. An expression of proclaimed extremism, the skull and crossbones designates the complete man, whose courage allows him to look at the sun and at death straight on; it makes him fit to pay the price of this ideological commitment: "Be victorious or die—that's the meaning of the skull and crossbones as symbol of the man who fights."[28] This nod to death and this readiness for self-sacrifice are eloquently staged and exalted in the two great Nazi propaganda films of 1933: *Hitlerjunge Quex* brings to the screen the fictional story of a poor young man who, at one time courted by communist youth leagues, turns toward the *Hitlerjugend* and, after a few twists and turns, pays for it with his life. *SA-Mann Brand* shows the heroic sacrifice of an SA, victim of a cowardly assassination by communists, just like the young Quex. Loyalty to the cause and stoicism win out as well an unshakeable faith expressed in the last instants of the young Quex's life; he expires singing the chant of the Hitler Youth, those "soldiers of tomorrow":

> Our flag flutters before us
> Our flag is the new era
> And will lead us into eternity
> Yes, our flag is greater than death.[29]

While death is exalted, murder is even more highly valued. The summit of virility is reached when these principles are put into play during combat operations by model soldiers, as when that SS officer gets his men to move forward in the face of a torrent of fire and forces himself to leave his refuge by taking the pin out of a grenade and rolling it behind the last man in the group, provoking a hasty, panicky assault.[30] The man who fears neither death nor murder has won his freedom from inherited moral prejudices and precepts. Fascist man is free, emancipated from moral teachings and others' judgments. He marches and fights for a cause whose necessity he has recognized, a necessity that has become his sole law, as the Waffen-SS sang in their marching song "The Devil's Chant:"

> We care about nothing around us,
> And the whole world can
> Curse or praise us,
> Just as it pleases.[31]

Joining a fascist militia is therefore as good as getting a certificate of virility. Joseph Goebbels knows it well; he is one who hardly appears during official demonstrations except in the brown uniform of the *Gauleiter* of Berlin. He thus signifies his membership in the militant Nazi *Männerbund*, which he risks being disqualified from for two reasons: his doctorate in literature and his clubfoot. Intellectual and handicapped, Goebbels is transfigured just the same by the uniform.

Similarly, wearing the SS uniform signals a particular aptitude for personal commitment: it attests to courage and potential violence just waiting to be put to the test. Himmler is so aware of this that he refuses to let the uniform of the blackshirts become a simple sign. One does not enter the SS just to sport a uniform—even if signed by Hugo Boss, official SS tailor—and parade around like a black peacock. Himmler warns that, once peace returns, SS veterans would have to live on the steppes of the East, at the most distant borders of the Reich, to guard the imperial borders against a hostile world: "The black uniform, of course, will be quite attractive during peace time. From now on everyone will know: if I enter the SS, there is always the possibility I might be knocked off by a bullet."[32] In principle at least, the SS were eager to avoid the influx that had plagued the SA, which was flooded by new members beginning in 1929. The coming of the economic crisis and its social consequences in Germany amply highlighted the attractiveness of the Nazi militia: for an unemployed man, a citizen on the outs, idle and burnt out by his inactivity, membership in the SA adds major significance to his identity. The SA member is a man again: lodged in the SA residences, he becomes resocialized into a fraternity of combat and festivity; fulfilled by a leader and a faith, he again finds meaning in his life; decked out in a uniform, he takes part in the prestige of military matters in a country that esteems them but where, since the Treaty of Versailles (which limits them to 100,000 men), only the "happy few" may be active-duty soldiers. The paramilitary outfits of the SA fit veterans like a charm; the latter find a combat community again, camaraderie similar to that of the trenches, the experience of which, over time and after defeat and crisis, turns out to be transformed into the good old days of virility. As for the youngest, they earn for themselves maturity and prestige that can compensate for the bitterness of not having been able to fight between the Somme and Langemarck.

The Nazi *Männerbund* is described and celebrated by Leni Riefenstahl in long sequences of *Triumph of the Will*. The filmmaker shows the preparation for the Congress of Nuremberg with entire divisions of SA lodged in tents lined up impeccably. She pauses over the morning cooking and washing up as well as the good-natured games of a troop whose ludic gaiety does not rule out, later on, in

the presence of their leaders, the mechanical, transfixed seriousness of standing at attention and the regulated march. This film becomes a nice promotion for the Party's militia organizations, in which a jocose sociability reigns along with a camaraderie of duty.

Most of the SA, however, play soldier on the cheap. It is striking to read in the sources about the efforts deployed by the SA to present its activities as combat operations at all costs. In Silesia, the new SA chief of the *Gau*, Edmund Heines, in 1931 imposes the use of backpacks so that his men look more like soldiers. A work published in 1933, aimed at exalting the military deeds of Nazi troops, evokes in epic, breathless terms the main heroic act of the Silesian SA, the "Battle of Salle" (*Saalschlacht*), in point of fact a bar brawl during a political meeting: "At the time of the struggle against the Young plan, indoor battles ensued. The bang of glasses of beer, the racket of chair legs and table tops, the rattles of windows at the sound of combat songs—all that quickly became a habit that we liked."[33] The terms chosen evoke the "bang" of grenades, the deafening "racket" of artillery, and the "rattle" of machine guns: no doubt about it, this is about a combat operation, not a burlesque brawl of liquored bar regulars.

Signs and words do count then for these men seeking a rehabilitation of identity after defeat and unemployment. In the iconography, the fascist or Nazi militiaman is always depicted under stress, towering above or jutting out forward in a body language signifying pride, readiness, and action. These expressions of aggressiveness and vigilance go along with a whole phallic symbolic field whose impressiveness cannot be solely due to chance in individuals who, like the Nazis, were so concerned with staging. The outstretched arm of the fascist or the Nazi salute is the most obvious example of this, just like the goose-step adopted by Mussolini after his visit to Berlin in 1937, or like the antiaircraft spotlight beams aimed into the sky that erect the "cathedral of light" that Speer wanted above the parade grounds at Nuremberg during the Party congress. This symbolism of the erection, which is also of domination (the pounding of the feet, the raising of the arm in and out of the sleeve, lording it over all), turns up again in the way the fascist orator's ideological message is voiced. While the oratorical art of Mussolini or Hitler cannot be reduced to a simple accumulation of decibels, it is noteworthy that the modulation of their speeches conforms to the greatest simplicity, with a narrow range along the harmonic scale: besides covering a few tones up and down, it is the loud, ejaculatory peroration—indeed the holler—that dominates: the vocal translation of the outstretched arm or of an act of physical violence pure and simple.

CREATING

With the figure of the orator, we begin a final outlining of virility: man expresses and displays himself in the domains of war and sports but also of culture. Man struggles with himself and against others but also against matter in an act just as revelatory of his power, which is that of creation. Virility, which is entirely a projection toward the outside and toward the future (whether it is through the conquest of *Lebensraum* or of an *imperio* or through procreation of descendants), is also illustrated in the inspiration of new works. Each of the fascisms actually reserves a prominent place for artistic creation. Mussolini never lets us forget the cultural merits of Italy, rich in a continuous cultural heritage from ancient Rome to the *Risorgimento* by way of the Middle Ages and the Renaissance. Fra Angelico and Michelangelo are the pride of the race, men who show themselves to be powerful by their creative fecundity. Italian virility is productive of beauty and of works that, stone by stone, construct brilliant, powerful civilizations. This reminder spares no one, not even Nazi Germany—too quick to exalt its superiority—insofar as the Germans were whimpering in the limbo of savagery when the Romans were keeping pace with the Greeks:

> Thirty centuries of History allow us to regard with supreme pity a doctrine from north of the Alps, a doctrine defended by the progeny of a people who did not know how to write and thus how to give testimony of their existence—at a time when Rome had Caesar, Virgil, and Augustus.[34]

The Duce made these inhospitable remarks at a time, in 1934, when relations with Berlin were anything but cordial, but the cultural superiority complex remains even after the warming of German-Italian relations.

Hitler is aware of this; he is consoled by convincing himself that if the Italians are great artists, they owe it to the Nordic blood that flows through their veins. For the Führer, a typology of peoples in the order of their cultural fecundity holds the Aryan on high, without any hesitation whatsoever:

> If humanity were divided into three categories, creators, transmitters, and destroyers of culture, then only the Aryan could be considered to represent the first. From him come the foundations and the walls of all human creations. . . . The Aryan supplies the powerful stones and the designs of all human progress.[35]

Only the Aryan is at once artist, architect, and mason: the pre-eminence of his blood is abundantly proven by the astounding fertility of his intelligence and his imagination. Germany, according to an established slogan, is certainly the "nation of poets and thinkers," cradle of a succession of geniuses, which might be called miraculous, were one to ignore the laws of biology: good blood does not lie.

From then on, it was important to show the race and the world the fertility of the Nordic mind by making of art a window onto the regime. Hitler, who keeps repeating that, although artist by vocation, he became a politician by necessity, lays the first stone in 1933 of a House of German Art in Munich and has a grand exhibition organized annually which gathers together the best of Nordic art, duly selected by a jury. An impressive stream of mountain landscapes, scenes of peasant life, portraits of leaders of the regime, and classical-styled statues is approved and exhibited each year—the production almost exclusively of male artists. The notion that creation is resolutely male is proven, actually, by the cultural commemorations of the regime: art bears the names of Schiller, Hölderlin, Bach, philosophy the names of Schopenhauer and Nietzsche. No woman is honored by the regime with the title of artist for her place in the German cultural patrimony: that is not her vocation. Creation, like procreation, is an active thing and therefore the business of men, even though Goebbels and Hitler know when to turn to the know-how of exceptionally accomplished women, such as the widow of the architect Paul Ludwig Troost or Leni Riefenstahl, who had an exceptional talent for exalting a world of men.

Creation is all the more male in that the Führer and the Duce are often compared to, indeed classed as, artists. Highly accomplished men, Hitler and Mussolini bring together all the denotative characteristic of virility: soldiers, militants, devoted and loyal to their mission, they are fecund geniuses who generate reality. Architects of the State, they are the sculptors who, out of a formless, dispersed mass, that of liberal individualism, create a united, powerful, holistic community. The sycophants of every stripe do not fail to braid the crown of the Muses over the forehead of their masters, who themselves lay claim to the metaphor, as Goebbels expresses it in this letter to Furtwängler:

> We who give form to modern German politics feel like artists who have been given the heavy responsibility of shaping, from a rough mass, the full and solid image of a people.[36]

Totalitarian ambition is demiurgic: and here on Earth the demiurge bears the name of artist.

Soldier, creator, and procreator, fascist man therefore presents the range of power by means of all modalities possible. By spiriting away virtues and qualities from women, he leaves the latter with nothing of value to affirm their dignity: they are limited to a virtual existence and a passive role, while man, sole absolute, is the only one crowned with the merits of activity. All of this is pretty banal, basically: fascism and Nazism are sexisms whose originality is, from this point of view, non-existent. But while this paean sung to the glory of man is hackneyed, the intensity, indeed the thunderous boom of the affirmation, is astounding. Fascist virility is the affirmation of a presence that claims to be all the more dominating and violent as the efforts of identity rehabilitation—indeed reconstruction and healing—became more overwhelming and pressing. Beyond the cultural upheavals brought about by the social and economic changes of the nineteenth century, European virility had to look toward the heritage of a Great War that, far from consecrating its value, instead demonstrated its powerlessness against the extreme violence of the contemporary "battle of materials" (battle of munitions, equipment). Italian fascism and German Nazism did not limit themselves to promising reparations to the peoples shaken by the war and its results. They also created a set of ideas offering disconcerted men the opportunity of getting involved again in a virility bruised by the fire and blood of World War I.

19

WORKING-CLASS VIRILITY

THIERRY PILLON

WORKING-CLASS VIRILITY cannot be separated from the way it is depicted. The image of a strong, masculine workforce, ready for labor and fighting, becomes an integral element of the early twentieth-century imaginary. Tied in part to revolutionary struggles, the image disappears with the weakening of communist parties by the end of the century. But beyond the social and political construction of a myth, it is in the experience of working, in the bonds woven together through working-class communities, that the values of courage and virility are felt. While during the first part of the century male culture found the means of affirming and consolidating itself in daily work, the last part of the twentieth century had a profound effect on its underpinnings. Largely devalued by the transformations of labor and social changes, the brutal affirmation of masculinity in deed as well as word has lost its function as a marker for identity. While the demonstration of virility does not disappear in working-class milieus, it does have less and less support in the domain of labor.

REPRESENTATIONS

DEPICTING THE INDUSTRIAL WORKER

While the depiction of labor and of workers is ancient, a "new aesthetic program"[1] at the end of the nineteenth century foregrounds the industrial worker and highlights such masculine attributes as strength and brawn.

When they focused on scenes of working during the nineteenth century, artists had frequently depicted peasants or craftsmen. Indicative of this

interest for the world of workers are the works of Gustave Courbet, such as *The Stone Breakers*, remarkable for its precision, or those of Jean-François Millet, such as *The Cooper*. Numerous other examples could augment this description of social types of the nineteenth-century rural and artisanal world. In the last part of the century, one aspect of modern social life changes the perspective of the artist's gaze. Industrial development along with the machine and its forces become objects of representation. In 1880, Huysmans sets out the program for it:

> All of modern life is to be studied. Everything is yet to be done. . . . All of man's labor as he toils in factories, on the assembly lines: all of this modern fever caused by industrial activity, all the magnificence of machines—this is still to be painted and will be painted, so long as the modernists truly worthy of the name agree not to shrink back and not to mummify themselves in the perpetual reproduction of the same subject.[2]

Prior to this appeal, painters had gotten to work on depicting the insides of factories and foundries, especially where the presence of fire and the play of light and dark lend the paintings a dramatic character. Such is the case of François Bonhommé, nicknamed "the Blacksmith," whose canvases of the Fourchambault and Creusot foundries stand out in the 1860s and 1870s, for the "naturalist" style of compositions that highlight the grandeur of industrial architecture: metallic structures, girders, machinery, and lifting devices. In *The Indret Foundries*, for example, the workers appear as conquering soldiers,[3] seeming nevertheless to be overtaken by the gigantism of the operations. The same impression is given in the canvas by German painter Adolph Menzel, *The Rolling Mill (The Modern Cyclops)* (1875) [fig. 19.1].

At the very end of the century, the works of Maximilien Luce and Constantin Meunier, both close to socialist and anarchist milieus, again change the attitude toward labor. While Luce, originally from Picardie, mainly devoted himself to outdoor scenes, work at Parisian construction sites, or factory landscapes, Meunier focused on the industrial world and on the mines in northern France and in Belgium, where he was from. The worker holds his attention above all: his body in particular, present, even powerful, and through him the expression of proletarian dignity [cf. fig. 19.2]. Thus, in *The Smelter* Meunier places in the center of his canvas bare-chested workers with finely drawn muscles, manipulating molten iron, protected by a blacksmith's apron. The realism of the scene is less important than the presence of men painted like so many full-length portraits. The worker at the center of the canvas, often half-naked, can be found in many others works of the

FIGURE 19.1 ADOLPH VON MENZEL, *THE ROLLING MILL.*
1875, BERLIN, ALTE NATIONALGALERIE.

For the sake of realism, the painter has represented in the same composition the whole plant and the different activities that take place there: manipulating molten iron, stockpiling it, and taking breaks. By playing on chiaroscuro effects and perspective, he gives the scene a quasi-dramatic look, making the workers "conquering soldiers."

Source: © ARTOTHEK

period: *The Floor Scrapers* (1875) by Gustave Caillebotte; *The Wrecker* (1899) by Paul Signac; and *The Pile Drivers* by Maximilien Luce, for example. But the work of Meunier, which is more "humanitarist" than realist,[4] ennobles this proletarian figure and imparts an allegorical dimension to the life of these men who work with iron and fire. This is what his sculptures convey with even greater force. *The Hammerer*, exhibited at Charleroi in Belgium, summarizes the main traits of a "proletarian iconography,"[5] in which the bare-chested worker keeps returning, his muscles bulging, with his work gear, a tool, and overalls. *The Docker*[6] in Anvers picks up the same imagery of the proud, robust male. The monumental fresco, *Monument to Labor*, still exhibited in Brussels, is inspired by the same ideals.

"The silhouette of the worker was drawn in profile as a shadow puppet, then in close-up, in depictions that disregarded him,"[7] writes Michelle Perrot with regard to the popularization of the workers' movement in France of the 1880s. The male body appears as the allegorical expression of this movement. It is an exalted body, whose

FIGURE 19.2 CONSTANTIN MEUNIER, *FOUNDRY WORKER*.
1920, HELSINKI, MUSEUM OF FINNISH ART.

The blacksmith is isolated in the foreground: muscular back, angular face, naked above the waist, equipped with his tool and his apron. Stylized in this manner, a new image of the worker's body becomes central at the end of the nineteenth century.

Source: Ateneum Art Museum, Finnish National Gallery, Helsinki, Finland/Bridgeman Images.

portrayal seems to indicate that it is the worker's only resource, his only source of pride, his sole weapon against capital. In the major countries of Europe, numerous paintings, engravings, and sculptures rework (at the end of the nineteenth and the beginning of the twentieth century) this image of the virile proletarian. He finds his place, for example, in the large scene of the *Monument to the Republic* (1889) by Jules Dalou, located in Paris, Place de la Nation. In the chariot carrying the tall figure of the Republic, "Labor" appears with the features of a naked man, with powerful muscles, holding a heavy hammer on his shoulder. At the end of his life, Dalou even imagines a workers monument in the form of the "emblem of Priapus:"

> I think I've finally found the monument to Workers that I've been looking for since 1889. The general arrangement would include the emblem of Priapus, God of gardens, symbol of creation—but also symbol of the boundary, cradle and tomb of

the poor man and symbol, finally, of the pipes of the factory, that prison where he spends his life. I want him simple, without decoration or ornament, with, if possible, the serious, imposing feature that Priapus has. Will I get it done? I am pretty old. . . .[8]

Dalou did not realize his project. But the sketches conserved at the Petit Palais in Paris allow us to glimpse what it might have been: a column, bulbous at one end, with figures of artisanal, rural, and industrial labor displayed below. For a number of artists, highlighting proletarian muscle against a background of tall smoking chimneys means also placing proletarian destiny under the sign of Priapus. This is the way the draftsman Théophile Steinlen, for example, illustrates the work of journalists Léon and Maurice Bonneff in *The Tragic Life of Workers* in 1908:[9] a muscular, bare-chested worker, with a steelworker's hammer in his hand and factory chimneys in the background.

In the case of socialist and anarchist illustrators, the depiction of political combat follows a similar aesthetic. In an issue from 1907 of the satirical review *L'Assiette au beurre* (*The Butter Dish, slang*: pork barrel), the draftsman Grandjouan illustrates a violent confrontation, the face-off between workers and soldiers at the time of a mining strike. The illustration draws on the same register of masculine virility, an expression of resistance and of working-class unity: the workers' bodies are taut, their chins forward, their eyes staring straight at the soldiers. The illustrator has accentuated the power of the bare forearms and the hands, gnarled, almost excessive in size, open like claws or firmly gripping a tool, a spade or a stick, some making a fist like a club. The virile strength of the group and their casual power are highlighted by the composition of bodies clustered into a pyramid.[10] The same virile pride, and the same scene of confrontation, can be found in 1948 in a canvas by the communist painter André Fougeron, *National Defense*, "in which naked, muscular miners, forming a luminous hydra, push back the CRS (riot control police), dark forces of repression: workers' power, proud and virile, ensure the defense of the quarry that looms in the background and whose scaffolding follows the line of the workers' raised arms and tight fists. . . ."[11] Two expressions of the same rhetoric of virility; two identical figures of socialist iconography.

FIGURES OF SOCIALISM: THE NEW MAN

By appropriating this new depiction of working and labor struggles at the end of the nineteenth century, the socialist movement fashions its own iconography;

it takes part in a "masculinization" of its symbolic references.[12] The traditional image for the French left of Marianne sporting her Phrygian cap, partially covered by a red flag, is replaced by a theatricalized figure of the blue-collar worker as a muscular man, usually bare-chested, the tool associated with his professional activity, and a factory at times in the distance. Maurice Agulhon has pointed out that this new image appears concurrently with the aging of the female allegory of the revolution.[13] Eric Hobsbawm has stressed the sexism of these images of labor and resistance.[14] The image that the socialist movement creates for itself of labor, through the dominant figure of man, relies on a naturalization of sexual difference, according to which women would be confined to domestic spaces only. Far from the realities of women's work of the late nineteenth and early twentieth centuries,[15] this sexist ideology is coupled with a reduction of labor to activities of strength only, to the sectors of metalworking and mining, leaving aside the textile industry, still important at the end of the nineteenth century, and especially the service and artisanal industries. True, the developing sectors, strategic industries on the eve of the war, are no doubt those on which strikes have the greatest impact. Mining's world of iron and fire is also the backdrop of the main craftsmen in these images—starting with those of Meunier. This simplistic depiction of the worker and the emphatic valorization of strength and brawn and its embodiment in work and labor struggles should be seen as a form of abstract synthesis that Dalou's project pushed to the limits.

In their formal references to ancient statuary, these representations prefigure the pictorial vocabulary of the images of the Soviet worker, although they are not their sole models. Meunier's sculptures and the illustrations at the end of the century portray above all a working-class tragedy; they stress the dignity of the half-naked man, his body providing his sole asset, and underline the hopelessness of his condition and the harshness and grandeur of his struggle. In this "new dramaturgy" of labor these artists show their humanist intentions through work focused on the lives of the humblest. While the communist depiction of the worker shares with these images the comparison of labor power with virility, it also draws on other sources. George Mosse reminds us of the break represented by World War I in the genesis of these images.[16] The ideal of valor that it forged and the ideology of courage, of endurance, and of male aggressivity offered to communist militancy a model for prolonging the fight in the arena of class struggle. Discipline and morality were embodied in resistance to capitalism and in the valorization of labor, the factory becoming the new battlefield. Depictions of the worker that spring from this ideal, amplified by the October Revolution, therefore first stress struggle and

combat. As an example: the cover of the first issue (1 May 1919) of the Bolshevik review, *The Communist International*,[17] shows a man with powerful muscles breaking the chains surrounding the world with his hammer. The movement of the body and the aggressiveness of the look distill the traits of the communist worker-soldier and convey a more emphatic impression of violence and rage than in works of the late nineteenth century. But, although he is always big, strong, and solid, exuding good health, during the Stalinist period the Soviet worker rarely appears half-naked. Mosse sees in this a wish to present an "abstract image of the worker, man or woman,"[18] even if it ends up being embodied in a real personage with the traits of Alexis Stakhanov. National Socialism draws in turn on the codes of Greek statuary to symbolize the "new man." Thus, in Arno Breker's sculptures, nudity and virility unite to express the power of Hitler's regime. This aesthetic will not be taken up again until after World War II in communist regimes such as in East Germany.[19] Mosse underlines the kinship of these communist images with fascist figurations, even though they differ in form: a virility that expresses energy and order, power and solidity; and poses accentuating a frank gaze, head held high, and a firm profile.

In France between the wars, many aspects of this imagery can be found in the works of filmmakers and photographers. The documentary work that François Kollar, for example, devoted to métiers in France[20] often plays on the same register in the expression of virility. The photo of the "railroad porter" (1932), with face in profile, muscles tensed, shirtsleeves rolled up, and bulging chest embodies the unshakeable assertiveness of the self-confident worker; the 1933 photo of the metalworker at the Longwy steel mill keeping watch over his oven shows his broad shoulders and his gaze always cast forward. The lyrical treatment of the situation, accentuated by the photo's black-and-white contrasts, can be found in the cinema, especially in one figure who, in the 1930s, is more central than others to the personification of the worker's power: that of Jean Gabin. In *La Bête humaine*, a 1938 film by Jean Renoir, Gabin shows the same profile that we see in Kollar's photos, with angular jaw, a distant look, forearms bare, and the body half out of the machine [fig. 19.3]. Playing on the diverse forms of the expression of virility, Gabin will manage in film after film to embody them all. In the main places where men gather, the cabaret, the barracks, the prison camp, the construction site, and the factory, he consolidates the qualities of strength, self-assurance, and authority over men as well as women. His is a moral virility, imposing by its power as much as by its reserve.[21] In another idiom, that of the militant film of the 1950s commissioned by the General Workers' Confederation (CGT) or the Communist

FIGURE 19.3 *LA BÊTE HUMAINE*, FILM BY JEAN RENOIR, 1938.

As the figure of the railwayman, Jean Gabin embodies better than anyone else the values of worker virility: self-assurance, strength, and authority.

Public Domain

Party, the filmmakers deploy the same images to exalt the virile resistance of the worker and, through him, that of his class. The miner, for example, appears "often isolated . . . , standing straight in the frame, with powerful chest, dripping with sweat; positioned at the coal face, he and his tool, most often the jackhammer, appear fused."[22]

POLITICAL DISCIPLINE: THE IRON MAN

The image of the virile proletarian also owes a great deal to the construction of an archetype that ideally blends physical attributes, moral virtues, and psychological qualities. It is a social and political construct that espouses the movement of disciplinary and moralizing measures for workers during the nineteenth century. Employers, engineers, and economists do not separate the efficiency of the organization from moral discipline. Karl Marx makes this one of the essential points in his analysis of the development of industrial capitalism. Industrial historians

have kept on stressing these issues. The work of E. P. Thomson, Michel Foucault, and many others has greatly contributed to further elucidating them by emphasizing the sedentary and concentrated condition of workers, the educating of work corps, and the schedules around which the daily routines of working-class families are organized. The reference to virile virtues—strength, productive power, commitment to violence—and their moral equivalents—courage, stoicism, pride—are partly tied in with this concern for discipline. In this regard, employers and political movements, socialist and communist alike, have often drawn on the same sources and dealt with the same images of proletarians dedicated to their jobs. The figure of the miner is worth dwelling upon, so emblematic is it of this construction, which is true for the metalworker or dockworker as well. The development of the steel and metalworking industries, along with other mining industries during the first half of the century, the tradition of struggle in these sectors, and their geographical concentration help construct the image of a worker who loves his condition and who is prompted by values of sacrifice and bravery.

"It takes a lot of long-term persuading and supervising to make of the miner the worker who corresponds to his legend," writes Bruno Mattei.[23] The enterprise begins early. The work of the mining engineer Louis Simonin, *Underground Life, or Mines and Miners*, written during the Second Empire, gives an early start to constructing the heroicized image of the miner: "The coal miner is naturally courageous and devoted. Always ready to sacrifice his life to save that of his comrades, he endures the toughest of trials, as we've seen, with stoic resignation." This "soldier worker, disciplined and energetic," is a man who has managed to break in his body "through the harshest exhaustion and stand up to continual perils:" "Let us salute them," writes Simonin, "as the dark, virile combatants of the lower depths."[24] Up to the beginning of the twentieth century mining companies have had recourse to this "disciplining through mythology,"[25] which draws so directly on the idiom of war. The trade union and socialist movement appropriate this image: at that point a model to identify with takes shape for the entire working class.

Its reprise in Soviet Russia during the 1930s, through such a popular figure as Alexis Stakhanov, is a spectacular demonstration of this. When he goes down into the central Irmino mine in the Donets Basin at 11:00 p.m. on 30 August 1935, Stakhanov is ready to set a record to mark International Youth Day. He is accompanied by the site foreman, Petrov, a party organizer, and Milhailov, editor of the mining newspaper. He sets out with his jackhammer to attack the 85 meters of strata. When he comes back up at 5:00 a.m. on the thirty-first, he has knocked off 102 tons of coal. Stakhanov mines fourteen times the average load. Of course,

conditions are exceptionally good and do not take into account the preparatory work, the help of other laborers and of retaining wall workers, or the time for rest. But the only thing that counts here is the "record" and how it is used politically: "My record," he says, "would only have been a record if they hadn't managed to draw from it practical conclusions for the work of our shaft and of our mine."[26] In November of the same year, Soviet authorities organize a "Conference of Vanguard Workers." Running counter to company managers, engineers, directors, and technicians, the propaganda exalts the "heroes of labor," the "Stakhanovists:" interviewed, photographed, filmed at their workplaces, crowned with socialist glory, they are, as V. M. Molotov says in 1935, "a veritable groundswell, a potent force."[27] Stakhanov's picture appears on the front page of newspapers, down in the mine, jackhammer in hand, absorbed in his effort. His smiling face as a proud, modest worker even appears on the cover of *Time* on 16 December 1935. Stakhanov always keeps his mischievous smile and his jackhammer, whether in a photo at the head of a group of workers or mounted as a bronze statue; the tool rests on his shoulder like a gun. He is even seen with his mining coworkers in procession, jackhammer on his shoulder, alongside Stalin. And, like Stalin, he sometimes raises an arm as a rallying sign or as a salute. The "hero of labor" brings together the main signs of glorified virility: the ubiquitous tool, pride, courage, and combativeness.

In an article from *Pravda* reported in *L'Humanité* in 1936, we read: "The Stakhanov movement reflects like a mirror the gigantic success of socialism. . . ."[28] Between the hero of labor and the party, a whole play of mirrors is put into place. The French Communist Party will play this dialectic of gratitude to a fault beginning in the 1930s. Physical strength, sturdiness of body, worker self-confidence—and most especially that of the miner—become idealized into political virtues. Marc Lazar has studied at length this veritable "political myth":[29] for the French Communist Party (CP), the proletarian is at once "loyal, fraternal, disciplined, courageous, virile, unshakeable; resolute, tenacious, generous, determined, etc."[30] His character is a triumph of strength and resistance as well as action and morality. In the 1930s, Maurice Thorez, a miner turned CP leader, personifies the qualities of dignity and courage that are as much those of his class as of his profession. After the victory of the Popular Front, in a hagiographic work, Maurice Sachs describes him in this way: "he is stocky, his body is solid. He carries on his rather broad shoulders a head whose most persistent expression is a laugh"—like Stakhanov, one might be tempted to say. His "forehead is uncovered," and when he speaks "his face takes on . . . a certain grandeur; and, while he does not transform himself really, the timbre of his voice transforms everyone and enhances the figure who is speaking. . . ."[31] Thorez's hands,

"small and strong" with "broad palms formed by the manual labor of childhood," have the peculiarity of being those of both worker and intellectual. The union of power and reserve constitutes Thorez's singular strength. The rhetoric is persistent in the language of the French CP. In 1950, *L'Humanité* describes Jules Bonnel, trade unionist, Resistance fighter, and miner, like this: "Stocky, broad-shouldered, solid. Traits that express energy, intelligence and uprightness. His whole being gives an impression of powerfulness under control."[32] The working-class hero and the communist leader bear visible marks of the class they belong to; they are those emblems of a collective body in which workers are urged to recognize themselves. In this working-class body, the hand holds a particular place. It embodies strength in movement, close engagement with things, and a weapon against exploitation. Symbol of power deployed on the job, it is also a rallying sign when it is raised, fist clenched, in the face of oppressors. The CP will appeal unreservedly to this "semiology of the hand:"[33] it can be found throughout the tradition of political illustration. Up to the 1980s, the CP and the CGT will use these images: hands closed around chains that are being broken, bare forearms, raised fists, hands resting on tools and on machines, and even men's hands joined together in a sign of class solidarity.

WORKING-CLASS VALUES

Taking a look at labor and its development allows us to see the benchmarks of virility differently. The ways of being a man relate to the different uses made of the workforce over the course of the century. From streamlining between the wars to the technical and social transformations of the 1950s and 1960s and up to contemporary unemployment, the conditions for acclaiming working-class virility are morphing. To trace their oscillations, we shall rely on eye-witness accounts, memoirs, and workers' autobiographies. Giving the floor in this way to the workers also means granting importance to the role of storytelling in the affirmation of virility—stressing that it shows up as much in the domain of practice as in that of talk.

"HANGING ON"

Historians and sociologists have often demonstrated it: working-class culture is a culture of spending[34] and of putting one's body on the line. It involves values tied

to labor and to the forms of socialization that have prevailed for a long time in working-class families. The early experience of work and its hold on individuals' lives; multitasking up to the end of the nineteenth century, then stabilization of the group; establishment of family continuity in a single trade beginning in the 1930s—all of this builds solidarity between generations around the values of effort and courage. This must be seen, no doubt, as making a virtue out of necessity. The social status of workers actually offers few chances of moving upward; within companies social relations are harsh; work conditions, hygiene, safety, and the ergonomics of the posts are deplorable for a number of professions until after World War II. Before the automation of material handling tasks, and even after the deployment of streamlining, the causes of other burnouts in a number of métiers—road workers, miners, dockworkers, and metalworkers, for example—required physical abilities of strength and power mobilized on a daily basis. Physical committedness, courage, and toughness thus remain the essential resources of labor for a long time; they bestow upon workers a legitimacy at times as precious as professional know-how. Accounts by miners, for example, all stress the roughness of the work and the imminence of danger. Constant Malva describes, in particular, the insensitivity of miners. Through fatalism or exhaustion, the "imperative to be brave" preserves the workers by helping them "hang on." This is also the case for manual workers in the salt marshes, whom Georges Navel speaks about between the two wars: "The weak or feeble-minded are pitilessly eliminated by the pace of the work."[35] And in the 1950s men are transporting 100-kilogram sacks on their heads, as Alfred Pacini describes it, along the docks of Marseilles.[36]

At the smaller workplaces, the tasks are no less difficult and the conditions no less dangerous. The autobiographical narrative by René Michaud, cobbler apprentice between the two wars, evokes a world of ordinary violence toward the youngest men. The injuries and ill-treatment require of them physical strength and, above all, firmness of character, which they are forced to acquire rapidly. The dedication to work, moreover, validates belonging to the world of men and remains the prime engine of apprenticeship for a long time. The miner Louis Lengrand recalls his arrival at the mine in the 1930s: "At eight years old I said to myself: 'Can't wait till I'm 13 to go to work.' When you go to the mine at 13 years old, you have your Sundays off, and you are truly a little man."[37] Jacques Tonnaire makes of this devotedness one of the qualities of a good railway worker at the time of the steam engine: "An engineer must learn to overcome incredible fatigue, break himself in hard from the very first moment and refuse any kind of self-pity."[38] Admission into the world of men has other kinds of support: alcohol, for example, with initiation

represented by the young worker's first bender, which Jean-Pierre Castelain speaks about among dockworkers.[39]

But the roughness, the acts of bravery, and the worker's courage have already been agreed to as conditions of the job. In Constant Malva's mine, the output regimen establishes a competitiveness among the men that has nothing in common with Stakhanov's heroism but reveals instead an oppressive social domination. Suspected of not working hard enough, Malva accepts the challenge: "They suspected me, and I defended myself well. Except that, in defending myself against the strong guys, I killed at the same time my weaker coworkers."[40] This is why the hardened character, elevated to the status of a moral attribute and so often affirmed in witness accounts, imposes on men new challenges, which contain so many new risks. Navel tells of the "fright" he is seized by when starting at Citroën and wonders about his ability to hold up: "Will you be as strong as the others?"[41]

PROLETARIAN STRENGTH AND ACTS OF VIOLENCE

It becomes clear from this that "labor seen as hand-to-hand engagement with things has its equivalent in dares and confrontations seen as hand-to-hand combat with other people."[42] Self-assertion and violence are frequent themes in discussions of working-class manners—discussions shared by observers and by workers about themselves. The meaning of this violence nevertheless changes over the course of the twentieth century. Narratives by journeymen during the last third of the nineteenth century relate scenes of the greatest cruelty: "Here's what you saw every day in town, like out walking: workers would meet; they wouldn't know one another; they've maybe never seen each other before. And so—without the slightest explanation, they would usually rush at each other like ferocious beasts."[43] Fights that leave men "torn up and bloody."[44] Although less definitive, the use of force pervades exchanges between Parisian workers in the late nineteenth century: "He won't be pigheaded in words, but he'll pack a powerful wallop," writes Denis Poulot in 1869 with regard to the "sublime" stubbornness of those who can't be disciplined.[45] "In the laboring class, muscles make the man as much as skills do," he goes on to say. To stand out, know-how and the reputation of being a good worker are worth just as much as "the display of big biceps."[46] In the course of the survey he takes in cabarets and working-class neighborhoods at the very end of the nineteenth century, the journalist Henry Leyret notes how quickly men resort to their fists to settle a disagreement: "From 15 to 30 years old, the worker seeks fist-fights—a matter

of keeping his muscles in shape!"[47] He delineates a characteristic peculiar to the class based on this taste for confrontation: "Workers are strong men, and they like strength; they maintain an admiration and a respect for it."[48]

From this admiration of strength comes the foregrounding of the vigorous man whose attributes are all it takes to signify his value: "Riton, a young road worker of 18, built like a colossus with bulging muscles and a powerful chest";[49] the "hardened jaws" and the "bare muscles" of salt gatherers;[50] the man who is "built like a Hercules."[51] Or again, this note that seems to pick up the traits of Constantin Meunier's sculptures: the "hairy blacksmith whose brutal interjections had the roughness of the scrap iron he was molding."[52] The temperament is crafted in the image of the body—brutal, rough, and above all courageous. For the weak man who cannot "bear the pain," who cannot be counted on, is missing some part of his masculinity.[53] The account of glorious scenes, valiant fights, "battles, brawls, amazing feats"[54] embellished by the group's memory also comes from this exaltation of strength. For a long time people talk at great length about the great deeds of some men, armed with axe handles, enacted against the "cops," the "scabs," the "bastards." One scene reported by René Michaud is significant:

> Young Henri recalled with pride the day a cop had ventured a bit imprudently into a group of fist-fighters, and he suddenly found himself face to face with this big, brutal guy. And Henri's voice shook as he told about the pathetic moment when, with two direct, well-placed punches, the big guy laid the cop out on a rubble heap.[55]

Ready to clash with matter, with other men, with the police—these are qualities that must be taken on, implemented, or at the very least transmitted and embellished in memoirs.

For we should not underestimate the part that theatricality plays in these narratives. Although the acts of violence are often vouched for, they reveal a ritualization that should not suggest a world of pure fury. Over the course of the twentieth century, relations between men are still brutal; the violence, however, seems diminished compared to the accounts about journeymen, some of whom lost their lives in fights along the roads of France.[56] It is not that references to strength and its uses lose their significance. But the social and juridical changes—in particular, the right to work—that structure relations between workers and bosses as well as the codification of professional training and career paths, confer on the spoken word such value that acts of explosive violence get a lot of press.[57] This does not eliminate

the symbolic order of a male world defined apart from women in which courage, strength, and temerity remain collective markers.

But confrontation, while still direct, takes some detours: often it only takes a little intimidation to impose one's authority. Physical power and the "magnetism" of certain men suffice to bring conflicts to an end,[58] Jean Oury reminds us after World War II. One scene will reveal how violence has been displaced. In a small metalworking company in the early 1950s, Oury gives an account of a veritable duel of strength. Between himself, a young worker, and an older man a fight breaks out over driving a metal stake into the ground; with everyone watching, they compete for who will hammer faster, harder, imposing his rhythm on the other; the fight is violent but displaced, with no physical contact between the two men, who never-theless confront one another with "rage," like "madmen," "indirectly." The victory of the young worker will win the men's respect; "the wanker's getting flabby," they say; a few more punches with a "company bully" will end up making him equal to the others.[59] The "big mouth," the man who "stands up to the bosses and managers" is a persistent figure in the working-class world, where "any weakness of character is prejudicial."[60] Virile confrontation in this case consists as much of speech as of actual violence.

WEARING OUT OF VIRILE VALUES

STREAMLINING OF LABOR AND VIRILE RESISTANCE

The twentieth century is marked by rapid developments that disrupt reference points for identity. In this regard "Taylorism," the name given to the principles developed by the American engineer Frederick W. Taylor, represents a profound change. Of course, "Taylorism" does not permeate equally all sectors of industry; its applications are not always faithful to its inventor, and while it is present in large factories, smaller shops, still numerous between the two wars, are outside the influence of its methods. But the root of Taylorist principles—prescription of operating modes and times, precise timing—dispossesses workers of a major part of their organizational autonomy. Between the worker and his labor is interposed a supervisor in charge of organizing the work. The supervisor is no longer the man-ager or taskmaster of olden days, when work teams were still organized by them-selves, served multiple purposes, and forged interpersonal relations based on skills acquired over time. Time calculation, standardization of parts, and simplification

of operations individualize and specialize the work. The logic of the job gives way to a new salary framework and the contracting of training courses, of qualifications, and of wages. The new work discipline, tied to efficiency, becomes a national issue at the time of World War I. The assembly line, which Henry Ford finalizes in 1914, applied in France to the production of mortar shells during the war, is developed in the automotive industry during the 1920s.[61] Taylorism and Fordism combine between the two wars to create a new industrial landscape and new work habits that require other physical and mental aptitudes.

It is not that the use of strength disappears, any more than does its function to signal virile identity, but the organization of labor implies other activities and consequently other stressors that are less dependent on brute energy than on sustained attention. For workers obliged to do the most repetitive tasks, boredom is predominant—the monotony of simple gestures, always identical and repeated all day long. Engagement is intense, to be sure, for the pace is increased (the first implementations of efficiency timing in automobile factories actually leads to strikes—at Berliet in 1912, at Renault in 1913), but it demands less effort than attention and skill and more maintaining of energy than exerting of strength. The particular wear and tear produced by assembly line work acquires its own designation: "industrial fatigue." Georges Friedmann has described this fatigue in the large Taylorized factories between the two wars.[62] He has shown how the pace of "piecework" lowers nervous resistance in the strongest of men and leads to anxiety and affective and nervous disorders, as vouched for by psychologists as soon as assembly lines were set up in France.[63] And the force that Simone Weil speaks of in the factories of the 1930s is mainly that which allows resistance to exhaustion: "I am very close to concluding that the salvation of a worker's soul depends first on his physical constitution. I do not see how those who are not sturdy can avoid succumbing to one form or another of despair."[64]

Efficiency norms quickly appear for what they are: insidious requirements with which the worker is not always in a position to comply. According to Navel, who went through the experience, they require the first worker up to attain a record that is in reality inaccessible: "Timekeepers and samplers fought against the worker."[65] In this case, muscular power is no longer a resource. In the automotive factories, for example, "flunking" referred to workers' inability to keep up with the pace of the assembly line; they were overwhelmed and literally overtaken by the work. The more skilled, toolmakers, regulators, who are in charge of precision operations, are nonetheless subject to the rational organization of the work. Navel again describes them at the Berliet plant in the 1930s:

Their hands made only a small back-and-forth movement. They carried out a job of extreme precision. [. . .] For a long time their work required no stress from them; there was boredom, but a boredom accepted and digested. None of them felt like becoming a road worker in order to go back to a life involving the whole body.[66]

The disappearance of worker initiative for a large part of the personnel at Taylorized factories opens to insidious questioning the values of virility not only in terms of abilities, limited from now on to a structured performance, but also by revealing a new kind of wearing down caused by small, brief, and repetitious actions.

Skilled workers do not disappear, for all that. In numerous industries, they assert their skills and succeed at impressing the boss, at least when the labor market permits it. Quitting the company without notice, for example on impulse, is still an affirmation of pride. Maurice Aline, a worker between the two wars, recalls this about toolmakers in the Paris region: "If something was not to their liking, they would say to the boss, with a certain casualness: 'Cash me out, I'll collect my tools and pack my bags.'"[67] The same experience held true for René Michaud, cobbler apprentice: "One slightly salty expression from the manager, a slightly abrupt questioning, which my precious pride could not abide, and I would leave the place. . . ."[68] In the large Taylorized factories, worker mobility represents, along with lounging and sabotage, continual forms of everyday resistance. Among these acts of assertiveness, the self-inflicted injury, called the "*macadam*," gave the worker the benefit of a work stoppage covered by medical insurance. In the mines, before World War II, Xavier Charpin cuts a coworker's hand with a stone. A ritualized episode, a show of virility in which each plays his part as the other looks on:

We pull off the stunt neat and clean; the skin is broken by the stone. Hector doesn't say a word. He shakes his hand every which way. He looks like he's hurting a lot. Very quickly, he collects himself and calms down. He puts his finger up to the lamp. The cut is bleeding a little—it's pretty deep, and the fingernail is torn away. Hector looks at me; he seems relaxed, though slightly pale. His voice shows no sign of emotion: "It's O.K.; I've got my wound; I'll have time to take care of myself. Touch my hand—you're a real man. I never thought you'd be able to do it."[69]

In these practices, which between the wars can still establish reputations, we should see, no doubt, an expression of those "defensive strategies" that psychologists talk about;[70] through such practices, the identity is asserted of a class "whose wealth lies only in its labor power," as Pierre Bourdieu has written.[71] But

the moment this power is no longer required by labor, the values that it supported grow weak as well.

SOCIOLOGICAL AND TECHNOLOGICAL CHANGES, TRANSFORMATIONS OF WORKING-CLASS VIRILITY

Between the 1950s and the early 1980s, the working class undergoes changes that deeply affect its values, its points of reference, and how it is depicted; virility is no exception. Though the postwar period experiences a growth in the number of workers, it does so at the price of a diminution of its relative percentage in relation to salaried employees as a whole and a deskilling of one part of the group: a gradual rise in the number of semi-skilled workers and manual laborers, principally women and immigrants. Beginning in the 1970s, the transformations in the French industrial landscape and the crisis in the large steel mills and mining fields result in the upheaval of the foundations of collective identity. The values of dignity and the pride in workmanship rooted in a métier or a specialty are directly affected by these changes. Professional mobility and new types of housing and consumption contribute to the unraveling of traditional communities. Since the end of World War II, workers have been experiencing an improvement in their quality of life; "consumer society" is accessible to them and mass media open up other cultural reference points for them. But this opening up of the group takes place against a backdrop of massive unemployment beginning in the 1980s. While these changes are gradual and produce different effects, depending on the categories of the workers, they demonstrate nevertheless a profound transformation of the standards and values of the group.

In numerous métiers, however, possessing strength is still imperative. This is first because of the forms of organizing work, as on construction sites, for example, where despite the progress made in automation, many tasks require a considerable deployment of physical force. The same is true among dockworkers and miners. In the factories, the institution of Taylorism does not eliminate virile behavior. The monotony of the work leads to erotic dreaming: "Nightfall arrives, and so do our phantasms," writes Charly Boyardjian in his account of factory work in the 1970s. The symbolic confrontation between men is kept up: ". . . Don't talk about fucking, you got such a small tool there! . . . When you've fucked as many girls as I have, you'll have the right to talk."[72] In this world of the factory, the body remains a resource that ensures one's place in the group of men: "We shouldn't

forget the automatic, widely used gesture that consists of feeling the weight of a friend's testicle sac," writes Marcel Durand with regard to Peugeot workers in the 1980s and 1990s. Exhibiting one's anatomy in response to an insult belongs to the same register of display and defiance—surely a comforting gesture for these workers, who are French males and for whom "it's reassuring to know there are some more exploited than oneself: immigrants and women."[73] But here the bragging and the confrontations do not refer back to a legitimacy acquired or valorized through labor. This type of behavior is probably less a matter of "moral benefit"[74] than a way out of boredom and repetitiveness. No doubt the most senior still seek legitimacy in the assertion of physical dominance. Such is the case of union delegates, for example, who are often "big mouths." Similarly, among former miners there still persist those spending habits, "valiant bouts of anger" and "agonistic generosity" that Olivier Schwartz describes among workers of the North in the 1980s. Such activities as gardening, odd jobs, and moonlighting, which men get into unreservedly, reactivate a masculine form "of agonistic involvement with things" that for a long time on the margins of labor was the means of getting additional income.[75]

But meanwhile, automation has transformed workers' labor. Though the movement begins earlier, it affects more and more professional specialties after World War II, and especially since the 1960s and 1970s. New skills appear—and with them new workers in charge of surveillance and the tasks of controlling the automated processes. At that point the term "new working class" is used to designate these workers, who are henceforth freed from work involving strength and whose new name/title aligns them with white-collar technicians.[76] The changes cause a gradual separation from the work material, a loss of contact in favor of screen, keyboard, and desk—at least for the fringe of skilled workers. There is a tendency toward expanding the "service sector" of the activity, in which physical exertion is no longer constitutive of the job and which is conveyed by euphemisms: no longer worker but "operator," "monitor," "associate." Otherwise, the feminization of labor, traditional in industrial and service sectors, today concerns every activity—to the point of speaking of an "inversion of genders" for certain professions.[77] To this is added the strong trend, since the 1980s, toward individualization of careers, of remuneration, and of skills, now called "competencies." The most contemporary forms of labor organization also structure worker initiative. The proliferation of rules and procedures, the continual control of work, the evaluation charts, and the respect for "quality norms" limit the free play of know-how based on experience. Finally, the proliferation of short-term labor contracts, especially temporary work, atomizes labor collectives.

The forms of virile sociability, furthermore, are weakened by the lifestyles and work modes of the younger generation that has benefited from the prolongation of their *lycée* study, the acquisition of professional diplomas, and the idea of social advancement by means of intellectual work. Changes in points of reference and practices and more pervasively in class lifestyle undermine identification with former workers, which used to serve as a means of integration. Thus, in the renovated workrooms of hospital cleaning services, where desks have replaced workbenches, the youngest workers give up posting nude pin-ups, identified with a "traditional territory of virility," in favor of a more individual appropriation of the premises.[78] The work unit itself is different from that of the older workers. "Visual conformity," bearing, gesture—what Bourdieu has named bodily "*hexis*"—clearly distinguishes the young workers from the older ones.[79] In certain working groups, the young abandon the blue overall, the primary working-class symbol, in favor of jeans and T-shirts.[80] They play on other behavioral registers that result from an expanded culture and classroom socialization. Speech re-establishes its rights over the most brutal forms of self-assertion. A young union delegate in an automobile factory thus tells that he "right away understood" that he "had to lose" his "glasses and wear contacts." . . . Glasses were not okay with the "old guys."[81] At the workplace, the opposition between the young and the old reflects a "crisis of succession" at work in other domains such as family and culture.

Having lost their legitimacy as a result of the new forms of labor organization, workers' acquisition of education certificates, and the erosion of community ties, the values of virility are affected more than anything else by massive unemployment. With it, the principal spaces of masculine legitimacy recede: in the workplace for sure but also in the social situations associated with it: the café and friends. This "investment from the outside" is from then on threatened by a "reflux toward familial space," which is traditionally feminine.[82] Running away, self-destructive behavior,[83] or commitment to domestic affairs: male reactions are diverse but they are all signs of an upheaval in social roles on which the legitimacy of virile conduct was based. The youngest cannot evade the movement; certain ones see looming the devaluing of their educational credentials without being able to turn to traditional resources offered by work that involves use of the body.[84] As has been said with regard to England, the working class is "threatened in its economic survival, but also powerless to get to the root of it by traditional physical resources alone."[85] This weakening of the values of working-class virility winds up on the terrain of politics. Besides the decline in the Communist Party's influence and in union membership, it is the forms of face-to-face protest that

are tending at this time to soften, to favor self-control—indeed to abandon violence during protest demonstrations.[86]

ENCLAVES OF VIRILITY

No doubt the values of combativeness and energy have not entirely disappeared though. They reappear among the youngest workers, in those "last bastions of the expression of virility:"[87] sports, especially team games, such as soccer, in which a male collective is maintained and reiterated as matches and training take place.[88] There is here a public demonstration of physical qualities, along with pugnaciousness and aggressiveness: the extolling of strength, the withstanding of pain, and collective rituals such as showering. The masculine sociability of these young men recovers former characteristics by which physical exertion is displayed for evaluation by the group and contributes to male bonding.

Working-class youth, those of the "projects" along the beltways of large cities, reproduces in its way the traditional forms of behavior in which violence and physical skills still represent major identity markers for boys. The very old link between body and character, between bravery and moral authority here maintains its pertinence.[89] References to force, to strength, to toughness, indeed to insensitivity toward social relations, sketch out a symbolic universe in which the ritualized use of violence, both physical and verbal, constitutes a legitimate means of settling conflicts and asserting oneself. David Lepoutre has studied at length among youth of the "projects" the complex ways of starting fights, their codes, and the norms that organize them. In the eyes of others, not every act of violence has the same value: in group combat, for example, regardless of the boisterousness of the action, one must know how to stay in character and not turn away when one is a boy known for fighting like a girl—i.e., by scratching and biting.[90] It is therefore a complex violence, in spite of appearances. Speech holds a pre-eminent place through verbal sparring, in which the most eloquent stand out, the "big kidders" and the "gabbers" being the most impressive.[91]

Still, these enclaves of virility find no counterpart in the work world—quite the opposite, actually. Gang behavior remains poorly adapted to the shop floor environment and its discipline. The "youth of the projects" find themselves destitute, isolated between the oldest of working-class traditions and young women, great numbers of whom work today in the factories. Their virility ends up "discredited" as a result.[92] Labor also keeps its distance from the outbursts of collective acts of

violence. Thus, recent "riots"—those of 2005, for example, which were partially political in character[93]—find no relevance in the institutional logic that held sway for so long over work conflicts in which the working class had been engaged since the 1930s. Identification with one's own territory, the rejection of the police and social institutions, and the experience of arbitrariness explain, above all, these working-class revolts.

Manifestations of working-class virility have been developed and maintained by speaking out in a self-justificatory way. Because of technological changes and the weakening of community ties, that kind of speaking out has today lost its legitimacy in the work world. It is no longer able to reflect practices that have now lost their validity.

20

HOMOSEXUAL TRANSFORMATIONS

FLORENCE TAMAGNE

FOR A long time, men who had sexual and/or amorous relations with men were defined not so much by their sexual practices as by their gender role (female) and sexual position (bottom). Beginning in the middle of the nineteenth century, with the particular influence of medical discourse, the "homosexual," a term employed for the first time in 1869 by the Hungarian writer Karoly Maria Kertbeny, came gradually to be categorized as a being apart, defined by his orientation and his sexual practices, who would thus be the opposite of the "heterosexual."[1] While homosexuals have been documented in the U.S. since the late nineteenth century, the term *gay* does not become widespread in Europe until the 1970s, following the lead of the gay rights movement. Its usage conveyed the wish on the part of homosexuals to be demarcated from the old defamatory words, while maintaining, by dint of the double meaning, the culture of secrecy in a society still marked by prejudice. At first applicable across the board, the term *gay* soon became reserved for men, women preferring to be referred to as lesbians. Beginning in the 1990s, the salvaging of the insult "queer," which means both "bizarre" and "faggot," denoted a critical movement with regard to a gay culture on its way toward normalization but also the questioning of the binary representation of sexual identity (homosexuality/heterosexuality) in favor of a more fluid and unstable conception of gender and sexualities. The choice today to speak of LGBT (Lesbian, Gay, Bi- and Trans-), indeed LGBTQI (Q for Queer and I for Intersexual) highlights the wish to reintegrate groups such as bisexuals and transgendered people, who have long been marginalized, into the gay community.

For Didier Éribon,

the contempt, at times the hatred, of those who like to think of themselves as masculine or virile toward "effeminate" men has been one of the great dividing factors, not only in the way that homosexuals have wanted to depict themselves but also in the rhetoric that has accompanied those images.[2]

Whether it is a matter of asserting difference by affecting, for example, a flamboyant manner, of marking one's refusal of stereotypes by preferring a hyper-virile presentation of self,[3] or of spreading confusion by blurring the signs, the play on appearances is at the heart of homosexual identities, for it allows both the expression of a personal sensibility and an affiliation with a group.[4] Nevertheless, and in spite of the numerous images that have come to complicate and/or contradict the cliché, the stereotype of the effeminate "invert" continues to pervade the way he is represented. The homosexual is still often perceived as a "dud" of a man, one who has failed the tests of virility. It is therefore important to "be a man," not to appear or act in a way that implies that one might be a homosexual. Insults such as "faggot" or "*enculé*" (butt-fucked) currently in use thus function as reminders of compulsory virility, which is also compulsory heterosexuality. While for a man loving, desiring, and/or having sexual relations with men constitute a challenge to what R. W. Connell calls "hegemonic masculinity," not all gays describe themselves as at odds with the latter or agree on the same definition of gender relations.[5] Under these conditions, the very notions of virility (which, from an essentialist perspective, would refer to a quality assumed to be proper to the male sex) or masculinity (which refers to the different constructions of the male gender) tend to be ambiguous. As Judith Butler stresses, "if gender is something that one becomes—but can never be, then gender is itself a kind of becoming or activity [. . .]."[6]

GENDER INVERSION, ANDROGYNY, AND TRANSGENDER

The homosexual had been defined at the end of the nineteenth century as a virile counter-type.[7] Certain militant homosexuals, such as Karl Heinrich Ulrichs and Magnus Hirschfeld, asserted the existence of a "third sex:" the "invert" was said to have "the soul of a woman in the body of a man."[8] While some men identified fully

with this image, others chose an effeminate presentation of themselves in order to fit better into the homosexual subculture or as a strategy aimed at capturing the attention of "heterosexual" partners. In the eyes of the public, the figure of the invert was often associated with leisured milieus or with artistic bohemianism, later becoming simplified as a figure of the decadent dandy à la Oscar Wilde, an image projected in the aftermath of World War I by such figures as Jean Cocteau or Cecil Beaton.[9] In working-class milieus also, however, "*tapettes*" and "fairies" chose to show themselves publicly in a feminine manner by means of make-up or gaudy accessories. Male prostitutes, taking on the names of actresses in vogue, affected enticing poses in a way that would better enhance their business but also to elicit the desire of men who did not think of themselves as homosexual but who were nonetheless attracted to their charms.[10] Even within the middle class, certain highly colorful personalities, such as Quentin Crisp, would not hesitate to go out made up and dressed as women at the risk of being attacked on the streets or more simply of being turned away at gay bars on the pretext that they were attracting too much attention.[11] In fact, during the 1920s and 1930s in London, police in charge of the surveillance of homosexual meeting places considered that possession of moisturizing cream or a pocket mirror sufficed as proof of a suspect's homosexuality. A majority of men therefore sought to pass unnoticed and to conform strictly to the gender norms in force, at least in public places. It was, however, possible to turn one's nose up at the conventions at any one of the numerous costume balls organized in Berlin as well as in Paris (Magic City, the ball at la Montagne Sainte-Geneviève), London (the Hampstead Ball), or New York (the Hamilton Lodge Ball in Harlem). For one evening, men in drag could dance with each other—and women with each other as well—often as a curious group looked on. The flamboyancy of the homosexual scene became an archetype of the "Roaring Twenties" celebrated by writers (Christopher Isherwood, *Goodbye to Berlin*, 1939), painters (Otto Dix, Christian Schad), and photographers (Brassaï) [cf. fig. 20.1].

The androgyny vogue, of which the "butch" look was the best known among women but which had its masculine counterpart, played into gender confusion during the 1920s. The 1930s saw the return to a more traditional masculine mode, supposedly to convey the necessary return to order in a period of crisis. Zurich, for example, experienced at the time a "virilization" of the gay scene.[12] While the noisy acting-out did not disappear entirely, discretion was required up to the 1950s, a time marked by strict moral conformism. The injunction of invisibility was issued not only from society as a whole but also from homophile movements created at the end of World War II. Reformist and assimilationist, they hoped that

FIGURE 20.1 BRASSAÏ, *TRAVESTIS DE MARDI GRAS AU BAL DE LA MONTAGNE-SAINTE-GENEVIÈVE* (MARDI GRAS TRANSVESTITES AT THE MONTAGNE-SAINTE-GENEVIÈVE BALL), CA. 1932.

In the early twentieth century costume balls were one of the rare places where men could dance in public with each other and dress in drag. The phantasmatic figures of homosexual virility—sailors, market porters—rubbed shoulders with the gigolos named after American actresses and the one-night countesses.

Source: © RMN-Grand Palais/Art Resource, NY

by stressing respectability they could guarantee a better integration of gays and lesbians. In France, the review *Arcadie* did advocate living one's sexuality "openly," but it also condemned the "*folles*" (queens) of Saint-Germain-des-Prés, who, according to the review, discredited homosexuals as a whole.[13]

The revolutionary movements of the 1970s fell at first into an awkward position with regard to the homophile movements. Gay pride assumed the rejection of homophobic stereotypes but also of the culture of the closet and of self-hatred. In France, the FHAR (Homosexual Front for Revolutionary Action, created in 1971) celebrated the queens, "our brothers," who were gone after by the "homo-cops" just as by the "hetero-cops."[14] In the U.S., activists advocated the radical questioning of gender norms by means of the "gender-fuck," provocatively pulling together a beard, a flouncy dress, and cowboy boots. For many, however, these experiments were difficult to manage on a day-to-day basis. Others considered that the play on effeminacy only reinforced prejudice toward gays and called for the establishment of new identity markers. Whereas at the beginning of the movement many gays were based in the hippie counter-culture and wore long hair and bell-bottom jeans, they soon broke with an image that did not allow them to be viewed as homosexuals and that maintained a suspicion, moreover, of androgyny. They therefore chose to display a resolutely virile look. Consequently, while at the beginning of

the twentieth century "playing the queen" could be a means of attracting male partners, some effeminate homosexuals felt constrained from then on "to play the virile man in order to have access to the marketplace of meeting up with others."[15]

They did not disappear, however. Repeatedly caricatured in popular culture, from *La Cage aux folles* (1978) to *Pédale douce* (1996), whether they are artistic (Jacques Chazot, Elton John) or militant (from the *"gazolines"* to the Sisters of Perpetual Indulgence [cf. fig. 20.2][16]), queens continue to occupy a place of their own in homosexual culture, to which they bring their camp sensibility, a mixture of parody, exhibitionism, and theatricality. These characteristics are found, for example, in the film character of Divine (*Hairspray* by John Waters, 1988), in the television series *Absolutely Fabulous* (1992–2004), in the play by Tony Kushner, *Angels in America* (1991), or in art (Pierre and Gilles, Gilbert and George). A showy variation of the queen, more recently given media attention (*Priscilla, Queen of the Desert* by Stephan Elliott, 1994), is the "drag queen," who wears platform shoes, extravagant dresses, wigs, and outrageous make-up to mimic such gay icons as Diana Ross or Barbra Streisand; she emerges in the 1980s in New York in poor black neighborhoods. "House balls" endeavor at the time to recreate the atmosphere of the transvestite balls of Harlem of the 1930s by organizing contests in which drag queens walk down a runway posing as top models ("voguing") or,

FIGURE 20.2 GAY PRIDE IN PARIS. SISTERS OF PERPETUAL INDULGENCE, 1998.

A movement of radical queens created in San Francisco in 1979, the Sisters of Perpetual Indulgence became engaged at an early stage in the fight against AIDS, advocating "safe sex." Opposed to homophobia, they use weapons of love—and camp humor. While all the sisters use white make-up on their faces, a symbol of death, the rest of their outfits, like their "Sister" names, are unique to each one.

Source: © Kharbine-Tapabor

conversely, enacting gangsters from the ghetto in a quest for virile realism, hence doubly parodic.[17] The Wigstock Festival, created in 1984, brought together in New York up to the 2000s the best drag queens (such as Dee-Lite and Ru Paul)—as well as drag kings—for competitions and gala events.

Privileged by queer activists, the usage over the past twenty years of the term "transgender" to refer to all those who transgress gender norms, marks a break both with the medical and pathological terminology ("transsexual") and a fixed, binary conception of gender (masculine/feminine). The notion of "transsexualism" thus gives way more and more to that of "trans-identity." In the case of MtF (male to female) and FtM (female to male) transsexuals, whose gender identity and biological sex appear to be in contradiction, a request for sex reassignment surgery may be made.[18] While the first operations date from 1930, it is not until 1949 that the psychiatrist David O. Cauldwell applies the term "transsexualism" to designate what is perceived as a pathology. In 1952, the sex change of George Jorgensen, who became Christine Jorgensen, is one of the first to receive widespread media attention. The work of the American psychologist Harry Benjamin (*The Transsexual Phenomenon*, 1966) establishes the protocol for the care of candidates for the operation, which involves a psychiatrist, a psychologist, an endocrinologist, and a surgeon. Significantly, general opinion shows a more notable interest in MtF transsexuals than in FtM transsexuals, a sign both of the objectification of woman and of the hegemony of the biological male. Although sex-change operations are today recognized in most Western countries, transphobia still persists, whether it is in the juridical realm (binary categorization of the sexes), the medical realm (refusal to recognize the "transsexual syndrome," a prerequisite for sex reassignment in France, and the equating of transsexuals with the mentally ill), or the social realm (discrimination, acts of physical and verbal violence). Since they wish to make their biological sex consistent with their gender identity, transsexuals have also been criticized within the LGBT community as promoters of heteronormativity, for they are seen as helping to reinforce gender stereotypes (hyperfemininity in the case of MtF). Just the same, not all transsexuals wish to have the operation; some construct their own definition of what is masculine and feminine. They are in accord, then, with the broader understanding of transvestitism, defined by Hirschfeld in 1910 as referring to a set of transgender practices, from wearing clothes of the opposite sex to the wish to change sex.

For Judith Butler, the transvestite has an exemplary function as indicator of the role-play that everyone takes part in: "*By imitating gender, drag implicitly reveals the imitative structure of gender itself—as well as its contingency.*"[19] In this sense,

cross-dressing is not the appropriation of another gender but a parody of the very idea of gender, which exists only by dint of a "stylized repetition of acts" across the surface of the body.[20] Indicator of a "crisis of categories," the transvestite expands possibilities and contributes to the destabilization of sexual and gender identities. Transvestitism is not to be confused with homosexuality. While some homosexuals have used transvestitism as a means of asserting their sexual identity, heterosexuals routinely cross-dress, although often partially (by wearing, for example, women's underwear) and intermittently, in the manner of director Ed Wood, whose life was brought to the screen by Tim Burton in 1994. The transvestite is otherwise tolerated in specific circumstances, such as carnivals or initiation rites, which are themselves not without ambiguity. Theater in the army during World War II relied on the cross-dressing of a portion of the military personnel, certain actors who played female roles being the object of a veritable cult. Transvestitism has also managed to be subsumed into popular culture, whether in a burlesque mode, when it first appears to be a means to an end (*Some Like It Hot* by Billy Wilder, 1959, *Tootsie* by Sydney Pollack, 1982, *Mrs. Doubtfire* by Chris Columbus, 1993) or in a dramatic mode, in which case it is frequently associated with deviance or violence (*Psycho* by Alfred Hitchcock, 1960, *The Crying Game* by Neil Jordan, 1992). Transvestites and transsexuals have nonetheless been empowered by a real counter-cultural boost, whether it be in literature (*Last Exit to Brooklyn* by Hubert Selby, Jr., 1964, *Myra Breckinridge* by Gore Vidal, 1968), the art world (Candy Darling and Holly Woodlawn, muses of Andy Warhol's Factory), cinema (*The Rocky Horror Picture Show* by Richard O'Brien, 1975, *All About my Mother* by Pedro Almodóvar, 1999, *Shortbus* by John Cameron Mitchell, 2006) or rock and roll (from Little Richard to Antony and the Johnsons, by way of David Bowie and Boy George).[21]

Nevertheless, as Marjorie Garber reminds us, the transvestite is worthy of being analyzed as such, beyond the binaries of feminine/masculine, homosexuality/heterosexuality, and the hidden motivations one might wish to see in them (transgression/instrumentalization).[22] Don Kulick shows that the Brazilian transvestites he has met do not think they are women and reject as odious the idea of a sex change, but they do see themselves as female and to this end use hormonal replacement treatments and silicone injections. While their clients often ask them to take an active role in sexual relations, with their boyfriends they assume an exclusively passive role, to the point of doing without an orgasm. "It is not sex that they get from their men—what they get, instead, is gender."[23] With these males, they are secure in their conviction of being female. The Latin American transvestites, then, do not take part in the confusion but rather in the reinforcement of gender, although

according to a division based not on sex but on sexuality: the male gender is that of "men" who must exclusively assume an active role in sexual relations (so they must never touch their partner's penis) lest they lose their status as men, whereas the female gender is that of "non-men," a heterogeneous group in appearance that includes women, transvestites, homosexuals, and any man who agrees to take the passive role in sexual relations. For these transvestites, being a virile homosexual makes them no less feminine than one of their "heterosexual" clients who, for example, wants to perform fellatio on them.

HOMOSEXUAL VIRILITIES

As early as the nineteenth century, certain doctors and psychiatrists, such as Jean-Martin Charcot and Victor Magnan, had asserted that the homosexual could show all the signs of virility. Freud also had stressed that "the most complete psychic virility is compatible with inversion."[24] In 1948, the Kinsey Report on the sexuality of Americans classified individuals along a scale ranging from exclusive heterosexuality to exclusive homosexuality, contradicting the idea that homosexuals could be identifiable by means of distinctive signs. In fact, it has always been possible for a certain number of homosexuals to "pass" as heterosexuals. Faced with stigmatization, homosexuals had learned dissimulation, separating public and private spheres. Up to the 1970s, a subtle play of codes structured the encounters and exchanges within gay subculture. Divine, in Jean Genet's *Our Lady of the Flowers*, remarks: "Queers, up there, had their separate language. Men used slang. That was the male tongue."[25] While gay liberation allowed more men—and women—to practice their sexuality in the open, these coded strategies did not disappear. Whether out of prudence, modesty, opportunism, a taste for dissimulation, or fondness for play, each person negotiates to a certain extent his/her presentation of self, according to the place, the milieu, and the situation.

Displaying a virile look may also express one's subscribing to a form of individual and/or collective identity. In the early twentieth century, the model of virile homosexuality was constructed around three major referents: Greek pederasty, male camaraderie, and working-class virility. Ancient Greece furnished an aesthetic, an ideal of beauty, redefined in the eighteenth century by Winckelmann, and a model of relations between men, i.e., "Socratic love," distinct from simple sensual passion. Plato's *Symposium* provided the model for it. André Gide thus

elaborated in *Corydon* (1924) the example of Sparta and the sacred battalion of Thebans to defend the model of a virile and elitist homosexuality. The pederastic relation thrived by association with ancient virtues: warrior spirit, courage, loyalty, and wisdom. This virile culture exalted male camaraderie, the bond of the regenerated nation (cf. *supra*, chapter 1, 4–18). In Germany, the *Gemeinschaft der Eigenen* ("community of exceptional men"), founded by Adolf Brand in 1903, supported the ideal of a male chivalric society devoted to the cult of friendship and adolescent beauty. Misogynist, anti-Semitic, and antimodernist, it rejected Magnus Hirschfeld's theory of the "third sex." The myth of male camaraderie also had a counterpart in youth movements, such as the *Wandervögel*, celebrated by Hans Blüher, theoretician of the *Männerbund* (the "virile State"—cf. *supra*, chapter 18, 508–11), whose thought influenced the German Freikorps and the SA (Assault Section, one of the paramilitary Nazi organizations). During World War I, the fraternity of the trenches had also been exalted as an experience of virile camaraderie, not devoid of homosexual implications (Robert Graves, *Goodbye to All That*, 1929). Between the two wars new heroes, adventurers, aviators, or mountainclimbers, such as T. E. Lawrence (aka Lawrence of Arabia), Manfred von Richthoffen, or George Mallory appeared to nourish the homoerotic imagination.

The cult of virile beauty should not be confused, however, with a fascination for war. Within the Bloomsbury Circle, celebration of the love between men symbolized the rejection of the values of bourgeois, patriarchal, and authoritarian society in line with the writings of the militant socialist Edward Carpenter, defender of the "intermediate sex" and ardent admirer of young workers and artisans. Since relations between men often transcended barriers of age, class, and race, they appeared as a menace to the established order, to the point of taking on a revolutionary aura. Christopher Isherwood thus justified *a posteriori* his communist sympathies by the fact that the USSR had been one of the first countries to decriminalize homosexuality, but also by his attraction to working-class boys.[26] A number of intellectuals, such as Daniel Guérin and E. M. Forster as well as men from the middle and upper classes did not conceal their attraction to manual laborers, whose physical strength and alleged absence of inhibition contrasted with their puritanical, bourgeois education. In the 1950s and 1960s, black shirts and bikers came along in turn to nourish the homosexual imagination. Leather functioned as a self-identifying sign and also as an access key to those homosocial—supposedly heterosexual—subcultures, which used leather as their identity marker and whose territories crossed those of the homosexuals. The allure of delinquent and potentially dangerous youth[27] was even found within the respectable review *Arcadie*. Certain male prostitutes played

on their status as "rough trade" to attract a bourgeois clientele. These virile figures fed a vast production of erotic images. In the 1920s, German homosexual magazines (*Der Eigene, Die Insel, Die Freundshcaft*) reproduced over and over the idealized figure of the young blond German with blue eyes, naked, healthy, and athletic, soon to be redirected by the Nazi regime toward nationalist and racial ends. In the 1950s, while the pornographic drawings of Roland Caillaux, Paula Smara, and Jean Boullet circulated undercover, the suggestive photographs of Bob Mizer for the *Athletic Model Guild* or the illustrations by George Quaintance for the "physique" magazines displayed the muscular bodies of "boys next door," on the pretext of "body building" and naturism. Kenneth Anger's underground film *Scorpio Rising* (1964) became a reference point for all who envisaged homosexuality as an erotic form of masculinity and a virile fraternity. It was not until the 1970s, however, that what had until then been a question of sexual preference would become a mass phenomenon. Virility ceased being something desirable in the other man, thought to be heterosexual, and became a homosexual marker.

The "clone" and the "gay macho" claimed to be men, "real ones."[28] The reference to machismo suggested a form of masculinity associated with Latino cultures in the U.S. or Mediterranean cultures in Europe. Interpreted in Latin American countries as a form of compensation for the sense of inferiority resulting from colonial domination, machismo was salvaged by American gays as a response to the stigmatization of which they were victims in a heterosexist society. However, while it was connoted rather negatively in Mexico, where it referred to misogyny, to phallocracy, indeed to violence, the term "macho" was interpreted much more positively in Anglo-Saxon countries, where it evoked more a sense of strength, self-confidence, and sex appeal.[29] The term "clone," on the other hand, highlighted the apparent uniformity of the homosexual scene in the 1970s, which affected first the gay areas of San Francisco and New York before reaching Europe, the result of the Americanization of lifestyles.

Although the clones were for the most part young whites from the middle class, they identified with a model of virility borrowed from the working class. The recurrent elements of dress were jeans, a tight T-shirt, and work boots. Some clones embodied a precise personage—cowboy, biker, lumberjack, or construction worker, usually in a cruising context. However, the clone distinguished himself from his model by transforming a functional work outfit and or a naturally careless look into a carefully stylized, polished show. The clone had short hair, a mustache, and/or a trimmed beard. His muscular body[30] was shown off by tight clothes and eroticized even more by the addition of accessories whose meaning was coded, such as

keys hanging from his belt or a handkerchief sticking out of the back pocket of his jeans; these indicated very precisely his preferences regarding sexual practices and positions.[31] In terms of behavior, the clone style was conveyed by the internalization of macho body language: verbal sputtering, virile postures (legs spread apart, pelvis out), and refusal of any manifestation of affectivity. In terms of sexual relations, the clone presented himself as a predator who objectified his partners ("tricks"), themselves reduced to certain physical characteristics (like penis size for the "size queens"). The symbolism of the handkerchief conveyed a rationalization of cruising techniques in the service of a hedonistic sexuality.[32] The clone favored anonymous encounters in public (parks, toilets with glory holes) or semi-public places (bars, discotheques, saunas, back rooms) and presented a sexual repertoire often more varied than the majority of gays, including, in particular, the use of recreational drugs ("poppers"), group sex, and even unusual sexual practices (fist-fucking, water sports [urinating on one another], BDSM).[33] In this context, the "passive" partner, or "bottom," is not perceived as any less "masculine" than his "active" partner, the "top"—quite the contrary, by enduring repeated and/or extreme penetrations, he gives proof of his virility ("he takes it like a man"). It is within the S/M subculture that tattoos and piercings, sometimes extreme (nipples, penis, perineum . . .), favored in virile communities (the army, the navy, the underworld, prison, Hell's Angels), were claimed to be an entirely separate form of art and erotic stimulation before becoming commonplace.

To outside observers, the clone embodied a new threat, that of the sexual predator, whose apparently uncontrollable hyper-virility represented a danger for youth, indeed for the society as a whole—a conviction reinforced by the AIDS epidemic. Criticisms were also heard within the gay community. Celebrated as a symbol of sexual liberation, the clone lifestyle fit within the process of marketing the homosexual subculture, which benefited first of all well-off white men.[34] Far from being liberating, the gay movement would be seen as generating new exclusions of anybody who could not match the new aesthetic requirements because they were too effeminate, not muscular enough, or too old. The leather men (S/M) were the ones who, among the clones, triggered the most negative reactions, both within and outside the homosexual community. More than for other hyper-virile gays, the suspicion of sympathy for fascism, maintained by the taste for boots and uniforms, hung over them. The illustrator Tom of Finland, famous for his gallery of supermen with chiseled torsos and oversized sex organs, was particularly targeted.[35] The macho phenomenon should not, however, be reduced to a form of submission by gays to hetero-normative injunctions. Clones were not trying to "pass" as heterosexuals. While they displayed the signs of traditional virility by reappropriating

them, they were first off men who loved men and who were the objects of desire of other men. Thus, the adoption of the clone style did not prevent them from distancing themselves, consciously or not, from what appeared in many respects to be a "performance of gender."[36] By dint of being overacted, hyper-virility ended up being camp. The gay macho, then, was nothing more than a male impersonator, a man cross-dressed as a man.[37] He was, finally, very queer.

ACTS OF VIOLENCE AND EXCLUSIONS

From the nineteenth to the twentieth century, most Western legislatures punishing homosexuality targeted "acts against nature" between men, in particular sodomy, while lesbianism was rarely prosecuted. The anguish about anal sex was tinged with religious connotations (Sodom) but also hygienic (accentuated by AIDS) and psychoanalytic ("anal stage") associations. Guy Hocquenghem thus notes: "Only the phallus is a dispenser of identity: any social usage of the anus other than sublimated runs the risk of loss of identity. From the back, we are all women; the anus knows no sexual difference."[38] Particular attention was paid to relations with minors, pederasty often being equated with pedophilia. Since it was believed that homosexuality could be learned, having sexual relations with younger boys constituted a form of "corruption of the youth," which threatened the future of the nation by depriving it of its virile potential.

An invisible enemy who corrupts the social body, the homosexual is always the other. In France, at the beginning of the twentieth century, homosexuality was referred to as the "German vice" and the invert was compared to a potential traitor. Saddled with flaws supposedly inherent in his "feminine" nature, fickle, cowardly, and talkative, he represents a danger all the more serious to national security in that he takes pleasure in acting two-faced. He is suspected of collaborating with a "free-masonry of vice," later with a "gay lobby," acting secretly and wielding a disproportionate influence in the media, foreign affairs, and diplomacy. The accusation of homosexuality was thus commonly used to discredit a political adversary, regardless of his sexual orientation. In the 1930s Léon Blum was caricatured in the right-wing press with feminine traits and in situations that suggested submission, unscrupulousness, and dirty tricks.

The alleged connection between homosexuality and communism was also denounced, both in the 1920s because of the seeming tolerance then displayed by

the USSR with respect to homosexuality and the support given in Germany by the KPD (Communist Party) to the decriminalization of homosexuality and in the 1950s in the U.S. during the McCarthy period. The USSR and, following suit, the different European communist parties, however, from 1934 on denounced homosexuality as "a fascist perversion." For his part, Heinrich Himmler, in a speech addressed to the SS generals on 18 February 1937,[39] characterized homosexuality as a consequence of the mixture of races and established a direct link between homosexuals and Jews, the two groups rejected as being "feminine." Some ambiguity was still present. Nazism, while persecuting male and female homosexuals, knew how to salvage for its own benefit the erotic charge underlying virile youth. Thus, at the very moment that the SA, whose avowed homosexual leader, Ernst Röhm, was the object of a June 1934 purge ("Night of Long Knives") aimed officially at ridding the SA of "corruption," the aesthetic of the regime played on the eroticism of the male body through the statues of Arno Breker, Joseph Thorak, or Georg Kolbe, the propaganda films of Leni Riefenstahl (*Triumph of the Will*, 1934, *Gods of the Stadium*, 1936), or such action films as *Hitlerjunge Quex* by Hans Steinhoff (1933).[40]

While the Nazi case is unquestionably specific, homosocial cultures are, in fact, shaped by the possibility of homosexual desire. Until the introduction of coeducation, boarding schools were often referred to as favored terrains for homosexual experimentation (Ernst von Salomon, *Die Kadetten* [The cadets], 1933, Roger Peyrefitte, *Special Friendships* [*Les amours particulières*], 1944, Henri de Montherlant, *The Boys* [*Les garçons*], 1969). Today still, in American student fraternities, as in certain major European colleges and universities, hazing may take the form of staged sexual scenes in which the transgression of the taboo of homosexuality is supposed to solidify the group in the simultaneous admission and negation that, at its core, homosexual desires—at least latent—exist. The same ambiguity is found in the world of sports. Because sports have been seen since the nineteenth century as a training ground of masculinity, even of warrior valor, and because athletic performance and virility are commonly associated, the homosexual would seem in principle excluded from the world of sports, where normative prescriptions are constantly reiterated. In school, on the playing fields, or in the locker rooms, he who fails athletic trials is called "faggot," so that many young gays hesitate to get involved in an apparently hostile milieu in which they think they have to hide their sexuality.[41] From another perspective, certain sports could be disqualified for being "effeminate" because they valorize aesthetic as much as athletic qualities. Male figure skating has thus been trying to build for itself a "virile" image moving forward at the risk of stigmatizing athletes like the American champion Johnny Weir, whose

very "queer" performances have earned him some disparaging remarks. The cases of high-level athletes "coming out" are even rarer (e.g., the American Olympic diving champion Greg Louganis, the Welsh rugby player Gareth Thomas) in that they can cause the end of a career (e.g., the English soccer player Justin Fashanu who committed suicide in 1998). This has led to the rise of alternative clubs or competitions, such as the Paris Foot Gay (gay soccer) or the Gay Games. The growing eroticization of athletes, in the manner of the rugby players who pose naked for the *Gods of the Stadium* calendar, attest, however, to the complexity of the connections between sports, gender, and sexuality. The athlete with a muscular body, or the "jock," feeds homosexual phantasms and keeps alive the passion for body building ("gym queens," doped with steroids), while team sports (soccer, rugby) or contact sports (boxing), which showcase contact between men, even manifestations of virile affection, maintain a homoerotic image. The world of fans shows signs of the same ambiguity: while homophobic insults pour out of the bleachers, spectators intone chants that are tantamount to gay hymns, such as "We Are the Champions" by Queen or "I Will Survive" by Gloria Gaynor.

Fear of homosexuality pervades homosocial cultures: fear of being, without knowing, in contact with homosexuals and fear of being taken for a homosexual, which drives an emphasis on macho behavior—to throw off any suspicion—and even exacerbates homophobic violence. The example of prison is revelatory. While consensual homosexual relations can spread freely there—an occurrence largely mythologized by gay culture (Jean Genet, *A Song of Love*, 1950, Todd Haynes, *Poison*, 1991), sexuality is also used as a means of ensuring one's place in the prison hierarchy ("jockers," "punks," and "queens" in American prisons), "punishing" fellow inmates ("molesters"), and/or mitigating sexual frustration. Some men are thus forced, after repeated rapes, to assume a "female" role, while those who take an active role not only are not considered homosexual, but quite the contrary see their virility reinforced.[42] Although it is evoked at times in a fictional form in cinema (Alan Parker, *Midnight Express*, 1978) or on television (*Oz, Prison Break*), male rape, rarely reported, remains a taboo subject, both within and outside the prison context.

These tensions are also felt in the military, where men are sometimes constrained to live with each other for very long periods. In order to neutralize any ambiguity linked to promiscuity, "newbies," upon their arrival in the barracks, are the butt of jokes with a sexual innuendo, a way again of testing their virility. For the leadership, repression of homosexual relations, especially between officers and soldiers, is justified by the necessity of maintaining discipline and respect for the

hierarchy in the ranks and avoiding dramas linked to jealousy and separations. The American army thus set up during World War II tests designed to identify homosexuals at the time of their enlistment. Based on such criteria as effeminacy, such tests were largely unreliable, but at the end of the conflict a number of gays and lesbians were kicked out of the American army with a derogatory "blue discharge." The rule of "Don't ask, don't tell," in force in the American army from 1993 to 2010, sent homosexuality back to the domain of the unthinkable and unspeakable, all the while reinforcing paranoia about it. The professional army has, however, always attracted homosexuals, keen on the opportunities for encounters that it offers, while the colonial army often served as a refuge for men who found themselves in the midst of scandals in their home country. Both soldier and sailor are, moreover, habitual figures of the gay imaginary. The prestige of the uniform, the eroticism of the tattoos, and the exotic aura reinforce the agitation of a seduction that is often for pay and sometimes tinged with sadomasochism (as in Jean Genet's *Querelle*, 1947). Prostitution in the military, although vigorously condemned by the authorities, is actually concomitant with the establishment since the late nineteenth century of a homosexual subculture in the ports and in large European and American metropolises like London, Paris, Toulon, Berlin, Hamburg, or New York.

MARRIAGE, FRIENDSHIPS, SOCIAL TIES

While gay subcultures could be justly thought of in terms of resistance to mainstream culture, they nonetheless reproduce certain aspects of it, such as male domination, which causes a certain ambiguity. Thus, since heterosexism draws a connection between homophobia and misogyny, an implicit convergence has often been assumed between the interests of gays and those of women, even a common commitment in feminist and homosexual struggles. Gays, lesbians, and/or feminists thus fought together in certain German homosexual movements in the 1920s, in the Gay Liberation Front and the FHAR in the early 1970s, or in the associations fighting against AIDS since the 1980s. Numerous heterosexual women, following the lead of Françoise d'Eaubonne in postwar France or Vera Cîmpeanu in postcommunist Rumania, became actively involved in the support of homosexual struggles. In terms of interpersonal relations, the privileged ties between certain gays and certain heterosexual women are well-documented, whether it involves friendly relations frequently evoked by popular culture such as the gay friend

playing the role of confidant and sentimental counselor for the female heroine (the TV series *Sex and the City, Will and Grace*, or the film *My Best Friend's Wedding*, 1997); reciprocal fascination: the cult of and/or identification among gays with iconic stars who often meet tragic ends (Judy Garland, Marilyn Monroe, Dalida); or fascination with gay sexuality and/or identification with gays on the part of women ("fag hags," "*slasheuses*"[43]). These relationships are not, though, lacking in tension. Male homosexual cultures are not impervious to misogyny and phallocentrism. The schism between gays and lesbians in the 1970s conveyed clearly the dissatisfaction of the latter faced with a culture perceived as aggressively masculine and incapable of taking account of women's specific demands. Allying oneself with the feminists or, more radically, with lesbian separatism, which was frequently accompanied by a refusal of mixing genders and was not free of man-hating, could appear at the time to some lesbians as the only means of being recognized as both women and homosexuals.

Although many gays or bisexuals have engaged, at one moment or another in their lives, in married heterosexual relations—whether out of love for a woman, the desire to be a father, social conformity, or the wish to conceal their sexual orientation—and have produced children, the main accusation made against homosexuals has for a long time been the neglect of their virile duty by not taking on the reproductive role they were destined for and, as a result, leading humanity to its doom. On the other hand, marriage—with a woman—has for a long time been considered the means of "curing" a man of his homosexuality, a belief that persists in certain milieus, for example in Muslim families of Pakistani origin in England.[44] Since the 1980s,[45] the debate over homosexual partnership, gay marriage, and homosexual parenting has seen a resurgence of prejudices (identification of homosexuality with pedophilia) and heterosexist arguments that are religious (the "sacrament of marriage"), anthropological (the necessity of "sexual difference"), or psychoanalytic (the "child's best interest"). This debate has contributed nonetheless to redefining homosexual virility while turning upside down traditional definitions of masculinity. While male homosexual sexuality has often been associated with multiple partners, surveys and reports on gay parent families have helped to make the gay couple commonplace in the eyes of the public. Popular culture shows the signs of this evolution. Television series include gay couples more frequently in their casting (*Six Feet Under, Desperate Housewives*), and some do not hesitate to treat gay parenting humorously (*Glee*).

From this point forward, the homosexual demands a paternal role equal to that of other men, while at the same time modifying its meaning, since he shows

that this role cannot be reduced to biological paternity but is based first on taking responsibility for and showing daily committment to the child, an argument that is echoed beyond the gay community.[46] These problematic situations are, in effect, at the core of single-parent and blended families, in which the paternal role is profoundly transformed, whether it is side-stepped or shared among several players, in particular the biological father and the step-father. Gay paternity also grants greater visibility to the male desire for a child, which resonates with the "new fathers" and the masculinist associations engaged in the debate over custody rights in divorce cases. The issues of gay marriage and homosexual parenting nonetheless divide gays and lesbians, some seeing in them a betrayal of the transgressive dimension of homosexuality. For others, the homosexual couple, while indicating a form of identification with the familial model that gives it some legitimacy, subverts the model in other ways by questioning its heterosexist bases. While it may function in a broad variety of modes, it tends to present itself as egalitarian and adopts the ideas of sharing tasks and coparenting advocated by feminists. In this sense, the same-sex couple takes part in renewing the definitions of the family, which would go beyond traditional bonds of blood and marriages to include a network of relations united by bonds of friendship and reciprocal commitment.[47]

In fact, the importance of friends in the social life of gays, especially friends of the same sex, contrasts sharply with the heterosexual virile model, in which the married man is supposed to refocus on his family, even if those private "gentlemen's clubs" between the two wars, the night out with "buds" in the present day, the bistro, or the soccer stadium have always been reserved for friendly male bonding.[48] Friendship, especially among persons of the same sex, is, on the other hand, an integral part of homosexual life. The "friend" designation has been for a long time an indirect way of referring to a sexual partner and/or a lover, such as when Maurice, the eponymous hero of E. M. Forster's novel, acknowledges he is looking for a "friend for life." But more than the intimate friend, it is really the group of friends, which may include former lovers, that is at the center of homosexual social alliances. For many gays, friends make up part of their family when they cannot put together a family by choice that substitutes for blood relationships judged to be inadequate. Friendship networks have thus played a central role in the establishment of contemporary homosexual subcultures by facilitating the integration of isolated men in large cities. In the 1970s, the group of friends, thought of in a utopian manner as egalitarian and free of power relations, was promoted as an alternative model of socialization for gays, as "invincible communities,"[49] fit to compete with, if not replace, the model of the conjugal family. With the AIDS epidemic,

this function of support and mutual aid was asserted even more so, to the point of being institutionalized through the figure of the volunteer specializing in support for the ill patients ("AIDS buddy"). With this foregrounding of qualities generally considered as feminine—trust, affection, benevolence, moral support—that find their expression through the care of the sick, we thus witness an inversion of traditional depictions of masculinity.

POSTMODERN MASCULINITIES

AIDS has had an effect on the feeling of virility among those stricken.[50] The disease, debilitating physically and trying psychologically, is perceived as compromising bodily wholeness and self-worth. The condom, by modifying the physical sensations during the sex act, may be experienced as an embarrassment and foster performance anxiety. While from this point of view, all men are exposed to the same problem, the risk is felt with particular keenness in gay culture, which often associates seduction with sexual performance. The promotion of the young, muscular body accentuates the feeling of inadequacy on the part of HIV-positive individuals who show signs of the illness, such as weight loss and loss of muscle mass. Playing sports and adopting a rigorously healthy lifestyle, then, fulfill a double function: that of halting the disease and remaining desirable. In fact, AIDS has brought about the redefinition of gay sexuality as a whole. By stressing "safe sex," it has called into question the centrality of anal sex in gay male relations. Defining sodomy as a risky practice, however, is not without some ambiguity, for its stigmatization makes it all the more desirable. Two contradictory visions of virility confront one another at that point: on the one hand, the choice of taking responsibility by using a condom; on the other hand, taking the risk by valorizing extreme practices, such as "bare-backing" (unprotected sexual relations) or even the willful seeking of contamination, perceived as a kind of solidarity with "poz" (HIV-positive) men.

The AIDS epidemic has also led to a redefinition of the modes of self-presentation. In the early 1980s, young gays, concerned with differentiating themselves from clones, whose lifestyle was censured, yet without breaking with virile codes, chose new models for themselves. In England, the "rockabilly" and "skinhead" subcultures, inspired by the rock culture of the 1950s and 1960s, were picked up by the new generation of gays who cobbled together from them distinctive signs (Doc Martens, Levi's 501, bomber jackets, short hair with a little crest) to fashion

their new image.[51] These young subcultures, thought of as heterosexual, recalled during the economically strapped 1980s the nostalgic, idealized masculinity of America during more prosperous times, the era of idols like Marlon Brando and James Dean. Working-class in origin, they renewed the phantasm of the worker lover and allowed the young gay, who based his appearance on the object of his desire, to increase his chances of encountering and seducing him. In sum, by adopting the appearance of groups reputed to be violent and which were suspected, in the case of the skinheads, of being homophobic and racist, young gays involved themselves in a transgressive gesture that helped blur points of reference. Popularized by the group Bronski Beat and their singer Jimmy Somerville, this style called "kiki" soon became established as a new conformism, adapting to various modes, from the S/M scene to queer activism, by way of the "in" clubs and bars. "Kiki" was also adopted by some lesbians. It was gradually replaced by the "street" look, which was inspired by suburban youth and street fashion and was just as ambiguous. Rejecting the dictatorship of youth, with their smooth, muscular bodies and depersonalized sex, "bears," coming from the leather culture of the 1980s,[52] celebrated their mature aspect and plump hairy body with hugs and camaraderie. They broke with clone culture, perceived as macho and alienating, while salvaging some of their codes, particularly in clothing, such as the worker and lumberjack look, which they saw as signifying a renewed and more "authentic" masculinity—although just as contested. The 2000s thus witnessed the fragmentation of the gay scene into a multitude of subcultures, not necessarily mutually exclusive, whereas extreme sexual practices, stimulated with the help of chemicals (Viagra, "Special K" [ketamine], and GHB), tended to become commonplace.

The "enchanted parenthesis" (1972 to 1982) witnessed the golden age of gay porn. In the United States, Falcon studios reigned supreme with stars like Chase Hunter, mustached and virile. Though the actors were paid, many were there for their own pleasure. With professionalization, gay porn became more impersonal. Many of the actors were heterosexuals who agreed to take part in the films only for the money ("gay for pay").[53] A hierarchy of actors took shape at that point: at the top, those who were identified as "tops," even "heterosexuals," at the base, those who were recognized as "bottoms," even if some managed to stand out as veritable stars (Joey Stefano, Brent Corrigan). Today, more and more actors are versatile. The Internet has fostered an explosion in pornographic offerings, with the proliferation of amateur videos. The codes of gay porn have thus evolved toward greater "closeness" or "realism," as evidenced by the success of sites that

present solo or group masturbation videos and "initiation" of young "straights" into the joys of gay sex. While muscular young white boys dominate productions, the "X" rating increases niche markets for all male types. So even though they were denied entry into gay clubs, young Arab men now ensure the success of French gay porn, whether they exaggerate their virility as scoundrels from the projects (Citébeur Studios, Jean-Noël René Clair's films, the actor François Sagat, with shaved head and black tattoos) or play on an imaginary exoticism (*Harem* by Jean-Daniel Cadinot, 1984).

The economics of sex reflect geopolitical upheavals. During the first half of the twentieth century, homosexuality was stigmatized as a vice peculiar to the colonies, particularly Arab and Asian, whereas the colonized peoples were seen as effeminate. The North African adolescent was thus a recurring figure of colonial domination: in André Gide's autobiography, *Si le grain ne meurt*, 1926, which has not entirely disappeared from the gay imagination; and in Sébastien Lifshitz's film *Open Bodies*, 1999. Owing to the rise of sexual tourism, that figure is now competing with that of the young Asian: Frédéric Mitterand, *The Bad Life: A Memoir*, 2005. During the 1960s, the far right constructed a hyper-sexualized image of the Algerian man ready to rape a France feminized and sold out by the "invert" de Gaulle.[54] During the 1970s, FHAR militants played on provocation: "We've been butt-fucked by Arabs. We're proud of it, and we'll do it again."[55] Jean Genet linked his support for the Black Panthers, the Algerian National Liberation Front, and the Palestinians to his love for black and Arab boys. The occasional extolling of interracial relations should not conceal, however, the reality of racism among white homosexuals, or homophobia among black heterosexuals. The variables of sex and gender in this case intensify or contradict the variable of race. Objectified for their sexual power, black and Arab men are also sought out because of self-hatred or a desire to be used or degraded. In the case of Asians, homosexuality reinforces the racial stereotypes that make of them effeminate, perverse, or desexualized beings.[56] Identifying as homosexual is then all the more difficult when homosexuality is stigmatized within one's own ethnic community or when it is defined by criteria different from those privileged by the majority white gay community. Thus among Latino, North African, or Caribbean men, often the only ones considered homosexual are those who assume a "passive" role in sexual relations, even though these characterizations are tending to change as a result of acculturation.

Ironically, although today a certain number of signs of homosexual identity have been co-opted by the straights, the codes of virility appear more and more

blurred. Youth culture has here played an essential role. As early as the 1950s, in England, the "Teddy boys," of working-class origin, borrowed elements of gay fashion as a sign of rebellion against the establishment. Beginning in the 1960s, the "mods" and the hippies helped to make it an ordinary thing for boys to wear long hair, bright colors, and flowered patterns—which still did not stop them from being commonly called "faggots." Beginning in the 1970s, the popularity of disco, then of electro music, placed gays and lesbians at the epicenter of the music scene, its DJs, and its modish clubs (Palace, Heaven, Queen). Today, androgyny is at the core of certain teenage subcultures, whether British- (*emo*) or Japanese-inspired (mangas, *visual kei*[57]). The influence of gay culture goes beyond its borders to affect the greater public. Significant in this regard is the case of underwear.[58] Immortalized by the publicity campaign of Bruce Weber and Herb Ritts, Calvin Klein white underpants took center stage in the 1980s as the fetish underwear of gays before being imitated by young people in general, from rapper to teenybopper. While men's periodicals favor attractive nude young women (e.g., *FHM*), they do not hesitate to put on their cover young, muscular men, with whom the reader is supposed to identify (e.g., *Men's Health*).[59] By playing on the signs of femininity, metrosexuals seduce women, but often men too. Heterosexual personalities like the soccer player David Beckham or the singer Robbie Williams are thus very popular with the gay public.

As R. W. Connell notes, "the presence of a stable alternative to hegemonic masculinity—the irreversible achievement of the last quarter-century—reconfigures the politics of masculinity as a whole, making gender dissidence a permanent possibility."[60] Nevertheless, while it is undeniable that for the past twenty years the visibility of gays—more than of lesbians—in the media has increased considerably, we must take into consideration what is attributable to opportunism: the choice on the part of companies to target a community with strong buying power, publicity agents' interest in a homosexual subculture that often anticipates trends, or the concern for building a politically correct image. It is the "constant appropriation of various elements borrowed from different types of masculinities that renders the hegemonic bloc capable of reconfiguring itself and adapting to new historic conjunctures."[61] The very notion of masculinity thus keeps getting redefined by successive hybridizations. The appropriation of elements associated with gay culture by heterosexual masculinities does not actually signify the calling into question of male domination or the disappearance of homophobic violence. Exemplary in this regard is the international success of the film *Brokeback Mountain* (2005), winner

of a Golden Lion at the Venice Film Festival. By situating this love story between men in Wyoming's wide open spaces, Ang Lee, who adapted the story by Annie Proulx, upended the codes of this quintessentially virile genre, the "western," while at the same time revealing its underlying homoeroticism.[62] The film even resonated with current events: the gratuitous murder of Jack in the film echoed the very real murder of young Matthew Shepard, in 1998, also in Wyoming, because he was a homosexual.

21

EXHIBITIONS

VIRILITY STRIPPED BARE

BRUNO NASSIM ABOUDRAR

UNDER "ACADEMY," a fine-arts dictionary from the middle of the eigh-
teenth century by Jacques Lacombe the first entry described, at length, the
institution founded in France by Mazarin; it is only as a second meaning,
in the plural, that "academies" designated "the name given to parts like the
head, the arms, the hands, etc., that are drawn first, from the model, to get
with precision the nude and its contours."[1] The Academy was the place of a
practice of drawing from nudes, although they were, out of modesty, broken
up into parts: heads, arms, hands. Less than fifty years later, Watelet's monu-
mental dictionary reverses the order of priorities: "What is called in artists'
language an *academy* is the imitation of a live model who is drawn, painted
or sculpted. . . . The Art Teachers place a naked man in a pose that he holds
for a length of time proportionate to the discomfort, greater or lesser, that
the pose causes."[2] The Academy ended up being confused with the supreme
exercise on which it has the monopoly: the imitation, in drawing, of a naked
man, the model, no longer parceled out but as Watelet makes clear, spread
over "the whole of the human body." When man is naked, at the height of his
humanity—that is, standing, since his verticality distinguishes him within
the animal kingdom, his genitals are necessarily seen in the middle of his
body and subvert, in places, the entire plastic and aesthetic order of which
the Academy, in the sense both of "institution" and of "artistic practice," is
the guarantor and highest expression.

Freud, at the beginning of the last century, attests at several points in his work to the inexorable scandal of displaying, in the very pose of human male pre-eminence—an upright stance, that which civilization (which is a corollary of the human male) requires to be hidden: the virile private parts. In a note to *Civilization and Its Discontents*, in which he explains the human devaluing of olfactory stimuli (fundamental to animal behavior) by the "verticalization of the human being," he writes: "Man's erecting himself from the earth . . . , his adoption of an upright gait, . . . made his genitals, that before had been covered, visible and in need of protection and so evoked feelings of shame."[3] It is a disconcerting remark, for only half of humanity, i.e., males, confirm it: the woman's vulva, when standing, is hidden by the bulge of the pubis and by pubic hair; it is the genitals of man, largely masked by his thighs when he is "on all fours," that the standing posture exposes. It is a remark that should be compared to another strange notation by Freud—this one aesthetic—which is that the genitals of the man or the woman cannot be judged beautiful, only arousing.[4]

Thus, at the beginning of the twentieth century, at the time when the artistic regime that has constantly claimed the pre-eminence of the Academy as genre is coming to an end, Freud picks up the fundamental confusion about it: there is, on the virile body, central and close by, something that is not beautiful, that cannot be beautiful, and that would best be hidden, were it not so obvious: the sex organ. Before any cultural, psychological, or moral consideration, one might wonder what constitutes the source of this aesthetic paradox that is integral to classical representation, namely, that its highest expression—the male nude—is either prevented from being displayed or degraded by displaying what is "supposed" to be the genitalia—so much so that one part of the history of art may be seen as the ways of obviating this problem, i.e, showing the naked man, standing, full-frontal view, in all his virile glory but without the organ of his virility.

ACADEMIES

At the end of his *Salon* of 1765, in a section devoted to statuary, Diderot judged sculpture to be by nature a bit too cold to candidly depict the naked sex organs since it is made of stone or metal. Painting, a more voluptuous art owing to its colors, has to show greater discretion. The chaste art of sculpture, in its rendering of the sex organs, is removed from the life model in that it commonly depicts women

without pubic hair but keeps, in a stylized form, men's "bush." There are several reasons for this. First, men are hairier. While sculpture most often avoids depicting a hairy torso, it maintains something of this secondary sex trait when necessary. But, above all, the pubis of standing women (and not their sex organ) is pleasing in art, and what is not pleasing in art is the uncertain form of the flaccid penis.

> [Art] will have you notice the beauty of [the woman's] contour, the charm of those twists and turns, of this slight, sweet, long curve that goes from the tip of one hip, dipping down and rising up in alternation, until it reaches the tip of the other hip; art will tell you that the path of this infinitely pleasurable line would be broken midway by an interposing tuft of hair, and that this isolated tuft, unconnected to anything else, becomes a blemish on the woman. But on the man this kind of natural covering, a rather dense shadow on mammals, grows lighter, in truth, on the sides and belly, yet does remain there even though sparse, and goes on, without interruption, becoming thicker, longer, and more plentiful around the private parts; art will show you these private parts of the man, stripped like a skinny intestine, a fairly unpleasant looking worm.[5]

Art itself takes the floor to justify its choice, since the difference at play between how the sexes look seems so essential to it. Indeed, the conflict between line and color, which structures classical aesthetics, gets reformulated at this precise place. The woman's pubic area is line, drawing, natural outline, not only curve but coil; her pubic hair, however, is described at once as macula and as color. It is therefore of a nature different from male pubic hair, described by Diderot in terms of shadow, which in turn derives from drawing. Stump drawing (using a cylindrical tool tapered at either end) enables line to forgo color by imitating its effects yet without giving up any of the rigor and judgment associated with color. Scrupulous and rational, line drawing is constantly thought of as tending toward the masculine as opposed to color, which is feminine and hence deceptive, sensual, and sentimental. One hundred years later, Charles Blanc will still be able to assert, in his *Grammar of the Art of Drawing*: "Line drawing is the male sex organ of art, color is its female sex organ," and to point out that: "The superiority of line drawing over color is inscribed in the very laws of nature, which has intended, in effect, for objects to become known to us by what outlines them and not by what colors them."[6]

Now, the unpleasing maggot that wriggles under the shady stump drawing of the man's pubic bush does not come from line drawing, or does so awkwardly, whereas the woman's elegant curve that winds from one hip to the other is, by contrast,

a worthy model for line drawing that is furnished by nature. The male member does not come from line drawing, or does so very poorly, because it is practically amorphous and its form so changeable, soft, flabby, and slack. The line, by contrast, which is contour and limit, belongs to the order of definition and the permanent, the certain, the firm, and the immutable. A spongy organ, which expands and contracts according to atmosphere and emotions, the ensemble formed by the penis and testicles belongs to that which, in the opinion of Diderot, and by way of other turns of thought (rather more moral), that of Freud, shrinks from the domain in which beauty rules. The *philosophe* explains his reasons for this in the first pages of the *Essay on Painting*:

> Childhood is almost a caricature; I'll say the same for old age. The child is a formless, fluid mass seeking development; the old man is another formless, dry mass turned in on itself and tending to boil down to nothing. It is only in the interval between the two ages, from the beginning of completed adolescence to the end of virility, that the artist subjects himself to the purity and rigorous precision of the line, and that, with a little more or a little less, the line, inside or outside, either comes up short or creates beauty.[7]

No doubt, except at times of great cold or great fear, man's genital apparatus is more the "child" than the "old man." It takes after, in any case, that model in which nature eludes the virile order of line drawing, thus giving up its claims to beauty.

It can be understood under these conditions that the avoidance of depicting the male sex organ has no basis in morality but is internal to the very system of art. This avoidance, not total (we will focus on the exceptions) but usual, traditionally follows three paths: erasure, stylization, or substitution.

Erasure consists in the rendering of a life drawing, at times very precise, in a frontal view but without sex organ. In its place, the drawing shows a blank, the negative flaring of a sort of misprint, not even bulging out, or the graphic notation not of the penis but of some vague, imprecise substitution for it, a careless curlicue made by the charcoal stick, ink, or red chalk. With regard to this norm of erasing the genital organs, it is edifying to consult the work that Claire Barbillon has devoted to the canons of the human body.[8] Thus, keeping more or less to the exemplary corpus that she presents, Charles-Paul Bellay publishes in 1890, in his *Proportions of the Human Body*, a paraphrase of Leonardo da Vinci's *Vitruvian Man*. On a square-patterned background, the man, simplified in relation to the original drawing (a single pair of arms and legs), is also more muscular. But where

Leonardo has a stylized sex organ and pubis, in Bellay only a sort of scribble is found, which evokes a bit the curly hair of the personage. Similarly, the *Proportions of the Human Body Measured against the Most Beautiful Figures of Antiquity*, a major work by Gérard Audran,[9] whose influence is considerable both in art and in anthropology, provides the exact proportions of, among others, the *Laocoön* and the *Farnese Hercules* but does not reproduce even the convex fig leaf that undoubtedly covered[10] their pudenda (today they are naked). At that place, on engravings in which each toe, every face muscle, the distance from the knee to the backbone and that from the hip joint to the navel are all measured, there is nothing but a blank. The male sex organ is a hatched oval in the engravings after Cochin from the *Method for Learning to Draw* by Jombert.[11] It might be tempting to justify this nearly systematic omission of the sex organ, paradoxical in works of artistic anatomy or life drawing, by the fact that the virile member is not subject, in life, to bodily proportionment. But this is just as true of other organs (the nose, the ears . . .), which are certainly depicted. Most of all, artistic anatomy and life-drawn nudes seek the correct balance between the lessons of ancient art, guardians of the ideal canon, and those of nature. The descriptive, empirical dimension is always trumped by a normative principle. Therefore nothing, in theory, would stop correct measurement of the penis and its eurhythmic proportions from being contained in these treatises. Such is not the case because the penis, anti–line drawing, has no correct proportion possible; it seems representable only as a lack or, as will be seen below, as an excess.

The second classical way of depicting the male sex organ does show it proportionally, but inaccurately. This is the ideal model, forcefully reasserted between the last quarter of the eighteenth century and the first quarter of the nineteenth, which would have it drawn small, in accordance with Greek practice.[12] Johann Winckelmann throughout Europe and Quatremère de Quincy in France not only convert general taste to the purity of ancient models—heroes naked, muses and goddesses draped—but also make accessible around the time of the French Revolution a fairly new form of homophilia, with the proliferation of figures of entirely naked ephebes and fully developed men with their sex organs barely hidden.[13] The genital size of the adolescents, not children, is at odds with their prepubescent size and with their boyhood sex organ, which is drawn and painted with all the precision demanded by neoclassical aesthetics. Girodet-Trioson's *Endymion*,[14] the large strapping lad of about 20, dozes, lying on his side and facing the spectator. It is thus hard not to notice in this position his little penis that hardly reaches the edge of his thigh and, nestled in the shade of the moon, his little boy's balls. In a painting

by Pierre Narcisse Guérin, Cephalous, endowed with an almost feminine beauty, lies asleep naked on a cloud as he receives a visit from Aurora.[15] The delicate cloud vapor that rises toward his sex organ might as well be transparent: it has practically nothing to hide. The Republican angel with broad wings spread in *Liberty or Death* by Jean-Baptiste-Régnault[16] is not sleeping on his side; he flies toward the spectator holding out his arms. His penis, however, assumes the same position across the groin as those of Endymion and Cephalous; and thus on display below a smooth pubis, his whole genital apparatus is, if possible, even more modest than that of the other two figures.

The frontal-view nude is, nevertheless, possible in painting only under the dual conditions of "Greek" stylization of the penis and a kind of hybridization of the model by which the body of a young adult takes on the child's prepubescence, the woman's delicacy of features, and the curly grace of her hair. When the story requires grown men—heroes or gods, the artist has no other choice but to substitute for the penis an object that hides it, while at the same time suggesting it. Albrecht Dürer provides the canonical example of this stratagem, humorously, in the engraving *The Men's Bath* (1496). On the left a man is seen standing, leaning against his elbow on a fountain whose spigot, a childlike figure of the penis, in profile, is inscribed precisely on the axis of what it is masking. But this play of images, still possible in the Renaissance in the context of a nonreligious engraving on a common theme, is censured by classical taste and judged unworthy of historical painting. The substitution takes place, but not without some procrastination. This is shown by the visual slips to which it is often subject. *Leonidas at Thermopiles*,[17] naked in all the preparatory drawings, has his sex organ hidden not by his sword, but by its sheath. In spite of its seeming banality, the solution chosen by David functions as a slip in two ways. First, because his form and his posture evoke a symbolic phallus; and second, especially, because the sheath—*vagina*, in Latin—can be consistent with this phallic stance only as a paradox. A century later, Marcel Duchamp will rediscover, not as the result of a slip but analytically, this plastic delineation of the sex organs in castings and prints. Indeed, conceived for the lower pane of his "Large Glass" in the *The Bride Stripped Bare by Her Bachelors*, the *Nine Malic Moulds* (1915) are in a way penis sheaths—*vaginae* (in slang this feminine of the male is retained in French, not *le moule* (mold), but *la moule* (pussy), while just as slangy the phallic *Dart Object* (1951) features as a projection the vaginal duct. The awkwardness of neoclassical substitutions does not escape contemporary connoisseurs of the works. Abigail Solomon-Godeau sums up the criticisms leveled at *Theseus Recognized by His Father* by Hippolyte Flandrin,[18] which features the hero

naked, with a very bushy pubis, behind a table on which a large piece of meat is positioned between his penis and the spectator's gaze: "The platter of cutlets used to hide Theseus's private parts [. . .] is a quite ridiculous idea, a rather grotesque kind of arrangement."[19] This visual lapse by Flandrin, by which the sex organ, suppressed from the field of representation, returns in the crude form of a cut of butcher's meat, expresses well the obsessive character taken on by the inevitable reality of this intimate, unstable piece of flesh. Inconsistent with the ideal, it remains in the middle of the body of fixed studio models holding the canonical posture of the role they are ordered to play.

This hyperpresence of the virile member, although irreducible to the canon of artistic beauty and secret source of classical layout and shown in drawing and painting only through the processes of avoidance, is betrayed by photography. As early as 1854, Eugène Durieu, religious administrator and photographic pioneer, fixes on a daguerreotype plate the nudity of the life model that his friend Delacroix offers him. Durieu activates the device, and Delacroix places the model according to the tradition and with the accessories of the "academies." Several shots show the same man, whom Delacroix called "the Bohemian,"[20] mustached, athletic, and at times entirely naked. With his sex organ thus uncovered, dark, dangling a bit toward the left thigh, the man's humanity, his fragile social conditions as a fairground wrestler or ex-soldier paid to take his clothes off, and his vulnerability as a man, suddenly bring to light the academic order and begin all at once to throw it off. Delacroix understood this subversion right away, although he did not name the cause of the paradoxical, scandalous bursting of the real penis into artistic convention. These shots, he writes, beginning with the first session of photographic poses in 1853, show models "looking poor and with exaggerated [sic] privates giving a rather unpleasant effect." But such as they are, ignoble, they exceed even the engravings of Marcantonio Raimondi (Raphael's collaborator), "which are taken as chefs d'oeuvre of the Italian School."[21] And, such as they are, they fascinate Delacroix. Two years later, on 5 October 1855: "I'm looking passionately and tirelessly at those photographs of naked men, this splendid poem, this human body from which I'm learning how to read and the viewing of which tells me more about it than scribblers' inventions."[22]

Photography literally strips bare the penis at the center of the whole academic—or classical—system of representation; and it is because of photography that the system endures through the first half of the twentieth century—senile, obscene, and fascinating—even when modernism rejects that system. Living at the beginning of the last century in Taormina, Baron Wilhelm von Gloedon specializes in

what he calls "Arcadian scenes"—the very idea of Arcady deriving from the era of academic imagery. It involves having adolescents or young adult males pose nude in the eclectic Mediterranean decor of the artist's Sicilian villa, or on the beach, most often with studio props: tunic, vine branch, tiger skin, amphora or pipe, the shepherd's instrument [fig. 21.1]. Poses, trinkets, and decors scrupulously respect, without adding a thing, the super-antiquated, moribund tradition of "academy" nudes: Gloeden wins prizes[23] for his nudes and even receives a gold medal from the Italian Minister of Public Instruction. But the convention that would have these images seen as the photographic version of the sexless academy nudes of the tradition soon begins to break apart. Gloeden dies in 1931, and by 1933 a proceeding has begun against his legatee for possession, diffusion, and sale of obscene material. Art or pornography? For the Public Minister, it is precisely the size of the models' virile member that prohibits these images from being considered art works, not so much because it breaks with the Greek canon as because it is the indicator of a history of desires in which the work of art ceases to exist. Gloeden "sought in the region of Taormina peasants and young men endowed with the most developed members in order to depict them completely naked and to bring out their genital organs."[24]

What is amazing, though, about the posthumous trial of Gloeden is not so much that obscenity could be evoked in relation to the photographic evidence of

FIGURE 21.1 WILHELM VON GLOEDEN, NAKED YOUNG MAN IN SICILY, CA. 1900.

Poses, accessories, and scenery—Wilhelm von Gloeden draws these stylistic elements from the "academic" tradition. But the transition to photography, which does not stylize the penis in accordance with "Greek" canons, brings to light the unique privacy of the model and reveals the libidinal investment of which this privacy is the object. Accepted during the artist's lifetime under the cover of academism, von Gloeden's photographs were judged to be pornographic after his death and censored.

Source: © The Granger Collection, New York

penises; it is the hesitation—in the midst of the fascist period—of the judiciary, which will end up dismissing the case. There is something at stake in these virile parts other than the automated mechanism of desire—something more troubling, something that evades the rules of fetishism, by which pornography, that commercialized eroticism, is held accountable for its self-assuredness: it is the living (hence mortal) identity of the models, their irreducible singularity as men. Roland Barthes clearly is not mistaken when he refers to those "peasant gigolos:" "(if one of them is still alive, may he pardon me, it's not an insult)." This possibility of a real life, addressed by the writer's parenthesis, is what the young Sicilians' penis, in itself, creates by means of everything that eludes the canonical order of artistic beauty and captures the gaze, finally proving Diderot right: "Prepuces quite visible, puffed up and no longer stylized, that is, thin and diminished: they are uncircumcised, and that's all you can see."[25]

PHYSIOGNOMIES

Puffed up prepuces and peasant gigolos: Barthes associates a penile physiognomy as blatant as a face (fleshy lips, bushy eyebrows . . .) with a social status—working-class, at times dangerous—which the bourgeoisie has been known to find delightful and frightening: "My lovers come not from the upper classes/They are workers from the depths of suburbs or the land."[26] Now, this idea that the aspect of the genital organs, at least as much as any other detail of the physiognomy, resonates with the psychological or social condition of subjects, became at the time of Gloeden and Verlaine and up through the twentieth century the object of rigorous speculation in medicine and criminology.[27]

A great conviction of the nineteenth century, the theory of degeneration, is based on the postulate of the inheritance of acquired traits. To the extent that it develops a reflection on heredity, degeneration is dependent on a questioning of generation, which leads it to formulate the hypothesis that the reproductive organs should be affected, as a matter of priority, by the degenerative process. Moreover, as Dr. Émile Laurent remarks in a study that appeared in the *Annals of Criminal Anthropology* in 1892, an anomaly of the penis cannot be simulated. The study of the physical structure of the genital organs is therefore particularly recommended in prisons because delinquents are degenerates and, in particular, because they are shammers who could be confused with others based on the shape of their penis.

From these studies comes the medical construction of a figure of the delinquent peculiar to the last years of the nineteenth century, the young effeminate thief who is rendered unfit for reproduction by atrophied sexual development:

> One often encounters in prison men who are infantile or feminized. These individuals, 18 to 20 years old, appear scarcely 14 or 15: short, lean, skinny, with a hairless face, smooth pubis, the penis and testicles looking like those of a child, the voice high-pitched; these men are indefinitely juveniles to whom it would be difficult to assign a precise age.[28]

From that point on, the "portrait" of his penis can complete or even substitute for the individual's facial portrait and furnish, like it, the indications of criminogenic degeneration.

> I saw one particularly remarkable subject whose penis measured only two centimeters in length and seven centimeters around; during erection it could acquire five or six centimeters in length. The glans was as small as a hazelnut, well covered over by the rudiments of a prepuce that could be pulled back.[29]

However, this case, in its singularity, is not enough to determine a clinical entity. Nosological notation comes off as the assessment of statistical frequency:

> Finally, in another man with enlarged breasts, the penis was short, not sizeable, but swollen into a club shape at the end.
> This anomaly is found actually quite frequently in criminal degenerates. It is constituted by an exaggerated development of the glans in comparison to the penis, as is indicated by the schema reproduced here.[30]

This business of a "club-shaped" penis and also one "formed like a bell clapper" noticed in a large number of delinquents at the beginning of the last century seems to have impressed medical examiners. Descriptions of it are already found in Ambroise Tardieu's *Medico-Legal Studies of Moral Terpitude*, a major work of forensic medicine. A positivist, Tardieu seeks proof based on impact and on prints: those left by the penis on the flesh it has penetrated. Therefore Tardieu is particularly interested in homosexual penetration, for in this case the crime consists not, as in heterosexual rape, of the criminal use of normal sexuality; it is the sexual orientation itself that is culpable. Thus, to deductive reasoning, which consists of finding

in the physical structure of the blunt body the etiology of the wound, Tardieu adds a fundamental reason that discovers in the physical structure of the genital organs a predisposition for the criminal use to which they may be put. So, a particular physical structure[31] of the penis of homosexual "tops" and "bottoms" corresponds to irrefutable lesions caused in the anus by passive sodomy.

> I am not afraid to assert that the physical structure of the penis in pederasts presents, if not always, at least very often, something characteristic. I know how much the forms and dimensions of that organ are variable, and in order to protect myself, as much as possible, from error, I have been examining for several years, from this point of view, all the men placed in the hospital service who are entrusted to me.[32]

There follows a formal classification of penises, polarized between two tendencies: "excessive in one sense or the other," between "very skinny" penises and "very big" ones, accompanied by extraordinarily precise descriptions and images:

> When the penis is very big, it is no longer the organ as a whole that undergoes a gradual diminution from the root to the tip: it is the glans that, choked off at its base, grows sometimes disproportionately long, making it look like the muzzle on certain animals.[33]

While he resorts to animal comparisons, Tardieu's clinic never gives in to erotico-aesthetic considerations. But at the end of the century, Laurent publishes an astonishing work of vulgarization about those whom he calls *The Habitués of the Paris Prisons*—criminals, thieves, pimps, and prostitutes, most of them renegades from the working class. The medical examiner affects the pleasant tone of the eminent specialist who knows how to make his knowledge accessible to the reader curious about such things—and very ingeniously restores to the thugs from the barricades the splendor of their virile attributes.

> I showed in the preceding chapter two types of pimps, admirably muscular; their testicles and their penis were no less worthy of admiration and corresponded to the rest. I saw another one who, though 45 years old, still knew how to give pleasure to the girls thanks to the magnificence of his genital organs. His penis measured 13 cm. in a flaccid state and 12 cm. around at the glans. "You must be proud," I told him, "to possess such a lovely organ!" "Ah, monsieur," he replied cynically, "without it I would have died of hunger a long time ago!"[34]

Magnificent, admirable, lovely organ, writes Laurent. The aesthetic context is that of academism, but the judgment in terms of taste is this time determined by a presumption of use: the "lovely" penis is not a small one or tied by a "kynodesme," that knot with which Greek athletes secured their prepuce, but a large one.

For the pimp, it is a matter of his work implement. But this link established between how the virile organs look—especially the size of the penis—and social or racial determinants becomes one of the effective springboards for erotic imaginings of a bourgeoisie that sees itself as removed from the subject. There are hardly any doctors, lawyers, or professors with a large penis; the working class and the indigenous from the colonies furnish an inexhaustible supply of men with this attribute. To be convinced of this, one need only skim the print-seller known by the name of *The Rotenburg Collection*:[35] when the men are not entirely naked, they appear—pants down, with an erection—as delivery men or servants (in a cap, collarless), bellboys, or mailmen (in uniform), and less frequently as high-society habitués (in tails and top hat). In this collection the men's genital organs are always conspicuous, framed in such a way that they are entirely visible. We will not pursue the pointless question of which kind of desire these images are addressed to: the scene is (almost) always heterosexual, but it is clear that a part of the anticipated visual pleasure is in the response to the social curiosity evoked (later) by a popular song; one gets to see, close up, the pee-pee of the . . . soldier, apprentice, etc. Social curiosity? No doubt, in the ludic sense of discovering the exact physiognomy of that which custom most often keeps hidden—but not if one takes curiosity in the sense of the possibility of being surprised. Indeed, these images recycle familiar clichés about racism and social prejudice (tinged, as it turns out, by admiration): "well-hung" Arabs, Negroes, and proletarians. Special mention should be made of two professions regularly associated with impressive dimensions of the intimate parts: clergymen and sailors.

The image of the licentious monk or curate, sexually very well-endowed, has pervaded Christianity from the Middle Ages to the last photographic avatars of the 1920s. Monks' fertility is proverbial, according to Rabelais, to the point that "the mere shadow of an abbey steeple instills fecundity";[36] and the phallic image of the steeple is so significant that Mikhail Bakhtine was able to make of it one of the models of the grotesque body, complete with hyperbolic protuberances and orifices.[37] Among the sinister monks who hold Justine prisoner in their hermitage, one has "a Herculean member," the other is "endowed with gigantic equipment,"[38] and a third has "a formidable organ." There is even the curate of Camaret, whose anatomy is described toward the end of the nineteenth century in a famous bawdy

song. Photographs from between the wars also show a bearded curate, with a round hat, two buttons of his Roman cassock undone to let out his long penis, sticking up toward the obliging lips of a nun; in others, a paunchy monk with a thick sex organ, the skirt of his habit rumpled, flirts in various positions with a nun wearing a cornet.[39] This image of the well-endowed clergyman must be seen, no doubt, as a mixture of subversion, since the Catholic clergy is supposed to have taken a vow of chastity, and deference with regard to a figure construed as paternal. The foundational Christian antinomy between virginity and paternity, which belongs only to Roman Catholicism, concerns only its clergy, and libertine imagery is not found of pastors, Orthodox priests, or rabbis with abundant virile attributes.

This very old figure disappears toward the middle of the twentieth century with the secularization of Western societies. It is also the period in which a modern cliché, unrepresented in the literature or picture books of past centuries, comes into greatest fashion: that of the sailor, young, thin, very virile and "gay friendly." In his sexual ambivalence, Genet's Querelle (hero who gives his name to the novel, 1947), handsome sailor-assassin, irresistibly drawn to the manager of a brothel, then to a cop, both manly and powerful, certainly has well-known predecessors, on shipboard such as Billy Budd (Melville) and James Wait (Conrad) or hanging around the ports (Mac Orlan). But Genet undertakes a new focus in literature on the hero's penis itself and that of his acolytes. Cocteau illustrated the novel, forming with the same fluid, clear line the curly heads of hair and bushes, the strong necks, the broad shoulders, the heavy balls and the long tumescent penises of his creatures having an orgasm, brutes who are secretly feminine, such as Genet describes them. Cocteau, however, is not the first in this genre: as early as 1930, in the U.S., Charles Demuth devotes a series of watercolors to encounters between sailors. One is set amidst urinals. Two sailors are seen, deck pants open, short pea-jackets, comparing their swelling penises, yet still flaccid, while in the background two others are urinating side by side. Another watercolor is set on a beach; in the center, a sailor is wearing only his boots and his beret. Seated on the sand, he gets an erection at the sight of a friend's thick organ sticking out of his boxers; behind them, a third cohort is getting undressed. An aquatint by Pavel Tchelitchew shows a sailor asleep, pea-jacket above his navel, pants down to his knees. Jonathan Weinberg, who publishes the image, notes that, despite its huge size, the erect penis seems more a sign of vulnerability than of phallic power.[40] He is surely right. With their swaggering gait, their pea-jackets with braided collars, and their pom-pom hats—the ones that children of the bourgeoisie were still wearing in the 1940s—and probably also because of the places they travel through (ports and high seas), sailors are sort of stuck at an

uncertain in-between, perpetual adolescents, virile and feminine, whose strong sex organs contrast sharply with their prettified uniforms in the colors of the Virgin, blue and white. Outside the realm of art for the initiated,[41] the sailor becomes, beginning in the 1960s, a commonplace of homosexual erotic iconography. He is found, pants down, asleep on a docking bollard, in one of the first shots of complete nudity in the American "body-building" magazine, *Physique Pictorial* (1962), while in the images that the illustrator Tom of Finland sends to special American periodicals, whole crews check each other out and compare their colossal members.

Curates, sailors, tradespeople, Negroes and Arabs from the colonies, and later body-builder porn stars from California—these sexual figures of virility are endowed with archetypal organs: swollen or standing up, in every case exaggerated, also no doubt less and less "personal" as the production of licentious images evolves from the artisanal to the industrial stage. From the outset, physiognomy is thought of in terms of a collective, statistical modality, whether in the field of serious scientific, forensic medical study—e.g., the degenerate penis physiognomy of delinquents—or in the libertine field of erotic, pornographic imagery—professional penile physiognomy of the models (real or imaginary). This conflict between the ideal statistical truth and the experience of individuality is both humorously and unwittingly exemplified by an American illustration from the 1960s, which proposes to entertain the reader with five faces and five sex organs in close-up. Which penis corresponds to which face? The comparison between the portrait (of face) and the portrait (of penis) is thus posed. But the five teenagers confuse their physiognomic specificity in terms of general codes of American lifestyle of the 1960s—they all take after, as much as they can, Elvis Presley and James Dean—and their penises, equally circumcised, long, thin, and half-hard, look alike, strangely subjected to the same social and historical determination: sex organs of American "twinks" of the Vietnam War era, as was the case with the sex organs of the Sicilian *ragazzi* in the 1920s.

Although rare, full-size portraits and self-portraits do, however, exist in which, just like the face, the sex organ has its own physiognomy not in terms of history or social status but in terms of the person. The diptych by the American artist Wynn Chamberlain, *Poets (Clothed) and Poets (Naked)* (1964) represents, in this regard, a case study. In effect, on one panel Chamberlain has depicted writer friends,[42] three seated on a bench, the fourth behind the middle one, grouped a little like a class photo. Smiling, they are all dressed in the same ordinary manner, shirt and tie, blue pants, and are distinguishable only by their physiognomy, e.g., features, color and cut of their hair. A second panel shows them about in the same position,

but naked. And this time their genital organs distinguish them as much and in the same manner (color and form of their pubic hair; size and disposition of the penis; ridge of the prepuce or circumcision), as did their faces in the first image.

Less humorous and more preoccupied with humanity is the work of Lucian Freud, which includes many male nudes and offers several examples of this pictorial interrogation of the singular physiognomy of the model's genital organs. He paints Leigh Bowery without his usual attire as performer or dandy often in drag, but instead naked, bald, plump, corporeal, with thick penis and heavy balls. Freud depicted him standing on a draped platform, bathed in noonday light from a studio skylight—a perfect academic nude from a life model, yet very much removed from the Parnassian Movement and the Homeric heroes: too human. Freud again painted Bowery, sprawled on a pile of dirty laundry, one leg on a bare mattress, the other on the floor; his sex organ at rest hangs across his thigh, exposing his balls and his most secret parts, which extend them and open out beyond.

Rare, even in the twentieth century, these sexual portraits of men are practically without equivalent in the tradition: the social context of the portrait, an art of memory and ceremony, does not seem relevant here. By contrast, though the historical examples remain uncommon, the genre of the nude self-portrait has a prestigious origin in that of Dürer (1505). Around 34 years of age, the artist depicted himself almost frontally, the left arm behind the back and the right thigh slightly forward. His face is emaciated, his hair held back by a kind of headband, his beard sparse. Both the penetrating look and the whole expression of the figure make his act of seeing attentive, tense, almost anxious. It is an observation of the "objectal body," reflected no doubt by a mirror, as much as of the internal image that the artist keeps of his body. And at the juncture of these two images, that of the specular body and that of the body imagined from inside and known more intimately by touch than by sight, we see—modeled almost sculpturally in ink with white highlights—the thick penis, the glans of which is clearly outlined beneath the sheath of the prepuce, and pendulous balls, the irregular oval of one testicle sheathed in a quasi-anatomical manner by the supple tissue of the scrotum.

A tactile as well as visual image, the nude self-portrait of Dürer contains the private experience of self that it results from, although it does not elucidate that experience. The graphic analysis by an artist of his own sexuality, articulated in a systematic portraiture of his own sex organ, comes at the time of Krafft-Ebing and Freud, and in their city, Vienna, but without their knowledge, in the work of Egon Schiele. A self-portrait of 1910, in sepia ink, evokes that of Dürer by the personage's posture and the intensity of the stare—the gaze toward the spectator is not actually

focused on him but on the painter himself and on the mirror; even the framing, which cuts off the legs at the knees, accentuates the presence of the sex organ. The latter is treated with a less diluted, darker ink than the rest of the body: meatus, glans, balls, clearly delineated with a thick stroke of the pen. As Dürer, with hairless chest, emphasizes the whiskers of his beard, of his mustache, and a very fine line of hair on the pubis, so Schiele denotes on himself his pattern of hairiness—tufts above the penis, under the arms, and a fine line in the middle of the chest. Another self-portrait (probably) from 1910 breaks with the Dürer model. The watercolor in this case cuts off not only the lower legs but also the torso above the chest and hence the face. The man is seated on a blue footstool, one arm behind the back, skinny and contorted. His sex organ, pink and orangeish in the middle of the bright green folds of the groin, is less precisely drawn than in the preceding sketch, but its curve repeats exactly the twisting of the foot farther down, which is reminiscent of the spasms of the feet of Grünewald's or Holbein's tortured Christ. The real subject of the work, at the center of the picture, the organ of orgasm and generation, is also shown as the mainstay of anguish and mortality, as will be the case with sexuality, at the theoretical level, in the work of Georges Bataille.

It is an anguish that subsides perhaps when the cutting edge of desire and death, so keen during manhood, becomes blunted in a meditation of the effects of time. Dürer, who died at 57, and Schiele, at 28, did not reach the age at which John Coplans began his work. Feet, hands, fists, knees, torso, buttocks—the sexagenarian Coplans shoots photos close up, in black and white, that contain all the fragments of his body except his face. *Self-Portrait Six Times* (1986) [fig. 21.2], a sort of triptych, is devoted to that part of him that goes from the chest to the middle of the thighs: navel, belly, pubis, penis. Covered with short, curly hair, the shaft retracted, the balls wrinkled and dilated, with the naked glans in their midst looking like an acorn, the artist's sex organ, so singularly his own by the wear and tear of life that it expresses, coincides at the same time with other realms—animal and botanical—in which nature, always alive, in perpetual transformation, is fortified by the aging and death of the beings it animates. The sexual condition of man, which dooms him to be born, to grow old, to die, and also to procreate, overlaps with the physical fate of his sex organ in these images, while physiognomic resemblance is diffracted through them, splitting between the absolute singularity (the unique sex organ of this unique man at a single moment) and the dissimilarity or the infinite metamorphosis of the organic (e.g., bug, gnarled wood, mossy stone).

Coplans's sex organ already belongs to a staggering nature that shapes him, but it is the sex organ of an aging man, and the artist's own—there is no confusion

FIGURE 21.2 JOHN COPLANS, *SELF-PORTRAIT SIX TIMES*, 1987.

The older man's penis (here, the artist's own penis) eludes the erotic associations that imagery—even artistic imagery—commonly ascribes to it. Here it expresses the human condition, subject to the inexorable laws of nature and time, the aging that reshapes and deforms or transforms and reconfigures.

Source: Private Collection Photo © Christie's Images/Bridgeman Images

about its identification. Such is not exactly the case as regards the organ that fills the first shot of the short subject *Hoist* by Matthew Barney (2007). A sparkling, black invertebrate, algae or slug, palpitates, moves and, very slowly, dilates, swells, and extends in an environment of sand, lichen, and foam that seems to be breathing. It is only after three long minutes, when the thing is fully developed and gives a final jerk that the spectator can identify a man's penis. In the film, the being whose sex organ this is is not really a man but rather a hybrid machine, the distressed flesh of a colossal hoisting apparatus. From the more and more feasible intermixing that crosses man not with nature but with machine there results an unrecognizable penis, which nonetheless is a sex organ, dozing, vulnerable, then growing to erection: the human root of the machine.

And what is the result of the intermixing of man with God?

PHALLUS AND PENIS

In his famous work on the "sexuality of Christ,"[43] Leo Steinberg drew attention to a rare, neglected iconography, rather precisely delimited in time to the first third of the sixteenth century. It shows the "Man of Sorrows," the tortured Christ or the

crucified God, with the perizoma (loin cloth) made to bulge at the place of the sex organ by what must be seen as a powerful erection. These incongruous, apparently blasphemous images, which indeed Christian iconography wasted no time repudiating, correspond, however, to a lofty Christological conception that identifies in the person of the Son the conjunction of phallus and penis, elsewhere separate. The phallic symbol seems to have been affirmed throughout the world since ancient times. The values attributed to it—fertility, renewal, resurrection; protection; power—are very far removed from the determinant actions associated with the male's penis—concupiscence, violence, and mortality. The erection of Christ at the cruelest moments of his Passion point to the Resurrection, victory over death; it assumes, in a sense divinely, phallic values. But it is the erection of a man's penis, in the place on the human body where the penis is located and not detached and brandished in the manner of the ancient ithyphallus. As an erection of the penis, it points to what is called the "humanation" of God in Christ, the manifestation that the Father has become man in the Son, is really made man (not woman or God), subject to death and anguish—though not to carnal desire. Thus, the agonizing Jesus is at once immortal and mortal, impassible and passionate, victorious and subjected: at once phallus and penis. That said, visually, the man-God's standing penis, whose depiction remains quite rare, is as different from a common penis as is that of the man-machine (*Hoist*) resulting from Matthew Barney's creative imagination. It is a bulging cloth, which could be caused by flesh, but also by wind.

Except perhaps in the case of Jesus, phallic power is not man's power: one is universal and impassible, the other only virile and subject to the passions. The ithyphallus (figure of erect penis), however, is certainly a penis, most often immense, but sometimes reduced to the portable dimensions of an apotropaic (designed to avert evil) amulet. Inversely, men infer from the anatomical sex organ a natural right to participate in the pre-eminent symbolic order of the phallus: this is what is called "phallocracy." The architect Jean-Jacques Lequeu, at the very end of the eighteenth century, gives, in two plates, a visual version of this assimilation. The first, entitled *Lubricious Pose of Bacchus*, shows a man's groin, the sex organ at rest, with handwritten notations: "The member unfortunately unmoving," "Noble parts, organs of procreation," and "Balls." The second is *The God Priapus*. A standing penis: "The straight up, dreadful member in the process of performing its function," according to one of the notations on the drawing. Very precise anatomical plates are thus related to their guardian gods, as if the man's sex organ were actually the priapic and bacchic phallus. But a third plate, which shows a penis painfully deformed by paraphimosis[44] and attributed to a satyr with his goat-like thigh, is all

it takes to disturb this hierarchy: a mythological bacchanalian figure could actually be prevented from getting an erection! Since then, the art of the twentieth century has at times affirmed but more often criticized this hierarchical relation: either elevating the penis to the dignity of the phallus—and often, then, to mortify that prideful flesh—or lowering the phallus to the state of the penis.

The twentieth century was not skeptical but cynical and disillusioned: neither modesty nor religion has the clout to inhibit depictions of the phallic symbol owing to its formal identity with the virile member; and in fact, artists shaped, painted, or photographed more erect penises in less than one hundred years than during the four millennia before 1900, although they have rarely been dominant. An exception should be made for Constantin Brancusi's *Torso of a Young Man* (1917–1922); it is an upright wooden shaft (of marble in subsequent versions) with two shorter shafts arranged in a chevron at its base. Of course, as the title indicates, the sculpture represents a torso, starting with the thighs. But it is all the more difficult not to see at the same time a phallic symbol in that it resembles the Phallus of Delos to the point of being a citation of it. There is clear evidence that Brancusi intended to magnify the "young man's" virility by refining the body to the point of abstraction in order to exalt it as a body-phallus, a pure virile principle, standing up—and truncated, as is its model from Delos (although that one is in ruins). Thus, this rare moment of phallic affirmation in twentieth-century art is not total but already secretly melancholic, identified as it is with a glory of the past.

Several of Robert Mapplethorpe's photographs, without having recourse to the archeological reference, proceed in their manner toward a sublimation of the penis. This is particularly true in the case of the black male nudes collected in *The Black Book*. In one of them, for example, the model Jimmy Freeman poses stooping, his arms crossed on the axis of the legs, his head, covered with a white skullcap, between his shoulders; in the triangle thus formed by the horizontal line of the thighs and the diagonal lines of the calves is inscribed, as powerful and abstract as an architectural element, the vertical line of the virile member. A long penis sticks out of the fly in *The Man with a Polyester Suit*. But, by the framing (isolating the central third of the body), by the unusual size of the member, and especially by the grain and the black light of the skin that evokes a finely tanned goat skin more than a man's living epidermis, the nudity of the sex organ is detached from sexuality and elevated to a universal symbol. It is a symbol, however, without symbolic system: Mapplethorpe's photographs, once one chooses not to reduce them to the history of American queer movements, allow for total absorption in their aesthetic perfection.

Andres Serrano's cycle, *A History of Sex* (1996), is probably not devoted to the primacy of the phallus: the sex organ, in all its forms, is here absolute. The perfection of the images, whose enameled chromatism and apparent rigidity might evoke portraits by Bronzino as well as the decision to fix the models in the iconic, hence atemporal, position of their sexuality, help construct, no doubt, this absolutism in the monarchical sense of the term. The hieratic quality of Serrano's images is in contrast with the momentum toward sexual desire itself, which is movement: impetus, disorder or, more recently, drive. It is in this sense that the virile members visible in these photographic images, whatever their state, have to do with the phallus rather than the penis, with an emblematic sex organ rather than a carnal sex organ: less a symbol, though, than a fetish. And in this order, whether they get hard horizontally, are at right angles against nearly solid backgrounds of sky or sea, or, like one of them, hang out of the open fly of a sad Pierrot, these phalluses are mortified, fixed in an immutable individuality, without desire. This fine-tuning of "sex organ" against the unfading permanence of the fetish (e.g., in Serrano's work, erections do not precede orgasm and detumescence, and flaccid penises never seem meant to desire) actually ends up fetishizing the phallus. Thus, the example of *Master of Pain*:[45] a man against a dark background, his hands tied behind his back and a little cord, passed through three rings piercing, respectively, his two nipples and his glans, raises his penis; his testicles are tethered; on his face there is an inscrutable fixed grin.

Free or tied up, the penises of *A History of Sex* are phallic not as symbols but as fetishes, to the extent that this "history" does not subscribe to the ideological order of the phallus—either in defense of it or as critique of it. In other words, Andres Serrano's history of sex is not a history of the battle of the sexes. The same is true for another mortified phallus, *Fillette*[46] by Louise Bourgeois [fig. 21.3], a latex penis, brown like smoked meat, which appears scorched, standing up above two exposed balls (without protective scrotum). When it is not under the artist's arm, as in a 1982 portrait by Mapplethorpe, the sculpture is attached by the glans to the gallery ceiling and hangs this way like a game bird to cure or to be smoked. Bourgeois supposedly wanted to express the fragility of men and the necessity of protecting them.[47] Duly noted. She goes about it, in any case, in the manner of a Maenad. Castrated, skinned, hung, its name ridiculed, the penis gets this treatment just because it is the organ of the phallus, the way the head of the decapitated king is still the head of power. Such as it is, however, *Fillette* shows a close likeness (probably unwitting) to the *Effigy of the Human Penis* that the anatomist Joannes Ladmiral publishes in Leyden in 1741. The organ had been prepared with

FIGURE 21.3 LOUISE BOURGEOISE, *FILLETTE*, 1968. NEW YORK, MUSEUM OF MODERN ART.

The artist intended to express in this work her affection for male fragility. It is difficult, however, not to discern a certain misandry in this castrated, skinned, suspended phallus, ironically named *Fillette* [little girl]. Prohibited for a long time to women artists by phallocratic propriety, the depiction of male genitals often serves, in the last third of the twentieth century, as essentialist and vindictive forms of feminism.

Source: Art © The Easton Foundation/Licensed by VAGA, New York, NY. Digital Image © The Museum of Modern Art/ Licensed by SCALA /Art Resource, NY

injections of wax and "arranged from a perspective in which all parts could be seen as in real life," so that, thus presented, it would foster scientific investigation into human procreation. Ladmiral's print is therefore the inverse of Louise Bourgeois's sculpture: the latter makes of the castrated penis a doll or a hide; the former makes of the penis a natural wonder, whose evisceration reveals to the scholar the perfection—while contributing to the dissipation—of the mystery of procreation. Here, a fallen god; there, a virile effigy.

The ridiculed penis becomes, in the 1970s, a required figure of feminist art. In November 1974, Lynda Benglis publishes in *Artforum*, as an advertising insert, a photograph of herself, eyes covered by sunglasses with a white "butterfly" frame, lips half-open, body naked, oiled, in a slight, provocative hip-swaying pose—in short, the artist as a pin-up for a men's magazine, except that she is holding against her sex organ a long plastic dildo. The image in itself is complex: the pose of a professional, belied by the body of a woman with small breasts, short-cut hair, body language at once provocative and macho, in the manner of a man who wanted to show off his enormous penis, while holding it at the base of its shaft. The dildo, in turn, is literally ambivalent, since it is double-headed; one end is stuck into the artist's vagina (she is thus penetrated "as a woman"), the other is sticking out in

front of her (and she is stroking it off, "as a man"). The image, thought to be vulgar, provoked a sort of scandal in the American art world, feminists disapproving that a woman would play the pornography card,[48] and all agreeing that it was indecent of her to lash out against the lifeblood of a magazine: its publicity pages. In any case, the presentation of the ready-made man with phallus appears quite ridiculous when presented as a grotesque, vaguely obscene plastic penis, which has, dare we say, neither head nor tail.

Two years earlier, the art historian Linda Nochlin had already played on the register, if not of pornography, at least of libertine imagery in order to topple the phallocratic regime of images and of image producers, the artists.[49] Humorously plagiarizing a naughty French photograph of the nineteenth century, in which we see a comely young woman wearing nothing but her black stockings present a platter as she says: "Try my apples!" Nocklin photographs a man in socks, long-haired, bearded, hairy, big-balled, with a platter, saying: "Buy my bananas." Despite its plastic success, the demonstrative effectiveness of Nochlin's stratagem was to be short-lived. The point was to show, by the incongruity of a male pin-up, the asymmetrical, vectorized constitution of the gaze—the phallus sees, and its authority keeps it from being seen in return; an object of the gaze, the woman is subjected to vision—organizing the history of art in accordance with a rigidly heterosexual and masculine model.

We are surely no longer at that juncture today. But it is true that it was a woman's sex organ, and not a man's, that the Ottoman diplomat Khalil Bey had Courbet paint for his private delectation. Orlan, in direct lineage of Nochlin and Benglis, re-establishes the balance: she creates a counterpart to *The Origin of the World* (Courbet, 1866) with her *The Origin of War* (1989). The man, with his penis casually sticking up above well-rounded balls, takes from Courbet's (nude female) model the spread thighs and, more or less, the sheet pulled up above the navel. But the respectful title given by tradition to the work of the nineteenth-century master is reversed: from the world to war—the phallus (not all that impressive, seen up close as Orlan shows it) as attribute of virility is a principle of destruction. Marina Ambramović, known in the 1970s for performances during which the violence of spectators was allowed to be vented, shot a funny short subject: *Balkan Erotic Epic* (2005) parodies a documentary about folk rituals of a Balkan people. Men and women, each according to gender, entreat the elements. By shaking their naked breasts, women call for rain on the new-sprung wheat; before planting, men fertilize the earth with their sperm. The last scene of the film shows these men standing, in traditional costume, their penises sticking out of their open flies; proud

tumescent phalluses at first, they more or less quickly droop and dangle as the virile chorus resounds, warlike and nostalgic.

In these feminist works, the women artists seem divided between condemnation and commiseration for the place of the penis-phallus. The claim of males to assume the right to phallic authority deserves to be corrected, but the penis, manipulated for their enjoyment, their pain, or even their death, appears quite fragile. A last series of works endeavors to show the virile member, and through it the virility of which it is at once organ and symbol, less prideful and perhaps by the same token vulnerable. These artists form the hypothesis that man might also remove himself from the order of the phallus; and his penis takes on then, in these works, the paradoxical charge of showing the part of femininity that works its way into his virility.

The moral and hygienic opprobrium attached for a long time to masturbation[50] makes of it a shameful, exhilarating, solitary, and secret activity par excellence. At the beginning of the last century still, physicians and pedagogues are unanimous in condemning it, and while Freud may appear to be less severe, he nonetheless regularly makes mention of masturbation in his clinical notes as one element among others in the patient's history that is symptomatic of neurosis. It is against this background that we should measure the audacity of a self-portrait by Schiele, dating from 1911 [fig. 21.4], in which the artist is shown naked with only an open black jacket, caressing his penis with one hand, his balls with the other—so that, though the autoerotic activity leaves no doubt as to its intention, the genital organs, hidden by the hands that stroke them, are, strictly speaking, not visible. But the audacity consists in showing oneself at a moment of abandon and tenderness toward oneself, at once focused on male genital pleasure and removed from the whole arsenal of virile values: self-control, conquest of the other, and contempt for caresses and relaxation. The portrait or self-portrait of masturbating, which survives the medical and religious condemnation of the practice to the point of becoming a kind of commonplace of American underground culture of the 1970s and 1980s, draws its real subversive force from this unusual mixture of effrontery, assumed defiance of mores, modesty, and even hygiene and voluptuous tenderness for oneself. Thus, *Booby*, a cigarette in one hand, his thick penis sticking out of his fly and held between three fingers, with a vague look and his tongue between his lips, greets the lens of Larry Clark (1978) [fig. 21.5]. The teenager, kind of a prostitute, presents his merchandise as if making a gallant last stand, valiant yet pitiful. David Wajnarowicz, Rimbaud-like figure from New York in the queer movements during the years in which AIDS was decimating the homosexual community, photographs himself

FIGURE 21.4 EGON SCHIELE, *SELF-PORTRAIT AS SEMI-NUDE WITH BLACK JACKET*. 1911, VIENNA, GRAPHISCHE SAMMLUNG.

The nude self-portrait springs from a discreet but ancient tradition. Few artists, however, have depicted themselves naked with the same constancy and the same intensity as Egon Schiele, whose small oeuvre demonstrates a kind of self-analysis of his own sexual condition. Moreover, at the time when the artist is showing himself in the process of caressing himself (and in another watercolor in the process of masturbating), onanism is still condemned by both medicine and morality.

Source: © akg-images

FIGURE 21.5 LARRY CLARK, *BOOBY*, 1978.

Autoeroticism or selling oneself? With Larry Clark, whose work falls between art and social documentary, the virulent virility of poor teenagers, with permanently swollen penises, seems to be the source of a vulnerability that is at times mortal.

Source: © Larry Clark; courtesy of the artist and Luhring Augustine, New York.

naked, sitting on a chair, his penis sticking up, firmly held in his right hand (1981); Nan Goldin (1980) photographs her friend Bobby, naked, kneeling on the ground, taking care of himself.[51] A few years later,[52] in 1993, in Europe but by means of an aesthetic dependent on American antecedents, Wolfgang Tillmans shows a man lying on a tiled floor, his face hidden under the sole of a tropical boot, whose rough caress he seems to like, his glans engorged by the pressure of his hand. There too, the display of virility is in keeping with the consent for orgasm, which is always disarming and at times requires submission.

Sylvie Blocher filmed *The Judgment of Paris* in 1997, a single shot of nine minutes, during which a man, through the gradual display of his nakedness before the artist's camera, detaches himself from virile rigidity, rejects paternal authority ("Fathers are disappointing," he murmurs with a sigh, at the moment he lowers his underpants), and finally takes on a bit of femininity. The man is at first prostrated on the floor and moans: "I can't, I can't." He gets up slowly, and reluctantly, sorrowfully, removes his clothing, piece by piece. With his pants at his ankles, he weeps, his head down, as if overwhelmed by shame. It is only when, naked, he brings his hand to his sex organ and caresses it gently, delicately, that he finally dares to confront the artist's gaze through the camera. Who is Paris in this story? Through a reversal, Paris is the artist who gets a man to show himself naked in front of her, just as the shepherd (Paris) had seen the three goddesses. But she makes no judgment. The man also goes through another reversal in which his dignity suddenly changes register. In the myth, Helen ("most beautiful" woman promised to Paris by Hera if he chose her) was the exclusive prerogative of the fathers, clothed men judging nakedness; yet she becomes, through the astonishing conjuncture of the still firm gaze and the extreme bareness of the hand caressing the penis before offering it, fragile and vulnerable, to the camera, the attribute of a son who no longer completely believes in the immutability of the phallic order. The force of the work comes, no doubt, from its use of the progressiveness of cinema: nine minutes, during which we see a man give up his all-powerfulness and restructure himself, heterogeneous and new. But it is the stratagem that interests us above all here, which consists, for the artist, of locating the secret femininity of her model precisely at the place of the virile member, at the juncture of the gaze and the touch of a caress.

We have been rediscovering over the past few years the complexity of the links between man's anatomical sex organ, the symbolic sex organ, and identity. Artists take part decisively in this rediscovery, no doubt because this question, in which the very idea of representation is at play, has haunted them for a long time. Around 1513–1514, Leonardo da Vinci makes a drawing known today by the (modern) title

of *Embodied Angel.* It shows a personage very close, by dint of the look on his face, to the very feminine *St. John the Baptist* in the Louvre. He is naked, and a transparent veil over the torso emphasizes the beginnings of a woman's breast; but his male sex organ is standing out in a powerful erection. Daniel Arasse has shown how much this drawing corresponds to the artist's private desire, springing from his genius, to find the original man, the Adamic androgyne of creation, but actually free of sexuality.[53] Nevertheless, beyond the intimate elaboration of a phantasm, the long-forgotten image is emblematic of an ambivalence bearing on the organ of virility itself. Leonardo, in his anatomical notes, detached the organ from the man, endowing it with a life of its own, independent from that of the person attached to it:

> On the penis.
>
> It is related to human intelligence, and at times it possesses an intelligence of its own; in spite of the will that desires to stimulate it, it persists and acts as it wishes, moving at times without the man's authorization or even without his knowledge; whether he is sleeping or in a waking state, it follows only its own impulse. [. . .] It therefore seems that this being has often a life and intelligence distinct from the man's, and that the man is wrong to be ashamed of naming it or showing it off, constantly trying to cover up or dissimulate what he should adorn and display magnificently, like a priestly celebrant.[54]

: : :
·

22

BRAWN IN CIVILIZATION

· · · · · · ·

VIRILE MYTH AND MUSCULAR POWER

JEAN-JACQUES COURTINE

IT IS common to reproach Sigmund Freud, bourgeois man of the nineteenth century that he was, for having forgotten the question of "gender," and for having written off male domination. It would be safe to point out the anachronism of the accusation or to indicate that this has not always been the case. In a long note to *Civilization and Its Discontents*, the inventor of psychoanalysis actually does come to speculate in these terms on the discovery of fire, "that great cultural acquisition:"

> It is as though primal man had the habit, when he came in contact with fire, of satisfying an infantile desire connected with it, by putting it out with a stream of urine. . . . Putting out fire by micturating—a theme to which modern giants, Gulliver in Lilliput and Rabelais's Gargantua, still hark back—was therefore a kind of sexual act with a male, an enjoyment of sexual potency in a homosexual competition. The first person to renounce this desire and spare the fire was able to carry it off with him and subdue it for his own use. By damping down the fire of his own sexual excitation, he had tamed the natural force of fire. This great cultural conquest was thus the reward for his renunciation of instinct. Further, it is as though woman had been appointed guardian of the fire, captured and conserved on the domestic hearth, because her anatomy made it impossible for her to yield to the temptation of putting it out.[1]

TWILIGHT OF THE PENIS?

As with many of the anthropological developments of Freud's work, this narrative must be understood with caution, in the manner of a fable. Whatever the case may be, the lesson from it is clear: the economic foundation of a sedentary society (the hearth), just as male domination (that assigning of women to the guardianship of the fire within the domestic space), implies the abandonment of an infantile form of virile power, i.e., renouncing the enjoyment of standing up to piss—farther, stronger, and longer. The Freudian conclusion is therefore paradoxical: at the origin of the wielding of virile power, rather than the manifestation of all-powerfulness, we find the necessity of a renunciation.

Echoes of this fable come to us from contemporary Western societies, although weakened and considerably deformed. In these societies the perception of virility remains profoundly divided: a widespread feeling of crisis, vulnerability, and uncertainty about masculine identity coexists with the aggressive proliferation of virile images, displays, and parades.

Let us turn, for example, to those who in literature have explored most closely the condition of the modern male: Philip Roth's entire oeuvre could thus, in some ways, be read as the uninterrupted chronicle of the contemporary setbacks of American virility.

> [A] man bearing between his legs a spigot of wrinkled flesh where once he'd had the fully functioning sexual organ, complete with bladder sphincter control, of a robust adult male. The once rigid instrument of procreation was now like the end of a pipe you see sticking out of a field somewhere, a meaningless piece of pipe that spurts and gushes intermittently, spitting forth water to no end, until a day arrives when somebody remembers to give the valve the extra turn that shuts the damn sluice down.[2]

From the adolescent problems in *Portnoy's Complaint*, passing by adult glory, followed by the tragic fall in *American Pastoral*, to the later novels about the terminal crumbling of masculinity in the agony of prostate surgery, this pathway across the ages of virility makes Roth's work similar to the Stations of the Cross. Miracles in them are of short duration—"It's all called back—the come back virile man called back to life! Only there is no virility. There is only the brevity of expectations"[3]—and the result is ineluctable: "Should he ever write an autobiography,

he'd call it *Life and Death of a Male Body*."[4] Virility is not an object of renunciation but of mourning. No use seeking consolation somewhere else, on the other literary side of the Atlantic, whether yesterday ("There is virility, and there is male disease, with its millennia of possession, vanity and fear of loss")[5] or today ("It is possible that in earlier times when bears were numerous, virility may have played a specific and irreplaceable role; but for several centuries men have no longer been visibly good for anything").[6] Abandon all hope, ye who enter the empire of the male. . . .

This feeling of a twilight of the penis in the West coexists, however, with what seems to be its opposite, its daily, obsessive, universal celebration in the manner of a depressive base that maniacal rituals would continually ward off: the rampant deflation of the self would be compensated for by a continual inflation of the body, a hyperbolic virility consisting of extreme muscular development and hypermasculine appearances that has never had an equivalent or precedent in the history of the body in the West. It is the historical anthropology of this paradox that the following pages sketch out by tracing in Europe and North America the genealogy of the images and practices of these virile displays—their ostentatiousness, but also the worry that accompanies them.

SIMULACRUM CULTURES

Let us consider American society in this way today. Virile muscle has set up its Mecca in Venice, one of those Los Angeles neighborhoods that stretch along the ocean. The crowd of yuppies on the go—joggers, cyclists, skaters, and surfers—press around, curious, in front of a fenced enclosure, where bodies with bulging muscles "pump iron." Muscle Beach, California: tourists snap photos, and the bodybuilders strike a pose. Make no mistake, however: even though the fencing of the enclosure suggests a cage at the zoo and the overdeveloped strong men's bodies at county fairs of bygone days, this muscular unpacking is not the residue of some freak show. Bodybuilding fully takes part in the muscle culture celebrated by the middle class, although in a hyperbolic mode. The history of the place[7] actually retraces and condenses the gradual integration of the model of a hypervirilized anatomy into the labor devoted to masculine appearances in contemporary America. Muscle Beach opens its door in the 1930s, in the midst of economic depression, and offers right away a labor-like distraction for the male population hit by unemployment: gyms,

after all, share with the factory this one distinctive trait: the greatest possible concentration of machines and the most restrictive mechanical discipline of gestures. The athletic exercises practiced there legitimate the display of partially naked male bodies in a still puritanical America. They are quickly converted into magazine images, whose distribution contributes to the gradual erosion of modesty. A virile photographic genre is invented then: the masculine muscleman smiling against a background of a sunny beach, a delighted young woman at some point leaning on his shoulder. Then in the 1950s, the place becomes the inescapable meeting place between muscle and cinema as it experiences its first golden age by furnishing Hollywood studios on a daily basis with hordes of Roman legionnaires and gladiators needed for the shooting of innumerable epics. We also see the unveiling of the first male stars, such as Steve Reeves, who move directly from the catwalks of Mr. Universe to the big screen. Cinema thus helps these virile, sculpted muscular stereotypes in the flesh at Muscle Beach saturate visual mass culture before making the place itself a cinematic subject.[8] This will immortalize its world of iron, machines, sweat, and grunts, to the point of fostering its replication in a chain of commercial franchises.[9] The place will experience a second golden age in the 1970s, now even promoting its guests—including the most famous among them, Arnold Schwarzenegger—to the rank of universal ambassadors of oversized virility, recruited on occasion when the threats of the second Cold War come to trouble movie screens, and during the time when Ronald Reagan could conclude a speech thus: "And, in the spirit of Rambo, let me tell you, we're going to win this time." Muscle is patriotic, but the history of the diffusion of these virile models stops being a strictly American affair relatively soon and is enlisted in a global history, in which the international film industry has played an essential role[10]—a phenomenon that Marcel Mauss had already perceived in the early 1930s with regard to the transmission of corporeal characteristics beyond national borders. Hypermasculinity has become a central element of body culture in contemporary America, and beyond that of global visual culture. It possesses in this regard the value of a symptom; it presents this symptom by enlarging it, literally, as much as possible.

For muscle is everywhere. It jumped over the walls of the stadium and the ropes of the ring a long time ago. It reigns absolute on screens large and small.[11] It has ceased being the prerogative of one sex and the crushing sign of the domination of one over the other: women first appeared among the elite of bodybuilding in the 1970s and have proliferated ever since.[12] The claim on muscles has been democratized, the practice of bodybuilding now tends to be widespread, and anatomical power is displayed as a continuous, obsessive, universal spectacle.

The spectacle is first of all in the street.[13] Among the crowd of walkers, bodybuilders draw attention to themselves by the way they walk: arms outstretched, head sunk into the neck, chest sticking out, stiffness of step, and a mechanical balance. The practice has engendered its own "theory of walking," which its enthusiasts name, among themselves, "the walk." For the virile man does not walk; he moves his body. Not in the manner of the obese man, that other creature indigenous to American crowds, who drags his anatomy like a burden that hampers and stigmatizes him. The bodybuilder's body, on the contrary, seeks to get all the benefit of its weight into the field of vision, to saturate what is seen with muscular mass. It aims "to be impressive," to make an impression on the gaze of the other by the combined action of an effect of mass and mechanical movement. Muscle calls out. It is one of the favored modes of the male body's prominence within the urban anonymity of physiognomies, the veritable signature of a virile lifestyle.

Most often, bodybuilders can be found near or in the nutritional supplements aisles of supermarkets, in the neighborhood of many gymnasiums, or else in bookstores paging through magazines devoted to them. But virile muscle does not live in a ghetto. On television and in the movies, the displays of muscles have become widespread since the 1980s. Special cable channels and occasionally major broadcast networks have conducted bodybuilding competitions on ordinary programs. It is a strange spectacle, however: men's bulging bodies, artificially tanned, carefully depilated and oiled, lined up on stage in accordance with a ritual that evokes beauty queen contests: mutant women whose sex is effaced under the transvestitism of muscles. They strike curious poses—those who think they are reviving classical statuary when the oversized quality of their anatomies sticks out like an insult to the art of ancient sculpture. They are unusual muscle masses, purely decorative; they serve neither to run nor to throw and thus break with everything in sports logic that associates muscle with movement. These leaden choreographies are striking confrontations, images of duels without contact or violence contests purely of appearances that separate virility from its origins in the trials of warriors in favor of a simulacrum.

All this should lead to a questioning of the fate of the most up-to-the-minute virility. Historically, virility has always been associated with the use as well as the image of strength. It originates in hunting and combat; and the competitive sports that keep it most explicitly alive today are the most brutal: rugby and football, certain martial arts, and boxing, about which Joyce Carol Oates has written: "Boxing is for men, and is about men, and *is* men. A celebration of the lost religion of masculinity all the more trenchant for its being lost."[14] This celebration

"of the male in the man"[15] has retained its enthusiasts, and the "tragic theatre"[16] of virile violence always fills sports arenas. But a cult of the sole image of virility has gradually emerged in the course of the twentieth century, before becoming more and more radically dissociated from virility. It has given rise to a culture of the simulacrum, which will be our main point of interest here. This culture strengthens today the original founding principles of the virile tradition by parodying them, one after the other, in mass spectacle: strength in bodybuilding contests; the extreme popularity of wrestling bouts on TV; the seductiveness of the Chippendale shows; and the sexual power of the moneymaking porn film industry. Now we have to understand why.

BILDUNGSROMANE, PATERNITY SEARCHES

The fact remains that in view of the paradoxes and excesses of this grand virile show, the most surprising thing is probably that the paucity of astonishment has made such headway throughout the West and probably beyond it. This is because our eyes, little by little, have become accustomed to this muscular kitsch: bodybuilding and the spectacles that are related to it are just one of the forms of a visual culture of the masculine image, dating from much earlier, which has become gradually established and which exploded beginning in the 1980s at the same time that it took on new characteristics. The instances of it are too abundant to be detailed here, whether it is in the world of advertising saturated with pectorals or in the media's constant broadcasting of sports events, whether it is children's toys, comics,[17] the number and extensive distribution of magazines devoted to body culture, even the "gay" aesthetic inspired by it, or finally the fabulous public success of Arnold Schwarzenegger, thanks to whom muscles have had their Hollywood apotheosis before winning their political and social recognition.

More recently, hypermasculinity has appeared on the literary scene, and no longer only in the useless old form of the how-to manual on improving virility, which appeared earlier in the century as penned by strongmen of yesteryear, Eugene Sandow and Charles Atlas (*How I Succeeded in Life Thanks to Weightlifting, I Was a 97-Pound Weakling . . .*). Now the novel is finding subjects in the area,[18] and, for the first time, with the autobiographical narrative of Sam Fussell, the confession is available of an intellectual converted to weights and barbells. He traces his

discovery of bodybuilding, details his practice of it, dissects its virile rationality and necessity, relates the quasi-religious intensity of the experience, and in the end tells the story of his disillusionment.[19] Upon closer reading, however, one realizes that this narrative is but a contemporary variant of an older genre: the building of muscles has come to play a central role in male initiation novels (*Bildungsromane*). Physical education tends to be substituted for sentimental education in the American *Bildungsroman*. The same scenario is repeated, more or less. It begins with a supposed paternal failure—an absent, indifferent, or brutal father; this leads the young man on a quest, beyond this missing link in the genealogy of masculinity, for a model of virile mastery, which the experience of a mature man will be able to transmit to him—unless the fraternal warmth of a community is involved. Thus, with the help of an old coach or blood brothers, virility is acquired. This extremely old literary model, in which the genealogical quest for virile modeling in an exclusively male lineage is still the rule, has recently seen a spectacular flourishing, fostered no doubt by the feeling that something about virility has been lost. It includes now, besides its extensions in the novel,[20] a quasi-universal diffusion in mangas (*Dragon Ball*) and a literature aimed at the global adolescent (*Harry Potter*). In mainstream Hollywood film production, it stands guard over the access to virile violence by young immigrant men (*Gran Torino*) or even by young women (*Million Dollar Baby*). America as a whole and the global culture of the West seem engaged in an interminable search for paternity.

PROSTHESES AND STIMULATIONS

Bodybuilding thus constitutes one of the most spectacular manifestations of a culture that is virile in appearance. But it would be wrong to take virility for a simple ideal or for the sole representation of an ideal in our society of the spectacle. It is based, like all ideological constructions, on a materialist foundation: it is produced by an industry, organized into a market, and disseminated across various manifestations of mass participation.

A considerable development can thus be noted, since the 1980s, in the marketing of muscles and the consumption of goods and services devoted to body maintenance. Industrial empires, in diverse sectors, have occupied this niche market for iron, vitamins, and sweat, producing muscle-building machines as well as nutritional

supplements and also publishing magazines specializing in fitness, health, diets, and physical exercise.[21] Muscle building at home has become an activity of mass participation, as shown by the exponential growth of the exercise machine market.[22] But at the same time, the latter was being transformed: the weights and barbells of the early days as well as the simply mechanical machines were replaced little by little by apparatuses making use of all the possibilities of electronics. This technology of sweat extended but also modified practices of muscular remodeling. Thus there developed a whole range of devices, indispensable from then on for virilizing one's appearance. The machines have become familiar: user-friendly, they dispense "amicable" stimulation, furnish psychological support, and prevent possible failure. They have even managed to be transformed into elements of home decor, a piece of furniture like any other, placed sufficiently in view—whereas the barbells used to be placed discreetly in the back of a closet—to demonstrate the integration of the bodily norms in force and to furnish proof of participation in a shared body culture. Muscle building is a way of life, and work on one's virile image requires attention at every moment, the puritan "work ethic" having been revived.

But the machines do even more: they are directly hooked up to bodily functions. The apparatus is intended to be listening to the organism, its pulsations and its rhythms, which it translates instantaneously into measurable quantities. The muscular development of virility may be controlled and calibrated, its increases calculated, the augmentation of muscle mass added up. Even the most cursory anthropological observation of the practices that prevail in West Coast gyms makes this immediately apparent. Surrounded by mirrors that infinitely increase the reflection of one's image, attached to mechanical devices indispensable to one's muscular development, the man looking to build up a virile body reaches the point of incorporating an imaginary machine, which leads him to perceive and treat his own body as an apparatus external to himself. It is separated into muscular cogs, submitted to the rhythmic repetition of thrusts and push-ups, subjected to the imposed circuit, which leads from one machine to another, doing over and over the routines of effort and sweat. This is the uncanniness of gymnasiums: bodies end up at times becoming indiscernible from the machines; the muscles that grow there and the virilities sought there appear to be those of robots.

Arnold Schwarzenegger confided one day to a *Los Angeles Times* reporter, "I dreamed, once I got to the U.S., of having a gymnasium built across from every supermarket." Sometimes dreams of immigrants are, alas, finally realized, beyond all expectations. This one, though, has the merit of locating the contemporary manufacture of the virile body where it ought to be: in our consumer society.

VIRILE OBSESSIONS AND THE DREAD
OF POWERLESSNESS

The practices and depictions of the body in consumer society are in fact shot through with diverse strategies for regulating the flux, the matter, and the energy of incorporating, channeling, and eliminating. They make of each individual the manager of his or her own body and of each male subject the guarantor of the virility of his image. Bodybuilding and the constellation of practices developed during the same period and more or less related to it—jogging, aerobics, low-calorie diets, and even the unprecedented development of plastic surgery . . .[23]—all these techniques of body management that have been flourishing since the 1980s are underpinned by an obsession with body exteriors. This obsession is expressed in a love of the smooth, the shiny, the fresh, the svelte, and the young; it has spread just about everywhere and with this comes the anxiety about what seems, by appearances, loose, lined, baggy, rumpled, wrinkled, weighed down, soft, or slack—an active denial of the signs of the organism's aging. It is the laborious denial of a foreshadowed death.

In the culture of hypermasculinity that concerns us here, these contemporary forms of the care of self yield to a desire for a massive increase and extreme tightness of the male's exterior, augmented by a desire for quasi-transparent skin. The ideal image of the male's body wavers between the representation of priapism and that of the flayed man, all the muscles bulging of a self-without-skin. It will not be surprising that from then on the market for masculine muscle development coincides closely with that of synthetic testosterone and anabolic androgenic steroids. Virility would seem to have found its miraculous cure: rejuvenation of the organism, stimulation of sexual activity, and augmentation of muscle mass and muscular performance—but above all the treatment of aging as if it involved a disease, prompted by the confusion between the natural signs of age and the diagnostics of declining male hormones. Getting old is a pathology: combatting the years, impotence, and death becomes a virile obsession.

As the sun rises over the Palm Springs Life Extension Institute, situated amid the palm trees in the desert a hundred miles east of Los Angeles, a bare-chested patient named Bob Jones is already ascending into the foothills of the Little San Bernardino Mountains. Clasping two hiking sticks, his bodybuilder's torso dripping with sweat, the seventy-year-old prodigy wipes a lock of implanted hair out of his eyes and

presses on toward the summit. His new and strenuous life under medical supervision has become a single-minded campaign against death and decay. "No one," he says, "can age with dignity without a body that works." Not surprisingly, the dignity of the body comes at a price for the institute's affluent clientele: Jones has invested $60,000 in his own rejuvenation, and it is hard to imagine how this novice bodybuilder will deal with the fact of his mortality when the end finally comes.[24]

Meanwhile, indifferent to the paradox there may be in wanting to die in top shape, he pursues his individualized regimen of "total hormone replacement therapy:" "Old age," asserts the director of the Institute, "is a disease, and it can be treated, thanks to hormones."[25] Whether with pills or with injections, virility is, from now on, for sale over the counter.

Contemporary hypermasculinity bears the sharp imprint of this denial of death, this nostalgia for an earlier time, and this regenerative passion for the prime of life.[26] And it does so in several ways. First the singular way that Philip Roth expressed it earlier, regretting in the autumn of his life the lost youth and strength of the male subject he once was. Another way is collective, the evocation of a permanently past time of virility, in which men were still "real men" before depending on the historical moment, the decay of morals, the falling off of education, paternal failure, maternal tyranny, and the advancement of gender and class equality—or else all of these at the same time—came along to corrupt eternal virility. We see right off that this double complaint is actually only one: it is the projection of the individual dimension of biological aging onto the collective understanding of history, that is, the essential operation of dehistoricizing virility. This is the reason why it is perceived as immutable masculine nature, why also it turns out in every era to be in crisis, and why, finally, it remains the object of interminable mourning.

It can be just as easily understood why writing its history is necessary. This brings us back to one of the introductory questions of this volume: writing the history of virility is writing the history of an erasure of history, of a "historical work of dehistoricizing," which Pierre Bourdieu and the feminist works that preceded him located at the very core of the conditions for reproducing male domination.[27] To address it, we must change perspective, put into operation a tiny displacement, and consider the history of virility in a scarcely different way but one that does change our perspective on it.

Virility is most often understood as the assertion of power, the perpetuation of domination. This is not false if one still agrees to see it as the consequence of

a primordial fact, anthropologically essential: but what counts in virility is just as much the dread of powerlessness as the wielding of power. The phantom of powerlessness (or impotence) haunts virile figures, practices, and assertions. In the beginning, then, there would have been fear as much as power: a fear turned back into power, a dread denied in the forms of domination, which can be brutal and aggressive and deadly at times.

It is this primordial dread—that of defeat in combat—which was long ago a fear for the survival of the species, later became dread of defeat in war, and today is fear of losing in sports; that of moral failure, of cowardice; or of breakdown, of sexual failure. All this is nourished by the powerlessness experienced by the male subject at the beginning and at the end of his existence. It engenders the confusion between historical time and biological time, encourages the quest for a mature age of virility and a virile prime of life anterior to the decrepitude of the present. Are our societies still virile? Is virile man a species going extinct? It is precisely the projection of the fears of biological time onto historical time that prompts such questions. This is why the ideal of virility can be maintained intact only by erasing history. And this allows us to return to one of the questions posed to contemporary virility earlier: is it in crisis? Virility is always, necessarily, in a state of crisis, and this is the case each time that the reality of history contradicts this ideal of power that denies powerlessness, each time that real history locks away factors that destabilize the male power that virility assumes—that is, continually. The crisis is therefore endemic, and it will remain so.

GENEALOGIES: IN THE BEGINNING WAS MUSCLE

This never-ending crisis forces virility into a continuous genealogical obsession—of which I will give a few examples in the ancient and modern worlds. The quest for virile strength has existed in the past, and, dissipated or weakened since, that quest is seen as something to revive. In this case, it involves a structural element in the configuration of virility as the organizing principle of pronouncements made on the nature of man, much more than a contingent historical fact. This is true, as we shall see, though in a historically variable manner, in ancient Europe as well as in contemporary America. And it remains true wherever ideas that celebrate the old patriarchal domination have taken root, e.g., in the depths of the *colonia Santo Domingo*, one of those working-class areas of Mexico where the macho was

invented, Today, "machismo carries with it a certain element of nostalgia; it is cultivated by those who feel they were born too late."[28] At the very foundation of virile domination there might very well have been nothing more than the fear of powerlessness, which points the male psyche toward a triple quest: the interminable search for a supposedly lost all-powerfulness; muscular or sexual embodiment in the body itself; and the search for the avatars that will, by default, furnish simulacra of it.

That is to say that the ideologues who locate in virility the very nature of man, who believe they are distinguishing, in contemporary images of masculinity, the memory of a former power, who legitimate in precisely that way the domination of one gender over another—the mind-sets of those ideologues possess all the characteristics that Claude Lévi-Strauss attributed to mythic discourse.[29] Like myth, virility "always refers back to past events, 'before the creation of the world,' or 'during the earliest ages,' in any case 'a long time ago.'"[30] So, let us return to old Europe, when Edmond Desbonnet, one of the pioneers of physical fitness ("*culture physique*") in France, writing in the first decades of the twentieth century, tries to locate in history the necessity of "regenerating" a mass of men who are "deplorably incompetent, disdainful of engaging in muscular training,"[31] and "victims of the poison of immobility." It is quite natural that he should write about it by evoking a primitive virility:

> In the beginning of humanity, strength took precedence over intelligence. The chief was supposed to be the strongest of his tribe . . . , the one who came out of the caves triumphant after fighting bears. . . . It would only be natural, in the Stone Age, that when two traveling hordes met, in order to recognize the chief, everyone's eyes sought in the middle of the caravan, in one of the chariots made of squared-off tree trunks, the tallest, biggest man, with bulging muscles, broad chest and grave, energetic face.[32]

In the beginning was muscle, and in its presence was recognized authority: first verse of the gospel of virility. The remedy for the powerlessness of those "men who work in offices," stigmatized by Desbonnet, is retrospective: it must be drawn from the exemplary lineage of primitive hunters, ancient strength, medieval prowess, and the modern warrior. For the virile legend does manifest this other trait of the mythic discourse: recording its story in a reversible time: "These events, which are supposed to unfold at a moment in time, form a permanent structure. That structure refers simultaneously to the past, the present and the future."[33] Virility is

ageless: the soul of warriors travels through time, and bodies that have managed to remain virile or endeavor to become so again recapture and revive powers thought to have disappeared. Desbonnet, again, refers to a wrestler from the beginning of the century: "Apollon, the King of human strength. . . . His perfect form and his Justinian mask-like face recall the gladiators of ancient Rome. Apollon is French, born in Marsillargues, Hérault."[34] As for Jules Vallès, assiduous spectator of fights in Parisian rings, he was able to discern the aristocratic nostalgia that weaves together these virile lineages: "Vigneron is still one of the most brilliant representatives of French vigor. I can't tell what powerful grace makes this son of the Parisian suburbs resemble a hero of the ancient palestra."[35]

A virile je ne sais quoi ensures the reincarnation of an ancient hero in a Parisian proletarian: thus the question of the transmission of virility is posed at the very core of its legend. The answer comes in two stages. Virile man, first of all, is engendered by himself. Thus Triat, strongman, owner of a famous gymnasium and inventor of a method of muscular development in Paris at the beginning of the century, was able to bring into the world his own Herculean nature:

> There is the Master. Stop and take a look. . . . Why does his heroic vigor seem to mock our decadence? Because M. Triat, unrivaled athlete, a Hercules of modern times, is the legitimate son of his own method. . . . M. Triat, in response to his own method, has literally made his muscles swell and molded his flesh.[36]

Then onto "the most moving" spectacle of this modern Hercules, "the only man capable of holding such a mass of cast iron, with outstretched arms, above his head:" rallied by "his vibrant and sonorous voice, fifty students obey the Master's words. . . . From professor to student a magnetic current passes; the Master's power splits up, pours forth, and each one has within himself a mysterious voice that says to him: 'March! March! . . .'"[37]

Genealogical obsession, reversibility of time, and the march through the ages engender a birth immediately displayed through a kind of erectile dramaturgy. It is the birth of a corporeal power and the quasi-miraculous transmission of that power. The virile myth presents an imaginary theory of the engendering of males by themselves. Immemorial yet completely current, this legend has at its disposal a vast anthropological foundation within the cultural space of the West—and most probably beyond, given the global diffusion today of cultural merchandise. As an integral part of the apparatus of the "archaic dominant model," it challenges the exclusive right of giving birth, this "exorbitant and unfounded privilege" that

grants women "the incomprehensible capacity"[38] to produce bodies similar to, but also different from, themselves. But men, too, can give birth to other men, or more exactly to that most masculine part of men, to what makes the man a man, virility. Women may very well deliver boys, so long as men will reproduce virile men. Joyce Carol Oates had the striking intuition about this masculine factory of virility that boxing has retained: "Men fighting men to establish worth (i.e., masculinity) excludes women as completely as the female experience of childbirth excludes men. And is there, perhaps, some connection?"[39]

This myth, related to heroic epics and endowed with an extreme structural plasticity, was able to be parsed on the basis of a whole set of historical and cultural variants. If we turn back to the New World, we can easily spot it at the very moment when Desbonnet is counseling muscle building to the middle classes of old Europe. As the historical experience of the Frontier is closing, Americans, too, become aware of the necessity of struggling against the new evils of a sedentary life: overwork linked to office jobs, urban stress, and "American nervousness." As in large European towns, numerous gymnasiums begin to be built in the cities, conceived by their promoters as islands of regenerative good health in the morally and physically corrupt areas of the large city. And the genealogical quest starts up again here, tirelessly taking on historical forms that are appropriate, though, to a puritanical society. The time when the exaltation of virility preserves most often in France a flavor of the countryside blended with national defense is the moment when Americans choose to appear particularly sensitive to the crusade launched by the disciples of muscular Christianity. This movement, which arises at the beginning of the nineteenth century in England, reappears in the U.S. among the numerous religious revivals of the second half of the nineteenth century. Its credo? Morality is as much a question of muscular form as of religious piety, and the best of Christian men have the obligation to possess a virile body.[40] Is this not the very example preached by the first and foremost among them? Virility never stops drawing on its origins for its ideal. And at the turn of the century, within a great number of churches, a greater and greater number of voices are raised by those who discern in Christ most of all a man of action, a spiritual athlete, enterprising and daring. This crusade for muscle building and health was vigorously passed on by organizations such as the Young Men's Christian Association as well as by all those who supported the idea that America's spiritual regeneration was to go through a transformation of lifestyle. "Jesus Christ was a healer because he was the first physical fitness enthusiast. . . . My teachings are those of the early prophets. I live as they did. It is my duty to influence the world to live that way."[41] The profound, lasting influence of muscular Christianity is stated

most explicitly in this rereading of Scripture, later reiterated by Bernarr Macfadden, who was to be the evangelist of bodybuilding after the turn of the century, the man who supporters baptized "Father of physical fitness and Apostle of health"; he was one of the pioneers of the great American pastoral of sweat. It should be acknowledged that, as the original progenitor of virility, Christ possessed some advantages: a mortal body that has escaped the devirilization of age and an immortal body that is the eternal carrier of exemplarity, not to mention a purely masculine version of the Immaculate Conception.

PHANTOM VIRILITIES: DOUBLINGS, AVATARS

"Nothing resembles mythic thought more than political ideology," adds Claude Lévi-Strauss.[42] Contemporary continuations of the virile myth tend to prove him right. The genealogical obsession does not weaken; on the contrary, it runs through the entire century.

> His straight and perfect figure, muscled as the best of the ancient Roman gladiators must have been muscled, and yet with the soft and sinuous curves of a Greek god, told at a glance the wondrous combination of enormous strength with suppleness and speed.[43]

It is in this form, steeped in genealogy, that *Tarzan of the Apes* appears to Jane, as invented by Edgar Rice Burroughs in 1914. Published as a comic strip, then appearing in novel form until 1940, the twenty-six volumes of adventures and the numerous films of Tarzan arose from feelings about the corruption of urban society and from a taste for hunting literature that took over America following the disappearance of the Frontier, leaving virility orphaned from the wilderness that had cradled it. Furthermore, the success of Tarzan made of him the first global virile icon of inward-turning masculinity. Equipped to confront the untamed world, able to find the primitive man deep within, this icon inspired a continuous current of "revitalization" movements that crisscrossed the entire century, e.g., more or less militarized youth organizations, hunting clubs, tests of "survival," "masculinist" movements of which the poet Robert Bly became the spokesman,[44] or even the initiatory workshops of the Mankind Project offering the "discovery of the urban warrior who slumbers inside you. . . ."[45]

The same genealogical obsession traverses the visual culture of masculinity. The strongmen at the turn of the century, George Winship or Eugene Sandow, had been its precursors: poses in the ancient style, with Greek or Roman accessories, the visual memory of a remote European aristocracy of strength continued to grant democratic muscle its warrior patronage.[46] It was while contemplating the musculature of the classical statues in the Brooklyn Museum that Charles Atlas, the Hercules between the two world wars, disembarking from Italy, poor and puny, had the revelation of the path to take.[47] In this regard, there is no more exemplary story than his in the great American saga of muscles and success: his conversion to bodybuilding paid off, as with others after him, in a great fortune and offered proof that, in America, one can strike it rich with muscles. But above all, the body of Charles Atlas will be the first of male anatomies to become an object of publicity in the modern sense of the term [cf. fig. 22.1]. For this is one of the paradoxes of contemporary virility: the distancing, then erasure, of the experience of combat, later increased by the accumulation, circulation, and merchandizing of images of muscular strength, ended up giving rise to a virile phantasmagoria that gained autonomy in the realm of images by distancing and then separating itself more and more radically from the brutal, wartime origins and practices that had furnished virility its historical crucible. Thus, a traumatic gap was carved between the virtual triumphs of this "phantom virility" on the screen and the misfortunes of real virility during the wars. Rambo, strangely, was absent on 9/11.

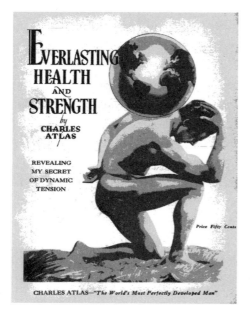

FIGURE 22.1 CHARLES ATLAS, 1924.

There is no more exemplary story among the great American bodybuilding sagas and success stories than that of Charles Atlas, getting off the boat from Italy poor and puny. Thanks to bodybuilding, one can strike it rich with one's muscles. But the body of Charles Atlas in particular is one of the first male anatomies to become a publicity object in the modern sense of the term and to promote an image of virility detached from its warrior or even athletic origins.

Source: Charles Atlas*

Virility today, then, is based largely on such dreams of strength. Thus, when Bernarr "Body Love" Macfadden founded *Physical Culture* in 1899, the first mass publication devoted to muscle development and the cornerstone of a press empire that was to celebrate the glory of the male body during the first half of the twentieth century, his editorials tirelessly hammered home: "Be 100% a man! Weakness is a crime. Don't be a criminal!"[48] In light of such insistence, one cannot help but sense a mounting anxiety when confronted with a sudden weakness of the strong sex. These slogans are avowals: the development of muscle mass of the ideal masculine type in the first years of the century and the hyperdevelopment that will follow are also an implicit denial of the symbolic rebalancing of men's and women's respective places and of the upheavals in the relations between the sexes that were sparked throughout the century [cf. fig. 22.2].

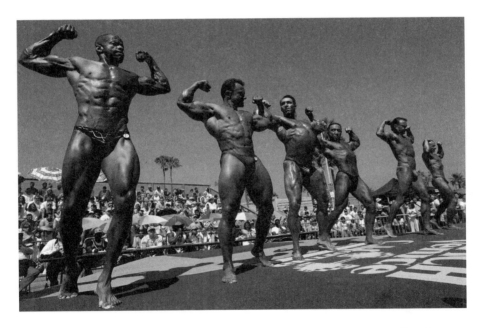

FIGURE 22.2 A GROUP OF MIDDLEWEIGHTS, MR. AND MISS MUSCLE BEACH BODYBUILDING AND FIGURE CONTEST. VENICE, CALIFORNIA, 4 JULY 2006.

"Muscle Beach," today. Strange spectacle: puffed up male bodies, bronzed, epilated, and oiled, lined up as in the ritual of a female beauty contest; unusual muscular masses, purely decorative; and competitions of appearance, without contact or violence. The twentieth century has seen the development of a culture of the simulacrum that repeats, in parody mode, the foundations of the virile tradition. Group portrait with men dressed up as men.

Source: (AP Photo/Ric Francis)

"The objective of myth," continues Lévi-Strauss, "is to furnish a logical model to resolve a contradiction."[49] One could add straight away: the virile myth attempts to resolve the insoluble contradiction between the desires for all-powerfulness and the realities of male powerlessness. Joe Shuster and Jerome Siegel understood this perfectly when they invented Superman in 1938, the first in a long line of patriotic super-heroes, whose success to this day has never been disputed.[50] So many avatars of masculine strength appeared, outfitted in tights and masks and equipped with those essential super-powers; but all of them were children of the Depression as well, of bureaucratic inertia and the war effort; all of them were also "tricksters," two-faced characters, such as that timid, self-effacing reporter (Clark Kent) who changes into the intrepid defender of America—imaginary solutions to the insoluble virile dilemma.

The anthropology of bodybuilding makes it sufficiently clear: the feeling of male vulnerability and insecurity and the memory of past humiliations are often the triggers of a muscular escalation that will use as its models precisely the avatars of masculine all-powerfulness that populate comic strips.[51] For it is the symptomatic destiny—in some ways both tragic and grotesque—of this muscular quest to try to incorporate avatars:

> He was a human anatomy chart. His skin was a transparent as rice paper and beneath that gauze I saw a trellis of capillaries, veins, and arteries. His body fat was so freakishly low that every muscle fiber beneath the skin visibly shook and swayed with every movement.[52]

In the pursuit of such dreams of body strength, there is evidently an impasse for the kind of virilities that are sought today. We will therefore stick here to the Freudian warning with which we started: better a voluntary renunciation than an endless mourning.

NOTES

1. GREEK VIRILITIES

1. Aeschylus, *Seven against Thebes* 52–53, trans. Herbert Weir Smith (Cambridge, MA: Harvard University Press, 1926), accessed 30 May 2015, http://www.perseus .tufts.edu/hopper/text?doc=Perseus%3Atext%3A1999.01.0014%3Acard %3D39.

2. Plutarch, *Life of Lycurgus* 16:1–3, trans. Berrnadotte Perrin (Cambridge, MA: Harvard University Press, 1914), accessed 30 May 2015, http://www.perseus .tufts.edu/hopper/text?doc=Plut.+Lyc.+16.1&fromdoc=Perseus%3Atext. %3A2008.01.0047 (trans. modified)—Trans.

3. Ibid., 16:4–5 (emphasis added, trans. modified)—Trans.

4. Ibid., 16:6 (trans. modified)—Trans.

5. Ibid., 16:5 (trans. modified)—Trans.

6. The *eiren* was a young man in his twenties who led the company of boys.

7. Plutarch, *The Life of Lycurgus*, op. cit., 18:2–3 (trans. modified)—Trans.

8. Ibid., 28:5 (trans. modified)—Trans.

9. Ibid., 12:4 (trans. modified)—Trans.

10. Ibid., 27:1–2 (emphasis added, trans. modified)—Trans.

11. *Nouveau choix d'inscriptions grecques* (Paris: Les Belles Lettres, 1971), 105–09, no. 19.

12. Herodotus, *The Histories* 7:231–232, trans. A. D. Godley (Cambridge, MA: Harvard University Press, 1920), accessed 3 June 2015, http://www.perseus.tufts .edu/hopper/text?doc=Perseus%3Atext%3A1999.01.0126%3Abook%3D7%3 Achapter%3D231%3Asection%3D1.

13. Plutarch, *The Life of Lycurgus*, op. cit., 24:1 (trans. modified)—Trans.

14. Ibid., 25:1–3 (trans. modified)—Trans.

15. Ephorus cited in Strabo, *The Geography of Strabo*, 10.4, 16 and 20, trans. H. C. Hamilton and W. Falconer (Cambridge, MA: Harvard University Press, 1924), accessed 30 May 2015, http://www.perseus.tufts.edu/hopper/text?doc =Perseus%3Atext%3A1999.01.0198%3Abook%3D10%3Achapter%3D4%3Asection

%3D16 and http://www.perseus.tufts.edu/hopper/text?doc=Perseus%3Atext%3A1999 .01.0198%3Abook%3D10%3Achapter%3D4%3Asection%3D20. My interpolations to quoted material in this book appear in brackets and include ellipses as well as (for translated material) terms from the original language.

16. Ibid.

17. Aristophanes, *The Clouds* vv. 961–83, trans. G. Theodoridis (2007), accessed 3 June 2015, http://www.poetryintranslation.com/PITBR/Greek/Clouds.htm; (trans. modified)— Trans.

18. Ibid., v. 987; (trans. modified)—Trans.

19. Thucydides, *The Peloponnesian War* 2:37, 40, trans. Rex Warner, (Baltimore: Penguin, 1954), 117, 118–19.

20. Aristotle, *Athenian Constitution* 42:3, trans. H. Rackham, (Cambridge, MA: Harvard University Press, 1952), accessed 4 June 2015, http://www.perseus.tufts.edu/hopper /text?doc=Perseus%3Atext%3A1999.01.0046%3Achapter%3D42%3Asection%3D3; (trans. modified)—Trans.

21. François Lafitau was the author of *Moeurs des sauvages américains comparées aux moeurs des premiers temps* (Paris: Saugrain l'aîné, 1724).

22. M. N. Tod, *A Selection of Greek Historical Inscriptions* (Oxford: Clarendon, 1946), 303.

23. Ephorus cited in Strabo, *The Geography of Strabo*, 10:4, 21.

24. Aristotle, *Athenian Constitution* 42:5.

25. Ibid.

26. Bernard Sergent, Homosexualité et initiation chez les peuples indo-européens, (Paris: Payot, 1996).

27. Ephorus cited in Strabo, *The Geography of Strabo*, 10:4, 21; (trans. modified)—Trans.

28. Sophie Lalanne, *Une éducation grecque. Rites de passage et construction des genres dans le roman grec ancien* (Paris: La Découverte, 2006), 204.

29. Aristophanes, *The Clouds*, op. cit. vv. 1002–21; (trans. modified)—Trans.

30. Alain Fleischer, *Éros, Hercule: Pour une érotique du sport* (Paris: La Musardine, 2005).

31. Dio Chrysostom, *Melancomas* in *Discourses 12–30*, trans. J. W. Cohoon, (Cambridge, MA: Harvard University Press, 1939), discourse 28, §3.

32. Ibid., §5.

33. Pindar, "Olympia 7," *The Odes of Pindar*, trans. Richmond Lattimore, (Chicago: University of Chicago Press, 1947), 19–22.

34. Peter A. Hansen, ed., *Carmina epigraphica Graeca saeculorum VIII–V* (Berlin: De Gruyter, 1983), 19.

35. Aeschines, *Contra Timarchus* 131, trans. Charles Darwin Adams, (Cambridge, MA: Harvard University Press; London, William Heinemann Ltd., 1919), accessed 2 June 2015 http://www.perseus.tufts.edu/hopper/text?doc=Perseus%3Atext%3A1999.01.0002 %3Aspeech%3D1%3Asection%3D137; (trans. modified)—Trans.

36. Pindar, "Olympia 7."

37. Ephorus cited in Strabo, *The Geography of Strabo*, 10:4, 21; (trans. modified)—Trans.

38. J. J. Winkler, *Constraints of Desire: The Anthropology of Sex and Desire in Ancient Greece* (New York: Routledge, 1990), 40.

39. M.-Chr. Anest, *Zoophilie, homosexualité, rites de passage et initiation masculine dans la Grèce contemporaine* (Paris: L'Harmattan, 1994), observes that the rites and trials that she analyzes serve to establish a virile hierarchy from which emerge a leader and a range of positions from weakest to strongest, from the person who is only penetrated to the person who only penetrates. Now, in any homosexual relation, even outside specific rites, even in the case of paid sex, the one who penetrates is never considered to be homosexual.

40. Aeschines, *Contra Timarchus* 137 (trans. modified)—Trans.

41. Ibid., 139 (trans. modified)—Trans.

42. Ibid., 41.

43. Aristophanes, *The Clouds*, vv. 979–80.

44. Strato, "*Musa Puerilis*," trans. W. H. Paton, *The Greek Anthology* (Cambridge, MA: Harvard University Press, 1918; rev. and rpt. 1979), vol. 12:4, 285, accessed 5 June 2015, http://www.loebclassics.com/view/greek_anthology_12/1918/pb_LCL085.285.xml (trans. modified)—Trans.

45. Stobaeus, *Florilegium* 4.21b.23, cited in *Diogenes the Cynic: Sayings and Anecdotes, with Other Popular Moralists*, ed. and trans., Robin Hard (New York: Oxford University Press, 2012), 112.

46. Winkler, *Constraints of Desire*, 11.

47. Xenophon, *Memorabilia* 1:3, 11, trans. Otis Johnson Todd (Cambridge, MA: Harvard University Press, 1923), accessed 5 June 2015, http://www.perseus.tufts.edu/hopper /text?doc=Perseus:text:1999.01.0208.

48. Longus, *Daphne and Chloe* 4:12, 1, trans. William Blake Tyrell, accessed 5 June 2015, http://people.uncw.edu/deagona/lit/Longus.pdf.

49. K. Schauenburg, "Eurymedon eimi," *Athenische Middeilungen* 90 (1975): 97–121 and pl. 25–42. Cf. K. J. Dover, *Greek Homosexuality*, 2d ed. (London: Duckworth, 1978), 105; Winkler, *Constraints of Desire*, 51.

50. Plato, *Symposium* 176c, *The Dialogues of Plato*, trans. Benjamin Jowett (Chicago: Encyclopedia Britannica, Inc. [rpt. of Oxford University Press ed.], 1952), 151 (trans. modified)—Trans.

51. Plutarch, *The Life of Lycurgus*, 15:1–2 (trans. modified)—Trans.

52. Plutarch, *The Life of Pericles* 24:5, trans. Berrnadotte Perrin [orig. Cambridge, MA: Harvard University Press, 1916]; accessed 2 June 2015, http://www.perseus.tufts.edu /hopper/text?doc=Perseus%3Atext%3A2008.01.0055%3Achapter%3D24%3Asection %3D5.

53. Ibid., 24:4.

54. That is, the sole heiress of paternal assets in the absence of a male heir.

55. Plutarch, *The Life of Lycurgus*, 15:7–9 (trans. modified)—Trans.

56. E. Manni, "Aristodemo di Cume, detto il Malaco," *Klearchos* 7 (1965): 63–78.

57. Hyperides, in Rutilius Lupus, *Schemata dianoeas et lexeos*, ed. G. Barabina (Genoa: Pubblicazionni dell'Istituto de filologia classica et mediovale dell'Università di Genova, 1967), 2:6: "Nonne vehementissime admiraretur se quisquam no gratissimum munus arbirtraretur, virum se natum, sed depravato naturae beneficio in mulierem convertere properasse?"

2. ROMAN VIRILITIES

1. When two words belong to the same semantic order, it is common that one of them vanishes in late Latin and therefore in the Romance languages: thus, *iocus* (*jeu* or play on words) pushed aside *ludus* (*jeu* or play in actions), and so we have *jeu* and *jouer* (French for "game" and "to play").

2. Citations of the poems of Catullus are from *Carmina*, trans. Sir Richard Francis Burton (London: Smithers, 1894), accessed 9 July 2015, http://www.perseus.tufts.edu /hopper/text?doc=Perseus%3Atext%3A1999.02.0006%3Apoem%3D32.—Trans.

3. Martial, *Epigrams*, 9:36, trans. D. R. Shackleton Bailey, (Cambridge: Harvard University Press, 1993). Except when otherwise indicated, the French translations of these Latin authors were taken from texts published by Belles Lettres, Collection des Universités de France. (Trans. note: English translations are from standard digital and print sources except for brief phrases translated from French. Subsequent references to Martial's *Epigrams* are to Bailey's translation unless otherwise noted; they are occasionally modified on the basis of more modern renderings.).

4. Paul Veyne, "L'empire romain," in *Histoire de la vie privée*, vol. 1, ed. H. Ariès and G. Duby, *De l'Empire romain à l'an mil*, ed. P. Veyne (Paris: Seuil, 1985), 39.

5. In citing Catullus and Martial, as with others we will be referring to, we are well aware of the diverse problems that these literary sources give rise to: Is it the poet or his narrator who speaks? Are these simply caricatures or do they have something to do with reality? However, bearing in mind that we are dealing with a masculine point of view, we are betting that these poems, at times obscene, inform us about many things regarding Roman society, which was preeminently macho.

6. Persius, *Satires* 5:30–33, trans. A. S. Kline, accessed 8 June 2015, http://www.poetryin translation.com/PITBR/Latin/PersiusSatires.htm.

7. The custom of reading the Latin epigram authors through the wise French translations of Belles Lettres, especially if they go back several decades, gives no hint of the spiciness of numerous passages, and most of the authors of these editions are perfectly aware of the disparity between the original and the translation. (The same may be said about the standard English translations—Trans.).

8. *Lives of the Later Caesars: The First Part of the Augustan History*, trans. Anthony Birley (New York: Penguin, 1976), Antinoninus Elagabalus 8:7.

9. Ibid., Commodus Antoninus 10:9.

10. Craig A. Williams, *Roman Homosexuality: Ideologies of Masculinity in Classical Antiquity* (New York: Oxford University Press, 1999), 203.

11. The same remarks on the "virilization" of certain women can be found, along with the parallel between the penis and the clitoris, in the Goncourt brothers: cf. Arnelle Le Bris-Chopard, *Le masculin, le sexe et le politique* (Paris: Plon, 2004).

12. Florence Dupont and Thierry Éloi, *L'érotisme masculin dans la Rome antique* (Paris: Belin, 2001), 100–02.

13. Veyne, "L'empire romain," 197. See also, by the same author, "La famille et l'amour sous le Haut-Empire romain," *Annales ESC* 33 (1978): 35–63.

14. The best study of this subject is Williams's *Roman Homosexuality*, and also of great use is Marilyn B. Skinner, *Sexuality in Greek and Roman Culture* (Oxford: Blackwell, 2005).

15. G. Lafaye, ed., introduction to Catulle, *Poésies*, Collection des Universités de France (Paris: Les Belles Lettres, 1932), xxxvii.

16. For Lafaye's translation: Catulle, *Poésies,* trans. G. Lafaye, 16:1–2, ibid. See also J. N. Adams, *The Latin Sexual Vocabulary* (London: Duckworth, 1982). [Trans.: cf. Bailey's English rendering: "I will make you my boys and bone you, sexually submissive Aurelius and Furius the sodomite" (16:1–2) and, more recently, A. Z. Foreman's version: "I'll fuck you up the ass and down the throat, /Anal Aurelius and facial Furius," accessed 6 June 2015, http://poemsintranslation.blogspot.com/2010/11/catullus-poem-16-pedicabo-ego-vos-from.html.]

17. Martial, *Epigrams*, 2:28, trans. Shackleton Bailey, op. cit., vol. 2, 129 (trans. modified)—Trans.

18. On Gallo-Roman graffiti: Alix Barbet and Michel Fuchs, eds., *Les murs murmurent* (Lausanne: Infolio/Gollion, 2008).

19. Martial, *Epigrams*, 7:62, trans. Shackleton Bailey, op. cit., vol. 2, 129 (trans. modified)—Trans.

20. Juvenal, *Satires* 9:26–27, trans. A. S. Kline, accessed 6 June 2015, http://www.poetryintranslation.com/PITBR/Latin/JuvenalSatires9.htm#anchor_Toc283816894. Subsequent references to Juvenal's *Satires* will be to this translation unless otherwise indicated.

21. A poetic piece of graffiti by Villard-d'Héria seems to play well on this possibility: "Cunt, you may cry out or brood all night long, / An asshole has ravished what was once your quarry." Barbet and Fuchs, *Les murs murmurent*, 150.

22. Martial, *Epigrams*, trans. Bailey, op. cit.

23. Ibid., 11:43 (trans. modified)—Trans.

24. The translation, however, is ambiguous here: the Latin refers to Patroclus as the *levis amicus*, the "smooth, hairless friend," and we shall see that in Rome this is not a sign of virility.

25. Dupont and Éloi, *L'érotisme masculin*, 42–46.

26. Kenneth J. Dover, *Greek Homosexuality* (London: Duckworth, 1978).

27. Wolfgang Decker and Jean-Paul Thuillier, *Le sport dans l'antiquité: Égypte, Grèce, Rome* (Paris: Picard, 2004).

28. Juvenal, *Satires*, trans. C. A. Tabart (Paris: Gallimard, 1996).

29. Elaine Fantham, "*Stuprum*: Public Attitudes and Penalties for Sexual Offences in Republican Rome," *Échos du monde classique/Classical Views* 35 (1991): 267–91. On these different questions, see Éva Cantarella, *Selon la nature, l'usage et la loi. La bisexualité dans le monde antique* (Paris: La Découverte, 1991).

30. Aline Rouselle, "Gestes et signes de la famille dans l'empire romain," in *Histoire de la famille*, vol. 1, *Mondes lointains, mondes anciens*, ed. A. Bugière, M. Segalen, C. Klapisch-Zuber, and F. Zonabend (Paris: Livre de Poche, 1994), 238–39.

31. Plutarch, *Lives*, trans. Bernadotte Perrin (Cambridge, MA: Harvard University Press, 1914), vol. 2, accessed 6 June 2015, http://penelope.uchicago.edu/Thayer/E/Roman /Texts/Plutarch/Lives/Cato_Major*.html. Subsequent references to Plutarch are to this work and this translation—Trans.

32. Yvon Thébart, *Thermes romains d'Afrique du Nord et leur contexte méditerranéen : Études d'histoire et d'archéologie* (Rome: École Française de Rome, 2003)—Trans.

33. On this point our poet is a bit off the mark, as we shall see in the following pages.

34. Martial, *Epigrams*, 7:35, 1–6. (trans. modified)—Trans.

35. *Satires*, 11:156–60. (trans. modified)—Trans.

36. Saint Augustine, *Confessions*, trans. R. S. Pine-Coffin (New York: Penguin, 1961), 45—Trans.

37. Of course, this point of view is shared by others besides the Romans: thus man, in the sense of a male, is *bărbat* in Rumanian (like the French for beard, *barbe*, from the Latin *barbatus*), whereas eunuchs are hairless (cf. D. C. Buck, *A Dictionary of Selected Synonyms in the Principal Indo-European Languages* [Chicago: University of Chicago Press, 1949]), 81, 84. On the virile beard in a number of other civilizations (China, the Muslim world, etc.), see Elizabeth Azoulay, *100,000 Ans de beauté* (Paris: Gallimard, 2009), passim.

38. "Now you plead beard and years and hairy limbs. [. . .] Why do you mock me? Yesterday you were a boy, Hyllus. Tell me, how do you come to be a man today?" (Martial, 4:7, 3–6, trans. modified). Such a reaction reveals well that these young slaves were subjected to an actual rape.

39. Juvenal, *Satires*, 2, 99ff., accessed 12 August 2013, www.poetryintranslation.com /PITBR/Latin/JuvenalSatires2.htm#_Toc280783784.

40. Translated from the French rendering by Dominique Noguez, aiming to convey what the author wishes to highlight in that modern version—Trans.

41. Juvenal, *Satires*, 2:8–13. In Martial, the Ionians are treated as *soft*, and therefore effeminate, from the beginning of his work (*Epigrams,* 1:3).

42. Perhaps Dominique Noguez's very high-flown translation is preferable: "I must tell you: I like neither little curls nor tousled hair; / I don't like skin that is too white, but I don't like dirt either; / And I don't like beardless guys or heavily bearded ones. / In sum, I don't like the man to be too virile or not virile enough. In you, dear, there are both extremes: / Your legs and chest are hairy, / But your soul is shaved." Martial, *Épigrammes*, 2:36, trans. D. Noguez (Paris: Arlea, 2001).

43. The epitaph reads in part:
 Cornelius Lucius Scipio Barbatus, sprung from Gnaeus his father,
 a man strong and wise, whose appearance was most in keeping with his virtue,
 who was consul, censor, and magistrate among you . . .
 —Trans.

3. BARBARIAN AND KNIGHT

1. Sidonius Apollinaris, *Panegyric on Maiorianus*, 5:249–50, trans. W. B. Anderson (Cambridge, MA: Harvard University Press, 1936), 83, http://www.archive.org/stream/poemsletterswith01sidouoft#page/82/mode/2up; accessed 7 June 2015 (trans. modified)—Trans.

2. Tacitus, *Germania*, trans. Anthony Birley (Oxford: Oxford University Press, 2009, rev. Edward Brooks, Jr.), 38, http://www.gutenberg.org/files/7524/7524-h/7524-h.htm, accessed 30 May 2015 (trans. modified)—Trans.

3. On the exploits and career of Rainouart, a complex personage: Jean Frappier, *Les chansons de geste du cycle de Guillaume d'Orange* (Paris: SEDES, 1955), 219–33.

4. E. Langlois, ed., *Le couronnement de Louis. Chanson de geste du XII^e siècle* (Paris: Honoré Champion, 1965), 78, v. 2510: "El tertre monte Guillelmes li marchis."

5. Jean Renart, *Le roman de la rose ou de Guillaume de Dole*, ed. Félix Lecoy (Paris: Honoré Champion, 1969), vv. 2548–49: "Des cuers et des ieux les confoient / Tant com la grant rue lor dure." The crowd admires the knights arriving on the grounds for the jousting match (vv. 2492–2549), and upon the knights' return the spectators hear about their exploits (vv. 2854–94).

6. Perrine Mane, *La vie dans les campagnes au Moyen Age à travers les calendriers* (Paris: De La Martinière, 2004).

7. Robert Frossier, *Ces gens du Moyen Âge* (Paris: Fayard, 2007), 139.

8. Abuse of virile strength against women will be returned to in later chapters—Trans.

4. ABSOLUTE VIRILITY IN THE EARLY MODERN WORLD

1. Eustache de Refuge, *Traicté de la cour* (Paris, 1616), 134.

2. See P. Robert, *Dictionnaire alphabétique de la langue française* (Paris: Le Robert, 1964), "Virilité."

3. B. Gracián, *L'honnête homme* [1646], in *Traités politiques, esthétiques, éthiques*, ed. and trans. B. Pelegrin (Paris: Seuil, 2005), 211.

4. Baldassare Castiglione, *Book of the Courtier*, trans. Leonard E. Opkycke (New York: Scribner's, 1903), passim, accessed August 2013, http://archive.org/stream /bookofcourtier00castuoft/bookofcourtier00castuoft_djvu.txt.

5. Gracián, *L'honnête homme*; see note by B. Pelegrin, 202.

6. Ibid.

7. N. Elias's text remains key in this respect: *La civilisation des moeurs* (1939; repr., Paris: Calmann-Lévy, 1973). See also A. Montandon, ed., *Dictionnaire raisonné de la politesse et du savoir-vivre du Moyen Age à nos jours* (Paris: Seuil, 1995).

8. William Shakespeare, *As You Like It* (1599), 2.7.96.

9. *Le livre des faicts du Maréchal de Boucicaut* [fifteenth century], in *Nouvelle collection des mémoires pour servir à l'histoire de France, depuis le XIII^e siècle jusqu'à la fin du XVIII^e siècle*, ed. Joseph-François Michaud and M. Poujoulat (Paris, 1836), 2:219–20.

10. F. de Bassompierre, *Mémoires* in *Nouvelle collection des Mémoires pour servir à l'histoire de France, depuis le XIII^e siècle jusqu'à la fin du XVIIIe siècle*, ed. J. F. Michaud and J. J. F. Poujoulat (Lyon: Guyot, 1851), vol. 6, 19.

11. Castiglione, *Book of the Courtier*, op. cit., 31.

12. Ibid., 30.

13. Ibid., 32.

14. F. de Callière, *Des mots à la mode et des nouvelles façons de parler* (Paris: Cl. Barbin, 1792).

15. G. della Casa, *Galatée ou la manière et fasson comme le gentilhomme doit se gouverner en toute compagnie* (Paris, 1562), 16.

16. Antoine de Courtin, *Traité du véritable point d'honneur ou la science du monde* (Amsterdam, 1698), 215.

17. Ibid., 145.

18. P. Erlanger, *Les idées et les moeurs au temps des rois, 1558–1715* (Paris: Flammarion, 1969), 50.

19. See R. Muchembled, "La criminalisation de l'homme moderne," in *L'invention de l'homme moderne: Culture et sensibilités en France du XV^e au XVIII^e siècle* (Paris: Fayard, "Pluriel," 1988), 135ff.

20. M. de Montaigne, *Essais* (1580; repr., Paris: Gallimard, "Bibliothèque de la Pléiade," 1958), 825; *The Complete Essays of Montaigne*, trans. Donald M. Frame (Stanford: Stanford University Press, 1958), 644.

21. F. Béroalde de Verville, *Le moyen de parvenir* (ca. 1616; repr., Paris, 1842), 115.

22. M. Bakhtine, *Rabelais and His World*, trans. H. Iwolsky (Cambridge, MA: MIT Press, 1968), 320.

23. P. Desportes, "Que faites-vous mignon?" [sixteenth century], in *Les chefs-d'oeuvre de Philippe Desportes* (Paris: Poulet-Malassis, 1862), cited in P. Erlanger, *Les idées et moeurs au temps des rois 1558–1715* (1970; repr. Paris: Flammarion, 1992), 43.

24. Louis Petit, *Satire contre la mode* (Paris, 1686), v. 17.

25. T. Artus, *L'isle des hermaphrodites nouvellement descouverte* (Paris, 1606), 8ff.

26. J. de Mailles, *Histoire du gentil chevalier Bayard* (sixteenth century; repr., Paris: Balland, 1960), 83.

27. P. Bourdeille de Brantôme, *Discours sur les duels* (sixteenth century; repr., Paris, 1873), 321.

28. Henry Porter, *The Two Angry Women of Abington* (1599; repr. London: General Books LLC, 2010), 15.

29. A. Darcie, *Annales d'Élisabeth*, cited in E. Castle, *L'escrime et le escrimeurs* (1885; repr., Paris, 1888), 24.

30. Montaigne, *Essais*, 782; Frame, 612.

31. Ibid. "Cowardice, Mother of Cruelty;" Frame, 527.

32. Castiglione, *Book of the Courtier*, op. cit., 28.

33. A. Du Verdier, *Les diverses leçons* (Lyon: T. Soubron, 1592), 472.

34. Ibid.

35. H. Romei, *La semaine ou sept journées ...* (1552; Paris: G. Robinot, 1595), 13.

36. Ibid., 43.

37. Castiglione, *Book of the Courtier*, 29.

38. Ibid.

39. A. de Bandole, *Les parallèles de César et de Henri IV* (Paris: J. Richer, 1609), 90.

40. Castiglione, *Book of the Courtier*, 82.

41. P. Bourdeille de Brantôme, *Les grands capitaines français*, in *Oeuvres complètes* (Paris: Jules Renouard, 1867), 3:93.

42. B. Gracián, *Oracle manuel et art de la prudence* [1647], in *Traités du véritable point d'honneur ou la science du monde*, 325.

43. Ibid., 314.

44. Ibid., 309.

45. Gracián, *L'honnête homme*, 191.

46. Ibid., 193.

47. Titian, *The Emperor Charles V*, 1548, oil on canvas, Prado Museum, Madrid.

48. H. Testelin, *Portrait of Louis XIV, King of France and Navarre*, 1648, oil on canvas, Musée du Chateau, Versailles.

49. H. Rigaud, *Portrait of Louis XIV, King of France and Navarre*, 1648, oil on canvas, Musée du Chateau, Versailles.

50. James I to Prince Henry, his son, 1599, in *Letters of King James VI & I*, ed. G. P. V. Akrigg (Berkeley: University of California, 1984).

51. On the question of masculinity in French literature of the Renaissance, see Lawrence D. Kritzman, *The Rhetoric of Sexuality and the Literature of the French Renaissance* (Cambridge: Cambridge University Press, 1991); Kritzman, *The Fabulous Imagination: On Montaigne's Essays* (New York: Columbia University Press, 2009); Todd Reeser, *Moderating Masculinity in Early Modern Culture* (Chapel Hill: University of North Carolina Press, UNC Romance Monographs, 2006); Floyd Gray, *Gender Rhetoric and Print Culture in French Renaissance Writing* (Cambridge: Cambridge University Press, 2000); and Kathleen Perry Long, ed., *High Anxiety. Masculinity in Crisis in Early Modern France* (Kirksville, MO: Truman State University Press, 2002).

52. See the brilliant study by Reeser, *Moderating Masculinity in Early Modern Culture*.

53. Judith Butler, "Sex and Gender in Simone de Beauvoir's *The Second Sex*," *Yale French Studies* 72 (1986): 35–49.

54. Simone de Beauvoir, *Le deuxième sexe* (Paris: Gallimard, 1949). Cf. ch. 17 *infra*, esp. 467–68, for further discussion of this quote; also ch. 16, 447–49.—Trans.

55. Brantôme, *Recueil des Dames. Poésies et tombeaux*, ed. Étienne Vaucheret (Paris: Gallimard, "Bibliothèque de la Pléiade," 1991).

56. Ibid., 239.

57. Ibid., 254.

58. François Rabelais, *Quart livre*, in *Oeuvres complètes*, ed. Pierre Jourda (Paris: Garnier, 1974), 2:14; *The Complete Works of Rabelais*, trans. Sir Thomas Urquhart of Cromarty and Peter Antony Motteux (1894), 4:II, accessed 12 August 2013 (trans. modified), www.gutenberg.org/files/1200/1200-h/1200-h.htm.

59. François Rabelais, *Tiers livre*, in *Oeuvres complètes*, op. cit., 1:539–40, *The Complete Works of Rabelais*, op. cit. 3:XXXII.

60. Ibid., *Pantagruel*, in *Oeuvre complètes*, 1:256. Trans. 2:VIII. Readers should note that Rabelais's work is divided into five parts: *Gargantua* is vol. 1, *Pantagruel* vol. 2, and *Tiers livre* vol. 3 (followed by *Quart livre* and *Quint livre*). Subsequent references are to the Urquhart-Motteux translation with volume followed by chapter number.

61. Ibid.

62. Ibid., 1:258. Trans. 3:VIII.

63. Ibid., 36. On the codpiece, see Terence Cave, *The Cornucopian Text. Problems of Writing in the French Renaissance* (New York: Clarendon, 1979).

64. See Kritzman, *The Rhetoric of Sexuality*.

65. Rabelais, *Tiers livre*, 1:538. Trans. 3:XXXII.

66. Rabelais, *Quart livre*, 2:565. Trans. 4:XII.

67. Pierre Bourdieu, *Ce que parler veut dire. L'économie des échanges linguistiques* (Paris: Fayard, 1982), 121–22.

68. Rabelais, *Quart livre*, 2:129. Trans. 4:XXXII.

69. Samuel Kinser, *Rabelais' Carnival: Text, Context, Metatext* (Berkeley: University of California Press, 1990).

70. Rabelais, *Quart livre*, 2:129. Trans. 4:XXX.

71. Ibid., 127. Trans. 4:XXIX, accessed 5 September 2013.

72. Ibid., 157. Trans. 4:XLII.

73. Butler, "Sex and Gender."

74. Ambroise Paré, *Des monstres, des prodiges, des voyages*, ed. Patrice Boussel (Paris: Club du Libraire, 1964).

75. Reeser, *Moderating Masculinity in Early Modern Culture*.

76. On the rhetoric of the blazon, see Kritzman, *The Rhetoric of Sexuality*.

77. Pierre de Ronsard, *Les amours*, ed. C. and H. Weber (Paris: Garnier, "Classiques Garnier," 1963), 45.

78. *Lyrics of the French Renaissance*, trans. Norman R. Shapiro (New Haven: Yale University Press, 2002), electronic version: Google Books, 307, accessed 25 November 2012. The first line of the first stanza would read more literally: "Little navel that my thoughts adore." The second stanza, substantially different in various editions, could be more accurately translated as follows: "Amorous sign of which Love is proud, /Representing the Androgynous link, / How much both you, my darling, / And your twin flanks I dearly honor!"—Trans.

79. Pierre de Ronsard, "Page, Follow Me," trans. David Wyatt, *The Lied, Art Song and Choral Text Archives*, accessed 19 May 2013, www.recmusic.org/lieder/get_text .html?TextId=91528.—Trans.

80. Pierre de Ronsard, *Selected Poems*, trans. A. S. Kline, accessed 26 November 2012, www .poetryintranslation.com/PITBR/French/Ronsard.htm#_Toc69989170.—Trans.

81. Michel de Montaigne, *Essais*, ed. Pierre Villey (Paris: Presses Universitaires de France, 1988), 3:5, 842; *Essais* is hereafter cited as "Montaigne" followed by the French book and page number, then the corresponding page numbers in the Frame translation—Trans.

82. Montaigne, 3:842; Frame, 639.

83. Montaigne, 3:884; Frame, 641.

84. Montaigne, 3:887; Frame, 677

85. Montaigne, 2:30; Frame, 538–39. See Kritzman, *The Fabulous Imagination*, op. cit.

86. Montaigne, 2:712–13; Frame, 539.

87. Montaigne, 2:713; Frame, ibid.

88. Ibid.

89. Montaigne, 1:37, 229; Frame, 169.

90. Montaigne, 2:30, 713; Frame, 539.

91. Ibid.

92. Ibid.

93. It was perhaps a question of choice. But the reticence manifested notably by the church at the time with respect to the opening up of bodies was more considerable if the cadaver involved were that of a woman. And elsewhere, at least in Rome, Leonardo dissected cadavers of executed criminals—men more often than women. Cf. note 95.

94. Leonardo da Vinci, *The Copulation*, also called *Coition of a Hemisected Man and Woman*, 1492–1493, pen and ink drawing, Royal Library, Windsor, UK.

95. Rembrandt, *The Anatomy Lesson of Dr. Nicolaes Tulp*, 1632, oil on canvas, Mauritshaus, The Hague; *The Anatomy Lesson of Dr. Joan Deyman*, oil on canvas, Rijksmuseum, Amsterdam. Not even Hogarth, in his famous series of engravings *The Four Stages of Cruelty* (1751), dreams of depicting a woman in the print (IV) that shows an anatomy amphitheater.

96. The painting is held today in the Pinacoteca Brera in Milan.

97. The manuscript is conserved in New York, the Pierpont Morgan Library. Cf. Erwin Panofsky, *The Codex Huygens and Leonardo da Vinci's Art Theory* (London: Warburg Institute, 1940).

98. Leonardo da Vinci, *Treatise on Painting*, trans. J. F. Rigaud (New York: Dover, 2002). The manuscript was compiled after Leonardo's death by his companion Francesco Melzi.

99. Are we to think that physical exertion is traditionally reserved for men, women specializing in less energy-intensive tasks? It is obvious that such is not the case in early modern culture, when men and women exerted their bodies almost equally in fieldwork. And explaining this male exclusivity by modesty—i.e., by the reluctance to undress a female body in order to show its movements—is not sufficient at a time, the sixteenth and seventeenth centuries, when the female nude is an artistic tradition.

100. Vitruvius, *De architectura libri*, ca. 25 B.C.E.

101. *The Four Books on Human Proportions* by the German Dürer, in 1528, is the first to include women.

102. The text dates from 1486.

103. D. V. Thompson, Jr., *The Craftsman's Handbook:* Il Libro dell' Arte *by Cennino d'A. Cennini* (New Haven: Yale University Press, 1933). Cennini, moreover, retells the old legend according to which woman, born from Adam's rib, was to possess one rib more than her companion.

104. Please see my edition of this text, Pierre-Paul Rubens, *Théorie de la figure humaine*, ed. N. Laneyrie-Dagen (Paris: Éditions de la Rue d'Ulm, 2003). The citations that follow are all drawn from this edition.

105. It will be noted that, again at the end of the nineteenth century, in *The Kiss* by Gustav Klimt, the pattern on the man's clothes is of quadrangular form, whereas the pattern adorning the woman's are circular.

106. The manuscript of the *Théorie de la figure humaine* was written in Latin. I cite here from the Parisian edition of the eighteenth century, for whose correction and completion I was responsible.

107. At the time, one said "sympathy" or "correspondence."

108. Leonardo da Vinci, *Old Man with Ivy Wreath and Lion's Head*, ca. 1505, chalk on paper, Royal British collections, Royal Library, Windsor, UK.

109. Titian, *Portrait of Francesco Maria della Rovere*, 1537, oil on canvas, Florence, Uffizi Gallery.

110. As Maurice Brock observes in *Bronzino* (Paris: Éditions du Regard, 2002), 50, these words were not pronounced for nothing: Francesco Maria della Rovere was not afraid of assassinating a prelate who had insulted him, and he adopted after this crime an emblem (*impresa*) depicting . . . a rising lion holding a dagger in its paw. The caption that accompanied this motif insisted on Rovere's *virtus*, in other words, on "inherent nature" (as expressed at the time by Paolo Pino, also a painter and theoretician in Venice) of the *vir*: *non deest generoso in pectore virtus*—"a generous heart cannot be lacking in virtue."

111. The etymology, which places the root of "virtue" in *virtus*, is significant in this evolution.

112. On the emergence of the figure of Saint Jerome at the end of the Middle Ages, in connection with the beginnings of humanism, see Daniel Russo, *Saint Jérôme en Italie. Étude d'iconographie et de spiritualité (XIII^e–XIV^e siècle)* (Paris/Rome: La Découverte/École française de Rome, 1987).

113. The painting is conserved at the National Gallery in London.

114. In fact, on cardstock—a "model"—for a mural that was destroyed. A copy of this painting is also known to exist from the seventeenth century (London, Hampton Court Palace).

115. The painting is conserved in the Louvre in Paris.

116. The painting is conserved in the Louvre in Paris.

117. This is the son of the very Francesco Maria della Rovere, painted by Titian, whose portrait I commented upon in connection with the leonine prototype.

118. Étienne Jollet, *Les Clouet* (Enghien: Lagune, 1998), 118.

119. The word "silhouette" dates from the end of the eighteenth century.

120. Agnolo Bronzino, *Portrait of Stefano Colonna*, 1546, oil on wood, Galleria d'Arte Antica, Rome.

121. The painting was acquired several years ago by the Getty Museum of Los Angeles.

122. Jacopo Pontormo, *Portrait of a Beefeater*, ca. 1529–1530, oil on wood transposed onto canvas, Los Angeles, Getty Museum. See Brock, *Bronzino*, 51.

123. In religious scenes, which can include hidden portraits, the gesture appears as early as the fifteenth century: in *The Flagellation of Christ* by Piero della Francesca in Urbino, and in the *Procession of the Magi* by Benozzo Gozzoli, completed in 1459, chapel of the Medici Riccardi Palace, Florence (the young magi, the future Lorenzo, is standing this way).

124. Agnolo Bronzino, *Portrait of Young Man with Book*, ca. 1530–1545, oil on wood, Metropolitan Museum of Art, New York.

125. Such as Sebastiano Florigerio, *Portrait of Rafaele Grassi*, oil on canvas, first half of the sixteenth century, Uffizi Gallery, Florence.

126. Rembrandt, *The Polish Rider*, also called sometimes *The Departure of the Prodigal Son*, ca. 1655, oil on canvas, Frick Collection, New York.

127. See note 94. The man's name is Gisjbert Matthijs Calckoen.

128. Rembrandt, *The Night Watch*, 1642, oil on canvas, Rijksmuseum, Amsterdam. The gesture of the hand resting on the hip is found also in Rembrandt's engravings: e.g., *Portrait of Jan Asselijn*, n.d., Bibliothèque Nationale de France, Paris.

129. Antoon van Dyck, *Self-portrait*, 1622–1623, oil on canvas, Hermitage Museum, St. Petersburg. There exist two other similar portraits—also showing the same pose—in New York and Munich. Cf. Christopher Brown and Hans Vlieghe, *Van Dyck, 1599–1641* (Anvers/London: Royal Academy Publications, 1999), catalog 31, 164.

130. Antoon van Dyck, *Self-portrait with Sir Endymion Porter*, ca. 1635, oil on canvas, Prado Museum, Madrid.

131. Antoon van Dyck, *James Stuart, Duke of Lennox and of Richmond*, 1633, Metropolitan Museum of Art, New York.

132. Another portrait by van Dyck depicts the king in the same pose: *Charles I*, 1636, Royal British Collections (Brown and Vlieghe, *Van Dyck*, catalog 90, 304). Other examples could be cited by van Dyck, viz. the portrait of Prince Charles-Louis of the Palatinate, the elder son and therefore virtual heir to the misfortunate "Winter King," Rupert of Bohemia (1631–1632, Kunsthistorisches Museum, Vienna); or two other young men, the elegant William Russell in the double portrait of George, Lord Digby, and William, Lord Russell (ca. 1637 or earlier, private collection [Brown and Vlieghe, *Van Dyck*, catalog 93, 310]), and the cousin of Charles I, Bernard Stuart, in *Lord John Stuart and His Brother Lord Bernard Stuart* (ca. 1638), National Gallery, London.

133. Studio of Henri and Charles Beaubrun, *Portrait of Anne of Austria, Regent of France, with Her Sons Louis XIV and Philippe de France, Duke of Anjou*, 1646, Gripsholm Castle, Gripsholm, Sweden.

134. Hyacinthe Rigaud, *Portrait of Louis XIV* (portrait in armor with a white scarf waving), 1694, Louvre Museum; *Portrait of Louis XIV* (portrait in ceremonial cloak and red heels), 1701, Louvre Museum, Paris; *Portrait of Louis XIV* (in armor), 1701, Prado Museum, Madrid. In French paintings of the seventeenth century the hand on the hip is evidenced in a number of pictures besides those depicting Louis XIV. Consider in this light the conceited young man in *The Fortune Teller* by Georges de la Tour, self-satisfied in his yellow and red outfit, who is being fleeced as he listens to his (certainly good) fortune being told by an old Bohemian woman (ca. 1635, Metropolitan Museum of Art, New York).

135. The man whom Rubens painted on the right edge of the picture, Roger de Bellegarde, a loyal supporter of Henry IV, also holds his hand on his hip with his legs spread.

136. Rubens, then in Italy, actually attended the ceremony, which took place in the Santa Maria del Fiore Cathedral in Florence on 5 October 1600. About thirty years later, he certainly is not painting from memory, which would have been too vague (besides, as a young member of the duke of Mantua's retinue, he was not likely to have had the benefit of a privileged place allowing him a good vantage point), but he reconstructs and embellishes the scene in his usual manner.

137. His immediate charge is to recapture Romagna, occupied by Venice.

138. *Malo mori quam foedari.*

139. The portrait, dating from 1539 to 1540, conserved in the Galleria Nazionale d'Arte Antica in Rome, is in tempera on wood.

140. Pierre Bourdieu, *La distinction. Critique social du jugement* (Paris: Minuit, 1979); Norbert Elias, *The Civilizing Process*, vol. 1, *The History of Manners* (New York: Urizen, 1978).

141. It seems that Holbein, who traveled a great deal in France, borrowed from French painting, and notably François Clouet's manner of painting the royal portrait. Cf. Oskar Bätschmann and Pascal Griener, *Hans Holbein* (Paris: Gallimard, 1997). The role of the Flemish painter Gossaert (Mabuse) in elaborating the male portrait has also been justly emphasized: the *Portrait of a Gentleman*, perhaps by Adolphe de Bourgogne, bastard son of Philip the Good, shows a man in magnificent clothing not entirely contained in the space of the painting, whose hand gestures draw attention to the codpiece and emblematic objects, notably a short sword with pommel and a dagger (ca. 1525–1528, Berlin).

142. François Clouet (or perhaps François and Jean Clouet), *Francis I*, ca. 1525 (or in 1529–1530), oil on wood, Louvre Museum, Paris.

143. In the *Portrait of Henry VIII* by Holbein, the king's fingers are not visible. The painter has depicted only the back of the hand—the rest is clutched around the objects: he thus highlights the breadth and solidity of these hands. In another portrait by Holbein, *Charles de Solier, Lord of Morette* (1534–1535), the model, a man advanced in years, of a stature not entirely contained in the painting, bearded and magnificently dressed, holds in the same way a sword and a glove (the left hand is gloved). The fingers again are not visible (wood, Gemäldegalerie, Dresden).

144. Pontormo's painting dates from 1518 and is conserved in the Uffizi Gallery in Florence. Vasari's of Lorenzo the Magnificent dates from 1533 and is in the same place.

145. Besides the portrait with a dog, which I will speak about later, one of these exceptions is the portrait of the emperor seated, dating from 1548, in the Pinacoteca in Munich.

146. Titian, *Charles V at Mühlberg*, 1548, oil on canvas, Prado Museum, Madrid; Titian, *Philippe II*, 1551, oil on canvas, Prado Museum, Madrid.

147. Diego Velásquez, *Phillipe IV*, ca. 1626–1628, oil on canvas, Prado Museum, Madrid.

148. Henri Testelin, *Portrait of Louis XIV, King of France and of Navarre*, 1648, oil on canvas, Musée du Château, Versailles. The king was twelve years old at the time. See also Henri Testelin, *Louis XIV, Protector of the Arts*, 1648, oil on canvas, Musée du Château, Versailles.

149. Hyacinthe Rigaud, *Portrait of Louis XIV in Royal Garb*, 1701, oil on canvas, Louvre Museum, Paris.

150. The Royal Academy of Dance.

151. This is in fact the model of the king's costume. The artist is not known for sure; it is most probably Henri de Gissey.

152. In 1701, by Pierre Beauchamp (1631–1705), who was one of the king's dance instructors, or by his disciple Raoul Auger Feuillet, *Choréographie de l'art d'écrire la danse par caractères, figures et signes démonstratifs* (Paris: Michel Brunet, 1701).

153. Philippe de Champaigne, *Louis XIII Crowned by Victory*, 1628, oil on canvas, Louvre Museum, Paris.

154. James I ruled from 1603 until his death in 1625.

155. Antoon van Dyck, *Sir George Villiers and Lady Katherine Manners in Venus and Adonis* (1620–1621), oil on canvas, private collection.

156. For a history of male stockings, and more generally of male clothing and its meaning, see in particular, Daniel Roche, *La culture des apparences. Une histoire du vêtement, XVIIᵉ–XVIIIᵉ siècle* (Paris: Seuil, "Points Histoire," 2007).

157. See notes 94, 127, and 129.

158. In paintings, women are depicted in prayer or, later, in a nonreligious posture always marked by an extreme gestural reserve, notably with arms joined over the body, often crossed. Such is the case with the very famous *Mona Lisa* by Leonardo. As far as we know, the pose that we are about to discuss—hand on the stomach, under the garment—is evidenced for the first or one of the first times in painting in *Portrait of Lady Scudamore* by Marcus Gheeraerts the Younger, 1614, oil on panel (National Portrait Gallery, London)—before becoming a typical masculine gesture.

159. Jean-Dominique Ingres ascribes this movement to a woman for a precise reason: she is pregnant. *The Viscountess of Haussonville*, 1845, oil on canvas, New York, Frick Collection.

160. The famous stomach ulcer from which Napoleon is said to have died.

161. I am indebted to Julien Magnier, former student at the École normale supérieure and a doctoral student at the University of Paris IV, for these observations on the origins of the hand in the waistcoat. Magnier notes that clothes of this period have no pockets and that the pose in question could be the equivalent of the attitude, deliberately and subtly casual, of the man today who slides his hands in his pockets.

162. 1826, oil on canvas, Art Institute, Chicago. The pose with the hand on the hip is found in several other works by Ingres: in a martial mode, it appears in the *Portrait of the Duke of Orleans Ferdinand de Bourbon* (1842, oil on canvas, Louvre Museum, Paris). More discreetly, it appears in the drawing depicting Liszt in 1839: the musician, very thin, is standing in three-quarter profile, the more distant hand—almost invisible— placed on his hip (graphite with white highlights, Nationalarchiv der Wagner-Stiftung, Bayreuth).

163. In the drawings that Ingres tried and went back to in the course of the long and difficult genesis of this painting, the model is first captured standing and in three-quarter profile, which tones down his corpulence. The portrait is in the Louvre in Paris.

164. Treatises of manners, up to the beginning of the twentieth century, absolutely prohibit this position for gentlemen, who are supposed to keep their legs crossed while seated. On Bertin, allow me to refer to my book, *L'invention du corps* (Paris: Flammarion, 1997; rev. ed., 2009).

165. Ingres copied as a drawing the torso portrait of Henry VIII by Holbein. The sketch dates from ca. 1815 and is kept in a private collection.

166. The term is employed by several historians of the horse. See, esp. Daniel Roche, *La culture equestre en Occident, XVI^e–XIX^e siècle. L'ombre du cheval* (Paris: Fayard, 2008). Roche draws attention to the veritable revolution constituted in the twentieth century, paralleling the transformation of equitation into a leisure activity, by the feminization of the practice of equitation, which heretofore had been a typically masculine activity.

167. In the following discussion—on the relationship of the male child to the horse—the examples would be too numerous to list. Allow me to refer to the collective work, Sébastien Allard, Nadeije Laneyrie-Dagen, Emmanuel Pernoud, eds., *L'enfant dans la peinture* (Paris: Citadelles et Mazenod, 2011).

168. Jean-Antoine Laurent, *Le peintre et sa famille, 1797–1798* (Paris: Musée Cognacq-Jay). In the picaresque novel by William Thackeray, *The Luck of Barry Lyndon* (1843–1844), which relates events that were to have taken place during the Seven Years' War, and in the Stanley Kubrick film based on it (1975), one will recall the role played by the possession and mastery (or lack of mastery) of a pony, then a horse, by a child, heir, and source of a family's expectations.

169. While there exist, beginning in the seventeenth century, portraits of women on horseback (e.g., Diego Velásquez, *Equestrian Portrait of Queen Marguerite* [as an Amazon], 1634–1635, Prado Museum, Madrid), they are, however, few in number, and equestrian monuments sculpted in honor of women are more or less nonexistent.

170. The painting dates from 1800 and is conserved at the Chateau de Malmaison, in Rueil-Malmaison.

171. Salon of 1812, Louvre Museum, Paris.

172. *Equestrian Portrait of Charles V*, 1548, Prado Museum, Madrid.

173. In Géricault's painting, one of the hind feet is bent and the other stretched out straight, which does not correspond to any figure of cavalry art.

174. As in the drawings of Leonardo or paintings by Rubens.

175. Velásquez, *Prince Balthasar Charles on Horseback*, 1634–1635, oil on canvas, Prado Museum, Madrid.
176. Velásquez, *Philip IV on Horseback*, 1634–1635, oil on canvas, Prado Museum, Madrid.
177. Jacob Jordaens, *Cavalier Executing a Levade in front of a Portal*, 1643, Museum of Fine Art, Springfield, MA; Jordaens, *Levade Performed Under the Auspices of Mars and in the Presence of Mercury, Venus and a Squire*, 1645, oil on canvas, National Gallery of Canada, Ottawa, Ontario.
178. The French and Austrian equitation "schools" practiced this art of lightness in the handling of the horse; modern carousels are the last vestige of the art of the equestrian ballet.
179. Antoon van Dyck, *Charles I Hunting*, 1631, oil on canvas, Louvre Museum, Paris.
180. The painting, an oil on canvas, dates from 1634. It is conserved in the Prado Museum in Madrid.
181. Jan van Eyck, *Portrait of the Arnolfinis*, 1434, oil on oak panel, National Gallery, London. One should note that, in *The Arranged Marriage*, painted by Rubens, a little dog is also painted in the foreground, on the left, that is, on the side of the wife. It is scratching its fleas: an unusual and somewhat offhand choice on the part of the painter, whose relations with Maria de Médicis, a persnickety patroness, were, without doubt, sometimes good and other times difficult. See also, among a number of other examples, the *Portrait of Eleonora Gonzaga della Rovere, Duchess of Urbino* by Titian in the Uffizi Gallery in Florence: the little dog—very similar to the one in Titian's *Venus of Urbino*—is calmly stretched out on the table under a precious pendulum clock: the association of the object and the animal probably suggest the permanence of feeling throughout time.
182. Paul, Harmann, and Jean de Limbourg, *Les très riches heures du duc de Berry*, from 1411, ms., Musée Condé, Chantilly. See, in particular, the white greyhound in the foreground of the miniature depicting the delivery of Christmas presents in January.
183. Andrea Mantegna, *Camera degli sposi* [bridal chamber], 1465–1474, fresco, Ducal Palace, Mantua.
184. The two life-size panels, which date from 1514, were originally together in a single composition. They are conserved at the Gemäldegalerie of Dresden.
185. Titian, *Boy with Dogs in a Landscape*, 1565–1576, oil on canvas, Boijmans van Beuningen Museum, Rotterdam. The subject of this painting and its original dimensions (is this the fragment of a much larger canvas?) are controversial. It is possible that Titian did it in response to Veronese's *Cupid with Two Dogs*, conserved in the Pinocateca of Munich.
186. Titian, *Portrait of Frederick Gonzaga*, ca. 1525, Prado Museum, Madrid.
187. The painting is conserved in Kassel, Staatliche Kunstsammlungen Gemäldegalerie Alte Meister. The dog is probably the same as the one in *Boy with Dogs* in Rotterdam. Cf. Brown and Vlieghe, *Van Dyck*, catalog 72, 358.
188. 1532–1533, Prado Museum, Madrid. The portrait is life-size, if not larger than life-size.
189. Antoon van Dyck, *The Five Eldest Children of Charles I*, 1637, oil on canvas, Royal British Collections, Windsor, UK.

190. Respectively 1630, Wallacre Collection, London; and 1632–1633, Fitzwilliam Collection.

191. Ca. 1633–1635, Metropolitan Museum of Art, New York.

192. 1631–1632, Kunsthistorisches Museum, Vienna. The model, younger son of the so-called Winter King, Frederik V von der Pfalz, was twelve years old when the painting was done. The painting is, again, life-size.

193. Cf. Michel Foucault's analysis in *The Order of Things: An Archeology of the Human Sciences* (New York: Random House, 1970). One should note, however, that Velásquez cultivated the ambiguity between painting and mirror: it took the talent of Foucault to recognize the image of the royal couple as a reflection and not as a painting within the painting. If one goes along with our demonstration—the painting as an overview of contemporary dynastic problems—then the ambiguity is welcome: Isn't the problem that of the transfer of power, that is, the moment when the king and queen, alive (as their reflection proves), will be dead, and therefore visible in effigy (in the painting)?

194. The marriage of Philip IV and Elizabeth of France's daughter, Maria Theresa, born in 1638, to Louis XIV, was most probably foreseen from the start of negotiations that will lead, at the end of a quarter century of war between the two countries, to the Treaty of the Pyrenees. Now, these negotiations were planned to begin at least as early as spring 1656: in July, Hugues de Lionne, representing France, arrived in Madrid—Maria Theresa would indeed be married in 1660. The price of the union was the renunciation by the Spanish princess of her rights to the throne (thanks to a dowry in gold that was never transferred, which allowed France to later assert its rights to Spanish succession). Other points of chronology also need to be mentioned. In December 1655, Marie-Anne had just given birth again to a little girl who died at two weeks of age—so the hope of seeing a child born was dashed. And according to one of the most widely recognized specialists on Velásquez, Francisco Javier Sánchez Cantón, in *Las Meninas y sus personajes* (Barcelona: Juventud, 1943), 13—cited in Yves Bottineau, *Vélasquez* (Paris: Citadelles et Mazenod, 1998), 280n39, "the picture must not have been painted before the end of the summer"—that is, at the moment when negotiations were getting into full swing.

195. Daughters of Spain could inherit from the crown only on the condition that they had no younger brother; and it fell to their husband to rule in actuality. This is why—in order to preserve the rights of the Hapsburg branch—the infante was promised in 1663 to her uncle, the Emperor Leopold II. In the twenty-first century, the birth of two daughters in succession by the prince and heir Felipe has posed the question of revising the Constitution, which stipulates always a "preference for the man over the woman," in the same line and to the same degree.

196. Iago is the equivalent of Jacques in Spanish—the name of a great saint and an unusual name for a dog. It would be impossible not to recall that Iago was also the hero's henchman in Shakespeare's *Othello* (1604): a faithful soul to all appearances (as a dog should be) and a traitor, an imposter, in reality.

197. Art historians or other commentators on the painting have never, or hardly ever, so far as I know, commented on Pertusato's kick to the dog. The authors who show interest

in it do not attempt any kind of interpretation based on this detail (for instance, Julián Gallego, Velásquez, catalog of the exhibition in Prado Museum, Madrid, French ed. [Paris: Herscher, 1991], catalog 73: "His left foot is placed upon a large calm dog…not at all bothered by this game"). It should be recalled that the formulation of an implicit warning—if warning there is—was made all the more possible inasmuch as the painting was not intended originally to be seen by any other eyes than those of the king and his intimates. The anticipated placement of the canvas was, in effect, the study of the summer apartments (*pieza del despacho da verano*) in the north part of the Alcazar—reserved for the king's personal use. Cf. Jonathan Brown, *Velásquez: Painter and Courtier* (New Haven: Yale University Press, 1988), 256. Margarita never actually ruled: her brother Carlos, born ten years after her (1661), acceded to the throne under the name of Charles II of Spain and the nickname "the Enchanted"—due to his frightful physical state, probably the result of consanguineous marriages. He lived until 1700. The parameters of this note do not allow me to develop beyond this analysis, or beyond the seventeenth century, this study of the relationship between masculinity and the dog. The same phenomenon that I noted in the evolution of poses (from the hand on the sword to the gloved hand) and in the transformation of the equestrian portrait (from combatant to display horseman) can be found in the portraits that show male models with this animal: in England during the eighteenth century, paintings, notably those by Reynolds, frequently depict a plump aristocrat in breeches and wig, comfortably seated with a dog, itself more fat than powerful, which he pets affectionately. The trained animal, "civilized and fattened," had replaced the hunting or fighting animal.

198. In Venetian frescoes around 1500, women are shown as observers from windows or balconies, or else from doorsteps. The street belongs, almost without exception, to men. Cf. Fabien Lacouture, "Espace urbain et espace domestique : La représentation des femmes dans la peinture vénitienne du XVIᵉ siècle, *Clio. Femmes, Genre, Histoire* 2012, 36: 235–257.

199. 1560, oil on canvas, Kunsthistorisches Museum, Vienna.

200. Two little girls appear in the foreground, on the left, near the door to their house. Calmly sitting down, they play a peaceful game of jacks. Other girls, on the square, take part in simulations of adult ceremonies and of family life: a marriage cortege, a baptism. In the oratory of Trescore, near Bergamo, in 1524, Lorenzo Lotto similarly depicts a marketplace where little boys kick up a fuss among salespeople—but not a single little girl.

201. See Philippe Braunstein, *Un banquier mis à nu. Autobiographie de Matthäus Schwartz bourgeois d'Augsbourg. Livre des costumes* (Paris: Gallimard, 1992). The manuscript is conserved in Paris at the Bibliothèque nationale. One of the watercolors depicts the child, bigger (he is 13 or so), at the door of his school.

202. The pretext of the painting is the Massacre of Innocents—the little boys assassinated by Herod's decree shortly after the birth of Christ. The work dates from 1610.

203. These are perhaps broad beans, or rather navy beans or white beans. The painting dates from 1583–1584 and is conserved in Rome in the Colonna Gallery.

204. One of these Yawners is displayed in the Musées Royaux des Beaux-Arts in Brussels. Another Rubens kept till his death.

205. Pieter de Hooch, *The Drinker*, 1658, Louvre Museum, Paris.

206. Examples can also be found—though rarer—of isolated figures throwing up what they have just swallowed or getting ready to throw up or belching: e.g., Adriaen Brouwer, *The Bitter Potion*, ca. 1630–1640, oil on wood, Städelsches Institute, Frankfurt.

207. It might happen that the painter would make a self-portrait as a smoker—would political correctness today censure such a situation?—as in Joos Van Craesbeeck's *The Smoker*, before 1660, oil on panel, in the Louvre Museum in Paris.

208. French translation, *L'art du mariage* [Art of marriage], Latin poem with facing French text (Paris: Barrois, 1830).

209. *Self-Portrait as a Bagpipe Player*, 1644, oil on canvas, Anvers, Rubenshuis.

210. Known also as *Grotesque Old Woman*, 1525–1530, National Gallery, London. The painting was probably inspired by a Leonardo da Vinci drawing, one of those caricatures that the Italian artist produced prolifically.

211. Ca. 1808–1812, Musée des Beaux Arts, Lille.

212. As in the portraits and self-portraits assumed to be of Leonardo as an old man—e.g., the drawing conserved in the Galleria dell'Accademia in Venice.

213. *Saint Jerome*, 1521, Museu de Arte Antiga, Lisbon.

214. For example, the *Saint Jerome* of 1637, Galleria Doria Pamphili, Rome. See also the old men painted by Georges de la Tour: *Joseph* and *Job*.

215. Ca. 1427–1432, and perhaps completed ca. 1440, oil on oak, Metropolitan Museum of Art, New York. Because of the object that Joseph is working on, taken to be a mousetrap, the work was regarded as a denunciation of female sexuality—the mouse and mousetrap being thought of as erotic emblems (Meyer Schapiro, *Theory and Philosophy of Art: Style, Artist, and Society* [New York: Braziller, 1994]). The hypothesis has been advanced that Mrs. Ingelbrecht was added, along with the servant near the door opening onto the street, after the painting was finished, once the sponsor had taken a wife.

216. Pierre Michel Bertrant, *Le portrait de Van Eyck* (Paris: Hermann, 1997).

217. This statuette corresponds to the young woman's gesture: she lifts up the dress on her belly, either because she is pregnant (as is the case much later with Mme. D'Haussonville) or because the movement acts as a promise or affirmation of fertility.

218. With a much more self-confident character, a double portrait by Franz Hals, formerly regarded as a self-portrait of marriage and today as the portrait of a merchant couple, presents an arrangement not much different, with the husband stronger than the wife, higher than her, and also entirely on the left (*Married Couple in a Garden*, probably by Isaac Massa and Beatrix van der Laen, ca. 1622, Rijksmuseum, Amsterdam).

219. *Family Portrait*, 1618 (formerly known as the *Portrait of the Snyders Family*, 1620), Hermitage Museum, St. Petersburg; *Charles I and Queen Henrietta Maria with Charles, Prince of Wales, and Princess Mary*, 1632, Buckingham Palace, Royal Collections, London.

220. Thus, in the *Portrait of a Married Couple*, in Budapest: the man holds his wife's hand in his, and not the other way around. The portrait dates from the painter's Anvers period.

In the *Portrait of the Lomelli Family*—a painting done in Genoa—not only the father but also another adult male family member (in armor and posing, significantly, before a crevice in the wall) are standing next to the mistress of the house, who is holding her children by the hand.

221. 1641, oil on canvas, Gemäldegalerie, Berlin-Dahlem.

222. Another very beautiful portrait of an old couple by Rembrandt, conserved in the Royal British Collections in Buckingham Palace in London (1633, oil on canvas), depicts *The Ship Builder Jan Rickjsen and His Wife Griet Jans*. The scene takes place in the naval engineer's office, and his wife (on the right) is standing and, exceptionally, is larger, as posed, than her husband: but this is only because she is doing something for him. She is bringing him an urgent note to which he will respond.

223. Rembrandt married Saskia van Uylenburgh in 1634.

224. The first known pornographic engravings, sixteen in number, are those produced by Marc Antoine Raimondi in 1524 based on drawings by Giulio Romano and known under the title of *I modi* (The positions [of love]). They illustrate erotic poems, the *Sonnets luxurieux* by l'Arétin. Around 1590–1595 Agostino Carracci accomplished another series of engravings of the type of *I modi*, *Le lascivie* (The lascivious ones), just as frankly pornographic, which also met with success, despite a strict ban.

225. Erasmus complains about the frequency of these subjects, which he judges to be illustrated by perversity and done not at all in a Christian spirit. Cf. Erwin Panofsky, "Erasmus and the Visual Arts," *Journal of the Warburg and Courtauld Institute* 32 (1969): 220–27. Just think, in this connection, of the success of the theme of the chaste Suzanne in Venice in the era of Veronese and Tintoretto.

226. Thus, Guido Reni, 1631, Pushkin Museum, Moscow; or, to a lesser degree, it is true, Tintoretto's painting of 1555, Kunsthistorisches Museum, Vienna.

227. Rembrandt, 1634, etching, Bibliothèque Nationale, Paris. It is significant that Rembrandt chose another moment from the story of Joseph when he takes up the subject for a work on canvas: he shows Joseph reproached for his alleged seduction attempt and not the actual act committed against his modesty by Potiphar's wife.

228. Andrea Mantegna, *Samson and Delilah*, 1504, and Rubens, *Samson and Delilah*, 1609–1610, both at the National Gallery in London. As for Rembrandt, he depicts the awful moment of *The Blinding of Samson* (1636, Städelsches Kunstinstitut, Frankfurt).

229. Pieter-Paul Rubens, *Hercules and Omphale*, ca. 1602–1605, oil on canvas, Louvre Museum, Paris. The canvas is of a considerable size: 215 cm × 278 cm. To add to the silliness of the situation, Rubens invented the idea that Omphale would be tugging on Hercules' ear. In an anonymous book, decorated with engravings after artists of the time and accompanied by mottoes and short texts, the *Théâtre d'amour* or *Dévisement d'amour*, ca. 1620, the vignette depicting Hercules and Omphale is accompanied by verses, the last of which runs: "I become like you, Madame, in serving you" (Carsten-Peter Warnke, ed., *Théâtre d'amour. Le jardin de l'amour et ses délices. Redécouverte d'un livre oublié de l'époque baroque* [Paris: Taschen, 2004], folio 40).

230. Giulio Romano, *The Wedding Feast of Cupid and Psyche*, 1526–1534, fresco, Te Palace, Mantua. The "man" is, in fact, Jupiter seducing Olympia.

231. Annibale Carraci, *Jupiter and Juno*, ca. 1600, fresco, vault of the Farnese Palace, Rome.

232. The engraving dates from 1646. Quite remarkably, Rembrandt hesitated among several poses (and he chose not to erase the trace of this hesitation). In one version, the woman—whose face shows a blissful smile—lets her arms drop calmly onto the sheet, without making the slightest movement—as was to be expected of a Christian bride, one is tempted to say; in another version, he has depicted her hands (in a way that actually gives her too much arm) gripping the waist (almost the buttocks) of her lover.

233. The painting, which dates from around 1545, is conserved in the Toledo Museum of Art. It is oil on canvas. A painting attributed to Niccolò dell'Abbate, very similar in composition and with the same play of gestures, depicts Eros and Psyche.

234. The gesture of the hand stroking the chin is found as early as the Roman period, for example, in the story of St. John the Baptist, to signify King Herod's desire for the young Herodiade.

235. The representation of families changes appreciably in the eighteenth century. From the earliest moments of childhood, the father becomes more present in the images; he continues to be, henceforth, whether the baby is a girl or a boy. Cf. Allard et al., *L'enfant dans la peinture*.

236. The examples are too numerous to mention. Let me propose, however, since it is a curious painting in which the models are depicted in prayer, like donors, but without any holy or divine figures separating the male group on the left from the female group on the right, *Epitaph of the Frank Family*, attributed to Bernhard Striegel, ca. 1513, Switzerland, Schaffhouse Museum. The father is accompanied by the six sons, four of them dead (recognizable because they are all painted in early childhood and in the nightgown used for their coffin) and the mother by her six daughters (four dead).

237. Ca. 1571, Gemäldegalerie, Dresden.

238. Ca. 1559.

239. Rotterdam, Boymans-Van Beuningen Museum. I am indebted for this observation and this interpretive hypothesis to Fabien Lacouture (cited in note 198), who is writing a thesis on "The Child in Painting in Venice and Florence."

240. One of the most typical and monumental examples of this arrangement is provided by a specialist in family portraiture in Anvers during the second quarter of the seventeenth century: it depicts *Portrait of Anthony Reyniers and His Family* (1631, oil on canvas, Philadelphia Museum of Art).

241. Thus, in the very curious family portrait by Lorenzo Lotto, in which the little boy, naked, scarcely covered by a veil, his father gently stroking his head, could very well be dead.

242. Franz Hals, *Self-Portrait with Wife and Daughter Elizabeth*, 1621–1622, oil on canvas, Prado Museum, Madrid.

243. Pedro Beruguette, *Federigo da Montefeltro and His Son*, ca. 1475, National Gallery of Marche, Urbino.

244. Ghirlandaio, *Portrait of Old Man and Child*, ca. 1490, tempera on panel, Louvre Museum, Paris.

245. One work is by a female painter, and a relative exception (there are two children), explainable by the widowhood of the father: the portrait by Sofonisba Anguissola that depicts her sister Minerva as an adolescent with her father—and her little brother Hasdrubal.

5. THE VIRILE MAN AND THE SAVAGE IN THE LANDS OF EXPLORATION

1. Christopher Columbus, *Journal of the First Voyage to America* (New York: Boni, 1924). On these first markers of the encounter, see the foundational book by Tsvetan Todorov, *The Conquest of America: The Question of the Other*, trans. Richard Howard (New York: Harper & Row, 1984).

2. Amerigo Vespucci, *Relation d'un voyage aux côtes du Brésil, fait en 1501 et 1502* in Édouard Charton, ed., *Voyageurs anciens et modernes*, vol. 3, 200. *The Third Voyage*, trans. Clements R. Markham, accessed 5 September 2013, www.gutenberg.org /files/36924/36924-h/36924-h.htm#, 34, 45–46.

3. Antoine Furetière, *Dictionnaire universel* (Paris, 1691), "Homme."

4. For this view from the "East," see: D. K. Richter, *Facing East from Indian Country: A Native History of Native America* (Cambridge, MA: Harvard University Press, 2001).

5. François de Belleforest, *La cosmographie universelle de tout le monde*, vol. 3 (Paris: Michel Sonnius, 1575), 2176.

6. See Olive Patricia Dickason, *The Myth of the Savage and the Beginnings of French Colonialism in the Americas* (Edmonton: University of Alberta Press, 1997), 30ff.

7. Vespucci, *The Third Voyage*, 46.

8. Belleforest, *La cosmographie universelle de tout le monde*, op. cit., vol. 3, 2195.

9. Vespucci, *The Third Voyage*, 46

10. Ibid.: "They look more like monsters than men" (translation modified).

11. Joannes Boemus, *Gli Costumi, le leggi e l'usanze di tutte le genti* (Venice, 1569), 197.

12. Belleforest, *La cosmographie universelle de tout le monde*, vol. 3, 2178.

13. Antonio Pigafetta, *Premier voyage autour du monde* (1516; repr., Paris: J. Jansen, revolutionary year IX [1800]), 16.

14. A. Thévet, *La cosmographie universelle, illustrée de diverses figures des choses plus remarquables vecuës par l'auteur*, vol. 1 (Paris, 1575), 79.

15. Ibid.

16. Pigafetta, *Premier voyage autour du monde*, 20.

17. Ibid., 21.

18. Vespucci, *The Third Voyage*, 46–47.

19. Belleforest, *La cosmographie universelle de tout le monde*, vol. 3, 2100.

20. Thévet, *La cosmographie universelle*, vol. 1, 81. See also S. Colin, "The Wild Man and the Indian in Early 16th century Book Illustrations," in *Indians and Europe: An Interdisciplinary Collection of Essays*, ed. Christian F. Feest (Aachen: Herodot, 1987).

21. Furetière, *Dictionnaire universel*, "Homme." The Spaniards "questioned whether the Indians were men and whether they should be baptized."

22. Álvaro de Mendaña y Neyra, *Courte relation à la recherche de la Nouvelle-Guinée* [1567], in Édouard Charton, *Voyageurs anciens et modernes* (Paris: Bureaux du Magasin Pittoresque, 1861), vol. 4, 194.

23. Columbus, *Journal of the First Voyage to America*.

24. Ibid.

25. Thévet, *La cosmographie universelle*, 146.

26. José de Acosta, *Histoire naturelle et morale des Indes tant orientales qu'occidentales* (Paris: Adrian Tiffaine, 1598), 321.

27. Ibid., 229.

28. Jacques Chartier, cited in Belleforest, *La cosmographie universelle de tout le monde*, vol. 3, "Deuxième voyage, 1535," 2187.

29. Fernand de Magellan, *Voyage autour du monde (1518–1521)*, in Charton, *Voyageurs anciens et modernes*, vol. 3, 279.

30. Vespucci, *Relation d'un voyage*, 202.

31. Mendaña, *Courte relation à la recherche de la Nouvelle-Guinée*, 190.

32. Vespucci, *Relation d'un voyage*, 200.

33. Belleforest, *La cosmographie universelle de tout le monde*, vol. 3, 2177.

34. Magellan, *Voyage autour du monde*, 278.

35. Pedro Fernandes de Queiros, *Voyages aux Nouvelles-Galles* [1606], in Charton, *Voyageurs anciens et modernes*, vol. 4, 237.

36. Columbus, *Journal of the First Voyage to America*, 120. On this theme of domination, see Mary-Louise Pratt, *Imperial Eyes: Travel Writing and Transculturation* (London: Routledge, 1992).

37. *Le Mercure galant*, April 1681. See, moreover, the statements made about the "Brazilians" in one of the first dictionaries about religions and manners of the seventeenth century, that of D. de Juigné Broissinière, *Dictionnaire théologique, historique, poétique, cosmographique et chronologique* (1643; repr., Paris, 1669): "The majority of these nations live without a knowledge of God, without religion, without writing and without law; given over so much, though, to sorcery and magic, many become rabid." Online original in French: https://books.google.com/books?id=1AmzIBW9DDgC&pg=PT165&lpg=PT165&dq=dictionnaire+historique,+poétique,+cosmographique+et+chronologique+de+la+religion&source=bl&ots=qt57WohOio&sig=rfZcldiuol1sDi7QPgIsu7OHAtc&hl=en&sa=X&ei=L49eVbaHHMbXsAWSyIBo&ved=0CB8Q6AEwAA#v=onepage&q=dictionnaire%20historique%2C%20poétique%2C%20cosmographique%20et%20chronologique%20de%20la%20religion&f=false.

38. Queiros, *Voyages aux Nouvelles-Galles*, 231.

39. Ibid., 227.

40. Thévet, *La cosmographie universelle*, 79.

41. Bartolomé de Las Casas, prologue to *The Devastation of the Indies: A Brief Account* (New York: Seabury, 1974).

42. G. Chinard, *L'exotisme américain dans la littérature française au XVIᵉ siècle d'après Rabelais, Ronsard, Montaigne, etc.* (Paris: Hachette, 1911), 178.

43. Las Casas, prologue.

44. Chinard, *L'exotisme*, 216.

45. Ibid., 146.

46. See Frank Lestringant, *Le Huguenot et le sauvage. L'Amérique et la controverse coloniale en France au temps des guerres de Religion* (Geneva: Droz, 2004), esp. "Jean de Léry, historien du Brésil français," 77ff.

47. Jean de Léry, *Histoire d'un voyage fait en la terre du Brésil autrement dite Amérique* (Paris, 1585), 121.

48. Ibid., 171.

49. Michel de Certeau, *L'écriture de l'histoire* (Paris: Gallimard, 1975), 243, and esp. "Ethno-graphie. L'oralité ou l'espace de l'autre: Léry," 215ff.

50. Ibid.

51. Cited by Certeau, *L'écriture de l'histoire*, 221.

52. Ibid., 237.

53. Michel de Montaigne, *Essais* (1595; repr., Paris: Gallimard, "Bibliothèque de la Pléiade," 1950), 1018; *The Complete Essays of Montaigne*, trans. Donald M. Frame (Stanford: Stanford University Press, 1958), 693. *Essais* hereafter cited as "Montaigne" followed by the corresponding pages in the Frame translation.—Trans.

54. See Bernard Sheehan, *Savagism and Civility: Indians and English in Colonial Virginia* (Cambridge: Cambridge University Press, 1980), who pays particular attention to the "abstract" view of the savage proposed here.

55. Montaigne, 243–44; Frame, 152–3.

56. Whence that decisive observation referring to an Old World made up of members fallen "into paralysis" and a New World made up of members "in full vigor." Ibid., 1018; Frame translation, 693.

57. Ibid., 242; Frame, 152.

58. Ibid., 242–43; Frame, 152.

59. Chinard, *L'exotisme*, 216.

60. Ibid., 245.

61. Lawrence D. Kritzman gives a fine treatment of this theme: see *The Fabulous Imagination: On Montaigne's Essays* (New York: Columbia University Press, 2009), 24–26.

62. Ibid., 249. See also Jean Plattard, *Montaigne. "Des Cannibales"* (Paris: Tournier et Constans, 1941), 41: "the word 'virtue' must be understood in the sense of the Latin *virtus*."

63. Montaigne, 250; Frame, 157.

64. Ibid., 252; Frame, 158 (trans. modified)—Trans.

65. See the text that has become a classic by John H. Kennedy, *Jesuit and Savage in New France* (New Haven: Yale University Press, 1950).

66. "Relation de 1639," in *Lettres édifiantes et curieuses écrites, collationnées sur les meilleures éditions et enrichies de nouvelles notes par des missionnaires de la compagnie de Jésus* [The curious and edifying letters, collated into the finest editions and augmented with new notes by the missionaries of the Society of Jesus], vol. 17 (Paris, 1829–1832), 144.

67. Pierre de Charlevois, *Histoire et description générale de l'ancienne France*, vol. 2 (Paris, 1744), 42. The history written by Pierre de Charlevois, of the Society of Jesus, takes up during the 1740s the descriptions and commentaries of the "edifying letters" of the seventeenth century.

68. Pierre de Charlevois, *Histoire et description générale de l'ancienne France*, vol. 3 (Paris, 1744), 118.

69. See Dominique Deslandres, "Le Jésuite, 'l'intoléré' et le 'sauvage,' la fabrication par omission d'un mythe," in *Primitivisme et mythe des origines dans la France des Lumières, 1680–1820*, ed. C. Grell and C. Michel (Paris: Presses de l'Université de Paris-Sorbonne, 1989), 99: "Deux pôles donc: 'positif,' le Sauvage est converti; 'négatif,' il est encore païen." [Two poles therefore: if "positive," the Savage is converted; if "negative," he is still a pagan.]

70. See Anthony Pagden, *European Encounters with the New World: From Renaissance to Romanticism* (New Haven: Yale University Press, 1993). See the manner by which the cultural context of the Other also oriented the occidental perspective (184).

71. "Relation de 1634," in *Lettres édifiantes et curieuses écrites, collationnées sur les meilleures éditions et enrichies de nouvelles notes par des missionnaires de la compagnie de Jésus*, vol. 6 (Paris, 1829–1832), 228.

72. Ibid.

73. Ibid.

74. G. Chinard, *L'Amérique et le rêve exotique dans la littérature française au XVIIe et au XVIIIe siècle* (1913; repr., Paris: Hachette, 1934), 138.

75. On Louis Armand de Lahontan, see Robert Sayre, *La modernité et son autre. Récits de la rencontre avec l'Indien en Amérique du Nord au XVIIIe siècle* (Bécherel: Les Perséides, 2008), 140ff: "Lahontan."

76. Lahontan, "Lettre du 18 juin 1684," cited by Sayre, *La modernité et son autre*, 149.

77. Paul Hazard, *The Crisis of the European Mind, 1680–1715*, trans. J. Lewis May (New York: NYRB Classics, 2013).

78. Louis Armand de Lahontan, *Dialogues de M. le baron de Lahontan et d'un sauvage, dans l'Amérique, contenant une description exacte des moeurs et des coutumes de ces peuples sauvages. Avec les voyages du même en Portugal et en Danemarc . . .* (Amsterdam, 1704), 260.

79. Ibid., 280.

80. See Lionello Sozzi, *Immagini del salvaggio. Mito e realità nel primitivismo europeo* (Rome: Edizione di storia e litteratura, 2002), esp. "Libertà e independanza," 63.

81. Sayre, *La modernité et son autre*, 149.

82. Chinard, *L'Amérique et le rêve exotique dans la littérature française au XVIIe et au XVIIIe siècle*, 185.

83. Jean-François Lafitau, *Moeurs des sauvages américains comparés aux moeurs des premiers temps*, 2 vols. (Paris, 1724).

84. Ibid., 1:531.

85. See J. Edward Chamberlin, *Degeneration: The Dark Side of Progress* (New York: Columbia University Press, 1985).

86. Jean-Baptiste Moheau, *Recherches et considérations sur la population de la France* (Paris: Paul Geuthner, 1778), 122.

87. See André Burguière, "Le prêtre, le prince et la famille," in *Histoire de la famille*, vol. 3, ed. André Burguière, Christiane Klapisch-Zuber, Martine Segalen, and Françoise Zonabend (Paris: Armand Colin, 1986; repr., Paris: Livre de Poche, 1994), 184.

88. Jean-Joseph Expilly, *Dictionnaire historique, géographique and politique de la Gaule et de la France*, vol. 1 (Paris, 1767), "Avertissement" [forward], xi.

89. Jacques Ballexserd, *Dissertation sur l'éducation physique des enfants depuis leur naissance jusqu'à l'âge de la puberté* (Paris: Bosch, 1762), 23.

90. Moheau, *Recherches et considérations sur la population de la France*, 122.

91. Ballexserd, *Dissertation sur l'éducation physique des enfants depuis leur naissance jusqu'à l'âge de la puberté*, 25.

92. S. Chaffrey, "Le corps amérindien dans les relations de voyage en Nouvelle France au XVIIIe siècle" (thesis, Université de Paris IV, 2006). On this theme, see the "Position de thèse."

93. Jean-Jacques Rousseau, *Émile* (1762; repr., Paris: Garnier, 1951), 37–38.

94. Jean-Jacques Rousseau, *Discours sur l'origine et les fondements de l'inégalité parmi les hommes et si elle est autorisée par la loi naturelle* (Amsterdam: Michel Rey, 1755; repr., Paris: Garnier Flammarion, 1995), 90.

95. Louis Antoine de Bougainville, *Voyage autour du monde* (Paris, 1771), 214.

96. Denis Diderot, *Supplément au voyage de Bougainville* (1772; repr., Paris: Gallimard, "Bibliothèque de la Pléiade," 1951), 971.

97. Bougainville, *Voyage autour du monde*, 197.

98. Ibid., 228.

99. A. A. Bruzen de la Martinière, *Le grand dictionnaire géographique, historique et critique* (1726–1739; repr., The Hague, 1768).

100. Ibid., "Mexique." See also R. H. Pearce, *The Savages of America: A Study of the Indian and the Idea of Civilization* (Baltimore: Johns Hopkins University Press, 1953).

101. Diderot, "Comparaison des peuples policés et des peuples sauvages," in *Extraits de l'histoire des deux Indes* [1774], *Oeuvres complètes*, ed. R. Lewinter (Paris: Club français du livre, 1973), 15:525–26.

102. See A. Thomson, "Sauvages, barbares, civilisés, l'histoire des sociétés au XVIIIe siècle," in *Barbares et Sauvages. Images et reflets dans la culture occidentale*, ed. J.-L. Chevalier, M. Colin, and A. Thomson (Caen: Presses Universitaires de Caen, 1994).

103. Michèle Duchet, *Anthropologie et histoire au siècle des Lumières* (Paris: Maspéro, 1971), 205.

104. Guillaume-Thomas Raynal, *L'histoire philosophique et politique de l'établissement et du commerce des Européens dans les deux Indes* (Amsterdam, 1770).

105. F. M. Grimm, *Correspondance littéraire, philosophique et critique,* vol. 8 (Paris, 1812–1813), 228.

106. Raynal, *L'histoire philosophique et politique de l'établissement et du commerce des Européens dans les deux Indes,* vol. 8 (Paris, 1775), 112.

107. Chinard, *L'Amérique et le rêve exotique dans la littérature française au XVII^e et au XVIII^e siècle,* 398.

108. Raynal, *L'histoire philosophique et politique de l'établissement et du commerce des Européens dans les deux Indes,* vol. 4 (Amsterdam, 1770), 39.

109. Raynal, *L'histoire philosophique et politique de l'établissement et du commerce des Européens dans les deux Indes,* vol. 8 (Paris, 1775), 24.

110. Ibid., 14.

111. Ibid., 25.

112. Ibid., 22.

113. Ibid., 14.

114. Yves Benot, "Les sauvages d'Amérique du Nord: modèle ou épouvantail?" *Cromohs* 10 (2005): 7.

115. Sayre, *La modernité et son autre,* 109. See also C. G. Calloway, *The American Revolution in Indian Country: Crisis and Diversity in Native American Communities* (Cambridge: Cambridge University Press, 1995); in particular, see the epilogue: "A World Without Indians?"

116. Jonathan Carver, *The Journal and Related Documents, 1766–1770* (St. Paul, MN: Historical Society Press, 1976).

117. William Bartram, *Travels Through North and South Carolina, Georgia, East and West Florida, the Cherokee Country, the Extensive Territories of the Muscogulges or Greek Confederacy, and the Country of Chactaws* (Philadelphia: James and Johnson, 1793).

118. See Sayre, *La modernité et son autre,* 210.

119. François Péron, *Voyage de découverte dans les terres australes* (Paris, 1807), 449.

6. VIRILITY ON EDGE IN THE AGE OF ENLIGHTENMENT

1. The French word *populaire,* used throughout this chapter, is usually rendered as "working-class," especially in the industrial era. Since the time frame of this chapter is the eighteenth-century Enlightenment, "working-class" does not always seem apt, and so I have translated the word also as "popular" or as referring to "common folks," depending on the context.—Trans.

2. E. M. Benabou, *La prostitution et la police des moeurs* (Paris: Perrin, 1987). For example, two trials found in the departmental Archives of Seine-et-Oise (Magny-Moussy) in 1724 and 1726:

> Trial against Sir B., priest, chaplain of Charity of Magny parish, petitioned by Marie C., his penitent, head of the Magny post office, for having seduced her and having tried to make her abort.

Trial against Sir E., curate of Magny, for having buried a newborn infant of Geneviève C. without customary formalities, having had the infant transported from the home of the woman who gave birth to it to the vicarage, where it was exhumed, and against Geneviève C. for not having made a declaration of pregnancy.

3. J. E. Fournel, *Traité de l'adultère considéré dans l'ordre judiciaire* (Paris: J. E. Bastien, 1778). Fournel was a lawyer in the Paris Parliament. (The French penal code was established in 1791 and the Napoleonic Code in 1804.—Trans.)

4. Natalie Zemon Davis, "The Reasons of Misrule: Youth Groups and Charivaris in Sixteenth-Century France," *Past and Present* (February 1971): 41–75; E. P. Thompson, "'Rough music,' le charivari anglais," *AESC* (March–April 1972): 228ff.

5. C. Cusset, *Qui peut définer les femmes? L'article "Femme" de l'Encyclopédie (1756) sur les femmes de Diderot (1772)* (Paris: Indigo & Côté Femmes, 1999), 2.

6. Lise Andriès and Geneviève Bollème, eds., *La bibliothèque bleue*, Bouquins (Paris: Laffont, 2003); and Arlette Farge, *Le miroir des femmes. Textes de la Bibliothèque bleue* (Paris: Montalba, 1982).

7. On this subject, see the work of Michel Delon, *Le savoir-vivre libertin* (Paris: Hachette, 2000), notably "Hommes de fiction" (467–98), reprinted below as "Men of Fiction," 186–214.

8. Delon, *Le savoir-vivre libertin* 58; "Men of Fiction," 170.

9. Arlette Farge, ed., *Flagrants délits aux Champs-Élysées. 1777–1791. Les dossiers de police du gardien Federici* (Paris: Mercure de France, 2008).

10. C. Cusset, *Qui peut définer les femmes?*, 23–25. We should add the avant-garde work, almost feminist for its time, by Poulain de la Barre, *De l'égalité des deux sexes* (Paris: Jean Du Puis, 1673).

11. Arlette Farge, *Effusion et tourment. Le récit des corps. Histoire du peuple au XVIII^e siècle* (Paris: Odile Jacob, 2007).

12. Maurice Daumas, *Au bonheur des mâles. Adultère et cocuage à la Renaissance* (Paris: Colin, 2007).

13. *Jacques-Louis Ménétra, compagnon vitrier au XVIII^e siècle. Journal de ma vie*, ed. Daniel Roche (Paris: Montalba, 1982).

14. Ibid., 49.

15. Ibid., 131.

16. Ibid., 116–17.

17. Arlette Farge, *La vie fragile. Violence, pouvoirs et solidarités à Paris au XVIII^e siècle* (Paris: Points, "Histoire," 2007), "Femmes séduites et abandonnées."

18. *Jacques-Louis Ménétra, compagnon vitrier au XVIII^e siècle*, 101.

19. Ibid., 103.

20. Ibid., 91.

21. Ibid., 172.

22. Ibid., 262.

23. Farge, *La vie fragile*.

24. Élisabeth Bourguinat, *Le siècle du persiflage. 1734–1789* (Paris: Presses Universitaires de France, 1998); Delon, *Le savoir-vivre libertin.*

25. Speaking of a servant, Ménétra writes: "I take her, I find an open stable, and here we are together at the moment our souls will lose themselves in the heavens" (197).

26. *Jacques-Louis Ménétra, compagnon vitrier au XVIII^e siècle*, 103.

27. Louis-Sébastien Mercier, *Tableau de Paris*, vol. 5 (Paris: Mercure de France, n.d.), chap. 383, "Devinez."

28. French National Archives, Châtelait de Paris, Criminal Court, 1785, Y 9947.

29. Ibid., Y 9833.

30. Delon, *Le savoir-vivre libertin*, 221; "Men of Fiction," 179.

31. Farge, *La vie fragile.*

32. French National Archives, Châtelait de Paris, Criminal Court, 14 March 1781, Y 9887.

33. C. Dauphin and A. Farge, eds., *De la violence et des femmes* (Paris: Michel, 1997).

34. Gérard Bord, "Le divorce pendant la Révolution," *Revue de la Révolution française* (1883).

35. Daumas, *Le mariage amoureux. Histoire du lien conjugal sous l'Ancien Régime* (Paris: Colin, 2004), 259; A. Walch, *Histoire du couple en France, de la Renaissance à nos jours* (Rennes: Ouest France, 2003).

36. Following the expression of M. Delon.

37. Pierre Darmon, *Le tribunal de l'impuissance* (Paris: Seuil, 1979).

38. Drs. Petit and Tissot wrote medical treatises on topics treating sexual functioning, the latter publishing in 1764 a work entitled *Onanism: Dissertation on the Illnesses Produced by Masturbation* (4th ed.: Lausanne: Marc Chapuis, 1773). See infra ch. 7, "Sublimating Sex"—Trans.

39. D. Teysseire, ed., *Obèse et impuissant. Le dossier médical d'Élie de Beaumont* (Grenoble: Millon, 1995).

40. French National Archives, Châtelait de Paris, Criminal Court, 1765, Y 9710.

41. Ibid., 1770, Y 9767.

42. Mercier, *Tableau de Paris.*

43. Maurice Daumas, *Le syndrome des Grieux. La relation père/fils au XVIII^e siècle* (Paris: Seuil, 1990); and Jean-Claude Bonnet, "La malédiction paternelle," *Dix-huitième Siècle* 12 (1980): 195–208. More generally, Yvonne Knibiehler, *Les pères ont aussi une histoire* (Paris: Hachette, 1987); and Jean Delumeau and Daniel Roche, *Histoire des pères et de la paternité* (Paris: Larousse, 1990).

44. See Jean-Michel Glicksohn, *Iphigénie. De la Grèce antique à l'Europe des Lumières* (Paris: Presses Universitaires de France, 1985).

45. See Robert Herbert, *David, Voltaire, Brutus and the French Revolution: An Essay in Art and Politics* (London: Viking, 1972); and Philippe Bordes, *La mort de Brutus de Pierre-Narcisse Guérin* (Vizille: Musée de la Révolution française, 1996).

46. Alain Grosrichard, *Structure du sérail. La fiction du despotisme asiatique dans l'Occident classique* (Paris: Seuil, 1979).

47. Charlotte Charrier, *Héloïse dans l'histoire et dans la légende* (Paris: Champion, 1933).

48. Patrick Barbier, *Les castrats* (Paris: Grasset, 2003); and M. Delon, M. G. Percelli, and M. Sajous D'Oria, *Farinelli. La gloire du castrat* (Taranto, Italy: Lisi, 2009).

49. As if parodying Diderot's *Paradoxe sur le comédien* (Paradox of the actor).—Trans.

50. Yves Citton, *Impuissances. Défaillances masculines et pouvoir politique, de Montaigne à Stendhal* (Paris: Aubier, 1994); and Margaret Waller, *The Male Malady: Fictions of Impotence in the French Romantic Novel* (New Brunswick, NJ: Rutgers University Press, 1993).

51. Torquato Tasso, *Jerusalem Delivered*, trans. Edward Fairfax (1923; repr., New York: Nabu, 2010); and Raymond Abbingiati and José Guidi, *Les belles infidèles de la Jérusalem délivrée. La fortune du poème de Tasse* (Aix-en-Provence: Publications de l'Université de Provence, 2004).

52. Tasso, *Jerusalem Delivered*, trans. Edward Fairfax, canto 1, §58, accessed 6 September 2013, www.gutenberg.org/cache/epub/392/pg392.html.

53. Ibid., canto 16, §29, accessed 6 September 2013.

54. Ibid., canto 12, §67.

55. Voltaire, *La Pucelle d'Orléans* in *Contes en vers et en prose*, vol. 1, ed. S. Menant (Paris: Garnier, 1993), 336; *The Maid of Orleans*, trans. Ernest Dowson (London: Lutetian Society, 1899), 190.—Trans.

56. Voltaire, *Contes en vers et en prose*, vol. 2, 143.

57. Voltaire, *La Princesse de Babylone* in *Contes en vers et en prose,* vol. 2, 450; *The Princess of Babylon* (New York: Peter Eckler, 1885; repr., New York: Mondial, 2008), 3; (trans. modified)—Trans.

58. Voltaire, *L'Histoire de Jenni* in *Contes en vers et en prose*, vol. II, 450.

59. Voltaire, *Maid of Orleans*, 191.—Trans.

60. Voltaire, *Contes en vers et en prose*, vol. 1, 339.

61. See Patrick Graille, *Les hermaphrodites aux XVIIᵉ et XVIIIᵉ siècles* (Paris: Les Belles Lettres, 2001).

62. These instances of transvestitism are consistent with actual practice, as reported by Sylvie Steinberg, *La confession des sexes. Le travestissement de la Renaissance à la Révolution* (Paris: Fayard, 2001).

63. Louvet de Couvray, *Les amours du chevalier de Faublas* (Paris: Gallimard, "Folio," 1996), 526 and note 1.

64. See Lynn Hunt, "The Imagery of Radicalism," *Politics, Culture, and Class in the French Revolution* (1984; repr., Berkeley: University of California Press, 2004).

65. Richaud-Martelly, *Les deux Figaro* (Paris, Revolutionary Year IV [1795]), 16.

66. B. de St. V. [Bins de Saint-Victor], *Amour et galanterie, dans le genre de Faublas*, vol. 1 (Paris: Barba, Revolutionary Year XI [1801]), 4.

67. *Les conteurs du XVIIIᵉ siècle. Meusnier de Querlon* (Paris: Flammarion, n.d.), 9 and 19.

68. *Vénus en rut ou Vie d'une célèbre courtisane* [1771], in *Oeuvres anonymes du XVIIIᵉ siècle*, vol. 6 (Paris: Fayard, "L'Enfer de la Bibliothèque nationale," 1987), vol. 6, 140–41, 146.

69. Ibid., 208, 231.

70. Andréa de Nerciat, *Lelote*, ed. J.-Ch. Abramovici (1792; repr., Paris: Zulma, 2001), 74–75.

71. Fanny de Beauharnais, *L'aveugle par amour* (Amsterdam/Paris, 1781), 10 (emphasis added).

72. Mme. de Charrière, *Lettres trouvées dans des porte-feuilles d'émigrés, Oeuvres complètes*, vol. 8 (Amsterdam: G. A. van Oorschot, 1980), 468.

73. L. C. L. G., *Sophie de Beauregard, ou le véritable amour*, vol. 1 (Paris: Le Prieur, Revolutionary Year VII [1798]), 167–68.

74. Mme. de Staël, *Corinne ou l'Italie* (Paris: Gallimard, "Folio," 1985), book 8, chap. 2, 218.

75. De Staël, *De l'Allemagne*, part 1, chap. 6, cited and commented on by Claire Garry-Boussel, *Statut et function du personage masculin chez Mme de Staël* (Paris: Champion, 2002).

76. Antoine Jean Bourlin [a.k.a. Dumaniant], *Les amours et aventures d'un émigré* (Paris: Revolutionary Year VI [1795]), 51, 72–73.

77. Ibid., 81–82.

78. Rétif de la Bretonne, "La belle imagère ou la fille dupe de sa moquerie," in *Les contemporaines du commun* (1782; repr., Paris: Robert Laffont, "Bouqins," 2002), 880.

79. Rétif de la Bretonne, *Le paysan perverti*, in *Les contemporaines du commun*, op. cit., 514.

80. Le Vacher de Charnois, *Histoire de Sophie et d'Ursule*, vol. 2, rev. ed. (London/Paris, 1789), 12–13.

81. *Quelques Semaines à Paris*, vol. 1 (Paris: Maradan, Revolutionary Year IX [1800]), 148.

82. Chaussard, *Le nouveau diable boiteux. Tableau philosophique et moral de Paris*, vol. 2, (Paris: F. Buisson, Revolutionary Year VII [1798]), 19.

83. Marquis de Sade, *La Nouvelle Justine*, in *Oeuvres complètes*, vol. 2 (Paris: Gallimard, "Bibliothèque de la Pléiade," 1995), 495.

84. Jean Molino, "Sade devant la beauté," *Le Marquis de Sade* (Paris: Colin, 1968), 154.

85. Sade, *La Nouvelle Justine, Oeuvres complètes*, vol. 2, 35.

86. Sade, *Histoire de Juliette*, in *Oeuvres complètes*, vol. 3, 1097.

87. Sade, *Aline et Valcour*, in *Oeuvres complètes*, vol. 1, 662.

88. Louis-Antoine de Bougainville, *Voyage autour du monde par la frégate du Roi* La Boudeuse *et la flûte* L'Étoile (Paris: Gallimard, "Folio," 1982), 252.

89. "Narcisse dans l'île de Vénus" [1768], in *Poésies de Malfilâtre* (Paris: A. Quantin, 1884), 62, 71.

90. *Semelion. Histoire véritable* [attributed to Charles Louis Auguste Fouquet de Belle-Isle], vol. 1, rev. augmented ed. (Hamburg/Paris, 1807), 33. See Aurélia Gaillard, *L'année 1700* (Tübingen: Narr, 2004).

91. Ibid., vol. 2, 233.

92. *Éléonore, ou l'heureuse personne* [Revolutionary Year VIII (1799)] (repr., Paris: Fayard, "L'Enfer de la Bibliothèque nationale," 1987), 2d ed., in *Oeuvres anonymes du XVIIIᵉ siècle*, vol. 6, 65.

93. Élisabeth Badinter, *L'Amour en plus: histoire de l'amour maternel (XVIIe–XXe siècle)* (Paris: Flammarion, 1980)—Trans.

7. THE CODE OF VIRILITY: INCULCATION

1. P. Larousse, *Grand Dictionnaire universel du XIX^e siècle*, vol. 15, part 2 (Paris, 1866–1879; repr., Geneva/Paris: Slatkine, 1982), 1106: "Virilité."

2. P. Lhande, *Jeunesse. L'âge tendre. L'âge critique. L'âge viril. Petit code d'éducation au foyer, d'après Clément d'Alexandre* (Paris: Beauchesne, 1923), 12.

3. P. Kergomard, *L'éducation maternelle dans l'école*, vol. 1 (Paris: Hachette, 1886), 37.

4. M. Koenig and A. Durand, *Jeux et travaux enfantins à l'usage des écoles maternelles, des classes enfantines . . .* , vol. 1, *Le monde en papier* (Paris: Jeandé, 1889), viii.

5. N. Laisné, *La gymnastique à l'école maternelle* (Paris: Picard-Bernheim, 1882), 8–9. More generally, see J.-N. Luc, *L'invention du jeune enfant au XIX^e siècle. De la salle d'asile à l'école maternelle* (Paris: Belin, 1997); and I. Jablonka, "L'âme des écoles maternelles, Pauline Kergomard (1838–1925) et l'éveil du jeune enfant sous la III^e République," *Bulletin de la Société de l'histoire du protestantisme français* 149 (July–September 2003): 449–63.

6. C. Berville, *Le premier livre des petits garçons. Scènes enfantines. Morale tirée des exemples. Qualités à acquérir. Défauts à éviter* (Paris: Larousse, 1906), 113.

7. A. de Savignac, *Enfants d'après nature. Les petits garçons* (Paris: Eymery: "Bibliothèque d'éducation," 1836), 4–6.

8. "Le petit boudeur" and "Monsieur Coup de poing," in E. Blondeau, *La chanson à l'école et dans la famille. Ouvrage destiné aux écoles maternelles, aux cours préparatoires et élémentaires des écoles primaires* (Paris: Molouan, 1901), 12–13, 37.

9. *Abécédaire des petits garçons, avec des leçons tirées de leurs jeux et de leurs occupations ordinaires*, 16th ed. (Paris: Duverger, 1846), 57–60.

10. Ibid., 62.

11. J. Michel, *Le livre des petits garçons, ou les Délassements du cœur et de l'esprit* (Limoges: Ardant, 1884), 18–23. More generally, see M. Manson, "La poupée et le tambour, ou de l'histoire du jouet en France du XVI^e au XIX^e siècle," in *Histoire de l'enfance en Occident*, vol. 1, ed. E. Becchi and D. Julia (Paris: Seuil, 1998), 432–64.

12. Berville, *Le premier livre des petits garçons*, 77–78.

13. B. C. Faust, *À l'Assemblée nationale, sur un vêtement libre et national, à l'usage des enfants ou Réclamation solennelle des droits des enfants* (n.p., 1792), 45.

14. H. Klemm, *Traitement pratique de l'habillement, enseignant la préparation et l'exécution de tous les patrons concernant la toilette des dames et des enfants* (Paris: Firmin-Didot, 1878), 99–100, 115–16. But there are also "pants for little girls from four to 15 years old" (ibid., 141).

15. M. Dessault, *Traité pratique de la coupe et de la confection des vêtements pour dames et enfants* (Paris: Garnier, 1896), esp. 501–02.

16. E. Teyssier, *Méthode pour apprendre à couper la confection de dames, corsages de robes et jupes . . .* , *précédée d'un système pour fillettes et petits garçons* (Paris: privately printed, 1879), 69.

17. Klemm, *Traitement pratique de l'habillement*, 20.

18. J. Petit, *La coupe des vêtements d'hommes et de garçonnets* (Paris: Chiron, 1922), 59–61.

19. P. Bonhomme, *Le premier pantalon. Monologue pour jeune garçon* (Paris: Librairie théâtrale, 1887), 3–5. On this point, see P. Ariès, *L'enfant et la vie familiale sous l'Ancien Régime* (Paris: Plon, 1960); and C. Bard, *Une histoire politique du pantalon* (Paris: Seuil, 2010).

20. *Exemples aux jeunes garçons ou vies et morts chrétiennes* (Paris: Risler, 1834), 61.

21. J. Cauvière, *Les devoirs du jeune homme au sortir du collège, discours prononcé à l'École Saint-François-de-Sales, à Dijon* (Marseilles: Imprimerie marseillaise, 1890), 2.

22. See A.-M. Sohn, *"Be a man!" La construction de la masculinité au XIXe siècle* (Paris: Seuil, 2009); F. Chauvaud, *Les passions villageois au XIXe siècle. Les émotions rurales dans les pays de Beauce, du Hurepoix et du Mantois* (Paris: Publisud, 1995); and, on one particular point, F. Guillet, *La mort en face. Histoire du duel de la Révolution à nos jours* (Paris: Aubier, 2008).

23. Abbé V. Jacques, *La virilité de caractère et le Collège chrétien. Discours prononcé à la distribution des prix* (Nancy: Vagnez, 1899), 5–9.

24. L. Desers, *Lettre à un jeune bachelier sur la virilité chrétienne du caractère* (Paris: Poussielgue, 1904), 8–10.

25. O. Bordage, *Sois un homme! Sermon pour la première communion des garçons, prêché au Petit-Temple le 2 juin 1901* (Nîmes: Chastanier, 1901), 12.

26. A. Thomas, *Sois un homme! Sermon prononcé à Saint-Pierre le 5 février 1905 pour la consécration de M. Henry Mottu* (Geneva: Robert, 1905), 15.

27. A. Coquerel, *Sois un homme! Appel à la jeunesse française d'aujourd'hui, prononcé le 5 mai 1872, à la salle Saint-André* (Paris: Sandoz et Fischbacher, 1872), 46.

28. *Manuel républicain. Ouvrage destiné à l'éducation des enfants de l'un et de l'autre sexe, et à leur inspirer le goût du travail et des vertus républicaines* (Paris: Debarle, Year II [1793–1794]), 85. On the masculinity of revolutionary values, see L. Hunt, *The Family Romance of the French Revolution* (Berkeley: University of California Press, 1993).

29. J. Le Peyre, *Livres d'éducation morale pour les garçons. Opuscule du maître* (Paris: Armand Colin, 1896), 34.

30. A. Sicard, *Manuel d'éducation morale et d'instruction civique* (Paris: Lecène et Oudin, 1888), 163.

31. C. Boniface, *Éducation morale et pratique dans les écoles de garçons. Pour le commencement de la classe (garçons), 200 lectures morales quotidiennes* (Paris: Armand Colin, 1896), 41, 44.

32. H. Baudrillart, *Manuel d'éducation morale et d'instruction civique* (Paris: Lecène et Oudin, 1885), 3, 182.

33. P. Cabanel, *Le tour de la nation par des enfants. Romans scolaires et espaces nationaux (XIXe–XXe siècle)* (Paris: Belin, 2007), 194–95, 862. See also the special issue of *Romantisme*, "Le grand homme," 100 (1998) (notably C. Amalvi, "L'exemple des grands hommes de l'histoire de France à l'école et au foyer, 1814–1914," 91–103).

34. G. Bruno, *Le tour de la France par deux enfants. Devoir et patrie*, 128th ed. (1877; repr., Paris: Belin, 1884), passim, notably, 5, 6, 15–17, 68, 72, 201, 206–07.

35. S. Pellico, *Des devoirs des hommes, discours à un jeune homme* (1834; repr., Paris: Chamerot et Renouard, 1893), 70.

36. J.-B.-C. *Notions de politesse et de savoir-vivre recueillies par un grand-père pour ses petits-enfants* (Paris: Bloud et Barral, 1882), 107.

37. J.-E. Defranoux, *Le petit livre du devoir, ou école de morale et de savoir-vivre des fils de l'ouvrier, soit de la terre, soit du marteau* (Paris: Humbert, 1862), 35, 53.

38. M. Salva, *Le savoir-vivre pour les jeunes gens* (Paris: Bloud et Barral, 1898), 74.

39. T. Bénard, *Nouveau manuel de civilité chrétienne, contenant un choix d'anecdotes historiques à l'usage des institutions et des maisons religieuses d'éducation* (Paris: Belin, 1851), 51.

40. N. Commandant, *Conseils d'un ancien à un jeune gendarme. Petit recueil des règles élémentaires de politesse, de savoir-vivre et de correspondance...* (Paris: Charles-Lavauzelle, 1928), 29.

41. See N. Elias, *La civilisation des moeurs* (1939; repr., Paris: Calmann-Lévy, Pocket, 1975).

42. M. du Camp, *Mémoires d'un suicidé* (Paris: Girard et Boitte, 1890), 50–56.

43. F. Lefeuvre, *Souvenirs nantais. L'éducation des garçons au temps passé* (Nantes: Forest-Grimaud, 1886), 15–16.

44. L.-L. Vallée, *L'éducation domestique de l'enfant et de l'adulte, ou l'Art de corriger les défauts et les vices et d'exciter les qualités et les vertus* (Paris: Hachette, 1858), 85–88.

45. A. Bidart, *Les parents éducateurs. Conseils pratiques pour assurer aux enfants bonne santé et bon caractère* (Tarbes: Bidart, 1890), 186.

46. J.-C. Caron, *À l'école de la violence. Châtiments et sévices dans l'institution scolaire au XIXᵉ siècle* (Paris: Aubier, 1999), 82ff.

47. Abbé A. Lefebvre, *Pour nos enfants. Entretiens sur l'éducation offerts à tous les parents chrétiens...* (Paris: Amat, 1902), 49, 77–82.

48. Dr. L. O'Followell, *Des punitions chez les enfants* (Avize: Waris-Debret, 1911), 7.

49. See A. Bourzac, *Les bataillons scolaires, 1880–1891. L'éducation militaire à l'école de la République* (Paris: L'Harmattan, 2004), as well J.-F. Chanet, "Pour la patrie, par l'école ou par l'épée? L'école face au tournant nationaliste," *Mil neuf cent* 19 (2001): 127–44, and "La fabrique des héros. Pédagogie républicaine et culte des grands hommes de Sedan à Vichy," *Vingtième siècle. Revue d'histoire* 65 (January–March 2000): 20–21.

50. C. Lhomme, *Code manuel des bataillons scolaires* (Paris: Picard-Bernheim, 1885), 9.

51. *Le Livre universel. Revue populaire illustrée...* (second semester 1883), vol. 1, 7:3.

52. Augustin Garçon, *L'éducation militaire à l'école* (Paris: Charles-Lavauzelle, 1886), 13.

53. C. About, "L'éducation militaire à l'école," in Lhomme, *Code manuel des bataillons scolaires*, ix–xi.

54. Cited by P. Arnaud, "Le geste et la parole. Mobilisation conscriptive et célébration de la République. Lyon, 1879–1889," *Mots* 29, no. 1 (1991): 11.

55. See G. L. Mosse, *The Image of Man: The Creation of Modern Masculinity* (New York: Oxford University Press, 1998); and, for France, P. Arnaud, ed., *Les athlètes de la République. Gymnastique, sport et idéologie républicaine, 1870–1914* (Toulouse: Privat, 1987); and Arnaud, *Le militaire, l'écolier, le gymnaste. Naissance de l'éducation physique en France, 1869–1889* (Lyon: Presses Universitaires de Lyon, 1991).

56. C. Pilat and A. Gosselet, *Catéchisme d'hygiène à l'usage des enfants* (Lille: Lefebvre-Ducrocq, 1850), 17.

57. J.-B. Fonssagrives, *L'éducation physique des garçons, ou Avis aux familles et aux instituteurs sur l'art de diriger leur santé et leur développement* (Paris: Delagrave, 1870), passim, esp. 56, 61, 64, and 76.

58. P.-M. Le Guénec, *Manuel de gymnastique théorique et pédagogique comprenant la gymnastique sans appareils et avec appareils, les exercices militaires, la natation, le bâton, la boxe, l'escrime à l'épée, etc.* (Paris: Delalain, 1886), xiv.

59. *Les jeux des jeunes garçons représentés en 25 gravures à l'aqua-tinta . . .* (Paris: Lehuby, 1839), 112, 131.

60. C. de Nadaillac and J. Rousseau, *Les jeux de collège* (Paris: Delalain, 1875), v.

61. A. Baudry, *L'escrime pratique au XIXᵉ siècle* (Paris: privately printed, 1893), 5.

62. Vallée, *L'éducation domestique de l'enfant et de l'adulte*, 161. There exist, however, a number of equitation treatises for ladies.

63. J.-B.-C., *Notions de politesse et de savoir-vivre recueillies par un grand-père pour ses petits-enfants*, 101.

64. P.-F. Martin-Dupont, *Mes impressions (1803–1876)* (Paris: Sandoz et Fischbacher, 1878), 217–18, 230. Martin-Dupont was director of the Protestant colony of Sainte-Foy.

65. R. Allier, *Études sur le système pénitentiaire et les sociétés de patronage* (Paris: Marc-Aurel frères, 1842), 237.

66. *Le chansonnier du jeune âge. Chansons et romances choisies avec le plus grand soin. Recueil spécialement destiné à la jeunesse des pensionnats, ateliers, fermes-écoles, colonies agricoles, etc.* (Citeaux: Imprimerie de la colonie de Citeaux, 1876), 17.

67. *Annales d'hygiène publique et de médecine légale*, series 1 (Paris: J.-B. Baillière et Fils, January–April 1832): 220.

68. F. Cantagrel, *Mettray et Ostwald. Études sur ces deux colonies agricoles* (Paris: Librairie de l'école sociétaire, 1842), 21.

69. *Annales du Sénat et du corps législatif*, vol. 7 (Paris: À l'administration du Moniteur universel, 1865), 131.

70. *Bulletin de la Société générale des prisons*, vol. 12 (Paris: Marchal et Billard, May 1888): 628. Hereafter *BSGP*.

71. *BSGP* (May 1884): 291. On Mettray, see esp. É. Pierre, "F.-A. Demetz et la colonie agricole de Mettray entre réformisme 'romantique' et injonctions administratives," *Pedagogia Historica* 38, no. 2–3 (2002): 451–66; J. Bourquin and É. Pierre, "Une visite à Mettray par l'image: l'album de gravures de 1844," *Société et Représentations* 18 (2004): 207–16; and L. Forlivesi, G.-F. Pottier, and S. Chassat, eds., *Éduquer et punir. La colonie agricole pénitentiaire de Mettray (1839–1937)* (Rennes: PUR, 2005).

72. A. Vandelet, *De l'éducation physique rationnelle chez les jeunes détenus* (Paris: Larose, 1896), 12, 20.

73. E. Picard, *Une visite à la colonie agricole et pénitentiaire de La Motte-Beuvron* (Orléans: Puget, 1875), 34.

74. L.-C. Michel, *Colonie de Cîteaux, sa fondation, son développement et ses progrès, son état actuel* (Dijon/Paris: Manière/Bray et Retaux, 1873), 17.

75. *BSGP* (April 1880): 425.

76. P. Bucquet, *Tableau de la situation morale et matérielle en France des jeunes détenus et des jeunes libérés . . .* (Paris: Dupont, 1853), 32.

77. Ligue française pour l'éducation en plein air, *Premier congrès international des écoles de plein air de la Faculté de médecine de Paris (24–28 juin 1922)* (Paris: Maloine et fils, 1925), 92. See A.-M. Châtelet, D. Lerch, and J.-N. Luc, eds., *L'école en plein air. Une expérience pédagogique et architecturale dans l'Europe du XXᵉ siècle* (Paris: Recherches, 2003). Created at the end of the nineteenth century, summer camps bring into play a similar problematic (see L. Downs, *Histoire des colonies de vacances de 1880 à nos jours* [Paris: Perrin, 2009]).

78. M. de La Baume, *Des colonies pénitentiaires agricoles. Mettray, Les Matelles* (Montpellier: Gras, 1859), 9.

79. Vandelet, *De l'éducation physique rationnelle chez les jeunes détenus*, 20.

80. S. Stall, *Ce que tout jeune garçon devrait savoir. Vingt et une causeries dédiées aux garçons et à leurs parents*, 2d ed., "Sexe séries, pureté et vérité" (Paris: Fishbacher, 1910), 79, 129.

81. W. Acton, *Fonctions et désordres des organes de la génération chez l'enfant, le jeune homme, l'adulte et le vieillard, sous le rapport physiologique, social et moral* (Paris: Masson, 1863), 48–49. See T. Laqueur, *Le sexe en solitude. Contribution à l'histoire culturelle de la sexualité* (Paris: Gallimard, 2005); and more generally, A. Corbin, *L'harmonie des plaisirs. Les manières de jouir du siècle des Lumières à l'avènement de la sexologie* (Paris: Perrin, 2007).

82. *Le conservateur de l'enfance et de la jeunesse, ou Principes à suivre dans la manière d'élever les enfants depuis leur naissance jusqu'à l'âge de puberté* (Paris: Delaunay, 1825), 40–41.

83. Dr. Royer, *Manuel des mères de famille, ou Règles et principes à suivre pour l'éducation physique des enfants depuis la naissance jusqu'à l'âge de puberté* (Valenciennes, 1851), 99.

84. Acton, *Fonctions et désordres des organes de la génération chez l'enfant*, 9.

85. F. Gall, *Sur les fonctions du cerveau et sur celles de chacune de ses parties . . .* , vol. 3, *Influence du cerveau sur la forme du crâne . . .* (Paris: Baillière, 1825), 261.

86. Dr. É. Laurent, *La criminalité infantile* (Paris: Maloine, 1906), 60, 68, 72. See also Dr. A. Rodier, *L'alcoholisme chez l'enfant, ses causes et ses effets en pathologie mentale* (Paris: Carré et Naud, 1897).

87. F. Pélofi, "De la précosité et des perversions de l'instinct sexuel chez les enfants," thèse pour le doctorat en médecine (Bordeaux: Imprimerie du Midi/Cassignol, 1897), 45.

88. C. Feré, *Contribution à l'étude de la descendance des invertis* (Évreux: Hérissey, 1898), 7–8.

89. Abbé M. Aubert, *L'ami des écoliers, ou Instructions sur les devoirs des jeunes gens pour sanctifier leurs études avec des traits historiques* (Châtillon-sur-Seine: Cornillac, 1855), 154ff.

90. É. Clément, *Guide des parents pour la santé et l'éducation morale et intellectuelle des enfants* (Sens: Clément, 1871), 107–08.

91. *ABC du Bonheur, recette contre l'ennui. Conseils d'un père à son fils sur le moyen d'être heureux et de conserver la santé, par un Parisien* (Paris/Geneva: Fischbacher/Stapelmohr, 1890), 6, 8. See also P. Barbet, *La préparation du jeune homme au mariage par la chasteté* (Paris: Baillière, 1930).

92. Bidart, *Les parents éducateurs*, 352.

93. *L'entrée dans le monde, ou Conseils à un jeune homme quittant l'école pour choisir un état* (Versailles: Beau Jeune, 1864), 24–25.

94. Dr. H. Fischer, *De l'éducation sexuelle* (Paris: Ollier-Henry, 1903), 4, 27.

95. L. Gravière, "De l'éducation sexuelle," thèse de doctorat en médecine (Paris: Jouve, 1924), 11.

96. L. Baudry de Saunier, *Le mécanisme sexuel (éducation sexuelle)* (Paris: Flammarion, 1930), 9.

97. A. Calmette, *Simple causerie pour l'éducation sexuelle des jeunes garçons de quinze ans* (Paris: Masson, 1920), 8.

98. R. P. Ganay, Dr. Henri Abrand, and Abbé J. Viollet, *Les initiations nécessaires*, 26th ed. (Paris: Association du mariage chrétien/Éditions familiales de France, 1938), 31–32.

99. G. Flaubert, *L'éducation sentimentale. Histoire d'un jeune homme*, vol. 2 (Paris: Lévy, 1870), 330–31.

100. L. Ollé-Laprune, *De la virilité intellectuelle. Discours prononcé à Lyon le 20 mars 1896* (Paris: Belin, 1896), 26.

101. S. Venayre, *La gloire de l'aventure. Genèse d'une mystique moderne, 1850–1940* (Paris: Aubier, 2002), 61–80.

102. T. Mayne-Reid, *En mer. Récit pour les jeunes garçons* (Tours: Mame, 1887).

103. E. Domergue, *Les voyages célèbres, aventures et découvertes des grands explorateurs* (1873), passim, esp. 2.

104. Venayre, *La gloire de l'aventure*, 80.

105. P. du Chaillu. *L'Afrique occidentale. Nouvelles aventures de chasse et de voyage chez les sauvages* (Paris: Lévy, 1875), passim, esp. 188, 192.

106. J.-F. Brunet, "Les jeunes aventuriers de la Floride," *Magasin d'éducation et de recréation* vol. 26, no. 1 (Paris: J. Hetzel, 1890): passim, esp. 27, 370, 389.

107. J. Verne, *Les enfants du capitaine Grant*, vol. 1 (Paris: Hachette, 1930), 128ff, 255.

108. L. du Cauzé, *Au collège. Récit pour les jeunes garçons* (Toulouse: Société des publications morales and religieuses, 1905), passim, esp. 24–25, 35, 151, 220–21.

109. Ibid.

110. M. Rosenthal, *The Character Factory: Baden-Powell and the Origins of the Boy Scout Movement* (London: Cox, 1981), 181. See R. Baden-Powell, *Scouting for Boys* (London: Windsor House, 1908); and Baden-Powell, *Pour devenir un homme* (Neufchatel/Paris:

Delachaux et Niestlé, 1938). See also A. Baubérot, *L'invention d'un scoutisme chrétien. Les éclaireurs unionistes de 1911 à 1921* (Paris: Les Bergers et les Mages, 1997).

111. Cited in C. Bonnamaux, "Le garçon à l'âge ingrat et son éducation par le scoutisme. Exposé fait à l'agape d'octobre de *Coude-à-coude*," supplement, *Coude-à-coude* 59 (Fontainebleau, November 1925): 13.

112. Ibid., 1.

8. THE DUEL AND THE DEFENSE OF VIRILE HONOR

1. *Gazette des tribunaux*, Friday, 26 March 1885, 221.

2. The term *combat singulier*, used throughout this chapter and translated as "individual combat," is another phrase for "duel."—Trans.

3. A. de Vigny, *Journal d'un poète* (Paris: Calmann-Lévy, 1882), 96.

4. F.-R. de Chateaubriand, *Mémoires de ma vie, Mémoires d'outre-tombe* (Paris: Garnier, 1989), 51–54.

5. C.-A. Sainte-Beuve, *Volupté*, vol. 2 (Paris: Renduel, 1834), 2.

6. On this subject, see *Le Réformateur*, 29 and 30 December 1834.

7. P. Haubtmann, ed., *Carnets de P.-J. Proudhon*, vol. 3 (Paris: Marcel Rivière, 1968), 149–56.

8. The church condemns the duel as soon as it appears in the sixteenth century, and most notably during the Council of Trent. For the nineteenth century, the bull *Detestabilem* of Pope Benedict in 1752, then the bull *Ad apostolicate sedis* of Pope Pius IX in 1851, formally renew the interdiction against it. For the reformists, let us cite J. Basnage, *Dissertation historique sur les duels et les ordres de chevalerie* (Amsterdam: Pierre Brunel, 1720), esp. the preface; and P. Gaches, *Essai sur le duel considéré au point de vue historique, religieux et moral* (Strasbourg: Berger-Levrault, 1851).

9. F.-V. Toussaint, *Les moeurs* (1755), 278.

10. Voltaire, *Le siècle de Louis XIV, Oeuvres historiques* (Paris: Gallimard, 1957), 972.

11. J.-J. Rousseau, *Julie ou la Nouvelle Héloïse* (1761); *Eloisa, or A Series of Letters* (Philadelphia: John Longcope, 1796), letter 57, 161 (trans. modified)—Trans.

12. In response to Montesquieu, whom he actually interprets incorrectly, Voltaire asserts that it is precisely at court that the least honor is found, and he cites the regent, the duke d'Orléans, speaking of a certain gentleman: "He was the perfect courtier: he had neither humor nor honor." Voltaire, "Honor," in *Questions sur l'Encyclopédie*, vol. 3 (Geneva: Cramer, 1774), 438.

13. Haubtmann, *Carnets de P.-J. Proudhon*, vol. 3, 149.

14. Ibid., 150.

15. Ibid., 156. On this duel, see also P. Haubtmann, *Pierre-Joseph Proudhon. Sa vie et sa pensée, 1809–1849*, vol. 1 (Paris: Beauchesne, 1982), 970–75.

16. A single example, that of *L'illustre Gaudissart* by Balzac. But the theme is also used pervasively in the theater, notably by E. Labiche in *Le voyage de monsieur Perrichon*.

17. Haubtmann, *Carnets de P.-J. Proudhon*, 151–52.

18. Thus, for example, Vallès plumbed his personal memories—the duel he had in 1856 with the journalist Poupart-Davyl—to describe, in *Le bachelier*, the agony that overtakes Jacques Vingtras before his fight against Legrand, his companion in misery; see J. Vallès, *Le bachelier* (Paris: Livre de Poche, 1985), 356–68.

19. A. Ranc, *Le Matin*, 5 August, 1887. "Field of honor" designates the space of the duel; it can also be applied to the battlefield, as in chapter 10.—Trans.

20. Haubtmann, *Carnets de P.-J. Proudhon*, 155.

21. As presented in the classic work by T. Lacqueur, *Making Sex: Body and Gender from the Greeks to Freud* (Cambridge, MA: Harvard University Press, 1990).

22. P.-J.-G. Cabanis, *Rapports du physique et du moral de l'homme* (Paris: Crapart/Caille et Ravier, 1802; rev. ed., Paris: Béchet jeune, 1824), 224.

23. To wit, the affair that took place in Montrouge in 1816 between two medical students, cited by J.-C. Caron, *Générations romantiques. Les étudiants de Paris et le Quartier latin, 1814–1851* (Paris: Armand Colin, 1990), 183.

24. A. de Vigny, *Servitude et grandeur militaires. Souvenirs de servitude militaire* (Paris: Bonnot, 1972), 212.

25. G. Simmel, *Sociologie. Études sur les formes de la socialisation* (Paris: Presses Universitaires de France, 1999), 528.

26. P. Bourdieu, "Sur le pouvoir symbolique," *Annales*, 3 (May–June 1977): 405–11.

27. National Archives F 7 6693, report by the prefect of l'Oise to the minister of the interior, 17 July 1823.

28. P.-A. Merlin, *Recueil alphabétique des questions de droit qui se présentent le plus fréquemment dans les tribunaux*, 3d ed., vol. 3 (Paris: Garnery et Roret, 1828), 553.

29. *Le Moniteur Universel*, 14 March 1829, 553.

30. As emphasized by Simmel, *Sociologie*, 528.

31. Cited by E. Cauchy, *Du duel considéré dans ses origines et dans l'état actuel des moeurs* (Paris: Charles Hingray, 1846), 328.

32. C. de Rémusat, *Mémoires de ma vie*, vol. 4 (Paris: Plon, 1958–1967), 12.

33. Vigny, *Journal d'un poète*, 94, 86.

34. As in the case of the young merchant's assistant denied a religious sepulcher by the archbishop of Bordeaux in 1819 for having obstinately refused the presence of a priest after being shot during a duel with another assistant. This example is elaborated in F. Guillet, *La mort en face. Histoire du duel de la Révolution à nos jours* (Paris: Aubier, 2008), 326.

35. J. Michelet, *L'étudiant* (Paris: Calmann-Lévy, 1885), 121–22.

36. This attachment to freedom is emphasized by J.-B. Duroselle, *Clemenceau* (Paris: Fayard, 1990), 190.

37. On this subject, see the works of A. Crépin, esp. *La conscription en débat ou le triple apprentissage de la nation, de la citoyenneté, de la République, 1798–1889* (Arras: Artois presses université, 1998).

38. Cited by J. Thibault, *L'influence du mouvement sportif sur l'évolution physique dans l'enseignement secondaire français* (Paris: Vrin, 2002), 70.

39. O. Weininger, *Sex and Character*, trans. Ladislau Löb (1903; repr., Charleston, SC: Bibliolife, 2009). Cited by C. Bard and N. Pellegrin, introduction to "Femmes traves-ties: un 'mauvais' genre," *Clio, histoire, femmes et société* 10 (1999): 3.

40. P.-A. Grouvelle, *Adresse des habitants du ci-devant bailliage de . . . à M. de ***, leur député à l'Assemblée nationale. Sur son duel et sur le préjugé du point d'honneur* (Paris: Desenne, 1790), 14.

41. M. Ozouf has explained the importance of this concept in "Régénération," F. Furet and M. Ozouf, *Dictionnaire critique de la Révolution française* [1989], vol. 1, *Idées* (Paris: Flammarion, 1992), 373–89.

42. We are following here the analysis by A. de Baecque, *Le corps de l'histoire. Métaphores et politique (1770–1800)* (Paris: Calmann-Lévy, 1993).

43. Grouvelle, *Adresse des habitants du ci-devant bailliage de . . .*, 15.

44. G. Tarde, "Le duel," in *Études pénales et sociales* (Paris: Masson, 1892), 61–62.

45. For example, E. Blaze, *Souvenirs d'un officier de la Grande Armée. La vie militaire sous le Premier Empire* (Paris: Fayard, 1906).

46. Numerous works have been devoted to this subject. Among the most recent: O. Huf-ton, *Women and the Limits of Citizenship in the French Revolution* (Toronto: University of Toronto Press, 1992); A. Verjus, *Le cens de la famille. Les femmes et le vote, 1789–1848* (Paris: Belin, 2002); and L. E. Talamante, *Les Marseillaises: Women and Political Change During the French Revolution* (Berkeley: University of California Press, 2003).

47. As demonstrated by Lacquer, *Making Sex*, 216.

48. As shown by J. B. Landes, *Women and the Public Sphere in the Age of the French Revolution* (Ithaca: Cornell University Press, 1988); and L. Hunt, "L'axe féminin/masculin dans le discours révolutionnaire," in *La Révolution française et les processus de socialisation de l'homme moderne. Actes du colloque international de Rouen (13–15 October 1988, IRED/Université de Rouen)*, ed. C. Mazauric (Paris: Messidor, 1989), 17–51.

49. The "marshals' court," also known as the *point d'honneur* court, was specifically charged with regulating offenses arising from duels.—Trans.

50. J.-L. Vergnaud, "Les sourires de la raison ou l'honneur en clair-obscur: Le tribunal des maréchaux de France au siècle des Lumières," in *Du sentiment de l'honneur à la Légion d'honneur*, ed. X. Boniface, colloque de Boulogne-sur-Mer, 17–18 May 2004, *La Phalère, revue européenne d'histoire des ordres et décorations* 5 (2004): 29–30. See also on this subject Landes, *Women and the Public Sphere*, 17–38.

51. J.-B. Sirey, *Recueil général des lois et des arrêts* (Paris: Sirey, 1868). Cited by N. Arnaud-Duc, "Les contradictions du droit," in *Histoire des femmes en Occident*, vol. 4, *Le XIX^e siècle*, ed. G. Fraisse and M. Perrot (Paris: Perrin, 2002), 122.

52. I have elaborated such cases in Guillet, *La mort en face*, 330–32.

53. In particular, the work of F. Héritier, *Masculin/féminin*, vol. 1, *La pensée de la différence* (Paris: Odile-Jacob, 1996), 15; as well as that of J. S. Goldstein, *War and Gender: How Gender Shapes the War System and Vice-Versa* (Cambridge: Cambridge University Press, 2001).

54. *Correspondance de George Sand*, texts collected, classified, and annotated by G. Lubin, vol. 3 (Paris: Garnier, 1967), letter 131 to Adolphe Guéroult, 9 November 1835, 116, 1013.

55. As emphasized by M. Perrot, "Drames et conflits familiaux," in *Histoire de la vie privée*, vol. 4, *De la Révolution à la Grande Guerre*, ed. P. Ariès and G. Duby (Paris: Seuil, 1987), 266.

56. On this topic, see the remarks of Hunt ("L'axe féminin/masculin dans le discours révolutionnaire," 17–51) and Perrot ("Drames et conflits familiaux," 93–103).

57. L. Jeudon, *Le monde de l'honneur* (Paris: Félix Alcan, 1911), 124.

58. A. Valette, "Rapport sur le duel," *Revue critique de legislation et de jurisprudence* 4 (1857): 427.

59. A. Signol, *Apologie du duel ou Quelques mots sur le nouveau projet de loi* (Paris: Chaumerot, 1829), 22.

60. C. Habib, *Galanterie française* (Paris: Gallimard, 2006).

61. "Affaire Sirey," in *Histoire des femmes*, vol. 4, ed. G. Fraisse and M. Perrot, 109.

62. National Archives BB18 1054, report by the prosecutor from the royal court of Agen to the minister of justice, 1819.

63. Ibid., report by the prosecutor from the royal court of Nancy to the minister of justice, 1819.

64. Archives of the Paris police department, catalogue Q 86, registry 21, 16 November 1903.

65. Such is the case with the affair that pits in 1873 Constantin Souzo, Greek officer in the French army, against Rumanian Nicolas Ghika, over the wife of the former. The duel that ensues will end in Ghika's death and Souzo's sentence to four years in prison. The affair is recounted, in particular in the work by Baron de Vaux, *Les duels célèbres* (Paris: É. Rouveyre et G. Blond, 1884), 122–30.

66. See the survey ordered in 1819 by Minister de Serre from the royal prosecutors in preparation for the bill of 1819 on the suppression of the duel, conserved in the National Archives, and the one conducted by É. Dujardin in the newspapers under the pseudonym of Ferréus, *Annuaire du duel* (Paris: Perrin, 1891).

67. *Le Moniteur Universel*, 14 March 1829. Intervention by the duc de Raguse: 334.

68. Dr. L. Véron, *Mémoires d'un bourgeois de Paris*, vol. 5 (Paris: Gabrile de Gonet, 1856), 319. Cited by M. Agulhon, *Le cercle dans la France bourgeoise* (Paris: Colin, 1977), from whom we borrow this analysis.

69. Writer during the French Revolution with strong anti-monarchist beliefs—Trans.

70. *Archives parlementaires de 1787 à 1860*, vol. 20 (Paris: Dupont, 1878), 420.

71. On this topic, see the analysis by J. B. Freeman, *Affairs of Honor: National Politics in the New Republic* (New Haven: Yale University Press, 2001), 159–98.

72. G. Palante, "L'embourgeoisement du sentiment de l'honneur," *La Plume* 317 (1 July 1902): 777.

73. J.-N. Jeanneney, *Le duel. Une passion française, 1789–1914* (Paris: Seuil, 2004), 148. I wish to stress here my indebtedness to this work.

74. M.-É. Thérenty, *Mosaïques. Être écrivain entre presse et roman* (Paris: Champion, 2003), 192–93.

75. As shown by C. Deporte, *Les journalistes en France, 1880–1950* (Paris: Seuil, 1999), 53–54.

76. G. Mihaely, "L'émergence du modèle militaro-viril. Pratiques et représentations masculines en France au XIX^e siècle" (doctoral thesis directed by C. Prochasson, École des Hautes Études en Sciences Sociales, 2004).

77. N. Hamson, "The French Revolution and the Nationalisation of Honor," in M. R. D. Foot, *War and Society* (London: Elek, 1973), 207; also G. Best, *War and Society in Revolutionary Europe, 1770–1870* (Leicester: Leicester University Press/Fontana, 1982).

78. On this topic, see J.-P. Bertaud, "Napoléon's Officers," *Past and Present* 112 (August 1986): 91–111.

79. "There can be no soldier without honor; the soldier who has none would be nothing more than a privileged brigand," declares A. Desbordeliers, author of *Morale militaire* (Paris: Dumaine, 1844), 98.

80. On this topic, see N. Petiteau, *Lendemain d'Empire. Les soldats de Napoléon dans la France du XIX^e siècle* (Sèvres: Boutique de l'histoire, 2003).

81. National Archives BB18 1054, report by the prosecutor of the royal court of Nancy to the minister of justice, 1819.

82. Petiteau, *Lendemain d'Empire*, 150.

83. F. Dupetit-Méré and J.-B. Dubois, *Fanfan le Tulipe ou En avant! Pièce en un acte mêlée de vaudevilles*, Théâtre de la Gaîté, 1 August 1820 (Paris: Quoy, 1820). Cited by Mihaely, "L'émergence du modèle militaro-viril," 152–53.

84. Such is the thesis of S. Maza, *The Myth of the French Bourgeoisie: An Essay on the Social Imaginary, 1750–1850* (Cambridge, MA: Harvard University Press, 2003). Also, "Construire et déconstruire la bourgeoisie: discours politique et imaginaire social au début du XIX^e siècle," *Revue d'histoire du XIX^e siècle* 34, no. 1 (2007): 21–37.

85. National Archives, F7 6867, dossier 5055.

86. We are following here the analyses by Milhaely, "L'émergence du modèle militaro-viril," passim.

87. Service Historique de l'Armée de Terre [SHAT] I M 2036. Cited by A. Crépin, "Les 'Lumières dans le camp.' De l'honneur à la vertu citoyenne, de la civilisation à la régénération," in Boniface, *Du sentiment de l'honneur*, 97.

88. A. Crépin and O. Roynette, "Jeunes hommes, jeunesse et service militaire au XIX^e siècle," in *Jeunesse oblige. Histoire des jeunes en France, XIX^e–XXI^e siècle*, ed. L. Bantigny and I. Jablonka (Paris: Presses Universitaires de France, 2009), 74–75.

89. Phrase patterned on *noblesse oblige*, nobility has its moral obligations—hence, youth has its moral obligations.—Trans.

90. J.-J. Rousseau, *Émile, ou De l'éducation* (Paris: Flammarion, "GF," 1966), esp. 285–86.

91. As emphasized by J.-C. Caron, "La jeunesse dans la France des notables. Sur la construction politique d'une catégorie sociale (1815–1870)," in Bantigny and Jablonka, *Jeunesse oblige*, 21–35.

92. A. de Musset, *La confession d'un enfant du siècle* (1836; repr., Paris: Livre de Poche, 2003), 65.

93. On this topic, see the recollections of A. Blanqui, "Souvenirs d'un lycéen de 1814," *Revue de Paris* 134 (1 May 1916): 97–118.

94. A. B. Spitzer, *The French Generation of 1820* (Princeton: Princeton University Press, 1987).

95. Symbolized by the work of J. Fazy, *De la génération, ou Abus de la sagesse des vieillards dans le gouvernement de la France* (Paris: Delaforest, 1828).

96. On this topic, see A.-C. Thibaudeau, *Biographie. Mémoires avant ma nomination à la Convention, 1765–1792* (Paris: Champion, 1875), 61–62.

97. A.-M. Sohn gives numerous examples of this in her work *"Sois un homme!" La construction de la masculinité au XIXᵉ siècle* (Paris: Seuil, 2009).

98. A. Corbin, "L'agitation dans les théâtres de province sous la Révolution," *Le temps, le désir et l'horreur* (Paris: Flammarion, 1998), 53–79.

99. E. Scribe and H. Dupin, *Le combat des montagnes ou la Folie-Beaujon. Folie vaudeville en un acte*, Théâtre de Variétés, 12 July 1817.

100. On all of these aspects, see Mihaely, "L'émergence du modèle militaro-viril," 274–76.

101. R. Duplantier, "Les duels à Poitiers et dans la Vienne au cours de la première moitié du XIXᵉ siècle," *Bulletin de la Société des antiquaires de l'Ouest* (first trimester 1950): 276.

102. National Archives F7 6860 A, Bulletin de la préfecture de police de Paris, 13 August 1819.

103. *Gazette des tribunaux*, 16 June 1840, 785.

104. National Archives BB18 1054, report by the prosecutor at the royal court of Grenoble to the minister of justice, 1819.

105. As emphasized by B. Desmars, "La violence et les rôles sociaux. Les acteurs de l'affrontement dans la société rurale de la première moitié du XIXᵉ siècle," in *Les violences rurales au quotidien, Actes du 21e congrès de l'Association des ruralistes français*, ed. F. Chauvaud and J.-L. Mayaud (Sèvres: Boutique de l'histoire, 2005), 155–56. See also F. Ploux, "L'homicide en France," in *Histoire de l'homicide en Europe. De la fin du Moyen Âge à nos jours*, ed. L. Mucchielli and P. Spierenburg (Paris: L. Martinet, 1850), 83–96.

106. F. Ploux, *Guerres paysannes en Quercy. Violences, conciliations et répression pénale dans les campagnes du Lot (1810–1860)* (Sèvres: Boutique de l'histoire, 2002), 160–62, 176–79.

107. This is the opinion, for example, of Dr. A. Brierre de Boismont in his work *De l'ennui* (Paris: L. Martinet, 1850).

108. Stendhal, *Le rouge et le noir* (Paris: Gallimard, "Folio," 2000), 421.

109. Vallès, *Le bachelier*, 158.

110. A theme that can be found, in particular, in Balzac's work, especially *La rabouilleuse* or *Le père Goriot*.

111. Vallès, *Le bachelier*, 353–74.

112. P. Larousse, *Grand Dictionnaire du XIXᵉ siècle*, vol. 6 (Paris: Larousse, 1866–1876; rev. ed. Geneva/Paris: Slatkine, 1982), 1347.

113. A. Goujon, *Manuel de l'homme de bon ton, ou Cérémonial de la bonne société* (Paris: Parmantier et Audin, 1821), 141–42.

114. *Duel suivi de mort entre M. Rosemond de Beauvallon et M. Dujarrier. Accusation d'homicide volontaire* (Paris: Moquet, 1846).

115. F. Billacois, *Le duel dans la société française des XVI–XVII siècles* (Paris: École des Hautes Études en Sciences Sociales, 1986), 208–09.

116. As emphasized by F. Rouvillois, *Histoire de la politesse. De 1789 à nos jours* (Paris: Flammarion, 2006), 52.

117. On this topic, see my remarks in Guillet, *La mort en face*, 214–24.

118. National Archives F7 3874, Bulletin de la préfecture de police de Paris, 23 June 1819.

119. On this topic, see the remarks of J. McCormick, *Popular Theatres in Nineteenth Century France* (New York: Routledge, 1993), 79.

120. G. Mihaely, "Un poil de différence: masculinités dans le monde du travail, 1870–1900," in *Hommes et masculinités de 1789 à nos jours. Contributions à l'histoire du genre et de la sexualité en France*, ed. R. Revenin (Paris: Autrement, 2007), 128–45.

121. As emphasized by P. Bourdieu, *La domination masculine* (Paris: Seuil, 1998), 57.

122. A. Farge, *Vivre dans la rue à Paris au XVIIIᵉ siècle* (Paris: Gallimard, 1979), 100.

123. N. Castan, *Justice et repression en Languedoc à l'époque des Lumières* (Paris: Flammarion, 1980), 57.

124. J.-F. Simon, "Les armes de la violence paysanne. Faux et penn-baz: usages anciens et représentations contemporaines," in *Violence et société en Bretagne et dans les pays celtiques, colloque international de Brest, 18–20 March 1999*, ed. J.-Y. Carluer (Brest, Centre de recherche bretonne et celtique/Université de Bretagne occidentale, 2000), 151–52. The *penn-baz* is a three-foot long club, one end of which is rounded so as to be used as a bludgeon; a traditional weapon among Breton peasants—Trans.

125. As noted by Ploux, "L'homicide en France," 86.

126. Farge, *Vivre dans la rue à Paris au XVIIIᵉ siècle*, 102.

127. G. Lavalley, *Les duellistes de Caen de l'an IV à 1848 et le bretteur Alexis Dumesnil* (Caen: Louis Jouan, 1914), 13.

128. A. Perdiguier, *Mémoires d'un compagnon* (Paris: Imprimerie nationale, 1992), 200.

129. Ploux, *Guerres paysannes en Quercy*, 88.

130. Castan, *Justice et repression en Languedoc à l'époque des Lumières*, 57.

131. Departmental archives, Moselle, 3 U 25, 27 September 1836.

132. Perdiguier, *Mémoires d'un compagnon*, 368–70.

133. M. Nadaud, *Mémoires de Léonard, ancien garçon maçon* (Saint-Paul: Lucien Souny, 1998), 137.

134. A. Dumas, *Filles, lovettes et courtisanes* (Paris: Flammarion, 2000), 32–37.

135. Paris archives, circuit court of la Seine, charge sheet against Joseph Gastin, 23 January 1880.

136. As emphasized by J. Pitt-Rivers, *Anthropologie de l'honneur. La mésaventure de Sichem* (Paris: Sycomore, 1977), 24.

137. In the Penal Code of 1810, article 375 finds to be criminal those insults and offensive expressions "that would contain the accusation of no precise fact, but only that of a defined vice." Punishments differed according to whether the offenses were committed in a public or private place. These arrangements were abrogated under the Restoration. The insult is more precisely defined in the law of 29 July 1881, which distinguishes it from defamation. See Rouvillois, *Histoire de la politesse*, 240.

138. Pitt-Rivers, *Anthropologie de l'honneur*, 32.

139. As analyzed by Ploux, *Guerres paysannes en Quercy*, 64–65.

140. Comte de Chatauvillard, *Essai sur le duel* (Paris: Bohaire, 1836), 9–12.

141. The act of aiming for the head has a long tradition. The list of wounds caused by sword thrusts shows, in the countryside of Picardie during the sixteenth century, a clear preponderance of wounds to the head, according to I. Paresys, *Aux marges du royaume. Violence, justice et société en Picardie sous François Ier* (Paris: Publications de la Sorbonne, 1998).

142. *Criminal trial of Lemaire, on the basis of his duel with Huet, or Complete collection of arguments of the circuit court of the département du Nord, convened at Douai, during his two hearings on 25 November 1828, recorded by M. Aimé Paris, stenographer* (Lille: Bronner-Bauwens, 1829), 25.

143. Vigny, *Servitude et grandeur militaires*, 211.

144. These remarks should be compared with those of P. Bourdieu with regard to Kabyle society in "Le sens de l'honneur," in *Esquisse d'une théorie de la pratique* (Paris: Seuil, 2000), 24–26.

145. Cited by C. Vidallet, "Le duel dans la société civile française à la fin du XIXe siècle (1880–1899)" (master's thesis directed by C. Charle, Université de Paris I, 2003), 18–24.

146. P. Maine de Biran, *Journal*, vol. 1 (Neufchâtel: La Baconnière, 1954–1957), 160; A. de Tocqueville, *De la démocratie en Amérique*, vol. 2 (Paris: Gallimard, 1951), 146–47.

147. G. Simmel, *Philosophie de la modernité* (Paris: Payot, 2004), 175.

148. R. Sennett, *Les tyrannies de l'intimité* (Paris: Seuil, 1979), 128.

149. R. B. Shoemaker, "The Taming of the Duel: Masculinity, Honour and Ritual Violence in London, 1600–1800," *Historical Journal* 45 (September 2002): 525–45.

150. This is shown by Rouvillois in his *Histoire de la politesse*.

151. Ibid., 253.

152. A. Croabbon, *La science du point d'honneur, commentaire raisonné sur l'offense. Le duel, ses usages et sa législation en Europe, la responsabilité civile, pénale, religieuse des adversaires et des témoins, avec des pièces justificatives* (Paris: Librairie-imprimeries réunies, 1894), 10.

153. *Gazette des tribunaux*, 2 June 1842, 908.

154. National Archives BB18 1054, report by the general prosecutor for the royal court of Caen to the minister of justice, 24 August 1819.

155. Dr. J.-B. Descuret, *La médecine des passions, ou les Passions considérées dans leurs rapports avec les maladies, les lois et la religion* (Paris: Béchet et Labé, 1841), 706–07.

156. The bibliography is quite ample on this subject, which has been studied a great deal by historians, in particular by É. Claverie, "'L'honneur': une société de défis au XIXe siècle," *Annale ESC* 4 (July–August 1979): 744–59; and Claverie, "De la difficulté de faire un citoyen: les 'acquittements scandaleux' du jury dans la France provincial du début du XIXe siècle," *études rurales* 95–96 (July–Dec. 1984): 143–66. The subject is also taken up by Ploux, *Guerres paysannes en Quercy*, passim.

157. Paris archives, circuit court of la Seine, charge sheet against Joseph Gastin, 23 January 1880.

158. To be precise, not until the arrest of La Vergne on 11 January 1856. See É. Garçon, *Code penal annoté*, vol. 2 (Paris: Sirey, 1956), 18.

159. National Archives, BB20 95, dossier 2, circuit court of Calvados, 2d trimester 1838, hearing of 21 May 1838. See also Lavalley, *Les duellistes de Caen de l'an IV à 1848 et le bretteur Alexis Dumesnil*, 109.

160. This law remained famous in that it grapples with abortion.

161. A. E. Simpson, "Dandelions on the Field of Honor: Dueling, the Middle Classes and the Law in Nineteenth-Century England," *Criminal Justice History* 9 (1988): 123.

162. National Archives, BB18 1054, report of the general prosecutor of the court of Nancy to the minister of justice, 1819.

163. National Archives, BB20 96, royal court of Grenoble, département of la Drôme, 1st trimester 1838, hearing of 28 February 1838.

164. *Gazette des tribunaux*, 18 May 1834.

165. National Archives, BB20 97, circuit court of la Meuse, 3d trimester 1838, hearing of 5 July 1838.

166. Cited by Claverie, "De la difficulté de faire un citoyen," 156.

9. THE NECESSARY MANIFESTATION OF SEXUAL ENERGY

1. Mathilde Larrère, "La garde nationale de Paris sous la monarchie de Juillet" (thesis, Université de Paris I, 2000), 455–57.

2. On this topic, see the essential book by Marie-Véronique Gauthier, *Chanson, sociabilité et grivoiserie au XIXe siècle* (Paris: Aubier, 1992).

3. Alfred Delvau, *Dictionnaire érotique moderne* (Paris, 1864; rev. ed. Paris: 10/18, 1997).

4. Cf. chap. 7.

5. Delvau, *Dictionnaire érotique moderne*, 267. The following short citations are taken from this work.

6. Cf. Agnès Walch, *La spiritualité conjugale dans le catholicisme français, XVIe–XIXe siècle* (Paris: Cerf, 2002).

7. Delvau, *Dictionnaire érotique moderne*, 408.

8. Cf. Antoine de Baeque, *Le corps de l'histoire. Métaphores et politique, 1770–1800* (Paris: Calmann-Lévy, 1993); regarding the figure of Hercules at the dawn of the Revolution, cf. the excellent article by Lynn Hunt, "Hercules and the Radical Image of the French Revolution," *Representations* 2 (1983): 95–117.

9. Gauthier, *Chanson, sociabilité et grivoiserie au XIXe siècle*, 236.

10. Delvau, *Dictionnaire érotique moderne*, 267. The following short citations are taken from this work.

11. Cf. Michel Delon, *Le savoir-vivre libertin* (Paris: Hachette, 2000), passim.

12. Alain Corbin, *L'harmonie des plaisirs. Les manières de jouir du siècle des Lumières à l'avènement de la sexologie* (Paris: Perrin, 2007).

13. Delvau, *Dictionnaire érotique moderne*, 422.

14. Corbin, *L'harmonie des plaisirs*, passim.

15. Ibid.; and Dr. Ch. Montalban, *La petite bible des jeunes époux*, rev. ed. (Grenoble: Millon, 2009).

16. Corbin, *L'harmonie des plaisirs*, 434–38.

17. Delvau, *Dictionnaire érotique moderne*, 456, 484, 100.

18. Ibid., 137.

19. On these metaphors, cf. Corbin, *L'harmonie des plaisirs*, 384–86.

20. Cf. Gérard de Puymège, *Chauvin, le soldat-laboureur. Contribution à l'étude des nationalismes* (Paris: Gallimard, "Bibliothèque des histoires," 1993), passim.

21. The preceding set of formulas is taken from Delvau's *Dictionnaire*, but they will often be found in the sources brought up in this chapter as a whole.

22. On this topic, see Georges Vigarello, *Histoire du viol, XVI–XXe siècle* (Paris: Seuil, "L'Univers historique," 1998).

23. Significant in this respect is the comparison between methods of performing and the man's artisanal profession; this is particularly evident in the collection *Art de foutre en quarante manières* [Art of fucking in forty positions] (1833; rev. ed., presented by Michel Delon, Paris: Fayard, 2005).

24. References to numerous works, since the publication of Mario Praz's *The Romantic Agony* (New York: Meridian, 1956), that treat this new writing on desire can be found in Corbin, *L'harmonie des plaisirs*, 442–47.

25. Cf. Pierre Laforgue, *L'Éros romantique. Représentations de l'amour en 1830* (Paris: Presses Universitaires de France, 1998).

26. Pierre Larousse, *Dictionnaire universel du XIXe siècle*, cited in Alain Corbin, ed., *Histoire du corps*, vol. 2, *De la Révolution à la Grande Guerre* (Paris: Seuil, 2005), 160.

27. Delvau, *Dictionnaire érotique moderne*, 104, 197.

28. Ibid., 231.

29. Already highlighted in the erotic literature of the eighteenth century; cf. Delon, 109.

30. Stendhal, Journal, 2 September 1811, in *Oeuvres intimes* (Paris: Gallimard, "Bibliothèque de la Pléiade," 1981), 1:726–27.

31. As with all correspondence; cf. Roger Chartier, ed., *La correspondance. Les usages de la lettre au XIXe siècle* (Paris: Fayard, "Nouvelles études historiques," 1991).

32. Cf. Jean Borie, *Le tyran timide. Le naturalisme de la femme au XIXe siècle* (Paris: Klincksieck, 1973).

33. Prosper Mérimée, 3 June 1829 and 24 December 1833, in *Correspondance générale*, M. Parturier, P. Josserand, and J. Mallion, 2 vols. (Paris: Le Divan, 1941–1942), vol. 1: *1822–1835* (emphasis added).

34. Gustave Flaubert to Louise Colet, 29 November 1853, in Flaubert, *Correspondance* (Paris: Gallimard, "Bibliothèque de la Pléiade," 1980), 2 vols., vol. 2, 471. Subsequent references to Flaubert's correspondence will be to this edition.

35. Flaubert to Louise Colet, 27 March 1853, in Flaubert, *Correspondance*, 2:285.

36. Stendhal, *De l'amour* [1822], ed. V. del Litto (Paris: Gallimard, "Folio," 1980), 149.

37. For example, Flaubert to Alfred Le Poittevin, 17 June 1845, in Flaubert, *Correspondance*, 1:241.

38. Edmond and Jules Goncourt, *Journal. Mémoires de la vie littéraire*, vol. 1, *1851–1861* (Paris: Charpentier, 1887), 240.

39. Prosper Mérimée to Stendhal (late October 1832), in Stendhal, *Correspondance* (Paris: Gallimard, "Bibliothèque de la Pléiade," 1962, 1967, 1968), 3 vols., 3:529; Mérimée, *Correspondance générale*, 1:246.

40. Alfred Le Poittevin, letter cited in Flaubert, *Correspondance*, 1:832.

41. Mérimée to Édouard Grasset, 20 October 1832, in Mérimée, *Correspondance*, 1.

42. Théophile Gautier to Eugène Piot, in Gautier, *Correspondance générale* (Geneva: Droz, 1985), 1:73.

43. Mérimée to édouard Grasset, Mérimée, *Correspondance*, 1:316.

44. For example, Stendhal, Journal, 2 March 1806, in *Oeuvres intimes*, 393.

45. Cited by Frank Lestringant, *Alfred de Musset* (Paris: Flammarion, "Grandes biographies," 1998), 746n6.

46. Stendhal, "Souvenirs d'égoisme," *Oeuvres intimes*, 2:455.

47. Mérimée, *Correspondance*, 1:215.

48. Stendhal, Journal, in *Oeuvres intimes*, 1:20–21.

49. Maxime du Camp to Gustave Flaubert, end of August–beginning of September 1851, in Flaubert, *Correspondance*, 2:860.

50. Flaubert to Louis Bouilhet, 8 December 1853, in Flaubert, *Correspondance*, 2:475.

51. Gautier to Eugène de Nully, in Gautier, *Correspondance*, 1:58.

52. Mérimée to Édouard Grasset, 26 October 1831, in Mérimée, *Correspondance*, 1.

53. Alfred Le Poittevin to Gustave Flaubert, 28 March 1843, in Flaubert, *Correspondance*, 1:832; but Poittevin adds, "What a farce!"

54. Charles Fromentin to Eugène Fromentin, 4 January 1842, in *Correspondance d'Eugène Fromentin*, vol. 1, *1838–1858*, ed. Barbara Wright (Paris: CNRS Éditions, 1997).

55. Flaubert to Louis Bouilhet, 20 August 1850, in Flaubert, *Correspondance*, 1:664.

56. Flaubert to Louis Bouilhet, 13 March 1850, in Flaubert, *Correspondance*, 1:606.

57. Mérimée, *Correspondance*, 14 September 1831, 1:122.

58. Prosper Mérimée to Stendhal, 25–28 May 1832, in Stendhal, *Correspondance*, 4.

59. Gautier to Julien Turgan, in Gautier, *Correspondance*, 7:168–69.

60. Goncourt, 22 July 1856, *Journal*, 1:138.

61. Mérimée to Esprit Requiem, 19 June 1835, Mérimée, *Correspondance*, 1:431.

62. Letter from Prosper Mérimée to Stendhal, late October 1832, in Stendhal, *Correspondance*, 4:529.

63. Flaubert to Louis Bouilhet, 19 December 1850, in Flaubert, *Correspondance*, 1:729. On the other hand, Gustave finds "Greek and Armenian whores" acceptable.

64. For what follows, see Lestringant, *Alfred de Musset*, passim.

65. Cited in ibid., 102.

66. Set of perceivable elements as a whole upon reading his correspondence, notably Flaubert to Louise Colet, 1 June 1853, in Flaubert, *Correspondance*, 2:340.

67. Stendhal highlights, in this regard, the case of Romain Derrien, 28 March 1805, in *Oeuvres intimes*, 1:1009–10.

68. Krafft-Ebing, *Psychopathia Sexualis* (repr. New York: Arcade, 2011).

69. Émile Zola, *Pot-Bouille* (Paris: Charpentier, 1883).

70. Cf. Alain Corbin, "La mauvaise éducation de la prostituée au XIXᵉ siècle," in *Le temps, le désir et l'horreur . . .* (Paris: Auber, 1991), 107–15.

71. Corbin, *L'harmonie des plaisirs*, 350ff.

72. For example, Flaubert is seen to be preoccupied about the addresses and prices during his trip to Egypt; cf. Pierre-Marc de Biasi, introduction to Gustave Flaubert, *Voyage en Égypte* (Paris: Grasset, 1991), 73; and for what follows, Gautier, *Correspondance*, 1:58.

73. Cf. Claude Pichois and Michel Brix, *Gérard de Nerval* (Paris: Fayard, 1995), 113.

74. Musset, *Correspondance*, (Paris: Mercure de France, 1807), letter 35–22, 163; letter to Stendhal, 30 April 1835, cited by Lestringant, *Alfred de Musset*, 307.

75. Letter from Prosper Mérimée to Stendhal, April 1835, in Stendhal, *Correspondance*, 5:30.

76. Ibid.

77. Mérimée to A. H. Royer-Collard, 3 July 1836, Mérimée, *Correspondance générale*, op. cit., vol. 2 (1836–1840), 46.

78. Mérimée, *Correspondance générale*, 1:429.

79. Mérimée to A. H. Royer-Collard, in Mérimée, *Correspondance générale*, 1:338, 2:45.

80. Gautier, *Correspondance*, 4:250.

81. Flaubert to Camille Rosier, 11 March 1851, in Flaubert, *Correspondance*, 1:760, 761.

82. Stendhal, *Oeuvres intimes*, 1:383, 387.

83. Stendhal, "Souvenirs d'égotisme," 2:444–45.

84. Flaubert, cited in de Biasi, introduction, 25.

85. Ibid., 31.

86. Flaubert to Louis Bouilhet, 14 November 1850, in Flaubert, *Correspondance*, 1:290.

87. Gautier, *Correspondance*, 4:246–47.

88. Jean Bormerot, ed., *Correspondance générale de Sainte-Beuve* (Paris: Stock, 1935), 1:281–82.

89. Flaubert to Louise Colet, 24 April 1852, in Flaubert, *Correspondance*, 1:707.

90. Napoleon Bonaparte, *Correspondance générale*, vol. 1, *Les apprentissages, 1784–1797*, ed. Thierry Lentz (Paris: Fayard, 2004), caresses cited in the letters of 7 April 1796 (327), 24 April 1796 (359–60), 23 May 1796 (414), and 15 June 1796 (451–52).

91. Ibid., 228.

92. Vigny to Marie Dorval, 7 January 1833, in *Correspondance d'Alfred de Vigny*, ed. Madeleine Ambrière (Paris: Presses Universitaires de France, 1989), 7 vols., vol. 2. Marie Dorval will keep the letter, like a talisman, under her pillow.

93. Simone Delattre, "Un amour en coulisses" (master's thesis, Université de Paris I, 1991).

94. Flaubert to Louise Colet, 9 August 1846, in Flaubert, *Correspondance*, 1:290.

95. Flaubert to Louise Colet, 15 August 1846, in Flaubert, *Correspondance*, 1:301.

96. Flaubert to Louise Colet, 23 August 1846, in Flaubert, *Correspondance*, 1:309.

97. Paula Cossart, ed., *Vingt-cinq ans d'amours adultères. Correspondance sentimentale d'Adèle Schunck et d'Aimé Goyet de Fernex (1824–1849)* (Paris: Fayard, 2005), 344.

98. Ibid., letters of 12 September 1826, 16 September 1826, and 13 September 1837, 209, 216, and 473.

99. Ibid., letter of 18 September 1829, 312.

100. Marie Mattei to Théophile Gautier, January 1850, in Gautier, *Correspondance*, 4:104, 105.

101. Marie Dorval to Alfred de Vigny, 11 January 1837, in *Correspondance d'Alfred de Vigny*, 3.

102. The bibliography, from this time on, is quite long as regards the diary; let us cite in particular, among the most recent books, Béatrice Dider, *Le journal intime* (Paris: Presses Universitaires de France, "Littératures modernes," 2002); Pierre Pachet, *Les baromètres de l'âme. Naissance du journal intime* (Paris: Hachette, "Pluriel," 2001); and the whole of Phillipe Lejeune's work.

103. Benjamin Constant, "Journaux intimes," in *Oeuvres* (Paris: Gallimard, "Bibliothèque de la Pléiade," 1957), 430–31.

104. For all the preceding citations, ibid., 432–34.

105. Ibid., 468.

106. Ibid., 406.

107. Ibid., 214.

108. Eugène Delacroix, *Journal, 1822–1863* (Paris: Plon, 1980), 87–88.

109. Stendhal, Journal, 9 November 1807, in *Oeuvres intimes*, 1:486.

110. Cf. A. Parent-Duchâtelet, *La prostitution à Paris au XIXe siècle. Extraits*, presented by Alain Corbin (Paris: Seuil, 1981). The text of St. Augustine's *De ordine* comes on p. 204.

111. Constant, *Oeuvres*, 664.

112. Delacroix, 3 March 1824, in *Journal*, 54.

113. Flaubert, *Correspondance*, passim; in particular, the letter to Alfred Le Poittevin, 26 May 1845, 1:235.

114. Constant, *Oeuvres*, 708–10.

115. Alfred Le Poittevin to Gustave Flaubert, in Flaubert, *Correspondance*, 1:956. But this time it is about a project expressed in a letter.

116. Stendhal, Journal, in *Oeuvres intimes*, 1:936 and 1574.

117. George Sand, *Correspondance* (Paris: Garnier, n.d.), 2:568–69.

118. Ibid., 3:734, 790.

119. Stendhal, *De l'amour*, 245.

120. Cf. Xavier Darcos, *Mérimée* (Paris: Flammarion, "Grandes biographies," 1998). This work is full of information on Prosper Mérimée's sexual behavior.

121. Stendhal, Journal, 17 June 1807, in *Oeuvres intimes*, 1:475.

122. Ibid., 770.

123. Nathalie Bajos and Michel Bozon, *Enquête sur la sexualité en France. Pratiques, genre et santé* (Paris: La Découverte, 2008).

124. Regarding the precision of the accounting of sins of lust, cf. Corbin, *L'harmonie des plaisirs*, 309–34.

125. Ibid., 91ff., with regard to Lignac's advice. As regards Jules Michelet, see the entry for 24 June 1862 in his *Journal* (Paris: Gallimard, n.d.), 3:120.

126. Michelet, 24 September 1857, in *Journal*, 2:355.

127. Athénaïs's hemorrhoids.

128. Michelet, *Journal*, 3:237, 277, and 365.

129. Michelet, 7 August 1866, in *Journal*, 3:407.

130. Stendhal, Journal, in *Oeuvres intimes*, 126 and 1077, 185 and 1109.

131. Stendhal writes this sentence in English, coyly spelling "make" Maque: "I make that one or two every day," meaning "I have one or two orgasms every day"—Trans.

132. Stendhal, Journal, 17 March 1811, in *Oeuvres intimes*, 663. Stendhal writes these notes partially in English.

133. "I saw, I mated, I mated from the rear." Similarly, the phrase "q. r" in the previous sentence, may mean, as editor suggests, "cul" (homonym of the letter "q" as pronounced in French), or "ass," "retro," or "from the rear"—Trans.

134. Series of citations taken from Michelet, *Journal*, 3:259, 260, 267, 269, 286. From 1863, Michelet becomes interested in Indian eroticism, to which he sometimes refers.

135. All the citations by Alfred de Vigny that follow are taken from his datebook for the year 1838, which figures in volume 3 of the *Correspondance*.

136. Ibid., "Journal."

137. Michelet, 17 November 1862, in *Journal*, 3:155.

138. Correspondance de Vigny, datebook cited.

139. Stendhal, Journal, 10 July 1807, in *Oeuvres intimes*, 1:483.

140. Historians' attention has been focused on these books; actually, the journal is of extreme interest. On Jules Michelet, see the recent work by Paule Petitier, *Michelet. L'homme histoire* (Paris: Grasset, 2006).

141. Michelet, 22 May 1857, in *Journal*, 2:327.

142. Ibid., 4 July 1857, 2:335–36.

143. Ibid., 8 July 1865, 3:298.

144. Stendhal, Journal, 10 August 1811, *Oeuvres intimes*, 1:709.

145. Letter from Saturday, 10 May 1834, cited by Lestringant, *Alfred de Musset*.

146. Cf. Michelet, leitmotif in the *Journal*; cf. also that which involves the "spurt of tenderness," ibid., 11 October 1858, 3:430.

147. Ibid., 5 March 1856, 2:299.

148. Ibid., 26 November 1850 (2:139) and 29 June 1863; Michelet regrets the excess that leads to a lack of consideration.

149. Ibid; this preoccupation returns often, for example on 1 September 1862.

150. Ibid., 26 September 1858 (2).

151. Cf. previous chapters in this volume.

10. MILITARY VIRILITY

1. J.-P. Bertaud, *La Révolution armée. Les soldats citoyens et la Révolution française* (Paris: Robert Laffont, 1979), 290ff.

2. N. Petiteau. *Lendemain d'Empire. Les soldats de Napoléon dans la France du XIX^e siècle* (Paris: La Boutique de l'histoire, 2003), 111ff.

3. Cited by Charles Dejob, "Le soldat dans la littérature française du XVIII^e siècle," *Revue politique et littéraire* 15 (7 October 1899): 451.

4. Ibid., 457.

5. M. Armand (fils), *Le moyen d'être heureux, ou les Bienfaisants* (Paris: Cailleaux, 1773).

6. André Corvisier, ed., *Histoire militaire de la France* (Paris: Presses Universitaires de France, 1992), chap. 5, 119ff.; Jean Chagniot, *Guerre et société à l'époque moderne* (Paris: Presses Universitaires de France, 2000), 236ff.

7. Samuel F. Scott, *The Response of the Royal Army to the French Revolution: The Role and Development of the Line Army, 1787–1793* (Oxford: Clarendon, 1978), 4ff.

8. M. de Zimmermann, infantry colonel, *Essais de principe d'une morale militaire* (Amsterdam: Merlin, 1765), 25.

9. Ibid., 82.

10. Armand (fils), *Le moyen d'être heureux ou les Bienfaisants*, 62.

11. *Le militaire en solitude, ou le Philosophe chrétien*, (The Hague: Pierre de Hondt, 1736), by M. de XXX, chevalier de l'ordre militaire de Saint-Louis, part 1, 177–78.

12. Zimmermann, *Essais de principe d'une morale militaire*, 45.

13. *Le militaire en solitude*, 178.

14. Chagniot, *Guerre et société à l'époque moderne*, 238–39.

15. Joseph Servan, *Le soldat citoyen, ou Vues patriotiques sur la manière la plus avantageuse de pourvoir à la défense du royaume, 1741–1780* (Neufchâtel, 1780), 157ff.

16. Ibid., 104ff.

17. Ibid., 233.

18. Scott, *The Response of the Royal Army to the French Revolution*, 46ff.

19. George L. Mosse, *The Image of Man: The Creation of Modern Masculinity* (New York: Oxford University Press, 1998), 56.

20. Bertaud, *La Révolution armée*, 201.

21. War archives, Service Historique de l'Armée de Terre, Vincennes, Xw 98.

22. Bertaud, *La Révolution armée*, 201.

23. Ibid., 203.

24. *Le camp de Grandpré ou le triomphe de la République*, music by François Joseph Gossec, first performed 27 January 1793 in Paris; score published by Naderman.

25. Bertaud, *La Révolution armée*, 198.

26. *Receuil d'hymnes patriotiques chantés aux séances du conseil général de la commune par les citoyens de la première requisition* (Paris, 1794).

27. Bertaud, *La Révolution armée*, 206.

28. Parliamentary archives (Paris, 1980), 316.

29. The hymn composed in honor of Bara and Viala says this explicitly.

30. Philippe Goujand, "Une notion-concepte en construction, l'héroïsme révolutionnaire," in *Dictionnaire des usages sociopolitiques (1770–1815)* (Paris: Kincksieck, 1987), 9ff.

31. Lt. Cl. Priard, "Les juges militaires sous la Révolution," *Commission française d'histoire militaire comparée* (Paris: Vincennes, 1969), 12.

32. Ibid.

33. Lucien Bonaparte, *Discours prononcé dans le temple de Mars, le 25 messidor an VIII, pour fêter le 14 juillet* (Paris: Imprimerie de la République, 1800).

34. Jean-Paul Sartre, *L'idiot de la famille* 3 vols. (Paris: Gallimard, "Bibliothèque de la Pléiade," 1971–1972, 1976), 3:561.

35. Parliamentary archives, legislative session (Paris: 19 May 1802).

36. Ibid. (15 May 1802).

37. C. Léger, *Éloge funèbre du citoyen Latour d'Auvergne, premier grenadier de la République, prononcé dans le temple de la commune de Passy* (Paris: Pougers, Year VIII [1799]), 37.

38. D. Cubiéres, *Les regrets d'un Français sur la mort de Latour d'Auvergne-Corret, premier grenadier de la République, ou le Modèle des guerriers* (Paris: n.p., Year VIII [1799]), 8.

39. Léger, *Éloge funèbre du citoyen Latour d'Auvergne*, 22.

40. J. Debry, *Rapports au Tribunat au nom d'une commission spéciale sur les honneurs à rendre à Latour d'Auvergne* (Paris: Imprimérie nationale, 2 Thermidor Year VIII [21 July 1800]).

41. *Vie politique de Latour d'Auvergne, descendant du grand Turenne* (Paris: Renaudières, Year VIII [1799]), 5, 11.

42. I. L. Landry, *Discours sur l'esprit de l'éducation publique prononcé à l'occasion de la distribution des prix du lycée impérial de Paris, le 18 août 1807* (Paris: Gilles fils, 1807).

43. Jean-Pierre Cosard, *L'École du monde ouverte à la jeunesse* (Paris: Hubert, 1805).

44. Cf. Zimmermann, *Essais de principe d'une morale militaire*, 5.

45. P. Crouzet, *Discours sur l'honneur prononcé à la distribution des prix du Prytanée militaire français, le 14 août 1806* (Paris: Firmin-Didot, 1806), 10.

46. P. Crouzet, *Dialogue en vers* (Paris: Gillé, 1802).

47. Jean-Paul Bertaud, *Quand les enfants parlaient de gloire. L'armée au coeur de la France napoléonienne* (Paris: Aubier, 2007), 191, 263.

48. Alfred de Vigny, *Oeuvres complètes* (Paris: Gallimard, "Bibliothèque de la Pléiade," 1993), 2:522.

49. Bertaud, *Quand les enfants parlaient de gloire*, 229ff.

50. Ibid., 271.

51. *Le Moniteur*, 8 January 1806.

52. Bruno Foucart, "Peinture militaire et idéologie à l'époque impérial," in *Armée, guerre et société à l'époque napoléonienne*, ed. Jacques-Olivier Boudon (Paris: SPM, 2004), 219.

53. Police Bulletin of 28 May 1807, National Archives, Paris, AFIV 1500.

54. Pierre Chaussard, *Le Pausanias français, ou Description du salon de 1806* (Paris, 1806), 70.

55. Cited by Yvette Cantarel-Besson, "Les morts exemplaires dans la peinture militaire," *Revue de l'Institut Napoléon* 133 (1977): 97.

56. *Correspondance de Napoléon Ier* (Paris: H. Plon, J. Dumaine, 1858), C21, August 1807; https://archive.org/details/correspondancede07naporich, accessed 19 June 2015.

57. Dr. J. Colombier, *Préceptes sur la santé des gens de guerre, ou Hygiène militaire* (Paris: Lacombe, 1775), 63.

58. M. J. Hughes, "Making Frenchmen into Warriors: Martial Masculinity in Napoleonic France," in *French Masculinites: History, Culture and Politics*, ed. C. E. Forth and B. Tarth (London: Rowe, 2007), 60.

59. *Le chansonnier de la Grande Armée, ou Choix de chansons militaires dédiées aux braves* (Paris: Marchand, 1809), 4–5.

60. "Le retour," in ibid., 67.

61. *Hommage à la Grande Armée du Caveau moderne, chanté à Tivoli pendant le dîner donné par la ville de Paris aux Braves qui ont traversé la capitale dans le courant de septembre 1808* (Paris, 1809), 12.

62. *Le chansonnier de la Grande Armée*, 95.

11. VIRILITY IN THE COLONIAL CONTEXT

1. Cited by Edward W. Said, *Orientalism* (1978; repr., New York: Vintage, 1979), 219.

2. Alfred Rambaud, preface, in *L'expansion de l'Angleterre*, xxxii. Cited by Olivier Le Cour Grandmaison, *La République impériale. Politique et racisme d'État* (Paris: Fayard, 2009), 227.

3. A term I borrow from Fabrice Virgili, *La France virile* (Paris: Payot, 2002).

4. As Albert Sarraut writes in 1931: "In its beginnings, colonization was not an act of civilization but an act of force," *Grandeurs et servitudes coloniales* (Paris: Éditions du Sagittaire, 1931), 29, 107.

5. Nicolas Bancel, Pascal Blanchard, and Françoise Vergès, *La République coloniale* (Paris: Hachette, 2007), 86, 87.

6. Paul Leroy-Beaulieu, *De la colonisation chez les peuples modernes* (Paris: Guillaumin, 1874).

7. On this question, see Le Cour Grandmaison, "De l'espace vital impérial," *La République impériale*, 282–96.

8. On the heels of the founding of the Deutscher Kolonial Veirein (German Colonial Association) on 6 December 1883. In 1885 this association comprised 10,272 members, including industrialists, shopkeepers, scholars, university professors, officers, explorers, publicists, journalists, émigrés, and workers. In January 1884, it began publishing a newsletter, the *Deutsche Kolonialzeitung*.

9. See Jacques Frémeaux, *De quoi fut fait l'Empire. Les guerres coloniales au XIX^e siècle* (Paris: CNRS Éditions, 2010).

10. I borrow this term from Le Cour Grandmaison, *Coloniser. Exterminer. Sur la guerre et l'État colonial* (Paris: Fayard, 2005).

11. Only the front of colonization is under French control from 1830 to 1870, that is, essentially, the large cities of colonial Algeria and the immediate outskirts of the interior.

12. Eugène Pellissier de Reynaud, *Annales algériennes* (Paris: Anselin, 1836), 2:249–50.

13. In April 1832 the tribe of Offias is massacred on the orders of the Duke de Rovigo, and their leader, El Rabbia, is executed by a decision of the war council in retaliation for the supposed assassination—by this same tribe—of Arab members of Parliament who had pledged allegiance to France. Very quickly it is known—and the Duke de Rovigo is so informed—that the tribe was innocent of the deeds that led to its quasi extinction by French troops.

14. Pellissier de Reynaud, *Annales algériennes*, 2:27.

15. Another example of this type in a different part of the empire: at the moment the city of Hue is taken by the French, General de Courcy, who commanded their expedition in 1885, grabs the royal saber from the emperor of Annam and makes a gift of it, very symbolically, to the minister of war. Henry Wesseling, *Les empires coloniaux européens, 1815–1919* (Paris: Gallimard, "Folio histoire," 2009), 415.

16. Jean-Toussaint Merle, *Anecdotes historiques et politiques pour servir à l'histoire de la conquête d'Alger en 1830* (Paris, 1831), 114ff.

17. Armand de Saint-Arnaud, *Lettres du maréchal de Saint-Arnaud. 1832–1854* (Paris: Lévy frères, 1858), vol. 1, 336–37.

18. As Pierre Darmon reminds us: "In 1840 227 soldiers fall on the field of honor. But in the hospitals, 9567 die, or forty-two times more! Based on a total force of 61,264 men, that is therefore 15.6% of the expeditionary corps that succumbs to sickness. One soldier out of every seven! . . . The life expectancy of a soldier in Africa would be, then, about a dozen years, disregarding the mortality rate on the battlefield." *Un siècle de passions algériennes* (Paris: Fayard, 2009), 86.

19. Ibid., 98.

20. Alexis de Tocqueville, *Sur l'Algérie. Lettre sur l'Algérie, 1837. Notes du voyage en Algérie, 1841. Travail sur l'Algérie, 1841. Rapports sur l'Algérie, 1847* (Paris: Flammarion, "GF," 2003).

21. For another view of the war of conquest and colonization, see also the very interesting work by Henri Vermeren and Patrice Vermeren, *Un gendarme aux colonies. Madagascar, Indochine, 1895–1907* (Paris: Albin Michel, 2003).

22. The War of Punjab (1845–1846), which led to that region's annexation in 1849.

23. The war against the Herero in the Afro-German southwest in 1904, in which the order to destroy (*Vernichtungsbefelh*) issued by General Lothar von Trotha led to the disappearance, in 1906, of 60,000 out of a population of 80,000.

24. The Congolese war of conquest, which will allow for the creation of the independent Congo Free State, personal property of King Leopold until 1908.

25. The War of Atjeh, on the island of Sumatra, one of the longest (1873–1903) and fiercest carried out by a European colonial power.

26. On this question, see esp. Anne-Marie Sohn, "*Sois un homme!*" *La construction de la masculinité au XIX^e siècle* (Paris: Seuil, 2009).

27. Albert Paluel-Marmont, *Bugeaud. Premier Français d'Algérie.* (Paris: Mame, "Découvertes. Exploits héroiques," 1944).

28. Expression borrowed from Gil Mihaely, "L'émergence du modèle militaro-viril. Représentations masculines en France au XIX^e siècle" (thesis, École des Hautes Études en Sciences, 2004).

29. A. Villacrose, *Vingt ans en Algérie, ou Tribulations d'un colon racontées par lui-même* (Paris, 1875), 310–11.

30. Those condemned to the penitentiary—which goes by the nebulous name "Biribi" in Africa—know this well. On this question, see Dominique Kalifa's *Biribi. Les bagnes coloniaux de l'armée française* (Paris: Perrin, 2009) [a study of the extensive network of penal colonies in North Africa to which disobedient soldiers were sent; maintained from 1818 to the 1970s.—Trans.]

31. Thus, at the time of the German conquest of Cameroon, the competitiveness is evident and is actually played out in a virile mode: "At the beginning the army was not very solid. It was composed of *Polizeitruppen* who were not very efficient or reliable. As resistance movements manifested themselves at regular intervals, real colonial troops arrived in Cameroon in 1895. These *Schutztruppen* despised their colleagues, the *Polizeitruppen*, calling them effeminate soldiers (*Weibersoldaten*)." Cited in Wesseling, *Les empires coloniaux européens*, 315.

32. Ibid., 80.

33. Nigel Barley, *White Rajah* (London: Little, Brown, 2002).

34. On this question, see Le Cour Grandmaison, "La coloniale contre la sociale," *Coloniser*, 277–334.

35. Cited in Darmon, *Un siècle de passions algériennes*, 170.

36. Jean-Luc Einaudi, *Un rêve algérien. Histoire de Lisette Vincent, une femme d'Algérie* (Paris: Dagorno, 1994), 27–28.

37. Jean-Baptiste Piolet, *La France hors la France* (Paris: Ferdinand Alcon, 1900), 85.

38. That is, by the spread of mixed interracial marriages with the goal of founding a new people who would be the fusion of East and West.

39. It might be asked, moreover, why it was not possible to realize, within colonized spaces, a united front between the dangerous European classes and the "indigenous." For the beginnings of an answer, see Fanny Colonna and Christelle Taraud, "La minorité

européenne d'Algérie (1830–1962): inégalités entre 'nationalités,' résistances à la francisation et conséquences sur les relations avec la 'majorité musulmane,'" conference on Franco-Algerian history, "Pour une histoire critique et citoyenne" held at the École Normale Supérieure de Lyon, 20–22 June 2006. Transcript may be found here: http://yahia-ksentina.blogspot.com/2008/07/fanny-colonna-et-christelle-taraud-la.html along with a video of the presentation.

40. Paluel-Marmont, *Bugeaud*, 53.

41. On this question, see Germaine Tillion, *Le harem et les cousins* (Paris: Seuil, "Point Essais," 1982).

42. The use of this term during this period is not proper, but it nonetheless allows us to target more easily the category of men concerned.

43. Cited in Darmon, *Un siècle de passions algériennes*, 475.

44. Whence the desire of France to "frenchify" the whole lot of these Europeans, while using their virile force placed in the service of the country. This is what will be accomplished by the law of 1889 that automatically naturalizes all children born in Algeria of foreign parentage—children who, during the World War I, will leave for metropolitan France to fight the Germans.

45. J. Saint-Germès, *Économie algérienne* (Algiers: La Maison des livres, 1950), 34.

46. Kalifa, *Biribi,* op. cit.

47. On this question, see Claudine Guiard, *Des Européennes en situation coloniale. Algérie 1830–1939* (Aix-en-Provence: Publications de l'Université de Provence, 2009).

48. Note: this is not unique to Europeans. Numerous white women, in fact, populated the harems of Muslim princes in the precolonial period. On this question, see Christelle Taraud, *La prostitution coloniale. Algérie, Tunisie, Maroc, 1830–1962* (Paris: Payot, 2003).

49. In the Dutch Indies, for example, marriage was, until the nineteenth century, prohibited to all the colonists (except for the prominent dignitaries of the VOK [Dutch Company of the East Indies]), at least during their first ten years' posting in the colony.

50. Amandine Lauro, *Coloniaux, ménagères et prostituées au Congo belge (1885–1930)* (Brussels: Labor, 2005).

51. Stéphanie Loriaux, "Anges et demons: les femmes colons, indigènes et métisses à l'épreuve des moeurs sexuelles dans la société coloniale des Indes néerlandaises," in *Hétérotopies sexuelles. Formes et pratiques du désir d'ailleurs*, ed. Laurent Gaissad and Christelle Taraud (Brussels: ULB, 2008).

52. In Indochina, the French thus saw in the Tonkinese women "stretched out dictionaries." On this question, see Isabelle Tracol-Huynh, "La prostitution au Tonkin colonial, entre races et genres. Prostitution in a French colony: Tonkin. Race and gender issues," *Genre, sexualité et société* 2 (Autumn 2009): 1–45. Accessible also online: https://gss.revues.org/1219.

53. On the question of mixed-race children, see Emmanuelle Saada, *Les enfants de la colonie. Les métis de l'Empire français entre sujétion et citoyenneté* (Paris: La Découverte, "Espace de l'histoire," 2007).

54. Thus, in 1909, the Crewe memorandum was promulgated, named for Lord Crewe, minister of the British colonies; it forbade functionaries of the British administration from frequenting local women. See Wesseling, *Les empires coloniaux européens*, 60. Similarly, in 1905, the Germans opposed mixed marriages in their territories in southwest Africa on the pretext that they were contrary to "racial good health."

55. For more detail on this question, see Christelle Taraud, "Genre, classe et 'race' en contexte colonial et post-colonial: une approche par la mixité sexuelle," in *Ce que le genre fait aux personnes*, ed. Pascale Bonnemère and Irène Théry (Paris: Éditions de l'École des Hautes Études en Sciences, "Enquête," 2008), 157–71.

56. For a comparison with another part of the French Empire, see Franck Proschan, "'Syphilis, Opiomania, and Pederasty': Colonial Construction of Vietnamese (and French) Social Diseases," *Journal of the History of Sexuality* 11, no. 4 (October 2002): 610–36.

57. This idea will be recapped at the beginning of the twentieth century by Dr. G. Lacapère in his book entitled *La syphilis arabe* (Paris: Droin, 1923).

58. Thus L. Galibert confusingly denounces Moors reputed to be "soft, cruel, effeminate, egotistical," *L'Algérie ancienne et moderne* (Paris: Furne & Compagnie, 1844), 71.

59. The same goes for other parts of the empire: the Kanaks of New Caledonia against the Vahine of Tahiti, for example, and in other imperial contexts, the Hottentots against the Bushmen in South Africa, the Hutus against the Tutsis in Rwanda.

60. Note that black populations are the object of the same stereotypes. On this question, see Serge Bilé, *La légende du sexe surdimensionnel des Noirs* (Paris: Éditions du Rocher, "Essai/Document," 2005).

61. Dr. Jacobus, *L'art d'aimer aux colonies* (Paris: Éditions G. Anquetil, 1927), 170.

62. Joseph Maire, *Souvenirs d'Alger* (Paris: n.p., 1884), 45. Numerous authors, it should be noted, considered the Arab to also be an "innate" rapist of white women. This idea actually goes well beyond the colonial French Empire.

63. F. Leblanc de Prébois, *Algérie. De la nécessité de substituer le gouvernement civil au gouvernement militaire pour le succès de la colonisation d'Alger* (Paris: Delaunay, 1840), 7.

64. Proschan, "'Syphilis, Opiomania, and Pederasty,'" 634.

65. Roland Barthes thus notes that the *boy* is "the only fully reassuring image of the Negro" who, through successful domestication, accedes to the status of "domestic barbarian," "Bichon chez les Nègres," in *Mythologies* (Paris: Seuil, 1970), 66. [The English word "boy" is used throughout this passage in the original text.—Trans.]

66. On this question, see Christelle Taraud, "Le rêve masculin des femmes dominées et soumises," in *Générations. Un siècle d'histoire culturelle des Maghrébins en France*, ed. Driss el-Yazami, Yvan Gastaut, and Naïma Yahi (Paris: Gallimard, 2000), 63–68.

67. Hérisson, *La chasse à l'homme. Guerres d'Algérie* (Paris: Ollendorf, 1891), 281.

68. Émile Zola, *La Terre* (Paris: Gallimard, "Folio," 2002), 96.

69. I borrow this term from Catherine Coquery-Vidrovitch, *L'Afrique occidentale aux temps des Français: colonisateurs et colonisés, 1860–1960* (Paris: La Découverte, 1992),

89. An example of this type of phenomenon, as specified by the governor general of AOF [French West Africa], Joost Van Vollenhoven, at the beginning of the twentieth century: "[In AOF], leaders wield no personal power, for there are not two authorities in the region, the French and the native, but rather one, so that the French commander is the sole legitimate responsible party—the native chief being only an instrument, an auxiliary [hence, 'subaltern annexation']."

70. The word comes from the Portuguese—*chicote*—and refers to a whip, a bat, or any instrument used for corporal punishment.

71. Félicien Challaye, *Un livre noir du colonialisme. Souvenirs sur la colonisation* (Paris: Les Nuits rouges, 2003), 45.

72. Abdelmalek Sayad, *La double absence. Des illusions de l'émigré aux souffrances de l'immigré* (Paris: Seuil, "Liber," 1999).

73. Emmanuel Blanchard, "Le mauvais genre des Algériens. Des hommes sans femme face au virilisme policier dans le Paris d'après-guerre," *Clio. Femmes, genre, histoire*, 27 (2008): 209–24.

74. Régis Revenin, "Jalons pour une histoire (culturelle et sociale) de la prostitution masculine juvénile dans la France des 'Trente Glorieuses,'" in "La prostitution des mineur(e)s au XX^e siècle," ed. Christine Gachiels and Éric Pierre, special issue, *Revue d'histoire de l'enfance "irrégulière,"* 10 (October 2008): 90–91.

75. Jean-Luc Hennig, *Les garçons de passe. Enquête sur la prostitution masculine* (Paris: Éditions Libres-Hallier, 1978), 128–30 (interview with a prostitute), cited in Revenin, "Jalons pour une histoire (culturelle et sociale) de la prostitution masculine juvénile dans la France des 'Trente Glorieuses,'" 91.

76. There is no precise study on this question. The existence, however, of avowed mixed couples can be noted, including among the "cultivated" and the nationalist leaders, modeled on Blaise Diagme and Marie-Odette Villain, and Messali Hadj and Émilie Busquant.

77. Véronique Willemin, *La mondaine. Histoire et archives de la police des mœurs* (Paris: Hoëbeke, 2009), 282.

78. On all these struggles, see Mogniss H. Abdallah, *J'y suis, j'y reste. Les luttes de l'immigration en France depuis les années 1970* (Paris: Réflex, 2000).

79. On this question, see, for example, the publications of the Homosexual Front for Revolutionary Action (FHAR), and in particular, "Les Arabes et nous," *L'Antinorme* 2 (February–March 1973); Todd Shepard, "Le Front homosexuel d'action révolution-naire (1971–1974) et ses représentations du 'Maghrébin,'" workshop on "Féminisme, sexualité et (post)-colonialisme," held at the École Normale Supérieure, Paris, 3 February 2006; and Emmanuel Blanchard, "Des Algériens dans le Paris gay (années 1950–1960). Frontières raciales et sexualités entre hommes sous le regard policier," in *Politique et administration du genre en migration. Mondes Atlantiques, XIX^e–XX^e siècles*, ed. P. Rygiel (Paris: Publibook, 2012), 157–74.

80. See, in particular, the very beautiful film by Rainer Werner Fassbinder, *Ali: Fear Eats the Soul* (1974). For an exhaustive analysis of the film in connection with the question of virility, see Christelle Taraud, *Sexes et colonies. Virilité, "homosexualité et tourisme sexuel au Maghreb à l'époque colonial* (Paris: Payot, 2010).

81. Abdallah, *J'y suis, j'y reste*, 56.

82. Narcira Guénif-Souilamas and Éric Macé, *Les féministes et le garçon arabe* (Paris: L'Aube, 2004); and Christelle Hamel, "Le 'mélange des genres': une question d'honneur. Étude des rapports sociaux de sexe chez de jeunes Maghrébins de France," *AWAL. Cahiers d'études berbères* 19 (1999): 19–32.

83. Christelle Hamel, "'Faire tourner les meufs.' Les viols collectifs: discours des medias et des agresseurs," *Gradhiva* 33 (2003): 85–92; Samira Belil, *Dans l'enfer des tournantes* (Paris: Gallimard, "Folio," 2003); and Laurent Mucchielli, *Le scandale des tournantes. Dérives médiatiques, contre-enquête sociologique* (Paris: La Découverte, "Sur le vif," 2005).

84. Like that of Sohane Benziane, burned alive in the projects of Vitry-sur-Seine, October 2002; her atrocious death gave rise to the association "Ni putes, ni soumises" [Neither whores nor subjected women], founded, it should be noted, by Fadela Amara in 2003.

85. Christelle Hamel, "'Questions d'honneur': l'homosexualité en milieu maghrébin," in *Dissemblances, jeux et enjeux du genre*, ed. Rose-Marie Lagrave (Paris: L'Harmattan, 2002), 37–50; Brahim Naït-Balk, *Un homo dans la cité* (Paris: Calmann-Lévy, 2009); and Franck Chaumont, *Homo-ghetto. Gays et lesbiennes dans les cités. Les clandestins de la République* (Paris: Le Cherche-Midi, 2009).

86. During the terrorist attacks of 1995 in Paris the figure of Khaled Kelkal emerges as a ringleader of all types of "barbus" (radicalized Muslims) who were threatening France.

12. THE BURDEN OF VIRILITY

1. Fernel's aphorism is cited in this way by Dr. Alexandre Mayer, *Des rapports conjugaux* (Paris: J.-B. Baillière, 1860), 367; by Dr. Louis Seraine, *De la santé des gens mariés, ou Physiologie de la génération de l'homme et hygiène philosophique du mariage* (Paris: F. Savy, 1865), 70; and by Ellen Bayuk Rosenman, "Body Doubles: the Spermatorrhea Panic," *Journal of the History of Sexuality* 12 (July 2003): 370.

2. On this point and what follows: cf. Simon Richter, "Wet-Nursing, Onanism, and the Breast in 18th Century Germany," *Journal of the History of Sexuality* 7, no. 1 (July 1996); and Barbara Duden, *The Woman Beneath the Skin*, cited by Richter, ibid.

3. Anne Vincent-Buffault, *Histoire des larmes, XVII I^e–XX^e siècle* (Paris: Rivages, "Histoire," 1986).

4. For this whole group of assertions: cf. Alain Corbin, *L'harmonie des plaisirs. Les manières de jouir du siècle des Lumières à l'avènement de la sexologie* (Paris: Perrin, 2007), 117–90.

5. The major part of this research was done in 2008. Corbin, *L'harmonie des plaisirs*.

6. Patrick Singy, "Friction of the Genitals and Secularization of Morality," *Journal of the History of Sexuality* 3, no. 3 (July 2003): 345–64; see also Singy's critique of Thomas Laqueur's work, *Le sexe solitaire* (Paris: Gallimard, 2003), in *Critique* (2006), and the reflections by Theodor Taczylo on this subject in *Sexe et liberté au siècle des Lumières* (Paris: Presses de la Renaissance, 1983), 110.

7. For these topics, see the summary provided by Michael Stolberg, "Self-Pollution, Moral Reform, and the Venereal Trade: Notes on the Sources and Historical Context of *Onania* (1716)," *Journal of the History of Sexuality* 9 (January–April 2000): 37–42.

8. Cf. Vincent Barras, Micheline Louis-Courvoisier, eds., *La médecine des Lumières. Tout autour de Tissot* (Geneva: Georg, 2001).

9. Cf. Corbin, *L'harmonie des plaisirs*, 153–54.

10. James Paget, *Clinical Lectures and Essays* (London: Longmans, Green, 1875), 284.

11. Charles Féré, *L'instinct sexuel. Évolution et dissolution* (Paris: Félix Alcan: 1899), 299, 300. In this work, Féré summarizes the debate over the effects of abstinence (303–04), citing Seved Ribbing, *L'hygiène sexuelles et ses conséquences morales* (Paris: Félix Alcan, 1895).

12. Cf., besides Peter Gay, Alan Hunt, "The Great Masturbation Panic and the Discourses of Moral Regulation in 19th and Early 20th Century Britain," *Journal of the History of Sexuality* 8, no. 4 (April 1998): 575–615; and Lesley Hall, "Forbidden by God, Despised by Men: Masturbation Medical Writing, Moral Panic, and Manhood in Great Britain, 1850–1950," *Journal of the History of Sexuality* 2, no. 3 (January 1992): 371.

13. Cf. Franz X. Eder, "Discourse and Sexual Desire: German Language Discourse on Masturbation in the Late 18th Century," *Journal of the History of Sexuality* 13, no. 4 (October 2004). See reflections along the same lines in Karen Harvey, "The Century of Sex? Gender, Bodies and Sexuality in the Long Eighteenth Century," *Historical Journal* 45, no. 4 (December 2002): 915.

14. Claude François Lallemand, *Des pertes séminales involontaires*, 3 vols. (Paris: Bechet jeune, 1836–1842). On nocturnal emissions, cf. Corbin, *L'harmonie des plaisirs*, 172–81. One should not overlook, however, F. B. Courtenay, *A Practical Essay on the Debilities of the Generation System: Their Variety, Causes, Treatment, and Cure* (London, 1839), which appeared the same year as Lallemand's second volume.

15. See William Acton, *The Functions and Disorders of the Reproductive Organs in Childhood, Youth, Adult Age, and Advanced Life* (London: J. A. Churchill, 1863). Among the British doctors who treated the disorder, let us cite Marris Wilson, "Contributions to the Physiology, Pathology and Treatment of Spermatorrhoea," *Lancet* 68, no. 1737 (1856): 215; and, later, John Laws Milton, *On Spermatorrhea: Its Pathology, Results and Complications* (London, 1875).

16. For this case, see Alain Corbin, "Écriture de soi sur ordonnance. Étude d'un cas du professeur Lallemand," in *Des experiences intérieures pour quelles modernités?*, ed. Julia Kristeva (Paris: Cécile Defaut, 2012). The texts appear in Professor Lallemand's treatise, *Des pertes séminales involontaires*, 1:291–309.

17. Merriam-Webster defines cenesthesia as "the general feeling of inhabiting one's body that arises from multiple stimuli from various bodily organs"; evidently it referred in the early nineteenth century to an abnormally heightened sense of one bodily function or another—Trans.

18. It appears in this way in the *Nouveau Larousse Illustré*: Claude Augé, ed., *Dictionnaire universel illustré encyclopédique* (Paris: Larousse, 1905), "Spermatorrhée."

19. An expression used, for instance, by Mayer, *Des rapports conjugaux*, 109.

20. Dr. Parent-Auber, *Almanach des mystères de l'amour conjugal et de l'hygiène du mariage* (Paris: privately printed, 1852), 19.

21. Dr. Francis Devay, *Hygiène des familles* (Paris: Labé, 1858), 299.

22. This is what comes out of the corpus of medical works cited.

23. Cf. Corbin, *L'harmonie des plaisirs*, chap. 6, "Impuissance et anaphrodisie," 191–211.

24. Pierre Darmon, *Le tribunal de l'impuissance* (Paris: Seuil, 1979), passim.

25. Ibid.

26. This is very well analyzed by Yves Citton in a remarkable work, *Impuissance. Défaillances masculines et pouvoir politique de Montaigne à Stendhal* (Paris: Auber, 1994). On this subject, see also Margaret Waller, *The Male Malady: Fictions of Impotence in French Romantic Novels* (New Brunswick, NJ: Rutgers University Press, 1993); and Deborah Gutermann, "Le désir et l'entrave. L'impuissance dans la construction de l'identité masculine romantique," in *Hommes et masculinités de 1789 à nos jours*, ed. R. Revenin (Paris: Autrement, 2007), 55–75.

27. Citton, *Impuissance*, 300–66.

28. Such is the case with Mlle. Cormon, who becomes Mme. Dubousquet-Laborderie in Balzac's novel *La vieille fille*.

29. Cf. Annelise Maugue, *L'identité masculine en crise au tournant du siècle* (Marseilles: Rivages, "Histoire," 1987); and André Rauch, *Le premier sexe. Mutations et crise de l'identité masculine* (Paris: Hachette, 2000; rev. ed. "Pluriel," 2001).

30. J. Alfred Fournier and Louis J. Bégin, *Dictionnaire des sciences médicales* (Paris: C. L. F. Panchoucke, 1819), 122–25, "Masturbation."

31. Seraine, *De la santé des gens mariés*, 231 (emphasis added).

32. Mayer, *Des rapports conjugaux*, 367 (emphasis added).

33. Seraine, *De la santé des gens mariés*, 23.

34. Ibid., 24.

35. Ibid., 71.

36. Ibid., 82.

37. Paolo Mantegazza, *Hygiène de l'amour* (Paris: J. Tallendier, 1900).

38. Ribbing, *L'hygiène sexuelles et ses conséquences morales*.

39. On the concept of degeneration, its diffusion, and its effects, amid a vast bibliography, see Jean-Christophe Coffin, *La transmission de la folie, 1850–1914* (Paris: L'Harmattan, "L'histoire du social," 2003). On the teratological family: Charles Féré, *La famille névropathique. Théorie tératologique de l'hérédité et de la prédisposition morbide de la dégénérescence*, 2d ed. (Paris: Félix Alcan, 1898); and the very illuminating book by Jean Borie, *Le tyran timide. Le naturalisme de la femme au XIXᵉ siècle* (Paris: Klincksieck, "Publications de l'Université d'Orléans," no. 3, 1973).

40. Coffin, *La transmission de la folie*; and Robert A. Nye, ed., *Masculinity and the Male Code of Honour in Modern France* (New York: Oxford University Press, 1993).

41. Cf. Alain Corbin, "L'hérédosyphilis ou l'impossible redemption," in *Le temps, le désir et l'horreur* (Paris: Flammarion, "Champs," 1991).

42. To evoke the title of a fundamental work by Charles Féré.

43. Féré, *L'instinct sexuel*, 209, 134, 213.

44. Michel Foucault, *Histoire de la sexualité*, vol. 1, *La volonté de savoir* (Paris: Gallimard, 1976); *The History of Sexuality: An Introduction*, trans. Robert Hurley, three volumes (New York: Random House), vol. 1, 64.

45. A synthesis of the current status of the question about "inversion" appears in Alain Corbin, ed., *Histoire du corps*, vol. 2, *De la Révolution à la Grande Guerre* (Paris: Seuil, 2005), 198–202.

46. Féré, *L'instinct sexuel*, 158.

47. For this group of citations, ibid., 168–69 and J. Chevalier, *L'inversion de l'instinct sexuel au point de vue médico-légal* (Lyon, 1885). An overview of this topic is in Christian Bonnello, "Discours médical sur l'homosexualité en France à la fin du XIXᵉ siècle. Des années 1870 aux années 1900" (thesis, Université de Paris VII, 1979).

48. Richard von Krafft-Ebing, *Psychopathia sexualis* (repr., New York: Arcade, 2011).

49. Féré, *L'instinct sexuel*, 138.

50. Acton, *The Functions and Disorders of the Reproductive Organs*.

51. Alfred Binet, "Le fétichisme dans l'amour," *Revue philosophique* 24 (August 1887), 143–67; (September 1887), 252–74; (1887), and in Binet, *Études de psychologie expérimentale* (Paris: Doin, 1888). See, in this regard, Paul Laurent, *Fétichistes et érotomanes* (Paris: Vigot, 1905); and Dr. Paul Garnier, *Les fétichistes. Pervertis et invertis sexuels* (Paris: J.-B. Baillière, 1896). An overview of the question has since been provided by Emily Apter, *Feminizing the Fetish: Psychoanalysis and Narrative Obsession in Turn-of-the-Century France* (Ithaca: Cornell University Press, 1991).

52. Auguste Forel, *La question sexuelle exposée aux adultes cultivées* (Paris: G. Steinheil, 1906), 263.

53. Gustave Macé, *La police parisienne. Un joli monde* (Paris: Charpentier, 1887).

54. On all these points, see Féré, *L'instinct sexuel*.

55. Laurent, cited by Apter, *Feminizing the Fetish*, 17.

56. Cf. Florence Rochefort and Laurence Klejman, *L'égalité en marche. Le feminisme sous la Troisième République* (Paris: Presses de la Fondation nationale des sciences politiques, 1989).

57. Corbin, *L'harmonie des plaisirs*, passim.

58. Simone Delattre, *Les douze heures noires. La nuit à Paris au XIXᵉ siècle* (Paris: Albin Michel, 2000).

59. Cf. the entirety of Francis Ronsin's work.

60. Joëlle Guillais, *La chair de l'autre. Le crime passionnel au XIXᵉ siècle* (Paris: Orban, 1986); and, regarding the twentieth century, André Rauch, *L'amour à la lumière du crime. 1936–2007* (Paris: Hachette, 2009).

61. Alain Corbin, *Les filles de noce. Misère sexuelle et prostitution au XIXᵉ siècle* (Paris: Auber, 1978; rev. ed. Paris: Flammarion, "Champs," 1982).

62. Fabienne Casta-Rosaz, "Le flirt. Pratique et représentation en France (1870–1968)" (thesis, Université de Paris I, 2009).

63. Dr. Ch. Montalban (Charles Thomas Caraman), *La petite bible des jeunes époux* (Paris: Maarpon/Flammarion, 1885; repr., Grenoble: Millon, 2008).

64. Sylvain Venayre, "Le temps du voyage de noces," *L'Histoire* 321 (June 2007).

65. Philippe Ariès and Georges Duby, eds., *Histoire de la vie privée*, vol. 4, *De la Révolution à la Grande Guerre*, ed. Michelle Perrot (Paris: Seuil, 1987), 547–48.

66. Francis Ronsin, *La grève des ventres. Propoagande néo-malthusienne et baisse de la natalité en France. XIX^e–XX^e siècle* (Paris: Aubier-Montaigne, "Collection historique," 1980).

67. Patrick Wald Lasowski, *Syphilis. Essai sur la littérature française du XIX^e siècle* (Paris: Gallimard, 1982).

68. Joris-Karl Huysmans, *À rebours* (Paris: Charpentier, 1884).

69. On the following, see in particular Bram Dijkstra, *Idols of Perversity: Figures of Feminine Evil in Fin-de-Siècle Culture* (New York: Oxford University Press, 1988).

70. Claude Courouve, *Vocabulaire de l'homosexualité masculine* (Paris: Payot, 1985).

71. Ibid.

72. David M. Halperin, *How to Do the History of Homosexuality* (Chicago: University of Chicago Press, 2002).

73. Élisabeth Roudinesco, *La part obscure de nous-mêmes. Une histoire des pervers* (Paris: Michel, 2007).

74. Maurice Lever, *Les bûchers de Sodome* (Paris: Fayard, 1985); Michel Rey, "Police et sodomie à Paris au XVIII^e siècle: du péché au désordre," *Revue d'histoire moderne et contemporaine* 29 (1982): 113–24; Jeffrey Merrick, "Sodomitical Inclinations in Early Eighteenth-Century Paris," *Eighteenth-Century Studies* 30 (1997): 289–95; and Merrick, "Nocturnal Birds in the Champs-Élysées: Police and Pederasty in Pre-revolutionary Paris," *GLQ, A Journal of Lesbian and Gay Studies* 8 (2002): 425–31.

75. Michael D. Sibalis, "The Regulation of Male Homosexuality in Revolutionary and Napoleonic France, 1789–1815," in *Homosexuality in Modern France*, ed. Jeffrey Merrick and Bryant T. Ragan (New York: Oxford University Press, 1996), 80–101.

76. Michael D. Sibalis, "L'homosexualité masculine à l'époque des Lumières et des révolutions, 1680–1850," in *Une histoire de l'homosexualité*, ed. Robert Aldrich (Paris: Seuil, 2006), 103–23.

77. Florence Tamagne, "L'âge de l'homosexualité, 1870–1940," in Aldrich, *Une histoire de l'homosexualité*, 186.

78. On Paris, Régis Revenin, *Homosexualité et prostitution masculines à Paris, 1870–1918* (Paris: L'Harmattan, 2005); on New York, George Chauncey, *Gay New York: Gender, Urban Culture and the Making of the Gay Male World (1890–1940)* (New York: Basic, 1995); and David Higgs, ed., *Queer Sites: Gay Urban Histories Since 1600* (New York: Routledge, 1999).

79. Revenin, *Homosexualité et prostitution masculines à Paris*.

80. Ibid.

81. Ibid.

82. Michel Foucault, *The History of Sexuality: An Introduction*, vol. 1, 43.

83. Ibid., vol. 2, *The Uses of Pleasure*.

84. According to the definition given in the *Petit Robert de la langue française* (Paris: Le Robert, 2009).

85. Jonathan Ned Katz, *The Invention of Heterosexuality* (Chicago: University of Chicago Press, 1996); Alain Giami, "Cent ans d'hétérosexualité," *Actes de la recherche en sciences sociales* 128 (1999): 38–45; Louis-Georges Tin, *L'invention de la culture hétérosexuelle* (Paris: Autrement, 2008); and Catherine Deschamps, Laurent Gaissad, and Christelle Taraud, eds., *Hétéros. Discours, lieux, pratiques* (Paris: EPEL, 2009).

86. Sylvie Steinberg, *La confusion des sexes. Le travestissement de la Renaissance à la Révolution* (Paris: Fayard, 2001).

87. Michel Delon, *Le savoir-vivre libertin* (Paris: Hachette, 2000). See also, by the same author, "Dentelles, perruques, chaussures à boucles: la confusion des genres," *Histoire* 297 (April 2005): 50–51.

88. Jean-Yves Le Talec, *Folles de France. Repenser l'homosexualité masculine* (Paris: La Découverte, 2008).

89. Michael Pollak, *Les homosexuels et le Sida. Sociologie d'une épidémie* (Paris: Métailié, 1988), 45–47.

90. Halperin, *How to Do the History of Homosexuality*.

91. Corbin, *L'harmonie des plaisirs*, 367.

92. As defined by Michael D. Sibalis, "Une *subculture* d'efféminés? L'homosexualité masculine sous Napoléon Ier," in Revenin, *Hommes et masculinités de 1789 à nos jours*: the term "subculture" (and I would say "subcultural world") refers back to "a marginalized culture that exists within dominant culture, yet which is distinct from it; it is characterized by lifestyles, social practices, ways of being and particular values at times in contradiction with those of the surrounding culture" (77).

93. Randolph Trumbach, "Gender and the Homosexual Role in Modern Western Culture: The 18th and 19th Centuries Compared," in *Homosexuality, Which Homosexuality? International Conference on Gay and Lesbian History*, ed. Dennis Altmann, Theo van der Meer, and Anja van Kooten Niekerk (London: GMP, 1989), 149–69.

94. Randolph Trumbach, "London's Sodomites: Homosexual Behavior and Western Culture in the 18th Century," *Journal of Social History* 11 (1977–1978): 1–33; and Rictor Norton, *Mother Clap's Molly House. The Gay Subculture in England, 1700–1830* (London: GMP, 1992)

95. Lever, *Les bûchers de Sodome*; Rey, "Police et sodomie": Merrick, "Sodomitical Inclinations": Michael D. Sibalis, "High-Heels or Hiking Boots? Masculinity, Effeminacy and Male Homosexuals in Modern France," in *French Masculinities, History, Culture and Politics*, ed. Christopher E. Forth and Bertrand Taithe (New York: Palgrave MacMillan, 2007), 172–89; Sibalis, "Une *subculture* d'efféminées?"; Revenin, *Homosexualité et prostitution masculines à Paris*; and William A. Peniston, *Pederasts and Others: Urban Culture and Sexual Identity in Nineteenth-Century Paris* (New York: Harrington Park, 2004).

96. Gert Hekma, "Homosexual Behavior in the Nineteenth-Century Dutch Army," in *Forbidden History: The State, Society and the Regulation of Sexuality in Modern Europe*, ed. John C. Fout (Chicago: University of Chicago Press, 1992), 237–38.

97. Régis Revenin, "Conception et théories savantes de l'homosexualité masculine en France, de la monarchie de Juillet à la Première Guerre mondiale," *Revue d'histoire et des sciences humaines* 17 (2007): 23–45; Vernon A. Rosario, *L'irrésistible ascension du pervers. Entre littérature et psychiatrie* (1997; repr., Paris: EPEL, 2000); Sylvie Chaperon, *Les origines de la sexologie (1850–1900)* (Paris: Audibert, 2007); Bonello, "Discours médical sur l'homosexualité en France à la fin du XIXᵉ siècle"; André Béjin, *Le nouveau tempérament sexuel. Essai sur la rationalisation et la democratisation de la sexualité* (Paris: Kimé, 1990); and Laurent-Paul Sueur, "Le message médical français concernant les identités de genre: seconde moitié du XIXᵉ–fin du XXᵉ siècle," *Déviance et société* 4 (1999): 359–74.

98. Alexandre Lacassagne, one of the founders of criminal anthropology in France and father of the École Lyonnaise (which is, in fact, the French School of Criminal Anthropology), was a professor at the Université de Lyon, with a chair in legal medicine.

99. Julien Chevalier, *L'inversion sexuelle* (Paris: Masson, 1893).

100. For example, Benjamin Ball, *La folie érotique* (Paris: Baillière, 1888), 151; Georges Saint-Paul (Dr. Laupt), *Tares et poisons. Perversion et perversité sexuelles. Une enquête médicale sur l'inversion* (Paris: Carré, 1896), 20. See also the police archives cited in Revenin, *Homosexualité et prostitution masculines à Paris*.

101. Saint-Paul, *Tares et poisons*. Émile Zola's letter, dated 25 June 1895, is on pp. 1–4 (the preface to the work), and the confidential material, published in the form of one chapter, on pp. 46–103.

102. Thomas W. Laqueur, *Solitary Sex: A Cultural History of Masturbation* (New York: Zone, 2003).

103. Ambroise Tardieu, *Étude médico-légale sur les attentats aux moeurs* (Paris: Baillière, 1857), 120.

104. Johann Ludwig Casper, *Traité pratique de médecine légale*, vol. 1 (1852; repr., Paris: Baillière, 1883)

105. Karl Westphal, "Die conträre Sexualempfindung. Symptom eines neuropathischen (psychopathischen) Zustandes," *Archive für Neurologie* 2 (1869): 73–108.

106. Guillaume Ferrus, Achille-Louis Foville, and Alexandre Brierre de Boismont, "Attentats aux moeurs," *Annales médico-psychologiques* 1 (1843): 289–99.

107. Claude-François Michéa, "Des déviations maladives de l'appétit vénérien," *Union médicale* 3 (1849): 338–39.

108. Archives of the Préfecture de Police of Paris (hereafter APP), fonds BB5, "Pédés." Three registries entitled "Pédés" (BB4 and BB5) and "Pédérastes et divers" (BB6) are part of the series "Femmes galantes (ladies of the night) et homosexuels" and cover the whole first part of the nineteenth century.

109. Paul Fabre, "De l'hystérie chez l'homme," *Annales médico-psychologiques*, 5th ser., 13: 354–73.

110. Auguste Klein, *De l'hystérie chez l'homme* (Paris: Derenne, 1880).

111. Paul Fabre, "De l'hystérie chez l'homme," *Gazette médicale de Paris*, 6th ser., 3: 654–57, 687–88, 734–35.

112. Karl Ulrichs, *Forschungen über das Räthsel der mann-männlichen Liebe* (1864–1879; repr., Berlin: Verlag Rosa Winkel, 1994).

113. Magnus Hirschfeld, *Die Homosexualität des Mannes und des Weißes* (1914; repr., Berlin: Walter de Gruyter, 1984).

114. Krafft-Ebing, *Psychopathia sexualis*.

115. Ibid.

116. Bénédict Morel, *Traité des dégénérescences physiques, intellectuelles et morales de l'espèce humaine et des causes qui produisent ces variétés maladives* (Paris: Baillière, 1857).

117. Jean-Martin Charcot and Victor Magnan, "Inversion du sens génital," *Archives de neurologie* vol. 3 (1882), 7–9: 53–60, 296–322.

118. Havelock Ellis, *Studies in the Psychology of Sex*, vol. 2, *Sexual Inversion* (New York: Random House, 1940).

119. See, in chronological order: Tardieu, *Étude médico-légale sur les attentats aux moeurs*, 137–39; Félix Carlier, *Les deux prostitutions* (Paris: Dentu, 1887), 315–52; Chevalier, *L'inversion sexuelle*, 190–95; Paul-Émile Garnier, *Les fétichistes, pervertis et invertis sexuels*; Saint-Paul, *Tares et poisons*, 191–92; Léon-Henri Thoinot, "L'inversion du sens génital," in *Attentats aux moeurs et perversion du sens génital* (Paris: Douin, 1898), lesson 14, 304–37; Féré, *L'instinct sexuel*, chap. 8.

120. Regarding Marc-André Raffalovich and Patrick Cardon, *Discours littéraires et scientifiques fin de siècle. Autour de Marc-André Raffalovich* (Paris: L'Harmattan Orizons, 2008).

121. Marc-André Raffalovich, "Quelques observations sur l'inversion," *Archives d'anthropologie criminelle* [hereafter *AAC*], 9 (1984): 216–18; Raffalovich, "L'éducation des invertis," *AAC* 9 (1984): 738–40; Raffalovich, "À propos du *Roman d'un inverti* et de quelques travaux récents sur l'inversion sexuelle," *AAC* 10 (1895): 333–36; Raffalovich, "L'affaire Oscar Wilde," *AAC* 10 (1895): 445–77; Raffalovich, "Homosexualité et hétérosexualité. Trois confessions," *AAC* 10 (1895): 748–58; Raffalovich, *Uranisme et unisexualité* (Paris: Masson: 1896); Raffalovich, "Affair du Prince de Bragance," *AAC* 18 (1903): 159–61; Raffalovich, "Les groups uranistes à Paris et à Berlin," *AAC* 19 (1904): 926–36; Raffalovich, *AAC* 20 (1905): 182–85, 411–14; Raffalovich, "À propos du syndicat des uranistes," *AAC* 20 (1905): 283–86; Raffalovich, "Des mariages entre hommes," *AAC* 22 (1907): 267–68; Raffalovich, "Chronique de l'unisexualité," *AAC* 22 (1907): 606–32, 767–86.

122. Raffalovich, *Uranisme et unisexualité*, 18.

123. Harry Oosterhuis and Hubert Kennedy, *Homosexuality and Male Bonding in Pre-Nazi Germany: The Youth Movement, the Gay Movement, and Male Bonding Before Hitler's Rise* (New York: Routledge, 1991).

124. Raffalovich, "Les groupes uranistes à Paris et à Berlin," 926.

125. Ibid. On the other hand, la Villette is not mentioned in the BM2 series as being "frequented by pederasts." Nevertheless, a dossier exists (APP, series BM2, no. 37).

126. Joris-Karl Huysmans, *À rebours* (1884; repr., Paris: Flammarion, "GF," 1978). The hero, the duke des Esseintes, is the figure of the dandy.

127. Émile Zola, *Le ventre de Paris* (1873; repr., Paris: Grasset & Fasquelle, 1973).

128. Raffalovich, "Les groupes uranistes à Paris et à Berlin," 927–28.

129. Nicolas Edme Restif de la Bretonne, *Les nuits de Paris, ou le Spectateur nocturne* (1788–1794; repr., Paris: Gallimard, 1986), 71–74.

130. Marquis de Sade, *Philosophy of the Bedroom* [1795], 5th dialogue, trans. Richard Seaver and Austryn Wainhouse, accessed 12 August 2013, http://easywaytowrite.com/philosophy_in_the_bedroom.pdf. (trans. modified—Trans.)

131. Michael Lucey, *The Misfit of the Family: Balzac and the Social Forms of Sexuality* (Durham: Duke University Press, 2003), 97–109. In 1824 the Marquis de Custine was assaulted, beaten, and robbed by a group of soldiers, to one of whom the Marquis had made sexual advances.—Trans.

132. Philippe Berthier, "Balzac du côté de Sodome," *Année balzacienne*, 1979: 160. This pioneering article (147–70) is the first to analyze inversion in Balzac.

133. Lucey, *The Misfit of the Family*, 98.

134. Honoré de Balzac, *Splendeurs et misères des courtisanes, la Comédie humaine*, vol. 6 (Paris: Bibliothèque de la Pléiade, n.d.), 814–15. Cited by Laure Murat, "La tante, le policier et l'écrivain: pour une proto-sexologie de commissariats et de romans," *Revue d'histoire des sciences humaines* 17 (2007): 47–59.

135. This is where the theory of homosexual "plot" comes in. Thus, while homosexual visibility (often linked to effeminacy) is criticized, its invisibility leads one to believe paradoxically that homosexuals are organized into secret micronetworks, acting behind the scenes, considered in the same way as Jews. Homosexuals and Jews are the scapegoats blamed for the social malaises of the period. The terms "confederacy," "sect," or "syndicate" are frequently used. On this topic, see: Régis Revenin, "Le complot homosexuel," in *Homosexualité et prostitution masculines à Paris*, 99–102. Marcel Proust, in *Sodom and Gomorrah*, trans. C. K. S. Moncrieff and T. Kilmartin (New York: Random House, 1993), writes this: "Forming a freemasonry far more extensive, more effective and less suspected than that of the Lodges, for it rests upon an identity of tastes, needs, habits, dangers, apprenticeship, knowledge, traffic, vocabulary, and one in which even members who do not wish to know one another recognize one another immediately by natural or conventional, involuntary or deliberate signs" (23).

136. Deborah Gutermann, "Mal du siècle ou mal du 'sexe': les identités sexuées romantiques aux prises avec le reel," *Sociétés et representations* 24 (2007): 195–210. See also Lucey, *The Misfit of the Family*.

137. Achille Essebac, *Dédé* (Paris: Ambert, 1901); Essebac, *Luc* (Paris: Ambert, 1902); Essebac, *L'élu* (Paris: Ambert, 1903).

138. Jean-Gustave Binet-Valmer, *Lucien* (Paris: Ollendorff: 1910), 31.

139. André Gide, *L'immoraliste* (1902; repr., Paris: Mercure de France, 1970).

140. André Gide, *Saül* (1896; repr., Paris: Gallimard, 1922).

141. André Gide, *Si le grain ne meurt* (1920–1926; repr., Paris: Gallimard, 1972), 348.

142. André Gide, *Le ramier* (1907; repr., Paris: Gallimard, 2002).

143. Proust evokes this mixture of the worldly homosexual of the *Belle Époque* and young proletarians: "In this life of anachronistic fiction the ambassador is a bosom friend of the felon, the prince, with a certain insolent aplomb born of his aristocratic breeding which the timorous bourgeois lacks, on leaving the duchess's party goes off to confer in private with the ruffian" (*Sodom and Gomorrah*, 23).

144. Marcel Proust, *Time Regained* [1927], trans. A. Mayor and T. Kilmartin (New York: Modern Library, 1999), 217. The scene of the baron de Charlus being flagellated by a young sailor is found on p. 181ff.

145. Proust, *Sodom and Gomorrah*, 19–20.

146. Ibid., 40.

147. Elisabeth Ladenson, *Proust's Lesbianism* (Ithaca: Cornell University Press, 1999).

148. APP, series BM2, no. 43, police report of 19 January 1918.

149. Gustave Macé, *Mes lundis en prison* (Paris: Charpentier, 1889), 160–61.

150. APP, series BB4 and BB5, "Pédés" registry.

151. Albert Bataille, "Affaire Mielle dit la Belle Nana," in *Causes criminielles et mondaines 1885* (Paris: Dentu, 1886), 57–75.

152. See especially *La Gazette des tribunaux*, 25 April and 2 and 4 May 1891.

153. APP, series BM2, no. 65.

154. APP, series BA 1690.

155. APP, series BM2, no. 65, police report of 19 January 1890.

156. Egon Erwin Kisch, *La chute du colonel Redl. Enquête sur la fin de L'Autriche-Hongrie* (1924; repr., Paris: Desjonquières, 1992).

157. André Rauch, *Histoire du premier sexe. De la Révolution à nos jours* (2000; repr., Paris: Hachette Littératures, 2006).

158. George L. Mosse, *The Image of Man: The Creation of Modern Masculinity* (New York: Oxford University Press, 1996), 113.

159. APP, series BM2, no. 16, anonymous letter received on 9 March 1915 at the Préfecture de Police.

160. APP, series BA 1690, "Notes sur la pédérastie" (n.d., most likely late 1910s).

161. *L'Intransigeant*, 9 January 1918, "Boulevardiers suspects."

162. APP, series BM2, no. 61, police note of 6 April 1903.

163. APP, series BA 1690, "Notes sur la pédérastie."

164. APP, series BM2, no. 57, police report of 6 June 1907 concerning the bathhouse at 160 rue Oberkampf (11th arrondissement).

165. APP, series BA 1690, "Notes sur la pédérastie."

166. Ibid.

167. Ibid.

168. APP, series BM2, no. 37, police report of 8 March 1866.

169. APP, series BM2, no. 60, anonymous undated letter (probably August 1895).

170. APP, series BM2, no. 15, police report of 20 November 1893.

171. APP, series BM2, no. 15, police report of 3 November 1893.

172. Lever, *Les bûchers de Sodome*; Rey, "Police et sodomie"; Merrick, "Sodomitical Inclinations"; Jeffrey Merrick, "Commissioner Foucault, Inspector Noël and the Pederasts of Paris, 1780–1783," *Journal of Social History*, vol. 32, no. 2 (Winter, 1998): 287–307; Merrick, "Nocturnal Birds"; Sibalis, "High-Heels or Hiking Boots?"

173. As mentioned above, these registries from the Parisian police archives cover the whole first part of the nineteenth century.

174. APP, series BB5, "Pédés" registry, no. 293, June 1853. Cited by Murat, "La tante, le policier et l'écrivain." See also Laure Murat, *La loi du genre. Une histoire culturelle du "troisième sexe"* (Paris, Fayard, 2006).

175. Benjamin Tarnowsky, *L'instinct sexuel et ses manifestations morbides au double point de vue de la jurisprudence et de la psychiatrie* (1898; repr., Paris: Carrington, 1904), 31.

176. René Jude, *Les dégénérés dans les bataillons d'Afrique* (Vannes: Le Beau, 1907), 66.

177. Charles Perrier, *Les criminels. Étude concernant 859 condamnés*, vol. 2 (Paris: Maloine, 1905), 203–07. On this question, see Dominique Kalifa, *Biribi. Les bagnes coloniaux de l'armée française* (Paris: Perrin, 2009), 242–63.

178. Revenin, *Homosexualité et prostitution masculines à Paris*.

179. APP, series BM2, no. 38, extract from dossier no. 599.621, 1903.

180. Gil Mihaely, "L'émergence du modèle militaro-viril: pratiques et représentations masculines en France au XIX^e siècle" (doctoral thesis in history, École des Hautes Études en Sciences, 2004). I am grateful to Gil Mihaely for having communicated to me the unpublished chapters of his research, especially on the mustache. See also by the same author: "Un poil de différence: masculinités dans le monde du travail (années 1870–1900)," in Revenin, *Hommes et masculinités de 1789 à nos jours*, 128–45; and Mosse, *The Image of Man*, 92–106.

181. APP, series BM2, no. 15, police report of 16 May 1905.

182. APP, series BM2, no. 59, police report of 2 June 1904.

183. Dr. Jaf, *Sécurité des deux sexes en amour. Hygiène des sexes. La stérilité vaincue. L'infécondité volontaire. Étude médicale . . .* (Paris: De Porter, 1907), 96.

184. APP, series BA 1690, police report of 21 March 1904.

185. Edward I. Prime-Stevenson, *The Intersexes: A History of Similisexualism as a Problem in Social Life* (privately published, n.d., preface 1908). Chapters 8 and 10 were translated and published in France in 2003; the original edition, apparently published in 1909–1910, came out under the pseudonym Xavier Mayne.

186. APP, series BA 1690, police report of 21 March 1904.

187. Roger Peyrefitte, *Les amours singulières. La maîtresse de piano. Le Baron de Gloeden* (Paris: Vigneau, 1949; rev. ed. Paris: Vigneau "Textes gais," 2008).

188. Judith Butler, *Gender Trouble* (New York: Routledge, 1990); see also J.-P. Gaudillière, "On ne naît pas homme . . . À propos de la construction biologique du masculin," *Mouvements* 31 (2004): 15–23; Ilana Löwy, *L'emprise du genre. Masculinité, féminité, inégalité* (Paris: La Dispute, 2006).

189. André Gide, *Corydon* (1911; 1924; repr., Paris: Gallimard, 1993).

13. THE GREAT WAR AND THE HISTORY OF VIRILITY

1. André Rauch, *Le premier sexe. Mutations et crise de l'identité masculine* (Paris: Hachette, 2000), 253.

2. George L. Mosse, *The Image of Man: The Creation of Modern Masculinity* (New York: Oxford University Press, 1996), 51.

3. Ibid., 44.

4. Anne-Marie Sohn, *"Sois un homme!" La construction de la masculinité au XIX^e siècle* (Paris: Seuil, 2009).

5. Françoise Thébaud, "Femmes et genre dans la guerre," in *Encyclopédie de la Grande Guerre, 1914–1918*, ed. Stéphane Audoin-Rouzeau and Jean-Jacques Becker (Paris: Bayard, 2004), 619.

6. I am adopting here, of course, Georges Vigarello's expression in *Le corps redressé. Histoire d'un pouvoir pédagogique* (Paris: Delarge, 1978). I refer also to Stéphane Audoin-Rouzeau's chapter "Massacres. Le corps et la guerre," in *L'histoire du corps*, vol. 3, *Le XX^e siècle. Les mutations du regard*, ed. Jean-Jacques Courtine (Paris: Seuil, 2006), 281–320.

7. Gabriel Chevallier, *La peur* (Paris: Stock, 1930), 54.

8. Ibid., 228–29.

9. Joanna Bourke, *Dismembering the Male: Men's Bodies, Britain and the Great War* (London: Reaktion, 1996).

10. Ibid., 33.

11. Cited in ibid., 34–35.

12. Georges Duhamel, *Civilisation, 1914–1917* (Paris: Mercure de France, 1918), 38.

13. Sophie Delaporte, "Névroses de guerre," in Audoin-Rouzeau and Becker, *Encyclopédie de la Grande Guerre*, 357–65.

14. Bruno Cabanes, "Démobilisation et retour des hommes," in Audouin-Rouzeau and Becker, *Encyclopédie de la Grande Guerre*, 1060.

15. M. Creach-Henry and D. Marten, *The Unknown Warrior* (London, 1923). Cited by Bourke, *Dismembering the Male*, 75.

16. The drawing appeared in *The Sphere* in September 1918. Illustration presented by Bourke, *Dismembering the Male*, 32.

17. Ibid., 58.

18. Ibid., 60.

19. Mosse, *The Image of Man*, 105.

20. The reader is referred to the third chapter of part 2 in the third volume of the original French edition of *Histoire de la virilité*, not included here: "Armées et guerres aux XX^e et XXI^e siècles: une brèche au coeur du modèle viril?" [Armies and wars in the twentieth and twenty-first centuries: a crack in the foundation of the virile model?] (Paris: Seuil, 2011), esp. 201–03.

14. ORIGINS AND TRANSFORMATIONS OF MALE DOMINATION

1. *The Politics of Hope* (Boston: Houghton Mifflin, 1962), orig. in *Esquire*, Nov. 1958.

2. *Masculin-Féminin. La pensée de la différence* (Paris: Odile Jacob, 1996); *Masculin-Féminin II. Dissoudre la hiérarchie* (Paris: Odile Jacob, 2002).

3. On the notion of "hegemonic masculinity," close to what is understood in these pages as "virility," see R. W. Connell, *Masculinities* (Berkeley: University of California Press, 1995).

4. Françoise Héritier, "Introduction," *Hommes, femmes. La construction de la différence* (Paris: Le Pommier/Cité des sciences et de l'industrie, 2005), 30.

5. Pierre Bourdieu, *La Domination masculine* (Paris: Seuil, 1998). *Masculine Domination,* Trans. Richard Nice (Stanford: Stanford University Press, 2002), 4 (trans. modified). —Trans.

6. See on this topic the contribution by Christopher Forth in the original edition of *Histoire de la virilité* (Paris: Seuil, 2011), vol. 3, I,5, 131–55; and his *Masculinities in the Modern West* (New York: Palgrave Macmillan, 2008).

7. On these questions, please consult especially, for France, the work of André Rauch, in particular, *Histoire du premier sexe. De la Révolution à nos jours* (Paris: Hachette littératures, 2006; also Christopher Forth and Bertrand Taithe, *French Masculinities: History, Culture & Politics* (New York: Palgrave Macmillan, 2007); Judith Surkis, *Sexing the Citizen: Morality & Masculinity in France* (Ithaca: Cornell University Press, 2006).

8. On this point, see George L. Mosse, *The Image of Man: The Creation of Modern Masculinity* (New York: Oxford University Press, 1996).

9. Judith Butler, *Gender Trouble: Feminism and the Subversion of Identity* (New York: Routledge, 1999).

10. Bourdieu, 75–76; trans. 50–51 (trans. modified).

11. Françoise Héritier, ed., *Hommes, femmes. La construction de la différence* (Paris: Le Pommier/Cité des sciences et de l'industrie, 2005), esp. introduction (chap. 1, "Théorie anthropologique de l'évolution") and chap. 11, "Construction d'un autre modèle du rapport des sexes. Peut-on le fonder sur l'absence de hiérarchie?"

12. Ibid., 45–46.

13. On the archaic forms, see Lewis H. Morgan, *Ancient Society, or Researches in the Lines of Human Progress from Savagery Through Barbarism to Civilization* (1877; repr., New York: Gordon, 1976).

14. See, in particular, on the representations of strength and power, the tradition of treaties on the education of princes in Claudine Haroche, *L'avenir du sensible* (Paris: Presses Universitaires de France, 2008), chap. 1, "Se gouverner, gouverner les autres."

15. Male domination in Western societies only is treated here.

16. Maurice Halbwachs, "Conscience individuelle et esprit collectif," in *Classes sociales et morphologie* (1938; repr., Paris: Minuit, 1972), 160–61.

17. Cornelius Castoriadis, *La montée de l'insignifiance* (Paris: Seuil, 1996).

18. Marcel Mauss, *Sociologie et anthropologie* (1950; repr., Paris: Presses Universitaires de France, 2004); more recently, Carlo Ginzburg, "Signes. Traces. Pistes. Essai pour un paradigme de l'indice" [1979], reprinted in *Morphologie et histoire* (Paris: Aubier, 1989).

19. Émile Durkheim, *Les règles de la méthode sociologique* (1894; repr., Paris: Flammarion, "GF," 1988), 95, 97.

20. Max Weber, "Les catégories de la sociologie," in *Économie et société* (1956; repr., Paris: Pocket, "Agora," 1995), 28–29.

21. Sigmund Freud, *Civilization and Its Discontents* [1929], trans. Joan Riviere, in *The Major Works of Sigmund Freud* (Chicago: Encyclopedia Britannica, 1952), 787.

22. Marie-France Irigoyen, *Le harcèlement moral. La violence perverse au quotidien* (1998; repr., Paris: Syros, 2009); Brigitte Grésy, *Petit traité contre le sexisme ordinaire* (Paris: Michel, 2009).

23. Bourdieu, *La domination masculine*, 84; trans, 58.

24. Grésy, *Petit traité contre le sexisme ordinaire*, 27–28.

25. Ibid., 28.

26. Ibid., 31

27. Ibid.

28. Ibid., 41.

29. Ibid., 45.

30. Ibid., 50.

31. Max Weber, *Le savant et le politique* (1919; repr., Paris: Plon, 1959), 95–96.

32. Max Weber, *économie et société*, vol. 2 (1921; repr., Paris: Plon, 1971; repr., Paris: Pocket, "Agora," 1995), chap. 4, "Les relations communautaires ethniques," 124.

33. Weber, *Le savant et le politique*, 96.

34. Weber, *Économie et société*, 127.

35. Walter Lacqueur, *Young Germany: A History of the German Youth Movement* (1962; repr., New Brunswick: Transaction, 1984); Peter Gay, *The Cultivation of Hatred: The Bourgeois Experience, Victoria to Freud*, vol. 3 (New York: Norton, 1993); and Gay, *Weimar Culture: The Outsider and Insider* (New York: Harper & Row, 1968).

36. Lacqueur, *Young Germany*, vii.

37. Ibid.

38. Note that the French word *impuissance* means both "powerlessness" and "impotence." The reader of the original text may think of "impotence" underlying "powerlessness," if only unconsciously, upon seeing the word *impuissance*. —Trans.

39. Gay, *The Cultivation of Hatred*, vol. 3, 95. See also Mosse, *The Image of Man*.

40. Ibid., 112.

41. Ibid., 96.

42. Elias Canetti, *Crowds and Power* (New York: Farrar, Straus & Giroux, 1984); see also Serge Moscovici, *La société contre nature* (Paris: 10/18, 1972); Eugène Enriquez, *De la horde à l'État. Essai de psychanalyse du lien social* (Paris: Gallimard, 1983).

43. The *freikorps* are militias that, after World War I, were to put down workers' revolts: they would later constitute the first soldiers of Nazism. On these questions, see Klaus Theweleit, *Male Fantasies* (1977; repr., Minneapolis: University of Minnesota Press, 1987), two volumes.

44. Klaus Theweleit, "Postface (2007)," in Jonathan Littell, *Le sec et l'humide. Une brève incursion en territoire fasciste* (Paris: L'Arbalète/Gallimard, 2008), 118; and Klaus Theweleit, *Male Fantasies*, 1:220–21.

45. Theweleit, "Postface," 122.

46. Ibid., 123, 130. Theweleit propounds the hypothesis according to which there is "a *universal structure* 'of the' male-soldier's body" that is manifested by a violence that "can be found in virile culture, be it Eurasian-American, Japanese or Islamic" (123).

47. Ibid., 117. See Wilhelm Reich, *The Mass Psychology of Fascism* (1933; repr., New York: Orgone Institute Press, 1946). Michael Haneke's film, *The White Ribbon* (2009), conveys perfectly this atmosphere.

48. Héritier, *Hommes, femmes*.

49. Max Horkheimer, "Authority and Family" [1936], in *Critical Theory: Selected Essays* (New York: Herder and Herder, 1972), 47–128. Horkheimer specifies that, for the family, it involves an explicit function whose appearance he dates "from the period of Reform and absolutism," noting that it continues "until the liberal era," at which time one sees "the claim of a new stage in authoritarian education." See also Erich Fromm, *Escape from Freedom* (New York: Farrar & Rinehart, 1941) (aka *Fear of Freedom* [(London: K. Paul, Trench, Trubner, 1942]).

50. Horkheimer, "Authority and Family," 107.

51. Wilhelm Reich, for his part, stressed that at the same time it is the family situation that helps us understand or decipher "the emotional foundation of character structure," the structure of the character and the characterological aspect of an individual, in the authoritarian patriarchal family (*The Mass Psychology of Fascism*, ed. Mary Higgins and Chester M. Raphael [New York: Farrar, Strauss and Giroux, 1970)].

52. The fascist personality appears as a particular, caricature-like form of the authoritarian personality.

53. Sigmund Freud, "The Ego and the Id" [1923], trans. J. Riviere and J. Strachey (New York: Norton, 1960).

54. Ibid., 49.

55. Sigmund Freud, *The Origins of Psychoanalysis: Letters to Wilhelm Fliess, Drafts and Notes, 1887–1902* (New York: Basic, 1954).

56. Adam Phillips, "L'impuissance de Freud," *Penser/Rêver* 15 (Spring 2009):11–40, 23.

57. Ibid, 23.

58. Sigmund Freud, *The Future of an Illusion* (1927; repr., New York: Liveright, 1928), cited in Phillips, "L'impuissance de Freud," 25.

59. Ibid.

60. Ibid., 18.

61. Ibid., 26.

62. Bourdieu, *La domination masculine*, 75; trans. 50.

63. See Jean Cournut, *Pourquoi les hommes ont peur des femmes* (2001; repr., Paris: Presses Universitaires de France, 2006).

64. Héritier, *Hommes, femmes*, 13. See also what Reich (*The Mass Psychology of Fascism*) stressed, in a radically different context, that of domination, the "subjugation of the oppressed class by the owners of the social means of production [which] takes place very rarely by brute force: their principal weapon is their ideological power over the oppressed" (46).

65. Héritier, *Hommes, femmes*, 180.

66. Ibid., 182–83.

67. With the decline of mediations and protections, dependency has become at present a crucial social question: the gap between the weak and the strong has increased considerably, the strong becoming stronger and stronger, the weak more and more numerous and vulnerable.

68. Claudine Haroche, "L'individu dans l'illimitation des sociétés contemporaines," in *L'émergence de l'individu entre formes substantielles et droits essentiels*, ed. Annette Ruelle (Bruxelles: Facultés universitaires Saint-Louis, 2010).

69. Donald Winnicott, postscript in *Playing and Reality* (London: Tavistock, 1971).

70. Cournut, *Pourquoi les hommes ont peur des femmes*, 49.

15. VIRILITIES ON EDGE, VIOLENT VIRILITIES

1. Anne-Marie Sohn, *"Sois un homme!" La construction de la masculinité au XIXᵉ siècle* (Paris: Seuil, 2009), 389ff.

2. *L'Aurore*, 17 January 1962.

3. A parallel may be drawn with childhood. Parental discipline, laid down in the Napoleonic Code of 1804, was for a long time considered essential to the child's education. Beginning with the law of 1889 allowing for a decline of parental rights, parental discipline is reduced and then finally disappears in 1970 in terms of law.

4. Daniel Welzer-Lang, *Les hommes violents* (Paris: Payot, 1991), 157.

5. Divorce: Naquet Law of 1884; law of 1875 introducing common consent. Adultery: law of 1975 suppressing its criminal character. Rape and indecent exposure: law of 1980.

6. Welzer-Lang, *Les hommes violents*, 75,

7. Victoria Vanneau, "Maris battus, histoire d'une interversion des rôles conjugaux," *Ethnologie française* 36:4 (April 2006): 699.

8. Daniel Lagache, *La jalousie amoureuse. Psychologie descriptive et psychanalytique*, vol. 2, *La jalousie vécue* (Paris: Presses Universitaires de France, 1947), 118.

9. Joseph Lévy-Valensi, *Les crimes passionnels,* Report to the congress on legal medicine (Paris: Baillière, April 1931).

10. Luc Capdevila, François Rouquet, Fabrice Virgili, and Danièle Voldman, *Hommes et femmes dans la France en guerre (1914–1945)* (Paris: Payot, 2003).

11. Florence Vatin, "Évolution historique d'une pratique: le passage de l'adultère à l'infidélité," *Sociétés* 75 (January 2002): 91–98.

12. Géo London, "La soudaine colère d'un mari cacochyme … et complaisant," *Les Grands Procès de l'année 1930* (Paris: Les Éditions de France, 1931), 163–67.

13. Lagache, *La jalousie amoureuse*, 2:93.

14. Criminal unit, A-1939/4, Di C . . . , 17 June 1939, Bondy, Police Commission Archives, Paris.

15. Ibid.

16. Antoine Prost, "Frontières et espaces du privé," in *Histoire de la vie privée*, vol. 5, ed. Antoine Prost and Gérard Vincent (Paris: Seuil, 1987), 78.

17. While, from 1938, the married woman no longer lacks civil standing, may have a passport and open a bank account without the permission of her husband, the latter holds onto the prerogatives of where to live, whether she may exercise a profession, and paternal authority.

18. Daniel Lagache, "Les états de la jalousie et le problème de la conscience morbide," in *La jalousie amoureuse. Psychologie descriptive et psychanalytique*, vol. 1, *Les états de jalousie et le problème de la conscience morbide* (Paris: Presses Universitaires de France), 265.

19. *L'Aurore*, 22 May 1962.

20. Irène Nemirovsky, *Deux* (Paris: Albin Michel, 1939), 137.

21. Lagache, *La jalousie amoureuse*, 2:119.

22. Criminal unit, A-1920/15, M . . . , 8 October 1920, Police Commission Archives, Paris.

23. Georges Simenon, *Le coup de vague* (Paris: Gallimard, 1939).

24. Welzer-Lang, *Les hommes violents*, 128.

25. Édouard Peisson, *Une femme* (Paris: Grasset, 1934), 67. Somewhat forgotten today, Peisson was a member of the group of "proletarian writers" and a prolific author of the 1930s.

26. Criminal unit, A-1949/2, C . . . , March 1949, Paris, Police Commission Archives, Paris.

27. Police Commission Archives, C^B 36/36, Paris: logbook of the Barbès commissioner, 1 September 1934–13 July 1935, no. 886, 1 June 1935, Class: "Simple assaults."

28. Judicial police order, sentencing report, A-1934/3, M . . . , 53 rue de Belleville, Paris, Police Commission Archives, Paris.

29. Maryse Jaspard, "Les violences conjugales en Europe," in *Le livre noir de la condition des femmes*, ed. Christine Ockrent and Sandrine Treiner (Paris: XO Éditions, 2006), 245.

30. Paul Voivenel, *Du timide au satyre* (Paris: Librairie des Champs-Élysées, 1933), 7.

31. Lagache, *La jalousie amoureuse*, 2:252–57.

32. Ibid., 55.

33. Ibid., 247

34. Welzer-Lang, *Les hommes violents*, 210.

35. Émile Garçon, *Code pénal annoté*, vol. 2 (Paris: Sirey, 1952).

36. Lévy-Valensi, *Les crimes passionnels*, 19.

37. Ferri, cited in Lévy-Valensi, *Les crimes passionnels*, 56.

38. Lévy-Valensi, *Les crimes passionnels*.

39. Ibid., 50.

40. Lagache, vol. 1, 295.

41. General administration, national police, *Étude nationale sur les morts violentes au sein du couple—2008* (Paris: Interior Ministry, 2009), 19.

42. Criminal unit, A-1928/12, T . . . , Paris, Police Commission Archives, Paris.

43. Criminal unit, A-1944/4, D . . . , Bobigny, Police Commission Archives, Paris.

44. "Drame de la séparation," *L'Aurore*, 5 November 1962, cited by Issam Sleiman, "Le crime passionnel" (doctoral thesis in law, University of Paris, 1964), 213.

45. General administration of the national police, "*Étude nationale sur les morts violentes au sein du couple—2008*," 19.

46. Criminal unit, A-1944/2, B..., 1 February 1944, Paris, Police Commission Archives, Paris.

47. Criminal unit, A-1949/2, C..., 6 April 1949, Paris, Police Commission Archives, Paris, testimony of the murderer's mother.

48. Lagache, *La jalousie amoureuse*, 2:246.

49. The use of sulfuric acid, or vitriol, is by no means new: Gustave Macé, *La police criminelle. Femmes criminelles* (Paris: Fasquelle, 1904), 8.

50. Police Commission Archives, C^B 36/36, logbook of the Barbès commissioner, 1 September 1934–13 July 1935, no. 272, 15 February 1935, "Battery and injuries that resulted in unintentional death."

51. On this topic, see Fabrice Virgili, *La France "virile." Des femmes tondues à la Libération* (Paris: Payot, 2000).

52. Lévy-Valensi, *Les crimes passionnels*, 65.

53. This trial, which involved a minor who terminated a pregnancy with the help of her mother and three other women, caused a huge, prolonged controversy in France and led to a relaxing of anti-abortion statutes and ultimately to the decriminalization of abortion in 1975.—Trans.

54. Benoîte Groult, preface in Susan Brownmiller, *Le viol* (Paris: Stock, 1976), 12.

55. The three lawyers were Anne-Marie Krywin, Marie-Thérèse Cuvelier, and Gisèle Halimi.

56. Corine Briche, "La souffrance de la jeune fille violée: de la barbarie de l'acte . . . au poids de l'indifférence et de la suspicion," *Pensée plurielle* 8 (February 2004): 69–80.

57. Marcela Iacub, *Le crime était presque sexuel* (Paris: EPEL, 2000), 39.

58. Dominique Fougeyrollas-Schwebel, Helena Hirata, and Danièle Senotier, "La violence, les mots, le corps," *Cahiers du genre* 35 (2003): 57.

59. Welzer-Lang, *Les hommes violents*, 34.

60. Marie-Victoire Louis, *Le droit de cuissage: France, 1860–1930* (Paris: L'Atelier, 1994).

61. Elizabeth Brown, Dominique Fougeyrollas-Schwebel, and Maryse Jaspard, "Les paroxysmes de la conciliation. Violence au travail et violence du conjoint," *Travail, genre et sociétés* 8 (February 2002): 149–65.

62. Marie-Victoire Louis, "Harcèlement sexuel et domination masculine," in *Un siècle d'antiféminisme*, ed. Christine Bard (Paris: Fayard, 1999), 401–16.

63. Jean-Claude Lauret and Raymond Lasierra, *La torture propre* (Paris: Grasset, 1975).

64. Third Council of Europe Conference of Ministers Responsible for Equality Between Women and Men, Rome, 21–22 October 1993.

65. Platform for action, cited in Jaspard, "Les violences conjugales en Europe," 249.

66. Maryse Jaspard, Elizabeth Brown, and Stéphanie Condon, *Les violences envers les femmes en France. Une enquête nationale* (Paris: Labor Ministry, 2003).

67. Stanley Kubrick's film, *A Clockwork Orange*, which came out in 1971, also puts this phenomenon on view.

68. Laurent Macchielli, "Approche sociologique de la violence sexuelle. Le cas des viols collectifs," *Stress et Trauma* 8 (2008): 243–52.

69. Ibid., 247.

70. Christine Castellain-Meunier, *Les hommes aujourd'hui. Virilité et identité* (Paris: Acropole, 1988), 84–85, cited by Welzer-Lang, *Les hommes violents*, 127.

71. Title of the Statistical Report of the National Observatory on Delinquency, *Grand Angle* 14 (July 2008).

16. VIRILITY THROUGH THE LOOKING GLASS OF WOMEN

1. Virginia Woolf, *A Room of One's Own* (New York: Harcourt, Brace, 1929), 35–36.

2. Ibid., 36.

3. Marcelle Capy, *Des hommes passèrent* (Paris: Éditions du Tambouin, 1930), 189.

4. Simone de Beauvoir, *Le deuxième sexe*, vol. 1, *Les faits et les mythes* (Paris: Gallimard, 1949; rev. ed. "Folio," 1976), 257.

5. Françoise d'Eaubonne, *Mémoires irréductibles de l'entre-deux-guerres à l'an 2000* (Paris: Dagorno, 2001), 101.

6. *La Donna Fascista*, 18 December 1939, cited by Denise Detragiache, "De la 'mamma' à la 'nouvelle Italienne': la presse des femmes fascistes de 1930 à 1942," in *La tentation nationaliste, 1914–1956*, ed. Rita Thalmann (Paris: Tierce, 1990), 150.

7. Jean-Paul Sartre, "Qu'est-ce qu'un collaborateur?" [1945], cited by Tony Judt, *Un passé imparfait. Les intellectuels en France 1944–1956* (Paris: Fayard, 1992), 64.

8. Nicole Gabriel, "Un corps à corps avec l'histoire: les feministes allemandes face au passé nazi," in Thalmann, *La tentation nationaliste*, 226.

9. Woolf, *A Room of One's Own*, 106.

10. Adolf Hitler, *Mein Kampf*, vol. 2 (Munich: Eher, 1925), 455, cited by Rita Thalmann, *Être femme sous le III^e Reich* (Paris: Laffont, 1982), 73.

11. Thalmann notes that in *Mein Kampf*, "Woman [is] always called *Weib*, [an] archaic or biological term, which had become more or less pejorative in ordinary usage, as opposed to the modern term *Frau*" (*Être femme sous le III^e Reich*, 66).

12. Cited by Claudia Koonz, *Les mères-patrie du III^e Reich. Les femmes et le nazisme*, trans. from English (Paris: Lieu commun, 1989), 237; orig. *Mothers in the Fatherland: Women, the Family and Nazi Politics* (New York: St. Martin's, 1988), 180.

13. Thalmann, *Être femme sous le III^e Reich*, 65.

14. Cited ibid., 72.

15. Guida Diehl, *Die deutsche Frau und der Nationalsozialismus*, cited ibid., 73.

16. The expression is Françoise Thébaud's, in *Histoire des femmes en Occident*, ed. Georges Duby and Michelle Perrot, vol. 5, *Le XX^e siècle*, ed. Françoise Thébaud (Paris: Plon, 1992).

17. Rita Thalmann, "Les femmes, les fascismes et l'antifascisme dans l'Europe des années 1930–1940," in *Les femmes dans les années quarante*, ed. Jacques Fijalkow (Paris: Éditions de Paris Max Chaleil, 2004), 17.

18. Interviewed by Koonz, *Les mères-patrie du III^e Reich*, 43; *Mothers in the Fatherland*, 14.

19. Vital space. For women, "a peaceful social sphere within which women of all classes and ages would cooperate to revive the gospel of love and harmony" (Koonz, *Les mères-patrie du III^e Reich*, 43; *Mothers in the Fatherland*, 13).

20. Karine Windaus-Walser, "La 'grâce de la naissance féminine:' un bilan," in *Féminisme et nazisme*, ed. Liliane Kandel (Paris: Jacob, 2004), 225–35.

21. Cited by Carmen Domingo, *Histoire politique des femmes espagnoles. De la II^e République à la fin du franquisme* (Rennes: Presses Universitaires de Rennes, 2008), 149.

22. Cited by Victoria de Grazia, "Le patriarcat fasciste—Mussolini et les Italiennes—1920–1940," in Thébaud, *Le XX^e siècle*, 124.

23. *Giornale della donna*, 15 August–1 September 1930, cited by Detragiache, "De la 'mamma' à la 'nouvelle Italienne,'" 148.

24. Maria Rosa Urraca Pastor, *Memoria de una enfermera* (Barcelona: Juventud, 1939), cited by Domingo, *Histoire politique des femmes espagnoles,* 107.

25. "In the sense that she locates the center of her pleasure and her ambition not in herself but in a person she loves and wants to be loved by: husband, children, father, friend, etc.," Gina Lombroso, *L'âme de la femme*, rev. ed., trans. from Italian by François Le Hénaff (Paris: Payot, 1947), 22.

26. Ibid., 29.

27. Michèle Le Doeuff, *L'étude et le Rouet. Des femmes, de la philosophie, etc.* (Paris: Seuil, 1989)

28. Beauvoir, *Le deuxième sexe*, 1:82.

29. Ibid., 91.

30. Ibid., 394.

31. Simone de Beauvoir, *Le deuxième sexe*, vol. 2 *L'Expérience vécue* (Paris: Gallimard, 1949; rev. ed. "Folio," 1976), 9.

32. Cécile Brunschvicg, "Onze novembre," *La Française*, 11 November 1933.

33. "Militant antimilitarisme," *Choisir*, no. 40 (March–April 1979); "Triste armée!," *Choisir*, June–July 1981.

34. Clara Malraux, *Le bruit de nos pas*, vol. 1 (Paris: Grasset, 1992), 151.

35. "Les femmes soldats," *La Française*, 5 October 1935.

36. This steroidal antiandrogen is prescribed today for female hirsutism, for prostate cancer, and for reduction of the sex drive.

37. Beauvoir, *Le deuxième sexe*, 2:96.

38. "Guerre et paix version," *Choisir*, no. 39 (January–February 1979).

39. Danielle Le Bricquir and Odette Thibault, *Féminisme et pacifisme. Même combat* (Paris: Les Lettres libres, 1985), 30.

40. Nancy Huston, "On ne naît pas homme," *Le Monde*, 16 May 2009.

41. Moïra Sauvage, *Les aventures de ce fabuleux vagin* (Paris: Calmann-Lévy, 2008).

42. Alice Schwarzer, *La petite différence et ses grandes conséquences*, trans. from German by Marthe Wendt and Leslie Gaspar (Paris: Éditions des femmes, 1977), 262, 267.

43. Ibid., 300.

44. Benoîte Groult, *Ainsi soit-elle* (Paris: Grasset, 1975), 191.

45. Luce Irigaray, interviewed in Marie-Françoise Hans and Gilles Lapouge, *Les femmes, la pornographie, l'érotisme* (Paris: Seuil, 1978), 55.

46. Louise Malette and Marie Chalouh, eds., *Polytechnique. 6 décembre* (Montreal: Les Éditions du Remue-Ménage, 1990), 97.

47. As indicated by the title of the work by Quebecois sexologist Yvon Dallaire, *Homme et fier de l'être* [Man and proud of it] (Quebec: Option Santé, 2001).

48. Mélissa Blais and Francis Dupuis-Déri, *Le mouvement masculiniste au Québec. L'antiféminisme démasqué* (Montreal: Les Éditions du Remue-Ménage, 2008), introduction.

49. Cf. Claudie Lesselier and Fiammetta Venner, *L'extrême droite et les femmes* (Villeurbanne: Golias, 1997).

50. Nicole-Claude Mathieu, *L'anatomie politique. Catégorisations et ideologies du sexe* (Paris: Côté femmes, 1991).

51. Adrienne Rich, "La contrainte à l'hétérosexualité," *Nouvelles Questions féministes*, 1 (March 1981):15ff.; orig. "Compulsory Heterosexuality and Lesbian Existence," pamphlet, (London: Onlywomen Press, 1980).

52. Monique Wittig, *The Straight Mind and Other Essays* (Boston: Beacon Press, 1992).

53. Cf. Christine Bard and Nicole Pellegrin, eds., "Femmes travesties. Un 'mauvais' genre," special number, *Clio. Histoire, femmes et société*, 10 (1999); and Sylvie Steinberg, *La confusion des sexes. Le travestissement de la Renaissance à la Révolution* (Paris: Fayard, 2001).

54. Diana Souhami, *The Trials of Radclyffe Hall* (New York: Doubleday, 1999).

55. Masculinized lesbian; a pejorative term perhaps because the "kiki" style originated among young gay men imitating the look of their presumed adversaries, "skinheads" of the 1950s and 1960s. Cf. *infra*, chapter 20, 555.—Trans.

56. Cf. for the American context Joan Nestle, ed., *The Persistent Desire: A Femme-Butch Reader* (Boston: Alyson, 1992); Lily Burana and Roxxie Linnea Due, eds., *Dagger: On Butch Women* (Pittsburgh: Cleis Press, 1994); Sally R. Munt, ed., *Butch/Femme: Inside Lesbian Gender* (London/Washington: Cassel, 1998); and for the French context, Christine Lemoine and Ingrid Renard, eds., *Attirances. Lesbiennes fem/Lesbiennes butch* (Paris: Éditions gaies et lesbiennes, 2001).

57. Dorothy Allison, *Skin: Talking About Sex, Class and Literature* (Ann Arbor, MI: Firebrand, 2005), 127.

58. Gayle Rubin, "The Traffic in Women: Notes on the 'Political Economy' of Sex," in *Deviations: A Gayle Rubin Reader* (Durham: Duke University Press, 2012).

59. Cf. the documentaries: Jennie Livingston, *Paris Is Burning* (1990) and Gabriel Bauer, *Venus Boyz* (2002).

60. Cf. Marie-Hélène Bourcier, *Queer Zones. Politiques des identités sexuelles, des représentations et des saviors* (Paris: Balland, 2001); Bourcier, *Sexpolitiques, Queer Zones 2* (Paris: La Fabrique, 2005); and Marie-Hélène Bourcier and Pascale Molinier, eds., special number, *Cahiers du genre*, "Les fleurs du mâle. Masculinités sans hommes?," 45 (2008).

61. Beatriz Preciado, *Manifeste contra-sexuel*, trans. M.-H. Bourcier (Paris: Balland, 2000). (Cf. infra: Prostheses and Stimulations, ch. 22, 591ff.—Trans.)

62. Judith Halberstam and Del LaGrace Volcano, *The Drag King Book* (New York: Serpent's Tail, 1999); and Halberstam, *Female Masculinity* (Durham: Duke University Press, 1998).

63. Del LaGrace Volcano, *Sublime Mutations* (Tübingen: Konkursbuchverlag, 2000).

64. Pat Califia, *Sex Changes: The Politics of Transgenderism* (Berkeley, CA: Cleis, 1997).

65. Maximilian Wolf Valerio, *The Testosterone Files: My Hormonal and Social Transformation from FEMALE to MALE* (Emeryville, CA: Seal, 2006).

66. Beatriz Preciado, *Testo junkie. Sexe, drogue et biopolitique* (Paris: Grasset, 2008), 319 English: *Testo Junkie: Sex, Drugs, and Biopolitics in the Pharmacopornographic Era*, (New York: The Feminist Press at CUNY, 2013.

67. Ibid., 348.

68. Ibid., 21.

69. Ibid., 347.

70. Kate Bornstein, *Gender Outlaw: On Men, Women and the Rest of Us* (New York: Vintage, 1994), 245.

71. Cf. Christine Bard, *Les garçonnes. Modes et fantasmes des Années folles* (Paris: Flammarion, 1998); and Mary Louise Roberts, *Civilization Without Sexes: Reconstructing Gender in Postwar France, 1917–1927* (Chicago: University of Chicago Press, 1994).

72. Dominique Bourque, "Être ou ne pas être subversives?" *Genre, sexualité et société* 1 (Spring 2009), http://gss.revues.org/index962.html.

73. An American television series (2004–2009) that depicts the life of a group of chic lesbian and bisexual women living in West Hollywood; they are cool, rather feminist on the whole, with some being very feminine.

74. Jules Falquet, "Rompre le tabou de l'hétérosexualité, en finir avec la différence des sexes: les apports du lesbianism comme mouvement social et théorie politique," *Genre, sexualité et société* 1 (Spring 2009), http://gss.revues.org/index705.html.

75. Woolf, *A Room of One's Own*, 36.

17. "ONE IS NOT BORN VIRILE, ONE BECOMES SO"

1. Simone de Beauvoir, *Tout compte fait* (Paris: Gallimard, 1972), 497.

2. Georges Falconnet and Nadine Lefaucheur, *La fabrication des mâles* (Paris: Seuil, 1975); and Élisabeth Badinter, *XY. De l'identité masculine* (Paris: Jacob, 1992).

3. For a synthesis of these diverse works, cf. Christine Guionnet and Érik Neveu, *Féminin-Masculin. Sociologie du genre* (Paris: Armand Colin, 2005).

4. Patricia Mercader and Laurence Tain, eds., *L'éternel masculin*, Cahiers Masculin/Féminin (Lyon: Presses Universitaires de Lyon, 2003), 5–6.

5. Sylvie Schweizer, *Les femmes ont toujours travaillé. Une histoire de leurs métiers. XIXe et XXe siècles* (Paris: Jacob, 2002), 77, 90.

6. Zella Luria, "Genre et étiquetage: l'effet Pirandello," in *Le fait féminin*, ed. Évelyne Sullerot and Odette Thibault (Paris: Fayard, 1978), 237–38; Elena Gianini Belotti, *Du côté des petites filles* (Paris: Éditions des femmes, 1973).

7. Pierre Jakez Hélias, *Le cheval d'orgueil. Mémoires d'un Breton du pays bigouden* (Paris: Plon, "Terre humaine," 1975), 67–68. (Cf. supra, Childhood, or the "Journey toward Virility," ch. 7, esp. 221–25.—Trans.)

8. Léo Clarétie, *Les jouets. Histoire, fabrication* (Le Lavandou: Éditions du Layet, 1982), 286; Stéphane Audoin-Rouzeau, *La guerre des enfants. 1914–1918. Essai d'histoire culturelle* (Paris: Colin, 1993), 46; and Claude Duneton, *Au plaisir des jouets. 150 ans de catalogues* (Paris: Hoëbeke, 2005), 56.

9. Duneton, *Au plaisir des jouets*, 70–72.

10. Antoine Prose, *Histoire de l'enseignement et de l'éducation en France*, vol. 4 (1981; repr., Paris: Perrin, "Tempus," 2004), 115.

11. William F. Whyte, *Street Corner Society: The Social Structure of an Italian Slum* (Chicago: University of Chicago Press, 1943), cited in Guionnet and Neveu, *Féminin-Masculin*, 40.

12. Ephraïm Grenadou, *Grenadou, paysan français* (1966; repr., Paris: Rombaldi, 1980), 57–58.

13. Daniel Fabre, "Faire la jeunesse au village," in *Histoire des jeunes en Occident*, vol. 2, ed. Giovanni Levi and Jean-Claude Schmitt (Paris: Seuil, 1996), 51–83.

14. Grenadou, *Grenadou, paysan français*, 52.

15. Clifford Putney, *Muscular Christianity: Manhood and Sports in Protestant America, 1800–1920* (Cambridge, MA: Harvard University Press, 2001).

16. Nicolas Benoît, *Les Éclaireurs de France* (Paris: Journal des voyages, 1911), 6.

17. Agnès Thiercé, *Histoire de l'adolescence (1850–1914)* (Paris: Belin, 1999), 212–14, 251–52.

18. Pierre Bovet, *Le génie de Baden-Powell* (Neuchâtel/Geneva: Forum, 1921).

19. George L. Mosse, *The Image of Man: The Creation of Modern Masculinity* (New York: Oxford University Press, 1996).

20. Lucette Heller-Goldenberg, "Histoire des auberges de jeunesse en France des origines à la liberation, 1929–1945" (doctoral thesis, Université de Nice, 1985), vol. 1, 345.

21. Michel Lacroix, *De la beauté comme violence. L'esthétique du fascisme français, 1919–1939* (Montreal: Presses de l'Université de Montréal, 2004), 156–57; and André Rauch, *Histoire du premier sexe* (2004; repr., Paris: Hachette, 2006), 349–56.

22. Christophe Pécout, *Les chantiers de la jeunesse et la revitalisation physique et morale de la jeunesse française (1940–1944)* (Paris: L'Harmattan, 2007), 33.

23. Cited in Maurice Crubellier, *L'enfance et la jeunesse dans la société française, 1800–1950* (Paris: Armand Colin, 1979), 258.

24. Béatrice Compagnon and Anne Thévenin, *L'école et la société française* (Brussels: Complexe, 1995), 71; and François Grèzes-Rueff and Jean Leduc, *Histoire des élèves en France. De l'Ancien Régime à nos jours* (Paris: Armand Colin, 2007), 21–27.

25. François Mayeur, *Histoire de l'enseignement et de l'éducation en France*, vol. 3 (1981; repr., Paris: Perrin, "Tempus," 2004), 537–38.

26. Grèzes-Rueff and Leduc, *Histoire des élèves en France*, 198–99.

27. Étiemble, *L'enfant de choeur* (Paris: Gallimard, 1937).

28. Charles Wagner, *Jeunesse* (Paris: Fischbacher, 1892), 341–42.

29. Edmond Goblot, *La barrière et le niveau. Étude sociologique sur la bourgeoisie française moderne* (Paris: Alcan, 1925), 55, 57.

30. Wagner, *Jeunesse*, 343–44.

31. Pierre Arnaud, ed., *Les athlètes de la République. Gymnastique, sport et idéologie républicaine, 1870–1914* (Paris: L'Harmattan, 1998).

32. Fabien Groeniger, *Sport, religion et nation. La Fédération des patronages de France d'une guerre mondiale à l'autre* (Paris: L'Harmattan, 2004).

33. Pierre Arnaud, "Les rapports du sport et de l'éducation physique en France depuis la fin du XIXᵉ siècle," in *Éducation physique et sport en France, 1920–1980*, ed. Pierre Arnaud, Jean-Paul Clément, and Michel Herr (Paris: AFRAPS, 1995), 257.

34. Jean-Louis Gay-Lescot, "Éducation physique et sports scolaires durant l'entre-deux-guerres (1919–1939): des textes à la réalité," in *L'éducation physique au XXᵉ siècle. Approches historique et culturelle*, ed. Jacques Gleyse (Paris: Vigot, 1999), 59–68.

35. Olivier Galland, "Adolescence et post-adolescence: la prolongation de la jeunesse," in *Jeunesse et société. Perspectives de la recherché en France et en Allemagne*, ed. Gérard Mauger, René Gendit, and Christian von Wolffersdorff (Paris: Colin, 1994), 71.

36. Georges Navel, *Travaux* (Paris: Stock, 1945; rev. ed., Paris: Gallimard, "Folio," 1979), 23 and 44–45; and Marthe Perrier, *Le XXᵉ siècle des enfants en Normandie* (Condé-sur-Noireau: Corlet, 2000), 59.

37. Christophe Gracieux, "Jeunesse et service militaire en France dans les années 1960 et 1970. Le déclin d'un rite de passage," in *Jeunesse oblige. Histoire des jeunes en France, XIXᵉ–XXᵉ siècle*, ed. Ludivine Bantigny and Ivan Jablonka (Paris: Presses Universitaires de France, 2009), 215–17.

38. Hélias, *Le cheval d'orgueil*, 445.

39. Odile Roynette, *"Bons pour le service." L'expérience de la caserne en France à la fin du XIXᵉ siècle* (Paris: Belin, 2000), 192.

40. Michel Bozon, *Les Conscrits* (Paris: Berger-Levrault, 1981), 35–36, 43.

41. Falconnet and Lefaucheur, *La fabrication des mâles*, 65.

42. Benjamin Spock, *Dr. Spock's Baby and Child Care*, 8th ed. (New York: Pocket Books, 1992), 164.

43. Benjamin Spock, *Raising Children in a Difficult Time* (New York: Norton, 1974), 253–54.

44. F. Hurstel and G. Delaisi de Parseval, "Mon fils ma bataille," in *Histoire des pères et de la paternité*, ed. Jean Delumeau and Daniel Roche (Paris: Larousse, 2000), 402–04.

45. A. Percheron, "Le domestique et le politique. Types de familles, modèles d'éducation et transmission des systèmes de normes et d'attitudes entre parents et enfants," *Revue française de science politique* 35, no. 3 (1985): 840–91.

46. Évelyne Sullerot, *La crise de la famille* (Paris: Fayard, "Pluriel," 1997), 191.

47. Sandrine Vincent, *Le jouet et ses usages sociaux* (Paris: La Dispute, 2001), 118–12; and *Contre les jouets sexistes* (Paris: L'Échappée, 2007), 41–57.

48. Gilbert Andrieu, *L'éducation physique au XXᵉ siècle. Une histoire des pratiques* (Paris: Actio, 1997), 44–48.

49. Jon Swain, "Masculinities in Education," in *Handbook of Studies on Men and Masculinities*, ed. Michael S. Kimmel, Jeff Hearn, and R. W. Connell (London: Sage, 2005), 215–16; and Guionnet and Neveu, *Féminin-Masculin*, 53.

50. Guionnet and Neveu, *Féminin-Masculin*, 56–58.

51. Source: Institut National de la Statistique et des Études Économiques.

52. Eugène-Jean Duval, *Regards sur la conscription. 1790–1997* (Paris: Fondation pour les études de defense, 1997), 127, 270.

53. Gracieux, "Jeunesse et service militaire en France dans les années 1960 et 1970," 217.

54. Galland, "Adolescence et post-adolescence," 71–76; Galland, "Entrer dans la vie adulte," *Économie et statistiques* 337–338 (July–August 2000): 13–36; and Martine Segalen, *Sociologie de la famille* (Paris: Armand Colin, 2006), 89.

55. Gérard Mauger, *Les bandes, le milieu et la Bohème populaire. Études de sociologie de la déviance des jeunes des classes populaires (1975–2005)* (Paris: Belin, 2006), 20–21.

56. Ibid., 10.

57. Stéphane Beaud and Michel Pialoux, eds., *Violences urbaines, violence sociale. Genèse des nouvelles classes dangereuses* (Paris: Fayard, 2003), 235; and Horia Kebabza and Daniel Welzer-Lang, *"Jeunes filles et garçons des quartiers": Une approche des injonctions de genre* (Toulouse: Université Toulouse Le Mirail, 2003).

58. Ibid.; and Isabelle Clair, *Les jeunes et l'amour dans les cités* (Paris: Armand Colin, 2008), 273–74.

59. Swain, "Masculinities in Education," 217; and Pierre Coslin, *La socialisation de l'adolescent* (Paris: Armand Colin, 2007), 52–55.

60. Ronan Chastellier, *Marketing jeune* (Paris: Pearson Education France, 2003), 49–60.

61. C. J. Pascoe, *Dude, You're a Fag: Masculinity and Sexuality in High School* (Berkeley: University of California Press, 2007); and Michael Kimmel, *Guyland: The Perilous World Where Boys Become Men* (New York: HarperCollins, 2008).

62. Thomas Johansson, *The Transformation of Sexuality: Gender and Identity in Contemporary Youth Culture* (Aldershot, UK: Ashgate, 2007), 73–76.

18. FASCIST VIRILITY

1. Marie-Anne Matard-Bonucci and Pierre Milza, eds., *L'homme nouveau dans l'Europe fasciste (1922–1945). Entre dictature et totalitarisme* (Paris: Fayard, 2004).

2. Claudia Koonz, *The Nazi Conscience* (Cambridge, MA: Harvard University Press, 2003), 147.

3. Klaus Theweleit, *Männerphantasien*, vol. 1, *Frauen, Fluten, Körper, Geshichte* (Frankfurt: Stroemfeld/Roter Stern, 1977). English: *Male Fantasies*, two volumes, trans. Erica Carter, Chris Turner, and Stephen Conway (Minneapolis: University of Minnesota Press, [vol. 1] 1987, [vol. 2] 1989).

4. Jonathan Littell, *Le sec et l'humide* (Paris: Gallimard, 2008).

5. Bruno Malitz, *Die Leibesübungen in der nationalsozialistischen Idee*, no. 46 (Munich: NS Bibliothek, 1934), 43–45.

6. Burkhard Jellonnek, *Homosexuelle unter dem Hakenkreuz. Die Verfolgung von Homosexuellen im Dritten Reich* (Paderborn: Schöningh, 1990); and Jellonnek, *Nationalsozialistischer Terror gegen Homosexuelle. Verdrängt und ungesühnt* (Paderborn: Schöningh, 2002).

7. Régis Schlagdenhauffen, *Triangle rose. La persécution des homosexuels Nazis et sa mémoire* (Paris: Autrement, 2011).

8. Cited in *The Hidden Holocaust?: Gay and Lesbian Persecution in Germany 1933–45*, Günter Grau and Claudia Shoppmann, eds. (Chicago: Fitzroy Dearborn, 1995), 11.

9. Marie-Anne Matard-Bonucci, "Italian Fascism's Ethiopian Conquest and the Dream of a Prescribed Sexuality," in *Brutality and Desire: War and Sexuality in Europe's Twentieth Century*, ed. Dagmar Herzog (Basingstoke, UK: Palgrave Macmillan, 2011), 91–108.

10. Adolf Hitler, Speech at the opening of the Grand Exhibition of German Art of 1938 (Munich, 1938).

11. Cf. Gunnar Brands, "Swischen Island un Athen. Griechische Kunst im Spiegel des Nationalsozialismus," in *Kunst auf Befehl?*, ed. Bazon Brock (Munich: Klinkhardt und Biermann, 1990); and Birgit Bressa, "Nachleben der Antike. Klassische Bilder des Körpers in der NS-Skulptur Arno Brekers" (thesis, University of Tübingen, 2001).

12. Daniel Wildmann, *Begehrte Körper. Konstruktion und Inszenierung des "arischen Menschenkörpers" im Dritten Reich* (Würzburg: Königshausen und Neumann, 1998).

13. Luc Capdevila, "L'identité masculine et les fatigues de la guerre (1914–1945)," *Vingtième Siècle. Revue d'histoire* 75 (July–September 2002): 97–108. Other useful sources are Klaus Wolbert, *Die Nackten und die Toten des Dritten Reiches. Folgen einer politischen Geshichte des Körpers in der Plastik des Deutschen Faschismus* (Giessen: Anabas, 1982); and Wolbert, "Die figurative NS-Plastik," in *Faszination und Gewalt. Zur politischen Ästhetik des Nationalsozialismus* (Nuremberg: Tümmels, 1992), 217–22.

14. David C. Large, *Nazi Games: The Olympics of 1936* (London: Norton, 2007).

15. Carl Diem, *Wir haben gesiegt. Eine Erzählung aus dem Altertum* (Berlin: Reichsport, 1936).

16. Alfred Bäumler, "Antrittsvorlesung in Berlin" [10 May 1933], in *Männerbund und Wissenschaft* (Berlin: Jünker und Dünnhaupt, 1943).

17. Ernst Jünger, *La guerre comme expérience intérieure* [Der Kampf als inneres Erlebnis, 1922], trans. Julien Hervier, François Poncet, and Henri Plard (orig. 1926; repr., Paris: Bourgois, 1997), 59.

18. Sven Reichardt, "Das Geschlecht der Gewalt: Bilder und Rhetorik der Männlichkeit," *Faschistische Kampfbünde. Gewalt und Gemeinschaft im italienishen Squadrismus und in der deutschen SA* (Cologne: Böhlau, 2002), 660–95.

19. Elias Canetti, *Crowds and Power* [Masse und Macht, 1960], trans. Carol Stewart (New York: Farrar, Straus & Giroux, 1984). Canetti contrasts the passivity of the masses, rallied and seduced by the Nazi propaganda machine, with the horde, a vigorous, violent, and determined elite.

20. Adolf Hitler, *Mein Kampf* (Munich: Eher, 1925), 276.

21. Ibid., 454.

22. Cf. Paula Diehl, ed., *Körper im Nationalsozialismus. Bilder und Praxen* (Paderborn: Fink, 2006); and Paula Diehl, *Macht—Mythos—Utopie. Die Körperbilder der SS-Männer* (Berlin: Akademie, 2005).

23. Cf. Johann Chapoutot, *Le National-Socialisme et l'Antiquité* (Paris: Presses Universitaires de France, 2008).

24. On this theme and on that of the relation between hunting and war, cf. Pierre Vidal-Naquet, *Le chasseur noir. Formes de pensée et formes de société dans le monde grec* (Paris: Maspero, 1981); and Christian Ingrao, *Les chasseurs noirs. La brigade Dirlewanger* (Paris: Perrin, 2006).

25. Harald Scholtz, *Erziehung und Unterricht unterm Hakenkreuz* (Gottingen: Vendenhoeck und Ruprecht, 1985).

26. Reichardt, "Das Geschlecht der Gewalt: Bilder und Rhetorik der Männlichkeit."

27. George L. Mosse, *Fallen Soldiers: Reshaping the Memory of the World Wars* (New York: Oxford University Press, 1991).

28. *Das Schwarze Korps*, 2 December 1937, p. 2.

29. Lyrics of the Hitlerjugend anthem from *Hitlerjunge Quex* (Hans Steinhoff, 1933; English title: Our Flags Lead Us Forward), trans. David Calvert Smith (trans. modified), accessed 4 July 2015, https://www.youtube.com/watch?v=HlPAfx1mAJ8 —Trans.

30. Cf. Jean-Luc Leleu, *La Waffen-SS* (Paris: Perrin, 2009), 543.

31. "SS marschiert in Feindesland" cited in Wikipedia, no translator listed, accessed 4 July 2015, https://en.wikipedia.org/wiki/SS_marschiert —Trans.

32. Heinrich Himmler, *Rede des Reichsführers SS in Charkow*, April 1943, BABL NS 19/4010, folio 142.

33. Klaus Gundelach, Leander von Volkmann, Adolf Hitler, and Edmund Heines, *Vom Kampf und Sieg der schlesischen SA. Ein Ehrenbuch—Herausgegeben von des SA-Gruppe Schlesien* (Breslau: Wilhelm Gottlieb Korn, 1933), 58.

34. Benito Mussolini, cited in Ernst Nolte, *Der Faschismus in seiner Epoche. Die Action Française, der italienische Faschismus, der Nationalsozialismus* (Munich: Piper, 1963), 584n399.

35. Hitler, *Mein Kampf*, 318.

36. Éric Michaud, *Un art de l'éternité. L'image et le temps du national-socialisme* (Paris: Gallimard, "Le Temps des images," 1996).

19. WORKING-CLASS VIRILITY

1. Marc Le Bot, "Peinture et machinisme," *Annales* 22, no. 1 (January–February 1967): 1–22.

2. Joris-Karl Huysmans, *Écrits sur l'art* (Paris: Flammarion, "GF," 2008), 130–31.

3. Marie-Laure Griffaton, *François Bonhommé. Peintre témoin de la vie industrielle au XIX* *siècle* (Metz: Serpenoise, 1996).

4. Le Bot, "Peinture et machinisme," 11. The term "humanitarist" is a neologism suggesting futile or utopian humanitarianism—Trans.

5. Maurice Agulhon, "Propos sur l'allégorie politique," *Actes de la recherche en sciences sociales* 28, no. 1 (1979): 27–32, 31.

6. In his novel, *Un pedigree* (Paris: Gallimard, 2005), Patrick Modiano writes about his great-grandfather, a dockworker: "He posed for the statue of the dockworker, made by Constantin Meunier, which can be seen in front of the City Hall of Antwerp" (7–8).

7. Michelle Perrot, *Les ouvriers en grève* (Paris: Mouton, 1974), 32; cited by Gérard Noiriel, *Les ouvriers dans la société française. XIX*–*XX* *siècle* (Paris: Seuil, 1986), 107–08.

8. Agulhon, "Propos sur l'allégorie politique," 31. Priapus is portrayed with an oversized phallus in a permanent state of erection—Trans.

9. Léon and Maurice Bonneff, *La vie tragique des travailleurs* (1908; repr., Paris: Rouff, 1984).

10. Élisabeth and Michel Dismier, *L'Assiette au beurre. Revue satirique illustré (1901–1912)* (Paris: Maspero, 1974), 128.

11. Marc Lazar, "Damné de la terre et homme de marbre. L'ouvrier dans l'imaginaire du PCF du milieu des années trente à la fin des années cinquante," *Annales ESC* 5 (September–October 1990): 1071–96, 1082.

12. Eric Hobsbawm, "Sexe, symboles, vêtements," *Actes de la recherche en sciences sociales* 23 (September 1978): 2–18.

13. Agulhon, "Propos sur l'allégorie politique."

14. Hobsbawm, "Sexe, symboles, vêtements."

15. See, for example, the story by Marguerite Audoux, seamstress in Paris at the end of the century: Marguerite Audoux, *L'atelier de Marie-Claire* (1902; repr., Paris: Grasset, 2008).

16. George L. Mosse, *The Image of Man: The Invention of Modern Masculinity* (New York: Oxford University Press, 1996).

17. Illustration by Boris Koustodiev. The review was published in Moscow under the direction of Zinoviev, in Russian, English, French, and German. *The Communist International* 1 (1 May 1919). Cf. David King, *Red Star over Russia: A Visual History of the Soviet Union from the Revolution to the Death of Stalin* (New York: Abrams, 2009), 120.

18. Mosse, *The Image of Man*, 145.

19. Ibid.

20. François Kollar, ed., *Le visage de la France. La France travaille* (Paris: Horizons de France, 1932–1934).

21. Claude Gauteur and Ginette Vincendeau, *Jean Gabin. Anatomie d'un mythe* (Paris: Nathan, 1994), 181.

22. E. Caron, M. Ionacu, and M. Richaoux, "Le cheminot, le mineur et le paysan," in *L'âge d'or du documentaire. Europe, années cinquante*, vol. 1, ed. R. Odin (Paris: L'Harmattan, 1998), 95. The first adaptation of *Germinal* dates from 1913. See Tangui Perron, "Nitrate et gueules noires, ou le film minier," *Positif* 393 (November 1993): 24–30.

23. Évelyne Desbois, Yves Jeanneau, and Bruno Mattei, *La foi des charbonniers. Les mineurs dans la Bataille du charbon. 1845–1947* (Paris: Éditions de la Maison des sciences de l'homme, 1986), 91.

24. Louis Simonin, cited in Bruno Mattei, *Rebelle, rebelle! Révoltes et mythes du mineur. 1830–1946* (Seyssel: Champ Vallon, 1987), 262.

25. Ibid., 264. To this form of enlistment of miners must be added the very important role played by the development, over the course of the nineteenth century, of social security and insurance funds.

26. Stakhanov, quoted in Albert Pasquier, "Le stakhanovisme. L'organisation du travail en URSS" (thesis, Université de Caen, 1937), 29.

27. *L'Humanité*, 20 November 1935, p. 3.

28. *L'Humanité*, 1 March 1936, p. 3.

29. On this point, see the key article by Lazar, "Damné de la terre et homme de marbre," 1071–96. Also, Lazar's *Communisme. Une passion française* (Paris: Perrin, 2005).

30. Lazar, "Damné de la terre et homme de marbre," 1083. On political posters depicting the workers' world, see *Le monde ouvrier s'affiche. Un siècle de combat social*, ed. Frédéric Cépède and Éric Lafon (Paris: Codhos/Nouveau Monde editions, 2008).

31. Cited by Annette Wievioka, *Maurice et Jeannette. Biographie du couple Thorez* (Paris: Fayard, 2010), 242–43.

32. *L'Humanité*, 1950, cited in Lazar, "Damné de la terre et homme de marbre," 1084.

33. Jacqueline Mer, *Le parti de Maurice Thorez ou le Bonheur communiste français* (Paris: Payot, 1977), cited in Wieviorka, *Maurice et Jeannette*, 197.

34. On the notion of "spending" (*dépense*) borrowed from Georges Bataille, see Olivier Schwartz, *Le monde privé des ouvriers* (Paris: Presses Universitaires de France, 1990).

35. Georges Navel, *Travaux* (1945; repr., Paris: Gallimard, 1994), 147.

36. Alfred Pacini and Dominique Pons, ed., *Docker à Marseille* (Paris: Payot, 1996), 65. On the métier of dockworker, see the key work by Michel Pigenet, "À propos des représentations et des rapports sociaux sexués: identité professionnelle et masculinité chez les dockers français (XIXᵉ–XXᵉ siècle)," *Le Mouvement social* 198 (January–March 2002): 55–74.

37. Louis Lengrand and Maria Craipeau, *Louis Lengrand, mineur du Nord* (Paris: Seuil, 1974), 20.

38. Jacques Tonnaire, *La vapeur. Souvenir d'un mécano de locomotive (1932–1950)* (Paris: Lattès, 1982), 51.

39. Jean-Pierre Castelain, *Manière de vivre, manière de boire. Alcool et sociabilité sur le port* (Paris: Imago, 1989).

40. Constant Malva, "Ma nuit au jour le jour," *Paroles de mineurs* (1937; repr., Paris: Omnibus, 2007), 107.

41. Navel, *Travaux*, 100.

42. Schwartz, *Le monde privé des ouvriers*, 294.

43. Toussain Guillaumou, *Les confessions d'un compagnon* (1863; repr., Paris: Grancher, 1996), 39.

44. Ibid., 38.

45. Denis Poulot, *Le sublime et le travailleur comme il est en 1870, et ce qu'il peut être* (1869; repr., Paris: Maspero, 1980), 196–98.

46. Ibid., 195.

47. Henry Leyret, *En plein faubourg. Notations d'un mastroquet sur les moeurs ouvrières* (1895) (Paris: Les Nuits rouges, 2000), 54.

48. Ibid., 53.

49. René Michaud, *J'avais vingt ans. Un jeune ouvrier au début du siècle* (Paris: Éditions syndicalistes, 1967), 71.

50. Navel, *Travaux*, 144–45.

51. J.-B. Dumay, *Mémoire d'un militant ouvrier du Creusot (1841–1905)* (Grenoble: Cenomane, 1976); and Yves Lequin, *Histoire des Français, XIXᵉ–XXᵉ siècle* (Paris: Armand Colin, 1983), 427.

52. Hyacinth Dubreuil, *J'ai fini ma journée* (Paris: Librairie du compagnonnage, 1971), 52–53.

53. Malva, "Ma nuit au jour le jour," 488.

54. Leyret, *En plein faubourg*, 53.

55. Both here and on page 527 the author makes reference to "les compagnons du tour de France," or journeymen. These were the apprentices who had completed their training and embarked on a trip around the country to improve their skills by working with masters. The practice is comparable to the "wandering journeyman's years" in the English-speaking world—Trans.

56. Michaud, *J'avais vingt ans*, 71–72.

57. Anne-Marie Sohn, *"Sois un homme!" La construction de la masculinité au XIXᵉ siècle* (Paris: Seuil, 2009).

58. Jean Oury, *Les prolos* (Paris: Denoël, 1973), 38.

59. Ibid., 30–33.

60. Ibid., 84.

61. Aimée Moutet, *Les logiques de l'entreprise. La nationalisation dans l'industrie française de l'entre-deux-guerres* (Paris: Éditions de l'École des Hautes Études en Sciences Sociales, 1997); and Yves Cohen, *Organiser à l'aube du taylorisme. La pratique d'Ernest Mattern chez Peugeot (1906–1919)* (Besançon: Presses Universitaires de Franche-Comté, 2001).

62. Georges Friedmann, *Problèmes humains du machinisme industriel* (Paris: Gallimard, 1946); and Patrick Fridenson, "Un tournant taylorien de la société française," *Annales ESC* 5 (September–October 1987): 1031–60. On the perception of fatigue, see Alain

Corbin, "La fatigue, le repos et la conquête du temps," in *L'avènement des loisirs, 1850–1960*, ed. Alain Corbin (Paris: Aubier, 1995), 276–301.

63. Thierry Pillon, *Georges Friedmann. Problèmes humains du machinisme industriel. Les débuts de la sociologie du travail* (Paris: Ellipses, 2009).

64. Simone Weil, *La condition ouvrière* (Paris: Gallimard, 1951), 68.

65. Navel, *Travaux*, 64.

66. Ibid., 71–72.

67. Maurice Aline, *Quand j'étais ouvrier. 1930–1948* (Rennes: Éditions Ouest-France, 2003), 114.

68. Michaud, *J'avais vingt ans*, 94.

69. Xavier Charpin, *L'adieu différé* (1968; repr., Saint-Étienne: Le Hénnaff, 1981), 61–62.

70. Christophe Dejours, *Travail, usure mentale. De la psychopathologie à la psychodynamique du travail* (Montrouge: Bayard, 1980).

71. Pierre Bourdieu, *La distinction. Critique sociale du jugement* (Paris: Minuit, 1979), 447.

72. Charly Boyadjian, *La nuit des machines* (Paris: Les Presses d'aujourd'hui, 1978), 70.

73. Marcel Durand, *Grain de sable sous le capot. Résistance et contre-culture ouvrière. Les chaînes de montage de Peugeot (1972–2003)* (Paris: Agon, 2006), 84–85.

74. Schwartz, *Le monde privé des ouvriers*, 290.

75. Ibid.; Florence Weber, *Le Travail d'à-côté. Une ethnographie des perceptions* (Paris: Institut national de la recherche agronomique/Éditions de l'École des Hautes Études en Sciences Sociales, 1989).

76. Pierre Belleville, *Une nouvelle classe ouvrière* (Paris: Julliard, 1963); and Serge Mallet, *La nouvelle classe ouvrière* (Paris: Seuil, 1963).

77. Danièle Kerkoat, Yvonne Guichard-Claudic, and Alain Vilbrot, eds., *L'inversion du genre. Quand les métiers masculins se conjuguent au féminin et réciproquement* (Rennes: Presses Universitaires de Rennes, 2008).

78. Anne Monjaret, "Images érotiques dans les ateliers masculins hospitaliers: virilité et/ou corporatisme en crise," *Mouvements* 31 (January–February 2004): 30–35.

79. Pierre Bourdieu, "Remarques provisoires sur la perception sociale des corps," *Actes de la recherche en sciences sociales* 14 (1977): 51.

80. Nicolas Renahy, *Les gars du coin* (Paris: La Découverte, 2010), 160.

81. Stéphane Beaud and Michel Pialoux, *Retour sur la condition ouvrière. Enquête aux usines Peugeot de Sochaux-Monbéliard* (Paris: Fayard, 1999), 332.

82. Schwartz, *Le monde privé des ouvriers*, 83.

83. See the accounts offered by Pascale Jamoulle, *Des hommes sur le fil. La construction de l'identité masculine en milieux précaires* (Paris: La Découverte, 2005).

84. Gérard Mauger, "La reproduction des milieux populaires 'en crise,'" *Ville-École-Intégration* 113 (June 1998): 6–15.

85. Dominique Memmi, "La recomposition du masculin dans les classes populaires: une issue à la domination sociale?" *Le Mouvement social* 198 (January–March 2002): 151–54, 153.

86. Isabelle Sommier, "Virilité et culture ouvrière: pour une lecture des actions spectaculaires de la CGT," *Cultures & Conflits* 9–10 (Spring–Summer 1993): 341–66; and

Dominique Memmi, "Le corps protestataire aujourd'hui: une économie de la menace et de la présence," *Sociétés contemporaines* 31 (1998): 87–106.

87. Christian Possiello, "Les défis de la légéreté," *Esprit* 11 (1993): 49–53; cited in Renahy, *Les gars du coin*, 98.

88. On these practices, see Renahy, *Les gars du coin*, 97–99.

89. Pascal Duret, *Les jeunes et l'identité masculine* (Paris: Presses Universitaires de France, 1999); and David Lepoutre, *Coeur de banlieue. Codes, rites et langages* (Paris: Odile Jacob, 2001).

90. Lepoutre, *Coeur de banlieue*.

91. Ibid., 350.

92. Stéphane Beaud and Michel Pialoux, "Jeunes ouvrier(e)s à l'usine. Notes de recherche sur la concurrence garçons/filles et sur la remise en cause de la masculinité ouvrière," *Travail, Genre et Société* 8 (November 2002): 88.

93. Michel Kokoreff, Odile Steinauer, and Pierre Barron, "Les émeutes urbaines à l'épreuve des situations locales," *Sociologies* (July 2007): 1–25, http://sociologies.revues.org/254.

20. HOMOSEXUAL TRANSFORMATIONS

1. See Jonathan Katz, *The Invention of Heterosexuality* (New York: Dutton/Penguin, 1995); and Louis-Georges Tin, *L'invention de la culture hétérosexuelle* (Paris: Autrement, 2008). The present chapter treats only male homosexuality. For the connection between lesbianism and virility, see chap. 16 in this volume by Christine Bard, "Virility Through the Looking Glass of Women."

2. Didier Éribon, *Réflexions sur la question gay* (Paris: Fayard, 1999), 13.

3. Erving Goffman, *The Presentation of Self in Everyday Life* (New York: Doubleday/Anchor, 1959).

4. Shaun Cole, *"Don We Now Our Gay Apparel": Gay Men's Dress in the Twentieth Century* (New York: Berg, 2000), 1–13.

5. See R. W. Connell, *Masculinities* (Berkeley: University of California Press, 1995); and Peter Nardi, ed., *Gay Masculinities* (Thousand Oaks, CA: Sage, 2000), 1–11.

6. Judith Butler, *Gender Trouble* (New York: Routledge, 1990), 112.

7. See George L. Mosse, *The Image of Man: The Invention of Modern Masculinity* (New York: Oxford University Press, 1996).

8. See Laure Murat, *La loi du genre. Une histoire culturelle du "troisième sexe"* (Paris: Fayard, 2006). Cf. *supra*, chapter 12 "The Burden of Virility: Injunctions, Homosexuality," 342–43 and passim.—Trans.

9. See Florence Tamagne, *Histoire de l'homosexualité en Europe. Paris, Londres, Berlin. 1919–1939* (Paris: Seuil, 2000).

10. See George Chauncey, *Gay New York: Gender, Urban Culture and the Making of the Gay Male World, 1890–1940* (New York: Basic, 1994).

11. Quentin Crisp, *The Naked Civil Servant* (1968; repr., London: Fontana, 1986).

12. See Thierry Delessert, "'Les homosexuels sont en danger absolu.' Homosexualité masculine en Suisse durant la Seconde Guerre mondiale" (doctoral thesis in political science, Université de Lausanne, 2010).

13. See Julian Jackson, *Arcadie. La vie homosexuelle en France de l'après-guerre à la dépénalisation* (Paris: Autrement, 2009).

14. Homosexual Front for Revolutionary Action, *Rapport contre la normalité* (Paris: Champ libre, 1971), 11, 14.

15. Jean-Yves Le Talec, *Folles de France. Repenser l'homosexualité masculine* (Paris: La Découverte, 2008), 289. I am borrowing from Le Talec the distinction between "artistic" and "militant" queens.

16. The *gazolines* were a group of women and queens from the FHAR who became known for their offbeat actions between 1972 and 1974. The Sisters of Perpetual Indulgence are a movement of radical queens created in San Francisco in 1979 who later became involved in the fight against AIDS. They engage in "gender-fuck" by bringing together with their nun's outfit a beard, white makeup, and various camp accessories.

17. See Cole, *"Don We Now Our Gay Apparel,"* 52. In 1990 Madonna paid homage to "voguing" in the title of her emblematic video *Vogue*, directed by David Fincher.

18. See Richard Ekins and Dave King, "Transgendering, Men, and Masculinities," in *Handbook of Studies on Men and Masculinities*, ed. Michael S. Kimmel, Jeff Hearn, and R. W. Connell (Thousand Oaks, CA: Sage, 2005), 379–93.

19. Butler, *Gender Trouble*, 137 (Butler's emphasis).

20. Ibid., 140.

21. See Sheila Whiteley and Jennifer Ryanga, eds., *Queering the Popular Pitch* (New York: Routledge, 2006).

22. Marjorie Garber, *Vested Interests: Cross-Dressing and Cultural Anxiety* (New York: Harper Perennial, 1993).

23. Don Kulick, "A Man in the House: The Boyfriends of Brazilian *Travesti* Prostitutes," in *Queer Studies: An Interdisciplinary Reader*, ed. Robert J. Corber and Stephen Valocchi (Oxford: Blackwell Publishing, 2003), 237.

24. Sigmund Freud, *Three Essays on the Theory of Sexuality*, trans. James Strachey (New York: Basic, 1962).

25. Jean Genet, *Notre-Dame-des-Fleurs* (1948; repr., Paris: Gallimard, 1987), 47.

26. Christopher Isherwood, *Christopher and His Kind* (London: Methuen, 1977).

27. Certain gangs of "black shirts" were adept in the "hunt for faggots"; certain male prostitutes picked their clients' pockets. See John Rechy, *City of Night* (New York: Grove, 1963).

28. See Martin P. Levine in *Gay Macho: The Life and Death of the Homosexual Clone* (New York: New York University Press, 1998). I reprise here one part of my contribution on "Le gay macho en France dans les années 1970" to the conference Histoire des hommes et des masculinités, organized by Anne-Marie Sohn at the ENS-LSH Lyon, 18–20 June 2009.

29. See Alfredo Mirandé, "'Macho': Contemporary Conceptions," in *Men and Masculinity: A Text Reader*, ed. Theodore F. Cohen (Belmont, CA: Wadsworth, 2001), 42–52.

30. A passion for body-building could be interpreted as a reaction of aggressiveness toward straights, the revalorization of a body perceived for a long time as shameful, and of course, a seduction strategy.

31. Keys or handkerchief worn on the left indicated that the man was a top, on the right, a bottom. Color codes were the signs of sexual preferences.

32. This refusal of affectivity applied only to "tricks," which did not stop a good many men from expressing the desire for a long-term relationship.

33. The acronym BDSM stands for bondage, discipline, domination/submission, and sadomasochism.

34. Michael Pollak, "L'homosexualité masculine, ou le bonheur dans le ghetto?" [1982], in Michael Pollak, *Une identité blessée* (Paris: Métailié, 1993).

35. Tom of Finland explained his taste for this aesthetic fascination by the fact that, as an adolescent during the war, he had occasion to mix with—and have sexual relations with—Nazi officers in Berlin and Helsinki.

36. See Butler, *Gender Trouble*.

37. See Mark Simpson, *Male Impersonators: Men Performing Masculinity* (London: Cassell, 1994).

38. Guy Hocquenghem, *Le désir homosexuel* (1972; repr., Paris: Fayard, 2000), 103–04.

39. Heinrich Himmler, *Discours secrets* (Paris: Gallimard, 1978).

40. See Klaus Theweleit, *Male Fantasies*, 2 vols. [1977, 1979] trans. Erica Carter, Chris Turner, and Stephen Conway (Minneapolis: University of Minnesota Press, [vol. 1] 1987, [vol. 2] 1989) (cf. *supra*, chapter 18, 509).

41. See Sylvain Ferez, *Le corps homosexuel en-jeu* (Nancy: Presses Universitaires de Nancy, 2007).

42. Don Sabo, Terry A. Kupers, and Willie London, eds., *Prison Masculinities* (Philadelphia: Temple University Press, 2001), 111–17. In the case of France and the United States, the number of prisoners who are victims of sexual aggression is estimated at between 10% and 30%, with the understanding that these figures are no doubt underestimated.

43. The term *slasheuse* refers to women (mostly heterosexual, but also asexual, bi, or lesbian), either readers, authors, or illustrators, who are followers of fan fiction that brings to the fore male characters in homosexual relationships and of "Boy's Love" (a type of manga with gay themes drawn by women).

44. See Asifa Siraj, "On Being Homosexual and Muslim: Conflicts and Challenges," in *Islamic Masculinities*, ed. Lahoucine Ouzgane (New York: Zed, 2006), 203–16.

45. The Netherlands was the first European country to recognize, in 1989, same-sex unions.

46. Paternity may be the result of a prior heterosexual relationship, an adoption, recourse to a surrogate mother, or a coparenting situation, when it involves the partner's child. It can be experienced alone or with a partner, with or without maternal backing.

47. See Jeffrey Weeks, Brian Heaphy, and Catherine Donovan, *Same-Sex Intimacies: Families of Choice and Other Life Experiments* (London: Routledge, 2001).

48. Peter M. Nardi, "That's What Friends Are For: Friends as Family in the Gay and Lesbian Community," in *Modern Homosexualities: Fragments of Lesbian and Gay Experience*, ed. Ken Plummer (New York: Routledge, 1992), 108–20.

49. Peter Nardi, *Gay Men's Friendships: Invincible Communities* (Chicago: University of Chicago Press, 1999).

50. Tim Edwards, "The AIDS Dialectics: Awareness, Identity, Death and Sexual Politics," in Plummer, *Modern Homosexualities*, 151–59.

51. See Cole, *"Don We Now Our Gay Apparel,"* 169–81.

52. The word "bear" was said to have come from the habit that some men had developed of carrying in their shirt pocket a stuffed bear, as a way of signifying that they were looking not only for sex but also for affection. See Peter Hennen, "Bear Bodies, Bear Masculinity: Recuperation, Resistance, or Retreat?," *Gender and Society* 19, no. 1 (February 2005): 25–43; and Cole, *"Don We Now Our Gay Apparel,"* 125–26.

53. John R. Burger, *One-Handed Histories: The Eroto-Politics of Gay Male Video Pornography* (New York: Haworth, 1995).

54. Todd Shepard, "L'extrême droite et 'Mai 68.' Une obsession d'Algérie et de virilité," *Clio* 29 (2009): 44.

55. *Tout*, "Nous sommes plus de 343 salopes" (We are more than 343 bitches) 12 (23 April 1971): 7.

56. Shinhee Han, "Asian American Gay Men's (Dis)claim on Masculinity," in Nardi, *Gay Masculinities*, 206–23.

57. "Emo," for "emotional," designates a musical genre derived from hardcore punk. "Visual kei" is a form of Japanese rock that places particular importance on the visual aesthetics of rock groups.

58. Cole, *"Don We Now Our Gay Apparel,"* 131–39.

59. Tim Edwards, *Cultures of Masculinity* (New York: Routledge, 2006), 36–43.

60. Connell, *Masculinities*, 219.

61. Demetrakis Z. Demetriou, "Connell's Concept of Hegemonic Masculinity: A Critique," *Theory and Society* 30, no. 3 (June 2001): 348.

62. See, for example, *Red River* (1948) by Howard Hawks, with Montgomery Clift and John Ireland.

21. EXHIBITIONS: VIRILITY STRIPPED BARE

1. J. Lacombe, *Dictionnaire portatif des beaux-arts* (Paris: Veuve Estienne, 1752), 11.

2. Cl. Watelet and P. Ch. Levesque, *Encyclopédie méthodique. Beaux-Arts*, vol. 1 (Paris: Panckoucke: 1788–91), 1.

3. Sigmund Freud, *Civilization and Its Discontents*, trans. Joan Riviere (London: Hogarth, 1953), 66n.

4. Sigmund Freud, *Three Essays on the Theory of Sexuality*, trans. James Strachey (New York: Basic, 1962); cf. H. Damisch, *Le jugement de Pâris* (Paris: Flammarion, 1992), 17.

5. D. Diderot, *Salon de 1765* (Paris: Hermann, 1984), 283.

6. Ch. Blanc, *Grammaire des arts du dessin* (1867; repr., Paris: École Nationale Supérieure des Beaux-Arts, 2000), 53.

7. D. Diderot, *Essais sur la peinture* (1759; repr., Paris: Hermann, 1984), 13.

8. Claire Barbillon, *Les canons du corps humain au XIX^e siècle* (Paris: Odile Jacob, 2004).

9. Cl. Barbillon publishes the Joubert edition from 1801: Gérard Audran, *Les proportions du corps humain mesurées sur les plus belles figures de l'Antiquité* (Paris: Joubert, 1801), 46, 47, 138, but this one is the same on this point as the original edition (Paris: Gérard Audran, 1683).

10. The 1821 edition of Jean Cousin's *L'art de dessiner* shows the Farnese Hercules naked, but the penis is noticeably diminished compared with the original.

11. Ch.-A. Jombert, *Méthode pour apprendre le dessin* (Paris, 1755), plates 39, 43, 44, 45.

12. The Greek preference for small sex organs seems to reflect a combination of moral, aesthetic, and physiological attitudes. In *The Clouds*, Aristophanes presents this attribute as the result of good education in the classical manner advocated by Just Reasoning: respect for elders, propriety, and obedience to a certain number of precepts result finally in a beautiful body: "If you keep everything I said in your head and do as I say, you'll:/Always have a splendid chest,/A resplendent skin,/Huge shoulders,/A tiny tongue,/A terrific bum/And,/A cute, slender dick." In contrast, debauchery makes the penis ugly and extends it. Aristophanes, *The Clouds*, trans. G. Theodoridis (2007), accessed 3 June 2015, http://www.poetryintranslation.com/PITBR/Greek/Clouds. htm. According to Aristotle, the smallness of the penis, which reduces the trajectory— hence, the cooling—of the semen, is a guarantee of fertility.

13. On this phenomenon, see A. Solomon-Godeau, *Male Trouble: A Crisis in Representation* (London: Thames and Hudson, 1997).

14. Girodet-Trioson, *Endymion*, 1793, oil on canvas, Paris, Louvre.

15. Pierre Narcisse Guérin, *Aurore et Céphale*, 1814, oil on canvas, Paris, Louvre.

16. Jean-Baptiste-Régnault, *Liberty or Death*, 1795, oil on canvas, Hamburg, Kunsthalle.

17. Jacques-Louis David, *Léonidas aux Thermopyles*, 1814, Pen, black ink, and gray wash, white highlights, graphite pencil on paper, Paris, Louvre.

18. Jean-Hippolyte Flandrin, *Theseus Recognized by His Father*, 1832, oil on canvas, Paris, École des Beaux-Arts.

19. Cited in Solomon-Godeau, *Male Trouble*, 224.

20. S. Aubenas, "Les albums de nus d'Eugène Delacroix," in *Delacroix et la photographie*, ed. Ch. Leribault (Paris: Musée du Louvre/Le Passage, 2008), 33.

21. E. Delacroix, *Journal* (Paris: Plon, 1996), 350.

22. Ibid., 550.

23. Wilhelm von Gloeden, Michele Falzone del Barbarò, and Goffredo Parise, *Le fotografie di von Gloeden* (Milan: Longanesi, 1980), 24.

24. Ibid., 28.

25. R. Barthes, *L'obvie et l'obtus* (Paris: Seuil, 1982), 179–80.

26. P. Verlaine, *Mille e tre, Hombre* (Paris: Desforges, 1977), 103; trans. Alistair Elliot, (Bronx, NY: Sheep Meadow Press, 1979, 89 (trans. modified).

27. I have developed these remarks in an earlier study: Bruno Nassim Aboudrar, "Images honteuses, parties honteuses," in *Les images honteuses*, ed. M. Gagnebin and J. Milly (Seyssel: Champ Vallon, 2006), 50, passim.

28. E. Laurent, "Observations sur quelques anomalies de la verge chez les dégénérés criminels," *Archives de l'anthropologie criminelle et des sciences pénales* 7 (1882): 27.

29. Ibid., 30.

30. Ibid.

31. A. Corbin, "La rencontre des corps," in *Histoire du corps*, vol. 2, *De la Révolution à la Grande Guerre*, ed. Alain Corbin (Paris: Seuil, 2005), 183.

32. A. Tardieu, *Études médico-légales sur les attentats aux moeurs* (Paris: J.-B. Ballières, 1873), 183.

33. Ibid., 241.

34. E. Laurent, *Les habitués des prisons de Paris* (Paris: Masson, 1890), 363.

35. *The Rotenburg Collection: Forbidden Erotica* (Cologne: Taschen, 2000).

36. Rabelais, *Gargantua* (Paris: Seuil, "L'Intégrale," 1973), 175.

37. M. Bakhtin, *Rabelais and His World*, trans. Helene Iswolsky (1965; repr., Bloomington: Indiana University Press, 2009).

38. D. A. F. de Sade, *Justine* (Paris: Le Livre de Poche, 1973), 159, 163.

39. *Rotenburg Collection*, 131–33.

40. J. Weinberg, *Male Desire: The Homoerotic in American Art* (New York: Abrams, 2004), 91.

41. Paul Morihien's edition of Genet's novel illustrated by Cocteau appears "under the counter," and the watercolors by Demuth or Tchelichew are reserved for use by their collector.

42. They are Frank O'Hara, Joe Brainard, Joseph Le Sueur, and Frank Lima: Weinberg, *Male Desire*, 125.

43. L. Steinberg, *The Sexuality of Christ in Renaissance Art and Modern Oblivion*, 2d ed. (Chicago: University of Chicago Press, 1996), 83, passim.

44. Paraphymosis is the constriction of the glans of the penis by a prepuce that is too tight—Trans.

45. A. Serrano, *A History of Sex* (Groningen: Museumeilan, 1996), chap. 9, plate 48.

46. Louise Bourgeois, *Fillete*, sculptured latex over plaster, 1968, London, Tate Modern.

47. M.-L. Bernadac and J. Storsve, *Louise Bourgeois* (Paris: Centre Pompidou, 2008), 150.

48. On the impact of the work, cf. R. Meyer, *Bone of Contention*, accessed 16 February 2011, www.thefreelibrary.com.

49. L. Nochlin, "Eroticism and Images of Femininity in Art of the 19th Century," *Women, Art and Power and Other Essays* (New York: Harper & Row, 1988). The photo appears there.

50. Corbin, "La rencontre des corps," 162, passim.

51. Nan Goldin, *Bobby Masturbating* (1980), in *Ballad of Sexual Dependency* (New York: Aperture, 1986; repr., 2012); also as part of a diaporama [photographic slideshow—Trans.] projected for the first time in Europe in Arles, 1987.

52. Wolfgang Tilmanns, *Stiefelknecht Cologne*, ink-jet print, 1993.
53. D. Arasse, *Léonard de Vinci* (Paris: Hazan, 1997), 468, passim.
54. Leonardo de Vinci, *Carnets*, vol. 1, trans. L. Servicien (Paris: Gallimard, "Tel," 1989), 128.

22. BRAWN IN CIVILIZATION

1. Sigmund Freud, *Civilization and Its Discontents*, trans. James Strachey (1929; repr., New York: Norton, 1962), 37n1.
2. Philip Roth, *Exit Ghost* (New York: Houghton Mifflin, 2010), 109–10.
3. Ibid., 104.
4. Roth, *Everyman* (New York: Houghton Mifflin, 2006), 52.
5. Romain Gary, *Au-delà de cette limite, votre ticket n'est plus valable* (Paris: Gallimard, "Folio," 1975), 37.
6. Michel Houellebecq, *Les particules élémentaires* (Paris: Flammarion, 1998), 165.
7. See, in particular, Maria Matzer Rose, *Muscle Beach* (New York: St. Martin's, 2001).
8. The documentary, *Pumping Iron* (1975) by George Butler and Robert Fiore.
9. Gold's Gym, the gymnasium historically linked to the origins of Muscle Beach and which served as setting for the film, greatly increased the number of its locations, becoming a commercial franchise in the 1980s, and today counts 650 gyms spread across 42 states and 30 countries. For a detailed anthropology of bodybuilding in California, its personages, and its gymnasiums, the essential reference work is Allen M. Klein, *Little Big Men: Bodybuilding Subculture and Gender Construction* (Albany: State University of New York Press, 1993).
10. On the "first wave" of cosmopolitan cinema, see Vanessa Schwartz, *It's So French! Paris-Hollywood and the Making of a Cosmopolitan Film Culture* (Chicago: University of Chicago Press, 2007). Muscular overdevelopment played a preeminent role in the second wave of global cosmopolitan cinema, that of the *Rambos* and *Terminators*.
11. See, in particular, the documentary film by Chris Bell, *Bigger, Stronger, Faster* (2008).
12. See, in particular, Maria R. Low, *Women of Steel: Female Body-Builders and the Struggle for Self-Definition* (New York: New York University Press, 1998); and for France, Peggy Roussel and Jean Griffet, "Le muscle au service de la beauté. La métamorphose des femmes culturistes," *Recherches féministes* 17, no. 1 (2004): 143–72.
13. The following observations are to be placed in the context of the continuation of earlier work on the history of bodybuilding in the United States (see Jean-Jacques Courtine, "Les stakhanovistes du narcissisme: *body-building* et puritanisme ostentoire dans la culture américaine du corps," *Communications*, 54 [March 1993]: 225–51); they take up some of the elements from that work; it is at the same time the recollection of the author's frequenting of West Coast gyms, in Santa Monica and Santa Barbara, which have given him the opportunity for participant observation over a fairly long period.
14. Joyce Carol Oates, *On Boxing* (1987; repr., New York: HarperCollins, 2006), 72.

15. Oates, "Rape & the Boxing Ring," in *At the Fights: American Writers on Boxing*, ed. George Kimball and John Schulian (New York: Literary Classics of the United States, 2011), 393.

16. Ibid.

17. On toys and comic books, see in particular, Lyn Mikel Brown, Sharon Lamb, and Mark Tappan, *Packaging Boyhood: Saving Our Sons from Superheroes, Slackers & Other Media Stereotypes* (New York: St. Martin's, 2009).

18. For example: Harry Crews, *Body* (New York: Poseidon, 1990); and the remarkable short story "Discipline" in Donald Ray Pollock's collection, *Knockemstiff* (New York: Anchor, 2008).

19. Sam Fussell, *Muscle: Confessions of an Unlikely Bodybuilder* (New York: Poseidon, 1991).

20. See, for example, Andre Dubus III, *Townie* (New York: Norton, 2011). It is thus symptomatic that Philip Roth has recently interrupted his series of novels on the breakdown of virility to return to the narrative of initiation in *Indignation* (New York: Houghton, Mifflin, Harcourt, 2008), the initiatory process of a young man subjected to the brutal domination of a butcher father.

21. For instance, the Weider group, one of those empires that reign over American—and global—bodybuilding. Founded by a former errand boy who managed to bring his passion for muscle building to fruition, this group of enterprises employed already at the beginning of the 1990s more than 2000 salaried workers with an annual profit of more than $300 million. Joe Weider is the creator and organizer of the contest for the most coveted title (Mr. Olympia) and the founder of the International Federation of Bodybuilding, represented in 136 countries. The group includes producers of nutritional products, manufacturers of exercise machines, owners of gymnasiums, and editors of specialty magazines that are among the most widely distributed (*Muscle & Fitness, Shape, Flex, Men's Fitness, Moxie*, and the list goes on); see Klein, *Little Big Men*, 81–107.

22. Exercise machines were among the fastest-growing consumer items during the 1980s (see the *Los Angeles Times*, 31 December 1989: "1980s Shoppers Charged into a Brave New World of Goods").

23. Plastic surgery experienced an astronomical boom during the 1980s with the appearance of new techniques for modification of body mass and shape. Its male clientele has increased. In the United States, one registered practitioner in five resides in Los Angeles. On the culture of cosmetic surgery, see in particular, Virginia L. Blum, *Flesh Wounds: The Culture of Cosmetic Surgery* (Berkeley: University of California Press, 2003).

24. John Hoberman, *Testosterone Dreams: Rejuvenation, Aphrodisia, Doping* (Berkeley: University of California Press, 2005), 13.

25. Ibid., 13–14. Another institution of the same type, the American Academy of Anti-Aging Medicine, founded in Chicago in 1993, includes 11,000 members, mostly doctors, and wages a fight with evangelical inflections against "andropause."

26. Hypermasculinity is generally analyzed in the lineage of work on the contemporary narcissistic personality. See in particular, Christopher Lasch, *The Culture of Narcissism* (New York: Norton, 1979), 210: "This irrational terror of old age and death is closely associated with the emergence of the narcissistic personality as the dominant type of personality structure in contemporary society."

27. Pierre Bourdieu, *La domination masculine* (Paris: Seuil, 1998), 114.

28. Matthew C. Gutmann, *The Meanings of Macho: Being a Man in Mexico City* (Berkeley: University of California Press, 1996), 227; also, Américo Paredes, "The United States, Mexico, and Machismo," *Journal of the Folklore Institute* 8, no. 1 (1971): 17–37.

29. Claude Lévi-Strauss, *L'anthropologie structurale*, vol. 1 (Paris: Plon, 1963). On masculinity as myth, see in particular, Joseph H. Pleck, *The Myth of Masculinity* (Cambridge, MA: MIT Press, 1981).

30. Lévi-Strauss, *L'anthropologie structurale*, 1:231.

31. Edmond Desbonnet, *Les rois de la force. Histoire de tous les hommes forts depuis les temps anciens jusqu'à nos jours* (Paris: Berger-Levrault [Librairie athlétique], 1911), 10.

32. Ibid., vii.

33. Lévi-Strauss, *L'anthropologie structurale*, 1:231.

34. Desbonnet, *Les rois de la force*.

35. Jules Vallès, *La rue* [1866], in *Oeuvres complètes* (Paris: Livre Club Diderot, 1969), 1:479.

36. Desbonnet, 64.

37. Ibid.

38. Françoise Héritier, *Hommes, femmes. La construction de la différence* (Paris: Le Pommier/Cité des sciences et de l'industrie, 2005), 38 and 39.

39. Oates, *On Boxing*, 72–73.

40. For a detailed study of "Muscular Christianity," see Clifford Putney, *Muscular Christianity: Manhood and Sports in Protestant America, 1880–1920* (Cambridge, MA: Harvard University Press, 2001); Bruce Haley, *The Healthy Body and Victorian Literature* (Cambridge, MA: Harvard University Press, 1978); and also Donald Mrozek, *Sport and American Mentality, 1880–1910* (Knoxville: University of Tennessee Press, 1983).

41. Bernarr Macfadden is cited by Robert Ernst, *Weakness Is a Crime: The Life of Bernarr Macfadden* (New York: Syracuse University Press, 1991), 60–61.

42. Lévi-Strauss, *L'anthropologie structurale*, 1:233.

43. Edgar Rice Burroughs, *Tarzan of the Apes* [1914], cited by John Pettegrew, *Brutes in Suits: Male Sensibility in America, 1890–1920* (Baltimore: Johns Hopkins University Press, 2007), 81; on Tarzan, see the recent book by Pascal Dibie, ed., *Tarzan!* (Paris: Somogy/Quai Branly, 2009).

44. Robert Bly, *Iron John: A Book About Men* (New York: Da Capo, 1990).

45. See http://www.mankindproject.org.

46. On the memory and genealogy of images, see Jean-Jacques Courtine, *Déchiffrer le corps. Penser avec Foucault* (Grenoble: Millon, 2011).

47. See Charles Gaines and George Butler, *Yours in Perfect Manhood: Charles Atlas* (New York: Simon and Schuster, 1982).

48. Ernst, *Weakness Is a Crime*.

49. Lévi-Strauss, *L'anthropologie structurale*, 1:254.

50. On this point, see, in particular, Claude Forest, ed., *Du héros aux super-héros. Mutations cinématographiques* (Paris: Presses de la Sorbonne nouvelle, 2009); and the vivid novel by Michael Chabon, *The Extraordinary Adventures of Kavalier and Clay* (New York: Picador, 2000).

51. What Allen M. Klein rightly names "comic book masculinity."

52. Fussell, *Muscle*, 115.

INDEX

EUROPEAN PERSPECTIVES

A SERIES IN SOCIAL THOUGHT AND CULTURAL CRITICISM

LAWRENCE D. KRITZMAN, EDITOR

Gilles Deleuze, *The Logic of Sense*

Julia Kristeva, *Strangers to Ourselves*

Theodor W. Adorno, *Notes to Literature*, vols. 1 and 2

Richard Wolin, ed., *The Heidegger Controversy*

Antonio Gramsci, *Prison Notebooks*, vols. 1, 2, and 3

Jacques LeGoff, *History and Memory*

Alain Finkielkraut, *Remembering in Vain: The Klaus Barbie Trial and Crimes Against Humanity*

Julia Kristeva, *Nations Without Nationalism*

Pierre Bourdieu, *The Field of Cultural Production*

Pierre Vidal-Naquet, *Assassins of Memory: Essays on the Denial of the Holocaust*

Hugo Ball, *Critique of the German Intelligentsia*

Gilles Deleuze, *Logic and Sense*

Gilles Deleuze and Félix Guattari, *What Is Philosophy?*

Karl Heinz Bohrer, *Suddenness: On the Moment of Aesthetic Appearance*

Julia Kristeva, *Time and Sense: Proust and the Experience of Literature*

Alain Finkielkraut, *The Defeat of the Mind*

Julia Kristeva, *New Maladies of the Soul*

Elisabeth Badinter, *XY: On Masculine Identity*

Karl Löwith, *Martin Heidegger and European Nihilism*

Gilles Deleuze, *Negotiations, 1972–1990*

Pierre Vidal-Naquet, *The Jews: History, Memory, and the Present*

Norbert Elias, *The Germans*

Louis Althusser, *Writings on Psychoanalysis: Freud and Lacan*

Elisabeth Roudinesco, *Jacques Lacan: His Life and Work*

Ross Guberman, *Julia Kristeva Interviews*

Kelly Oliver, *The Portable Kristeva*

Pierre Nora, *Realms of Memory: The Construction of the French Past*
 Vol. 1: *Conflicts and Divisions*
 Vol. 2: *Traditions*
 Vol. 3: *Symbols*

Claudine Fabre-Vassas, *The Singular Beast: Jews, Christians, and the Pig*

Paul Ricoeur, *Critique and Conviction: Conversations with François Azouvi and Marc de Launay*

Theodor W. Adorno, *Critical Models: Interventions and Catchwords*

Alain Corbin, *Village Bells: Sound and Meaning in the Nineteenth-Century French Countryside*

Zygmunt Bauman, *Globalization: The Human Consequences*

Emmanuel Levinas, *Entre Nous: Essays on Thinking-of-the-Other*

Jean-Louis Flandrin and Massimo Montanari, *Food: A Culinary History*

Tahar Ben Jelloun, *French Hospitality: Racism and North African Immigrants*

Emmanuel Levinas, *Alterity and Transcendence*

Sylviane Agacinski, *Parity of the Sexes*

Alain Finkielkraut, *In the Name of Humanity: Reflections on the Twentieth Century*

Julia Kristeva, *The Sense and Non-Sense of Revolt: The Powers and Limits of Psychoanalysis*

Régis Debray, *Transmitting Culture*

Catherine Clément and Julia Kristeva, *The Feminine and the Sacred*